THE BRITISH SCHOOL AT ATHENS

KNOSSOS
EXCAVATIONS 1957–1961

EARLY MINOAN

KNOSSOS

EXCAVATIONS 1957–1961

EARLY MINOAN

by

SINCLAIR HOOD AND GERALD CADOGAN

with contributions by

DONIERT EVELY, VALASIA ISAAKIDOU, JANE M. RENFREW,
RENA VEROPOULIDOU AND PETER WARREN

SUPPLEMENTARY VOLUME NO. 46

Published by

THE BRITISH SCHOOL AT ATHENS

2011

Published and distributed by
The British School at Athens

10 Carlton House Terrace
London SW1Y 5AH

Series Editor: Olga Krzyszkowska

ISBN 978-0-904887-64-8

Designed and computer typeset by Rayna Andrew

Printed by Short Run Press Ltd,
Exeter, Devon, United Kingdom

For Rachel and Lucy

Contents

List of Figures

List of Tables

List of Plates

List of Abbreviations

E / M / L	Early / Middle / Late	FN	Final Neolithic
B / C / H/ M /N	Bronze / Cycladic / Helladic / Minoan / Neolithic	G	Geometric
		Hell	Hellenistic
A	Archaic	O	Orientalising
BA	Bronze Age	PG	Protogeometric
Byz	Byzantine	R	Roman
Ch	Chalcolithic	SN	Sub-Neolithic
D	Dynastic	SM	Sub-Minoan

AM	Ashmolean Museum, Oxford	MRAH	Musées Royaux d'Art et d'Histoire, Brussels
BM	British Museum, London		
BSA	British School at Athens	NMC	National Museum, Copenhagen
cm	centimetre(s)	n.s.	new series
D.	diameter	PEM	Palace Early Minoan: code for Early Houses excavation of 1960
EEF	Egypt Exploration Fund		
EFA	École Française d'Athènes	pers. comm.	personal communication
FF4	trench FF level 4 (EM I deposit in J. D. Evans's West Court excavations)	pres.	preserved
		PW	Palace Well
		rest.	restored
FS	Furumark Shape	RR	Royal Road
frag./frags.	fragment(s)	RRN	Royal Road: North
Ht	height	RRS	Royal Road: South
HM	Herakleion (Archaeological) Museum	SFH	South Front House
		SMK	Stratigraphical Museum, Knossos
km	kilometre(s)	SMP	Stratigraphical Museum, Knossos, pottery catalogue number
L./l.	length		
LM	Liverpool Museum	sq	square
m	metre(s)	T.	Tomb
max.	maximum	Th./th.	thickness
MaxAu	Maximum Anatomical Units	UEW	Upper East Well
MinAu	Minimum Anatomical Units	W.	width
mm	millimetre(s)	WCH	West Court House
MMA	Metropolitan Museum of Art, New York	Wt	weight

Preface

This volume, the first of the final reports on the Minoan parts of the 1957–1961 programme of stratigraphic excavations at Knossos by the British School at Athens, has taken a long time to appear. We apologise for this. A draft covering the greater part of this report (especially Chapters 1–3, 5–8 and parts of 4 and 9) was completed by SH some 20 years ago. GC was invited to contribute sections now covered in Chapters 4, 9 and 10. In readying at last (2008–10) this volume for publication, GC has been able to reduce the length of the draft and endeavoured to bring the text up to date with reference to the considerable amount of work done on the Early Minoan period of Crete, principally by Stelios Andreou, Peter Day, Nicoletta Momigliano, Peter Tomkins and David Wilson, who have done much to elucidate the Early Minoan pottery and history of Knossos and who have included our material in their studies and regularly shared their views with us. We thank them warmly. We have attempted to revise the original text, so as both to make it as up-to-date as possible and at the same time not to repeat what is already well known — and now formalised in the prehistoric volume of the *Knossos Pottery Handbook* (2007).[1] The descriptions of the pottery, however, which form the core of this volume, have not been changed to any significant degree. The Introduction and Chapters 4 and 9 are the joint work of GC and SH, Chapters 1–3, 5–8 and some of 11 are essentially by SH, Chapters 10, 12 and much of 11 are by GC.

This work would not have been possible without the support and permissions of the Archaeological Service and the then Managing Committee of the British School at Athens. We should like to thank — and remember — in particular the Ephors of the Herakleion Ephoreia: †Nikolaos Platon, who gave permission to examine the Early Houses, and Stylianos Alexiou, who was Ephor when the main study of the pottery took place at Knossos, and permitted us to study and publish here Early Minoan pottery in the Herakleion Museum from Arthur Evans's excavations. At the School, we thank — and remember — especially: †Edith Clay and †Joan Thornton, London Secretaries; †Jane Rabnett, Athens Secretary; †Martin Robertson, Chairman of the Managing Committee — who were all in office at the time of the Early Minoan excavations and study — and †Peter Megaw, Director at the time of study. At Knossos, we were and are deeply grateful for the help of †Petros Petrakis, the School's potmender, and his wife †Eleni, as well as †Manolis Markoyiannakis, the School's foreman at the excavations, and his wife †Ourania, and †Spyros Vasilakis, a master excavator. We thank also the School's Curators and Fellows at Knossos: Jill Carington Smith, Doniert Evely, Eleni Hatzaki, Roger Howell, Colin Macdonald, Sandy MacGillivray, Alan Peatfield and Todd Whitelaw.

In preparing this volume, and for their discussion, direction and assistance in analysing this pottery and all other matters Early Minoan, and many fruitful conversations, we particularly thank: Stelios Andreou, for discussions and support over many years; Rayna Andrew for composing the book; Philip Betancourt, especially for advice on Vasiliki ware; John Cherry, for drawings of the obsidian; Pat Clarke and Jeff Clarke, for many of the drawings; Peter Day, for information, together with David Wilson, on the ware groups; †Michael Dudley, for photographing the pottery in the Ashmolean Museum, and developing and printing the photographs from Knossos; Don Evely, for help in preparing the volume for publication, and for study of the obsidian; Paul Halstead; †Reynold Higgins, for advice on the terracottas; Valasia Isaakidou, for her sections on the animal bones; Athanasia Kanta; †Victor Kenna, for study of the EM III sealing **1167**; Carl Knappett; Olga Krzyszkowska, for editing the volume and constant and ever-ready support and encouragement, without which this book could not be here; Alexandra Livarda, for identifying a second olive stone (in a mud brick); Colin Macdonald, for an advance copy of his forthcoming paper; Nicoletta Momigliano, for salutary advice on late Prepalatial pottery and the Early Houses; Jennifer Moody; Ingo Pini for the photographs of sealing **1167**, and the *CMS* Archive for drawings of it; Lefteris Platon, for excerpts from his father's notebook on his work at the Early Houses in 1957 and the photographs which he has generously allowed us to

[1] Momigliano 2007a. Our terminology may differ in places from that of the *Handbook*, but it should be clear enough what is being discussed.

publish here; Jane Renfrew, for her study of the olives from the Palace Well and the vine leaf impressions; Simon Pressey, for preparing the drawings for the press; Hugh Sackett, trench supervisor at RRN; †David Smyth and †William Taylor for plans; Simona Todaro for an advance copy of her forthcoming paper; Robin Torrence, who originally studied the obsidian; Peter Tomkins, for advice on Neolithic Knossos and its pottery, and giving us an advance copy of a forthcoming paper; Rena Veropoulidou, for her note on two shells from the Palace Well; Sheilagh Wall-Crowther, for identifying the bone of the bone tools; Peter Warren, for his study of the stone vessels, giving us an advance copy of his forthcoming paper and help over many years; Judith Weingarten, for advice on sealing **1167**; Todd Whitelaw, for helpful discussions of early Knossos and giving us advance copies of forthcoming papers; Alison Wilkins, for preparing the photographs for the press; David Wilson; and Carol Zerner.

Carl Knappett and David Wilson kindly read through earlier partial versions of the text, as Valasia Isaakidou has done for some, and David Wilson for all, of the recent version. We are deeply grateful to them for their observations, suggestions and references, while emphasising that we alone are responsible for any errors and misunderstandings.

For photographs of Early Minoan pottery now in museums outside Knossos and permission to publish them, or to draw and photograph the pottery ourselves, and for help with problems of provenance etc., we thank: the Ashmolean Museum and †Ann Brown, Yannis Galanakis and Anja Ulbrich; the Boston Museum of Fine Arts and †Cornelius Vermeule; the British Museum and †Reynold Higgins; the Musées Royaux d'Art et d'Histoire, Brussels, and Natacha Massar; the Herakleion Archaeological Museum and Stylianos Alexiou, Georgia Flouda and Eirini Galli; the Metropolitan Museum of Art and Brian Cook and Seán Hemingway.

The work has been funded principally by the British School at Athens, partly drawing on British Academy grants, and the Knossos Trust, whom we thank warmly.

Others who have helped in more ways than they may have ever imagined include: Lucy Cadogan; †Nicolas Coldstream; †Joan Evans; †John Evans; †Marc and †Ismene Fitch; †Larch Garrad; John Hayes; Rachel Hood; Alexandra Karetsou; Katerina Kopaka; †Mervyn Popham; Efi Sakellaraki; †Yannis Sakellarakis; †Fritz Schachermeyr; Michael Vickers; Malcolm Wiener.

It is sad that so many of the friends and colleagues who have been so generous to us and this project have died. We recall them with affection and gratitude. Among the living, our largest debt of gratitude is to our wives, Rachel and Lucy, with all our love.

Sinclair Hood
Gerald Cadogan
September 2011

Introduction

The excavations at Knossos, 1957–1961

The British School at Athens undertook excavations at Knossos from 1957 to 1961 (FIG. 0.1; TABLES 0.1–0.2) to obtain as complete a record as possible of the stratigraphic sequence of the site throughout its history, and in particular of the Bronze Age sequence, so as to define with greater precision the divisions of the Minoan system of periods as they had been outlined by Sir Arthur Evans.[1]

With this aim in view, two main areas were explored on opposite (N and S) sides of the Royal Road, which leads westwards from the Theatral Area at the NW corner of the Palace. There is a dip in the road, and the lowest part of this dip about 75 m W of the Theatral Area was chosen for excavation since the deepest deposits might reasonably be expected to have accumulated there. On the S side of the Royal Road (RRS) an area of about 160 sq m was opened between it and the region cleared by Evans when he excavated the House of the Frescoes in 1923 and 1926.[2] To the N of the Road (RRN) an area of nearly 200 sq m was investigated next to the Armoury or Arsenal, explored by Evans in 1904 and 1922, but filled back in the 1920s with spoil from his excavations S of the Road.[3]

A third area was also examined on the southern outskirts of the Bronze Age city some 300 m S of the Palace to the W of House A cleared by D. G. Hogarth during the first year of the British excavations at Knossos in 1900.[4] Trials here in 1956, after digging for a vineyard had destroyed walls of Bronze Age buildings, led to the discovery of complete vessels of Late Minoan I and deep Bronze Age deposits. It was felt that material from this region on the outskirts of the city might provide a useful supplement to whatever was recovered from the more central area by the Royal Road.

Finally, J. D. Evans's Neolithic excavations in the Central Court began in 1957 as part of Hood's programme and were taken over by Evans in 1958,[5] while the excavation of two chamber tombs at Sellopoulo was a collaboration between the Service and the School.[6] The 1957–61 programme also included a number of rescue excavations, at the request of the Ephoreia. The excavations, however, of W. H. C. Frend at the early Christian basilica near the Venizeleion had begun before 1957, albeit continuing until 1960.[7]

In the course of the 1957–61 excavations substantial deposits of pottery were found covering almost every phase of the Minoan Bronze Age recognised by Evans. RRS produced successive deposits attributable to MM IA, IB, IIA and IIB, followed by more than one phase of MM III. In RRN a large and spectacular deposit of LM IB was stratified above a fill of LM IA and earlier deposits reaching back to the beginning of EM II. The MM and LM I deposits on the Royal Road were supplemented by the discoveries in the area of Hogarth's House A. In addition, deposits of LM II, IIIA2 and IIIB, together with ones assignable to LM IIIC, were recovered in RRN below Early Iron Age (Protogeometric and Geometric), Classical, Hellenistic and Roman levels.

In summary fashion, the principal excavations of 1957–61 are shown in TABLE 0.1 and other, mostly rescue, excavations in TABLE 0.2. The codes are those that will be found in the notebooks and other records, as well as on the boxes in the SMK, where the year indicator has often been added. The publication references are strictly for the principal publications that have appeared to date. This does not imply that these publications are completely comprehensive covering all the contexts or finds of the relevant site but, with the information in Hood and Smyth 1981 or Hood and Taylor 1981, they will be a helpful lead for where to look next.

Hood conducted many other excavations at Knossos, by himself or collaboratively, between 1948 and 1951 and in 1953 and 1955–56, before the stratigraphic programme began, and again after the programme ended in 1963, 1966, 1973 and 1987. These excavations are not included in TABLES 0.1–0.2.

The two Sellopoulo tombs (T. 1, T. 2) were excavated jointly with Nikolaos Platon.

[1] Hood 1960*b*.
[2] *PM* II, 431; Hood and Smyth 1981, 51: 212.
[3] Hood and Smyth 1981, 51: 213.
[4] Hood and Smyth 1981, 56–7: 297.

[5] J. D. Evans 1964, 132 and n. 5; 1994, 1, n. 1; 2008, 16–17.
[6] Hood and Smyth 1981, 36: 28.
[7] Hood and Smyth 1981, 40: 74; Frend and Johnston 1962.

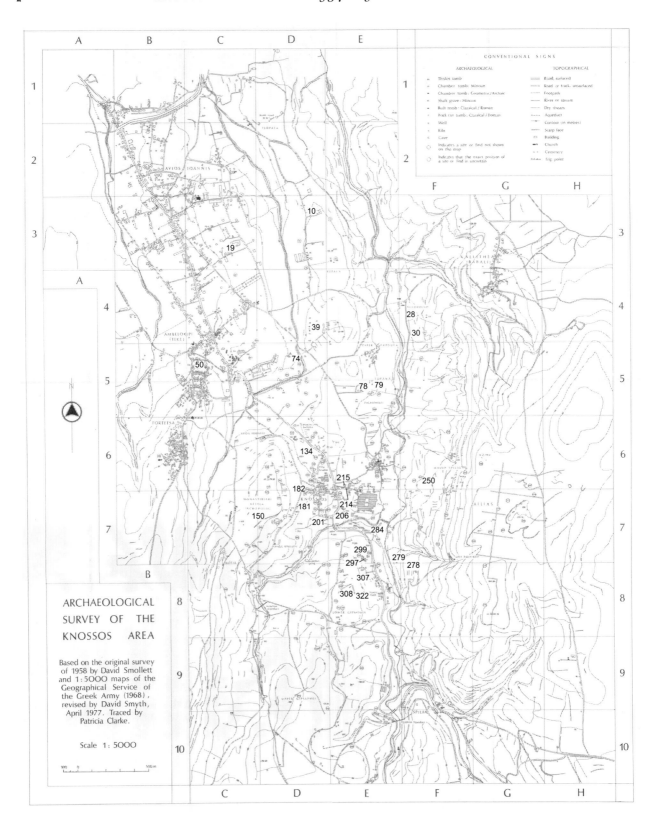

FIG. 0.1. Map of Knossos with the principal excavations outside the Palace area of the 1957–61 programme.
See TABLES 0.1 and 0.2.

TABLE O.1. The principal research and stratigraphic excavations of the 1957–61 programme at Knossos. Numbers in **bold** refer to those of Hood and Smyth 1981, and are shown in FIG. O.1. Further information will be found from the references in Hood and Smyth 1981 or Hood and Taylor 1981.

Site / Year(s)	Code	Date(s)	Hood and Smyth 1981 Hood and Taylor 1981	Principal publications
Central Court 1957–60	NEO	Neolithic	Hood and Taylor 1981: 85	J. D. Evans 1964, 1968
Palace Well 1958–59	PW/58–59	EM I	Hood and Taylor 1981: 183	this volume
Early Houses 1960	PEM/60	EM II–III	Hood and Taylor 1981: 2	this volume
RRN 1957–61	RR; RRN/57–61; LA/60–61	EM II–III; LM I–III; G; LO; A; R	**215**	this volume; Hayes 1971; Higgins 1971; Coldstream 1973a; Hood 2011, in preparation
RRS 1957–59	RR; RRS/57–59	MM IA–IIA; MM IIIB; PG; G	**214**	Coldstream 1972 Hood in preparation
Hogarth's Houses 1956–58, 1961	HH/56–58; HHS/61	MM I–LM III; G–EO; R	**297** **299**	Hood in preparation
Sanctuary of Demeter 1957–60	TC/57–60	(PG–)LG– R	**284**	Coldstream 1973b

TABLE O.2. Other, mostly rescue, excavations of 1957–61 at Knossos. Numbers in **bold** refer to those of Hood and Smyth 1981, and are shown in FIG. O.1. Further information will be found from the references in Hood and Smyth 1981.

Site / Year(s)	Code	Date(s)	Hood and Smyth 1981	Principal publications
Palace trials 1957	PT/57	MM; LM		
Kephala ridge tomb 1958	IS/58	MPG	**10**	Coldstream 1963
Ayios Ioannis tomb 1959	AJ/59	LM II; SM	**19**	Hood and Coldstream 1968
Sellopoulo T. 1, T. 2 1957	SEL/57	LM IIIA2–B	**28**	
Sellopoulo T. 1958	SEL/58	LM IIIA	**30**	
Kephala ridge tomb 1957	HOG/57	PG–O	**39**	Coldstream 1963
Teke tomb 1959	TEK/59	EPG	**50**	Coldstream 1963
Venezeleion tomb 1961	T.1/61	Geom; R	**74**	
Topana tomb; wall 1961	MK/61	R M?	**78** **79**	
Well 1958–59	VW/58–59	A	**134**	Coldstream 1973a
Acropolis trials 1959	AC/59	LM	**150**	
Well 1958–59	MW/58–59	R	**181**	Hayes 1971
Knossos tomb 1959	MT/59	LPG	**182**	Coldstream 1963
Well 1957	WEL/57	G	**201**	Coldstream 1960
Road trials 1959–60	RT/59–60	LG–EO; R	**206**	Hayes 1971; Coldstream 1972

TABLE O.2. continued.

Site / Year(s)	Code	Date(s)	Hood and Smyth 1981	Principal publications
Ailias tombs 1957	A/57	Hell	**238**	
Ailias tomb 1961	KAX/61	MM	**250**	
Ailias tomb 1958[8]	KAXXXI/58	G		
Ailias tombs 1960	KSP/60	LM	**278**	Hood and Preston in preparation
Gypsades tomb 1957		Byz	**279**	
Aqueduct well 1958[9]	AQW/58	MM IB	**290**	
Gypsades trials 1958		LM III	**301**	
Lower Gypsades T. III, T. IV 1959	LG II1/59, LG IV/59	R	**304**	
Lower Gypsades T. II 1957	LG II/57	MM	**307**	
Lower Gypsades tholos 1957	LG I/57	MM	**308**	
Lower Gypsades tomb 1958	AQT/58	LM IIIA2	**322**	Coldstream 1963

[8] The MM tombs (code: KA) that form the Ailias cemetery (Hood and Smyth 1981, 54: 257) were excavated between 1950 and 1955: Hood 2010. The first tomb was excavated jointly with Alexiou.

[9] This is not shown on FIG. O.1.

Chapter 1

The Minoan system of Arthur Evans

Arthur Evans announced the Minoan system of periods for the Cretan Bronze Age in 1905 after the completion of the main excavations in the Palace at Knossos, and published it in a definitive form in 1906 in his manifesto called *Essai de classification des époques de la civilisation minoenne*.[1] The system was ninefold, embracing three main periods of Early, Middle and Late Minoan, each with three subdivisions, thus reflecting Μίνως ἐννέωρος of the *Odyssey* (19.179). The possibility of further subdivisions, notably in MM III, was already apparent. These later crystallised, leading to the differentiation of A and B phases in MM I, II, and III and, eventually, also in LM I. LM III he divided into LM IIIA and IIIB, and he further distinguished two phases in LM IIIB: a mature phase corresponding to the 'Re-occupation Period' at Knossos, and a 'Late Revival'. In the Index volume (1936) to *The Palace of Minos* he added a LM IIIC period — in defiance of the logic of his own system.[2]

Arne Furumark regularised the division of LM IIIA and IIIB into earlier and later phases: LM IIIA1 and IIIA2, and LM IIIB1 and IIIB2.[3] He also restored the logic of the system by defining what Evans had called finally LM IIIC as Sub-Minoan. But, since Vincent Desborough,[4] Furumark's LM IIIB2 (which followed the scheme of Evans) has come to be known as LM IIIC. This brings it into harmony with LH (Myceneaean) IIIC for the equivalent period on the Greek mainland. In the first volume of *The Palace of Minos* Evans suggested the possibility of recognising earlier and later phases in EM I and EM II.[5]

Evans based his Minoan system on the sequence of pottery he found at Knossos. But some periods, for which material appeared to be lacking or was ill represented at Knossos, were largely or entirely defined by pottery from other parts of Crete. Thus, in the *Essai*, he defined EM II to a large extent in terms of material from the tholos tomb at Ayia Triada and pottery from Vasiliki, and EM III in terms of the Ayios Onouphrios deposit and the North Trench deposit at Gournia.[6] (FIG. 1.1 shows EM and other sites mentioned in this volume.) Later, in *The Palace of Minos*, MM IIB was defined to a large extent in terms of pottery from the destruction level of the First (or Early or Old) Palace at Phaistos.

The deposits of pottery found in the 1900–05 excavations in the Palace at Knossos were illustrated and described in summary fashion in annual preliminary reports.[7] These accounts were supplemented by two major articles by Duncan Mackenzie on the Bronze Age pottery of Knossos.[8] Additional groups of Bronze Age pottery recovered by Hogarth in soundings in 1900 in the area of the city around the Palace had already been described and illustrated.[9] Some deposits of pottery and individual vessels found after the main excavations ended in 1905 were recorded in successive volumes of *The Palace of Minos*, which appeared between 1921 and 1935.[10] But there was no systematic or complete publication of any of the key deposits of Bronze Age pottery found during the excavations at Knossos until the report by John and Hilda Pendlebury on the houses assigned to MM IA, which they explored in 1930 below the Kouloures in the West Court of the Palace.[11] This situation has been remedied since the 1960s by Mervyn Popham's publication of much of the surviving material of LM I–III date, and by the work undertaken by, principally, Stelios Andreou, Peter Day, Carl Knappett, Colin Macdonald, Sandy MacGillivray, Nicoletta Momigliano and David Wilson, and now Peter Tomkins, on the pottery from Early and Middle Minoan deposits kept in the Stratigraphical Museum (SMK).

The definition of the various phases of Middle Minoan in particular was further confused by the fact that, in *The Palace of Minos*, vessels and fragments are often assigned in different volumes, and even in different parts of the same volume, to different periods. An example is the goblet with barbotine decoration from the Upper East Well (UEW) (which is EM III in date), which Evans illustrated as an

[1] Evans 1906.
[2] *PM* index, 140–1.
[3] Furumark 1941.
[4] Desborough 1964.
[5] *PM* I, 70, 74–5, 78. See also the recent very helpful account of the development of the Knossian prehistoric ceramic sequence by Momigliano (2007*b*, esp. 3, table 0.1, and 7, table 0.2).

[6] Evans 1906, 6.
[7] Evans 1900, 1901, 1902, 1903, 1904, 1905.
[8] Mackenzie 1903, 1906.
[9] Hogarth and Welch 1901.
[10] *PM* I–IV.
[11] Pendlebury and Pendlebury 1930.

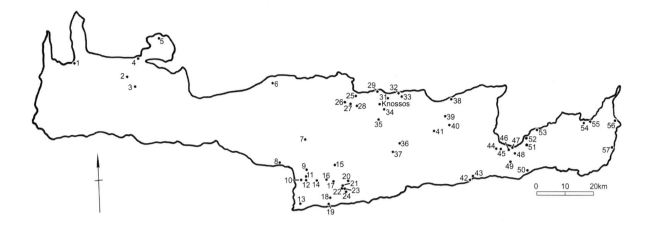

FIG. 1.1. Map of Crete with sites mentioned in the volume.

1	Nopigeia	16	Platanos	(30)	Knossos	44	Kalo Chorio	
2	Debla	17	Apesokari	31	Eileithyia	45	Vrokastro	
3	Platyvola	18	Miamou	32	Pyrgos	46	Gournia	
4	Chania	19	Lebena	33	Gournes	47	Sphoungaras	
5	Lera	20	Drakones	34	Archanes/Juktas	48	Vasiliki	
6	Chamalevri	21	Porti	35	Kyparissi	49	Aphrodite's Kephali	
7	Kamares	22	Koutsokera	36	Arkalochori	50	Ayia Fotia (Ierapetra)	
8	Ayia Galini	23	Salami	37	Partira	51	Kavousi	
9	Vorou	24	Koumasa	38	Malia	52	Ayios Antonios	
10	Ayia Triada	25	Gazi	39	Krasi	53	Mochlos	
11	Phaistos	26	Tylissos	40	Trapeza	54	Petras–Kephala	
12	Patrikies	27	Kavrochori–Keramoutsi	41	Ayios Charalambos	55	Ayia Fotia (Siteia)	
13	Ayia Kyriaki	28	Yiofyrakia	42	Myrtos–Pyrgos	56	Palaikastro	
14	Ayios Onouphrios	29	Poros–Katsambas	43	Myrtos–Fournou Korifi	57	Zakros	
15	Marathokephalo							

example of MM IB in *The Palace of Minos* I,[12] and described as MM IA in *The Palace of Minos* IV.[13] Another potential source of confusion, and one which may have helped to promote inconsistencies of this kind, is that in the preliminary reports for the main excavations between 1900 and 1905 the nomenclature of periods, and the assignment of deposits to them, developed and fluctuated from one year to another, as Evans and Mackenzie worked out their ideas.

This somewhat confused, nebulous situation existed for many years as regards the definition of the successive Minoan periods and in time led, not unreasonably, to pleas for the abandonment of the Minoan system and its replacement by one less strictly linked to Knossos. Doro Levi and Nikolaos Platon in particular suggested a scheme based upon stages in the history of the great palaces: that is, Prepalatial, Protopalatial, Neopalatial (to which others later appended Final Palatial) and Postpalatial. But as far as this palatial system has been elaborated by them and others it has in fact only changed names, and it has been correlated with the Minoan system, so that nothing has really been done to eliminate confusions. Furthermore, the palatial terminology, apart from being cumbersome, is a good deal less satisfactory than the Minoan one: it seems likely for instance that substantial 'palaces' already existed at Knossos and some other sites in Crete during the Prepalatial, a period equated with EM I–III and MM IA. Likewise, the division between an Early or Old Palace and a Late or New Palace, while reasonably clear at Phaistos, is somewhat arbitrary at Knossos.[14] Evans himself certainly spoke of an early Palace (and later changes)[15] in his first reports. This concept was no doubt helped by the architectural situation at Phaistos but it was, in effect, a restatement in different terms of the original basic distinction, which had been obvious before 1900, between so-called 'Kamares' (Middle Minoan light-on-dark) pottery and so-called 'Mycenaean' (Late Minoan dark-on-light) pottery.

[12] *PM* I, 180–1, fig. 129a.
[13] *PM* IV, 100, 102, fig. 68 (Momigliano 2007*c*, 84–7, 91, fig. 3.9: 1).

[14] Cf. MacGillivray 2007, 144.
[15] Already in 1900: Evans 1900, 65.

Evans seems to have been vague in the preliminary reports, however, about the line of division between Earlier Palace and Later Palace, which fluctuates from one report to another. After the campaign of 1903 for instance, the division was set well back in the Kamares period, with only the filling of the pits in the Early Keep area (latest material MM IA) assigned to the Earlier Palace: the deposit on the floor above, dating from MM II, and probably from MM IIA, was placed in the first stage of the Later Palace.[16]

The various destructions and rebuildings of the palaces at Knossos, Phaistos and Malia need not have been contemporary or have had the same significance or impact, even if they fell within the same archaeological period. It has indeed been suggested that the successive destructions of the palaces in Middle Minoan were caused by earthquakes that affected many parts of Crete during an era of marked seismic activity.[17] If this was really the situation, it could reasonably be argued that destructions at different sites falling within the same archaeological period were likely to have been contemporary. But most of the destructions were accompanied by fire, and other explanations for them are clearly possible. Some may have been the result of earthquakes, as the major destruction which affected Knossos in LM IA almost certainly was; but it seems most unlikely that a series of destructive earthquakes could have affected wide areas of the island, starting fires wherever they caused damage, in the way that has been postulated.

The Minoan terminology for the periods of the Cretan Bronze Age is reasonably neutral. The three main divisions (Early, Middle and Late) correspond, albeit very roughly, with the rise, acme and then decline of the Bronze Age civilisation of Crete, and — with rather more accuracy — with three obvious phases in the development of its pottery: a pre-Kamares (Early Minoan) stage, followed by a Kamares (Middle Minoan) stage with polychrome decoration on dark-washed surfaces, and then a post-Kamares stage (Late Minoan) when decoration in dark paint on a light ground was again in fashion.

Evans's Minoan system is fluid enough that it can be corrected, adapted and amplified, without the definitions of the successive phases becoming too remote from what Evans had in mind. EM I–III, as now defined, correspond more or less to his conception of them, except that much of what is now classed as EM IIA may have been included in his idea of mature EM I. EM III is based upon what Evans at one point at any rate called EM III at Knossos. For the Middle Minoan periods the situation is more difficult, but a fixed point is provided by the Royal Pottery Stores and related deposits elsewhere in the Palace that he assigned to MM IIA. A much clearer appreciation of the character of the successive phases of the Middle Minoan period at Knossos is now available through MacGillivray's publication of the mass of material from Middle Minoan deposits (in the SMK),[18] to be supplemented by the stratified deposits from our Royal Road: South (RRS) excavations in 1957–59.

In *The Palace of Minos* Evans attached pottery, singly or in groups, from other sites in Crete to his different periods, but many of these attributions have needed considerable modification, as Andreou was among the first to show in the case of early pottery from eastern Crete.[19] One large group that has been reassigned is that from the main destruction of the Early Palace at Phaistos. Evans classified some of its pottery as MM IIA;[20] but it clearly belongs to a later period than the Royal Pottery Stores and allied deposits at Knossos that are consistently assigned to MM IIA;[21] and, in the main, Evans designated it as MM IIB,[22] clearly seeing it as belonging to the same ceramic period as the pottery from the Knossos Loomweight Basement.[23]

In these circumstances we are justified in retaining the Minoan system of periods devised by Evans with such modifications and changes as new discoveries and a fresh study of older material make necessary. 'Its chief merit is convenience', was Harriet Boyd Hawes's robust judgement.[24] It must be emphasised, however, that the Minoan system is strictly applicable only to Knossos. At the same time Knossos appears to have been the most important centre in Crete, not only during Middle Minoan and the earlier part of Late Minoan but also, it would now seem, throughout Early Minoan and back into the Neolithic. The settlement on the Kephala hill at Knossos was probably the largest and most

[16] Evans 1903, 26, fig. 13; *PM* I, 234–5, fig. 177; III, 23–4, fig. 12; 360. Evans assigned the knobbed pithos here to MM IIA, but the base of it may have been sunk from a floor at a somewhat higher level into a burnt deposit of the MM IIA destruction.

[17] E.g. Platon 1981, vol. 1, 163, 256–7.

[18] MacGillivray 1998; cf. MacGillivray 2007 (down to MM IIIA). See also Hatzaki 2007 on MM IIIB; and cf. the earlier summary sequence agreed at a workshop at Knossos in 1992 (Cadogan *et al.* 1993).

[19] Andreou 1978.

[20] E.g. *PM* IV, 117, fig. 83.

[21] MacGillivray 2007, 122–34.

[22] E.g. *PM* I, 257–9, fig. 192b–g. Note that *PM* I, 231, 234, fig. 176, although illustrated under the heading of MM IIA, is also assigned (253–4) to the 'mature' (i.e. MM IIB) phase of MM II.

[23] MacGillivray (2007, 143, table 4.3, with references) agrees on the MM IIB date of the period 3 main destruction deposits of Phaistos.

[24] Boyd Hawes *et al.* 1908, 2.

flourishing in Crete, and was undoubtedly the source from which many ideas and fashions spread to the rest of the island, from the beginning of Neolithic until it suffered eclipse towards the end of the Bronze Age after the final destruction of the Palace, an event which has been variously dated by different authorities as early in LM IIIA2 *c.* 1375 BC, or in LM IIIA2, or on the borders of LM IIIA2 and IIIB *c.* 1300 BC, or late in LM IIIB *c.* 1200 BC. In addition, and perhaps in consequence of this pre-eminence, Knossos appears to have a more complex and detailed stratigraphy, and one more richly endowed with material, than any other prehistoric site in Crete. This means that it is possible to define a more complete succession of periods here in terms of changes in pottery fashions. Knossos is therefore in a position to serve as a time clock for the rest of Crete, if not for the whole Aegean, as Evans and Boyd Hawes originally hoped that it would.

It is not always easy, however, to relate deposits of pottery found at other sites in Crete to the Minoan sequence of Knossos, unless diagnostic imports from the Knossos region happen to be associated with, or incorporated into, them. This fact, and the example set by Evans in allocating pottery and deposits found in other parts of Crete to his (Knossos-based) Minoan periods in a somewhat arbitrary manner, have led to much confusion. The situation has not been helped by the practice of using the Minoan terminology to mean different things in different parts of the island, expressing this by systems of overlaps, such as deeming EM III in East Crete as overlapping with MM IA at Knossos. In the interests of clarity, it is surely better to think in terms of specific, localised sequences of pottery groups for other sites or regions of the island apart from Knossos and then, if possible, show how they relate to the Knossian Minoan sequence.[25] In this way, the Minoan system can be retained for chronological periods with an universal application, although these periods are of course essentially based upon, and defined in terms of, the stratification at Knossos and the sequence of pottery changes that can be discerned there.

DEFINING THE MINOAN PERIODS

Bronze Age pottery called 'Mycenaean', with decoration in dark paint on a light ground, as known from Rhodes and Thera in the 1860s, and from Mycenae itself after the work of Heinrich Schliemann in 1876, was recognised in Crete a little later when Minos Kalokairinos made soundings in the West Wing of the Palace at Knossos in the winter of 1878–79.[26]

Next, the existence of an earlier ceramic phase with designs in red and white paint on a dark washed surface was established through the recovery of pottery of this class by the villagers of Kamares from the cave of that name on Psiloritis in 1893. The pottery was brought to the Museum of the Syllogos in Herakleion where, at the invitation of the Director, Joseph Hazzidakis, it was studied that same year by John Myres and Lucio Mariani.[27] Myres recognised that this 'Kamares ware' was of the same fabric as the fragments of exotic Aegean ware found in 1889–90 by Petrie at Lahun (or Kahun) in Egypt, and now in the British Museum.[28]

A still earlier phase of the Bronze Age was reflected in some of the material from a deposit that had been discovered in 1887 at Ayios Onouphrios just north of Phaistos. The deposit, which evidently came from an important early tomb, was acquired for the Syllogos's Museum, and published by Evans in 1895.[29]

The basis for a triple division of the Bronze Age pottery of Crete, corresponding to what was later to be defined as Early, Middle and Late Minoan, existed in effect by the time that Evans and Mackenzie reopened excavations at Knossos in 1900. A similar tripartite division was recognised in the long Bronze Age sequence revealed at Phylakopi on Melos by the excavations of the British School from 1896 to 1899. Here an early group of pottery was seen to be followed by a 'Geometric' period, which preceded a 'Mycenaean' period.

In 1902 Evans adopted the term 'Minoan' in connection with 'the 'Middle Minôan' ceramic class'[30] as a substitute for 'Kamáres', but 'Mycenaean' continued to be used for the later pottery with dark-on-light designs and associated contexts.[31] Then in 1904 he applied the term Minoan to the whole of the

[25] As Andreou (1978) has done; cf. also Cadogan 1983.

[26] Aposkitou 1979; Kalokairinos (ed. Kopaka) 1990; Kopaka 1995.

[27] Myres 1895; Mariani 1895, 333–42.

[28] Petrie 1891, 9–11, pl. 1; Forsdyke 1928, nos. A548–A567; Cadogan 1978a; 1983, 514–15; Kemp and Merrillees 1980, 57–102, figs. 22–32; Karetsou *et al.* 2000, 50–1, nos. 26–7 (best illustrations); Merrillees 2003, 136; Barrett 2009, 214, table 2.

The pottery includes Minoan-style vessels as well as imports from Crete (Fitton *et al.* 1998; Quirke 2005, 91–3).

[29] Evans 1895, 105–36.

[30] Evans 1902, 1; cf. Cadogan 2006, 50–1. For earlier, pre-Evans usage of the term 'Minoan', see Karadimas and Momigliano 2004, and Karadimas forthcoming.

[31] As 'Kamáres' was too (e.g. Evans 1902, 25) — but note also 'Late Minôan (Kamáres)' (Evans 1902, 118).

Cretan Bronze Age.[32] In the following years, Evans finally presented his fully developed system of nine Minoan periods for the Cretan Bronze Age,[33] drawing on his and Mackenzie's tussles with the stratigraphy of Knossos from 1900 onwards.

In his first season in 1900, he recognised only two main periods of pottery: light-on-dark Kamares and dark-on-light Mycenaean, roughly corresponding to what were later to be Middle Minoan and Late Minoan; although F. B. Welch, describing the pottery found that year, does in fact speak of 'Proto-Mycenaean'[34] (which may refer to what eventually came to be called MM III). LM I pottery was evidently included in 'Mycenaean'. This dichotomy between Kamares and Mycenaean subsequently appears in the form of a division between an Earlier and a Later Palace: a concept no doubt helped by the situation at Phaistos, where the New Palace is a more obvious entity than its counterpart at Knossos.

By the end of the 1901 season, a 'good Mycenaean period' with a 'Palace Style', which included LM I as well as LM II, had been distinguished from the Late Mycenaean (of the 'Reoccupation'), which was compared with Amarna and assigned to the 14th century BC. A Late Kamares had also been distinguished from a pure or best Kamares; but 'degenerate Kamares' (i.e. MM III) was thought in fact to be of early Mycenaean date (but not older): this went with a belief at that time that Linear A was a native script in use alongside 'Mycenaean' Linear B.[35]

In the 1902 report, Minoan was first introduced as a reasonable substitute for Kamares over against Mycenaean. The Royal Pottery Stores (later to be MM IIA) were described as Middle Minoan, while Late Minoan was used for the Loomweight Basement vessels (later MM IIB).[36] A transitional class which included the Lily Vases (later MM IIIB[37]) was regarded as characteristic of the earliest period of the Later Palace. The main period of the Later Palace (afterwards called LM II) is followed by the Reoccupation (afterwards assigned to LM III).[38] The first report from Palaikastro also appeared in 1902. In illustrating some Early Minoan pots from the cemeteries, it calls them 'pre-Mycenaean', with a distinction between them and polychrome vessels 'of true Kamáres technique'.[39] This hints at the beginnings of the stylistic use of the term Kamares and the escape from keeping it tightly chronological.

The term Early Minoan does not appear in the 1902 report, but in the 1903 report it was used for early (i.e. pre-Royal Pottery Stores) polychrome (Kamares) ware, as was found in the Monolithic Pillar Basement — which is now seen to have had both MM IA and IB deposits.[40] Some degree of confusion, however, is apparent in this report in the use of the Minoan terminology as defined in 1902. The Hieroglyphic Deposit, for instance, is tentatively assigned to a time closely following the foundation of the Later Palace, but the 'ceramic associations' are said to be 'frankly Middle Minôan, though they may perhaps be more exactly expressed as "Middle Minôan II"'.[41] A note adds that the last phase of the culture of the Earlier Palace may be described as MM I, and the first of the Later Palace as MM II.[42] The idealised sections through the Early Keep[43] show both floors above the walled pits as Later Palace: only the pits themselves (filled it seems as early as MM IA) are assigned to the Earlier Palace.[44] Evans seems to have overlooked both the Royal Pottery Stores, which had been defined the previous year (1902) as Middle Minoan, and the Loomweight Basement vessels which were called then Late Minoan. MM II is being used here for what came to be MM III, and the following year the correction is duly made: for MM I and II read MM II and III.[45]

In the 1903 report, the Temple Repositories and the Magazine of the Lily Vases (both eventually to be called MM IIIB) are assigned to the First Period of the Later Palace, and this is described as 'a more or less transitional phase which may conveniently be termed Late Minôan I'.[46] What was later defined as LM IA, however, appears to be included along with LM IB in the latest Palace Period (what is afterwards called LM II).[47] This is followed by the Period of Partial Reoccupation (the Reoccupation Period afterwards assigned to LM III).

[32] Evans 1904; cf. Cadogan 2006, 52.

[33] Evans 1906.

[34] Welch 1900: at the back of the difference between Kamares and Mycenaean, Welch at least thought there must lie a racial difference.

[35] Evans 1901, 10–11.

[36] Evans 1902, 26–7, 118.

[37] PM III, 246 (refining the MM III date of PM I, 577–9), and now dated to LM IA (Hatzaki 2007, 151, table 5.1).

[38] With a reference (Evans 1902, 119) to Mackenzie's forthcoming article (1903) in the Journal of Hellenic Studies.

[39] Bosanquet 1902, 290–5, figs. 3–4, 7, 9–12.

[40] Evans 1903, 18–19. Cf. Momigliano 2007c, 96 (MM IA);

MacGillivray 2007, 108 (MM IB).

[41] Evans 1903, 20–1.

[42] Evans 1903, 21, n. 1.

[43] Evans 1903, 26–7, figs. 13–14.

[44] For the Keep see Branigan 1995, who suggests a construction date early in the history of the Old Palace — i.e. MM IB.

[45] Evans 1904, 13, n. 1.

[46] Evans 1903, 21, n. 1. For a date in LM IA for the Lily Vases and Temple Repositories, see now Hatzaki 2007, 151, table 5.1; 155, table 5.2; 157, table 5.3b; 173.

[47] Evans 1903, 116.

The ideas of Evans and Mackenzie about the succession of periods at Knossos were beginning to crystallise, and the triple system of Early, Middle and Late Minoan in the form in which it was to be outlined by Evans in 1905 is already implicit in Mackenzie's article of 1903 on the pottery of Knossos,[48] where he speaks of 'the Early and Middle Minoan classes' and 'a "late Minoan" stratum'. By now Early Minoan seems to include the EM III Upper East Well deposit,[49] but not the polychrome ware of MM IA.[50] Middle Minoan begins with the floor deposits of the First Palace — which are clearly those of the MM IIA destruction level. The two jars from the Loomweight Basement[51] are assigned to the same horizon as the MM IIA destruction; but a later phase of Middle Minoan is recognised and described.[52] It is implied, but not exactly stated, that Late Minoan is the period of the Later Palace (inaugurated by the levelling away of earlier deposits for the existing West Wing), and the Lily Vases are set in the beginning of this period, to which sherds that appear from their description to be LM IA[53] are also assigned.

Evans submitted 'a preliminary scheme for classifying' the material of the Cretan Bronze Age to a meeting of the Anthropological Section of the British Association at Cambridge in 1904;[54] and, by the time the report for 1904 was written, he appears to have developed his final ninefold scheme of Minoan periods, although only five of them appear in the West Court Section: EM I–III and MM II–III.[55] MM III embraces the latest deposits below the pavements of the West Court and the Corridor of the Procession, together with the Knobbed Pithoi, although it is noted that Knobbed Pithoi already occur at Phaistos in MM II, while mason's marks on jambs of the West Magazines are later in style than ones in the Magazines of the Giant Knobbed Pithoi in the East Wing of the Palace.[56] Evans concludes that the Later Palace, to which the cists in the Long Gallery and the West Magazines are assigned, was founded when the MM III style was already fully developed, but that the Temple Repositories and the Early Cists in the West Magazines were closed at the time of transition to LM I. He seems to be thinking of the Lily Vases and the pottery below the pavements of the West Court and the Corridor of the Procession as belonging to an earlier stage of Middle Minoan III than the Temple Repositories. In *The Palace of Minos* he defines two stages of MM III: IIIA and IIIB).[57] The Lily Vases and the Temple Repositories are brought together again, and assigned to MM IIIB, in the Index volume.[58]

In his report for 1904 Evans seems to overlook that in the 1902 report he had (correctly) assigned the Loomweight Basement vases to a later period than those of the Royal Pottery Stores (MM IIA).[59] He may have been influenced by Mackenzie, who in the previous year had placed the two large jars from the Loomweight Basement in the same horizon as the deposits of the MM IIA destruction.[60] Likewise, he appears to be thinking in 1904 in terms of a general destruction that involved both the Loomweight Basement and the Royal Pottery Stores and 'overwhelmed the Town and Earlier Palace at Knossos during the mature polychrome period':[61] this view is again made explicit two years later by Mackenzie in his second article in the *Journal of Hellenic Studies*.[62] At the same time Evans notes that two intervening stages of habitation were visible in the West Court Section between the deposit assigned to MM II (i.e. MM IIA) and that of MM III.[63]

In the composite West Court Section of 1904, and following on from several test pits that year in the West Court,[64] Evans identifies five periods between the Neolithic and the paving assigned to the Later Palace. His 'EM I' and 'II', however, lack clear definition, leading Warren to assign both levels to EM III, below MM IA;[65] while Wilson saw a sequence of: Neolithic + EM IIA ('EM I'); EM IIA ('EM II'); EM III.[66] But the bowls with high pedestals which Evans illustrates as from 'EM I' strata, although restored and perhaps somewhat distorted in his drawings, look more like Palace Well chalices than the types of pedestal bowl or cup in use in EM IIA;[67] and some EM I (in today's terms) was clearly found in the 1904 test pits.[68]

[48] Mackenzie 1903, 157.
[49] Mackenzie 1903, 167, fig. 1.
[50] Mackenzie 1903, 170.
[51] Mackenzie 1903, 177–9, figs. 4–5, later to be called MM IIB.
[52] Mackenzie 1903, 179–82.
[53] Mackenzie 1903, 188.
[54] *PM* I, vi.
[55] Evans 1904, 19, fig. 7.
[56] Evans 1904, 13.
[57] *PM* I, 576–9, figs. 420–1.
[58] *PM* index, 128.
[59] Evans 1902, 26.
[60] Mackenzie 1903, 178–9.

[61] Evans 1904, 16.
[62] Mackenzie 1906.
[63] Evans 1904, 16, n. 2.
[64] Cf. Wilson 2007, 50, fig. 2.1: 2; 57, fig. 2.5: 1–8; Momigliano 2007c, 95, fig. 3.11: 1; also Wilson 1985, 283, fig. 1.
[65] Warren 1965, 23–5; Warren and Hankey 1989, 18–19.
[66] Wilson 1984, 30–6; 1985, 282, n. 2.
[67] Evans 1904, 24, fig. 8b–c: 'Vessels from Sub-Neolithic Strata (Early Minoan I.)'. Cf. Evans 1921, 58, fig. 17, with indication of scale as *c.* 1/3, which seems too small; contrast, however, the shapes of rims and pedestals from EM IIA contexts in Wilson 1985, 302, fig. 11: P31–33, P37–41.
[68] Wilson and Day 2000, 23; Wilson 2007, 50.

Evans defines the 'EM III' of the Section in terms of the Vat Room deposit (where the latest elements appear assignable to MM IB[69]), the earliest material from the Monolithic Pillar Basement (i.e. MM IA),[70] and the UEW, which had been excavated in 1901–02[71] — a deposit that is EM III.[72] It seems now, if we combine the test pit results of 1904 and 1905, that there is a stratified sequence of MM IA above EM III;[73] but Evans expressly states that 'no relics representing the beginnings of the polychrome style or the First Middle Minoan Period to which these belong' were found here.[74] It appears then that he defined MM I in 1904 as covering what we still call MM I.

The excavators of Palaikastro adopted Evans's ninefold system in reporting on their 1904 season, with three phases of Middle Minoan followed by three of Late Minoan.[75] Early Minoan, however, could not yet be divided; but EM II and III were recognised the following year.[76]

That year (1905) Evans assigned a deposit on a floor below the West Court to MM I,[77] later placing it in MM IA.[78] It should probably be classified, however, as MM IB in view of the spiraliform decoration on the fine polychrome jug.[79] The West Court Section deposit (known as the Early Chamber beneath the West Court) that he had assigned in 1904 to 'MM II'[80] he later called MM IB,[81] a date that MacGillivray confirms,[82] although in 1904 he saw it as belonging to the same destruction level as in the earlier rooms beneath the Room of the Olive Press, and the Kamares Magazines of the SE Palace Quarter.[83]

In 1905 Evans also formally proclaimed his ninefold system of Minoan periods, publishing it definitively in the 1906 *Essai*.[84] Here Sub-Neolithic is qualified as Early Minoan I, with the claim that dark-faced wares with decoration in white paint are found alongside dark-on-light wares. However, he does not mention pattern burnish, which might suggest that it had been misinterpreted as traces of white painted decoration. But a belief in the use of white paint at Knossos in the period immediately succeeding the end of the Neolithic is already affirmed by Mackenzie, who describes the stratum of painted ware which merges with the latest Neolithic and has pottery with a black glaze slip and decoration in white alongside dark-on-light.[85] Later, Evans wrote of Sub-Neolithic as included in EM I, and recognised a possibility of dividing EM I into two phases, during the later of which dark-on-light painted ware came into prominence.[86]

EM II, of which deposits with complete pots had not yet been found at Knossos, he defines in the *Essai* in terms of the majority of the pottery from the tholos tomb at Ayia Triada (evidently the large tholos tomb excavated in 1904)[87] and Vasiliki, together with the earliest elements of the Ayios Onouphrios deposit, which he had published a decade earlier.[88]

EM III is similarly defined in terms of material from other parts of Crete far from Knossos: the North Trench deposit at Gournia, and a tholos tomb excavated by Xanthoudides at Koumasa in December 1904.[89] Evans states that EM III sees the first beginnings of polychromy, and the period as defined in the manifesto appears to cover MM IA as well as true EM III. The Vat Room deposit, in which the latest elements are probably MM IB,[90] is dated to the transition between EM III and MM I.

MM I is described in the *Essai* as having quite elaborate polychrome decoration including spiraliform designs, and evidently covers what is now defined as MM IB.[91] The same formula was adopted in the early notices of our 1957–61 excavations, where a late phase of MM IA[92] (which for a time we assigned to MM IB) is now set definitively in MM IA.[93] MM II of the 1906 manifesto with eggshell ware certainly embraces true MM IIA. Whether the Loomweight Basement pottery, later assigned to MM IIB,[94] is considered to be included here is not clear. Evans notes that the end of this period at Knossos is marked by many traces of a general destruction, which may refer to that at the end of MM IIA (Royal Pottery Stores' horizon).

[69] MacGillivray 2007, 107–08.
[70] Momigliano 2007c, 96; but cf. MacGillivray 2007, 108.
[71] Mackenzie 1903, 167, fig. 1.
[72] Andreou 1978, 13–14, 16–25; Momigliano 1991, 155–63; 2007c, 83–93.
[73] Momigliano 2007c, 82, 95–6 (and cf. MacGillivray 2007, 107).
[74] Evans 1904, 18; cf. Evans 1905, 16.
[75] Dawkins and Currelly 1904, esp. 195–6, table.
[76] Dawkins et al. 1905, 269–74.
[77] Evans 1905, 16–19, fig. 9, pl. 1.
[78] *PM* I, 172–4, figs. 122–3a.
[79] Evans 1905, pl. 1.
[80] Evans 1904, 15, fig. 4 (MacGillivray 1998, 24–7, pl. 31: Group A).
[81] *PM* I, 187, figs. 135–6.
[82] MacGillivray 2007, 107, with further references.
[83] Evans 1904, 16 and n. 1.

[84] Evans 1906.
[85] Mackenzie 1903, 157, 164–5.
[86] *PM* I, 57–70, esp. 63 (dark-on-light) and 70 (two phases).
[87] Paribeni 1904; Stefani 1931; Banti 1931.
[88] Evans 1895, 105–36, esp. 112–16.
[89] Xanthoudides 1924, 1.
[90] Momigliano 1991, 167–75; MacGillivray 1998, 35; 2007, 107–08; Panagiotaki 1998, esp. 169 and n. 6, and 184 (suggesting also the possibility of early MM IIA); 1999, 8–43; Macdonald and Knappett 2007, 150.
[91] This includes the Early Chamber deposit below the West Court discussed above, which Evans eventually assigned to MM IA: references in ns. 77–8.
[92] Hood 1962c, 94.
[93] Lowest basement floor: Cadogan et al. 1993, 25–6 (with references for MM IB attribution) and table 1; MacGillivray 1998, 51; Momigliano 2007c, 96.
[94] *PM* I, 255–6, fig. 191.

The *Essai* implies that MM III entirely overlaps the beginning of the Later Palace, when polychrome pottery was in full decadence. The Lily Vases are by implication assigned to an early phase of the period, along with the Hieroglyphic Deposit, while the Temple Repositories are placed towards the end of it. In 1904, as we have seen, the latest deposits below the paving of the West Court had been assigned to MM III, and the Lily Vases had been equated with them, coinciding with the end of the First Palace, while the Temple Repositories were set in the First Period of the Later Palace; at the same time the Later Palace was said to have been founded after the great age of polychrome pottery in MM II. This may reflect some confusion of thought, which continued into the period of the 1906 manifesto.

LM I in the manifesto corresponds to what is later defined as LM IA, but the Zakros sealings (which come from a deposit of LM IB date)[95] are assigned to the transition between MM III and LM I. LM II includes what was later to be defined as LM IB. The concept of LM IB was established by the time of *The Palace of Minos* II (1928);[96] some vessels from Palaikastro had been correctly assigned to that period five years earlier.[97] The 1906 account of LM III implies two chronological phases; the period had in fact already been divided into LM III *a* and *b* in the 1904 Palaikastro report.[98]

In his article on the Middle Minoan pottery of Knossos, also published in 1906, Mackenzie outlines a concept of three successive destruction horizons in the Palace during Middle Minoan,[99] calling the first of these MM I. It embraces material that in fact ranges from EM III to MM IB.[100] The MM II of his second horizon of catastrophe mostly consists of deposits assignable to MM IIA, but includes the two large jars from the Loomweight Basement.[101] For the third horizon at the end of MM III Mackenzie has a long list of deposits, including the Temple Repositories, the Lily Vases, the Knobbed Pithoi, and the latest pottery from below the paving of the West Court and that of the Corridor of the Procession.

In *The Palace of Minos* this relatively simple picture of the history of the Middle Minoan period in the Palace at Knossos was complicated by Evans's assigning the Loomweight Basement jars etc. to a later phase *in* MM II — i.e. MM IIB[102] — while the Knobbed Pithoi, mostly found in the eastern wing of the Palace, were firmly transferred in Evans's last writings to MM IIA[103] from the MM III horizon in which Mackenzie had set them.[104] At the same time, Evans assigned the Temple Repositories and the Lily Vases along with the deposits below the Corridor of the Procession to the later phase of MM III — i.e. MM IIIB. The latest elements in the fill of Kouloura 1 in the West Court were also dated to this period.[105]

In publishing Gournia in 1908, Boyd Hawes adopted, and argued strongly in favour of, Evans's 'new Minoan chronology'.[106] 'A tri-partite division of the Bronze Age of Crete', she wrote, 'into large periods of time, called "Early Minoan", "Middle Minoan" and "Late Minoan", which are severally subdivided into three smaller periods that represent rise, culmination, and decline or transition, is logical and easily remembered; it is found to be so comprehensive that all Bronze Age sites in the Aegean can be brought into relation with it. For these reasons, many scholars who at first were reluctant to adopt the new terminology proposed by Dr. Evans, now use it constantly.'

That same year (1908) Evans and Mackenzie made soundings in the Early Houses on the s edge of the Palace: our area B. The material from these soundings clarified the character of the EM sequence at Knossos, as Seager noted.[107] Deposits of EM III pottery were recognised here above floors with EM II vessels on them,[108] which were thought to belong to an early phase of EM II before the main period of Vasiliki ware, but are now assignable to EM IIB. As for the EM III pottery, he nowhere relates it to the UEW deposit, which is explicable since he assigned that to MM IA.[109]

The confusion and obscurity about EM III at Knossos were increased by the fact that Evans did not publish any EM III material from the Early Houses, relying upon examples of pottery from eastern Crete to illustrate the period. He may have been influenced by the view, which he shared with others among the fathers and mothers of Cretan archaeology, that in the earlier part of the Bronze Age the eastern part of Crete was in the lead, culturally speaking, and was the area where fashions began and from which they spread to the centre including Knossos. On this view, the situation only changed with the foundation of the palaces and the development of polychrome decoration in the Knossos

[95] Cf. Krzyskowska 2005, 178 and n. 66 (with references).
[96] E.g. *PM* II, 485–6, fig. 291.
[97] E.g. Bosanquet and Dawkins 1923, 22, 32.
[98] Dawkins and Currelly 1904, 196, table.
[99] Mackenzie 1906.
[100] Including that from the EM III UEW, the possibly MM IA earliest deposit in the Monolithic Pillar Basement, a floor deposit on the west borders of the West Court which, as we have seen, appears to be assignable to MM IB, and the Vat Room deposit found in 1903: see p. 11 above and ns. 69–72.

[101] Evans 1902, 26–7, fig. 13a–b.
[102] *PM* I, 255–7, figs. 191–2a; MacGillivray (2007, 134; cf. also 1998, 39–42) agrees.
[103] *PM* IV, 644, fig. 632.
[104] Mackenzie 1906, 265–6, following Evans 1904, 11.
[105] E.g. *PM* II, 610; IV, 64.
[106] Boyd Hawes *et al.* 1908, 2.
[107] Seager 1912, 6–7.
[108] *PM* I, 108.
[109] *PM* I, 175; IV, 85.

region, from which it later spread to the east of the island. Indeed, according to Charbonneaux,[110] the shapes and principles of decoration which prevailed throughout Crete until MM III and inspired the Kamares style were developed in eastern Crete between EM II and MM I. It seems more likely, however, that from Neolithic onwards Knossos was the prime inhabited centre on Crete, and often the source from which fashions and influences spread to the rest of the island.

As we have seen, the concept of EM III in the 1906 *Essai* appears to embrace also MM IA. Later, Evans continued to claim[111] that, at Knossos at any rate, vessels with polychrome decoration were being made before the end of EM III. It should have been clear, however, from the UEW dug already in 1901–02, and supplemented in 1908 by the EM III deposits in the Early Houses, that polychrome decoration did not occur at Knossos before MM IA. No example of it comes from the UEW, or from our deposits in our Areas B (the Early Houses) or A (Royal Road North: RRN). The supposed EM III vessel with polychrome decoration Evans acquired at Knossos before the excavations[112] seems much later, and may be an import from the Mesara, while the 'Indian red' that Evans thought was peculiar to EM III occurs on later pottery at Knossos.[113]

In the 1930s, despite the difficulties in recognising EM III in the Knossos region at the time, Marinatos suggested, correctly it seems, that some of the pottery from Yiofyrakia southwest of Herakleion might go back to the end of Early Minoan;[114] and EM III pottery has now been recognised at other sites in the area, including Archanes, Poros and Tylissos,[115] where Hazzidakis thought that the pottery from the earliest deposits belonged to a single stratum.[116] Zois accepted this unitary claim, assigning it to MM IA, and by preference to its earlier part.[117] However, the material Hazzidakis publishes covers several periods and includes EM II as well as EM III and MM I–II,[118] as he recognised.

After World War II, Levi argued similarly for the existence of one relatively short period at Phaistos between the end of Final Neolithic there and the foundation of the First Palace.[119] In this case there was more justification for such a minimalist view. The end of Phaistian Neolithic may, or may not, overlap with part of EM I at Knossos: cf. below p. 282; and it is still not that easy to isolate EM III in southern Crete, although it appears now to have two phases at Phaistos.[120]

THE EARLY MINOAN SEQUENCE REPRESENTED IN THE 1957–1961 EXCAVATIONS

In the light of our excavations and of the work of others (see p. 239) in studying material from the old excavations, it has been possible for several years now to define and assign distinctive features to four main successive periods (with sub-divisions) of Early Minoan at Knossos in terms of changes of fashion in pottery: EM I, IIA, IIB and III.

Our definitions of these periods are reasonably consistent with those made by Evans, Mackenzie and Pendlebury. There has inevitably been a certain shifting of boundaries, however, and it is important to bear in mind that much that we define as EM I has in the past been called Subneolithic, while some if not most of what is now included in EM IIA appears to be what Evans regarded as late EM I. Thus Evans[121] implies that Vasiliki I (now classified as EM IIA)[122] was to be assigned to EM I in spite of the presence of Vasiliki ware. In harmony with this, the material from the Early Houses, now defined as EM IIB, was regarded by Evans as belonging to an early stage of EM II. Our EM III material seems to correspond to what Evans called EM III in the Houses, although he assigned other EM III deposits to MM I.[123]

EARLY MINOAN I

This period is defined in terms of the material from the Palace Well. No other settlement deposits of EM I have been identified elsewhere in Crete apart from nearby Poros[124] and, very recently, Aphrodite's

[110] Charbonneaux 1928, 375.
[111] E.g. *PM* I, 175–6.
[112] AM 1931.235: *PM* I, 110, fig. 78. *PM* index, 120 says it was found at Knossos *c.* 1896.
[113] Andreou 1978, 44.
[114] Marinatos 1935, 51. Cf. Momigliano 2007*c*, 81, 93, table 3.1.
[115] Momigliano 2007*c*, 81, 93, table 3.1. On Tylissos, see Andreou 1978, 177, n. 9.
[116] Hazzidakis 1934, 84.
[117] Zois 1969, 34.
[118] Andreou 1978, 173, n. 1; 177, n. 9.
[119] Levi 1965; but cf. Todaro 2005, 15–16.

[120] La Rosa 2002, 643, 740–1; Todaro 2005, 40–2, fig. 7B; Momigliano 2007*c*, 93, table 3.1. The Patrikies material (Bonacasa 1968; Momigliano 2007*c*, 99, table 3.2; cf. Todaro 2009*a*) is best assigned to MM IA. Some vessels from the Mesara tholos tombs probably date to EM III (Zois 1967*b*, 151; Andreou 1978, 164), but note Watrous and Hadzi-Vallianou 2004, 252.
[121] *PM* I, 60, 78.
[122] Zois 1992.
[123] Notably the UEW: see p. 11 above and ns. 71–2 (with references); also Lee 1974.
[124] Dimopoulou-Rethemiotaki *et al.* 2007.

Kephali in the Ierapetra isthmus[125] and Petras–Kephala.[126] A small deposit of comparable material found by J. D. Evans in 1970 in sounding FF (FF4) below the West Court[127] was stratified above an important deposit assigned to FN IV, with features linking it closely with both the later and earlier Neolithic (so-called FN) of Phaistos.[128] The relationship of Knossian EM I with Sub-Neolithic or FN in Crete is discussed later (pp. 282–5).

In our excavations we came upon no deposits linking the EM I of the Palace Well with EM II. Considerable changes, however, had evidently taken place in the pottery in use at Knossos between the EM I stage represented in the material from the Well and the horizons now defined as EM IIA. We shall also discuss below (pp. 282–3, 288–9) where in the EM I–II sequence the Palace Well fill lies, and whether it is still possible — as used to be the case — to distinguish an EM IA from an EM IB.

EARLY MINOAN IIA

The horizon now defined as EM IIA is very well represented by the material from the West Court House (WCH) deposits[129] and corresponds to what has come to be understood as EM IIA not only at Knossos but elsewhere in Crete (even if Evans would have included much of it in a late stage of EM I). Similar deposits occur in Warren's RRS excavations (to the west of our 1957–59 excavations) and include pieces of imported sauceboats of EH II type, of obvious importance for correlations with the Greek mainland.[130] In RRN our earliest, small deposit with recognisable features (A1: Floor VI) is assignable to this EM IIA horizon, but may be slightly later than the WCH deposits.[131]

EARLY MINOAN IIB

EM IIB as defined at Knossos appears to overlap with the main period of Vasiliki ware. This distinctive fabric evidently originated in the eastern part of Crete where it was the dominant fine ware during EM IIB although, as might be expected, it seems already attested in earlier EM II (see pp. 131–2).

In our area A two successive floor levels (V and IV) were identified sandwiched between Floors VI (deposit A2) (EM IIB) and III (deposits A6, and probably A7) (EM III). Floor V (deposit A4), the lower of the two, is certainly to be assigned to EM IIB.[132] In area B we found no deposits between Neolithic and levels with pottery assignable to EM IIB, which corresponds to that published by Evans[133] and is partly presented below (pp. 266–74).[134] Evans, however, did assign this EM IIB group to an early phase of EM II, and Zois cited our **1332** as an example of his EM IIA Koumasa style.[135] This raises the question of whether the horizon identified as EM IIA in southern and eastern Crete may not in fact overlap with the beginning of EM IIB at Knossos — as the EM III style of East Crete overlapped with EM III and MM IA at Knossos (see below, p. 223).

The pottery (deposit A5) from Floor IV in area A reflects the transition at Knossos from EM IIB to EM III, with a shift in fashion from decorating the finest table ware in dark-on-light to light-on-dark. The vessel shapes, however, are still often in line with EM IIB norms but there is much that corresponds with our B3 deposit of EM III. We did, however, at one point consider calling this phase EM IIC,[136] but there seems no justification for making further sub-divisions of a period on the basis of a single small deposit of this kind. In any case, in the system of Evans any further sub-division of a period like EM II should take the form of EM IIB1 and IIB2 rather than EM IIB and IIC. We note, however, that the *Knossos Pottery Handbook* now uses the forms: EM IIA early and late, and EM III early and late.[137]

EARLY MINOAN III

The character of the pottery of this phase at Knossos has been well described by Andreou and Momigliano.[138] It is clearly distinguished by the predominance of the fashion for decoration of the finer table ware with designs in white-on-dark. At the same time there was a definite shift in the shapes of vessels, with a strong predilection for bowls with flaring or everted rims of our type 8/9 (see below p. 127). EM III footed goblets are virtually indistinguishable in shape and decoration from

[125] Betancourt 2008a, 2010.
[126] Papadatos 2008, in preparation.
[127] Wilson 1985, 359–64; Tomkins 2007, 44–5; Wilson 2007, 50.
[128] J. D. Evans 1971, 113–14; Tomkins 2007, 41–4, esp. 44 (with references to Vagnetti 1973a).
[129] Wilson 1985; 2007, 56–7 (assigning them to EM II Early).
[130] Warren 1972b. For EC II sauceboats at Knossos see Wilson 2007, 69–70.
[131] Wilson 1985, 292.

[132] Cf. Wilson and Day 1999, 5.
[133] *PM* I, 73–5, fig. 40.
[134] Much of the sherd material from the Early Houses is published in Wilson and Day 1999.
[135] Zois 1968a, 93; 1969, 42.
[136] Cf. Hood 1978, 15, table.
[137] Momigliano 2007a; Wilson 2007; Momigliano 2007c.
[138] Andreou 1978; Momigliano 2007c (with references).

many of those of MM IA, but have no sign of polychrome decoration. That is attested for the first time at Knossos in MM IA. Some characteristic features, however, of MM I decoration, notably barbotine and reserved strips with incised hatching, appear for the first time in EM III, in our deposits and the UEW.

In many respects the EM III pottery of Knossos appears to be closer to MM IA than to EM II. Indeed, when we first came upon EM III in 1960–61, we were inclined to classify the pottery as belonging to an early phase of MM IA and deny the existence of an EM III period at Knossos.[139] It is better, however, to retain the term as it was ultimately used by Evans. This is all the more desirable since there was clearly a substantial overlap between this Knossian EM III and East Cretan EM III (or the East Cretan EM III style), as the East Cretan EM III import **1124** in our B3 deposit makes quite clear. We were confused, as others have been, by the fact that, although Evans noted the existence of EM III deposits at Knossos, he chose to define EM III in terms of published material from East Crete — which led to suggestions that the horizon of East Cretan EM III was wholly contemporary with MM IA at Knossos. But, since the rehabilitation of EM III by Antonis Zois,[140] it is certain that this was not the case — although (earlier) MM IA at Knossos certainly overlapped with (later) East Cretan EM III, as has long been recognised.[141]

MIDDLE MINOAN IA AND LATER

MM IA is defined at Knossos as a stage when the fashion for polychrome decoration (in red combined with white on a dark ground) on pottery flourished before the adoption of the fast potter's wheel. A deep fill of rubbish with abundant fragmentary pottery of this period was excavated at RRS,[142] with floor deposits above it in a sequence of MM IA, MM IB and MM IIA,[143] and a later deposit assignable to MM IIIA.

Small deposits of MM IIIB came from both the RRS and RRN excavations, while LM IA and IB were very well represented by material from RRN.[144] The large LM IB deposit in RRN[145] seems to have been associated with a shrine; an ivory carver's workshop may have been connected with this. LM II deposits with complete vessels were found in RRS and at the site of the Sanctuary of Demeter south of the Palace.[146] Deposits of the latest phases of the Cretan Bronze Age, LM IIIA2, LM IIIB and LM IIIC, have been identified in both RRN and RRS.[147]

[139] Cf. Hood 1962c, 93–4.
[140] Zois 1967b.
[141] E.g. H. W. Pendlebury et al. 1936, 24.
[142] Hood 1960a, 23; Momigliano 2007c, 96–103.
[143] Momigliano 2007c, 96; MacGillivray 2007, 108, 124.

[144] Hood 1960a, 23–4; 1960b, 265; 1961, 26–7; 1962a, 25–7; 1962b; 1962c, 96.
[145] Hood in preparation.
[146] Hood and Smyth 1981, 56: 286; Hood 1962c, 97.
[147] Hood 1962c, 97.

Chapter 2

The Early Minoan excavations of 1958–1961

During the excavations of the British School at Athens between 1957 and 1961 at Knossos, Early Minoan remains were found in three main areas (FIG. 2.1, PLATE 1):

Palace Well. A well found in 1958 in the NE quarter of the later Palace[1] had been filled in during EM I. We present the excavation and finds in chapter 3.

Royal Road: North (RRN): Area A. In the centre of our excavations on the N side of the Royal Road,[2] intact EM deposits survived in ground next to later (MM III–LM I) basements. In 1961 we opened a small sounding here, which we are calling Area A. We present the excavation in chapter 4, the pottery in chapter 7 and other finds in chapter 9.

No house floors with EM pottery were identified on the S side of the Royal Road (RRS), although Warren later revealed some to the W of our excavations;[3] nor were there any pure EM deposits in the 1957–61 excavations in the region of Hogarth's House A or anywhere else on the hill of Gypsades to the S of the Palace.

Early Houses: Area B. In 1960 three small trenches (two of which, totalling only *c.* 5.2 m², are relevant for this study) were opened in untouched deposits in the 'Early Houses' on the S edge of the later Palace, revealing a series of floors and levels attributable to EM II and III.[4] We present the excavation in chapter 4, the pottery in chapter 8, other finds in chapter 9, and some of the pottery that Evans and Mackenzie found in 1908 at the Early Houses in chapter 10.

TABLE 4.2 shows how this sequence of deposits in Area B appears to correlate with the sequence in the larger sounding in Area A (RRN), and TABLE 2.1 the relative quantities of EM pottery we recovered. The amount from the EM I Palace Well is reckoned in baskets, but the unit for the rest of the material assignable to EM II and III is a table, namely the work-table or, that is to say, the amount of pottery when it was spread for study on the standard work-table with a top measuring 1 × 2 m making a surface area of 2 sq m. One table spread is roughly the equivalent of one full basket. It will be noted that the amount of pottery from the Palace Well (15 baskets of pure EM I material, with two baskets of later rubbish from the top of the fill in the Well) was about as much as everything put together from the EM II and III deposits in Areas A and B.

Comparisons on this basis are clearly rough and approximate, but they are perhaps less misleading and easier for making a quick appraisal of the relative amounts of material involved than some other systems, such as counting the total number of sherds, or weighing the pottery, which may give an impression of precision that is largely spurious. For conversion to other systems, the average number of sherds for one table may be taken as about 500.

METHODS OF STUDY, AND PRESENTATION OF THE FINDS

The pottery has been considered by types and not by fabrics in the first instance. There has been no attempt to divide the types between fine wares and coarse wares. Fine and coarse wares in effect shade into each other, the size of a vessel being in general the criterion as to whether it is of fine ware without grit, or of coarse ware tempered with grit. An exception, however, is made for the very distinctive, mostly dark surfaced burnished wares found in EM II deposits, and for the mottled Vasiliki ware, exotic at Knossos, even if some (or most) of it was locally made, as Betancourt has suggested.[5]

The vessel types are arranged on the clear and logical system adopted by Blegen and his collaborators in dealing with the pottery from Troy. That is to say, the fine tableware is considered first, beginning with drinking vessels (cups, goblets) and various kinds of food vessels (bowls). Then come pouring vessels (jugs and spouted jars), storage vessels, lids (mostly from storage vessels), cooking pots, miscellaneous vessels and large pithoi.

[1] Hood and Taylor 1981, 20: 183.
[2] Hood and Smyth 1981, 51: 215.
[3] Warren 1972*b*, 1973*b*, 1974.
[4] Hood and Taylor 1981, 13: 2.
[5] Betancourt 1979.

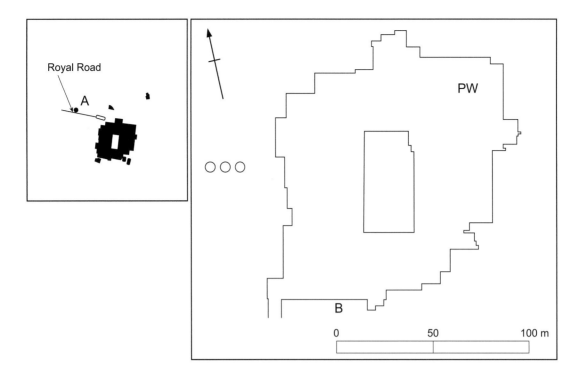

FIG. 2.1. The 1958–61 Early Minoan excavations in the Palace area at Knossos: PW: Palace Well;
A: Royal Road: North; B: Early Houses.

TABLE 2.1. Areas A and B. Amounts of pottery examined, as estimated by table surfaces (measuring *c.* 2 × 1 m) or baskets.

3	EM III	B3		
2	EM II	B2		
1	EM II	B1		
1.25	EM II	A8	LA94	
0.2	EM III	A7	FLOOR III?	2
1.25	EM III	A7	FLOOR III?	1
0.25	EM III	A6	FLOOR III	
1	EM III	A5	FLOOR IV	
0.5	EM II	A4	FLOOR V	
1	EM II	A3	FLOOR VI — ?mixed + V	
2	EM II	A2	FLOOR VI	
1	EM I	A1	FLOOR VII	
15	EM I	Palace Well (in baskets)		

Amount of tables and baskets

Vessels and sherds described or illustrated are given a **serial number in bold**. This should make it easy to find anything to which we refer. During the excavations complete vessels and large fragments were catalogued: the catalogue number marked on the object is noted after the serial number in the text. In the case of pottery now in Herakleion, the Herakleion Archaeological Museum (HM) number is given when known. Most of the other fragments described or illustrated were numbered when the material was being studied and drawn. This number, which was marked on the fragment, is also given in the text after the serial number. These numbered fragments and other non-catalogued pieces described and illustrated are housed in the Stratigraphical Museum at Knossos (SMK).

The sections of vessels and sherds have been drawn on the right, following the precedent which Pendlebury and his collaborators set in the reports of their excavations in Lasithi in the 1930s.[6] Their figures contain the first large body to be published of archaeological drawings of EM and MM pottery: it seems appropriate to continue the tradition they established.

Diameters are measured from the outside edge of the rim unless it is stated otherwise. Measurements are in centimetres, unless otherwise stated.

The pottery and other finds from the excavations, which are now in the HM or SMK, are marked in ink. The more or less complete vessels and some profiles, together with most of the other finds apart from pottery, were marked with an excavation catalogue number, which consists of a code for the specific site, e.g. RR for the Royal Road (but LA for the catalogued pottery from the EM sounding), PEM (Palace Early Minoan) for the Early Houses, and PW for the Palace Well, followed by the year and a serial number. The numbers for the pottery from each area are preceded by P and form a separate series from the numbers for other artefacts.

Uncatalogued pottery fragments, which were selected for eventual publication, were given provisional serial numbers by areas, with RRN and RRS being treated as separate areas: the provisional serial numbers for RRN are preceded by N, and those for RRS by S.

The catalogue and provisional serial numbers for the pottery and other finds from the EM I Palace Well, since they form a homogeneous deposit, are listed in a concordance at the end of the chapter. For the EM II and III material, however, these numbers are added in brackets after the final publication number.

In the pottery drawings diagonal hatching indicates red paint, and vertical hatching normally implies black paint. In a few cases, however, black paint is rendered solid black to emphasise the contrast with decoration in white. In the catalogue and descriptions a wash is to be assumed to be overall, that is inside and outside, unless we say otherwise.

We include the sample numbers (as Wilson and Day sample KN 92/1 etc.) of pieces that Wilson and Day have examined petrographically: see p. 297 below.

Finally, we wish to make it clear that, when we discuss Neolithic contexts and dates, we are following Tomkins's revised sequence of 2007 (although we may include the date in the earlier sequence of Furness and J. D. Evans).[7]

[6] H. W. Pendlebury *et al.* 1936, 1938.
[7] Tomkins 2007 (and 2008); Furness 1953; J. D. Evans 1964, 1968, 1971, 1994.

Chapter 3

Early Minoan I: the Palace Well

INTRODUCTION

An important EM I assemblage came to light in the Palace Well,[1] which lies in the eroded NE quarter of the Palace (FIG. 3.1, PLATES 1, 2 *a*), at a point where all traces of the structures of the Palace itself had disappeared before Evans began excavations there in 1901. The Palace Well contained the most substantial ceramic and faunal assemblages of this period that have yet been found at Knossos and thus gives crucial insights into this otherwise little known period in the history of the settlement.

The Well may have been the main source of water for the settlement on the Kephala hill at the beginning of the EBA. It went out of use and was filled with debris before the end of EM I. Our original interpretation was that the main deposit in the well (deposit 2: see below) represented debris from a destruction by fire in/of the settlement.[2] Peter Day and David Wilson, however, have argued in recent papers that the nature of the assemblage suggests communal drinking and feasting.[3] In this chapter we present the evidence from the excavation and analysis of the assemblages (Valasia Isaakidou presents the faunal remains) and try to address the interpretations put forward since its excavation.

The Palace Well is the earliest Bronze Age well known at Knossos. None has been found of EM II date;[4] but fairly near the Well are the EM III Upper East Well (UEW) and what may have been a Neolithic well but is probably a later one cut into Neolithic levels (FIG. 3.1).

The potentially Neolithic well cannot be found in any publication, but is described in Mackenzie's Daybook for 1902. It seems to have been a little upslope (to the W) from the East Bastion. The fill was of mostly 'early Mycenaean' (suggesting LM I) and Neolithic sherds. Neolithic became steadily more dominant from 11 m from the surface until the bottom at 14.5 m, where the sherds were all Neolithic.[5] If this suggests that it was originally a Neolithic well, one must set against this the improbability that such a deep hole remained open for millennia![6]

Higher up the E side, the UEW lay just to the W of the Court of the Stone Spout and was excavated in 1901 and 1902.[7] We may guess that it became known as this after the discovery of the possible Neolithic well, which could have then been seen as the 'Lower East Well'. The UEW was at least 19.4 m (and possibly more than 22.5 m) deep,[8] as against the 17.2 m of the Palace Well. The presence of these three wells on the E slope suggests that the Early Minoan (I and III), and possibly the Neolithic, inhabitants of the Kephala hill were aware — perhaps from water divining — that digging deep in this part of the hill could give access to subterranean aquifers. A fourth well on the E slope was dug, Evans suggests, in MM IIIB, with LM I pottery in the fill, and some LM IIIB in the upper layers.[9]

Other Bronze Age wells are known inside the immediate area of the Palace. One, assigned to late EM III, was immediately N of Kouloura House A,[10] and another, of uncertain original date, in the SW

[1] Hood and Taylor 1981, 20: 183; Wilson 2007, 49–50, fig. 2.1: 7.

[2] E.g. Hood 1990*a*, 371.

[3] Wilson and Day 2000, 52, 59–60, 62; Day and Wilson 2002, 149; 2004, 55.

[4] The Fourni well with a fill of mostly FN IV pottery, but deposited in EM I, remains unique in Neolithic Crete: Manteli 1992; Tomkins 2007, 47 (for the dating).
An EM II well is known at Vasiliki, in Space 39. It was in primary use, and was presumably dug, in EM IIB (to judge from the Vasiliki ware sherds at the bottom): Seager 1907, 112–13, fig. 1; 118–20. Cut through 8 m of rock, it had a funnel shape: 1 m wide at its mouth, it soon narrowed to 0.75 m, but reverted to 1 m at about 2 m down. Small notches cut in its opposite sides would enable climbing in and out. In EM III it was filled with pottery. See also Zois 1976, 23, 113, 118–19, plan 9, pl. 56β.

[5] We thank Todd Whitelaw for telling us of this forgotten, and otherwise unrecorded, well. The description is in Mackenzie's notes between 27 March and 11 April 1902: DM/DB 1902, 52, 58, 60, 62, 64, 66, 68, 70, 72–6, 78–9.

[6] Peter Tomkins, whom we thank, suggests to us that it may

have been the so-called 'Blind Well' of the Court of the Stone Spout (Hood and Taylor 1981, 21: 194), excavated in 1902. Its two boxes of pottery (SMK I.I.5 970–1) are dated by Eccles *et al.* (1933, 8) to MM III.

[7] Hood and Taylor 1981, 21: 198 (with references esp. *PM* III, 254); Momigliano 1991, 155, pl. 17. It was just to the W of, and on the terrace above, the Court of the Stone Spout. For the pottery, and other references, see Momigliano 1991, 155–63, figs. 1–3, pls. 18–21 (further to Andreou 1978, 12–25); 2007*c*, 81–3, fig. 3.4: 6: EM III late.

[8] Momigliano 1991, 155 and n. 39, citing Mackenzie's notes for 1902. Evans (*PM* III, 254) says that it was excavated to 22.5 m, when work stopped because it was too dangerous. This comment reflects a note by Mackenzie in 1907 (cf. Momigliano, *loc. cit.*).

[9] In the SE corner of the portico of the Hall of the Double Axes, and dug at 'about the close' of MM IIIB: *PM* III, 255, 326, 328, fig. 218; Hood and Taylor 1981, 22: 234.

[10] *PM* III, 255–7, figs. 175–6 (illustrating the clay cylinders that lined this well); Momigliano 1991, 240–2 and n. 268 (for other references); Hood and Taylor 1981, 16: 88: SMK B.II.4 388; Momigliano 2007*c*, 82, fig. 3.3: 2.

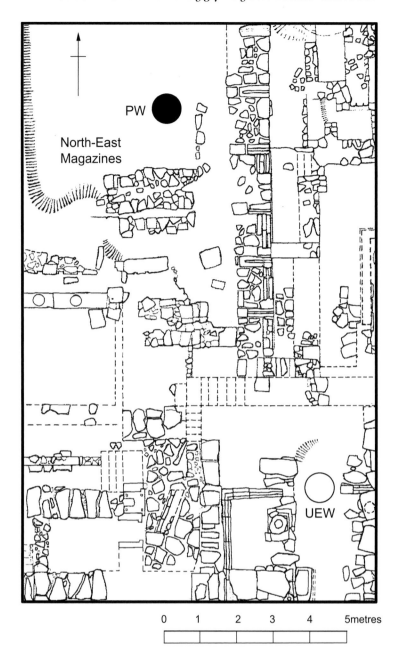

FIG. 3.1. Palace Well. Location of Palace Well (PW); approximate location of Upper East Well (UEW).

corner of the West Court.[11] sw of this, a third well produced mainly EM III (but also EM IIB) pottery.[12] On the s side the mysterious rock-cut Hypogaeum, whose construction Evans ascribed to EM III,[13] may have been a large public well of a type found in early times in the Levant (that is, a circular pit with a staircase winding down its side) — if it was not a granary.[14]

[11] *PM* IV, 222; Hood and Taylor 1981, 14: 42: SMK B.I.22 357.
[12] Hood and Taylor 1981, 14: 42: SMK B.I.31 371–3. The material includes: **1357–1360, 1363–1365**.
[13] Hood and Taylor 1981, 13: 10; *PM* I, 104–7, fig. 74; II, 762, fig. 490; Cadogan 1986, 159; Momigliano 1991, 195–8; 2007c, 96 (pottery is MM IA); Belli 1999; McEnroe 2010, 41. Tomkins (forthcoming *a*: we thank him for an advance copy of the paper)

suggests that it is one of a series of Neolithic hypogaea (including one encountered in J. D. Evans's trench Z close to the Early Houses) on the s and se slopes of the Kephala hill, which have similarities with the MN–LN hypogaea at Katsambas. Cf. also Tomkins forthcoming *b*. For trench Z, see further p. 82.
[14] Halstead 1981, 198; Branigan 1988, 67–8; Sbonias 1999, 45. Marinatos (1946, 348) was the first to query the use of this structure.

EXCAVATION

The top of the Well was exposed when the NE part of the Palace was cleaned by the Archaeological Service in June 1958. As the School was excavating at Knossos at the time, the Ephor, Professor Nikolaos Platon, generously called upon us to examine the Well. It was excavated between 23 and 28 June 1958, and 16 and 18 June 1959, under the supervision of John Hayes and †Larch Garrad.[15] The code for the excavation is PW/58 or 59.

The Well (which is no longer visible, but PLATE 2 *a* shows the present appearance of the ground where it lies) was deep (FIG. 3.2), its bottom 17.2 m below the present surface of the ground, which appears to be at about the same level as when the Well was dug. It was cut for some distance through Neolithic deposits, and lower down through the soft white *kouskouras* rock of the Knossos area. At the top it was over 1.5 m in diameter where the sides, consisting of Neolithic material, had collapsed; but after about 1 m it became oval, some 1.4 × 1.5 m across. At 5 m from the present surface it began to narrow with the sides somewhat irregular, until at about 12.5 m it was only 0.57 × 0.59 m across. From 13 m it again widened to a maximum of 0.83 × 0.88 m at a depth of 14.8 m. It was still 0.82 × 0.77 m across within 0.1 m of the bottom, which was flat, and 0.62 × 0.68 m across.

The fill in the Well divides into three separate deposits:

Deposit 3, from the surface down to about 3 m and excavated as levels 1–2, produced a good deal of earlier (Neolithic) material together with some later (Minoan) pottery, mainly Late Minoan, including LM IA and IB and some LM III.

Deposit 2, starting below 3 m from the surface and excavated as levels 3–21, was entirely free from later contamination, but did produce some 80 fragments of Neolithic pottery. They include pieces of presumably FN IA[16] (formerly MN) rippled ware (PLATE 2 *b*) and other sherds dating to LN–FN IB.[17] The Neolithic pottery appears as isolated sherds which, on the whole, are clearly distinguishable in fabric from the pottery of EM I. (One or two MM and LM sherds, including **162–163**, that were found in the baskets when the pottery was studied in the autumn of 1964 may have fallen from the surface during excavation, but are more likely to have strayed into the baskets after the pottery had been washed and while it was in store from 1959 to 1964.)

This deposit appears to be a fill that was deliberately tipped into the Well after a fire and is the principal part of the Well's contents, and over 10 m deep. It began to bottom out at around 13.6 m from the surface (to judge from the first appearance of the jugs that mark deposit 1) but did not cease altogether until around 14.2 m from the surface. The fill that formed deposit 2 consisted of stones with layers of wood ash and lumps of fire-hardened clay that were identified in 2009 as pieces of clay storage bins which, most probably, had been preserved by having been burnt. Much of the pottery in the fill had been discoloured by fire. Consequently, fragments that join are often of quite different colours, suggesting that the vessels were broken at the time of the fire(s). Minor differences were noted in the character of the fill at various depths, and the pottery was kept in 25 separate levels, which ranged in thickness from about 0.15 m to 1.5 m. Deposit 2, however, had evidently been filled in one single operation, and the pottery throughout was uniform in character, with joining fragments found dispersed at different levels: fragments of lid **124**, for instance, came from depths of around 9, 11, 12 and 13 m. The only significant change in the make up of the group is the appearance of some body fragments of jugs towards the bottom of the deposit.

Deposit 1. At a depth of about 14.2 m, and 3 m above the bottom of the Well, the soft ashy debris of deposit 2 came to an end, to be succeeded by two rather different layers that form deposit 1. The upper part of deposit 1, excavated as level 22, consisted of layers of grey clay with much green vegetable matter and specks of carbonised wood. This was apparently a deposit that had formed below the ancient water level, producing virtually no pottery. Below it was a clay deposit, excavated as levels 23–5, with lumps of *kouskouras* that may represent debris fallen from the sides of the Well before it went out of use. This bottom level did produce some pottery, including pithos fragments.

Jug fragments were much in evidence in the Well from about 13.6 m downwards (levels 20–1). This is above the stratigraphical change (from level 21 to level 22) noticed at around 14.2 m, but may be a sign of the probably uneven tipping of deposit 2 into the Well — or of the difficulties of excavating at such a depth in the Well. While these first jug fragments may belong with deposit 2, it is quite as likely, if not more probable, that they should be grouped with deposit 1, which represents the original use of the Well. Thus, the bottom metre in the Well produced one small complete jug **89** of type 12,

[15] Preliminary notices: Hood 1959, 18; 1960*a*, 25.
[16] Cf. Tomkins 2007, 32–3.

[17] Tomkins, pers. comm.

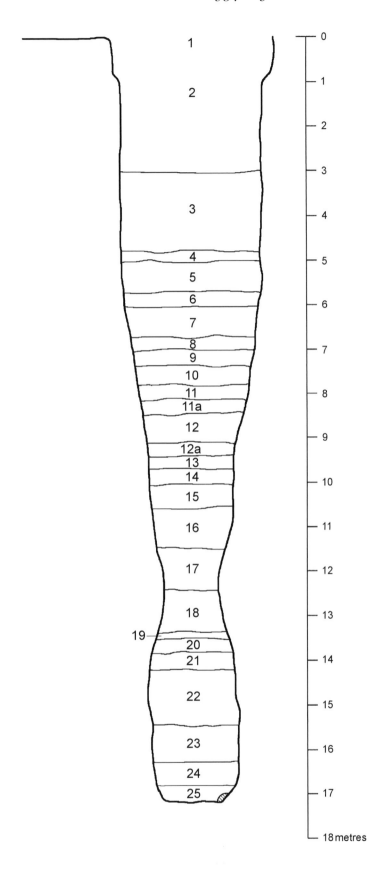

FIG. 3.2. Palace Well. Section, with excavation levels.

and the greater part of another large one **90**, together with the bodies of what appear to have been four more large jugs like it. These jugs had presumably been let down for water — and been lost. In four out of five cases the bodies of the large jugs were in the Well, but their necks were missing. This suggests that, if a jug broke, the mouth and handle were pulled back to the surface still attached to the rope, and then thrown away. These jugs, and various pieces of pithoi, must represent the primary use of the Well; and deposit 1 has to be earlier, if perhaps only slightly earlier, than deposit 2. The clayey matrix of the deposit gives us probably a clue to the (maximum) depth of water in the Well (some 3 m), while the broadening of the Well at the bottom may have been intentional (in part, at least), to make it easier to scoop up the water.

When we first studied the pottery from the Well, we believed that it (that is, deposits 1 and 2) should be dated to EM I early — or 'EM IA'. For many years this judgement informed our discussions and presentations of the development of EM I–II pottery.[18] However, study in the late 1990s by Day and Wilson of the pottery from Poros (downstream from Knossos, at the mouth of the river Kairatos) has suggested that the Well is in general contemporary with the Poros EM I deposits, which exhibit features that used to be classed as EM IA together with what used to be EM IB. This leads to assigning the Palace Well to an advanced stage of EM I — where the other EM I deposits of Crete in general seem also to belong.[19]

In view of this development, and pending whatever consensus emerges once the Poros pottery has been published, we think it prudent to call the Palace Well deposit simply EM I in presenting it now, and leave until later (pp. 281–5, 288–9) discussion of its precise place in the sequence of Cretan Early Minoan deposits. This will include reviewing its relationship to the FF4 deposit below the West Court. In the recent *Knossos Pottery Handbook*, Peter Tomkins[20] shows that it is stratigraphically later than FN IV (level FF10 in the same trench) and probably belongs to early EM I, with ceramic features that are on the whole less developed, and thus earlier, than those in the Palace Well. A few pages later, however, Wilson[21] classes FF4 as part of his EM I Well Group, which characterises and unites all the Knossian pottery of EM I.

POTTERY

In the account that follows of the pottery from the Well, the pottery is from Deposit 2 unless stated otherwise. The jugs, and pithos fragments, from Deposit 1 are the principal exception.

FABRIC

There is no sharp distinction between fine and coarse wares, although the beginnings of a distinctive cooking pot fabric of the kind that occurred from EM II onwards are already visible, for instance, in the baking plates of type 10 (type chart for EM I: FIG. 3.3) or the unique rim **75** with an external ledge.

The pottery is often tolerably well fired, and the fabric hard. This suggests that some at least of the vessels were being fired in an oven. The oven may have been the bread oven of a house, especially if pottery was homemade and not produced by specialist potters; but we cannot rule out specialist potters and dedicated pottery kilns even in EM I,[22] although no EM I ovens have been found.[23] On the other hand, little is yet known about Cretan non-funerary architecture of the time. Ovens were in use at a very early period in Anatolia, and what may have been a pair of ovens was identified by J. D. Evans in an EN level at Knossos.[24] Ovens have now been recognised in connection with several houses of later Minoan periods; some of these later ovens appear to have been employed, not for baking bread, but as kilns for industrial purposes that include firing clay pottery[25] and making lime powder for wall plaster.[26]

Even with the best fired vessels from the Well the clay is often grey in the break, and the firing in general appears to be uneven. Normally, the clay is orange to dusky, with a temper of chopped straw and fine grit or sand. In the larger vessels, which tend to be of coarser fabric, the straw and grit temper is more pronounced. The vessels regularly appear to have had a wash or slip, and this is often sharply different in colour (buff, green or red) from the clay of the pot to which it has been applied.

[18] E.g. Hood 1971a, 36–8 and fig. 14 (which distinguishes 'EM IA' goblets from the Well from those of 'EM IB' in the Pyrgos burial cave); Cadogan 1983, 508; and cf. Cadogan *et al.* 1993.

[19] Wilson and Day 2000, esp. 50–6; Wilson *et al.* 2004, 67–9; Wilson 2007, 55–6 and table 2.2. Cf. Day and Wilson 2002.

[20] Tomkins 2007, 45–7.

[21] Wilson 2007, 50.

[22] A reasonable inference from the recent thorough discussion by Betancourt (2008b, 13–23).

[23] For the firing of EM pottery, cf. Jones 1986, 784.

[24] J. D. Evans 1964, 148: Stratum VIII.

[25] Davaras 1973b, 1980 (with references); Shaw *et al.* 2001.

[26] Warren 1981b, 75–9.

It is of great interest to find a variety of wares and forms. Different shapes of vessel have surfaces finished in very different ways so that they appear totally different. Thus what seem to be the drinking and food vessels, the fine tableware, have more or less dark, grey-black, brown or red, surfaces which are generally decorated in pattern burnish.

This ware has often been called 'Pyrgos ware' but, like Wilson in the *Knossos Pottery Handbook*, we prefer a label that is not constrained by place and with him shall call it dark grey burnished ware or red burnished ware as appropriate.[27] We agree here wholeheartedly with Haggis's wise observation on the need to avoid 'imprecise and regionally biased ware group designations',[28] while allowing one exception: Vasiliki ware, which it would be otiose to rename now (even though several different groups of mottled vessels come under its umbrella). By avoiding a site-specific approach to labelling the other pottery wares that we present in this book, we hope to avoid often spurious suggestions of ceramic exchange and at the same time to make it easier for all to see what is in the deposits. However, in rejecting 'Ayios Onouphrios' etc., we do not reject the (limited) use of site-names in connection with *styles* of EM pottery, such as, for example, to refer to a style of painted dark-on-light fan motifs on principally jugs, as first noticed at Myrtos–Fournou Korifi.[29] Calling this now 'Myrtos style' (rather than 'Myrtos ware') allows anyone to know immediately what is being discussed, without any suggestion of a specific provenance or production centre.[30]

By contrast, the large jugs used for drawing water from the Well, and some other types of large vessel, have dark brown or reddish surfaces which have been scored or wiped. Smaller jugs are light surfaced with simple painted decoration in red: this used to be known as 'Ayios Onouphrios' ware, after the tomb at Ayios Onouphrios near Phaistos that became the type-site, following its recognition by Evans in 1894.[31] In the past there was a tendency to think of pattern burnished (Pyrgos) ware as appearing earlier in Crete than dark-on-light painted (Ayios Onouphrios) ware. Levi long ago emphasised that they were in fact contemporary.[32]

Much of the pottery from the Well — and especially the finer table shapes such as the chalice and the pedestal bowl (types 1 and 2) — has a stroke burnished surface. This was normally done it seems with some eye for decorative effect, and has been loosely called the Pyrgos style for some time. Much of it may now be classed as pattern burnish: a burnishing tool was used to make designs on a part of the surface which had usually been reserved without burnish, but sometimes the designs are on an already burnished surface. Designs in pattern burnish on a reserved zone are characteristic of EM I, and extremely rare in Cretan Neolithic. Pattern burnish is found on cups of type 4 and bowls of type 8 as well as on the chalices and pedestal bowls. Its most elaborate use is on small suspension pots of type 14.

A slip or wash was often, if not invariably, applied to the surfaces of vessels before they were burnished; but many vessels have an unburnished slip or wash. Since what we call a wash — and we believe we are correct — is often referred to as a slip,[33] we must explain how we use the two terms:

A wash is a coloured coating of a vessel that is wholly *paint-based*, with no apparent admixture of clay.

A slip, however, is and can only be *clay-based*, a coating of liquid or slurry-like clay. This may either be a thin 'self-slip' of the same clay as was used for the body of the vessel, which can be easily achieved by the potter's passing the vessel through her/his hands, and smearing or smoothing it, when they are wet with the muddy, clayey water she/he has been using in making the vessel. Or it can be a different clay altogether that is overlaid on some or all of the vessel, when there is often an intent to change its appearance by giving it a different colour (the White Slip pottery of Cyprus is a paradigm of this), or to make it less porous and better able to hold liquids, as is observable on, say, Middle Minoan bowls in cooking pot ware.

To return to the EM I pottery of the Palace Well, a thick light slip is particularly noticeable on jugs of type 11 with painted decoration; but some of these jugs have a thin red wash. In the case of washes the paint is apt to be unevenly applied, so that the surface of the vessel presents a streaky or mottled appearance. Red slips and washes occur, and some examples of an unburnished dark wash foreshadow

[27] EM I pottery at Knossos: Wilson 2007, 51–6. See also Wilson and Day 2000.
[28] Haggis 2005, 48. Obvious examples would be such terms as 'Ayios Onouphrios', 'Koumasa', 'Myrtos', 'Pyrgos' and 'Salame' wares.
[29] Warren 1972*a*, 133–4: 'Myrtos ware'.
[30] Cf. Cadogan 2010, 42–3.
[31] Evans 1895, 105–16, 124–6, 135–6; Brown 2001, 18.
[32] Levi 1964, 5.
[33] For example, Wilson (2007, 58, 64, 73; cf. Momigliano 2007*c*, 84) refers to red and black slipped wares which often have

light-on-dark decoration. We see these as having a wash. On the other hand, Wilson (2007, 54) does use the term 'wiped and/or washed ware', especially for our type 12 large jugs, and writes of 'an added wash of diluted red to dark brown paint or slip'. The 'wash' seems then to refer only to dilute solutions of pigment rather than, in our terms, any application of paint overall or covering a large area of the vessel — an effect that was probably achieved by immersing the vessel in a vat or other receptacle containing the coloured wash.

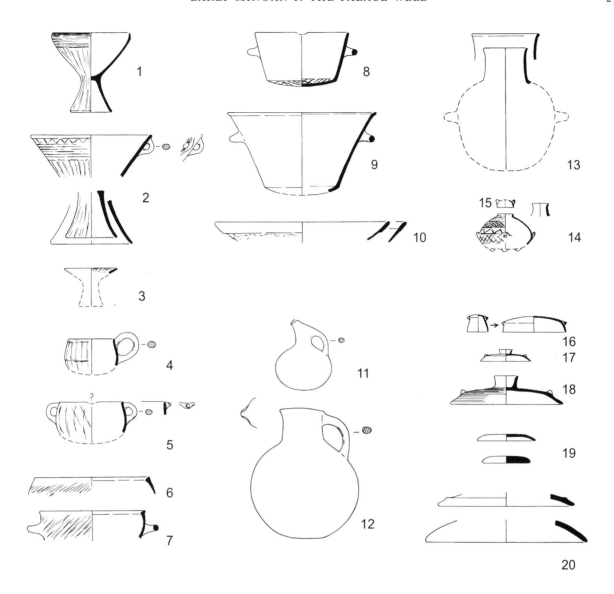

FIG. 3.3. Palace Well. EM I pottery types: type 1 chalices; type 2 pedestal bowls; type 3 small pedestal dishes; type 4 deep cups or bowls with incurving rim and single large vertical handle; type 5 bowls with incurving rim and one or more small vertical handles; type 6 bowls of coarse ware with wiped surface and incurving rim; type 7 bowls with rim thickened internally, and horizontal or vertical handles; type 8 deep bowls with horizontal handles and carinated base; type 9 large bowls with everted rims; type 10 baking plates; type 11 jugs with cutaway spout; type 12 jugs with globular body and pinched-in spout; type 13 collar-necked jars; type 14 suspension pots; type 15 suspension pot lids; type 16 flanged lids; type 17 cover lids with hollow cylindrical handle; type 18 large cover lid with hollow cylindrical handle; type 19 flat lids or plates; type 20 large flat lids or dishes with thick walls; type 21 large storage jars (pithoi).

the dark surfaced wares that became increasingly popular during EM II. There are even hints of the light-on-dark style decoration, with white paint on a dark surface, which is in evidence from the beginning of EM II and which, with the growth of the fashion for dark washed wares, largely supplanted dark-on-light decoration by the end of that period and in EM III.

Surface colour and finish seem to be matters of deliberate choice. Thus a dark grey or, more rarely, light brown or red surface decorated with pattern burnish is characteristic of the fine tableware chalices and pedestal bowls of types 1 and 2. Bowls of type 8 with pattern burnish normally appear to have light brown or reddish surfaces. Smaller bowls, with a wide variety of surface colour, may also have simple pattern burnish. A light slip with painted decoration in shades of red, brown or black is virtually confined to jugs with cutaway spouts of type 11.

SCORED WARE

Scored (or wiped) ware has received several names that all describe the same practice: scored ware; scored style; wiped ware, and wiped and/or washed ware; and brushed ware.[34]

The large water jugs of type 12, and some large bowls (types 6 and 7), had their surfaces wiped or scraped in a way that left fine scorings over them. In EM I at Knossos, and to a lesser extent in EM II, scoring (or wiping) of this kind seems to have been used on these larger vessels for decorative appeal. The direction of the scoring is controlled; on jugs of type 12 vertical strokes on the upper parts of the bodies contrast with horizontal strokes round the bottoms, while diagonal strokes are normal on bowls of types 6 and 7. The diagonal tendency of the scoring on these bowls might even be considered as an embryonic manifestation of that feeling for torsion or spiralling movement, which is such a striking feature of subsequent Minoan art.

Surfaces treated in this way were at home in many other parts of Crete during the earlier part of Early Minoan; they are variously described as wiped, brushed, combed, or scored.

Fragments of such scored ware from the Lera cave on Akrotiri assigned to EM I come from jugs or bowls with horizontal handles like those from the Well;[35] but this treatment of the surface is already attested at Knossos in FN when red 'wiped' ware became characteristic.[36] It continued to be used, in a conservative way, for the surfaces of bowls and jars of cooking pot fabric into later EM II (e.g. EM II types 11 and 18).

The Trapeza ware of Lasithi, which used to be assigned to LN in general and has recently been placed in (Knossian) FN IV,[37] 'often shows shallow scorings, as though from wiping while wet'.[38] A similar treatment of the surface is also usual on the standard class A Red ware of FN Phaistos.[39] Vagnetti draws a contrast between this scored ware from Phaistos and the heavily scored surfaces of comparable ware from Debla, where this type of scored ware is very much at home in phase I, on both jugs and bowls, and appears to have almost ceased in phase II.[40] The treatment of the surfaces of the type 12 jugs from the Well seems closer to that of the Phaistos Red ware than to that of the Debla scored ware.[41]

This may have a chronological significance. Wiped or scored wares are attested at other sites in central Crete besides Knossos,[42] but they do not seem much in evidence in eastern Crete;[43] in southern Crete they are reported from Phaistos, Ayia Triada and Ayia Kyriaki.[44] In western Crete, however, they appear common, notably in several caves.[45] Faure lists 12 on the northern slopes of the White Mountains,[46] to which one may add the Lera and Arkoudia caves on the Akrotiri peninsula.[47] Faure called this ware 'Subneolithic', but emphasised that it may in fact be contemporary with Early Minoan, and may even have continued in use in this part of Crete until the beginning of the period of the New Palaces. The evidence from Debla, however, shows that the ware was on the wane there by phase II. We should also note its appearance — perhaps at the western and offshore end of a string of sites on Crete[48] — on Kythera in deposit α at Kastraki (next to Kastri and part of the same occupation nexus)[49] in the Orange Micaceous fabric, produced most likely in the north of that island and dated to EB II by Broodbank and Kiriatzi. They recognise, however, that most parallels in Crete are dated to EM I, although they suggest the possibility that the practice continued into EM IIA, to judge from likely evidence from Nopigeia.[50]

[34] Betancourt 2008b, 64; Tomkins 2007, 46; Wilson 2007, 64 (recognising two fabrics: 'fine reddish brown with a reduced core and fine orange buff').
[35] Guest-Papamanoli and Lambraki 1976, 201.
[36] Furness 1953, 95, 126–8; cf. J. D. Evans 1964, 225; Tomkins 2007, 39, who notes 'pattern wiping on coarse vessels' in Stratum IIA of FN III and (46) in FN IV, and also 'EM I early' (FF4); Wilson 2007, 54–5.
[37] Tomkins 2007, 20, table 1.6.
[38] H. W. Pendlebury et al., 1936, 28, where comparison is made with LN and 'SN' sherds from Knossos.
[39] Vagnetti 1973b, 5; Vagnetti and Belli 1978, 151.
[40] Warren and Tzedakis 1974, 321, 323–4, 338–9.
[41] Warren and Tzedakis 1974, pls. 52d, 53a–c.
[42] E.g. Kyparissi: Alexiou 1951, 278–9, pls. 13.1: 1.5–7, 13.2: 1; 282–5; and the Eileithyia cave at Amnisos, where Betancourt et al. (2000, 202–03, 205, fig. 14: 62–3 (jugs), 64 (jar)) call it combed, suggesting that it was made with a comb or bunch of pointed reeds; cf. also 204–05, fig. 14: 67 and perhaps 68 (jar sherds): 67 has punctuated decoration made with a comb, and 68 seems similar.

[43] Betancourt 1985, 31.
[44] Phaistos: Todaro 2005, 36–7 (and assigned to EM IA); Ayia Triada: Todaro 2003, 75; 2005, 21. Ayia Kyriaki: Blackman and Branigan 1982, 27, 37, table 1: wiped ware. A light grey ware suspension pot from Koumasa, cited by Alexiou (1951, 285, n. 10), has entirely different combing: 'innumerable impressed dots set very close together in irregular lines' (Xanthoudides 1924, 35, pl. 25: 4294; Betancourt 1985, pl. 3 J). Wilson and Day call this 'comb-pricked decoration', listing this (1994, 14: FG 68) and other vessels with this decoration from Koumasa (1994, 14–15: FG 66, FG 71) and Gournia (1994, 17: FG 89).
[45] Warren and Tzedakis 1974, 324.
[46] Faure 1969, 201, n. 2.
[47] Guest-Papamanoli and Lambraki 1976, 198–202, 211, 238.
[48] Guest-Papamanoli and Lambraki (1976, 201) suggest that these are probably Cretan imports.
[49] Coldstream and Huxley 1972, 80, pl. 16: 41–6, 51.
[50] Broodbank and Kiriatzi 2007 (an important reassessment of Kastri/Kastraki deposits α and β, dating α to a span from FN through EB I to advanced EB II), 250–1, n. 62 and n. 66. Nopigeia: Andreadaki-Vlazaki 1996, 19; Karantzali 1996, 90, fig. 95.

The upper part of a large jug from the Platyvola cave with bold scoring (described as combing) of the surface of the type illustrated from Debla has been assigned to EM II;[51] it appears to have been not unlike the jugs of type 12 from the Well in shape, but the handle is set to the neck well below the rim, which may be a late feature, on the analogy of the change of position in jug handles from rim to neck which began in the Northeast Aegean in the horizon of Troy I and was more pronounced in that of Troy II.[52] Some of the scored ware from western Crete, however, to judge from descriptions and illustrations, appears to be more comparable with that of the jugs and bowls from the Well.[53] A fragment from Chania–Kastelli[54] also appears to have relatively fine scoring closer to that of the Well or Phaistos FN than to Debla.

How was the scoring of the surface done? Possible instruments may have been a bunch of twigs, or rough cloth, stiff brush or potter's comb. Blackman and Branigan suggested wiping with cloth or grass,[55] and Alexiou use of a comb or brush.[56] Guest-Papamanoli thought a brush unlikely, preferring a potter's comb, made perhaps of schist, with irregular shallow teeth.[57] For Debla Warren suggested that it was done 'possibly with the firm spiky ends of a bunch of straws or with firm brushwood or with a bone or obsidian point'.[58] A stiff coarse brush, used while the clay was still damp and soft, seems as likely as anything to have produced the wiping and scoring on the jugs and bowls from the Well.

Outside Crete, wiped, combed or scored surfaces of this kind are found on vessels of local manufacture in other parts of the Aegean besides Kythera at about this time, for instance at LN Kephala on Kea;[59] and scoring is still in evidence on some pottery of EC II/EH II from Ayia Irini on that island.[60]

On the Greek mainland scored surfaces appear on local wares at the beginning of EB, from the Peloponnese to Thessaly and Macedonia.[61] The fashion for treating the surfaces of vessels in this way may have spread to the Aegean from the east, and could reflect the imitation of imported container vessels in the first instance. It is found, of course, on the imported Scored Ware of Troy, which was most at home in Middle and Late Troy I, but occurred, although not abundantly, in early levels of Troy II.[62] The Obsidian ware of Emporio in Chios may be the same as Trojan Scored ware and was certainly exotic there:[63] it occurred in small quantities in levels of (pre-Troy) periods VII and VI, which may overlap with Kephala on Kea, as well as from levels of periods V–IV and II contemporary with Troy I and perhaps the early part of Troy II. The fragment of another import (not Obsidian ware) from an Emporio VI deposit has the surface scored in a manner very reminiscent of the jugs from the Well;[64] it may even come from a jug, although perhaps not a Cretan one, since no (other) Minoan imports were recognised at Emporio. The *ceramica striata* occurring at Poliochni in Blue levels, and abundant in Green and Red levels, also appears comparable with Trojan Scored Ware.[65] The fragments of this come apparently from large globular jars with a variety of rims and a pair of wide strap handles on the belly. Trojan Scored Ware vessels may have been of a similar type.[66]

Blegen thought that Scored Ware found its way to Troy from somewhere in the Aegean.[67] French reported similar sherds from other third millennium sites in NW Turkey,[68] and indicated that such large vessels might have been of local manufacture; but their size would not militate against their being imports if they had served as containers for a foreign liquid substance, like the Palestinian jars which reached the Aegean later in the Bronze Age. Mellaart noted a coarse scored ware as characteristic of the early phase of EB in the Konya plain,[69] and suggested that Trojan Scored Ware might be related to it: the shapes seem to be mostly large vessels with funnel necks and ledge handles. Scored ware is attested as early as the Late Chalcolithic (Can Hasan level 1) in the Konya region, and in EB I and II in Cilicia.[70] Some pottery from EB I Tarsus[71] has the surface treated in a way that is very reminiscent of EM I scored ware at Knossos.

[51] Alexiou 1964, 446, pl. 523α.
[52] Hood 1981, 188.
[53] E.g. Lera: Guest-Papamanoli and Lambraki 1976, 198–202, fig. 6, pl. 42: S14b; Perivolia: Tzedakis 1968a, pl. 135α: this fragment of a jug with a circular-sectioned handle seems to have had the surface wiped in the same way as the jugs from the Well.
[54] Tzedakis 1965, 568, pl. 711δ.
[55] Blackman and Branigan 1982, 27.
[56] Alexiou 1951, 278.
[57] Guest-Papamanoli and Lambraki 1976, 200.
[58] Warren and Tzedakis 1974, 323.
[59] Coleman 1977, 10, pls. 81 A, 91 E–G, J.
[60] Wilson 1999, 32, pl. 48: II-126–7 (late EB II 'deep bowls/open jars'). These two rims recall the more or less contemporary ones of our EM II type 18.
[61] Blegen et al. 1950, 54; also, Lerna (in EH II contexts): Wiencke 2000, 97, 408–09, fig. II.33, pl. 10: P609 (also pp. 563–4); 142, 436–7, fig. II.45, pl. 13: P789; Athens, Grotto above

the Asklipieion: Levi 1931, 473, fig. 54a, c–d; Eutresis: Goldman 1931, 90, fig. 112:1; Vardaroftsa (Axiochori): Heurtley 1939, 83, 181, fig. 53; Saratsi: Heurtley 1939, 185: 265. Holmberg (1944, 79) notes that on some EH (but not Neolithic) coarse ware from Asea one can 'observe numerous marks of fingers or of a rag with which the vessel has been wiped while the clay was still wet'.
[62] Blegen et al. 1950, 39, 53–4, 222.
[63] Hood 1981, 358.
[64] Hood 1981, 350, pl. 56: 814.
[65] Bernabò-Brea 1964, 582–3, pls. 78–9.
[66] Blegen et al. 1950, 53–4.
[67] Blegen et al. 1950, 53.
[68] French 1961, 120.
[69] Mellaart 1954, 196, 218, fig. 159.
[70] Hood 1981, 358. Mellaart 1963, 224–6, fig. 13; French 1964, 126, 132–3, figs. 7: 2, 8; 8: 4, 8; 1965, 185, 192, fig. 8: 12, 14; 194–5, figs. 10: 8; 11: 23–4.
[71] Goldman 1956, 102: 125; 103, pl. 243: 137.

The combed ware that flourished in Palestine Proto-Urban (Pre-Urban) and throughout the early part of the Bronze Age also appears comparable to our scored ware in surface treatment;[72] but the earlier (Proto-Urban) varieties, with irregular combing, seem more akin to the scored wares of Anatolia and the Aegean than to those of Knossos. Similar combing is also attested on vessels from the EB I horizon at Ras Shamra.[73] In Palestine combing of the surface to form deliberate patterns became common from EB I onwards. Two-handled jars with pattern combing of this kind, but of shapes comparable to those suggested by the fragments of scored ware found at Poliochni, were being exported as containers from Palestine to Egypt during EB III contemporary with the Old Kingdom;[74] and fragments of jars with similar pattern combing are also found in Syrian EB III.[75]

Somewhat different are some large bowls or open jars of coarse fabric with thick walls from the Well have deep lattice scoring (or gouging) on their insides: PLATES 6: **53**, 17: **158**. Scoring of this type, which is found on the insides of tubs and other large open vessels in Crete from EM II onwards, was evidently not decorative; signs of wear on the inside surface of **158** suggests that the fragments from the Well with scoring of this kind belonged to vessels used perhaps for grinding. For this and other possible uses, including as beehives for honey, see below (p. 59 and n. 288).

LIGHT GREY WARE

Rim **109** which appears to have belonged to a suspension pot is indistinguishable in fabric from the light grey ware so well known in EM IIA. It occurs, however, occasionally in other EM I contexts at Knossos.[76] For more on this ware, see pp. 247–52.

SHAPES

The pottery is fragmentary except for the small water jug **89** of type 12 from deposit 1 at the bottom of the Well. Although very few complete profiles could be restored, we could establish the shapes and the range of types represented by the fragments with a fair degree of accuracy. Thus, FIG. 3.3 gives a reasonable idea of the range of pottery used domestically at Knossos in EM I. The vessels tend to be large, although a few small, almost miniature pieces occur, like juglet **95**. The two commonest shapes in fine pattern burnish ware are the chalice (type 1) and the large pedestal bowl (type 2) which were, perhaps, the standard drinking cup and food vessel at the time.

Chalices of type 1 were rare, if not entirely unknown, in the Neolithic. It is perhaps significant that no chalice was recognised in the abundant FN pottery of Phaistos. At the same time fragments of tall pedestals of rather different shapes were identified by Furness in deposits of all phases of Neolithic from Evans's excavations at Knossos.[77] Some of these fragments may be rims of bowls, as she noted; but the diameters, if correctly estimated, and the poverty of the burnish on the insides of the pieces, are consistent with the idea that most of them at any rate come from pedestals. The bell-shaped pedestals that Furness assigns to EN I onwards are paralleled on Saliagos, and in the Halafian of the Levant.[78]

The chalices of type 1 may be ancestors at a long remove of the eggcup footed goblets of EM II and III and MM I (FIG. 5.1: 2); and Evans noted how the 'numerous cups with low pedestals' of EM II 'fit on to an E. M. I type'.[79] The possibility of a derivation of the clay footed goblet from small metal cups of the same size and shape introduced for wine drinking is discussed below (p. 103).[80]

Some type 1 chalices and some of the pedestal bowls of type 2 may have been provided with lids (types 17 and 18), as suggested in FIG. 3.8A.

A large handled bowl or cup (type 4) seems to occur, but is distinctly rare, as is its EM II successor, the cup with an exaggerated handle.

Bowls of types 5–9 may be decorated with pattern burnish or have their surfaces wiped. The bases of these bowls are often differentiated by a carination; but bases, whether carinated or not, are almost always rounded.

[72] Hennessy 1967, 31–2, 72–3.
[73] Schaeffer 1962, 452, fig. 41C; 472–3.
[74] Hennessy 1967, 72.
[75] Schaeffer 1962, 428–9, figs. 16, 18; cf. Hennessy 1967, 72–3, pl. 60.
[76] Wilson 2007, 56; Wilson and Day 1994 (esp. 7–11 and fig. 1: FG21, FG22, FG42, FG48 = **109**), suggesting that these pieces are imports from the Mesara.
[77] Furness 1953, 130, fig. 15: 7–13; 133–4. Cf. Tomkins 2007, 33–4, fig. 1.9: 15 (Stratum IIIA: FN IB); 36–7, fig. 1.10: 27

(Stratum IIB: FN II), usually with a fenestrated pedestal.
[78] Furness 1953, 130, fig. 15: 10, 134; Hood 1984, 27.
[79] PM I, 74; cf. H. W. Pendlebury et al. 1936, 59; Warren 1972a, 103, 157, fig. 41: P39–42, with examples of stems from Fournou Korifi I (EM IIA) intermediary between the pedestals of EM I chalices and typical EM II goblet feet.
[80] For the change from EM I chalice to EM II footed goblet, see Day and Wilson 2004, esp. 48, and 53 and 58 for the influence of metal prototypes on the late EM IIA products.

Early forms of the so-called baking plates, which become a characteristic shape of every period from EM II to LM IIIC and SM, occur already in the Well (type 10).

Jugs have pinched-in mouths (type 12) or cutaway spouts (type 11). The large water jugs from the bottom of the Well have pinched-in mouths, and large jugs in general appear to be of this type 12; but small and medium sized jugs with painted decoration (type 11) normally have cutaway spouts.

The two suspension pots (type 14) of which large fragments were recovered are both of fine pattern burnish ware. Little lids of type 15 evidently belonged to suspension pots like these.

No fragments of cylindrical pyxides were noted from the Well. Examples from Ayia Fotia (Siteia), where they have been called 'spool pyxides', belong to the Cycladic school/style of potting found there and at sites on or near the coast in north-central Crete.[81] They may now even validate the old, but disputed date in EM I for the example with incised decoration from the Patema ossuary at Palaikastro.[82]

Store jars with collar necks and apparently globular bodies (type 13), and large thick-walled pithoi, were evidently in use at the time of the Palace Well. Other EM I pithoi are now known from Knossos, Kalo Chorio and Aphrodite's Kephali.[83] The vessels grouped together under type 19, if they were not plates or dishes or vessel stands, may have served as lids for pithoi and store jars.

Open trough-like spouts, common in every subsequent Minoan period, are found on bowls, and there is one nozzle spout. Bases of small vessels, such as suspension pots of type 14, may have little lug-like pellet feet (e.g. **154**) of a kind that continued to occur in EM II and into MM I.

Handles are normally circular or thick oval in section. There is no example of a pushed-through handle of the type that has been regarded as characteristic for the Aegean EBA, although sporadic examples of such handles are found from later periods in Crete,[84] including one from the early EM IIA WCH.[85]

Feet of tripod cooking pots, which appear in EM II and are common in all subsequent Minoan periods, are conspicuously absent from the Palace Well. While we used to believe that tripod cooking pots were not used at Knossos, nor probably in Crete as a whole, in EM I, implying a significant change in ways of cooking when they did arrive in EM II,[86] we now know of examples from Ayia Fotia (Siteia);[87] but the floruit of that cemetery, if principally late EM I, seems to have continued into EM II (see below p. 116).

TYPE 1. CHALICES **1–6**

Chalices are very common.[88] The rims are normally incurving in contrast to the straight or slightly outcurving rims of the larger pedestal bowls of type 2. The rim diameter is large, from about 16 to 30, but in most cases between 18 and 22. Only two complete profiles are preserved to show the height: **1** is 22 high with a rim diameter of 22–24, **2** 18.5 high with a diameter of 20. The rims tend to be rather pointed, but not unduly thickened. Lids of type 17 of similar fabric to our chalices may have been used with them, as we suggest in FIG. 3.8A.

A chalice comparable to those from the Well in shape and size came from the upper level β[89] of what Tomkins calls House K below the Central Court of the Palace, assigning the material to his Stratum IB of EM I.[90] Evans had placed it at the very end of Neolithic, and Mackenzie in 'Sub-Neolithic' (i.e. EM I).[91] Evans noted finding 'other fragmentary specimens' of this type 'in a similar medium' beneath the pavement on the N border of the Central Court in 1913.[92] Fragments of similar chalices, however, which he had previously illustrated as 'Sub-Neolithic',[93] were described as Late Neolithic.[94]

[81] E.g. Ayia Fotia: Davaras and Betancourt 2004, 9–10, fig. 9: 2A.19+38; 11, fig. 11: 3.18+19; 112, fig. 268: 125.4+11 (and cf. Betancourt 2008b, 78, fig. 5.46); Gournes: Galanaki 2006, 230, 239, pl. 4: 2ε (also β and στ).

[82] Bosanquet and Dawkins 1923, 5, fig. 2; cf. Bosanquet et al. 1903, 351; Dawkins et al. 1905, 270, fig. 4: 5. MacGillivray (1984, 73, 76–7, n. 5) at one time thought it might be an EC IIIB import, but later referred it to a class of cylindrical pyxides with burnished surfaces, such as those in the Vat Room Deposit (Momigliano 1991, 171, 175, pls. 23, 26: 50–5), now placed in MM IB (MacGillivray 2007, 107–08). Clay analysis suggests that the Knossian examples are likely to have been made in Crete (MacGillivray et al. 1988, calling it 'Dark-faced Incised Ware').

The idea that the cylindrical pyxis developed first in the Cyclades during the Grotta-Pelos phase of EC I (Doumas 1977, 16; Broodbank 2000, 168–9, fig. 49a; cf. also Momigliano 1991, 171) is supported by the Cycladic-style finds from Ayia Fotia and other north coast sites. See Betancourt 2008b; also Day et al. 1998, 137.

[83] Knossos: Wilson and Day 2000, 48–50 (and fig. 8, pl. 13) P268–75; Kalo Chorio: Haggis 1996, 670–1, fig. 32, 675: KT

117–18; Aphrodite's Kephali: Betancourt 2008a; 2008b, 78–82, figs. 5.47–5.50; 106–08; 2010. Cf. also Christakis 2005, 74; Betancourt 2008b, 40.

[84] Cf. Hood 1981, 216.

[85] Wilson 1985, 317: P158.

[86] Cf. Cadogan 1986, 155.

[87] E.g. Betancourt 2008b, 34–6, fig. 4.1; 69–71, fig. 5.32 (Davaras and Betancourt 2004, 24–5, fig. 42: 17.20).

[88] Betancourt (2008b, 56–60) gives a new review of these chalices and their origins. See too Haggis 1997; Wilson and Day 2000, 27–30; Wilson 2007, 54.

[89] PM II, 10–12, fig. 4.

[90] Stratum IB: Tomkins 2007, 13, table 1.2; 16–17, table 1.3, 42, 45, dating 'the built features' of the stratum to EM I.

[91] For their differing views, see Hood 2006. Cf. too Tomkins 2007, 14.

[92] PM II, 12, n. 1.

[93] Evans 1904, 24, fig. 8b–c; PM I, 58, fig. 17.

[94] PM II, 12. See also Hood 2006.

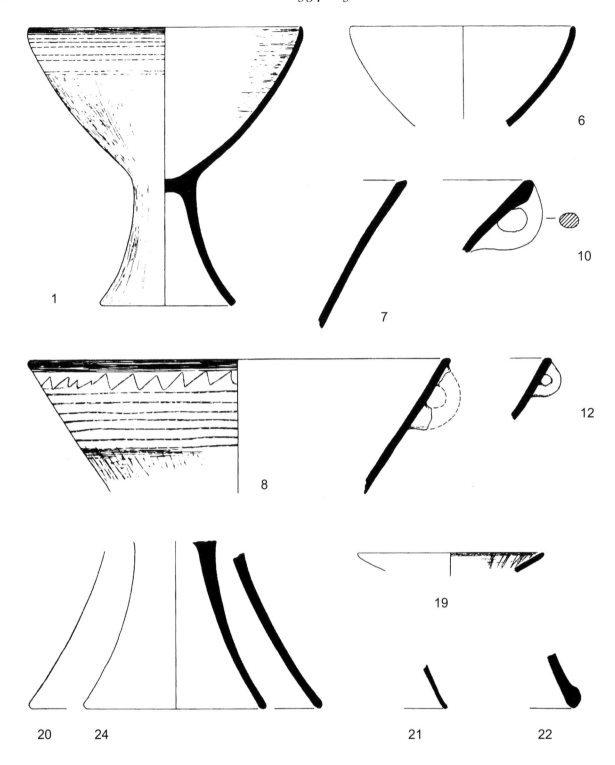

FIG. 3.4. Palace Well (EM I). Type 1 chalices **1**, **6**; type 2 pedestal bowls **7–8**, **10**, **12**; type 3 pedestal (?) dish **19**; pedestals **20–22**, **24**. Scale 1:3.

There is no indication that the chalices of type 1 from the Well or similar vessels from other contexts at Knossos had lugs or handles of any kind. The absence of lugs or handles distinguishes our type 1 chalices from the larger pedestal bowls of type 2. It also distinguishes them from the chalices at Pyrgos which, in other respects including size, appear to correspond to our type 1 rather than type 2. The shapes of these Pyrgos chalices appear more sophisticated, and their stems are thinner at the top at the junction with the bowl; in compensation perhaps for this, the top of the stem just below the bowl is often strengthened with a ring or bulb. Such a ring or bulb at the junction of the stem and the bowl

we took originally to suggest that they are later in EM I, and even a hallmark of 'EM IB'. The use of grooved decoration in place of, or in combination with, pattern burnish (as seen on several of the Pyrgos chalices) also appeared to be a relatively late feature.

There is no hint of a ring or bulb on any of the chalices or pedestal bowls of types 1 and 2 from the Well. At the same time there is not a great deal of evidence for pedestals with rings or bulbs in the material from the old excavations at Knossos (cf. pp. 282, 289). Evans published a high-footed goblet with a marked ring around the waist,[95] coming from the lower level α in the Central Court which he assigned to LN, and Tomkins places in FN IV:[96] it has incised decoration and is relatively small (only 7–8 high to judge from the scale). Evans's drawing is a restoration but, if correct, would certainly justify his comparison with Egyptian Early Dynastic copper goblets of the same size and shape;[97] and Xanthoudides thought that these chalices might be imitations of metal prototypes.[98] The closest among the chalices illustrated from Pyrgos to those from the Well in shape is only 15 high and has pattern burnish; the handles below the rim on this resemble the handles on the large pedestal bowls of type 2 from the Well.[99] Evans observed that the fine texture of the Pyrgos chalices also suggested 'metallic influences, which towards the close of this Period may certainly be taken into account'.[100]

A chalice from Malia somewhat resembles those from the Well in shape and size (Ht rest. 18.5) and, like them, has no lugs or handles; but the straight narrow stem is more reminiscent of stems assigned to EM IIA, and there is no pattern burnish decoration. Its associations seem relatively late.[101]

A chalice comparable in shape to the Malia one but smaller (Ht 15) from Vasiliki must also be EM IIA.[102] Evans set it in the same horizon as the chalices from Pyrgos,[103] but it corresponds to a type of chalice in dark grey burnished ware represented by fragments from the WCH, where they are grouped under goblets.[104] Renfrew, noting that this Vasiliki (not Gournia!) chalice should be placed at the beginning of EM II, observes that it differs from the Pyrgos chalices, and cites parallels from the Cyclades.[105] This, however, and other vessels which are like it in shape and come from the same horizon in the Cyclades, are of a rather different type, with bowls that are relatively wide and shallow compared with those of EM chalices.[106]

The only fragment of a chalice from Debla comes from phase I and could have belonged to a vessel like those from the Well.[107] There are other hints that chalices and pedestal bowls were at home in parts of western Crete in EM I. A rim from one of four chalices in the Lera cave has pattern burnish decoration of a zigzag above parallel lines, exactly like a motif standard on fragments from the Well;[108] and a goblet from the Platyvola cave appears to have pattern burnish inside and outside the bowl.[109]

In southern Crete chalices and pedestal bowls appear at home at Phaistos in the horizon(s) immediately after the end of FN there, with swellings at the tops of stems and grooved decoration. Todaro suggests that pedestal bowls in dark grey burnished ware appeared in what she defines as EM IA and pattern burnished chalices in her EM IB.[110] Her EM IA examples include a tall foot/pedestal with painted horizontal red lines on the foot over burnishing.[111] Similarly, chalices were not uncommon it seems at Ayia Kyriaki: fragments in various fabrics include plain, dark burnished, grey burnished and red slipped and burnished wares, besides pattern burnished ware; but the illustrations suggest that they all had a rib around the waist.[112] No chalices of any kind, however, were preserved enough in the early deposit of Lebena T. II to be catalogued, although there were five pedestal bases among loose sherds, which may include chalices,[113] albeit very few when compared to the rest of the pottery. None seems to have been recorded from any of the Mesara tombs.

[95] *PM* II, 10–11, fig. 3 m. Note too the grooved chalice pedestals in the SMK from K.II.1 921–2 (Wilson and Day 2000, 29–30, fig. 1: P22–4; for find spot, see below p. 242, FIG. 10.1: 34), where the grooving results in a rib-like appearance.
[96] House J (Stratum IC: FN IV): Tomkins 2007, 14, 16–17, table 1.3; 42.
[97] *PM* II, 12, n. 4.
[98] Xanthoudides 1918a, 155, fig. 11: 82; 157, 159, noting that its crinkly rim seems especially metallic; Betancourt 2008b, 60, fig. 5.17.
[99] Xanthoudides 1918a, 151, fig. 9: 57; 158.
[100] *PM* I, 59.
[101] Van Effenterre and Van Effenterre 1963, 71, pl. 29: 7795.
[102] Seager 1905, 212, fig. 2; Boyd Hawes *et al.* 1908, 50, pl. 12: 12.
[103] *PM* I, 59, n. 4, fig. 19A–B.
[104] Wilson 1985, 301: P37–41; cf. Malia: Van Effenterre 1980, 29, fig. 41; Mochlos: Seager 1909, 279, fig. 2 left.

[105] Renfrew 1964, 124, citing e.g. Tsountas 1898, 174, pl. 9: 15 (Zervos 1957, pl. 78) from the settlement at Pyrgos on Paros.
[106] E.g. Delos: MacGillivray 1980, 15–16, fig. 4: 417; Syros: Tsountas 1899, pls. 8: 6; 9: 16.
[107] Warren and Tzedakis 1974, 322–3, fig. 18: P5.
[108] Guest-Papamanoli and Lambraki 1976, 202–03, fig. 7, pl. 42: D1; cf. **1182** (FIG. 10.2, PLATE 53) for pattern burnishing inside and out.
[109] Tzedakis 1968b, 416, pl. 376δ–ε.
[110] Todaro 2005, 37–8, 44; cf. Levi 1976, 182, fig. 276; 293, fig. 456, pls. 6e–h, 12a–f, 13a–c, 14; Pernier 1935, 118, fig. 50.
[111] Todaro 2005, 37, discussing La Rosa 2002, 488, 804, fig. 492.
[112] Blackman and Branigan 1982, 22–3, fig. 7: E18–20; 30, fig. 10: 56; 39, fig. 14. 1. Note that red slipped and burnished ware was christened 'Salame' ware (p. 29).
[113] Alexiou and Warren 2004, 115 and fig. 32.

In north-central Crete, a fragmentary chalice from Kyparissi has a ringless stem, but the one complete example has, like ones at Pyrgos, a ring at the junction of the bowl and stem.[114] Fragments of other chalices have ribbed or grooved decoration.[115] Chalices at Krasi appear to have been like those from Pyrgos, and were found in a stratigraphically early context.[116]

In eastern Crete, the Ayia Fotia cemetery near Siteia has produced pedestal bowls as well as chalices.[117] Many of these have swellings at the junction of the pedestal and the bowl and form an important part of the Cycladic style there.[118] 'Minoan' chalices without such swellings, but with a perforated lug below the rim, come from T. 134 and T. 226.[119]

Fabric

The vessels are well and evenly made. The insides of the pedestals, which are not smoothed or burnished, often show the horizontal fingermarks of the potter; and these are so regular that on small fragments they could be taken for the marks of the fast wheel. Hazzidakis thought that the bowl of a chalice from Arkalochori showed the marks of the wheel, although still in a primitive state:[120] there would appear to be no question of the fast wheel, however, in Crete in this early period. The clay is fine. Exposed surfaces are occasionally light grey, but normally dark grey in colour, verging to black in the burnished parts: in a number of cases light brown, more rarely shades of dark brown, once or twice red-brown, but not it seems true red. The surface of a vessel can vary in colour, ranging through shades of light and dark brown with dusky patches; but some of these variations were evidently caused by unequal exposure to fire of pieces of a vessel after it had broken. Of the three joining rim fragments of **3**, one is dark grey, another dark brown, and the third light brown (PLATE 3). The chalice from which these came may have originally had a dark grey surface, like PLATE 3: **3A**.

The insides of the bowls of the chalices are more or less well burnished all over. The outsides are burnished for decorative effect: a band of solid burnish around the rim above a reserved zone with thin horizontal stripes of pattern burnish, normally five or six, but sometimes as many as seven or eight. The lower parts of the bowls and the stems are burnished with vertical strokes, sometimes to give an overall burnish, but usually with gaps between the strokes leaving reserved strips, it seems as a deliberate decorative effect, e.g. PLATE 3: **21**.

On rim **4** with a light brown surface the wide burnishing strokes have their edges furred (PLATE 3). The effect, which is similar to that of MM III tortoiseshell ripple, appears deliberate, created perhaps by burnishing the surface while the clay was wet or, less probably, by scraping it to make reserved strips after it had been burnished.

Rim **5**[121] (D. *c.* 17) which may have belonged to a chalice is exceptional (PLATE 3). In fabric and finish it resembles the bowls of type 4 (below). The inside is wiped, while the light and reddish brown to dusky outside, is well smoothed with vertical strokes of pattern burnish as found on bowls of types 4 and 5.

Another unique rim **6** (D. 18) (FIG. 3.4, PLATE 17), which may have belonged to a chalice, is of coarse fabric: the surface is shades of brown, wiped inside and out.

1 FIG. 3.4, PLATE 2. Most of rim and body missing. Ht 22. D. 22–24. Surface shades of light and dark brown verging to black, mottling to red in one area. Inside of bowl burnished, outside with horizontal stripes of pattern burnish below rim; rest of body and foot burnished with vertical strokes; inside of foot unburnished. Level 16 etc.

A chalice from FF4 (Wilson 1985, 361–2, fig. 42: FF1) is virtually identical in shape, size, fabric and decoration.

2 PLATE 3. Shape as **1**. Nearly 2/3 rim and base missing. Ht 18.5. D. 20. Light brown clay with surface light brown shading to light grey and reddish in places. Inside of bowl burnished, outside with horizontal stripes of pattern burnish; rest of body and foot burnished with vertical strokes; inside of foot unburnished. Levels 7, 8, 10 etc.

[114] Alexiou 1951, 280–1. pls. 14.1: 5, 14.2: 7.
[115] Alexiou 1951, 285, pl. 14.2: 12, 15.
[116] Marinatos 1929*b*, 114, 116, pl. 4: 12–13.
[117] Davaras and Betancourt 2004, 14–15, fig. 19: 7.19c; 72, fig. 161: 72.5; 84–5, fig. 194: 89.1; 92–3, fig, 216: 99.3; 96, fig. 226: 103.1; 151–2, fig. 365: 166.12 (Betancourt 2008*b*, 75, fig. 5.38); 163–4, fig. 400: 181.11+12 (without a swelling); fig. 419: 189.9; 189, fig. 467: 209.1; 202–3, fig. 499: 221.6; 229–30, fig. 568: 263.4. These pedestal bowls are all in 'Cycladic marble-tempered pottery', and called 'chalices'.

[118] Betancourt 2008*b*, 74–5.
[119] Davaras and Betancourt 2004, 118–19, fig. 286: 134.5 (Davaras n.d., fig. 2; Betancourt 2008*b*, 57–8, figs. 5.13 right, 5.14E); 207–8, fig. 512: 226.8 (Betancourt 2008*b*, 57, fig. 5.13 left); also 207: 226.14 (not illustrated). Also from Ayia Fotia is a Minoan chalice with a round section handle: Davaras and Betancourt 2004, 185–6, fig. 457: 203.4 (Betancourt 2008*b*, fig. 5.14F).
[120] Hazzidakis 1913, 40, fig. 5.
[121] Wilson and Day sample KN 92/4.

TYPE 2. LARGE PEDESTAL BOWLS 7–18

There are many fragments of these bowls, which were clearly a standard type in EM I culinary/consuming practices.[122] No fragments, however, have been identified in FF4.[123] They evidently have pedestals like the chalices of type 1; but unfortunately no pedestal would join a bowl, and no complete profile was recovered: the total heights of this type cannot therefore be estimated. Rims range in diameter from about 28 to 40 with some, it would seem, as much as 50 or more. A good many of the rims seem to have a diameter of *c.* 35.

The rims of these large pedestal bowls are normally straight or slightly outcurving in contrast to the incurving rims characteristic of the chalices of type 1. The tops of the rims are in general simple, being (a) rounded, or (b) flattened, like **7** (FIG. 3.4; D. 22),[124] or sometimes (c) slightly thickened and everted, like **8**. One or two large rims, which may be from vessels of this type, have (d) a wide rib round the outside, like **9** (PLATE 4)[125] and **10** (FIG. 3.4; D. 30). **10** is of unusually coarse fabric, more like that of the thick-walled dishes of types 6 and 7; its surface is reddish, wiped inside and outside instead of being burnished.

Small vertical round section handles set just below the rim appear to have been common, and may have been the rule, on bowls of this type, like **11** (PLATE 4). Some handles are very small and approximate to horizontally perforated lugs, like **12** (FIG. 3.4, PLATE 4; D. 30). It looks as if each bowl had only one handle, like **11** and **13–13A** (PLATE 4), or a pair of handles set close together, like **14** (PLATE 4), rather than handles set on opposite sides of the rim.

Rim **15** (PLATE 4)[126] has a pair of string-holes, and three other fragments preserve a single hole just below the rim, including PLATE 4: **16–17**. These are probably for rivets for mending the vessels, since in every case they appear to flank an old break:[127] large vessels of fine ware like this were no doubt difficult to make and prized. Their superior fabric and the degree of standardisation in shape and decoration suggest that they, like the chalices of type 1, may have been the work of specialist potters, and not manufactured by each family as it had occasion.[128]

In fabric and finish the pedestal bowls of type 2 resemble the chalices of type 1 but, in view of their larger size, the fabric is apt to be somewhat coarser. On the outside they are decorated with pattern burnish on a similar system to the chalices of type 1. Some, like the chalices, have a zone of horizontal stripes of pattern burnish below the rim, but there are usually about 10 stripes instead of the five or six normal on the chalices. Bowls of type 2, however, are often adorned with a characteristic wavy band of pattern burnish immediately below the burnished section of rim, between it and the zone of horizontal stripes, as on **8**, **14–15** and **17–18** (PLATES 4–5).

Large pedestal bowls of this kind do not appear much in evidence after the Palace Well.[129] Some fragments of rims with handles and simple vertical pattern burnish from a sounding on the W side of the Central Court at Phaistos look quite similar.[130] These are illustrated alongside FN material that was apparently found with them.

8 FIG. 3.4, PLATE 4. 1/2 rim and stump of handle pres. Ht pres. 11. D. 34. Orange clay with reddish brown to light brown surface, well burnished inside; the outside with pattern burnish. Levels 3, 15, 16, 19, etc.

TYPE 3. SMALL (PEDESTAL?) DISH 19

Two rim scraps of fine grey-brown burnished ware resemble one with an indication of what appears to be a flat base from FF4.[131] No evidence for the existence of flat bases was noted from the Well, however; and two small shallow dishes from the deposit below Mochlos T. V usually assigned to EM I have pedestals.[132] It is possible then that our rims come from vessels of this type rather than from flat-bottomed dishes.

[122] Wilson and Day (2000, 59–60) suggest that they would have been parts of sets with the chalices, and may have been like kraters for mixing drink rather than for more solid food. See also Wilson 2007, 54.

[123] Wilson 1985, 364. For other EM I examples from Knossos, see Wilson and Day 2000, 30–1, fig. 2, pl. 2: P32–33; pl. 2: P34–37.

[124] Wilson and Day sample KN 92/5.

[125] Wilson and Day sample KN 92/7.

[126] Wilson and Day sample KN 92/6.

[127] Cf. Hood 1981, 216.

[128] For the role of EM I potters, cf. Betancourt 2008b, esp. 108–10.

[129] Contrast Wilson 2007, 52–4, figs. 2.2: 1–2, 2.3: 1 (EM I) with (EM IIA Early) 58–9, table 2.3, and fig. 2.6: 4, and (in light grey ware) 61, 63, fig. 2.9: 20. Cf. too Wilson 1985, 364: 'very rare by the time of the West Court House'.

[130] Levi 1958a, 187, fig. 368. Cf. Todaro 2005, 36–7, 44 (assigning pattern burnish to EM IB); and forthcoming (and see below p. 282); Wilson 2007, 56, table 2.2.

[131] Wilson 1985, 361–2, fig. 42: FF6.

[132] Seager 1912, 93, fig. 48: 32–3.

19 FIG. 3.4, PLATE 3. Rim. D. 15. Fine fabric. Grey-brown clay with surface the same colour; underside well burnished; upper inside decorated with pattern burnish.

PEDESTALS **20–27**

Fragments of these are extremely common. Their diameter at the base ranges from *c.* 9 to 25, e.g. **20**. Most of the smaller pedestals no doubt belong to chalices of type 1, the larger to bowls of type 2. Pedestals are normally burnished on the outside. The straight vertical stroke burnishing is often partial, with gaps left between the areas of burnish, evidently with decorative intent. On some of the large pedestals the burnishing appears to have been slight and superficial. One or two fragments from what seem to be the bottom edges of large pedestals have no traces of burnishing at all: these may be from pedestals belonging to some other shape than the chalices and bowls of types 1 and 2. A few scraps from the edges of small pedestals show a distinct bead, e.g. **21** (FIG. 3.4; D. base 12). **22** (FIG. 3.4, PLATE 5) from a large pedestal (D. base *c.* 20), of fine orange clay with a paler orange surface and vertical pattern burnish, has a rib round the edge. **23**, probably from another large pedestal, has a white slip, smoothed or burnished on the outside (PLATE 5). One fragment of soft orange-buff clay is apparently from a pedestal, but has traces of burnishing inside, while the outside shows slight traces of a red wash which seems not to have been burnished. We list three pedestals:

20 FIG. 3.4. D. base 24. Surface shades of light and dark brown, burnished outside.

24 FIG. 3.4, PLATE 5. D. base 15. Surface shades of light and dark brown and grey, burnished outside.

25 PLATE 5. Ht 12. D. base 13.6. Broken, parts missing, including the bowl. Grey clay with pattern burnish in wide irregular vertical strokes outside; inside not burnished. Levels 7, 8, 10, etc.

A pedestal fragment with a line of burnish along the bottom and groups of vertical stripes of pattern burnish rising from, or descending to, it as on **27** (PLATE 3) was found in a later deposit in Vano LXIV at Phaistos.[133]

TYPE 4. DEEP CUPS OR BOWLS WITH INCURVING RIM AND SINGLE LARGE VERTICAL HANDLE **28–30**

These are evidently rare. They are interesting as possible ancestors of the cups with exaggerated handles that are characteristic, although they never appear to have been common, in EM II (our EM II type 1A: pp. 102, 248 (**1186**) and 267–8 (**1301**) below). It is not even entirely certain that the fragments from the Well assigned to this type come from bowls with only one handle rather than two opposite handles, since two-handled cups or bowls occur in contexts of EM I and II. Only handles **28–29** seem assignable to this type of bowl (PLATE 5); but rim **30** (PLATE 5), and a rounded base of orange clay, are also likely to come from bowls with such handles. Bases may also have been carinated. The two handles are circular in section, and comparatively large; they evidently rose higher than the bowl rim; their clay is orange or greenish with a paler slip of the same colour. Some of the bowls of this type appear to have been decorated with pattern burnish, e.g. **29** (FIG. 3.5); but others may have had painted decoration, since one of the two fragments of rim with handles bears traces of a patch of thin black paint on the outside of the rim. The simple rim fragment **30** assigned to this type similarly has a patch of thick matt red paint on the outside.

A Minoan chalice from Ayia Fotia (Siteia) is a pedestalled version of this type.[134] A cup or bowl with a single handle from Pyrgos has a rounded base as assumed for type 4, but the handle is exaggeratedly large as on EM II vessels of this type, and the top of it is set below the rim instead of to it.[135] A cup from Chania–Kastelli with rounded base and a single large handle, whose top is level with the rim, is grouped as EM I.[136] EM II cups or bowls with a single large handle have flat bases.[137]

TYPE 5. BOWLS WITH INCURVING RIM AND ONE OR MORE SMALL VERTICAL HANDLES **31–39**

Only rim fragments survive, with diameters on average of *c.* 18–20. Four or five of these have parts of vertical handles set just below the rim. The bowls to which they belong may have had two handles, and some at least of them appear to have had open trough spouts. Three small fragments of rims from bowls of this or a related type have vertically perforated lugs set on the rim, e.g. **32** (PLATE 16) and **33** (FIG. 3.5).

[133] Levi 1958*b*, 218, fig. 34.
[134] See n. 119.
[135] Xanthoudides 1918*a*, 147, fig. 7: 28; 149.
[136] Tzedakis 1972, 635, pl. 595β.

[137] E.g. Knossos: **1186** and **1301** below; Gournia: Boyd Hawes *et al.* 1908, 56, fig. 37: 4; Vasiliki: Boyd Hawes *et al.* 1908, 50, pl. 12: 17; Trapeza: H. W. Pendlebury *et al.* 1936, 56–8, fig. 13: 501–07; 63–4.

Rim **34** (PLATE 5), possibly from the same vessel as **33**, has a string-hole (rivet hole). Some of these bowls may have had carinated bases rather than simple rounded bases as shown on **31** in FIG. 3.5.

Fabric

There is considerable variation in the fabric of these bowls, some being of fine, others of rather coarse ware. The inside surfaces are not smoothed or burnished, but look as if they had been wiped with the fingers or a cloth. The outsides normally and, occasionally, all or part of the insides as well have a slip or wash, in most cases a shade of grey or brown or orange, but sometimes green as on **35** (PLATE 5). The outside slip often laps over the top of the rim inside, where its colour may be in marked contrast to the colour of the clay of the rest of the inside of the vessel, e.g. **36**.[138] The outsides — but never, it seems, the insides — of these bowls are normally smoothed, and the smoothed surface is characteristically decorated with thin strokes of vertical pattern burnish descending from a burnished band round the rim, e.g. **31** and **34**.

Rim **37** (FIG. 3.5, PLATE 6) with a vertical handle is exceptional: of fine orange clay with a white, slightly greenish slip on the outside, it has a dark purplish wash all over the inside, and is decorated outside with vertical stripes of the same dark purplish paint.

Two-handled bowls like **31** but with simple painted decoration are attested at Kyparissi and Pyrgos, and in the lower stratum of Lebena T. II.[139]

An upright bowl rim from Debla with a lug set to it resembles **32**.[140] Bowls with vertically perforated lugs like this on or just below the rim appear to be at home in Crete in FN and EM I–II contexts. Some bowls from Partira have a single lug of this kind,[141] and two bowls from Kyparissi a pair of such lugs, one each side of the rim.[142] A pair of neat vertically perforated lugs appear in this position on the rim of a shallow spouted bowl from Fournou Korifi II.[143]

TYPE 6. BOWLS OF COARSE WARE WITH WIPED SURFACE AND INCURVING RIM **40–44**

A number of rims and fragments are assignable to this type, but no complete profiles. The rims seem to range in diameter from 20 to 40 or more; they are sometimes thickened, e.g. **40** (FIG. 3.5, PLATE 6; D. 46), **41** (FIG. 3.5, PLATE 6; D. 40) and **42** (PLATE 6). The fabric is coarse, the clay shades of dark grey-brown to black, lighter brown or reddish. The insides of these bowls are wiped, and the outsides, except for a reserved zone round the top of the rim, wiped or scraped with bold diagonal strokes, which seems to be decorative in intent. In effect, the fabric of these bowls is embryo cooking pot ware, and the bowls of this type and type 7 may be the ancestors of the bowls and jars of cooking pot fabric with wiped outside surfaces that are common in EM II. **41** in particular is in fabric akin to the cooking pot ware of EM II: it is of coarse very gritty reddish clay with a red wash, diagonally wiped outside. Rims **43–44** (PLATE 6) assignable to this type are not wiped outside but have bold diagonal incisions. These do not seem to be Neolithic strays but, together with the miniature jug **88** (PLATE 9), are the only examples of true incised decoration from the Well: this rarity agrees with the marked decline in the fashion for it at the end of the Neolithic at Knossos.[144]

TYPE 7. BOWLS WITH RIM THICKENED INTERNALLY, AND HORIZONTAL OR VERTICAL HANDLES **45–59**

A good many rims may be grouped under this heading (FIG. 3.5). They vary in size and in the angles at which they are set. In diameter they seem to range from about 26 to 50, with many around 30, as **45–46**; but the larger rims **47–58** evidently have a diameter of 40 to 50 or more. Three or four rims of this type have horizontal handles set well below them, e.g. **45**; but there are at least two with vertical handles. There is no evidence for the kind of base which went with these bowl rims; some bases may have been carinated, e.g. **59** (PLATE 6).

Several of the smaller rims are of good fabric with their surfaces smoothed if not burnished. But most rims of this type belong to vessels of rather coarse ware. The surface often has clear traces of a wash or slip, in shades of grey or brown, or even red, and is normally wiped outside: the wiping is usually diagonal as on the rims of type 5. The somewhat anomalous rim **51** grouped here has pattern burnish outside.

[138] Wilson and Day sample KN 92/15.

[139] Kyparissi: Alexiou 1951, 279, pl. 13.2: 3; Pyrgos: Xanthoudides 1918a, 145, fig. 6: 16; 149; Lebena: Alexiou and Warren 2004, 111–12, fig. 31, pl. 105: 501.

[140] Warren and Tzedakis 1974, 322–3, fig. 18 bottom left: not well stratified and so assigned between Phases I and III.

[141] Type A in Mortzos's classification of the Partira bowls: Mortzos 1972, 389–90, pls. 8–24, 40. Cf. Tomkins 2007, 46: EM I ('Sub-Neolithic'), with other examples.

[142] Alexiou 1951, 279–80, pls. 13.2: 6, 14.1: 16.

[143] Warren 1972a, 117, pl. 41: P217.

[144] J. D. Evans 1964, 229; Tomkins 2007, 39 (FN III), 42 (FN IV).

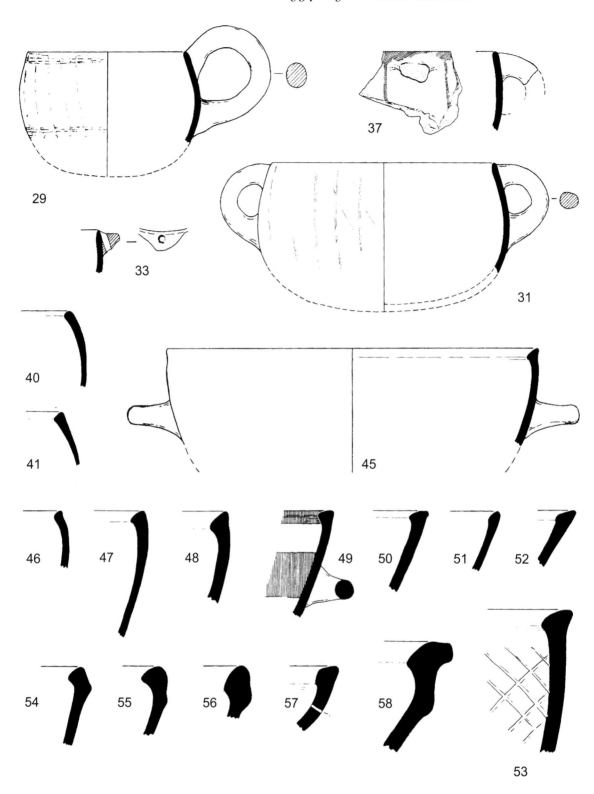

FIG. 3.5. Palace Well (EM I). Type 4 cup **29**; type 5 bowls **31**, **33**, **37**; type 6 bowls **40–41**; type 7 bowls **45–58**. Scale 1:3.

45 FIG. 3.5, PLATE 6. Orange clay with grey-brown wash. One fragment with dark grey-brown surface, the other joining it light grey, discoloured by fire. Outside diagonally wiped.
46 FIG. 3.5, PLATE 6. D. 27. Orange clay with a grey-brown wash. One fragment dark brown, the other light brown, discoloured by fire. Outside diagonally wiped.
47 FIG. 3.5, PLATE 6. D. 48. Coarse gritty orange clay

with buff slip. Slight diagonal wiping outside. Wilson and Day sample KN 92/23.
48 FIG. 3.5, PLATE 6. D. 46. Coarse gritty clay, with overall wash in shades of light brown and reddish. Outside diagonally wiped.

A rim of this shape from FF4 is somewhat smaller, but sounds comparable in fabric and surface treatment (Wilson

1985, 363, fig. 43: FF19). Cf. too Wilson and Day 2000, 44–5, fig. 6: P204, P209.

49　FIG. 3.5, PLATE 14. D. 30. Coarse clay with a large grit showing in surface; outside has overall wash, inside painted with horizontal bands, in dark brown.

50　FIG. 3.5, PLATE 6. D. 40. Coarse lightish brown clay. Outside diagonally wiped.

51　FIG. 3.5. D. 45. Fine orange clay; light brown surface. Inside smoothed, not burnished; outside has vertical stripes of pattern burnish descending from band of burnish round rim. In finish cf. type 5, but this is larger in diameter, with its rim internally thickened as in type 6.

52　FIG. 3.5, PLATE 6. D. 44. Coarse brown clay; brown to dusky surface, wiped. Horizontal wiping marks inside, diagonal outside.

53　FIG. 3.5, PLATE 6: inside (right), outside (left). D. 42? Several frags. of one vessel. Coarse, very gritty clay, like cooking pot fabric; surface shades of grey-brown and light brown; some frags. discoloured by fire to dark grey-brown, purplish and red. Outside horizontally wiped; deep lattice scoring inside.

Several large rims had a wide rib round the outside, giving them a hammer-headed profile. Large bowls with a thickened rim and horizontal rib below, reflecting a similar principle although not exactly comparable in profile, are characteristic of Debla phase I.[145]

54　FIG. 3.5, PLATE 6. D. c. 54? Coarse cooking pot type fabric; diagonally wiped outside below the rib.

55　FIG. 3.5. D. 48? Like **54**.

56　FIG. 3.5. D. 46? Dusky orange clay with traces of dark wash; surface worn by water action. From bottom of Well (level 25).

One large rim which appears to have belonged to a rather shallow bowl, with a string/rivet hole, may be placed here:

57　FIG. 3.5, PLATE 17. D. 50. Coarse grey-brown clay; outside wiped, horizontally round rim, diagonally below it.

One very large bowl rim, and a bowl base, are probably best grouped here:

58　FIG. 3.5. D. 60. Gritty orange clay with greenish slip outside. Wilson and Day sample KN 92/26.

59　PLATE 6. Carinated base.

TYPE 8. DEEP BOWLS WITH HORIZONTAL HANDLES AND CARINATED BASE **60–64**

Bowl **60** (FIG. 3.6), of which several non-joining fragments survive, appears to have had two opposite handles, an open trough spout between them, and a carinated base. Rims assignable to this type range in general from c. 20 to 25 in diameter; but one rim at least seems as little as c. 16–18. Some of the five or six open spouts found in the Well may belong to bowls like this. Nearly all of the smaller carinated bases from the Well are burnished or have pattern burnish inside, and are evidently from bowls of this or a similar type.

There is considerable variation in fabric. In some cases fine straw impressions and grit show clearly in the break and in those parts of the surface that are not burnished. The insides and outsides are burnished overall, or decorated with thin stripes of pattern burnish: outside, vertical or diagonal lines, which may descend from a band of burnishing round the top of the rim, e.g. **61** (PLATE 7); inside, irregular zones filled with parallel lines, the lines in one zone running at a different angle from those in the next, as on the base of **63**. **64**, with several fragments preserved, has thin matt paint, in shades of brown and red, slapped irregularly all over inside and outside.

Wilson notes another instance of this type in 'red burnished ware'.[146]

62　PLATE 7. Frags. including side-handle, part of carinated base, and open spout. D. c. 25. Orange clay with fine grit. Surface orange to light brown; inside burnished, outside with thin vertical stripes of pattern burnish descending from burnished band round rim. Levels 9, 11, 12, 21, etc. Wilson and Day sample KN 92/12.

63　FIG. 3.6, PLATE 7. Frags. of two or more bowls. D. of carinated base c. 18–20. Soft fabric, orange clay with orange to light brown surface, burnished inside and outside except on base, which is well smoothed and decorated on both sides in pattern burnish with groups of parallel lines. Levels 5, 6, 11A, 12 etc. Wilson and Day sample KN 92/13.

64　PLATE 8. Several frags., including scrap of rim with handle, and part of base. Wash slapped all over inside and outside; paint thin, matt and irregular in its application, ranging from shades of dark brown and dusky to red-brown. Wilson and Day sample KN 92/24.

[145] Warren and Tzedakis 1974, 322–3, fig. 18, pl. 52c: P2, P4; cf. Platyvola: Alexiou 1964, 446, pl. 523γ (Warren and Tzedakis 1974, 323, n. 24).

[146] Wilson 2007, 54, citing Wilson and Day 2000, 32–3, fig. 3: P59.

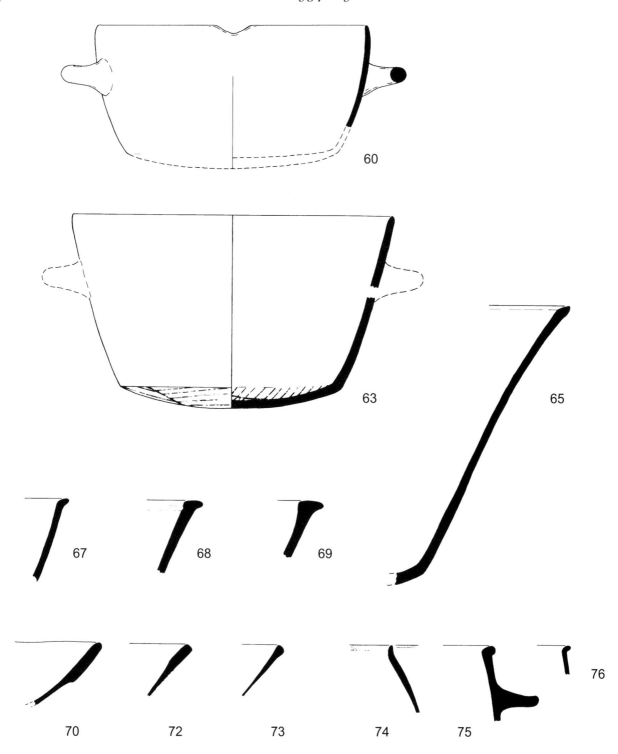

FIG. 3.6. Palace Well (EM I). Type 8 bowls **60**, **63**; type 9 bowls **65**, **67–69**; type 10 baking plates **70**, **72–73**; bowls or jars **74–76**. Scale 1:3.

TYPE 9. LARGE BOWLS AS TYPE 8, BUT WITH EVERTED RIM **65–69**

Considerable remains were found of two bowls **65–66** of this type, together with a fair number of fragments of others assignable to it. These bowls seem to have had horizontal handles set below the rim, and carinated bases. There is no evidence for open trough spouts in connection with this type of rim. The diameter in every case seems to have been large, about 40 or more. Surfaces normally appear more or less well burnished inside, while the outside is either burnished all over or decorated with vertical stripes of pattern burnish. **65** has a thick greenish white slip burnished all over inside and

outside; **66** has a thin overall wash in shades of dark purplish and light orange-brown, burnished inside, and outside was liberally splashed with dark purplish red-brown paint and then decorated with thin vertical stripes of pattern burnish.

65 FIG. 3.6, PLATE 8. D. 42. Frags. include stump of horizontal handle and part of carinated base. Ht pres. 19. D. rim 42. Orange clay, grey at core, with abundant grit, some showing in surface. Thick greenish white slip, well burnished inside and outside.

66 PLATE 8. Frags. include one horizontal handle. D. *c.*

40. Hard fabric, well fired; orange clay, grey at the core, with some grit. Wash in shades of dark purplish and light orange-brown; inside burnished, outside with liberal amounts of trickle in dark purplish red-brown paint, applied when the bowl was upside down, and then decorated with thin vertical stripes of pattern burnish.

One neat, evenly made rim with a sharp projection, from deposit 1 at the bottom of the Well (level 25), is grouped here, but may be Neolithic:

67 FIG. 3.6. D. 40. Orange clay, grey at core, which shows temper of grit and straw. Inside surface dark red,

well burnished; outside red to light brown, less well burnished, but worn by water action.

Some large rims appear to approximate to those of type 9:

68 FIG. 3.6, PLATE 7. D. 42. Dark grey-brown clay; thin vertical stripes of pattern burnish outside.

69 FIG. 3.6, PLATE 7. D. 48. Dark grey surface with poor burnish.

TYPE 10. BAKING PLATES **70–73**

A number of fragments belong to early representatives of this type of cooking dish which is not attested in Crete in the Neolithic, but was in continuous use throughout the Minoan era.[147] In diameter these EM I examples are large, over 40 or 50 across. The rims are always thickened, and the sides tail away to become very thin towards the middle.

Fragments from the bases of these baking plates have never yet been identified in any Minoan period. May it be that only the rims were made in clay, and some perishable material was used to form the sides and bases? Or might the surviving rims have lined the edges of holes in the ground, as suggested by MacGillivray in the case of somewhat comparable vessels from the Early Cycladic settlement on Mount Kynthos on Delos?[148] Their diameters seem to range from 43 to *c.* 60; and MacGillivray notes that they all appear to have been made in the ground and designed to remain in place in the floor. No Cretan baking plates, however, have been observed in association with a hollow in the ground in this manner.

The rims of baking plates from the Well are of two kinds, with the outside either (a) differentiated, as **70–71**,[149] or (b) undifferentiated, as **72–72C** (see FIG. 3.6 and PLATE 8).[150] One or two fragments of rims of class a are bent inwards like the cigarette-rest of an ashtray or a spout in reverse. This feature may be a spit rest. It is standard on baking plates at Myrtos–Pyrgos in period III (MM IIB), and still occurs on ones dating from the end of the Bronze Age or later.[151] The Well baking plates are not exactly similar to those from FF4;[152] but **72** has the rectangular section that Wilson contrasts with the rounded section of EM IIA baking plates.[153]

The fabric of the baking plates from the Well is virtually true cooking pot ware: coarse, gritty clay, in shades of dull brown or reddish; the grit abundant and large in size despite the thinness of the walls of the vessels; the surface has a brown to reddish wash, more or less smooth inside, characteristically rough below the rim zone outside. The fabric appears to be rather finer with rims of class b than with those of class a.[154] **73** may be grouped here.

[147] Down to LM IIIC at least, as for instance at Karphi (Seiradaki 1960, 9–10, pl. 2g) and Palaikastro–Kastri (Sackett *et al.* 1965, 285, 290 fig. 11p–s, pl. 78d). On EM I baking plates, see also Haggis 1996, 666–7, fig. 24: KT 36, fig. 27: KT 64; 672–3, 677 (Kalo Chorio); Wilson and Day 2000, 46–8, fig. 7; Wilson 2007, 55; and Betancourt 2008*b*, 36–7, fig. 4.2; 69–72, fig. 5.33 (preferring to call them 'cooking dishes').

[148] MacGillivray 1980, 30–9; cf. Wilson 1985, 337; 1999, 13–14, 45–6 (with discussion and references to examples on the Greek mainland).

[149] Wilson and Day sample KN 92/48. They also sampled **71** (KN 92/49). Other illustrations are of **70**: Betancourt 2008*b*, 71–2, fig. 5.33; and **70** and **72**: Wilson 2007, 55, fig. 2.4: 5.

[150] Wilson and Day sample KN 92/50.

[151] E.g. Seiradaki 1960, 10.

[152] Wilson 1985, 363, fig. 43: FF16–18; Wilson and Day 2000, 47–8; Tomkins 2007, 46.

[153] Wilson 1985, 358.

[154] Cf. and contrast the two varieties of EC I 'baking pans' from Poros–Katsambas (Wilson *et al.* 2008, 302, 304, fig. 26.3d–e).

73 FIG. 3.6, PLATE 8. D. *c.* 40. Walls become extremely thin below thickened rim. Cooking pot type fabric; surface shading from brown to red, smoothed but not burnished inside and outside. Wilson and Day sample KN 92/51.

MISCELLANEOUS BOWLS OR JARS WITH UPRIGHT OR EVERTED RIMS 74–76

Three rim fragments:

74 FIG. 3.6, PLATE 5. D. 18. Orange clay, grey at core; fabric hard. Surface buff, smoothed inside, poor burnish outside. Bands of thick red paint round top of rim inside and outside. In fabric, finish and shape, this rim is exceptional; it may be an import.

75 FIG. 3.6. With remains of external ledge for lid, or wide horizontal ledge-handle. D. and angle of rim uncertain. Cooking pot type ware; surface shades of reddish brown.

76 FIG. 3.6, PLATE 12. Scrap. D. *c.* 20. Soft grey-brown clay, outside surface brown, perhaps originally wiped.

TYPE 11. JUGS WITH CUTAWAY SPOUT 77–88

These are much less in evidence and appear to have been generally smaller in size than the jugs of type 12. Bodies are evidently more or less rounded, and bases rounded or roughly flattened, although the small carinated base **86** (PLATE 9) with red wash outside may have belonged to a jug of this kind. Handles are set to the rim, rather than to the neck below it as often in EM II and at Troy from period I onwards.[155] No complete profile was found, but there are six or seven distinctive cutaway spouts like **77** (FIG. 3.7), all except one with traces of painted decoration; the exception **78** is of light grey-brown clay with a plain burnished surface (PLATE 9). One uncatalogued fragment is clearly an import from the Mesara,[156] and so very probably is **85** (PLATE 9).[157]

Most of the jugs of this type were evidently decorated with painted designs. Indeed, it looks as if painted decoration with stripes in dark-on-light was virtually confined to jugs of type 11: the only similar piece from a different shape was bowl rim **74** (PLATE 5), which may have been an import. Dark-on-light painted decoration similarly appears to be restricted to jugs in the FF4 deposit.[158] On the other hand, the number of sherds from the Well with this decoration is very small; apart from **74**, there are only the spouts, necks or substantial fragments of a dozen or more jugs (PLATE 9).

There is much variation in the fabric of type 11 painted jugs. The clay is in general orange and contains some grit. The outside was usually given a paler slip, buff as a rule, but sometimes greenish-white or even reddish; it was normally well smoothed or burnished before decoration was applied. The paint for the decoration is matt or has only a slight lustre and ranges from bright red through shades of light and dark brown to black. The impression of variety in the colour of the paint may have been heightened by the effects of the fire in which the pottery (except for the water jars of type 12 found at the bottom of the Well) had been involved; but both the black and the bright red of some of the decoration appear to have been deliberate. The evidence from Knossos does not seem to indicate the existence of an earlier phase of dark-on-light with decoration in red followed by one with a vogue for decoration in brown.[159]

The designs in dark-on-light on pottery from the Well are extremely simple: horizontal stripes round the spouts and necks: **83** (PLATE 9); on the bodies, horizontal stripes: **85**, or vertical stripes in groups as **84** (PLATE 9)[160] and, most characteristically, diagonal stripes crossing to make a lattice. In three cases there is a solid blob inside the inverted triangle formed on the shoulder of the vessel by the diagonal lines which cross below the spout opposite the handle: **81** (PLATE 9). This scheme of decoration is exactly matched on a jug from Pyrgos.[161] Blobs also occur in the EM I repertory at Kyparissi, where one fragment has several blobs incorporated into a linear scheme of decoration.[162]

In the zone under the handle there may be a single diagonal stripe as **85**, or two crossing diagonals as **82** (PLATE 9).[163] Crossing diagonals also occur in the handle zone on a squat jar from Kyparissi.[164]

[155] Hood 1981, 188.

[156] Wilson and Day 1994, 69, pl. 11e: sample KN 92/38.

[157] Wilson and Day 1994, 69, pl. 11 f: sample KN 92/34.

[158] Wilson 1985, 361.

[159] As Schachermeyr (1962, 118) suggested, distinguishing a 'Lebena' phase of EM I with decoration in red followed by an 'Ayios Onouphrios' phase with brownish decoration. Cf. Blackman and Branigan 1982, 29–32, contrasting the red decoration of their 'Ayios Onouphrios I' ware (EM I) with the browns of their 'Ayios Onouphrios II' ware (EM IIA).

[160] Wilson and Day sample KN 92/32.

[161] Xanthoudides 1918a, 146–7, fig. 7: 26, called by Zois a fine

example of the transitional style between his 'Ayios Onouphrios' (EM I) and 'Koumasa' (EM IIA) styles; but the comparison with the Well pieces suggests a date for it in EM I (Zois 1967a, 726–7, pl. 26: 7535; noticed also by Wilson and Day 2000, 34 and n. 27). This jug has pellet feet, as known more widely in EM IIA early (Wilson 2007, 61–2, fig. 2.8: 2–3): see also p. 57 below.

[162] Alexiou 1951, 284, pl. 14.2: 14, assigned by Zois (1967a, 723–4, n. 8, pl. 24δ) to EM I.

[163] Wilson and Day sample KN 92/33.

[164] Alexiou 1951, 278–9, pl. 13.2: 2; for the motif, see Zois 1967a, 724.

Handles may have a single stripe down the middle. One handle is painted solid black on the top side.[165] The lower parts of the bodies of the dark-on-light jugs from the Well were, sometimes at any rate, painted solid, e.g. **86** (PLATE 9). This system is paralleled on a suspension pot from Ayia Fotia (Ierapetra).[166]

The dark-on-light decoration on jugs from FF4 appears to be similar, but the wider painted bands noted on some fragments[167] do not seem to be matched from the Well. The one jug neck from FF4 has horizontal banding like the Well necks.[168] Horizontal stripes were still the standard scheme of decoration on jug necks at Knossos in EM IIA early.[169] At Fournou Korifi this seems to have remained the usual way of decorating jug necks, when they were decorated at all, into period II (EM IIB).[170] It is curious that only one of the jugs with decoration in dark-on-light from Kyparissi has stripes round the neck like this;[171] the necks of the others are adorned with groups of diagonal or vertical lines.

An unique fragment with painted decoration is from a miniature jug: **88** (PLATE 9). It may have been a toy imitating a jug of this or another type. It is roughly made of orange clay without a slip. The surface was decorated with rude incisions, and then painted with horizontal stripes in red.

The shapes and the normally yellowish surface colour of the jugs of type 11, taken in conjunction with their size, strongly suggest that they were copies in the first instance of similar jugs made out of gourds.[172] The original gourd-jugs may have been decorated with comparable designs in red or black paint, but ultimately this type of decoration is probably based upon reproductions of the string nets or slings in which gourds were carried.[173]

Jugs of this type have been compared in the past with those of Troy I, but any resemblances are of a very general nature. Cutaway spouts characteristic of jugs of our type 11 occur on some Troy I jugs; but such spouts were never dominant at Troy or other sites of the Trojan cultural region, like Thermi or Emporio. At Emporio rare examples of cutaway spouts occur as early as period VII;[174] and the jugs of (the pre-Troy) periods VII–VI are indeed in some respects more akin to those of EM I Crete, in terms of a relatively close dependence on gourd prototypes, although reflecting an entirely different tradition of adaptation of gourd forms to clay.[175]

TYPE 12. JUGS WITH GLOBULAR BODY AND PINCHED-IN SPOUT **89–100**

'Or the pitcher be broken at the fountain' (Ecclesiastes 12.6)

In deposit 1 at the bottom of the Well were parts of several jugs of type 12 that had been used for drawing water. Coming from the original use level of the Well, these are among its earliest pots and older than the burnt pottery of the fill (deposit 2) — but how much older, of course we cannot tell.

These jugs have a wide, more or less flat mouth, with a roughly trefoil spout formed by pinching the sides of the rim together. Handles are circular or thick oval in section, set more or less to the rim (PLATE 11: **96–98**). Bases are rounded or roughly flattened; some may have been carinated. Jugs of this type tend to be large compared with those of type 11. But miniature jug **95** (PLATE 9) has a mouth and spout like this, although it bears painted decoration of the kind normally associated with jugs of type 11.

The small jug **89** is complete, as is the large jug **90**, except for bits of its body and most of the mouth and spout. There are also four complete bodies of similar large jugs, but no trace of their handles, necks or mouths, e.g. PLATE 10: **91–92**. These jugs presumably broke when in use to draw water. Their body pieces fell in, but the necks and handles were pulled up and thrown away up on top.

One of the bodies is 24 in diameter; the other three and the body of **90** are even larger (D. body 27–30). These large water jugs are all well made, with thin walls, although the grit used to temper the clay is upon occasion large and shows in the surface. They are also fired hard; but some jugs of this type were of softish fabric. The outside surfaces of jugs of type 12 normally at least appear to have been treated with a wash, in shades of grey to black, dark or light brown, or reddish. Before the wash was applied, the bodies of the jugs were wiped or scraped all over. On the upper parts of the six jug bodies from the bottom of the Well the wiping/scraping is vertical, or once at least (**89**) diagonal, but

[165] Cf. a handle from FF4 covered in red paint (Wilson 1985, 361, pl. 56 right: middle row right).

[166] Boyd Hawes *et al.* 1908, 56 fig. 38: 3; assigned by Evans (*PM* I, 63, fig. 27) and Pendlebury (1939, 51, pl. 9.2d) to EM I.

[167] Wilson 1985, 361, pl. 56 right.

[168] Wilson 1985, 361–2, fig. 42, pl. 56: FF8.

[169] Wilson 1985, 321; 2007, 61–2, fig. 2.8.

[170] E.g. Warren 1972*a*, 185, fig. 69.

[171] Alexiou 1951, 277, pl. 13.2: 7.

[172] As Evans (*PM* I, 63) pointed out. Cf. Hood 1971*a*, 30; Day and Wilson 2004, 53; Betancourt 2008*b*, 39–40, 49–51, 86. The same phenomenon occurred in Cyprus, where the round-bottomed, gourd-shaped jug had a long life: cf. Stewart 1962, 229–30.

[173] Cf. Frankfort 1924, 12–13, 15.

[174] Hood 1981, 325.

[175] Hood 1981, 326.

round the lower part of the bodies in every case it is horizontal. The contrast in the direction of the scraping on the upper and lower parts of the bodies appears to have been deliberate and no doubt had decorative intent. The necks of the jugs of this type were evidently left smooth in contrast to the scraped bodies, e.g. **93–94** (PLATE 11). This wiping or scraping of the surface continues a Neolithic practice (see p. 28 above).

Knossos provides other examples of this type.[176] The upper part of a jug from Platyvola looks comparable to type 12, but may be later than the Well examples, to judge from the position of the top of the handle, which joins the neck below the rim, and the boldness of the scoring.[177] Two small, almost miniature jugs from Kyparissi with rounded bases and handles to the rim approximate to this type: one has a combed surface, the other a red wash[178] (but other jugs from there with combed surfaces have cutaway spouts like our type 11).[179] A rim fragment from Miamou reconstructed as part of a square mouth[180] may have been a pinched-in spout;[181] if so, it may be from a jug.

89 PLATE 10. Virtually complete. Handle set to rim. Ht 14.5. D. body 13.6. Gritty reddish clay shading to black; grit and straw impressions showing in the surface. Outside worn, but with traces of wash the same colour as the clay; upper body wiped diagonally, lower horizontally; neck unwiped.

90 PLATE 10. Parts including most of rim and spout missing — but spout presumably pinched-in. Handle set slightly below rim, but not differentiated from it. Ht pres. 36. D. body c. 30. Orange clay with grit, some showing in surface, which is paler than the body clay; wash outside in shades of light and dark brown to red. Upper body wiped vertically, lower horizontally; neck unwiped.

Handles are invariably set more or less to the rim (PLATE 11: **96–98**).

96 Orange clay with fine grit. Green slip, with irregular reddish to black wash over it outside; thin black band round inside of rim.

97 Dusky orange clay. Upper surface of handle has irregular black wash.

98 Dusky orange clay with whiteish slip. Stripe in thin brown paint runs down top of handle.

Two handles with warts on the top near the junction with the rim appear to come from large jugs, perhaps of type 12. Warts of this kind may be rare in Neolithic Knossos, but there appears to be one example of FN III date;[182] and they are known at FN Phaistos.[183] Such warts are reminiscent of metal rivets. On later Minoan vessels that are generally thought to be imitations of metal originals, there is often a clay 'rivet' in this position. It is of course possible that metal vessels were available as early as EM I in Crete, even if they were not made there. Xanthoudides thought that some vessels from the Pyrgos cave clearly reflected metal prototypes.[184]

99 FIG. 3.7. Rim frag. with complete handle. Small, conical, nipple-like wart on top of handle. Black wash outside, continuing round inside of rim.

Most of the jugs from Debla II have round section handles like **99** surmounted by similar small warts (pellets): Warren and Tzedakis 1974, 324–7, figs. 19: P7–10, 20: P12–13. Cf. also the WCH (Wilson 1985, 321: P182).

100 FIG. 3.7, PLATE 9. Rim frag. with stump of handle, with large conical wart on it. Orange clay, with red wash, much worn. From very bottom of Well.

A large high wart resembling **100** appears on a cup handle from Kyparissi (Alexiou 1951, 279, pl. 14.1: 10). Bold warts also occur on some handles from Pyrgos (Xanthoudides 1918a, 153, fig. 10: 81; 155; 157, fig. 12: 85), and there is a large, apparently flat-topped wart on the handle of a jug with painted decoration from Arkalochori (Hazzidakis 1913, 39, fig. 4r; 42).

TYPE 13. COLLAR-NECKED JARS **101–104**

Several rim fragments appear to be from jars of this type rather than from jugs of type 12. The rims evidently range in diameter from *c.* 12 to 22. All have a wash outside. Handles on the swelling of the body were presumably horizontal as on later examples of the type. Neolithic jars of an equivalent type normally have vertical handles, and this tradition is maintained in Phaistos FN.[185] The type

[176] Wilson and Day 2000, 40–1, pls. 8–9.
[177] Alexiou 1964, 446, pl. 523α: 'EM II'.
[178] Alexiou 1951, 278, pls. 13.1: 7, 14.2: 8.
[179] Alexiou 1951, 278, pl. 13.1: 5–6.
[180] Taramelli 1897, 303, fig. 14.
[181] Vagnetti and Belli 1978, 135.
[182] Stratum IIA Group (Tomkins 2007, 39–40, fig. 1.12: 26,

calling it a 'horned handle').
[183] Vagnetti 1973a, 71, 76, fig. 69: 22.
[184] Xanthoudides 1918a, 156: 79; 157, 159: 82. At Emporio vertical handles surmounted by warts were found in the earliest levels reached and were especially common in period VIII contemporary with Kum Tepe IA (Hood 1981, 205–08, fig. 104).
[185] E.g. Vagnetti 1973a, 58–9, fig. 59: 1–2.

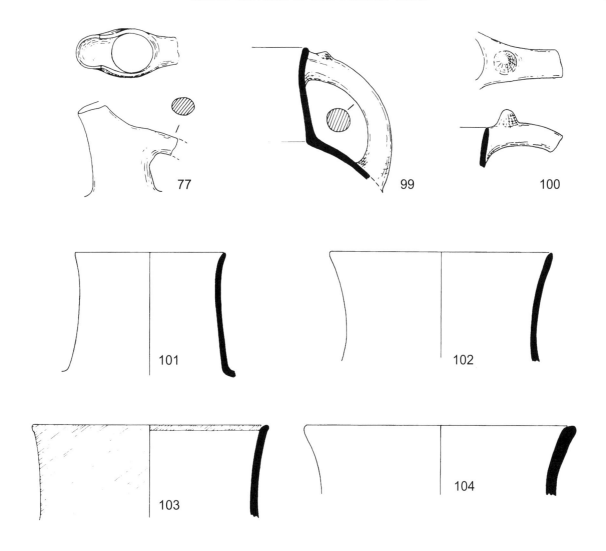

FIG. 3.7. Palace Well (EM I). Type 11 jug **77**; type 12 jugs **99–100**; type 13 collar-necked jars **101–104**. Scale 1:3.

continues into EM II, to the early part of which we assign **1294** (p. 263), and likewise a jar from Pyrgos with a flat base.[186] At the time of the Well the bases of such jars may have been rounded with a carination, as on bowls **60–63** and pithos **134**.[187]

101　FIG. 3.7, PLATE 11. D. *c.* 12. Fine orange clay shading to greyish; light brown wash outside very well burnished; the wash overlaps onto inside of rim, where it is burnished; inside shows horizontal fingermarks below the rim. Wilson and Day sample KN 92/16.

102　FIG. 3.7, PLATE 11. D. *c.* 18. Rim slightly beaded. Fine orange clay, with thin brown wash outside, continuing round inside of rim. Cf. Wilson 1985, 361–2, fig. 42: FF10,

for a collared jar neck of comparable size and set at this angle, from FF4.

103　FIG. 3.7, PLATE 11. D. *c.* 18. Fine orange clay. Thin unevenly applied red wash outside, continuing round inside of rim.

104　FIG. 3.7, PLATE 14. D. *c.* 22. Groove round outside of rim. Dusky orange clay with dark wash outside, continuing round inside of rim.

[186] Xanthoudides 1918*a*, 144, fig. 5: 4; 147 (Zois 1967*a*, 726, pl. 25: 7524, and dated to EM IIA).
[187] Other examples from Knossos: Wilson and Day 2000,

41–2, fig. 5: P179–182, pl. 9: P183–185, P187–189, calling them 'collared jars'. Cf. Wilson 2007, 54.

TYPE 14. SUSPENSION POTS **105–111**

105–106 are considerable parts of two suspension pots, both of somewhat squat globular shape, with at least two and perhaps four lugs, each lug having a single vertical, string-hole perforation. Both pots are of fine fabric with careful lattice pattern burnish on their shoulders. Their rims are missing, but the small collar rims **107** and **108** (FIG. 3.8) evidently belong to suspension pots like these. It seems that other suspension pots in use at Knossos at the time of the Well had high rims and tall lids to fit, such as rim **109** and lid **114**, like examples from Palaikastro–Ayios Nikolaos.[188]

The little jars of this type, much in evidence at the beginning of the EBA in Crete, are often called pyxides; but suspension pot is the traditional name for them, and is what Evans and Xanthoudides used, followed by Pendlebury and, more recently, Mortzos.[189] The term 'pyxis' was originally confined to the more or less cylindrical boxes resembling later Greek ones of clay and marble that are still called by that name. This cylindrical (or spool) pyxis is totally different in shape, and clearly has a different ancestry,[190] from the suspension pot, even if jars of both types were used for cosmetics. We believe that, to avoid confusion, we should keep the original name for the type 14 jars, even if it is somewhat misleading since, as Pendlebury noted,[191] the lugs were probably not in fact intended for suspending the vessels but simply for fastening their lids.

A suspension pot from Pyrgos with a dusky surface and four perforated lugs is like **105** in body shape and has a tall rim like **109** in profile,[192] but most EM suspension pots have only two perforated lugs. One from the WCH is like **105** in shape,[193] and one from Trapeza in light grey ware has two lugs and is close to type 14 in general.[194] Some from Partira and elsewhere that have been assigned to FN, but which may be EM I in date,[195] similarly have only two lugs. One from Partira has a low neck;[196] the others illustrated from there, the Eileithyia cave and Palaikastro–Ayios Nikolaos all have tall necks.[197] Suspension pots with a pair of lugs, each with a double or triple perforation, are known at Gournia and elsewhere.[198]

Small jars of various types akin to Cretan suspension pots and with two or four perforated lugs occur in the EBA in the Cyclades and on the Greek mainland; compare also the Trojan shape C27, found throughout early Troy I, and Emporio type 44.[199]

Fragments of small closed vessels of fine grey-brown ware with pattern burnish from the Well may come from suspension pots or larger jars of similar shape (PLATE 8 *a*). An unique tall rim **109** appears to have belonged to a suspension pot. In light grey ware (see p. 250), it is an import from the Mesara,[200] joining an uncatalogued dark-on-light jug fragment and, most probably, **85** as evidence for the importing of pottery from there already in EM I. It is interesting to find this ware in the Well, since it is generally regarded as characteristic of EM IIA; but this is not the only instance of its occurring in an EM I context at Knossos.[201]

105 FIG. 3.8, PLATE 12. Upper body only, with one vertically perforated string-hole lug pres. D. body est. *c*. 17. Fine sandy clay; inside, shades of light and dark brown to reddish; outside, shades of light and dark brown, well smoothed or burnished, with careful pattern burnish of two horizontal zones of lattice separated by one of chevrons. The variation in colour has evidently been heightened by exposure to fire: frags. with outside surfaces of contrasting light and dark brown join together. Levels 15, 17, 19 etc.

[188] Mortzos 1972, 387, 407, pls. 1–2: 9207 (Partira); 418, pls. 37–8: 3328–9 (Ayios Nikolaos).

[189] Mortzos 1972: 'αγγεία κρεμαστά'.

[190] For a likely origin, as far as concerns the Aegean, in the Cyclades, cf. p. 31 and n. 81 above. In recent publications, Todaro (2001) uses pyxis (*pisside*) for what we call suspension pot, and Betancourt (2008*b*) pyxis for both cylindrical pyxides and suspension pots, as Galanaki (2006, 230, pl. 4) does also. Wilson and Day, however, have called **109** a suspension pot (1994, 11: FG48), while another EM I fragment from Knossos is a pyxis (1994, 10: FG 42; cf. Wilson 2007, 56 for date).

[191] H. W. Pendlebury *et al.* 1936, 35.

[192] Xanthoudides 1918*a*, 151, fig. 9: 70; 155. Cf. also one from Ayios Onouphrios with a low rim, four perforated lugs and a matching lid (Evans 1895, 112, fig. 100 = *PM* I, 61, fig. 23).

[193] Wilson 1985, 317–18, fig. 20: P156). There are many from southern Crete, mostly assignable to EM II, but some perhaps EM I in date: e.g. Ayia Kyriaki: Blackman and Branigan 1982, 28, fig. 9: 4, with a squat globular body and rounded base, very close in shape to our type 14; Ayia Triada Tholos T. A: Banti

1931, 164–5, fig. 7a–b: 4058, 4051, both perhaps EM I according to Wilson (1984, 290); Koumasa: Xanthoudides 1924, pls. 1, 18: 4188; 25: 4291–3; 36: 5012; Lebena T. I: Alexiou and Warren 2004, 32–3 and fig. 7; Miamou, upper deposit: Taramelli 1897, 290 fig. 3, rather like **105** but with a wider mouth and somewhat carinated body.

[194] H. W. Pendlebury *et al.* 1936, 33–4, fig. 8; 39, pl. 8: 109. This and other suspension pots that are likely to be in light grey ware are not included by Wilson and Day (1994, 21).

[195] Tomkins 2007, 46, 48.

[196] Mortzos 1972, 409, pl. 5: 9211.

[197] Mortzos 1972, pls. 2–5 (Partira), 36 (Eileithyia), 37–8 (Ayios Nikolaos).

[198] Boyd Hawes *et al.* 1908, 56, figs. 37: 2, from Rock Shelter A; 38: 5, from Ayia Fotia (Ierapetra). Cf. Wilson and Day 1994, 9.

[199] Blegen *et al.* 1950, 71; Hood 1981, 197.

[200] Wilson and Day 1994, 11: FG 48 (sample KN 92/368, of Fabric Group 3).

[201] See n. 76 above.

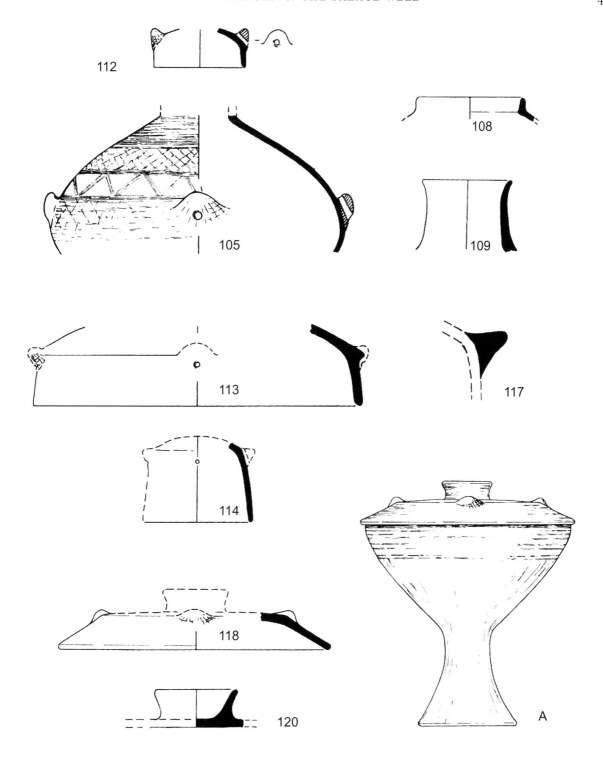

FIG. 3.8. Palace Well (EM I). Type 14 suspension pots **105**, **108–109**; type 15 suspension pot lid **112**; type 16 lids **113–114**, **117**; type 17 cover lids **118**, **120**; A: reconstruction showing cover lid on chalice. Scale 1:2.

Fine lattice pattern burnish also occurs on a two-handled bowl from Kyparissi (Alexiou 1951, 278, pl. 14.1: 6).
106 PLATE 12. Frag. like **105**; one string-hole lug pres. D. body est. *c.* 13.6. Fine grey-brown clay; inside light grey, unburnished; outside black, well burnished, except for dark grey strip of lattice pattern burnish on shoulder.

107 PLATE 12. Rim and part of shoulder. Outside light grey, well burnished, with strip of lattice pattern burnish.
109 FIG. 3.8, PLATE 12. Collared rim. D. 5. Light grey ware. Fine clay, with no sign of grit or straw temper, light grey throughout; outside burnished.

TYPE 15. SUSPENSION POT LID 112

Scrap **112** (FIG. 3.8, PLATE 13) is evidently from the lid for a small suspension pot of type 14. This lid must have had at least two, and perhaps more likely four, string-hole lugs, of which only one is preserved. It is of soft grey-brown clay with burnishing only on the outside.

Suspension pot lids of this type are very much at home in Early Minoan Crete. They have two or, more often, four perforated lugs, corresponding to the number of lugs on the body of the pot to which they belong.[202] A small lid of type 15 with central knob, exactly like Troy shape D 11, from Pyrgos has four lugs;[203] but an elegant lid from Partira, assignable to this type (rather than type 16), and the suspension pot to which it belongs have two lugs, as do other suspension pots from Partira and Palaikastro–Ayios Nikolaos and their lids.[204]

Lids of this type are akin to Troy shape D 11, of the early subperiod of Troy I.[205] These Trojan lids have four lugs, as do the small jars from Troy comparable with Cretan suspension pots.[206]

TYPE 16. FLANGED LIDS 113–117

Fragments of some 10 or more lids are assignable to this type. The lids seem to range in diameter from as little as 6, suitable for a suspension pot of type 14, to *c.* 22 or more. There is also considerable variation in the ratio of height to diameter: e.g., contrast **113**[207] and **114** (FIG. 3.8, PLATE 13). Most, if not all, of these lids appear to have had either two or four string-holes through the flange. There is often a bulge in the flange at the point where the string-hole was made. In some cases this bulge approximates to a definite lug, e.g. **113**. The outsides of the lids are more or less well burnished, black and shades of grey or brown in colour; the insides are untreated or at best smoothed.

117 FIG. 3.8. Two sections of an applied strip. D. body 24 +. Probably part of the flange torn from a large lid of type 16. Irregularly made and uneven; coarse orange clay; pale greenish slip; unburnished.

Lids of this general type are attested in the Aegean from very early times. The type itself may ultimately derive from the repertory of the Halaf culture of the Near East.[208] Flanged lids are found during the Neolithic on the Greek mainland, and during the EBA in the Trojan area and the Cyclades.[209] The earliest lid recognised from Emporio is of this type, from pre-Troy I period VI.[210]

A fragment from FN I (formerly MN) Knossos is drawn as if from a lid of this type, but is described as a vessel support.[211] There is a miniature flanged lid without lugs or string-holes from FN Phaistos.[212] Some lids from Eileithyia and Palaikastro–Ayios Nikolaos that have also been assigned to FN appear to correspond more to this type than to type 15, but have pairs of perforated lugs as **113**.[213]

Flanged lids of this type appear to have flourished in Crete from EM I and into IIA. A fragment of a type 16 lid from Fournou Korifi is assigned to period I;[214] no lids of this type appear in period II. Remains of several flanged lids were noted at Ayia Kyriaki, one of them from the pre-tomb soil.[215] Flanged lids with flat or slightly domed tops and string-holes are illustrated from the early level in Lebena T. II.[216] Such lids are not apparently represented in the Mesara tombs, however, except at Koutsokera.[217] A flanged lid from Trapeza has four string-holes: Pendlebury thought it might date from as late as EM III, but it was clearly for a suspension pot and not for a cylindrical pyxis as he suggested, and his Cycladic parallel from Phylakopi is hardly valid. The knob in the drawing is a restoration.[218]

[202] As seen on Evans 1895, 112, fig. 100, from Ayios Onouphrios; the lid of this appears to be closer to type 15 than 16.

[203] Xanthoudides 1918*a*, 155, 157, fig. 12: 99.

[204] Mortzos 1972, 408, pls. 1–2: 9207; cf. pls. 3–5, 36–8. Other examples of such lids with two perforated lugs come from the early burial level in Lebena T. II (Alexiou and Warren 2004, 78, fig. 22, pl. 111A: 153) and Marathokephalo (Xanthoudides 1918*b*, 19, fig. 4, bottom row, third from right).

[205] Blegen *et al.* 1950, 74; cf. Lamb 1936, pl. 40: type 14, current in Towns I–III at Thermi.

[206] Blegen *et al.* 1950, 71: C 25–7.

[207] Wilson and Day sample KN 92/11.

[208] E.g. Von Oppenheim 1943, pl. 24: 13.

[209] Hood 1981, 201, type 62.

[210] Hood 1981, 340: 754.

[211] Furness 1953, 130, fig. 15: 14; 134. Other lids are likely

of this period: Tomkins 2007, 33–4, fig. 1.9: 16 (Stratum IIIB: FN IA) and 52 (Stratum IIIA: FN IB), originally seen as a shallow dish (J. D. Evans 1964, 187, fig. 34: 47; 221).

[212] Vagnetti 1973*a*, 88–9, fig. 77: 3.

[213] Mortzos 1972, 418, pls. 36: 9440, 37–8: 3328–9; cf. Bosanquet *et al.* 1903, 340–2.

[214] Warren 1972*a*, 106, 158 fig. 42: P62.

[215] Blackman and Branigan 1982, 21–2, fig. 7: A5, with string holes through the flange and dark on light decoration (from the pre-tomb soil), 28, fig. 9: 3, 30, fig. 10: 61, 33, fig. 12: 136–8.

[216] Alexiou and Warren 2004, 81–2, fig. 23, pl. 111A: 194, 199.

[217] Frags. of several from there are illustrated in Xanthoudides 1924, pl. 40a, bottom row.

[218] H. W. Pendlebury *et al.* 1936, 34–6, fig. 8, 40, pl. 8: 119.

Lids of types 15 and 16 share some features, and both differ in character from the cover lids of types 17 and 18. One obvious difference between the two groups of lids is the way in which the rims of types 15 and 16 are more or less upright, while those of types 17 and 18 tend to slope. This, and other differences between the two groups, may reflect the fact that lids of types 15 and 16 were made to cap jars with more or less upright necks, while the cover lids of types 17 and 18 were perhaps for use with chalices and pedestal bowls of types 1 and 2, as we suggest in FIG. 3.8A.

TYPE 17. COVER LIDS WITH HOLLOW CYLINDRICAL HANDLE 118–123

Some 15 rim fragments together with two or three hollow cylindrical handles belong to lids of this type.[219] These lids seem to range from *c.* 14 to 20 in diameter, several being between 18 and 20. Most, if not all, of them appear to have had two or more probably three or four low oblong warts on the carination (PLATE 13: 121–123). A cover akin to this type from Pyrgos has three such warts.[220]

The fabric varies, but is in general fine, with the surface ranging from black to dark grey, light grey and shades of brown, especially light brown; the surface of one fragment is reddish. The top surface of the lid is always more or less well burnished: 119 of exceptionally fine fabric has rough lattice pattern burnish on top. The burnishing normally extends round the inside of the rim; apart from this, the under surface is left unburnished, although it is evenly finished or smoothed, like the insides of the pedestals of chalices of type 1. The three fragments of cylindrical handles assignable to lids of this type are all of fine fabric, and one of them has a grey-brown burnished outside surface; the other two show no trace of burnishing.

118 Probably Wilson and Day sample KN 92/2.
119 PLATE 13. Rim frag. of lid with carination and part of wart pres. Very fine fabric; dark grey burnished surface outside; rough pattern burnish lattice on flat top surface. Inside unburnished, but with regular fingermarks resembling those from use of the fast wheel. Wilson and Day sample KN 92/10.

120 FIG. 3.8, PLATE 13. Hollow cylindrical handle of lid. Orange clay with buff slip, smoothed inside. Wilson and Day sample 92/28.
A plain cover lid very like 120 in shape, but without warts around the top of the rim, comes from Ayia Triada Tholos T. A (Banti 1931, 166–7, fig. 11: 4063).

TYPE 18. LARGE COVER LIDS WITH HOLLOW CYLINDRICAL HANDLE 124

As type 17, but larger, and with bold grooved decoration of concentric circles. Considerable parts of one lid of this type were found, together with scraps of two others somewhat smaller. In view of their size and fine burnished finish, it seems possible that these lids were used to cover pedestal bowls of type 2.

124 FIG. 3.9, PLATE 13. About 1/2 pres., including stumps of what appear to be two out of probably four warts on carination. Handle missing. D. 32. Coarse clay with white grit; clay predominantly orange, but vessel much discoloured by fire, leaving surfaces of frags. various shades of dark and light brown, with some black and red. Top well burnished and decorated with incised concentric circles; incisions for the most part bold, groove-like, with U-shaped sections. Inside lightly wiped except around edge of rim, which has poor burnish. Wilson and Day sample KN 92/3.

Cover lids as large as 124 were noted at Trapeza, but are of a rather different shape and were dated to EM III–MM I.[221] Two other lids from Trapeza, reminiscent of 124 in shape and with similar grooved decoration, but smaller in size, were assigned to EM III;[222] and one from the Ayios Charalambos cave (which is across the Lasithi plain from Trapeza) has recently been dated to EM II–MM IA.[223] The fragment of a lid of fine black burnished ware with comparable grooves from Debla III dated to EM IIA might come from a cover of this type.[224]

Cover lids akin to our types 17 and 18 have been found in many parts of Crete, but mostly in the centre and east of the island. They seem to fall into three main groups: (1) with a differentiated rim, more or less corresponding to our types 17 and 18; (2) with a flange round the top of the rim, like type 16; (3) flat lids. The common feature for all these lids is the central hollow cylindrical handle. Some have small vertical loop handles in place of the solid warts which appear round the top of the rim on examples from the Well.[225]

[219] Wilson (2007, 54) highlights this type, and proposes diameters of 30 or more for the largest examples.
[220] Xanthoudides 1918a, 152, 157 fig. 12: 87.
[221] H. W. Pendlebury et al. 1936, 53–4, 56, fig. 12, pl. 9: 411.
[222] H. W. Pendlebury et al. 1936, 53, 56, fig. 12, pl. 9: 410.
[223] Langford-Verstegen 2008, 552–3, fig. 10; 556: 16: it is smaller (D. 21.4) than our example, and of the Lasithi–Pediada Red Fabric group.
[224] Warren and Tzedakis 1974, 329, pl. 56a top left.
[225] E.g. H. W. Pendlebury et al. 1936, 56, fig. 12, pl. 9: 410.

Such lids have been reported from all phases of Early Minoan and seem to have continued in some areas into Middle Minoan. An unpublished fragment from MM IIA levels in RRS appears to be of that date; it is of fine cooking pot ware with a red wash, and has a rudimentary flange like the lids of group 2.[226] A knob handle that comes presumably from a lid akin to our types 17 and 18 was found in Neolithic Stratum III at Knossos.[227]

Flanged cover lids of group 2 seem the most common. They are somewhat reminiscent of the 'frying pans' of the Keros-Syros group, with which Hazzidakis compared them, taking them to be lids.[228] Some of the cover lids from Trapeza fall into our group 1 and resemble lids of our types 17 and 18, but others are flanged, as are all of those illustrated from Mochlos, and those from Marathokephalo and Koumasa.[229]

There has been much discussion as to whether these vessels with hollow cylindrical handles were really lids. Seager thought it unlikely, because clay vessels could not be identified to go with them: 'of the many recovered, — often two or three from one grave, — none was ever found with a vessel to which it could possibly have belonged'.[230] Evans similarly interpreted them as pedestalled dishes or pans, prototypes perhaps 'of the typical Minoan "kernoi"';[231] and Davaras has suggested that two examples which he recovered from a pit in the North Room of T. I at Gournia are really fruitstands, since the pit contained no vessel for which they might have served as lids, and the hollow cylindrical projections are too large for handles but convincing as feet.[232] Branigan and Platon believe that these vessels may have been used for cult like the Cycladic frying pans often considered related to them.[233] Recently, Langford-Verstegen has seen them as stands or offering stands,[234] with which Serpetsidaki tends to concur for one in dark grey burnished ware from Kyparissi.[235]

Hazzidakis, however, was sure they were lids; and Xanthoudides felt that they might have served as covers for cooking pots, noting that comparable lids were used for cooking pots of the traditional type (χύτρα) in the mountain villages of Crete before the spread of the fashion for foreign ones (τσουκάλια) imported from France and elsewhere.[236] Pendlebury suggested that those from Trapeza might have been lids for bowls of similar fabric of which examples were found with them, or for vessels of some perishable material such as wood or gourds; and he aptly compared them with mediaeval Moorish covers that had central handles of the same kind.[237]

The weight of authority therefore appears to favour the idea that these vessels were lids. But the WCH has produced several vessels of dark coarse burnished ware in shape akin to our type 17: all the cylindrical handles and other fragments of these have traces of burning outside, and one piece inside as well.[238] Even if these vessels were basically meant for lids, they could have been used upside down as dishes: the same may have been true of their possible relatives, the mysterious frying pans of the Cyclades. In view of their size and comparable fabric, the cover lids of our type 17 may have been used with chalices of type 1 (FIG. 3.8A), while the larger type 18 covers could have belonged with pedestal bowls of type 2.

TYPE 19. FLAT LIDS OR PLATES 125–129

There are several fragments of these. They may have been used as dishes and/or lids for jars and pithoi. In diameter they seem to range from c. 15 to 24, but 125 is only 12 and the unusually thin 128 (FIG. 3.9, PLATE 14) seems to be nearly 30.

[226] A rather similar lid from Archanes–Fourni, Burial Building 8, may — or may not — be of comparable date: Sakellarakis and Sakellaraki (1997, 392–3, fig. 345) assign it to EM III. The MM pithos lid from Vrokastro (Hall 1914, 103, 115, fig. 57C; cited by H. W. Pendlebury et al. 1936, 54) is of a different type with a solid knob handle.
[227] J. D. Evans 1964, 180: 58/67; 220, fig. 57: 9.
[228] Hazzidakis 1913, 41.
[229] Trapeza: H. W. Pendlebury et al. 1936, 52–6, fig. 12, pl. 9; Mochlos: Seager 1912, 18–20, fig. 4: I.a; 59, fig. 28: XI.6; 67, fig. 37: XVI.10; 71, figs. 4 and 40: XIX.1; Marathokephalo: Xanthoudides 1918b, 19, fig. 4 bottom right; Koumasa: Xanthoudides 1924, pls. 18: 4926–7, 5036, 5656, 20: 4262a. For the variety of lids from Lebena, including flanged and unflanged, see Alexiou and Warren 2004, 31–2, 77–84, 144. There is a flanged cover lid from Sphoungaras (Hall 1912, 49–50, fig. 22F), and a flat cover lid from Pyrgos (Xanthoudides 1918a, 152, 157, fig. 12: 86). What seem to have been flat lids of this type were found in deposits of Vasiliki I and also at

Gournia (Boyd Hawes et al. 1908, 50, 53, 56, fig. 37: 3, described as flat dishes on low feet).
[230] Seager 1912, 18. Cf. the discussion on an uncertain piece from Lebena T. I: Alexiou and Warren 2004, 31–2, fig. 6, pl. 7B: 38.
[231] PM I, 75–6.
[232] Davaras 1973a, 588; Soles 1992, 14–16, fig. 5, pl. 5: G I-15–16, concurring with Davaras's interpretation. For a similar vessel from T. II at Gournia, see Soles 1992, 25–6, fig. 10, pl. 11: G II-8.
[233] Branigan 1970b, 80; Platon 1981, vol. 1, 146–7.
[234] Langford-Verstegen 2008, 553. Our examples from the Well are exceptions to her claim that these vessels come from exclusively funerary contexts.
[235] Serpetsidaki 2006, 246, 256, fig. 2β.
[236] Xanthoudides 1918a, 152.
[237] H. W. Pendlebury et al. 1936, 53–5, fig. 12a; Pendlebury 1939, 65, 66, n. 2.
[238] Wilson 1985, 353: P428–434.

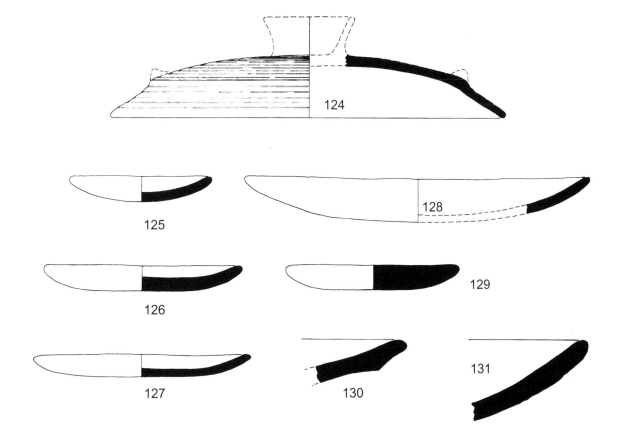

FIG. 3.9. Palace Well (EM I). Type 18 large cover lid **124**; type 19 flat lids or plates **125–129**; type 20 large flat lids or dishes **130–131**. Scale 1:3.

The fabric tends to be coarse and rather soft, although some examples are comparatively well fired. The surfaces are shades of grey or brown and reddish, never burnished, but in some cases smoothed. Normally the surfaces are treated alike on both sides but, where any differences in the treatment are observable, the inside (concave) surface appears less carefully finished, e.g. **126**. This may suggest that the objects were intended as lids. Some type 1 *a* dishes of class C Fine Burnished ware of FN Phaistos are similar in shape to **125–127**.[239]

125 FIG. 3.9, PLATE 13. About 1/2 pres. Ht 2.3. D. *c.* 11.5. Rather coarse fabric, clay grey at core; surface orange inside, dusky outside, smoothed but not burnished. Frags. discoloured by fire; one joining frag. has dusky inside surface, like the outside, instead of orange.
126 FIG. 3.9, PLATE 13. About 1/2 pres. Ht 2.5 D. *c.* 16.3. Coarse clay with large grit, dominantly white, showing outside; clay grey in break, but orange at surface; outside smoothed, inside crudely wiped. Wilson and Day sample KN 92/45.
127 FIG. 3.9, PLATE 13. About 1/2 pres. Ht 2. D. *c.* 17. Soft fabric; coarse clay, grey in break, with abundant straw temper showing as pittings in surface, which is grey inside, orange outside, both wiped. Wilson and Day sample KN 92/29.

Two or three fragments evidently come from thick discs, flat on one side and humped on the other, e.g. **129** (FIG. 3.9, PLATE 13). These are of coarse fabric, and light in weight; the clay is porous, with abundant straw temper, and orange, or greenish with a white slip, and a well smoothed surface on both sides.

Thick flat discs, somewhat akin to **129** in profile but mostly with a cross painted on one or both faces, in a Fournou Korifi I deposit have been interpreted as potter's turn-tables.[240] A large thick disc

[239] Vagnetti 1973*a*, 64, fig. 62: 1–2, 4; cf. Pernier 1935, 99, pl. 11 second row from bottom: relatively small, and some of them with a pair of holes through the edge (Pernier thought that these might have had a ritual use).

[240] Warren 1972*a*, 213–15, 224, 245, fig. 98, pls. 75–6; cf. Betancourt 1979, 12–13; Evely 1988, 84, 88, 94–7; Knappett 1999, 104.

with lines painted in red described, but not illustrated, from Kyparissi may have been similar, and could have been used for turning pottery: Alexiou cites Xanthoudides's suggestion that a wheel turned by hand in this way (*tournette*) was already in use in EM.[241] Such clay discs would have been in effect one alternative for the mats which appear to have served as turn-tables for making pottery in other parts of the Aegean at the beginning of the Bronze Age before the introduction of the fast potter's wheel.[242]

TYPE 20. LARGE FLAT LIDS OR DISHES WITH THICK WALLS **130–132**

These may have served as pithos lids. The few fragments of rims assignable to the type have a diameter of 40 or more. The rims are normally thickened with a rib round the outside as on **130** (FIG. 3.9, PLATE 14; D. 43),[243] but are sometimes simple like **131** (FIG. 3.9, PLATE 14; D. 47). The fabric is coarse, the surface shades of grey-brown and reddish, wiped on both sides but very much more marked inside — which may indicate that these vessels were used as lids. A rim from FN Phaistos resembles **130** in profile but is of fine burnished ware.[244]

TYPE 21. LARGE STORAGE JARS (PITHOI) **133–149**

A good many remains of these came from the Well, and notably from deposit 1. Some must have been very large, since fragments of them are as much as 3.6 thick. These thick-walled fragments are of coarse gritty clay with abundant straw impressions showing in the surface. In general, pithoi are of coarse fabric, the clay containing large lumps of grit. But some large storage jars that might qualify as pithoi are thin-walled and of relatively fine fabric like the base **134**; the surface in this case had been wiped inside and outside before applying a wash to the outside. Other pithoi seem to have had their surfaces wiped in this way; and the outside surfaces normally appear to have had a wash applied to them either overall, or in some cases only partially, as on the neck of **133**. Sometimes the surface was merely splashed with paint.

The rims of pithoi are, it seems, normally thickened. Many of the large rims grouped here are hammer-headed in profile owing to thickening on the inside as well as outside, e.g. **133**; cf. **136–140**.

Handles and lugs
Small strap handles set vertically like those on **133** seem not uncommon. Part of one large strap handle of thin oval section has a red wash. **149** (PLATE 15) from a large pithos has a vertically perforated lug set on a horizontal rib like those that surround **133**.

Bases
These are often, it seems, carinated and rounded, like many bases of smaller pots, e.g. **63**. Base **134** of this type had a hole made before firing at the bottom. But fragments from the edges of bases of pithoi or large jars suggest that some may have been flat, although no certain example of a flat base was noted.

Decoration
(1) Wiping of the surface, and (2) the application of washes, whether partial or overall, in red or dark paint, were no doubt decorative in intent. Similarly, splashing the insides of **133** and **134** with paint appears deliberate. (3) Relief: these pithoi are the first known from Crete with rope and raised band decoration.[245] Varieties include:
 (a) Ribs, wide and rather low with a sharp edge, are evidently not uncommon, as on **133**. They normally seem to run horizontally round the body of the jar, and are sometimes set close together as on the modern pithoi of the Kalamata area. The ribs on **141A** (PLATE 15) are reminiscent of those on pithoi from Chalcolithic Byblos.[246] Part of a curving rib is preserved on **142**, which has the stump of a small strap handle (PLATE 15).
 (b) Warts. A large disc-shaped wart **145** appears to have been applied to a pithos (PLATE 15).
(4) Incision, grooving and channelling. Some fragments have bold incised, grooved or channelled decoration made before firing. Most characteristic are rough herringbone designs or rows of

[241] Alexiou 1951, 286; Xanthoudides 1918*a*, 162.
[242] Crowfoot 1938. For a mat impression, see also **1366** (p. 279 below).
[243] Wilson and Day sample KN 92/30.
[244] Vagnetti 1973*a*, 70, fig. 65: 4.

[245] Christakis 2005, 24, noting no Cretan Neolithic predecessors with rope decoration.
[246] Dunand 1973, fig. 127, pls. 141: 27028 (T. 1239), ECh, 148: 22987 (T. 654), LCh.

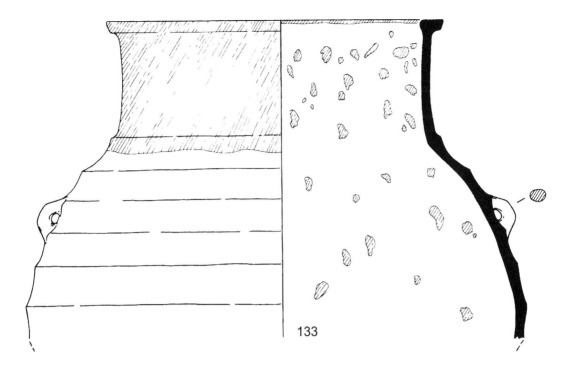

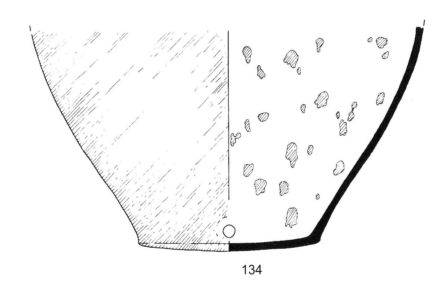

FIG. 3.10. Palace Well (EM I). Type 21 large storage jars (pithoi) **133–134**. Scale 1:3.

chevrons set on low horizontal ribs (PLATE 15: **146**) or in the flat spaces between such ribs (PLATE 15: **147**, from deposit 1). The unique **148** (PLATE 15), also from deposit 1, of very gritty orange clay with a plain orange surface,[247] has a low wide flat band with boldly incised hatching, like Late Minoan pithoi; but the fragment seems to be EM and in context. Several fragments, all apparently coming from one very large pithos, are decorated with bold U-shaped channels, arranged as horizontal bands of lattice (**144**); and there are fragments of other pithoi with similar decoration. It would have been done with a round-ended tool and should not be confused with internal scoring done with a pointed tool, such as **158** (PLATE 17).

[247] Wilson and Day sample KN 92/41.

Storage jars that might be classed as pithoi are not frequent in the Cretan Neolithic, although some large rims and fragments of vessels with walls up to 3 thick are attested from Knossos and FN Phaistos.[248] Pithoi, however, are comparatively well represented in the Well. The tradition of pithos making that appears to have been established at Knossos at the beginning of EM I may not have changed much later in Early Minoan.[249] These pithoi are quite different in appearance from those of Aphrodite's Kephali with their raised mouldings (without incisions) that may have been derived from the Cyclades, while their shape is like a large version of the collared jars (that are found for instance in the 'Cycladic' repertoire of Ayia Fotia [Siteia]).[250] They may also be different from the pithoi reported from Petras–Kephala, although warts ('knobs') are reported from there and, significantly, interiors with splashed paint,[251] to compare with **133–134**.

133	FIG. 3.10, PLATE 14. Upper body frag. of pithos, with vertical collar neck and hammer-headed rim. Ht pres. 55. D. apparently very large, perhaps as much as 68 (in FIG. 3.10 rest. as 55). Decorated with wide horizontal ribs set close together. One small vertical strap handle pres., springing from adjacent ribs. Hard, well fired fabric. Coarse orange clay with abundant grit showing in surface, which is roughly smoothed outside. Uneven rather thin wash, red shading to purple-brown, round outside of neck and continuing on inside of rim. Neck and body vigorously wiped inside, and splashed with red paint: cf. **134**.

A pithos that sounds as if it may have been somewhat comparable comes from Debla I, described as having a thickened rim and deep collar, and a reddish wash with rough scorings on the body (Warren and Tzedakis 1974, 313–4, 321, 323: P3). The upper part of a pithos with a rim apparently of this general type is illustrated from Fournou Korifi I (Warren 1972a, 107, pl. 37 A: P67); one or two amphora rims and a pithos rim of Fournou Korifi II are also comparable (Warren 1972a, 159, fig. 43: P74–75; 199, fig. 83: P630). Rims with a hammer-headed profile of this kind do not seem to be much in evidence, however, at Trapeza.

For the rim cf. also a pithos rim from Judeideh (Braidwood and Braidwood 1960, 234, fig. 174: 26) of Amuq F, which may overlap with the beginning of EM I.

134	FIG. 3.10, PLATE 14. Carinated base of pithos or large store vessel. Ht pres. 33.5. D. at carination c. 29.2. At bottom, hole (D. c. 2) apparently made before firing, and perhaps for attaching a spout or nozzle. One non-joining frag. from side has a rivet-hole made after firing. Fairly thin-walled. Hard fabric, orange clay with grit. Surface vigorously wiped inside and outside. Outside painted with uneven streaky purple-brown to black wash; inside splashed with same paint, here dark purplish red.

Many bases of pithoi and amphorai from Fournou Korifi have a hole near the bottom like **134** (Warren 1972a, 109, 146: nine out of 22 amphora bases, and 14 out of 31 pithos bases). Other examples from Crete include: Trapeza: H. W. Pendlebury et al. 1936, 88: 909, assigned to EM; Knossos, house below Kouloura 3: Pendlebury and Pendlebury 1930, 65–6, fig. 6. Such holes no doubt served the same purpose as the spouts sometimes found in this position near the bases

of pithoi and were for dispensing the liquids in them (e.g. Seager 1916, 17, pl. 16.4b). For pithoi with holes or spouts near the base from other parts of Greece and Anatolia during the earlier part of the Bronze Age, see Hood 1981, 199.

135	FIG. 3.11, PLATE 14. Several rim frags. of one or more large pithoi or bowls. D. 50. Coarse orange clay with dark or reddish wash.

136	FIG. 3.11, PLATE 14. Gritty orange clay, grey in break. Wiped horizontally inside and out, and then coated with red shading to purplish and brown wash.

Some pithos rims from the WCH are rather similar, e.g. Wilson 1985, 354–5, fig. 40: P437–438.

137	FIG. 3.11, PLATE 14. D. c. 40. Dusky orange clay. Horizontally wiped inside and outside; outside has dark brown to black wash.

138	FIG. 3.11, PLATE 14. D. 38. Slight ledge, perhaps to hold lid, on inside of rim. Gritty orange clay with reddish wash inside and outside. Joining fragments discoloured by fire. Wilson and Day sample KN 92/25.

139	FIG. 3.11, PLATE 14. D. 26. Orange clay with fine grit, well fired. Streaky dark brown to black wash outside, continuing round inside of rim. Splashes of thick red paint inside and outside.

140	FIG. 3.11, PLATE 14. D. 24. Reddish clay, grey at core, with fine grit. Black, almost lustrous wash outside, streaky dark red-brown to black inside.

141	FIG. 3.11, PLATE 15. D. c. 58 ? Huge rim, apparently from large bowl, with walls over 3 thick. Very coarse crumbly fabric; large grit and straw impressions showing in surface. Clay light grey-brown on surface, shading to dark grey and black at core. Wilson and Day sample KN 92/40.

142	PLATE 15. Frag. of pithos, with curving rib in relief and stump of small vertical strap handle. The piece is circular, and was perhaps deliberately cut to use as a lid. Coarse orange clay, with thin black wash splashed on outside.

143	PLATE 16. Several frags., apparently from one large pithos with walls over 2 thick. Coarse, gritty orange clay with straw, grey in centre of break, orange-brown at edges. Inside splashed with black paint; outside has patchy wash in thick, almost lustrous, black paint, over decoration of very bold U-shaped channels. These channels appear to form pattern of horizontal bands of lattice.

Fragments of other pithoi with similar decoration include **144**.

144	PLATE 16. Frags. of pithos with deep channelled decoration, as **143**, and thin red to purple-red wash outside. Cf. Wilson 1985, 354, pl. 53: P450–451, for pithoi from

the WCH with very comparable decoration. Similar decoration appears on a fragment of a large vessel from the EB I horizon at Ras Shamra (Schaeffer 1962, 452–3, fig. 40 J).

[248] E.g. J. D. Evans 1964, 163, fig. 22: 17 (Stratum VI = LN I, formerly EN I), 191, fig. 36: 15 (Stratum II = FN II–III, formerly LN); Vagnetti 1973a, 54 — and rims like 55, fig. 57: 5.

[249] For continuity in pithos ware from EM I into EM IIA (Early and Late) and IIB, see Wilson 2007, 55, 61, 69. See also Christakis 2005, 74. Other EM I pithos fragments at Knossos:

Wilson and Day 2000, 48–50, fig. 8: P268, pl. 13: P270–P274 and also PP269; also Kalo Chorio: Haggis 1996, 669–70, fig. 30: KT 87; 674. For Debla, see under **133**.

[250] Betancourt 2008a; 2008b, 78–83 (esp. 82), figs. 5.47–5.51; 2010.

[251] Papadatos 2008, 263–4, fig. 15.6d; in preparation.

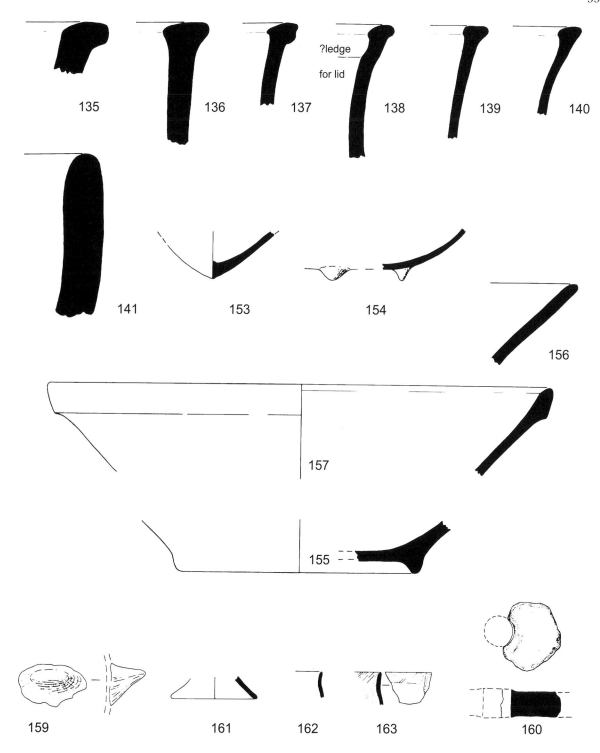

FIG. 3.11. Palace Well (EM I). Type 21 large storage jars (pithoi) **135–141**; bases **153–157**; relief wart **159**; miscellaneous **160–163**. Scale 1:3.

FEATURES

SPOUTS **150–152**

There are four or five open trough spouts (as FIG. 5.7: **a1–a2**), which appear to come from bowls. The bowls may be of type 8, since all the spouts are burnished. Spout **150** (PLATE 9), which is larger than the rest, has a white slip and rather coarse burnish.

In addition, there are two fragments of what seems to have been a long open spout **151**, belonging perhaps to a jug of type 11 (PLATE 17): this is of hard metallic fabric, of dark red clay, with a grey-

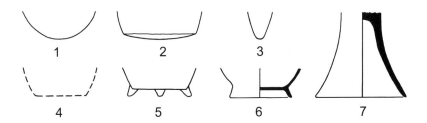

FIG. 3.12. Palace Well (EM I). Base types: 1, rounded; 2, carinated; 3, pointed; 4, flat; 5, lug (or pellet) feet; 6, ring; 7, pedestal.

black wash both sides; the outside is decorated with parallel lines of pattern burnish (but two small warts on the outside surface are just blisters from over-firing).

One fragmentary nozzle (as FIG. 5.7: **b1**) is **152** (PLATE 17); one of its two joining fragments has been discoloured by fire. There are no signs of the distinctive cutaway teapot spouts (FIG. 5.7: **c1–c2**) well attested in EM IIA.[252]

HANDLES

These are normally round or thick oval in section. Most no doubt belong to jugs, but some may come from bowls of types 7–9. **99–100**, evidently from jugs, have warts near the junction with the rim. Several wide strap handles with burnished surfaces seem Neolithic; but some small strap handles and one large one come from EM I pithoi.

PERFORATED LUGS

These are not common, but they occur in all sizes and are associated with a wide variety of vessel types. Three are from bowls (e.g. PLATE 16: **32**, and FIG. 3.5: **33**), others from large store jars or pithoi. The smaller ones mostly belong to suspension pots of type 14 or their lids (type 15), e.g. **110–111** (PLATE 12). All these lugs are of a simple type with a single vertical perforation; no example of a lug with a double perforation was noted, and these may not have been made in Crete before EM II.

BASES (FIG. 3.12) **153–157**

Rounded
More or less rounded or roughly flattened bases are common, especially on jugs of types 11 and 12. Many fragments of such bases, apparently from jugs of type 12, come from the lower part of the Well. It has long been axiomatic that bases in EM I are in general rounded.[253] The Well evidence confirms this. The prevalence of rounded bases in EM I is a marked contrast to the fashion for flat ones in EM II — and to the Neolithic tradition of Knossos.[254]

Differentiated by a carination, but slightly rounded
Bases of this kind seem especially popular on bowls of types 8 and 9, but not confined to them. Some jugs seem to have had bases like this.

Several bowls or cups assignable to EM I (or IIA at latest) have bases of this shallow rounded type separated by a sharp carination from the rest of the vessel. These include a bowl from Pyrgos with inward leaning sides and a pair of vertical handles like **31** (FIG. 3.5);[255] a bowl from Eileithyia;[256] and cups with outward curving sides from Kyparissi and Lebena T. II lower.[257] Such bases are also found on some small cup-like bowls (*bicchieri*) from Phaistos FN.[258] Some of what Xanthoudides[259] thought were the earliest cylindrical pyxides from Pyrgos have bases like this. Rather more elaborate forms of such bases occur on comparable EC pyxides.[260]

[252] E.g. Koumasa: Zois 1967a, 714–16, pl. 18.
[253] E.g. *PM* I, 63; Zois 1967a, 712, 728.
[254] At Phaistos FN bases are mostly flat, but some are rounded. Rounded bases are a feature of Trapeza ware (H. W. Pendlebury *et al.* 1936, 29–30, fig. 7) — which Tomkins (2007, 20, table 1.6; 44) assigns to FN IV.
[255] Xanthoudides 1918a, 153, fig. 10: 81; 155.

[256] Marinatos 1929a, 96, fig. 1 below.
[257] Alexiou 1951, 279, pl. 14.2: 3; Alexiou and Warren 2004, 69, fig. 21, pl. 41C: 74 — cf. too, for the pulling out of the body towards the rim, the mugs: 84, fig. 24, pl. 58A: 219–20.
[258] Vagnetti 1973a, 67, 71, fig. 66: 5.
[259] Xanthoudides 1918a, 143, fig. 7: 30–1, 34–5; 151, fig. 9: 73.
[260] E.g. Zervos 1957, pls. 81–2, 84.

The original inspiration for bases of this distinctive type, as for much else that appears for the first time in Crete in the pottery of EM I, may have come from the Levant. Bowls with bases like this and resembling **63** in shape, but without spouts or handles, occur in Ras Shamra III2 (IIIB), the horizon of Northern Ubaid which seems to correspond to Late Chalcolithic in Cilicia.[261] Similar bowls are attested in Egypt in Dynasty I.[262] Bases of the kind found on these bowls also occur on spouted bowl-jars from Arad II assignable to EB II, which falls within Egyptian Dynasty I.[263]

Pointed

The only example of a pointed base **153** may come from a bowl (FIG. 3.11, PLATE 16). Its outside surface is light red-brown, burnished; the inside is smoothed if not burnished.

Flat

No certain example of a flat or concave base was recognised, but some large store jars or pithoi may have had flat bases (see above).

Flat with lug (or pellet) feet [264]

Only two possible fragments were noted. The more convincing of these is **154** from a jug or small jar (FIG. 3.11, PLATE 16). Its inside surface is scored; the outside has a wash in shades of red and brown.

Zois notes lug (pellet) feet on vessels he assigns to EM I from Kyparissi and Pyrgos.[265] He suggests, however, that they did not occur on jugs with painted decoration until EM II; but they are found on jugs in Debla I and are well represented in Debla II,[266] and are found on Minoan pyxides at Ayia Fotia (Siteia).[267] A cup with painted decoration in dark-on-light from Kyparissi even has four tall wide feet that are like those of some EM tripod cooking pots.[268] For pellet feet in EM II, see p. 118, 131.

Ring

Three fragments seem to come from one or perhaps two wide ring bases belonging to large open bowls (FIG. 3.11, PLATE 17: **155**). The clay of these fragments is gritty, reddish and well fired, with a greyish white or greenish wash inside and outside. Similar in fabric, and possibly from the same vessel, is **156** (FIG. 3.11, PLATE 17), the rim of a very large shallow bowl (D. *c.* 60) of coarse gritty grey clay, much worn but with traces of a thick greenish slip inside, and outside diagonally wiped below the rim. Thickened rim **157** has been restored with base **155** on FIG. 3.11, but may in fact come from a very large pedestal, as suggested on PLATE 17.

Pedestal bases

These are common, and occur in all sizes (pp. 30–6). Most apparently belong to chalices or bowls of types 1 and 2, but some may come from other shapes, the smallest perhaps from suspension pots of type 14.

MISCELLANEOUS **160–163**

160 FIG. 3.11, PLATE 8. Frag. of flat object with large hole. Coarse, very crumbly greenish clay, with abundant large grey grit, and orange slip.

Three fragments of a markedly different fabric from the rest of the pottery found in the Well appear to be later (perhaps EM II) strays rather than imports, although the possibility of pottery travelling over long distances by sea in early times must be kept in mind; the recognition of what appears to have been a wheelmade vessel imported from Syria found by Schliemann in an early level of Troy I is highly suggestive in this connection.[269] The clay of these fragments is soft and orange; they have a slightly lustrous red wash. Apart from **161**, the fragments of this fabric

include a scrap of rim with a bead, and the base of a small jug or jar, which has no red wash inside.

161 FIG. 3.11. Frag. of small pedestal foot. D. base 7. Red wash inside and outside.

Two other rims found in baskets with material from deep in the fill of the Well are clearly strays of much later date.

162 FIG. 3.11. D. *c.* 14. Fine orange clay, with paler orange surface. Horizontal marks both sides seem wheel marks. LM III (?).

163 FIG. 3.11. D. *c.* 12. Fine orange clay, with buff well smoothed or burnished outside surface. Inside has light brown, slightly lustrous wash, which continues round outside of rim. LM I (?) cup.

[261] Schaeffer 1962, 483, fig. 4 C–D; 513; 1969, 83–4, fig. 24: 16.
[262] Emery 1949, 152–3, fig. 87: J1–J2.
[263] Amiran 1978, 116, pl. 42: 7, 9.
[264] Cf. Wilson 2007, 61.
[265] Zois 1967a, 723, discussing e.g. Alexiou 1951, 278–9, 281–2, pls. 13.2: 2, 14. 1: 2, 14.2: 4.

[266] Warren and Tzedakis 1974, 323–8, figs. 19–20: P7, P9–13, pl. 52c top right; 339 (for comparisons and date).
[267] T. 2: Betancourt 2008b, 62–3, fig. 5.22.
[268] Alexiou 1951, 282, pl. 14.2: 10.
[269] Kühne 1976, 49–50, pl. 40: 2.

DECORATION

PAINT

Painted decoration with simple linear designs in dark-on-light (shades of red, brown or black on a light, usually buff, ground) appears rare but characteristic, and largely confined to jugs with cutaway spouts of type 11 (see p. 42).

The extreme simplicity of this painted decoration corresponds to what has been observed in the past as characteristic of EM I, and makes a striking contrast to the more elaborate decoration of EM IIA.[270] Decoration is virtually confined to groups of rather thin parallel lines. Necks of jugs are regularly covered with multiple horizontal lines, as was still usual in EM IIA at Knossos to judge from the WCH.[271] Groups of horizontal, vertical or diagonal lines adorn jug bodies. Groups of diagonal lines may cross to form a lattice, as on **86–87**, and this type of lattice also occurs in pattern burnish on the remarkable suspension pot **105**; but there are no examples of the dense lattice pattern in clearly defined areas found in EM IIA. The crossing lines of **82** and **85** occur elsewhere in EM I and continue into EM II.[272] The solitary spot on **81** (one of three examples from the Well) has a very close parallel at Pyrgos.

Washes were evidently applied over all or part of the vessels with decorative intent, and the *deliberate* splashing of the outsides or insides of vessels (see pp. 41, 52) may be ancestral to the trickle ornament which is such a conspicuous feature of domestic pottery in all subsequent Minoan periods. Trickle or splash ornament of this kind was already standard in Crete by EM IIA, being found on pithoi from the WCH[273] and Fournou Korifi I — and abundant there in period II.[274] It also occurs on fragments of large vessels from the West Yerogalaro ridge at Prosymna in the Argolid. Blegen, while noting the resemblance to MM trickle ornament, assigned these to an early phase of Neolithic,[275] but the assemblage, of which they were part, seems to be LN.

BURNISH, INCLUDING PATTERN BURNISH

One of the most characteristic features of EM I pottery is the deliberate use of burnishing in various ways to give a decorative effect. This is achieved most simply by means of contrasted areas of vertical and horizontal stroke burnishing. The term 'pattern burnish' is confined to those cases where designs have been made with the burnishing instrument on an unburnished, or on an already smoothed or burnished area of surface, as seen on the suspension pots of type 14 and the chalices and pedestal bowls of types 1 and 2.

Pattern burnish occurs on various shapes from the Well, mostly on chalices and pedestalled bowls with dark surfaces, but also on suspension pots and some vessels with light surfaces.[276] By EM IIA it would seem that the shapes which have pattern burnish are more restricted, while those bearing painted decoration in dark on light are far more numerous than they had been in EM I, when dark on light decoration seems to have been virtually confined to jugs of type 11.

The designs that occur in pattern burnish from the Well are mostly very simple: groups of parallel lines, wavy bands or zigzags, more rarely lattice. Wavy bands characteristically occur below the rims of some pedestal bowls of type 2. The most elaborate examples of pattern burnish, including lattice, are on suspension pots of type 14 (PLATE 12). Fine lattice pattern burnish is also found on a two-handled bowl from Kyparissi.[277] The groups of parallel chevrons that appear on goblets at Pyrgos[278] and Knossos (**1228**) are not found in the Well, but this design does occur in pattern burnish in the EBA of Palestine. The spirals on chalice **1182**[279] and a chalice from Arkalochori[280] probably both date to EM I: these vessels may be from the same (Knossian) workshop (see p. 246).

One example of true pattern burnish from Evans's excavations at Knossos may come from a deposit assignable to EN.[281] Other examples recovered from possible LN contexts during the old excavations were illustrated by Furness.[282] The 'very few sherds with simple pattern burnish' found in 'LN' levels

[270] E.g. Zois 1967a, 713–14; cf. Wilson 1985, 319–30.
[271] Wilson 1985, 320–1, fig. 21, pl. 35: P179–181 etc.; 323, pl. 38: P218.
[272] Zois 1967a, 724.
[273] Wilson 1985, 353–4, pl. 55: P459–460.
[274] Warren 1972a, 107, pl. 37 A, and *passim*.
[275] Blegen 1937, vol. 1, 375; vol. 2, 156, fig. 634.
[276] For a discussion of pattern burnish in the 'Fine Dark Gray Burnished Class', with references, see also Betancourt 2008b, 56–63.

[277] Alexiou 1951, 278, pl. 14.1: 6.
[278] Xanthoudides 1918a, 155, fig. 11: 77; 159, pl. 2 right (Zervos 1956, 123, pl. 86).
[279] First noted by Furness (1953, 132).
[280] Hazzidakis 1913, 38–40, fig. 3.
[281] Furness 1953, 109, fig. 5c: 12: EN I — which equates to EN–LN I in Tomkins's scheme (2007, 13, table 1.2).
[282] Furness 1953, 132, pl. 31b: 14–16.

in J. D. Evans's 1957–60 excavations,[283] now assigned to FN,[284] appear to have been similar, with thick parallel stripes of pattern burnish unlike that from the Well but resembling that on some Final Neolithic pottery from Phaistos.[285]

Pattern burnish is at home from very early times in the Levant, and is also attested in what may be a relatively early horizon in the eastern Aegean and the Troad, as well as in EN in Thessaly.[286]

INCISION, GROOVING AND CHANNELLING

Decoration of this type is normally bold, and virtually confined to large storage jars and pithoi where it appears not uncommon (see pp. 52–3). Bold channelling is also found on the large lids of type 18. True incision occurs on bowl rims **43–44** (PLATE 6), but really fine incision only on a fragment of a miniature jug **88** (PLATE 9). The comparative rarity of true incised decoration might be regarded as merely the natural development of a tendency manifest in the latest Neolithic phase (Stratum I) at Knossos.[287]

Bold lattice work, gouged, incised or scored on the insides of some large bowls or open jars (e.g. PLATE 6: **53**, PLATE 17: **158**), was evidently not decoration but had a functional purpose. This kind of lattice scoring continued into MM I, if not later. In MM it may have been used as a device for ensuring the proper firing of thick-walled vessels, but in earlier periods such scoring could indicate that the vessel was used for grinding (or as husking trays), as the signs of possible wear at the bottom of the scoring on **158** would suggest. Another likely explanation is that they served as, or were designed to be, bee skips (hives), as is probably the case for tubs (lekanai) like those already frequent in Myrtos–Pyrgos II and III. The incisions helped the honey to stick.[288]

RELIEF

(a) Ribs are common on pithoi; they are usually straight and horizontal, e.g. **133**; but one at least curves (PLATE 15: **142**). (b) Warts. Low oblong warts appear as regular features on lids of types 17 and 18. Three large solid warts as **159** (FIG. 3.11, PLATE 16) with a red wash evidently come from one or more jars; they had been applied while the clay was wet and had subsequently come away from the surface. Handles **99–100** (FIG. 3.7), both apparently from jugs, have warts on them.

OTHER ARTEFACTS

PLASTER

Two scraps of wall plaster found in level 18 (deposit 2) have been analysed and discussed by Cameron *et al.* One fragment is of mud plaster and may have been a backing for a finer, white lime plaster[289] — of which there are indications on the other fragment, which is probably of mud mixed with lime with, perhaps, a lime-washed surface.[290] It is possible, however, that the 'lime' is only calcareous earth.

Cameron *et al.* note also that, if there was a lime wash, this marks a departure from the mud (only) plaster of Neolithic Knossos, and thus EM I saw the beginning of the Minoans' practice of putting lime plaster over coats of clay to prepare them for painting. The main purpose, however, of EM painted plasters was 'architectural rather than decorative,'[291] to provide a finish that was 'smooth, hard and somewhat impervious'.

[283] J. D. Evans 1964, 229.
[284] Cf. Tomkins 2007, 13, table 1.2.
[285] Vagnetti 1973a, 86, 107, fig. 108: 5; 112, fig. 119: 1–3, pl. 1: 9.
[286] Hood 1981, 221–5 with references. Cf. Betancourt's caution (1985, 28–9; 2008b, 60).
[287] J. D. Evans 1964, 229; Tomkins 2007, 42 (on Stratum IC: FN IV).
[288] Fragments with internal scoring and comparable signs of wear have been found at Neolithic Lerna. Vitelli (2007, 102–03, 216–17, fig, 16; 272–7, figs. 44–6) calls them 'Coarse Urf (= Urfirnis) gouged bowls'. They begin in Lerna I (EN), although the earliest are not gouged but have a pebble temper (214–15, fig. 15), and are a feature of Lerna II (MN). She has published similar bowls from the Franchthi cave (Vitelli 1993, 156, 186–7, 396–7, fig. 40g–h, pl. 3c), to be dated somewhere in Franchthi Ceramic Phases 2.1–2.2. Cf. Felsch 1971, 9, on internal scoring as a feature of MN in the Peloponnese; also Ayioryitika (Petrakis

2002, 42–3, figs. 26: 96; 27: 97–101; 28: 102–05; 77, citing 'the so-called husking bowl or bowl with interior scoring'), Asea (Holmberg 1944, 44–6, fig. 45) and Nemea (Blegen 1975, 264, fig. 5m; 270, pl. 68: 13–16).

Vitelli (1993, 185–7; 2007, 102–03) discusses their use, noting that the scoring could be as much for adhesion as for abrasion: but if they were bee skips, that means Lerna II had a lot a hives. She also mentions the husking trays of Tell Hassuna (Lloyd and Safar 1945, 277–8, fig. 3: 8–10, pl. 18: 1): cf. Weinberg 1965, 293.

For lekanai with internal scoring in the base as bee hives, see now Harissis and Harissis 2009, 20–1, fig. 7, and Melas 1999, 486–8, pls. 107a–f, 108a, c–d.

[289] Cameron *et al.* 1977, 125, 131–2, n. 15; 147–8, 174, pl. 11: 2.
[290] Level 18, small find 20: Cameron *et al.* 1977, 125, 147–8, 174, pl. 11: 1.
[291] Cameron *et al.* 1977, 148.

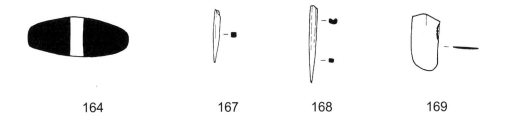

FIG. 3.13. Palace Well (EM I). Spindlewhorl **164**; bone tools **167–169**. Scale 1:2.

CLAY

A fragment of a spindlewhorl **164** is probably Neolithic, as may be two small discs **165–165A** that appear to have been deliberately cut from potsherds. Such discs are common at Knossos from Stratum VII (MN) onwards,[292] where they appear to be examples of deliberate fragmentation.[293] For other EM occurrences, see a fuller discussion with more parallels for **1153–1154** below (p. 227)

164 (level 5, small find 2) FIG. 3.13, PLATE 18. Spindlewhorl frag.; 1/2 missing. D. *c.* 5.5. Fairly coarse grey clay with mica. Surface smoothed or burnished.
 Probably Neolithic: cf. J. D. Evans 1964, 218, fig. 56, 233–5, pl. 57: 3–4. EM spindlewhorls from Fournou Korifi and Debla are of quite different types: e.g. Warren 1972*a*, 246–7, figs. 99–100; Warren and Tzedakis 1974, 331, fig. 21: Cl–2.
165 (level 3, small find 33) PLATE 18. Roundel cut from

sherd. D. 2.5. Dark grey-black clay, burnished inside and outside.
165A (level 5, small find 4) PLATE 18. Like **165**. D. 2.3.
166 PLATE 6. Rod. Broken at one end. L. pres. 3.7. Very roughly made, grey clay.
 Possibly a fragment of a 'calculus' of the type recognised from pre-literate and later contexts in Anatolia and elsewhere in the Near East: cf. Hood 1982, 627–9, pl. 131: 11–14.

We may include here the burnt fragments of what we believe to unbaked clay bins that were fired to a considerable extent in the fire(s) that burnt so much of the pottery in the Well. Forty-one fragments come from levels 5 and 6, near the top of deposit 2, together with pieces of burnt mud brick or daub.

The fabric of these pieces is like that of badly (kiln-)fired oatmeal or pithos wares — or a *paximadi* (rusk). After the (accidental) firing, their colour ranges from buff to light brown to grey and dark grey, and one piece is orange. They are covered on both sides with a smoothed skim of mud, and many of them have been wiped, almost certainly with grasses. In several cases the effect is like that of a paler slip, with a thin surface layer of clay being quite distinct from the body of the fragment. But other pieces look self-smoothed by the potter's wet, clayey hands. On one piece this slip is dark brown, which probably reflects the effects of the fire(s) rather than deliberate colouring of the surface. The interior of these pieces may be granular, and is often fractured, showing inclusions of lumps of apparently carbonised vegetal matter, small stones (gravel) and bits of *kouskouras*; there are no signs, however, of bones or sherds, in contrast to the mud brick pieces.

It is just possible that these pieces and the mud brick fragments are in fact all of the same mixed material, which has reacted differently in the heat; but we think it more likely that they are different. The grass marks and wiping tie in well with the wiping of the jugs from the Well.

The key features in interpreting the shape and functions of these remnants are: (1) finished surfaces on both sides; (2) a typical thickness of 2.5–3.5; (3) their having rims; and (4) the signs of a curve on many of the fragments. To us it suggests that they are (household) furniture of a considerable diameter. The best bet, we believe, is that they are the remains of flat-topped bins or tubs, since their apparent rims preclude their being domed ovens. If they were bins, they were slightly smaller than the clay bins (D. typically 80) that are such a feature of LH IIIC Lefkandi.[294]

The following rim fragments are shown in FIG. 3.14 and PLATE 19 (where **166A–166D** are shown on the inside, and **166E** on the outside).

166A D. ? Buff slip inside, as in later cooking pot ware. Four other similar rims.
166B D. inside *c.* 60?? Slight groove on top.
166C D. 60. Curve on inner lip.

166D D. *c.* 64. Pronounced groove on top. One other similar rim.
166E D. ? With flange.

[292] J. D. Evans 1964, 235, pl. 58: 1–2.
[293] Tomkins 2009, 133.
[294] Evely 2006, esp. 211.

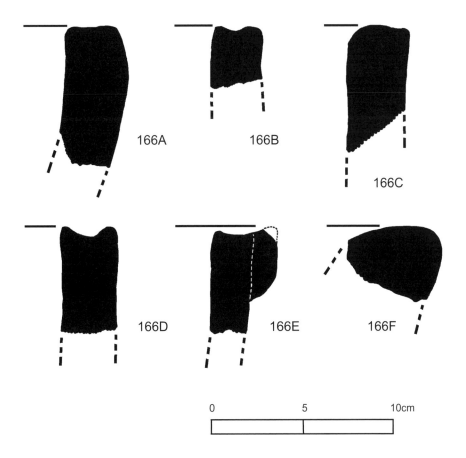

FIG. 3.14. Palace Well (EM I). Clay bins **166A–166E**; mud brick **166F**. Scale 1:2.

The approximately 26 pieces of mud brick or daub are generally of a pink to brown homogeneous clay, originally fairly muddy, and now ashy in appearance, and fired so that have become slightly porous. They have a remarkable range of inclusions: vegetal matter including probably a small olive stone (PLATE 19: **166F**);[295] burnt bone; small sherds, one of them possibly Neolithic; small stones including small lumps of, presumably, *kouskouras*. These inclusions need further study.

The larger pieces have partial indications of flat and/or smoothed surfaces. What is presumably part of a brick has two faces and is 7.1 thick. The largest piece measures *c.* 11.5 × 8.9 × 10. **166G** (FIG. 3.14) is curved (D. *c.* 32) and has two faces: might it be from a cover for a pithos? **166H** (PLATE 19), with maximum dimensions 6.5 × 4.5 × 2.9, is of either accidentally or badly fired unbaked clay. The clay is an earthy brown to dark brown with many vegetal inclusions and some bits of quartzite. Its one smooth surface, pink to orange in colour, has the impression of a vine leaf (for discussion, see pp. 68–9 below).

BONE

Three fragments of bone tools were found in the Well.

167 (level 16, small find 14) FIG. 3.13, PLATE 18. Tip of awl or pin. L. pres. 2.8. Circular section.
168 (level 22, small find 23) FIG. 3.13, PLATE 18. Tip of awl or point, from rib of sheep or goat (Wall-Crowther). L. pres. 4.2. Roughly rectangular section.
169 (level 23, small find 27) FIG. 3.13, PLATE 18. Tool frag., from rib of sheet or goat (Wall-Crowther). L. 3.1. W. 1.4. End rounded like a spatula and smooth through use.

STONE

A small fragment of a saddle quern and two or three pounders were found. A few stones of irregular shapes appear to have been used as rubbers. A couple of pot boilers had surfaces cracked and flaked by fire.

[295] We thank Alexandra Livarda for the suggested identification.

170 (level 23, small find 28) PLATE 18. Frag. of saddle quern. L. pres. 1.7. W. 2. Th. 3.6. Probably sandstone: light grey, fine-grained with black and silvery specks.

171 PLATE 18. Pounder, elongated, axe-like. L. pres. 9.1. W. 7.5. Grey limestone with white calcite veins (Warren). Broken at one end, perhaps from hammering; abraded from use at the other. Warren notes that the sides had been used for rubbing.

172 PLATE 18. Pounder, roughly cuboid. Fine hard grey-brown serpentine (Warren). D. 4.6. Pocked all over from use. Also **172A** (PLATE 18) frag. of another similar of basic rock with chlorite (D. 5).

Cf. Warren in Sackett *et al.* 1965, 310–11, fig. 24, pl. 80 a: 67 (group IB); Hood 1982, 648: pounders and rubbers (1).

173 (level 4, small find 32) PLATE 18. Rubber, flat, triangular in shape. Hard opaque creamy brown stone with a translucent grey layer on one face. 6 × 3.6 × 0.7. All surfaces polished.

174 (level 22, small find 34) PLATE 18. Rubber (?). Hard fine grey stone. 4.6 × 2.2 × 0.6. Smoothed by use, or water action.

175 PLATE 18. Rubber (?). Grey-brown stone, creamy white with a tinge of pink at the wide end. L. 4.5. W. 4.7.

176 PLATE 18. Rubber (?). Fairly hard grey stone with a tinge of green. 12.8 × 4 × 2.

177 PLATE 18. Pot boiler (?). Soft dark grey-brown stone with marks of burning. 8.2 × 6.8 × 4.6.

178 PLATE 18. Pot boiler (?). Light grey to dark brown stone with patches of black, red and green. 14.6 × 9 × 4.8. Surface cracked and flaked as if from fire.

179 (level 7, small find 7) Small lump of Naxian emery. W. *c.* 1.

OBSIDIAN

Doniert Evely

Some decades ago Robin Torrence studied the obsidian from Hood's excavations, with the help of John Cherry, who drew the more interesting pieces. Torrence has now given her notes and data, which were also part of her research into the obtaining and distribution of obsidian in the prehistoric Aegean,[296] together with the drawings to Hood for my use in this and the publications of the other excavations.[297] Hood, Cadogan and I thank her warmly, and Cherry for allowing us to present some of his drawings (FIG. 9.2): their quality is self-evident. With Torrence's encouragement and permission, I have made ample use of her records, but wish to stress that she is not responsible for what is said here. What follows is a summary of what will be part of a comprehensive account of the obsidian from Hood's excavations for publication elsewhere.

Torrence identified 48 fragments of obsidian from the Well: 33 prismatic blades and 15 flakes and chunks. About 35 of these fragments are from deposit 2, and four (two blades, a flake and a chip) from deposit 1.

The obsidian is in every case opaque, and probably from Melos, like that from the Neolithic levels. None is of the transparent glassy type that may originate from Yiali. No cores proper were recorded and only one crested blade; even the true flakes accounted for but 13 pieces (3 being chips and chunks). First series blades occasionally turn up, but were considered serviceable and may carry retouch/wear damage. Thus, although there can be little doubt that obsidian was being processed on site at Knossos in EM I, yet the material disposed of down the Well is weighted towards the primary desired end-product of the Bronze Age knapper, namely the prismatic blade. Their knapping seems to be by indirect pressure, although the tool responsible is not clear. An antler tine, or bone or wood fragment, perhaps remain the more likely candidates, but D'Annibale has suggested a metal-tipped tool for LN/EM blades at Petras.[298]

Of the blades measured, the examples fall at the upper limit of the typical EM Cretan example (with a length of up to 5 or so).[299] Thus, any Cycladic influence on them in terms of size is not readily discernable.[300] One-third of the blades carry clear, and at times quite heavy, patterns of retouch: discriminating between this and wear/use-damage has not been much pursued at present, as it requires specialist knowledge and equipment. Nonetheless, some of the medial blade segments clearly have been retouched.

For the flakes, as might be expected, one primary (completely cortical) flake is heavily outnumbered by secondary (some cortex: 7) and tertiary (no cortex: 5) flakes. One secondary piece has retouch/wear-damage on one edge.

[296] Torrence 1986. For a recent account of Neolithic obsidian at Knossos, see Conolly 2008.

[297] These records and the other records of Hood's excavations at Knossos will be deposited eventually in the Archive of the British School at Athens.

[298] D'Annibale 2008, in preparation, and pers. comm. Similar work on flint has been published for Indus Valley tools: Méry *et al.* 2007, 1105–09.

[299] See also p. 229 below, and ns. 21–22; also p. 236.

[300] The influence in question being seen in the published pieces from Ayia Fotia (Siteia), where the *average* complete blade is 6.7 long (Carter 1999, 10.7.8) — which is 1 cm or more than the *largest* Knossian fragment.

BIOARCHAEOLOGICAL REMAINS

FAUNAL REMAINS AND TAPHONOMY

Valasia Isaakidou

FAUNAL REMAINS

Although few, the animal teeth and bones collected from the Palace Well are an important resource, not only because faunal assemblages of EM I date are few and far between, both at Knossos and more generally on Crete, but also because they can contribute to debates concerning the nature of the Well deposits, most importantly that of deposit 2.[301] Unfortunately, the small size of individual assemblages (<400 specimens[302]) precludes a detailed and statistically valid analysis of *animal exploitation* here, although this has been attempted elsewhere in the context of a diachronic study.[303] Thus, the present section discusses data from the systematic recording and analysis[304] of selected animal bones and teeth from deposits 1 (levels 22–25) and 2 (levels 3–21),[305] mainly from the point of view of the taphonomic history of the assemblages.

Deposits 1 and 2 yielded in total 139 recordable specimens, representing 146 Maximum Anatomical Units (MaxAU) and 142 Minimum Anatomical Units (MinAU). The assemblages were hand-collected during excavation. Even though very small skeletal elements (e.g., foot bones, unfused ends) are most likely to have been missed due to low visibility,[306] the small size of some of the specimens suggests that considerable effort was made to collect all visible material. Thus, it may be cautiously suggested that the assemblages recovered are fairly representative of the material originally deposited.

In both deposits specimens were identified of all four major farmyard animals (TABLE 3.1) commonly present at Knossos,[307] while the assemblage from deposit 2 also included a dog bone. Some specimens bore butchery marks (TABLE 3.2), and some long bone fragments were of the 'end-and-shaft' type common in material broken to extract marrow (TABLE 3.3; 'cylinders' are more typical of attrition by dogs; shaft splinters are common results of both human and canine activity).[308] The range of species, butchery marks and high levels of bone fragmentation (there were no complete long bones; see TABLE 3.3) indicate that these assemblages are by-products of animal carcass processing for human consumption. Moreover, all parts of the skeleton (head — trunk — limbs — feet) were represented, including both meaty parts, which would have been discarded after consumption, and non-meaty parts (e.g., phalanges), which would have been discarded in the initial stages of carcass dressing (TABLES 3.5 and 3.6). This suggests limited, if any, spatio-temporal segregation of the different stages of carcass processing.[309]

TABLE 3.1. Palace Well. Species/taxon representation in deposits 1 and 2.

	Deposit 1		Deposit 2	
	MaxAU	MinAU	MaxAU	MinAU
Cattle	15	15	33	32
Pig	5	5	14	13
Sheep/Goat[310]	26	24	25	25
Sheep	9	9	12	12
Goat	4	4	2	2
Dog	0	0	1	1
TOTAL	**59**	**57**	**87**	**85**

[301] Wilson and Day 2000; Day and Wilson 2002, 2004.
[302] Van der Veen and Fieller 1982.
[303] Isaakidou 2004.
[304] Analysis of the material discussed here, funded by an AHRB doctoral studentship, was originally undertaken for my doctoral dissertation (Isaakidou 2004), which presents in detail the methodology and recording protocols used.
[305] Bones from deposit 3 were not studied, because of its chronologically mixed nature.
[306] Cf. Payne 1985, 220–1.
[307] Isaakidou 2007, 151–6.
[308] Binford 1981, 155, fig. 4.48.
[309] Cf. O'Connor 1993.
[310] This category includes specimens not identifiable to species level.

TABLE 3.2. Palace Well. Butchery marks observed in deposits 1 and 2 by stage of butchery and type of tool (MaxAU counts of all taxa combined).

| | 'Knife' marks | | | | 'Cleaver' marks |
	Dismembering	Filleting	Skinning	Filleting & Dismembering	Dismembering
Deposit 1	2	3	0	1	0
Deposit 2	5	3	1	1	1

TABLE 3.3. Palace Well. Fragmentation of 'long bones' from deposit 2 by fragment type (long bones = humerus, radius, femur, tibia and metapodials; MaxAU counts, excluding foetal/neonatal specimens and loose unfused epiphyses; 'Sheep & Goat' includes speciated sheep and goat and non-speciated sheep/goat specimens).

	Cattle	Pig	Sheep & Goat	Total
Whole	0	0	0	0
End/end+shaft fragment	9	4	22	35
Shaft splinter	10	1	17	28
Cylinder	1	0	7	8
TOTAL	**20**	**5**	**46**	**71**

TABLE 3.4. Palace Well. Frequency of gnawed (excluding loose teeth) and burnt specimens.

| | Deposit 1 | | Deposit 2 | |
	MaxAU	%	MaxAU	%
Not gnawed	36	64.3	59	72.8
Gnawed	20	35.7	22	27.2
Unburnt	51	86.4	76	87.4
Burnt	8	13.6	11	12.6

TAPHONOMY

The analysis of taphonomic markers is informative for the history of discard of the faunal remains and their deposition in the Well. First, a high proportion of specimens in both deposits bore carnivore (mostly) or rodent (rarely) gnawing marks (TABLE 3.4), implying that at least part of the assemblage had been exposed on the surface after human consumption and discard and prior to its deposition in the Well. The absence or rarity of vulnerable anatomical zones, such as proximal humerus and distal femur (TABLE 3.5 and 3.6), is also compatible with loss due to scavenger attrition.[311] Secondly, a number of specimens, belonging to both meaty (legs) and non-meaty (feet) parts and of all species/taxa, exhibited uniform discolouration caused by burning, with colours ranging from dark brown to grey/white (calcined). The colours and uniformity of burning on individual specimens are compatible with exposure to high temperatures, subsequent to stripping of surrounding soft tissues. Moreover, a pig's second phalanx from deposit 2 (level 5) was both burnt *and* gnawed by a rodent, and therefore burnt after discard. The above evidence is compatible both with accidental (e.g. cooking accidents, conflagration) and deliberate burning (e.g. of refuse), but not with the effects of cooking or roasting of meat on the bone.[312] Finally, all long bones were fragmented (an effect both of human processing and scavenger attrition) (TABLE 3.3.), no matching/paired or articulating skeletal elements could be identified, and the individual animals that contributed to the assemblages were represented by few of their body parts.

[311] Cf. Brain 1981, 23, fig. 18.
[312] Charring of bone from cooking/roasting would result only in localised charring of bone.

TABLE 3.5. Palace Well. Minimum Anatomical Unit (MinAU) counts by species in deposit 1.

Key to abbreviations: p = proximal; d = distal; HC = horn core; MD = mandible and loose mandibular teeth; SC = scapula; H = humerus; R = radius; U = ulna; MC = metacarpal; PE = pelvis; F = femur; T = tibia; A = astragalus; C = calcaneum; MT = metatarsal; PH = phalanx; MP = metapodial. Min = minimum; A = anatomical; U = units.

	HC	MD	SC	Hp	Hd	Rp	U	Rd	MCp	MCd	PE	Fp	Fd	Tp	Td	A	C	MTp	MTd	PH1	PH2	PH3	MPp	MPd	Total	%
Cattle	1	0	1	0	3	1	0	1	0	0	0	1	0	1	0	0	0	0	0	3	1	0	0	2	**15**	**26.3**
Pig	0	1	1	0	0	0	0	0	1	0	0	0	0	0	0	0	0	0	0	0	0	0	1	1	**5**	**8.8**
Sheep/Goat	0	0	0	0	2	5	2	2	2	1	0	2	0	1	1	0	0	2	0	3	1	0	0	0	**24**	**42.1**
Sheep	0	0	1	0	0	1	0	0	1	0	1	0	0	0	2	0	0	2	1	0	0	0	0	0	**9**	**15.8**
Goat	0	0	0	0	0	0	0	0	0	0	1	0	0	0	0	0	0	2	1	0	0	0	0	0	**4**	**7.0**
Total	**1**	**1**	**3**	**0**	**5**	**7**	**2**	**3**	**4**	**1**	**2**	**3**	**0**	**2**	**3**	**0**	**0**	**6**	**2**	**6**	**2**	**0**	**1**	**3**	**57**	

TABLE 3.6. Palace Well. Minimum Anatomical Unit (MinAU) counts by species in deposit 2. See TABLE 3.5 for abbreviations.

	HC	MD	SC	Hp	Hd	Rp	U	Rd	MCp	MCd	PE	Fp	Fd	Tp	Td	A	C	MTp	MTd	PH1	PH2	PH3	MPp	MPd	Total	%
Cattle	0	2	2	0	3	1	1	0	1	1	3	0	0	2	3	0	3	2	0	3	3	1	0	1	**32**	**37.6**
Pig	0	2	3	0	1	0	1	0	0	0	2	1	1	1	0	0	0	1	0	0	0	0	0	0	**13**	**15.3**
Sheep/Goat	0	1	1	0	1	2	0	1	2	0	2	2	1	4	4	0	1	1	1	1	0	0	0	0	**25**	**29.4**
Sheep	0	4	0	0	0	0	0	0	0	0	1	0	0	0	2	3	2	0	0	0	0	0	0	0	**12**	**14.1**
Goat	1	0	0	0	0	0	0	1	0	0	0	0	0	0	0	0	0	0	0	0	0	0	0	0	**2**	**2.4**
Dog	0	0	0	0	0	0	0	0	0	0	0	0	0	0	0	0	0	0	0	1	0	0	0	0	**1**	**1.2**
Total	**1**	**9**	**6**	**0**	**5**	**3**	**2**	**2**	**3**	**1**	**8**	**3**	**2**	**7**	**9**	**3**	**6**	**4**	**1**	**5**	**3**	**1**	**0**	**1**	**85**	

Interestingly, assemblages from both deposits display the above characteristics (TABLE 3.3).[313] The similarity could be explained as a result of comparable taphonomic histories, but equally, as many of the bones from deposit 1 were recovered from its uppermost level (level 22), part of the assemblage from deposit 1 may have percolated from the overlying deposit 2. In any case, the small number of bones in deposit 1 and their poor state of preservation is compatible with slow accumulation of debris as would be expected for the period during which the Well was in use, and presumably care would have been taken to avoid rubbish being discarded in the water. Another explanation for the presence of these few bones is that they are derived from the Neolithic strata through which the Well was cut and became incorporated into deposit 1 from the collapsing sides.

As regards deposit 2, the above taphonomic observations allow us to draw some important conclusions regarding the nature and formation of the assemblage. The admixture of burnt/unburnt and gnawed/ungnawed specimens,[314] the absence of matching/articulating skeletal elements, and the presence of all parts of the skeleton within the same deposit are compatible with at least secondary deposition and suggest that these assemblages consist of various components which, prior to their arrival in the Well, had followed different pre- and post-depositional pathways. Given the presence of Neolithic sherds (see above) in deposit 2, it is not impossible that at least some of the bones derive from the FN deposits through which the upper part of the Well was cut. Overall, the assemblage bears the hallmarks of generalised, slowly accumulated debris, typically encountered in settlement contexts.[315]

Does the taphonomy of the bones provide support for deposit 2 containing material from a fire destruction or a feasting event? As regards the first proposition, only a small minority of the bones are burnt, in contrast with material examined from LBA conflagrations at the Palace of Nestor at Pylos,[316] and at Assiros Toumba in northern Greece.[317] At best, therefore, the bones are only partly derived from a burnt destruction or are derived from a very patchy conflagration and, in the latter case, bone from food preparation had been discarded *within* a building to which both dogs and rodents had access. On the other hand, those bones that are burnt could have been exposed to fire in a number of different events and processes.

Secondly, might the faunal remains be derived from the feasting event(s) inferred by Day and Wilson from their study of the Palace Well pottery, on the basis of the state of preservation, stylistic homogeneity, highly elaborate nature and large size of a number of consumption and serving/ presentation vessels?[318] The bones offer no indication that primary butchery waste (e.g. heads and feet) was discarded separately from consumption debris (e.g. bones from meaty upper limbs), as sometimes occurs in ceremonial acts of consumption. Nor is there any hint of the 'wasteful' pattern of consumption that sometimes serves to distinguish 'feasts' from more run-of-the-mill commensality. The presence of cattle bones certainly indicates butchery of very large carcasses that could have been consumed at a very large commensal event, but they could alternatively have been distributed around the settlement for piecemeal consumption at a domestic level; the very sparse anatomical representation of individual animals is certainly compatible with dispersed consumption. More critically, the taphonomic characteristics of the faunal assemblage point to material that had accumulated gradually, potentially from a range of processing, consumption and discard events, *prior to* final deposition in the well. Although ceramic cross-joins throughout deposit 2 clearly indicate that the pottery in the main fill of the Well, together with the associated bones, was dumped in a single operation, the bones appear to represent gradually accumulated refuse of mixed origin. There are no hints, in the form of articulating or paired body parts or joins between specimens, that the bone refuse *includes* material rapidly buried from specific carcass-processing or consumption events. Given the apparently mixed origins of the bone material, there are no grounds for treating it as refuse from the same consumption event(s) as are represented by the ceramics in the Palace Well. In other words, the bones offer no indication that any feasting event(s) represented by the elaborate tableware involved consumption of meat, let alone allowing speculation as to the types of animals consumed, how they were butchered and cooked, or the number of participants they might have fed. It is also worth noting that, although less amenable to taphonomic analysis than the bones, the ceramic assemblage comprises a more or

[313] This observation is based on statistical (chi-square) tests comparing the frequency of gnawed and burnt specimens between the two deposits. It should be noted, however, that the results of the significance tests may only reflect the very small size of each individual assemblage.

[314] Burnt bones with unburnt were recorded in levels 5, 8, 12, 17, 20 and 21 and gnawed with ungnawed in levels 3, 5, 9,

16, 17, 20, 23.
[315] Cf. Halstead and Isaakidou 2004, 138, 140.
[316] Halstead and Isaakidou 2004; Isaakidou *et al.* 2002.
[317] Paul Halstead, pers. comm.
[318] Wilson and Day 2000, 52–3; Day and Wilson 2002, 149; 2004, 55.

less full range of functional types, including cooking and storage vessels. Moreover, despite multiple joins, the sherds recovered from the Well do not make up complete vessels and it is evident that burning occurred after breakage. The ceramic assemblage as a whole, therefore, is also not incompatible with a mixed origin and, although this does not affect arguments based on the size and elaboration of serving vessels, it does preclude further inferences from the composition of the assemblage as a whole or from its association with other material such as animal bones.

Molluscs
Rena Veropoulidou

Level 16 (deposit 2) produced two cockle shells (*Cerastoderma glaucum* Poiret 1789). One was water-worn when it was gathered from an estuary (the Kairatos at Poros?), and is naturally pierced; the other, a fragment, was gathered alive, whether for food or by chance.[319]

Olives and Vines
Jane M. Renfrew

OLIVES

An olive stone (small find 5) was found in level 5, which is near the top of the pure EM I deposit 2 (FIG. 3.2). There is no reason to suppose that it is a later stray. It is quite small: L. 0.85, W. 0.52. Another small olive stone can probably be seen in a mud brick from level 5 or 6 (PLATE 19: **166F**).

Crete has been famed since prehistoric times for its olives and olive oil. According to an ancient myth, Athena came from Crete and gave Cretans the sacred olive: certainly it was a staple for the Minoans. The earliest traces of olives in Crete occur in the pollen diagrams from Tersana on the Akrotiri peninsula in levels dating to Middle Neolithic, and by LN the pollen is abundant enough to suggest local cultivation, which appears to peak in the EBA levels.[320] It is thus not surprising to find palaeoethnobotanical evidence for olives in EM contexts. Besides these stones from the Palace Well, an olive stone is known from Fournou Korifi,[321] where there may also have been olive prunings,[322] and two from Lebena T. II;[323] and there are less well-dated stones from Debla.[324] The Palace Well stone confirms the picture that olives were used in EM Crete. While it has been suggested that not enough finds of olive stones have been made from EM contexts to infer that olive cultivation was of importance then,[325] one should remember that many excavations (including the three presented in this volume) took place before systematic flotation of soil samples for seeds was standard practice. The finds of olive stones have truly been subject to chance. Corroboration of the EBA cultivation of the olive comes from a study of the charcoal found in the EBA levels at Akrotiri on Santorini, where 50% was olive wood — possibly prunings used for firewood.[326]

It is not clear whether the olive, *Olea europaea L.*, was native to the Aegean area.[327] The remarkable finds of fossilised olive leaves preserved in successive volcanic deposits on Santorini show that they were present in the Pleistocene vegetation of the Aegean *c.* 60,000 years ago.[328]

There is fascinating evidence for the early extraction of oil, probably from wild olives, at several underwater sites off the Carmel coast of Israel. Most notable is installation No. 6 at Kfar Samir, where crushed olive stones and soft olive pulp were found in a circular pit buried under layers of sand. They were associated with woven mats, stone basins, concave mortars and grinding and chopping tools. Dates obtained from these olive stones range from 5530 to 4367 cal. BC.[329]

It is difficult to distinguish between wild and cultivated olives on the basis of size of the stones. In Crete today there are two main types of olives in cultivation: Chondroelia (also known as Throumbes)

[319] For the EM IIA shells from the WCH, and discussion of other EM shells, see Reese 1987.

[320] Rackham and Moody 1996, 125. See also Bottema and Sarpaki 2003.

[321] Warren 1972*a*, 23; J. M. Renfrew 1972, 316–17, fig. 126. *Pace* Hansen (1988, 45 and n. 38), the olive stones from the Spring Chamber at Knossos (*PM* II, 135) are most unlikely to be EM.

[322] Rackham 1972.

[323] They are slightly larger than the Knossos stones (Alexiou and Warren 2004, 16, 138).

[324] Warren and Tzedakis 1974, 336.

[325] Runnels and Hansen 1986, 301.

[326] Asouti 2003, 474.

[327] Bottema and Sarpaki (2003, 744) note that it 'did not occur in Crete by origin'.

[328] Some of them in the collection of Professor Evangelos Velitzelos are admirably illustrated in Talianis and Theodorides n.d., 13, 17.

[329] Galili *et al.* 1997.

with large fruits and stones, used both for eating and for the extraction of oil, and Psiloelia (also called Koroneiki) with very small fruits and stones, used mainly in oil production.[330] So distinguishing wild and cultivated olives on the basis of the size of the stones is not reliable.

What were olives used for apart from food and cooking in the EBA? There are numerous finds of clay lamps using wicks submerged in flammable liquid, probably olive oil, found in EM and MM tombs and also in EM settlements such as Koumasa, Fournou Korifi and Mochlos,[331] although there are no actual finds of olive oil from EM Crete comparable to the jug of oil and two pottery lamps in an EC tomb on Naxos.[332] By MM times stone and clay lamps were in widespread use. We cannot be sure that they were fuelled with olive oil, but it seems most likely.

The production of olive oil happens in three stages: the crushing of the fruits to form a pulp; the pressing of the pulp to extract the oil on a large flat surface often in a large spouted trough with a vessel below to receive the liquid; and finally the separation of the oil from water. This final stage took place automatically with oil being less dense than water and floating on top of it. Archaeological finds of vessels with a spout a little above the base may have been used to draw off the water so that only oil remained in the vessel. The spouted tubs at Fournou Korifi would have been as suitable for pressing olives as pressing grapes;[333] but these tubs do not appear in large numbers until the Neopalatial period, when at least 32 examples of spouted tubs (lekanes) and stone olive presses have been found.[334]

Blitzer gives a useful list of the MM and LM sites yielding olive stones,[335] most notably Kommos, and reminds us of the remarkable find in the well at the Palace of Zakros of a conical cup filled with olive fruits looking remarkably fresh, having been waterlogged since Minoan times.

The recording of olives on Linear A tablets[336] shows that olive cultivation was well established in the economy of Neopalatial Crete, and the tablets from Ayia Triada indicate that olives were probably used to pay labourers.[337] In the Linear B tablets olive oil was used as payment for labour and for cult offerings,[338] while oil from wild olives may have been used in perfumery.[339]

Large quantities of olive oil were stored in the enormous pithoi in the Minoan palaces. Those at Knossos may have held up to 82,000 litres of oil, the produce of between 16,000 and 32,000 trees planted in some 320 hectares.[340] It should be noted that olive trees usually fruit every other year, and that the oil has good keeping qualities.

Thus there can be little doubt that olives were cultivated in Crete from at least the EM period, if not earlier, and that they became an increasingly important part of Minoan economy during the Bronze Age.

VINES

166H (PLATE 19) seems to be part of a mud brick (see above) with the impression of a vine leaf. Other vine leaf impressions from pots being stood on the leaves during manufacture, and found at Knossos, are one of EM IIA date from the WCH,[341] **1155** from late EM IIB deposit A3 (pp. 227–8, PLATE 19), and **1364–1365** (PLATE 19) of less certain date but possibly EM III or, if not, then MM IA (p. 279).

Impressions of vine leaves on the bases of pots are quite common finds for the EBA Aegean. It seems that vine leaves were used with the smooth upper surface of the leaf on the ground and the underside uppermost, so that the impressions left on the base of the pots show the veins of the leaf clearly. The pots stood on these upturned leaves either while they were being coiled by hand, before the introduction of the potter's wheel, or at any rate when they were drying before firing. In the case of large pots several leaves were often used for this purpose, as was found at Markiani, on Amorgos, and Dhaskalio, on Keros (see below). These impressions are of interest not only from the technological point of view in the manufacture of handmade pots, but also because they imply that vines were growing close to the place of manufacture and vine leaves were readily available. Sometimes this is the only evidence that grapes were being grown in the district. Occasionally the pots are carefully placed on the centre of the leaves so that the resulting impression makes a symmetrical 'decoration' on the pot base, as is the case of some of the impressions from Chalandriani on Syros (see below). It has been suggested that vine leaf impressions indicate that the pots were used for the storage or consumption of wine.

[330] Rackham and Moody 1996, 81.
[331] Blitzer 1993, 166.
[332] Stefanos 1906.
[333] Warren 1972a, 139 and 191, fig. 75: P532–P533.
[334] Riley 2004, 3, table 1.
[335] Blitzer 1993, 164–5.

[336] GORILA passim.
[337] Was 1973.
[338] Ventris and Chadwick 1973, 13, 217–19.
[339] Melena 1983.
[340] Warren 1985. See also Christakis 2008, esp. 40–7.
[341] Wilson 1984, 223, pl. 59: P439.

Besides these impressions, there are EM IIB examples from Fournou Korifi[342] and apparently the cave of Stavromytis on Mt Juktas.[343] In the Cyclades plenty of evidence includes finds from: Chalandriani,[344] where at least 49 impressions have been found on the bases of small bowls; Paros;[345] Amorgos;[346] Markiani on Amorgos,[347] with 10 impressions on pot bases, including one large base with the impressions of two vine leaves; Dhaskalio Kavos on Keros[348] — and in the 2006–08 excavations at Dhaskalio settlement four sherds were found with impressions, including two on large bases with two leaves, and four more in the special deposit south at Kavos;[349] Naxos;[350] and Siphnos.[351] EH instances include Corinth.[352] They have also been found at Synoro in the Argolid[353] and Zygouries.[354] At the Menelaion the mouth of a reportedly 'LM III' jar was sealed with a sherd and clay which bore the impressions of vine leaves.[355]

In Greece the wild vine, *Vitis vinifera ssp sylvestris,* has been part of the natural vegetation since the Pleistocene, and today wild grape vines occur widely especially in the north, in Thrace, eastern and western Macedonia, Epirus, Thessaly, Euboea and the Peloponnese. It is difficult to distinguish between truly wild vines and feral forms since spontaneous crossing between wild plants and cultivars occurs easily when vineyards are established close to natural stands of the *sylvestris* forms. The earliest palaeothnobotanical finds of grapes in Greece come from the late Palaeolithic/Mesolithic levels of the Franchthi cave in the Argolid dating to around 11,000 BC. In the Early Neolithic the pips of the *sylvestris* form occur at Argissa, Achilleion and Sesklo, and in Middle Neolithic at Sesklo and Sitagroi. The Late Neolithic (4300–2800 BC) seems to have been a period of greater concentration on the collection of wild fruits including grapes: they are known from the Franchthi cave; Arapi, Dimini, Sesklo and Pefkakia in Thessaly; and Dimitra, Dikili Tash and Sitagroi in east Macedonia. The latter finds are the best documented, and it is likely that wild grapes were being used to make wine at Dikili Tash; and cultivated grapes may be present at Dimitra at this time and at Sitagroi a little later.

The earliest finds of grapes in Crete are known from Fournou Korifi and Phaistos. At Fournou Korifi two deposits were found containing remains of grapes: the first consisted of carbonised grape pips; the second larger find was of pips, loose stalks and empty grape skins inside a pithos — which seems to suggest that these grapes were being used in winemaking. In both deposits the pips were mainly small and gave the impression of coming from unripe fruit, although some were larger and more rounded and appear to have come from fully ripened grapes.[356] The find from Phaistos was of pips and stalks, the pip also being rather small.[357] Grapes seem to be the least well adapted of the major crops in Crete, coming late into leaf and the first to drop their leaves in the autumn. Most of the varieties grown today in Crete are peculiar to the island and differ from one region to another and have adapted to the island conditions surprisingly well.[358]

Winemaking was clearly a most significant development. Early indications for this occur at Fournou Korifi, where it may have been retsinated,[359] and EH Ayios Kosmas. With the appearance of cultivated grapes it became possible to manufacture quantities of a luxury item from quite modest raw materials. The wine stored well and could be extensively traded in sealed pottery vessels. That this was a highly regarded commodity is underlined by the appearance in the archaeological record of exotic drinking vessels made from precious materials.[360]

THE EARLY MINOAN I PALACE WELL AT KNOSSOS

The EM I Palace Well is the best evidence we have for society at Knossos at the beginning of the Bronze Age, both as a technical and social undertaking, and from its fill in deposits 1 and 2 that comprises the abandoned (deposit 1) and discarded (deposit 2) debris of the life of the settlement of which it was part.

[342] Warren 1972*a*, 239, 254, fig. 107, pl. 83D: 232; J. M. Renfrew 1972, 315–16.
[343] Sakellarakis and Sakellaraki 1997, 385, fig. 338. For the cave see Marinatos 1950, 251–7.
[344] Sherratt 2000, 355 and n. 15; also 51, pls. 26–7.
[345] Tsountas 1898, 174.
[346] Tsountas 1898, 167, pl. 19: 24.
[347] J. M. Renfrew 2006.
[348] J. M. Renfrew 2007.
[349] For both these sites see J. M. Renfrew forthcoming.
[350] Zervos 1957, 96, figs. 89, 91.
[351] Gropengiesser 1987, 29, 52: 60, pl. 4: 11.
[352] Kosmopoulos 1948, 61, fig. 45.

[353] Willerding 1973, 236–8, fig. 8.
[354] Blegen 1928, 106 fig. 91: 2.
[355] Vickery 1936, 32.
[356] For further details of these finds see J. M. Renfrew 1972.
[357] Logothetis 1970.
[358] Rackham and Moody 1996, 77–80.
[359] Tzedakis and Martlew 1999, 142–5 (with comments by Warren); McGovern *et al.* 2008, 179–80. Wine is also now reported, from gas chromatography, from EM I Aphrodite's Kephali (Betancourt 2008*b*, 106; 2010).
[360] For a fuller discussion of the early finds of grapes in prehistoric Greece, see J. M. Renfrew 1995.

In itself, the Well points to a considerable measure of social organisation or communal self-regulation, as well as technical know-how, in choosing the spot, planning the operation, and mustering the labour to undertake the dangerous task of digging it to a depth of over 17 m. There must have been a master well-digger in, or available to, the community, who supervised the operation, and whose reputation would rest on whether or not he found water — for the benefit of, presumably, the whole EM I community on the Kephala hill.

It must have become, at once or soon, a major improvement to communal life, especially as it seems that it held, at times at least, a considerable amount of water, perhaps as much as 2 tonnes. It also demanded social responsibility from all who used it, to ensure that it was not polluted by, for instance, throwing animal carcasses or other rubbish into it. The few bones in deposit 1 are not necessarily evidence of such antisocial behaviour, but may well be strays from upper layers, as Valasia Isaakidou suggests above.

The small number of other artefacts from the Well, mainly from deposits 2 (upper and lower levels, but not in the middle levels) and 3, fill out the picture of life in the settlement. Even if spindlewhorl **164** and clay discs **165–166** are Neolithic, we still have three bone tools **167–169**, a stone quern **170** and some pounders and rubbers **171–176**, and a lump of Naxian emery **179**, which could have been used for grinding or polishing by abrasion. There is also a quantity of blades and a tranchet arrowhead in Melian obsidian.

The probable pot boilers **177–178** represent a way of cooking/heating food that seems rare — or, more likely, has been little noticed by archaeologists — in Minoan Crete. They add to the type 10 baking plates from the Well as evidence of how different types of food were prepared and cooked at EM I Knossos. We did not find, however, any feet from tripod cooking vessels, a development that does not appear at Knossos until the WCH (and even then they are rare),[361] although one (at least) is known from the Ayia Fotia cemetery.[362]

The recently recognised fragments of unbaked clay bins **166A–166E** (that were preserved by having been burnt) form, with the Well itself and the two scraps of wall plaster (possibly lime plaster), the only architectural evidence we have of the EM I Kephala settlement. If the clay objects are bins, they add to the storage capacity of the community as identified first in the pithoi (type 21); but it is as impossible to quantify how much extra storage they could have provided as it is to know how much the pithoi did. At Aphrodite's Kephali, however, the pithoi could hold up to 165 kg.[363] Round bins are fairly rare in Bronze Age Crete[364] — or few have been recognised. It is clear that these fragments deserve further study, especially from an archaeobotanical view.

The animal bones point to a mixed diet as far as meats are concerned — and may suggest packs of dogs, in view of the amount of gnawing, as well of course as the rodents.

The pottery of deposits 1 and 2 has a wide range of shapes embodying a full range of culinary and dining functions. The jugs of deposit 1 represent the original use of the Well as a water source. Then it became a dumping ground (as deposit 2) for broken pottery in many varieties (much of which had been burnt) mixed with animal bones (some of which had been burnt and/or gnawed); all of these may have been tipped into the Well in a single event.

We may then presume that somewhere between the possibly fairly long episode of deposit 1 and the possibly short episode of deposit 2 some major event(s), possibly disaster(s), took place in the Kephala settlement. For a start the inhabitants lost their water supply. We cannot say why, or if it was a natural disaster, or somehow a human act. Even if other water sources were available, the (perhaps sudden) unavailability of the Well must have been a blow. Furthermore, there is sufficient evidence of burning to support the idea that we proposed a while ago,[365] that there had been a destructive fire in the settlement. This could have been linked directly to the Well's going out of use, or there may have been a period — how long we cannot tell — of abandonment between these two suggested episodes. If food remnants were lying around, it is easy to picture dogs scavenging in the ruins.

But other or additional explanations are possible, at least for the composition of the fill of deposit 2 but not, probably, for how it reached the Well, let alone for the Well's ceasing to be a water supply. In several articles over the last decade, Day and Wilson have proposed that the number of high quality chalices, pedestalled bowls and jugs are the debris, ritually discarded, of large-scale collective/communal feasting at Knossos, on one or more occasions. At this/these prestigious event(s), the chalices would have been passed from person to person (since they hold too much for one person, they are intended

[361] Wilson 1985, 341–2.
[362] Betancourt 2008*b*, 70–1, fig. 5.32; Davaras and Betancourt 2004, 24–5, fig. 42: 17.20 ('Cycladic marble-tempered pottery').

[363] Betancourt 2008*b*, 78–83, figs. 5.47–5.50; 2010.
[364] Cf. Christakis 2008.
[365] See n. 2.

for sharing), the drink poured from the (small) jugs that are a new shape in EM I, and other nourishment (liquid or solid) served from the pedestalled bowls and perhaps prepared/mixed in the carinated bowls (of type 9).[366] It is significant that these vessels are EM I shapes that also occur in prestigious burial deposits such as the Pyrgos cave, suggesting special, ritual usage.

The picture that analysis of the faunal remains is, as we see from Isaakidou's discussion, less clear: the meats come from different sources at, presumably different times, and do not support the idea of one large feast, and certainly not one centred on eating one type of animal alone; and the bones seem to have been left around for varying lengths of time.

To sum up then:

Was drinking the focus of any event(s)? On present evidence, that seems to be the case; but we do not have the evidence to compare the proportions of drinking vessels (or indeed serving and eating vessels) to the rest of the ceramic repertoire.[367]

Was such drinking in some way a ritualised event? In view of the types, size and quality of the pottery, that is more likely than its being an event for just one ordinary 'household'. (If it was the household of a 'chief', that becomes another matter.)

Could there have been many such events? There seems to have been at least one; and there may have been more.

What of the burning? Does it suggest several fires? It is hard to tell. While it seems more likely that there was just one fire that burnt the already broken crockery before it was dumped in the Well, the animal bones were both burnt and unburnt, which could perhaps point to fires on various occasions or to a fire restricted to part of settlement, such as a chief's house, when a fire could have been followed by ransacking.

Is there evidence for a ritual happening? Breaking the pottery and/or putting it in a fire before depositing it in the Well *may*, singly or together, have been such. However, we may well then have to include in a proposed ritual breakage, or series of breakages, the smashing of the pithoi and other vessels used to store the food and drink. This is *prima facie* unlikely, but it is quite compatible with destruction of the settlement by (external) human agency.

Are other explanations possible? Yes. The rest of the pottery in deposit 2, including the pithoi and bins, suggests that we may instead be looking at the debris of a household, or group of households, that contain *both* evidence for daily life (including the animal bones) *and* evidence of ceremonial drinking events. If it was the household of the leader of the community, this makes excellent sense. It is also possible that the pottery was all in store when the fire occurred — but this suggestion may be less satisfactory for explaining how the chalices and pedestalled bowls were already broken before the fire(s).

Could it have been a fire from a natural disaster or hostile human agency? Yes, this is as possible as a ritual bonfire, if not more so.

Is there any evidence to suggest that the secondary deposition of the pottery and other debris in the disused Well was a ritual happening? There is no direct evidence. Such a case would depend only on extrapolating from the numbers and types of drinking and feasting vessels and the fact that so many were broken before the fire(s). The alternative is that the Well had become a convenient dumping place.

In short:

— feasting is likely, but concentrated on drinking (to judge from the faunal evidence);
— subsequent ritual breakage and burning are possible, but not necessary, explanations;
— ritual deposition is less likely, especially in view of the other debris of the daily life of the settlement that occurred in deposit 2;
— and the breakages and burning (which both happened beyond any doubt) need not have been part of any ritual events, but may be the first of many destructions with fire that occurred at Bronze Age Knossos.

CONCORDANCE

TABLE 3.7 shows the publication numbers of the pottery and other finds from the Palace Well with the original catalogue numbers, and also the sample numbers of the pieces that Wilson and Day sampled for petrographical analysis.

[366] Wilson and Day 2000, 51–3, 59–60, 62; Day and Wilson 2002, 149, 152; 2004, 48, 50, 55; Wilson et al. 2004, 67–9; Wilson 2007, 56.

[367] We thank Valasia Isaakidou for reminding us of this and for much helpful advice in interpreting the Well's repertoire of pottery.

TABLE 3.7. Palace Well. Concordance of publication numbers of pottery and other finds with catalogue numbers.

	Publication number	Catalogue number	Wilson and Day sample number
Pottery			
Type 1	1	PW/59/P6	
	2	PW/59/P7	
	3	N 2	
	3A		
	4	N 19	KN 92/4
	5	N 4	
	6	N 83	
Type 2	7	N 10	KN 92/5
	8	PW/59/P8	
	9	N 7	KN 92/7
	10	N 78	
	11	N 12	
	12	N 11	
	13		
	13A		
	14	N 5	KN 92/6
	15	N 6	
	16		
	17		
	18		
Type 3 Pedestals	19	N 45	
	20	N 14	
	21	N 110	
	22	N 32	
	23		
	24	N 13	
	25	PW/59/P9	
	26		
	27		
Type 4	28		
	29		
	30		
Type 5	31		
	32	N 67	
	33	N 17	
	34	N 16	
	35	N 106	
	36	N 15	KN 92/15
	37	N 92	
	38		
	39		
Type 6	40	N 81	
	41	N 23	
	42	N 82	
	43		
	44		
Type 7	45	N 25	
	46	N 24	
	47	N 27	KN 92/23
	48	N 28	
	49	N 26	
	50	N 29	
	51	N 84	
	52	N 20	
	53	N 46	
	54	N 47	
	55	N 48	
	56	N 76	
	57	N 107	
	58	N 52	KN 92/26
	59		
Type 8	60		
	61	N 18	
	62	PW/59/P10	KN 92/12
	63	PW/59/P11	KN 92/13
	64	PW/59/P13 (also for **133**)	KN 92/24
Type 9	65	PW/59/P3	
	66	PW/59/P4	
	67	N 85	
	68	N 21	
	69	N 22	
Type 10	70	N 33	KN 92/48
	71	N 34	KN 92/49
	72	N 35	KN 92/50
	72A		
	72B		
	72C		
	73	N 86	KN 92/51
	74	N 87	
	75	N 96	
	76	N 40	
Type 11	77		
	78	N 66	
	79		
	80		
	81	N 102	
	82	N 104	KN 92/33
	83	N 103	
	84	N 101	KN 92/32
	85	N 105	KN 92/34
	86	N 93	
	87		
	88	N 1	
Type 12	89	PW/59/P1	
	90	PW/59/P2	
	91		
	92		
	93		
	94		
	95	N 100	
	96		
	97		
	98		
	99	N 64	
	100	N 65	
Type 13	101	N 50	KN 92/16
	102	N 108 (also	
	103	for **130**)	
	104	N 49	
		N 57	
Type 14	105	PW/59/P18	
	106	PW/59/P17	
	107	N 38	
	108	N 39	
	109	N 41	
	110		
	111		
Type 15	112	N 44	
Type 16	113	N 42	KN 92/11
	114	N 43	
	115		
	116		
	117	N 97	

	Publication number	Catalogue number	Wilson and Day sample number		Publication number	Catalogue number	Wilson and Day sample number
Type 17	118	N 109 (also	KN 92/2?	Bases	153	N 71	
	119	for 131)	KN 92/10		154	N 74	
	120	N 37	KN 92/28		155	N 73	
	121	N 36			156	N 77	
	122				157	N 79	
	123			Decoration	158	N 46	
Type 18	124	PW/59/P5	KN 92/3		159	N 69	
				Misc.	160	N 98	
Type 19	125	PW/59/P13			161	N 94	
	126	PW/59/P14	KN 92/45		162	N 88	
	127	PW/59/P15	KN 92/29		163	N 89	
	128	N 30					
	129	N 31		*Other artefacts*			
Type 20	130	N 108 (also	KN 92/30	Clay	164	PW/58/4	
	131	for 102)			165	PW/58/1	
	132	N 109 (also			165A	PW/58/3	
		for 118)			166	N 99	
					166A		
Pithoi	133	PW/59/P12			166B		
	134	(also for 64)			166C		
	135	PW/59/P16			166D		
	136	N 63			166E		
	137	N 51			166F		
	138	N 53	KN 92/25		166G		
	139	N 54			166H		
	140	N 55		Bone	167	PW/59/1	
	141	N 56	KN 92/40		168	PW/59/2	
	141A	N 58			169	PW/59/3	
	142			Stone	170	PW/59/4	
	143	N 62			171	PW/59/7	
	144				172	PW/59/6	
	145				172A	PW/59/8	
	146	N 68			173	PW/58/2	
	147				174	PW/59/5	
	148		KN 92/41		175	PW/59/9	
	149	N 61			176	PW/59/10	
		N 60			177	PW/59/11	
Spouts	150	N 70			178	PW/59/12	
	151	N 75			179	PW/58/5	
	152	N 72					

Chapter 4

The Early Minoan II–III excavations

AREA A. ROYAL ROAD: NORTH

In 1961 as the last stage of operations in RRN,[1] and as a result of a small trial the year before that produced deposit A7 (below) and appeared to promise more early levels, a larger trial was opened in trench LA near the centre of the area of excavation, with Hugh Sackett as trench supervisor.[2] This sounding (FIGS. 2.1, 4.1–4.4, PLATES 1, 20), measuring 2.75 m N–S × 2.45 m E–W, was taken down to a depth of 2 m below the level of Floor I, which had the LM IB destruction deposit including the debris of an ivory worker's shop.[3]

By contrast, in the W part of the RRN excavation to the W of the N–S wall uu, the floors of the LM IB destruction were at a much greater depth, being in a basement. Here the rock was reached at between 6.65 m and 6.74 m above datum, and the earliest deposits above it were assignable to MM III. The LM IB floors were for the most part only some 0.5 m above this (c. 7.25 m above datum).[4]

To the E of wall uu (PLATE 20 a), however, Floor I with the LM IB destruction deposit was over 2 m higher (9.28 m above datum). We expected that a sounding here might reveal deposits of earlier Middle Minoan, as in the excavations on the opposite side of the Royal Road (RRS);[5] but no deposit of any phase of MM was identified. Floor II, only 0.1 m below the LM IB Floor I, had evidently gone out of use in LM IA.[6] A pit had been filled with debris in LM IA, and then sealed by the LM IB floor (PLATE 20 a–b).

MISMARKED BOXES IN THE SMK

In June 2009 Cadogan noticed mistakes in marking the boxes for Area A in the SMK, which have led to some confusion. A mismarking of the boxes has meant that the correlations for EM II and III in the *Knossos Pottery Handbook* are one step out of order with the stratigraphic sequence of the excavation. Thus, where Momigliano mentions 'Floor II' of Area A,[7] assigning it to EM III late, this should read Floor III (deposit A6, and also perhaps A7). The real Floor II, whence the problem originated, is the LM IA level beneath the LM IB destruction deposit in trench LA (PLATE 20 a–b). Likewise, the 'Floor III' which she assigns to EM III early[8] is really Floor IV (deposit A5), the earlier EM III floor in Area A,[9] and the EM IIB level she mentions as being beneath it is our Floor V (A4), and not 'Floor IV'. Finally, 'Floor VI', the small deposit of late EM IIA that Wilson mentions,[10] should probably read as Floor VII (A1), which we see as being probably a little later than the WCH (p. 286); while our Floor VI (A2) is the first EM IIB deposit in Area A. TABLE 4.1 presents the correct sequence and the erroneous citations.

TABLE 4.1. Area A. Sequence of deposits and erroneous earlier citations.

Period	Deposit	Floor	'Floor' as in Wilson 2007, etc.
EM IIA	A1	VII	'VI' (Wilson 2007, 61; cf. Wilson and Day 1994, 12, 34)
EM IIB	A2	VI	'V' (Wilson and Day 1999, 5)
	A3		
	A4	V	'IV' (Momigliano 2007c, 81)
EM III	A5	IV	'III' (Momigliano 2007c, 81)
	A6	III	'II' (Momigliano 2007c, 81, 83)

[1] Hood and Taylor 1981, 20: 183.
[2] The first published accounts are: Hood 1962a, 27; 1962b, 295. Both reports assign the upper floors to MM IA, with EM III and EM II below.
[3] Hood forthcoming, in preparation.
[4] Hood 1962a, 25–6, figs. 32–3.

[5] Hood 1959, 19–20; 1960a, 22–3.
[6] Hood in preparation.
[7] Momigliano 2007c, 81, 83.
[8] Momigliano 2007c, 81.
[9] For its date, cf. also Wilson and Day 1994, 12.
[10] Wilson 2007, 61; cf. Wilson and Day 1994, 12.

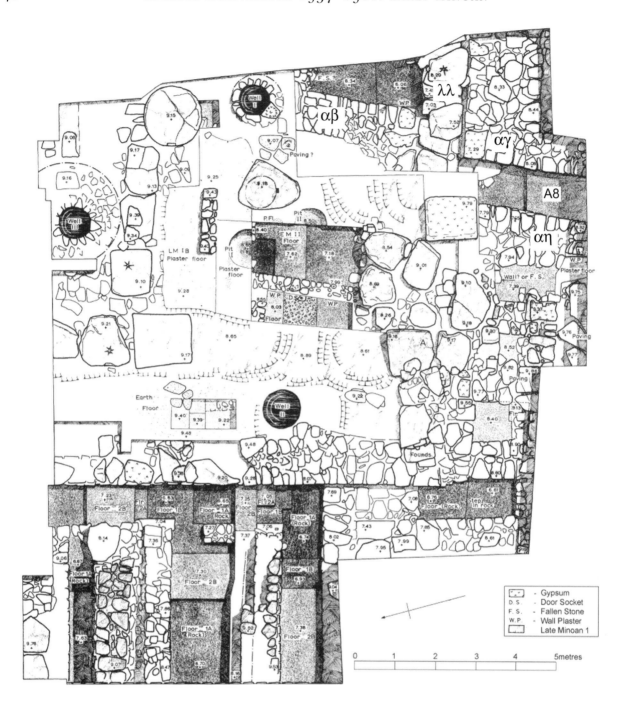

FIG. 4.1. Area A. Overall plan, with EM sounding.

In March 2010 the wrong markings on the boxes in the SMK were cancelled by putting a line through them, and the boxes re-marked at their other, clean end. This should preserve the history of the episode and, we hope, lead to correct citations in the future.

THE EARLY MINOAN FLOORS AND DEPOSITS

The sounding below the LM I Floors I and II in trench LA in Area A produced a long Early Minoan stratigraphic sequence (FIGS. 4.2–4.4; TABLE 4.2 for correlation with the sequence in Area B): five successive floors or occupation surfaces (Floors III–VII) and eight associated deposits (A7–A0) in a depth of *c.* 1.25 m. The deposits overlaid a scatter of Neolithic sherds that did not seem to amount to occupation debris (see below on A0). There was also a ninth separate deposit (A8) a little to the SE of the sounding.

TABLE 4.2. Areas A and B. Correlations between areas, floors and levels.

	AREA A		AREA B
	Deposits and floors	*Levels in trench LA*	*Deposits, floors and levels*
	A7 Floor III? 7.2 / 7.1	51 \| 54	
EM III	A6 Floor III	102 103	B3 Between floors 5 and 4 A3, A3a
	A5 Floor IV	99 99A	
EM IIB	A4 Floor V	104 104A	Pit C A11, A9
	A3 Floor VI ? Mixed + V	west 105A \| 105B east 105 \| 106	B2 Floor 3 A6 Floor 2 A7–A8, A10, A12
	A2 Floor VI	112 108 / \	B1 Floor 1 A13–A14 B9–B10
EM IIA		\| 109 110 \ / 114 111 116 \| 117 113	
	A1 Floor VII		
?	A0 below Floor VII	\| 115	

This area of Knossos was, then, part of the Bronze Age Prepalatial settlement from soon after EM I, but seems to have been occupied slightly later than the first deposits in Warren's RRS excavation. Most probably we have here house remains, as is especially evident in Floor VI.

The two EM III surfaces (Floors III and IV) were preserved only at the N end of the sounding (FIG. 4.2, PLATE 20 *b*). These were stratified above Floor V (deposit A4) assignable to EM IIB, which lay above Floor VI (deposit A2), which is earlier in EM IIB (while deposit A3 may represent Floor VI perhaps mixed with Floor V (TABLE 4.2). Floor VI in turn was above Floor VII, which went out of use in EM IIA. Since some of these floors relate to several deposits (which were studied individually), when we present the finds we shall do this primarily by the deposits which, we believe, will make the components of the sequence as clear as we can manage.

Floor III (levels LA103, LA102: deposit A6) of EM III was identified at *c.* 0.2 m below Floor I (LM IB) and some 0.1 m below Floor II (LM IA). No traces of walls were noted in association with this occupation surface, but the layer of hard yellow clay or *kouskouras* which marked it seemed like a floor. Feature αμ, consisting of a single course of stones set in a circle, was identified in the NW corner of the sounding resting on top of the yellow clay here (PLATE 20 *b*). A very small amount of pottery, about 1/4 table, comes from above Floor III. But the material descibed under A7, which occupied over 1 1/4 tables and had been excavated the previous year (1960) in the N part of the sounding in trench LA, is EM III in character and seems assignable to this horizon. Deposit A7 is in two parts: A7.2: level LA51; and, below it, A7.1: level LA54.

Floor IV (deposit A5: levels LA99–LA99A) lay some 0.35–0.40 m below Floor III (FIGS. 4.2, 4.4). On the E side of the sounding it was marked by an area of white plaster measuring *c.* 1.6 m N–S × 1.2 m E–W. A badly defined patch of red clay to the N of this plaster may have been the remains of dissolved mud brick. The material above this surface, covering about one table, was still EM III. No certain traces of walls were observed in conjunction with Floors III and IV. But short stretches of wall, only preserved one course thick in the NW and NE corners of the sounding (visible in FIG. 4.4 and PLATE 20 *a* in the N section of the sounding) appeared to belong with Floor V (deposit A4: levels LA104–LA104A), with pottery covering about 1/2 table and assignable to a late stage in EM IIB.

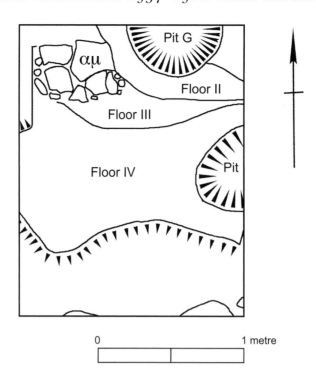

FIG. 4.2. Area A. EM sounding: Floors II (LM IA) and III–IV (EM III).

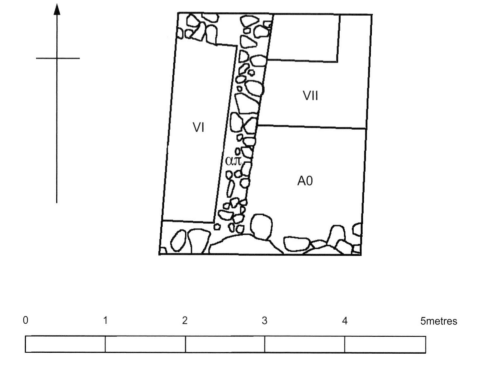

FIG. 4.3. Area A. EM sounding, final state: Floors VI (EM IIB) with wall απ, and VII (EM IIA).

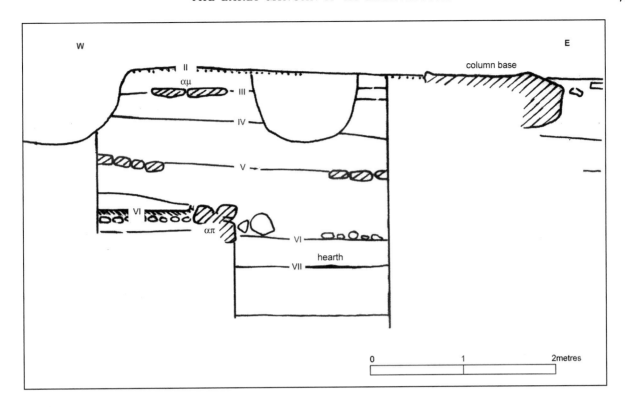

FIG. 4.4. Area A. N section of sounding.

Floor VI (deposit A2: levels LA106, LA108, LA105B), above which classic EM IIB pottery covering about two tables was found, lay some 0.4–0.5 m below the surface of Floor V. It was associated with a stretch of wall απ *c.* 0.35 m wide and preserved to a height of *c.* 0.3 m with two courses.

Wall απ ran N–S along the length of the sounding, and appeared to be the outside wall of a house, with part of a room on the w side (PLATE 20 *c*) and what seems to have been an open space (or yard) on the E (FIG. 4.3, PLATE 20 *d*). The wall had an opening for a doorway 1 m wide. A stone with a socket for a wooden doorpost was in position by the wall on the w side of the opening and just to the N of it (PLATE 20 *c, e*).[11] The wooden door, that is to say, made in one piece with the doorpost, would have opened inwards, and would have been protected from the weather by the width of the wall, if the space to the E was open ground.

The floor of the room w of wall απ had been carefully made with a layer of clay, greenish to red in colour, *c.* 0.06–0.07 m thick above a strew of small cobble-like stones. The layer of clay was traced rising upwards as a vertical (mud plaster) facing against the upper course preserved of απ on the E side of the room (PLATE 20 *e*). The floor of the room was *c.* 0.2 m higher than the surface (which may have been open ground) to the E of wall απ during the time it was in use. This surface, like Floors V–III above it, had a slight slope down towards the E. On top of it was an extensive patch of red clay, which may have been decayed mud brick, together with some stones that might have fallen from wall απ when it was finally destroyed (PLATE 20 *d*).

Wall απ appears to be at right angles to the earliest wall(s) that Evans found in his Armoury/Arsenal excavation,[12] which was adjacent to the RRN excavation to the E. Indeed, the early walls in the Armoury site are shown by Mackenzie[13] as continuing to the w — which could suggest a quite substantial building (if it was one building) and/or open space continuing that to the E of wall απ. It would imply that occupation here immediately to the N of the Kephala hill was quite extensive — and even substantial — by early EM IIB.

[11] Other EM stone door sockets include: Knossos (SMK E.III.2 663 — see p. 243: 24); Alykomouri (Haggis 1993, 21, 25, fig. 8, pl. 5.2: 155); Fournou Korifi II (Warren 1972*a*, 218–19 and pl. 71: 61–62, 66).

[12] Hood and Smyth 1981, 51 no. 213, with references.
[13] DM/DB 1904, 88 (Palmer 1963, pl. 25, where walls are shown continuing to the w; and, re-drawn, Boardman 1963, 68, fig. 14).

Deposit A3 (Floor VI mixed [?] with Floor V: levels LA105–LA105A) comes from the upper part of the deposit above Floor VI. It may be contemporary with A2 below it, and the pottery certainly looks earlier than that of A4 above it; but, in view of a possibility of contamination from A4, it was studied separately from A2.

Floor VII (deposit A1: levels LA114, LA116–LA117; LA111, LA113; and LA109–LA110, which may be mixed with material from deposit A2) was only reached in excavation on the E side of the sounding to the E of wall απ at a depth of 0.20–0.25 m below the surface associated with Floor VI (PLATE 20 c). A hearth was identified in the northern part of the sounding (FIG. 4.4); but whether the space here was open ground or inside a building was not clear. The material incorporated in the make-up of Floor VI to the w of wall απ seemed to be of the same character as that from below the surface of Floor VI to the E of the wall, and was included for analysis with it. All this pottery, covering about one table, seems assignable to EM IIA.

A trial (deposit A0: level LA115) was opened below the part of Floor VII that was exposed in the SE corner of the sounding (FIG. 4.2, PLATE 20 c bottom right). Measuring c. 1.3 m N–S × 1.4 m E–W, it was taken down to a depth of c. 0.4 m below the surface of Floor VII (7.18 m above datum) without reaching another occupation surface or the natural rock. This deposit seemed to consist of washed down soil rather than occupation debris. The few sherds are generally Neolithic, but two certainly Early Minoan.

Deposit A8 (level LA94) is somewhat separate from this sequence. It is from the lowest levels reached in the space between the later walls αγ and αη to the SE of the main EM sounding (FIG. 4.1). The deposit excavated was c. 1.4 m N–S × 1 m E–W, and 0.20–0.25 m deep. It may be a fill incorporating material of different dates, the latest apparently being EM II and stylistically probably between deposits A1 and A2: this should set it in later EM IIA.

Group A9, finally, is not a deposit at all but a collection of EM fragments of interest from later Minoan levels in RRS and RRN, with one from the Hogarth's Houses excavation on Lower Gypsades (see pp. 190–2).

The code for this Early Minoan sounding is LA/61 (and LA/60 for levels LA51 and LA54), covering deposits A0–A8; but some non-ceramic finds were catalogued with RR/61 numbers.

PREPALATIAL OCCUPATION IN ROYAL ROAD: NORTH

This small sounding has produced a sequence of apparently domestic occupation from EM IIA to EM III on the N slope of the Kephala hill. Although little architecture was preserved, its domestic nature is clear, as is the habit of rebuilding at the same spot over several centuries. A small mixed group of other artefacts (pp. 227–9) can be mirrored at better preserved settlements such as Myrtos Fournou Korifi. Obsidian was quite plentiful, especially in the EM II deposits; and, although no workshop space could be identified, it was probably worked somewhere nearby. The animal bones reveal the typical farmyard animals of Knossos, but also dog and badger (pp. 229–33).

AREA B. THE EARLY HOUSES TO THE SOUTH OF THE PALACE

Following the discovery in 1957 by Nikolaos Platon, then Ephor of Crete, of a red plastered floor and wall (PLATE 21 b–c) and pottery dating to EM II–MM IA during conservation work in the part of the Palace site known as the Early Houses (FIGS. 2.1, 10.1: 27, PLATES 1, 21 a), the School was invited to examine the Houses in more detail, with a view to learning more of the Prepalatial sequence and history of Knossos. This excavation took place in 1960.

The Early Houses to the s of the Palace are a group of much eroded EM II–III — and probably MM IA — buildings and deposits that antedate the Old Palace, and were set into and onto Neolithic levels (FIGS. 4.5–4.8). The name 'Early Houses' was coined by Duncan Mackenzie, who identified two sets of buildings: one he dated to EM II; and a substantial building above it he dated to MM I, calling it the 'MM I House'. Following Momigliano and Wilson, who conducted a further excavation in and around the Early Houses in 1993, Mackenzie's MM I House is now known as the South Front House (SFH) — a name that we follow — and is dated to EM III.[14] This name, however, cannot apply to the EM IIB structures beneath the SFH; and Early Houses remains the best general name for the buildings at this site.

[14] Momigliano and Wilson 1996, 6, 54.

The Early Houses lie immediately downhill to the s from the later Palace and face Gypsades hill and the Caravanserai across the Vlychia stream.[15] They are bounded to the N by the (later) South Corridor and to the w by the cutting for the South House (PLATE 21 *a–b, d*), which doubtless destroyed other Prepalatial structures. To the s the ground falls quickly away to the Vlychia stream; immediately to the E are the so-called Early Paving and the s entrance (South Porch) of the Palace.[16] The present extent of the Early Houses is *c.* 12.5 m N–S × 9 m E–W.

Hidden beneath the South Porch is the circular sunken building known as the Hypogaeum, whose fill contained MM IA and later pottery.[17] The cobble paving known as the Early Paving that lies between the Hypogaeum and the Early Houses,[18] measuring *c.* 6.4 m N–S × 9.4 m E–W as preserved, is the remains of a yard of MM IB, or later, date. The excavations in 1993 showed that it was laid over a deep MM IB fill and is most probably earlier than the South Façade of the Palace.[19] The Early Paving did not exist at the same time as the Hypogaeum, and so could not have linked it with the Early Houses. (This does not exclude the possibility of an earlier connecting open area, whether paved or not.)

THE HISTORY OF EXCAVATIONS AND INTERVENTIONS AROUND THE EARLY HOUSES

Since there have been at least seven excavation campaigns at the Early Houses, and a campaign of cleaning and conservation in 1957 before the current conservation of the Palace and its surrounds, it may be helpful to review the history of all of these before presenting the work in 1960.

1907–08

After excavating the South Façade and Early Paving in 1907,[20] Mackenzie moved westwards in 1908 and tackled the Neopalatial South House[21] and the Early Houses.[22] He and Evans appear to have concluded that there were EM II (on the whole)[23] and MM I deposits here, and buildings, which became the 'Early Houses', assignable to those phases. They included a substantial building which Mackenzie called the 'M.M.I.House',[24] now known as the South Front House (SFH). The EM II deposits appear to have included a floor deposit, or deposits, with whole and nearly whole vessels, which Evans discussed briefly.[25] We present this pottery again, as far as we can, below (pp. 266–74), while Wilson and Day have published the EM IIB sherds from the Early Houses, which they suggest come from fills.[26]

These deposits of 1907–08, together with those that we excavated and those that Momigliano and Wilson excavated in 1993, have led to Wilson's definition of an EM IIB South Front Group of pottery at Knossos.[27]

1957

During conservation work in December 1957, the Ephor Nikolaos Platon came upon two red plaster floors. The upper of these (which became floor 5 in our trench A) met a wall on the N (our wall α) that also had red plaster, and was above another floor with pottery resting on it (which became our floor 4). He reported also finding Vasiliki ware and a calcite figurine.[28]

Through the kindness of Lefteris Platon, who has given us copies of his photographs and notebook entry,[29] we can include here a fuller account of what his father found and present his photographs from 1957 (PLATE 21 *b–f*), while Wilson is publishing EM I–IIB pottery from his conservation work around the Palace, including some pottery from the Early Houses and from N of the South House.[30]

The upper red floor (5) belongs with wall α, Platon wrote in his notebook, which also had a red plaster facing. Both are part of a house datable to 'MM IA', which is equivalent to, but perhaps not

[15] Hood and Taylor 1981, 13 no. 2, with the name EARLY HOUSES. For a plan of the wider area of the Early Houses see Momigliano and Wilson 1996, 8, fig. 5.

[16] Hood and Taylor 1981, 13: 9.

[17] For references see p. 22 and n. 13.

[18] Hood and Taylor 1981, 13 no. 12 — EARLY PAVING.

[19] Momigliano and Wilson 1996, 10–12, 54.

[20] Reviewed by Momigliano and Wilson (1996, 3–4, fig. 1, pl. 1).

[21] Mountjoy 2003, 1–18; Driessen 2003, 27. There was further work in 1924.

[22] Brief reports: Dawkins 1908, 326; Evans, *The Times* 27.08.1908, 6. Momigliano and Wilson's account (1996, esp. 4–7, fig. 3) of the 1908 excavations gives lengthy excerpts from

Mackenzie's Daybook. The relevant pottery from the 1907–08 tests is now assigned to the South Front Group of EM IIB (Wilson 2007, 70: 1).

[23] 'On the whole', since one wall (Momigliano and Wilson 1996, 7–8, figs. 4–5: wall 9) was marked 'EM II-III' by Mackenzie (Momigliano and Wilson 1996, 5–6, fig. 3).

[24] Momigliano and Wilson 1996, 5–6, fig. 3; 54.

[25] *PM* I, 71, 73–5, fig. 40; cf. 108.

[26] Wilson and Day 1999.

[27] Wilson 2007, 70–7.

[28] Platon 1957, 338; Hood 1958, 21.

[29] Platon notebook p. 96 left and right.

[30] Wilson 2010.

precisely the same as, Mackenzie's MM I House (now the SFH). One has the impression that Platon based his date upon the pottery collected during the cleaning. He also noted 'a large number' of MM IA sherds and among them some datable to 'EM III' '(light on dark καί dark on light)', as well as 'some jugs and a teapot'. 'EM III' refers probably to what we should now assign to EM IIB: in 1957 the notion of light-on-dark pottery occurring in EM IIB was barely conceivable. And his 'MM IA' is more than likely to be what we are now calling EM III.

The calcite figurine, 'triangular and of Naqada type', came from 'inside the wall of the central room', while one small, narrow compartment 'μορφῆς αποθέτου' produced a lot of 'MM IA' sherds and small vessels. The compartment is likely to be the nearly rectangular space (some 2.8 m long) in the middle of FIG. 4.5, to the E of our trench B and wall γ, and S of the eastwards continuation of our wall β.[31]

PLATE 21 *d* shows the room with floor 5 (and presumably floor 4 below) ending more or less where our trench A stopped on the E, and almost on the line of N–S wall MW 13 (which should be the E wall of a long, narrow room — see below). The pottery included 'EM III light on dark'. Platon also mentions Vasiliki ware found a little to the E of the room with the red plaster 'during the cleaning of a wall (or paving of a *kalterimi*?)', which can refer only to wall MW 14, which is shown in the foreground of PLATE 21 *d*.[32]

Platon also cleaned the Early Paving, possibly revealing more of it than had been found in 1908.

1960

Platon's discoveries led to a small excavation by Hood in 1960. The aim was to elucidate the date(s) and building sequence of the Early Houses as part of the stratigraphical and chronological re-evaluation of Evans's sequence at Knossos. Three other small tests were also opened. The final account of this work follows below.

1969

In 1969 J. D. Evans opened trench Z in the cutting by the E side of the South House, finding Neolithic levels, the latest of which dates to LN I.[33] This area was clearly outside the main area of Neolithic inhabitation, and what appeared to be rubbish was found resting on the natural *kouskouras*,[34] outside, and below the level of, the Early Houses. Trench Z included part of a small tunnel cut into the *kouskouras*[35] that probably led to an underground chamber, and was sealed by several redepositions of mixed MN–LN I material.

1987

In 1987 Hood directed excavations in the Palace by the South Front near the Hypogaeum. They produced valuable information for the history of the Palace,[36] but no Prepalatial evidence.

1993: KARETSOU

In 1993 Karetsou made soundings in the area of the Early Houses, as part of the restoration programme of the Palace and surrounding buildings.[37] She notes:
(1) more 'EN' next to J. D. Evans's trench Z;
(2) a Protopalatial stone drain to the S of this, at a spot where there had already been 'unrecorded excavations', which could refer to our trenches D and/or E (see below);
(3) a possible E–W fortification wall by the South House, about which, she reports, no further information could be obtained:[38] this must be wall β, which we examined in 1960 in trenches D and E and discuss below;
(4) foundation deposits not noticed by Arthur Evans in the bedrock to the S of the South House: see below under trench F (p. 93);

[31] For a relatively recent photograph, see Momigliano and Wilson 1996, pl. 3d.
[32] For wall MW 14, see Momigliano and Wilson 1996, 54 and pl. 3d (for its appearance in 1993).
[33] Tomkins, pers. comm.

[34] J. D. Evans 1971, 96, fig. 1; 98, 106, pl. 6; 1994, 3, fig. 1; 10.
[35] Tomkins forthcoming *b*, and pers. comm.
[36] Hood 1994, 102; Momigliano and Hood 1994.
[37] Karetsou 2004, 552; 2006, 63; *BSAAR 1992–93*, 21.
[38] *BSAAR 1992–93*, 21.

(5) terracing operations to the N of the South House, which had cut back into the mound, revealing more Neolithic, including perhaps a kiln, and 'a thick EM III fill' at about the same level as the Early Houses — which suggests that the EM III occupation here continued to the W of our, and Momigliano and Wilson's, excavations.[39] In this same area there was also a large EM IIB deposit that seems similar to, or the same as, that below the SFH: together they would extend for more than 30 m.[40] Beneath that was a very large fill deposit that has been assigned to EM IIA late.[41]

1993: MOMIGLIANO AND WILSON

Also in 1993 Momigliano and Wilson re-investigated the Early Houses,[42] in effect extending our 1960 operation with the benefit of the by then much greater knowledge of the EM ceramic history of Knossos; they also examined the Early Paving. We recommend reading their excellent report to help understanding of our account below, where we include details of, and from, their trenches (using the prefix MW for their trench numbers, wall names etc.) as appropriate.[43] It is worth summarising the architectural and stratigraphic Prepalatial sequence which they reconstructed, combining the 1908, 1960 and 1993 results:[44]

1 Neolithic.
2 EM cuttings into the Neolithic levels: of uncertain date, but not later than EM IIB.
3 EM IIB: while the 1960 excavation identified four phases within EM IIB, the 1993 MW excavation found the three latest of these.[45] These four phases are:
 A: our deposit B1 (see below).
 B: a lower EM IIB floor.
 C: an upper EM IIB floor.
 D: an EM IIB pit.
4 EM III: a fill followed by three building phases (the fill and first two building phases occurring only to the S of, and thus outside, our two main trenches),[46] and that in turn by the occupation of the South Front House:
 A: the fill in MW trench V.
 B: building phase 1.
 C: building phase 2.
 D: building phase 3 — the building of the South Front House, later called the SFH Foundation Trench Group and assigned to EM III early.[47]
 E: the occupation of the SFH, later assigned to the UEW Group of EM III late,[48] and including our deposit B3.[49]

(1999)

Although not work in the field, the publication in 1999 by Wilson and Day of EM IIB pottery in the SMK — if mostly sherds — from the Early Houses[50] marks another important step in understanding the Prepalatial settlement at Knossos. Apart from their exhaustive analysis of the pottery and its ware groups, they propose that the large EM IIB deposits that Evans and Mackenzie found (and kept) were a secondary deposition, namely a fill that was laid down over the latest EM IIB floor levels and building remains to make a terrace that might be datable to EM IIB, or (subsequently?) to be a levelling fill in the construction in EM III of the SFH. They also suggest that the latest EM IIB pottery at the site (from our pit C, partly excavated by us in 1960, partly by Momigliano and Wilson in 1993) may be perhaps even later than the fill/pottery they publish.[51] If so, one could argue that the

[39] The 'thick EM III fill' matches what Momigliano (1991, 201) suggested for what is almost certainly the same deposit, noting that Mackenzie talked of the area 'covered' by what he called MM I pottery.
[40] Wilson and Day 1999, 4 and n. 11.
[41] A. Karetsou and D. Wilson (pers. comm., further to Wilson and Day 1999, 4, n. 11, and Karetsou 2004, 552). For the EM IIA deposit, cf. the North-East Magazines Group (EM IIA late) (Wilson 2007, 61–9).
[42] Momigliano and Wilson 1996; Momigliano 2007c, 80–94.
[43] Likewise, they summarise the 1960 excavations in conjunction with the 1908 excavations (Momigliano and Wilson 1996, 8–10).
[44] Momigliano and Wilson 1996, 9, 52–5.

[45] The relevant pottery from the 1993 tests is now assigned to the South Front Group of EM IIB (Wilson 2007, 70: 3).
[46] Momigliano and Wilson 1996, 7–8, figs. 4–5, 47–52: trenches IV and V.
[47] Momigliano 2007c, 80–1.
[48] For the EM III pottery from the 1908 excavations in the occupation levels of the SFH, see Momigliano and Wilson 1996, 1, n. 3; 48; Momigliano 1991, 198–204; 2007c, 83: 7.
[49] Momigliano 2007c, 83: 8.
[50] Wilson and Day 1999. Besides what is in the SMK (H.I.2 788–803), EM IIB pottery from the Early Houses is also to be found in the HM, AM, and other museums: see below pp. 266–74.
[51] Wilson and Day 1999, 4–5.

pit was dug into, and/or already existed as a hollow waiting to be filled within, not only the EM IIB building and occupation layers but also any EM IIB fill on top of them.

The general lack of whole vessels in the deposit and absence of signs of destruction by fire are, Wilson and Day believe, strong arguments for secondary deposition, with the pottery having been brought (as sherds) from elsewhere to be a hard core. This is an attractive idea, but it raises the question of whether the whole vessels that Evans and Mackenzie found here (see pp. 266–74) — and some of them come from the same boxes in the SMK as the sherds they publish — can really be part of the suggested fill or belonged with floor levels beneath it.[52] If the entry in Mackenzie's daybook is not completely clear on this,[53] Evans writes that these whole vessels are from house floors.[54] They form an impressive assemblage.

THE 1960 EXCAVATIONS

The excavations lasted from 20 to 27 July 1960.[55] Cadogan was trench supervisor and †Spyros Vasilakis senior workman, assisted by †Grigoris Kritzalakis. The plans were drawn by Edward Bird, excavation architect that year. The code for this excavation is PEM/60 (= Palace Early Minoan/1960).

The three main trenches of this small excavation produced principally Neolithic, EM IIB and EM III occupation remains. The first accounts, however, do not mention the EM III finds;[56] and in 1962 Hood specifically excluded the presence of EM III 'as this was defined by Evans (our italics)',[57] albeit noting the presence of a pre-polychrome phase that could qualify as EM III. Study of the pottery, however, in 1964–65 led to a restatement in late 1965 of the results of the 1960 campaign: at last, deposit B3 could be identified as definitively EM III with nothing at all — specifically, no polychrome — that had to be exclusively MM IA.[58]

There were two principal trenches, A and B (FIG. 4.5).[59] Trench A, measuring c. 1.75 m N–S × c. 1.8 m E–W, was bounded:
 — on the N, by the modern retaining wall of the South Corridor, but with Minoan wall α (MW wall 12) next to and beneath this modern wall on its S side;
 — on the E, by MW trench II with a baulk of c. 0.2 m between the E line of trench A and the W line of MW trench II,[60] with the consequence that MW wall 13 is outside trench A;
 — on the S, by wall β (MW wall 1);
 — and on the W, stopping c. 1.75 m short of the cutting for the South House.

Trench B, immediately S of trench A and on the far side of wall β, measuring c. 1.85 m N–S × c. 1.95 m (max.) E–W, was bounded:
 — on the N, by wall β (and trench A beyond it to the N);
 — on the E, by wall γ (MW wall 3);
 — to the S, the ground drops away;
 — and on the W, stopping c. 0.10–20 m short of MW wall 15 (which is just visible on the left in PLATE 12 f).

Trenches A and B revealed:
 — surfaces assignable to Neolithic (two or more deposits);
 — EM IIB levels in two principal deposits: B1 and B2, the lower B1 lying on what appeared to be Neolithic debris, with many small stones;
 — the EM III deposit B3 in a room with well preserved wall and floor plaster that was part of the SFH. Two pink/red plaster floors (originally exposed in 1957) sealed the EM III deposit above and below.

As in Area A on the NW side of the Kephala hill, no EM I level was observable; but here, unlike Area A, there was also no EM IIA level. The Neolithic levels were not excavated.

[52] Wilson and Day (1999, 4, n. 16) believe they are from the same (fill) deposit as the sherds.

[53] DM/DB for 05.06.1908, quoted by Momigliano and Wilson (1996, 6).

[54] PM I, 71, 74.

[55] Not 1961, as in Hood and Taylor 1981, 13: 2.

[56] Hood 1961, 27; 1962b, 265–6.

[57] Hood 1962c, 93.

[58] Hood 1966. Andreou (1978), Cadogan (1983, 508–09) and Cadogan et al. (1993) agreed, as does Momigliano (2007c, 81: 1, 83: 8).

[59] These are also shown in Momigliano and Wilson 1996, 7–8, figs. 4–5, together with the MW wall names.

[60] N. Momigliano and D. Wilson, pers. comm.

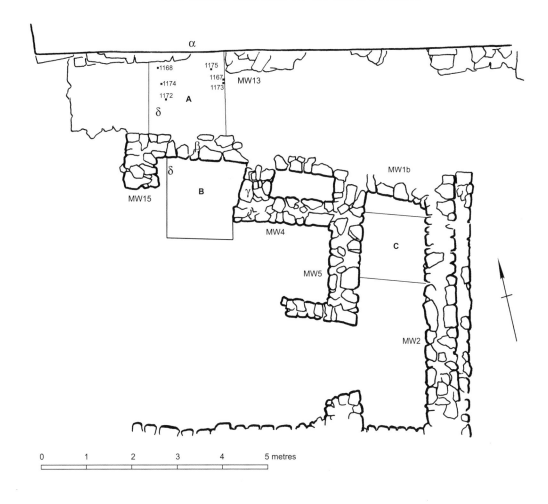

FIG. 4.5. Area B. Trenches A–C.

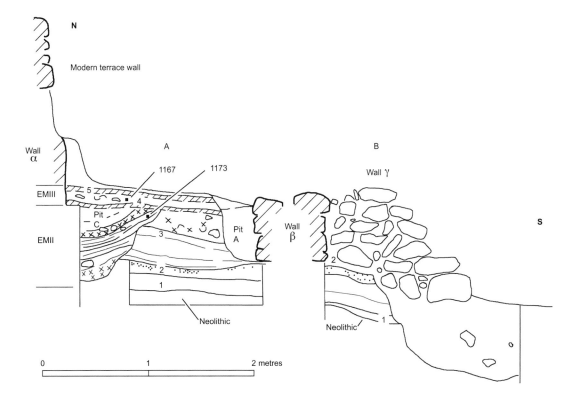

FIG. 4.6. Area B. Trenches A–B: E section.

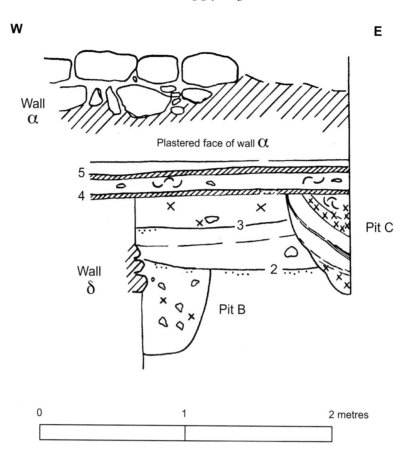

FIG. 4.7. Area B. Trench A: N section.

For the date of the use of the upper plaster floor in trench A, we do not have enough evidence. A few early polychrome and other sherds from the SFH might suggest a continuing use of the building into MM IA, but the evidence is little.[61]

The third trench was C, to the E of trench B. Trench C was *c.* 1.5 m square, and set towards the N end of a narrow space between the continuation of wall α (MW wall 1b) to the N, MW wall 2 to the E, and MW wall 5 to the W. It contained a recent fill, probably from the work in 1957, and a Neolithic deposit of grey earth and *kouskouras.*

We shall focus on trenches A and B.

NEOLITHIC AND EARLY MINOAN IIB

Trench A

Deposits B1 and B2

Sealed beneath the EM III pink/red floor 4 of the SFH were four successive EM IIB occupation levels (FIG. 4.6). At the top in the NE corner of the trench, immediately below floor 4, pit C extended 0.7 m along the E edge of the trench and 0.35 m along the N (FIGS. 4.6–4.7, PLATE 22 *a*). During excavation we believed that it was a hearth (calling it 'hearth H') that had been in use with floors 2 and 3; but when more of it was found in 1993 in the NW corner of MW trench II,[62] it became certain that this was a pit that cut through, or formed a hole in, both the EM IIB fill that Mackenzie and Evans found immediately below the EM III SFH remains, and also floors 2 and 3 (as the MW excavations confirmed). The contents of pit C are then among the latest, if not the latest, surviving EM IIB remains from the area of the Early Houses. The pit was filled with alternating bands of red

[61] Momigliano 1991, 198–204; 2007*c*, 83–94. The evidence is not strong enough to include the SFH in the House C/RRS Fill Group of MM IA: Momigliano and Wilson 1996, 48, n. 47;

Momigliano 2007*c*, 94–6.
[62] Momigliano and Wilson 1996, 11, fig. 6, 28, fig. 17, pl. 4.

and grey ashey earth, with some charcoal and stones. We removed its lower part as levels A9 and A11. The upper part was excavated with levels A6 and A7.

Following the work in 1993, we see now that what the 1960 excavations found as pit C, and the 1993 excavations found more of, is the s part of a large pit, 1 m or more deep, and *c.* 2.5 m wide on its s side; but its full dimensions cannot be known, since most of it is covered by the South Corridor of the Palace. Since the top of the pit as found in 1993 was above the levels of both our floor 4 and our floor 5, it is clear that the builders of the SFH cut into the latest EM IIB levels, and then sealed them (in trench A at any rate) beneath floor 4. In 1993 the pit produced a substantial deposit of late EM IIB pottery, as well as a stone pounder, three unfired clay loomweights and three pieces of mudplaster, one of them painted red.[63]

Our next level in descending order beneath floor 4 was a red-brown occupation deposit *c.* 0.2 m deep, excavated as level A6, over an upper EM IIB floor 3. This floor was a thin layer of *kouskouras* sloping to the sw and s — as all pre-EM III levels did, while EM III floors 4 and 5 were level and horizontal. We could not find any walls to associate with floor 3. This level is the upper EM IIB occupation level in MW trench II.[64]

Below floor 3 was a similar occupation level, excavated as levels A7, A8 and A10, over another *kouskouras* floor 2, which was only 0.01 m thick and excavated as level A12a (with no sherds). Immediately above floor 2 was a similarly thin level (A12) of hard, clayey reddish-white earth, which was presumably a re-lay, or the topping, of floor 2. This lower occupation deposit was 0.22–0.34 m deep, and overlay the *kouskouras* layers of deposit B1. It is the lower EM IIB level in MW trench II.[65]

Cut through these *kouskouras* layers in the w of trench A was a foundation trench (pit B) running N–S, 0.42 m wide and 0.53 m deep at the N section, narrowing to the s, and turning away there to the E, where it was 0.15 m wide and *c.* 0.3 m deep. This trench had a fill of heavy red clayey earth, with small stones and flecks of charcoal and *kouskouras*, and EM II sherds. It had been dug for wall δ, of which three courses were preserved in the w side of trench A (PLATE 22 *b*). Wall δ, which continues into trench B, belongs with the lower EM IIB occupation deposit (as is clear in the sections in FIGS. 4.8–4.9), and is the only EM II house wall that we could find beneath the SFH (but see below). Running roughly N–S, it is loosely constructed of small to medium-sized rough stones, and survives to a maximum height of *c.* 0.37 m. Only the stones on its E face were visible. Wall δ continued beneath wall β (MW wall 1) of the SFH into trench B (PLATE 22 *b–c*), for a total extant length of at least 3 m.

Pit B, the foundation trench of wall δ, was dug into a hard dark yellow layer beneath floor 2 with many small stones and lumps of *kouskouras*, which was excavated as level A13. The pottery from this level, which in effect is the top of pit B, together with that from level A14 in the lower part of the pit, together with the corresponding levels B10 and B9 in trench B, are all presented here as deposit B1.

Deposit B2 consists of the other, later EM IIB layers sealed beneath floor 4, that is to say: (1) levels A11 and A9 of pit C (which we had originally thought to be (part of) a hearth and saw consequently as belonging with floors 2 and 3, rather than being later); (2) level A6 of floor 3; and (3) levels A12, A10, A8–A7 of floor 2. However, although they were all studied together as one deposit, where relevant and possible we give the level numbers of the pieces of pottery and other finds — which should help any efforts to distinguish earlier and later pottery in this B2 deposit.

Finally in trench A, we made a small test (1.25 m N–S × 0.40 m E–W) against the E section of the trench to the s of Pit C, finding a layer (level A15) with much *kouskouras*. This lay above floor 1, of disturbed *kouskouras* sloping sharply to the w. Level A15 produced only Neolithic pottery and probably represents fallen Neolithic debris, including perhaps building debris, that had crumbled in the long interval until the EM II occupation. Floor 1 is most probably a Neolithic surface. Beneath floor 1 was a dark use layer that has to be Neolithic.

Trench B

In eroded ground, that must have been disturbed in 1908 and perhaps again in 1957, the two upper EM IIB levels of trench B barely survived (PLATE 22 *c*), as the sections (FIGS. 4.6, 4.8) show. Floor 2 of trench A, however, continued under wall β across all of trench B. Below it was the same early EM IIB deposit with wall δ and its foundation trench (pit B) continuing from trench A, and thus part of deposit B1.

[63] Momigliano and Wilson 1996, 30–43, figs. 19–26, pl. 8; Wilson 2007, 70–6. Other finds: Momigliano and Wilson 1996, 43: SF 19–22, and pl. 9.

[64] Momigliano and Wilson 1996, 28–30, figs. 17–18, pl. 6: P80–82.
[65] Momigliano and Wilson 1996, 28–9, fig. 17, pls. 6: P78; 9: SF 18.

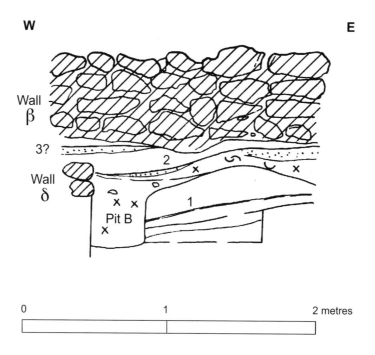

FIG. 4.8. Area B. Trench B: N section.

Pit B was excavated here as levels B9–B10; and level B6 (above B9) was probably also part of the same deposit and would be comparable to level A13 (but, however, has not been included in the pottery analysis in case of possible contamination). Between levels B9 and B10 in pit B was a thin layer of crumbly *kouskouras*. In this trench the pit/foundation trench was 0.4 m deep and 0.4 m wide where it cut the Neolithic *kouskouras* level B7,[66] which seems comparable to level A15. While wall δ is the only EM IIB wall that we found, there may have been one more at least that Mackenzie found in the area of trench B, which no longer exists;[67] and perhaps there were others.

Below level B7 were other Neolithic occupation layers: level B8[68] was a fairly hard dark grey layer with charcoal, which is comparable to the lowest level A16 in the other trench; while below it was another level with white to yellow and grey *kouskouras*. It is probable that, as in trench A, we have here Neolithic occupation debris.

Although most of the pottery from trench B was included for study with deposit B2, none of it is included in the pottery statistics and, when pieces from trench B are described, we say so.

Trenches A and B: Neolithic–Early Minoan II
The Neolithic–EM II sequence of phases (Neolithic: phase 1; EM IIB: phases 2–5) in trenches A and B may be summarised as:

1 Neolithic use: trenches A and B, below floor 1.
2 Above trenches A and B floor 1, and below trenches A and B floor 2; includes the foundation trench (pit B) of wall δ.
3 Above trenches A and B floor 2, and below trench A floor 3; includes wall δ.
4 Above trench A floor 3.
5 Pit C in NE corner of trench A.

There may of course be subdivisions in phase 1 (Neolithic), and further excavation could be worthwhile. As for the EM IIB phases,[69] we should emphasise that our deposit B1 represents phase 2, but our study of deposit B2 combined phases 3–5. The 1993 excavation separated them, and also found a

[66] Tomkins (pers. comm.) assigns the pottery to LN I–II.
[67] Momigliano and Wilson 1996, 5, fig. 3; 9.
[68] Its 'tiny, reworked' sherds seems pure LN I (Tomkins, pers. comm.).

[69] The relevant pottery from the 1960 tests is now assigned to the South Front Group of EM IIB (Wilson 2007, 70: 2).

phase of EM cuttings into the Neolithic,[70] which we did not find unless, as seems reasonable, we include the large pit B in this category.

EARLY MINOAN III

Trench A

The 1957 conservation revealed what would become, in trench A in 1960, important features of the South Front House: principally, the red plaster floor floor 5, bounded to the N by wall α (MW wall 12), which is faced with mud plaster, preserved in 1960 to a height of at least c. 0.68 m above floor 5, and with a red (plastered ?) surface apparent in 1957 (PLATE 21 c-d). Above and behind wall α is the modern terrace wall.[71] Both walls are visible in PLATE 22 b on the right, and wall α and its plaster facing show in the E and N sections of trench A (FIGS. 4.6–4.7, PLATE 22 a-b). Wall α, of medium-sized roughly shaped stones, runs E–W and survives to a height of at least 0.9–1.0 m.

This is clearly the interior of a room that certainly extended to the W of trench A, where the continuations of floors 5 and 4 were noted during the 1993 campaign, when it could be confirmed that floor 5 (and, almost certainly, floor 4) connected wall α to the N with wall β to the S to form this room (PLATE 22 b).[72] We do not know, however, how long the room is from E to W, since no W wall survives: it would have been destroyed when the big cutting was made for the South House. To the E, it is likely that a wall, which still survived in 1993 as a stump (MW wall 13) and did not appear at all in trench A, originally formed the E side of the room, connecting walls α and β.[73] We are fairly confident that this is correct, since the two red plaster floors 4 and 5 did not appear to the E of the line of MW wall 13 in MW trench II,[74] suggesting that this was a different space/room, separated from the room in trench A by MW wall 13. We suggest then that we have a long, narrow room or passage preserved between walls α (N) and β (S) and, in all probability, MW 13 (E). It measures c. 1.75 m N–S and perhaps some 5 m E–W.

We also do not know if wall α is an external wall: if so, and it is not improbable, it would have been the N wall of the SFH. Wall β, running E–W, is c. 0.55–0.60 m wide and survives to a maximum height of 1 m. It is made of medium-sized roughly shaped stones with a filling of smaller stones.

On the E side of trench A a recent disturbance (probably grubbing along wall β) was found to have cut floor 5, and apparently floor 4 also, so that it/they did not meet wall β: the disturbance appears in the section as the top (and, we believe, discrete top) of pit A (FIG. 4.6). A little pottery from clearing the ground above floor 5 is datable to MM IA, but hardly seems enough to draw conclusions about continuity of use of the SFH into MM IA, as we have already noted (p. 86 and n. 61). There is a case, however, for phasing in the SFH on architectural grounds (see below).

Beneath floor 5, and forming its bedding, was the sherd and stone fill of the EM III B3 deposit, 0.05–10 m thick, and resting on a similar plaster floor 4. This sealed assemblage, which has become an important deposit for characterising EM III at Knossos,[75] was dug mostly as level A3. There was, however, a slight chance of contamination of this level since part of pit A, the foundation trench of wall β, was removed with it. So a further tranche, 0.3 m wide, was opened on the W side of the trench as level A3a (PLATE 22 b), where there could be no possibility of contamination. In describing deposit B3 below, we say whether pieces are from level A3 or level A3a. In neither level was any polychrome pottery found (although in level A3 a footed goblet **1052** has a counterpart in the MM IA rubbish deposit of RRS — see p. 215). In retrospect, level A3 seems completely homogeneous and datable to EM III, together with level A3a. Recently, the combined levels have been assigned to the Upper East Well Group of EM III late.[76]

Floor 5 was removed as levels A2 and A2a. It appeared to have three separate layers of red plaster with white plaster beneath each, where the floor had been relaid — a *mille-feuille* effect when seen in section. These three layers were in all no deeper than 0.05 m. In places there may have been four layers. In the level A3a extension of the trench to the W, there was a thin scatter of charcoal above the bottom layer. On the N side of the trench the floor met the mudplaster facing of wall α.

Floor 4 (at the bottom of the B3 deposit) was equally distinctive in being exactly like floor 5 (above the deposit) in appearance and red plaster construction. This argues for their being fairly close in date and, since both floors belonged with wall α (FIG. 4.6), shows that there was in fact a second building

[70] Momigliano and Wilson 1996, 27, 52.

[71] This appears as a broken line on the S side of SOUTH CORRIDOR in the plan in Hood and Taylor 1981.

[72] Momigliano and Wilson 1996, 54, n. 52; Cadogan (personal experience).

[73] In 2009 wall MW 13 was no longer visible. It may have been buried during restoration work.

[74] Momigliano and Wilson 1996, 45.

[75] Cf. Cadogan et al. 1993, 24–6.

[76] Momigliano 2007c, 83: 8.

phase (at the least) in the SFH, when floor 5 was laid down in the long, narrow room some 0.14 m above floor 4. While it is possible that floor 4 belongs with an earlier phase, or predecessor, of wall α (whose existence we have no way of telling), two thin vertical lines of white plaster seemed to be a double edge (or skirting) to floor 4, where it met wall α. They are likely to be a facing (with a second skim of plaster) to the wall. Floor 4 to a great extent overlay the upper EM IIB occupation level A6, which is part of deposit B2 (see above). Floors 4 and 5 were not found in MW trench II.

A red floor or red floors, strikingly similar to floors 4 and 5, was/were, however, found some 10 m to the SE of our trench B in MW trenches IV and V. Momigliano and Wilson date it/them to their EM III building phase 1 rather than phase 3[77] (which is that of the construction of the SFH, including our floor 4). The gap in time between their phases, however, may have been fairly short, as we suspect it was between the laying of floor 4 and the laying of floor 5 in trench A. We may also wonder whether there may have been a terrace wall here, which could have the effect of amalgamating or truncating the proposed sequence of phases. Their excavation section, however, gives no support for this tentative suggestion, since any possible terrace walls do not go down far enough that one can say that they belong with the red floor(s) that Momigliano and Wilson found.[78]

That leaves the foundation trench (pit A) of wall β (PLATE 22 *a*), which appeared in both trench A and MW trench II, where it is the foundation trench of MW wall 1/1b).[79] It is key evidence in reconstructing the building history, but not easy to interpret. What makes it especially difficult is that, as already suggested, there seems to have been grubbing along the N face of wall β in 1957 and/or 1908. This grubbing seems to have cut through the floors and against the wall in a wedge-shape cutting, which narrowed sharply towards the W and tailed out at about the W edge/SW corner of level A3a (PLATE 22 *b*). It is easy to see why it stopped there: it is extremely close to the steep drop into the cutting of the South House, and there is considerable danger of falling in. As for the historical and ceramic importance of the trench, its contents in MW trench II (where there was some quantity of finds) are taken by Momigliano as the eponymous deposit — the SFH Foundation Trench Group — that constitutes EM III early, while our B3 deposit is an important, well stratified component in defining the Upper East Well Group of EM III late.[80]

In excavating our trench A some of the recent disturbance/grubbing that formed the top of pit A was removed initially in level A3. When this was realised, the rest of the pit was excavated as level A4: a fine dark fill that became steadily harder towards the bottom, which was partly formed by a white *kouskouras* block at the E end of the trench. At that end the pit was 0.3 m wide (and had a maximum depth of 0.52 m, which probably includes recent disruption) tapering to 0.075 m at the W end of the trench, where it was impossible to excavate it fully.

As far we could observe in trench A, pit A was dug into both of the EM IIB occupation layers, making it later than them. At the E end, as in the adjacent W part of MW trench II, it did not cut into Neolithic levels and was resting on the occupation level immediately above (EM IIB) floor 2.[81] But floors 4 and 5, and the B3 deposit between them, were cut at this end (in 1957/1908), which would have removed the evidence to connect them here with wall β. By contrast, at the W end of the trench where the (by now mainly or wholly 1957/1908) pit tapers out, it appeared to just cut floor 4, as PLATE 22 *b* suggests. But the further small investigation in 1993 (by Cadogan, during Momigliano and Wilson's excavation) in the small patch of ground between the W edge of level A3a and the South House cutting, combined with a comparison of the relative levels of the floors and top of the ancient part of pit A, led the group to conclude that floor 4 did originally cover pit A and did connect walls α and β to form the narrow room, as floor 5 did again a little later. If this reconstruction is sound, the corollary is that, with two floors (4 and 5) connecting walls α and β, there was a second phase in the life of this part of the SFH. The construction of this second phase is dated by deposit B3; how long it continued we cannot tell, possibly into MM IA.

The alternative view has to be either that pit A and deposit B3 belong together or that pit A is even later than B3. Either way, one or other scenario would thus date the construction of wall β and (at least this part of) the SFH to late in EM III, and floor 5 would be the first floor to connect with wall β. This would still leave the need to provide a context for the earlier red floor 4 that is so similar to floor 5: it would still probably connect with wall α but would be, as it were, left hanging on its S side. However, the red floor(s) in MW trenches IV and V shows that making red floors had some history, or had become a tradition, at this site. One need hardly add that, if the suggested alternative view is

[77] Momigliano and Wilson 1996, 7–8, figs. 4–5; 11, fig. 6; 47–8, fig. 28.

[78] Momigliano and Wilson 1996, 11, fig. 6.

[79] Momigliano and Wilson 1996, 8, fig. 5; 11, fig. 6; 28, fig. 17; 43–6.

[80] Momigliano 2007c, 81–3.

[81] Cf. Momigliano and Wilson 1996, 43.

correct, the EM III ceramic sequence at this site would differ to some extent from that recently proposed, which is based on seeing the pottery from the equivalent, or continuation, of pit A to the E (in MW trench II, the eponymous foundation trench of Momigliano's SFH Foundation Trench Group) as earlier, stratigraphically and stylistically, than our deposit B3.

We prefer, however, to stick with the first reconstruction as it makes sense of floor 4 as much as of floor 5 and produces, at the N end of the surviving remains of the SFH (which are perhaps the N end of the building), clearly two building phases. The earlier of these is the same as Momigliano and Wilson's EM III building phase 3 (see above). The later phase, the laying of floor 5, allows us to add now a building phase 4.

For the extent of the SFH, Momigliano and Wilson offer an attractive suggestion, projecting the levels of floors 4 and 5 to the s[82] — while we know already that it also extended to the W of trench A. These red floors, even if they are first known a little earlier in MW trenches IV and V, suggest that it was a building of some grandeur,[83] as do the finds in deposit B3 provided, that is, that they were rubbish from on the spot that was used for this hard core filling (and not material brought from somewhere else at Knossos). Besides its rich assemblage of pottery, the deposit also included a piece of a serpentine vessel **1176**, and a (fired) clay jar stopper **1167** with several partial impressions of a seal depicting parading lions. The original seal was probably made of ivory. This is valuable evidence, even as a discard, from a settlement context for dating the early seals of Crete and sealing practices at Prepalatial Knossos.

Trench B

In trench B the EM III levels connected with walls β and α were missing. Wall γ (MW wall 3) runs NNE–SSW, and is 0.65–70 m wide and has a maximum height of 0.85 m and a length of 1.4 m. It is made of medium-sized stones and is not bonded into wall β. It seemed to have been rebuilt and partly altered in the last century. Just outside the trench to the W, MW wall 15 runs N–S is c. 0.6m wide, and has a maximum height of 1.25 m and maximum length of 0.90 m. It is formed (now) of large rough stones on top and smaller ones below (which may be a sign of rebuilding: cf. wall γ). While neither wall γ nor wall MW 15 are bonded into wall β, we assume that they both somehow once formed part of the South Front House.[84]

Trenches A and B: EM III

We propose then an EM III sequence of phases in the construction and use of the South Front House of at least as follows, continuing the sequence above (for Neolithic–EM IIB):

6 Building of walls α and β and laying of floor 4 — EM III.
7 Laying of floor 5 — EM III.
8 Use of floor 5.

Trenches A and B: other finds

Obsidian was plentiful in both trenches in all levels except Neolithic in trenches A and B. A piece of white lime plaster with blue paint from level B1 (p. 234) may have fallen from the Palace: Mackenzie noted a few fragments of fresco.[85]

OTHER TRIALS

We made three other small trials (trenches D, E and F) (FIG. 4.9) in 1960 near, and inside, the South House.

Trenches D and E

Trench D measured c. 1.1 × 1.25 m, and trench E c. 1 × 2 m. Their purpose was to examine the massive more or less E–W wall (which we called wall β), over 2 m thick, that lies immediately s of the South House, and especially to look for dating evidence.[86] Trench D was opened immediately to the SW by W of the Pillar Basement of the South House, between an E–W wall that we called α (the N edge of the trench) and wall β (the s edge of the trench) (PLATE 22 e). Trench E was set against wall β from the s (PLATE 22 f).

[82] Momigliano and Wilson 1996, 11, fig. 6.
[83] Cf. Wilson 1994, 38.
[84] Cf. Momigliano and Wilson 1996, 53, fig. 31.

[85] DM/DB 1908, 53.
[86] As reported by Hood (1961, 27–8, fig. 31). Wall β is obvious in Driessen 2003, 29, fig. 1.1, at the bottom left.

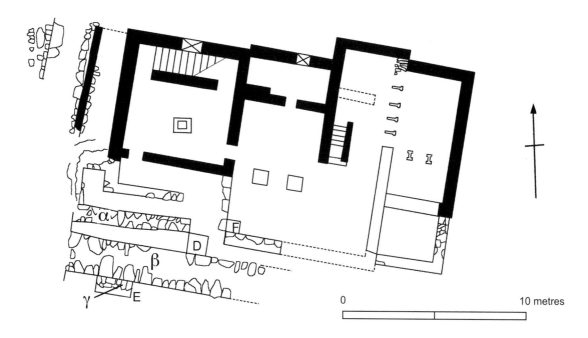

FIG. 4.9. Area B. Trenches D–F.

The first level excavated in trench D revealed that the bottom of wall β had been reached before we ever began: the wall stopped at the natural *kouskouras* (PLATE 22 *d–e*). In the N part of the trench level D2 was then excavated and also soon reached *kouskouras*. The *kouskouras* is, on average, *c.* 0.5 m below the present surface. Level D2 also revealed in the N part of the trench the S face of wall α, 0.4 m high at its E end in trench D and *c.* 0.55 m high at its W end in the trench D.[87]

This wall β (not to be confused with the wall β of the SFH above; the same applies to wall γ below) is composed of large, occasionally colossal roughly dressed blocks, with a fill of small stones between. It is 2.1 m wide and 0.95 m high. No specific dating evidence could be obtained:[88] burrowing beneath it (level D3) produced five Neolithic sherds. While it is possible that it had been built and was destroyed before the South House was built, Driessen has suggested that it could have been a terrace wall for the platform of the House or even supported a road terrace.[89] Alexiou, however, includes this wall in his likely evidence for defence and war in Minoan Crete.[90] And this must be the wall that Karetsou (re-)investigated in 1993[91] — see above.

Trench D having proved essentially abortive, trench E was begun on the S side of wall β. Immediately, wall γ was found parallel with wall β — and possibly forming its footings (PLATE 22 *f*). It extended 0.55 m out from wall β at the E end of the trench and was 0.9 m high, and 0.6 m out and was 0.8 m high at the W end of the trench. It is composed mainly of rough large stones, with a few small stones between. In the bottom course was a well-dressed block, *c.* 0.3 m square. Wall γ was clearly bonded into wall β.

Karetsou found the Protopalatial stone drain she reports (see above) to be running E–W due S of the Neolithic trench Z. It is likely that the 'unrecorded excavations' she mentions are, or include, one or other or both of our trenches D and E.

Trench E produced an unusual, and probably EM, clay foot, perhaps from a vessel: **1148**. The bottom level E4 of this trial, with light earth and much *kouskouras* which seemed to be the beginning of the natural rock, produced two scraps of pottery: one light brown burnished and perhaps Neolithic, the other a plain orange flaring bowl and perhaps Early Minoan.

[87] In Driessen 2003, 29, fig. 1.1, wall α is the wall near the bottom left corner of the plan, immediately north of the big wall (our wall β).
[88] Macdonald (pers. comm.) comments that it is perhaps comparable to a series of MM III walls found around the Palace site.

[89] Driessen 2003, 30.
[90] Alexiou 1980, 17.
[91] With the assistance of Maria Kladou. Work was (principally) to the W of wall β.

Trench F

Trench F was a small trial, *c.* 0.65 m square, in the SW corner of the Pillar Basement of the South House (PLATE 22 *d–e*).[92] It revealed the bottoms of the W and S walls of the Basement just below the present surface level. As in trench D, stratigraphy was virtually non-existent. In 1993 Karetsou cleaned here comprehensively down to the *kouskouras* or the Neolithic levels, finding fragments of handleless cups, possibly MM III, set into hollows in the *kouskouras*.[93]

NEOLITHIC AND PREPALATIAL OCCUPATION AT THE EARLY HOUSES AND SOUTH FRONT HOUSE

NEOLITHIC

The Neolithic debris noted in our trenches A and B, and J. D. Evans's trench Z, seems to be outside the (main) Neolithic inhabited area.[94] If, however, trenches A and B do show occupation levels and floors of houses rather than surfaces in an open space, such buildings are then probably right on the edge of the Neolithic settlement (although the precise chronology here needs clarifying). The rubbish noted in trench Z was, presumably, tipped outside the area with houses.

EARLY MINOAN I

Come EM I, there seems to have been at the least a lack of growth, and perhaps even a retrenchment, around the core settlement on the Kephala hill.[95] There is hardly anything in the stratigraphy or the pottery from any of the investigations of the Early Houses to suggest that this part of the hill was in use in EM I or EM IIA.[96]

EARLY MINOAN IIB

The situation changed in EM IIB, when settled life returned to this part of the hill. The late EM IIA fill to the N of the South House found by Karetsou in 1993 (see p. 83 above) may represent a levelling operation immediately prior to the EM IIB developments. While there appear to be two principal occupation layers resting on floors, we are short of walls to go with them; nor do we have any floor of superior quality comparable to the EM III red floors, on which the whole pottery found in 1908 could once have been standing.

On the other hand if there was considerable filling or dumping here in EM IIB, it might have comprised principally the 1908 pottery, perhaps coming from an EM IIB building at the site which now no longer exists. Alternatively, one might argue instead that this was a fill for building the South Front House;[97] the mixture of EM IIB and EM III pottery in the E part of the foundation trench for MW wall 1/1b in MW trench II would support the idea. However, in our trench A, and in the W part of MW trench II,[98] the EM III seems virtually pure, which makes this idea harder to accept, at least in this part of the site.

Later even than the likely fill of the 1908 excavations is pit C in trench A. Finally, it is hard to avoid seeing at least the whole vessels from 1908 as coming from a floor deposit of EM IIB (of which we have no further evidence),[99] rather than from a fill.

EARLY MINOAN III

The first evidence for construction in EM III was found outside our trenches, in MW trenches IV and V. Soon after this came the construction of the substantial South Front House, which appears to have had (at least) two building phases, as we believe we can see in trench A. How long it lasted in use is uncertain, perhaps into MM IA.

[92] Driessen 2003, 29, fig. 1.1; 33. The excavation, which would be just outside the bottom left corner of Mountjoy 2003, pl. 2a, is not mentioned in that report. EM and MM pottery from the South House and its surrounds includes an EM IIB type 2 goblet (Knappett (2003, 41–3, fig. 3.1: 1), an EM III–MM IA jug (Knappett 2003, 42, 47–8, fig. 3.3: 41) and EM III fragments found on the surface in 1902 (Knappett 2003, 42, 48–9, fig. 3.3: 46–9).

[93] Karetsou and Macdonald, pers. comm. Karetsou interprets these as foundation deposits (for references see n. 37 above).

[94] Tomkins, pers. comm.

[95] Whitelaw forthcoming is an excellent recent review of the history of the settlement.

[96] Apart that is from the late EM IIA fill found N of the South House in 1993 (see p. 83 above).

[97] Momigliano and Wilson 1996, 53.

[98] Momigliano and Wilson 1996, 44.

[99] Cf. Momigliano 1991, 200.

MIDDLE MINOAN IA

Evidence does not survive to show how much occupation, if any, there was here in MM IA. We note the complete lack of MM IA polychrome pottery in the 1960 and 1993 excavations, although it was found at the Early Houses in 1908, perhaps in a fill.[100]

[100] See the thorough discussion by Momigliano (1991, 198–204), including a review of the possible circumstances of deposition.

Chapter 5

The Early Minoan II pottery

FABRICS

1. Fine ware
 - A. Light surfaced wares
 - (a) Buff ware
 - (b) White burnished ware
 - (c) Light grey ware
 - B. Dark surfaced wares
 - (a) Dark grey burnished ware
 - (b) Red burnished ware
 - (c) Light brown burnished ware
 - (d) Dark (red and black) washed wares
 - (e) Vasiliki ware
2. Coarse ware
3. Cooking pot ware

FINE WARE

In all Minoan periods most of the small clay vessels, and even some quite large ones, are of fine ware. The clay of this standard fine ware is well levigated and has no marked traces of straw or grit temper; it is normally orange or buff in the break, and the surface is usually a paler colour than the core, often if not invariably due to wet smoothing (self-slip smoothing) rather than to the application of a true slip, except in cases where it is coated with a dark wash. At the beginning of EM II fine vessels with dark grey or grey-brown burnished surfaces continuing the EM I tradition are still relatively common. But from then onwards the fine ware approximates to that characteristic of the rest of the Cretan Bronze Age.

Even in EM I, if the pottery from the Palace Well is a guide, the dichotomy is apparent that continued through Early and Middle Minoan between dark surfaced and light surfaced wares. The fine table ware from the Palace Well (the chalices and food vessels of EM I types 1 and 2, and the suspension pots of EM I type 14) has dark burnished surfaces with decoration in pattern burnish in reserved areas. The light surfaced wares from the Well are also sometimes decorated with pattern burnish or, especially the jugs with cutaway spouts of EM I type 11, with dark-on-light painted decoration in red, shades of brown, or black.

During EM II red and black washed wares came to replace dark burnished wares as representatives of the dark surfaced wares. With more intensive firing to secure a harder fabric, the clay may have tended to bake a light colour, orange or buff, instead of shades of grey or grey-brown; and a wash would then become necessary to obtain a dark surface. Pattern burnish would have been an unsuitable technique for decorating the new washed surfaces, although these were often fairly well burnished. Pattern burnish was therefore almost entirely replaced from an early stage of EM II at Knossos (marking the change from EM IIA early to EM IIA late)[1] by decoration in white paint or, to a limited extent, by incised decoration. Evans did indeed hint that decoration in white, whether on washed or burnished surfaces, was already in use at Knossos in EM I;[2] and, for instance, a well marked class of pottery with white painted decoration on a red washed surface occurs in the early level of Lebena T. II.[3]

Side by side with this use of white paint on a dark surface in early EM II, there was also a comparative rise, followed by an eventual decline, in the popularity of light surfaced wares with decoration in red, brown or black paint, continuing the tradition of EM I. The fashion for dark surfaced ware with a red, brown or black wash, and decoration in white, became increasingly strong during the course of EM II and was well established by EM III.

[1] Cf. Wilson 2007, 64–5.
[2] *PM* I, 63: cf. H. W. Pendlebury *et al.* 1936, 28 and n. 1, with references.

[3] Alexiou and Warren 2004, 17, 123, with references.

LIGHT SURFACED WARES

Buff ware[4]

The clay is well levigated, orange or buff in the break, usually with the surface distinctly paler in colour, in most if not all cases from the potter's applying a slip.[5] Surfaces may be smoothed or burnished, and the marks of the burnishing implement are normally visible (stroke burnish). On larger vessels like bowls the burnishing can be very superficial (scribble burnish).

Where these burnished vessels had painted decoration, the paint was normally if not invariably applied after the surface had been burnished and before firing. This type of encrusted decoration, as it is called, is different from the technique employed for decorating the earliest Neolithic painted pottery of mainland Greece, where burnishing took place after the vessel had been decorated. Much later, encrusted ware is found in the Rachmani horizon assigned to the end of Neolithic or Chalcolithic in Thessaly, and in the Neolithic of the Balkans.

Buff burnished ware with painted decoration, characteristically in red, but also in shades of brown and black, is much in evidence in Crete during EM II. The standard footed goblets of type 2 from deposits A2 and B1 for instance are mostly of this fabric. But even in deposit B3 EM III jugs with cutaway necks of type 15 are regularly of buff burnished ware.

In all stages of EM II, if not later, some bowls, especially it would seem those with flaring rims of type 8, have orange or buff surfaces with very fine stroke burnishing but no decoration.

White burnished ware

This rare fabric is in effect a variety of buff ware, but the vessels have a thick white slip, which is very well burnished.

Light grey ware

This is another rare and distinctive fabric.[6] The clay is exceedingly fine, and light silvery grey throughout, with well burnished exposed surfaces. The best known shape in this fabric is the suspension pot (type 20), which often has elaborate incised or grooved decoration. There are also large jars of comparable shape and decoration in this fabric.[7]

DARK-SURFACED WARES

Dark grey burnished ware[8]

This fabric continues the tradition of the fine grey-brown burnished ware of EM I. At the beginning of EM II, to judge from deposit A1, many smaller vessels, notably goblets and chalices of various kinds, were still being made in dark grey burnished ware.[9] Fragments of this fabric occurred in A2, but not in A3–A5; and there were a few scraps in B1 and B2.

The fabric tends to be rather soft and is apt to flake. The clay is sandy, but without obvious grit; either grey throughout or more commonly red-brown to orange in the break. Outside surfaces are burnished, usually so well that the stroke marks of the burnishing implement are hardly or not at all visible, and the surfaces feel smooth and soapy as if polished. Often they have a mottled appearance.

The shapes for which this fabric was used would seem to be largely goblets or small bowls of various kinds, if the evidence from our deposits is reliable. In many details the shapes in this fabric from A1 are unlike those which occur in later EM II deposits.

Red burnished ware

This variety of fine burnished ware occurs alongside dark grey burnished ware, but is not so common.[10] Like dark grey burnished ware, it is best represented in A1, although it occurs in A2. Only scraps of red burnished ware were found in B1 and B2, but there is more of it than of dark grey burnished ware.

The fabric of red burnished ware seems more diverse than that of dark grey burnished ware, and the range of shapes and sizes less restricted. The clay is normally orange, and tends to be rather soft, which distinguishes red burnished ware from varieties of red washed ware with burnished surfaces. Most if not all red burnished ware vessels have a slip or wash, in red or orange shading to light brown, well burnished.

[4] See also Wilson 2007, 61, 65–9.

[5] For discussion of the terms 'slip' and 'wash', see above p. 26.

[6] See pp. 30, 247–52. See also Wilson 2007, 61, 69; Wilson and Day 1994, 4–22, calling it 'fine grey ware'.

[7] E.g. Vasiliki: Boyd Hawes et al. 1908, 50, pl. 12: 13 (Wilson and Day 1994, 21: FG 126).

[8] See also pp. 252–6, and Wilson 2007, 58 (including a coarser version: dark coarse burnished ware), 64.

[9] For the move from chalices to stemmed goblets between EM I and EM IIA, see Wilson 2007, 58.

[10] Cf. Wilson 2007, 61.

On some larger vessels in this fabric the burnishing tends to be superficial or partial (scribble burnish) with the stroke marks isolated and clearly visible; but some pieces have exceptionally fine red burnished surfaces, and are the equivalents of the finest dark grey burnished ware. The fragments of this distinctive fine red burnished ware come from various shapes, open and closed, but all evidently of small size. The burnishing on them is even and thorough, so that surfaces appear as if polished; but the stroke marks of the burnishing implement can be detected.

Branigan's 'Salame' ware may be a southern equivalent of our red burnished ware: at Ayia Kyriaki fragments of this accounted for 1.4% of the pottery, as against dark burnished ware with pattern burnish (Branigan's 'Pyrgos' ware), or without it, which accounted for 2%.[11]

Light brown burnished ware

The surfaces of some vessels in red burnished ware shade in places to light brown. Other pieces, such as lid **196** (A1), have a burnished surface that is entirely or predominantly light brown.

Dark (red and black) washed wares

These correspond to Wilson's red/black slipped ware.[12] Several of the wares defined by Blackman and Branigan at Ayia Kyriaki appear to fall within this category, notably 'red/brown slipped ware', 'red-wash ware', 'dark-wash ware', and 'Urfinis ware'.[13]

Vessels with an overall dark wash were already being made in EM I, as in the Palace Well (p. 58); and there are fragments in A1. During the course of EM II dark washes became increasingly fashionable on fine ware although, throughout this period and later, some of the finest decorated vessels remained light surfaced without a wash. The growth of dark washed ware at the expense of light surfaced buff ware can be traced most easily in the footed goblets of type 2.

The fabric of dark washed ware is basically the same as that of the fine light surfaced buff ware. The clay is well levigated, orange or buff in the break. The wash may be red or black, or intermediary shades of red-brown and purple-brown, and it often shades or mottles from one colour to another on the same pot. This variation in surface colour is more noticeable in EM II than in EM III and must reflect the rather haphazard firing of the pottery. Nothing suggests that it was deliberately induced for decorative effect like the mottling on classic Vasiliki ware. But the choice as to whether the wash should appear after firing as red or black appears to have been deliberate, although the result of firing was perhaps not always what had been intended. The washed surfaces are decorated in white paint (light-on-dark) in place of the red, shades of brown, or black paint used to decorate the light surfaced wares (dark-on-light).

The dark washed surfaces were sometimes smoothed or burnished after the wash had been applied: such burnishing would appear to have been more common, although not universal, at the beginning of EM II than later. In several cases the burnishing of the dark washed surface is very fine and thorough; but, even when the wash is burnished in this way, the surface of the vessel still looks different from the slipped surfaces of the grey and red burnished wares.

Normally, however, surfaces with dark washes were left unburnished. The lustrous character of the wash was no doubt regarded as a substitute for burnishing as far as appearances were concerned. At the same time improved firing may have meant that burnishing was less necessary for making vessels efficient as containers of liquids. The lustrous character of the wash is already clear on some EM II vessels — and no doubt was yet more obvious at the time they were made. As firing improved, the lustrous character of the wash becomes more marked, and more resistant to wear. In EM III the wash often has a distinct metallic sheen.

Vasiliki ware

This distinctive fabric is in effect a variety of dark washed ware that has long been considered a hallmark of EM II. Its distribution in our excavations at Knossos agrees with this. Some fragments come from EM III levels; the highest proportion occurs in EM IIB deposits; and some scraps come from deposit A1.[14] It is entirely absent, however, from the WCH. Even at the type site of Vasiliki it seems rare in period I. Similarly at Fournou Korifi, where it abounds in period II, there are only two sherds in a period I deposit.[15]

[11] Blackman and Branigan 1982, 29, 33, table 1.
[12] Wilson 2007, 58, 64–5.
[13] Blackman and Branigan 1982, 35.

[14] Wilson (2007, 69, 76) agrees on its rare occurrence in late EM IIA.
[15] Warren 1972a, 21, 108.

Vasiliki ware was defined first by Seager.[16] Betancourt, in a detailed study,[17] notes that it is simply a version of the red slipped and burnished ware found alongside it in the same range of shapes in eastern Crete.[18] According to his definition, the essential feature of the fabric is the mottling of the surface, which is invariably burnished. Betancourt studied the material from our excavations which we had classified as Vasiliki ware, and excluded a few pieces (**228, 421, 423, 1048**) from this class. A note of this has been added to each description.

In standard Vasiliki ware the clay is well refined, usually a pale shade of orange in colour, and often rather dusky in the break: this no doubt reflects somewhat inadequate firing, as a result of which the fabric is apt to be soft. The exposed surfaces (inside and outside for goblets or bowls, outside only for closed shapes like jugs) have a wash which, after firing, appears orange-red or light brown mottling to shades of dark brown and black. The wash does not seem to have been lustrous, but the washed surfaces were well smoothed or stroke burnished so that they have a lustrous appearance and are soapy to feel. The marks of the burnishing tool may be, but are not always, visible.

Blackman and Branigan claim that they found no evidence of actual burnishing on Vasiliki ware from Ayia Kyriaki.[19] Similarly on some of our fragments from Knossos, which in other respects would appear to be assignable to this fabric, the washed surfaces do not seem to have been smoothed or burnished. **1048** is a good example of an unburnished wash from the EM III B3 deposit, and most fragments of this kind are probably from relatively late products; but two possible fragments come from B1, which is EM IIB. None of these, however, would qualify as Vasiliki ware according to Betancourt's definition, and he has rejected **1048**.

Even in small scraps Vasiliki ware, with its soft fabric, pale orange clay and distinctive mottling, is usually quite easy to distinguish from standard dark washed ware. Furthermore, the majority of dark washed ware vessels at Knossos in EM II–III has painted decoration in white, while standard Vasiliki ware was rarely painted — although Seager notes a few examples with added white or dark bands,[20] and Betancourt observes that some pieces, which presumably date from late in the tradition, have the same white painted decoration as is typical of EM III in eastern Crete.[21]

A basically red surfaced mottled ware has been noted in some parts of Crete in contexts assigned to EM I or FN. 'Class F' ware at Phaistos is of this kind: Vagnetti argues that its mottling was deliberately induced, as with Vasiliki ware,[22] and that it was the forebear of the red mottled ware in the early deposit in Lebena T. II.[23] Marinatos similarly suggested that a ware from the Eileithyia cave, apparently comparable to Phaistos F ware, might have been ancestral to Vasiliki ware;[24] the mottling he thought was in some cases certainly deliberate. A similar basically red mottled ware is characteristic of bowls with Kum Tepe IB internally thickened rims from the horizon of periods VII–VI at Emporio in Chios.[25] This horizon overlaps with EC I, and therefore probably with EM I and FN in Crete. Finally, even the mottled surfaces of the much older EN Variegated or Rainbow ware on the Greek mainland might have been deliberate.[26]

The mottling of Vasiliki ware was clearly decorative and deliberate. Various suggestions have been made as to how it was achieved. Betancourt is probably right in concluding that more than one method was employed, and there was a family of techniques, some highly deliberate, others more or less accidental.[27]

A tradition of mottled surfaces could have persisted in parts of Crete from the end of Neolithic into EM II, which might be one factor in the development of Vasiliki ware. But the shapes of the Vasiliki ware vessels and some of the features that seem peculiar to them suggest that they may have been made, in the first instance at any rate, as deliberate imitations of metal vessels. Evans, Pendlebury and Branigan have stressed the metallic antecedents of the ware.[28] At Knossos features that seem confined to Vasiliki ware include 'rivets' on the tops of rims of bowls or goblets (e.g. **288**), bead rims on jars (e.g. **289**), and ring bases, e.g. **823**. These features could be interpreted as metallic, and suit the idea that Vasiliki ware may have been developed in an attempt to reproduce the look of copper vessels.

Many Vasiliki ware vessels come from Vasiliki itself, and over 100 from Fournou Korifi, while sherds of this ware abound on the surface of early settlement sites in the region. In Betancourt's lists

[16] Seager 1905, 215–17.
[17] Betancourt 1979.
[18] Betancourt 1979, 14.
[19] Although they note that this might reflect their view of what constitutes such evidence (Blackman and Branigan 1982, 35 and n. 41).
[20] Seager 1905, 217.
[21] Betancourt 1979, 4.

[22] Vagnetti 1973a, 85.
[23] Vagnetti 1973a, 84; cf. Levi 1965, 225; and Alexiou and Warren 2004, 117–18.
[24] Marinatos 1929a, 98, fig. 4 top; 100.
[25] Hood 1981, 302–03.
[26] Blegen 1975, 261.
[27] Betancourt 1979, 16 (and 12–20).
[28] *PM* I, 80; Pendlebury 1939, 68, 75; Branigan 1970a, 129–30.

(of 1979 — there are certainly more now) of sites with fragments of vessels of recognisable types in Vasiliki ware,[29] 15 out of 26 sites are in eastern Crete, with over 20 pieces on average recorded from each. The other 11 sites, which are scattered through the rest of the island, have an average of only just over four pieces each.

The distribution suggests that Vasiliki ware developed originally, and continued to flourish, in eastern Crete, especially in the region of the isthmus of Ierapetra as far at least as Priniatikos Pyrgos west of Vasiliki.[30] It was almost certainly made, however, at more than one centre in this area: one of these was probably Malia, on about the western limits of this area,[31] and Betancourt has suggested others in the region of Fournou Korifi and Gournia (Sphoungaras).[32]

It was widely exported to other parts of Crete and much imitated locally. In the Mesara, for instance, it is found in the circular tombs;[33] Betancourt suggests that there may have been a workshop near Lebena, and another/others in the Mesara itself.[34] In western Crete Vasiliki ware is said to be very common in the Platyvola cave and at Chania–Kastelli, and the existence of a local workshop for it has been inferred; but only one piece from each of these sites is included in Betancourt's lists.[35] In the Lera cave it was thought to have been imported from the east of the island.[36] At Trapeza Pendlebury, and Blackman and Branigan at Ayia Kyriaki, felt able to distinguish between imported Vasiliki ware and imitations.[37] Banti evidently regarded it as locally made at Ayia Triada, and Pendlebury agreed.[38]

Some (or, if Betancourt is right, most) of what has been grouped as Vasiliki ware from our excavations may have been made in the Knossos region. After a study of this material Betancourt formed the impression that it was all of local manufacture with a few exceptions such as **420** imported from eastern Crete.[39] He has suggested that there was at least one workshop in the Knossos region making mottled pottery with several distinctive local features, such as small rivet-like pellets on or near the rims (e.g. **288**), which set off the local cups and bowls from those found elsewhere.[40] Such pellets do occur on rims in other fabrics than Vasiliki ware in our EM IIB deposits, e.g. **279**, **787**, **865** (but none in A1 or the WCH). On the other hand, pellets or excrescences of one kind or another are found in various fabrics including Vasiliki ware at Fournou Korifi II.[41]

COARSE WARE

Coarse ware is essentially the same as the fine ware used for the great mass of the smaller vessels, but with lumps of grit added to the clay to temper it. Large bowls of type 10 were normally made of coarse ware, as were some jars of type 17 and some pithoi. Coarse ware vessels are usually light surfaced, but sometimes have a dark wash.[42]

COOKING POT WARE

This is really a specialised variety of coarse ware, and was already on the way to becoming differentiated from ordinary coarse ware back in EM I, where pieces of embryo cooking pot ware come from the Palace Well. By the start of EM II a distinctive cooking pot ware had emerged,[43] which continued in use during all subsequent Minoan periods and into the Iron Age.

In Middle and Late Minoan times this fabric tends to a very large extent, if not exclusively, to be used for cooking vessels with or without tripod legs. In EM II, however, it was also used extensively

[29] Betancourt 1979, 32–51. In the Kavousi area it is rather rarer: Haggis 2005, 49.

[30] See now Day *et al.* 2005, esp. 178–83.

[31] Pelon and Schmitt 2003. Cf. Van Effenterre and Van Effenterre 1969, 9; Betancourt 1979, 28.

[32] Betancourt 1979, 27–8.

[33] These include eight from Ayia Triada listed by Betancourt (1979, 38–40, 42), a teapot and two cups from Porti (Xanthoudides 1924, 60–1, pls. 6, 35: 5067, 36b: 5100, 5668), and a goblet and spouted bowl from Platanos (Xanthoudides 1924, 95, pl. 1: 6892; 96, pl. 51a: 6894). Betancourt (1979, 34, 40, 42, 46–7, 49) also lists nine vessels from Lebena, which Alexiou and Warren (2004, 13–14, 18, 21, 123, 171–3) see as mostly locally made. Some is reported from Ayia Kyriaki: Blackman and Branigan 1982, 32–5, 37, table 1.

[34] Betancourt 1979, 27.

[35] Tzedakis 1965, 568; 1967, 505; Betancourt 1979, 27–8, 42–3.

[36] Guest-Papamanoli and Lambraki 1976, 204, 212.

[37] Trapeza: H. W. Pendlebury *et al.* 1936, 48–9, 58, 71–3, 78–9, 86 (Betancourt 1979, 27–8 concurs in the possibility of local production); Ayia Kyriaki: Blackman and Branigan 1982, 32, 35.

[38] Banti 1931, 236–7; H. W. Pendlebury *et al.* 1936, 71. Cf. Betancourt 1979, 27.

[39] From petrography, Day *et al.* (1999, 1032–3) see a Mirabello group in the Vasiliki ware at Knossos, and a metamorphic group of unclear origin. Cf. Wilson 2007, 76. See also on analyses of Vasiliki ware: Wilson and Day 1999, esp. 39–40; Day *et al.* 2005, 181–2; Pelon and Schmitt 2003.

[40] Betancourt 1979, 27.

[41] E.g. Warren 1972a, 116: P196–197, P207; 118: P247, P249.

[42] See also Wilson 2007, 55, 61, 69, on 'pithos ware'.

[43] Cf. Wilson 2007, 54–5, 61.

for large bowls and jars that were evidently storage vessels, as well as for rare examples of bowls of other types, and small jars and occasionally jugs (e.g. **484**). Certain shapes current in EM II are almost always made in cooking pot ware, including tripod cooking vessels of type 23, large open plates or dishes and baking plates of types 12–14, the distinctive large open bowls of type 11, deep bowls and jars of type 18, and the EM IIA horned stands of type 24.

The fabric is generally coarse. The clay is gritty (although the grit may be quite fine) and normally reddish, or shades of light and dark brown. With thicker walled vessels the clay is not always fired an even colour throughout, but may appear dusky in the break. Surfaces may have a slip or wash, red or a shade of brown, and are quite often well smoothed or burnished.

At the beginning of EM II the surfaces, especially of the large bowls and bowl-jars of types 11 and 18, are still as a rule more or less boldly wiped or scored with a bunch of twigs, as in EM I; but this wiping seems virtually confined to cooking pot ware vessels, and the practice was evidently on the wane. Fragments with a wiped surface occur in A1, and are not uncommon in A2 and B1 but rare or non-existent in the latest EM II deposits, with the virtual disappearance of the bowls and jars of types 11 and 18 (which characteristically had wiped surfaces).

Some cooking pot ware vessels, especially large spouted jars of type 17, had painted decoration in white. Subsequently, white decoration is found on cooking pot ware until LM IB and into LM III. But after the end of EM II jars of type 17 were normally made of ordinary coarse ware; and it is largely for this reason it would seem that the use of white paint to decorate cooking pot ware is more prominent in EM II than in succeeding periods.

TYPES, FEATURES, AND DECORATION

The following are the principal types of EM II pottery that we could identify in Areas A and B.

TYPES (FIG. 5.1)

1A. Cups with large loop handle
1B. Cups with vertical handle
2. Footed goblets
3. Goblets
4. Shallow bowls or plates with rim thickened internally: (**a**) rounded rims, (**b**) bevelled rims
5. Shallow bowls with upright sides and rim thickened internally: (**a**) rounded rims,
 (**b**) flat-topped rims
6. Deep bowls with trough spout and horizontal side-handles: (**a**) rims thickened internally,
 (**b**) bevelled rims, (**c**) tapered rims
7. Shallow bowls with straight or inward curving sides
8. Bowls with flaring rim: (A) shallow, (B) deep
9. Bowls with everted rim: (A) shallow, (B) steep-sided
10. Large bowls with straight sides and thick everted rim: (A) shallow, (B) deep
11. Large bowls with curving, often carinated sides, and thickened rim (cooking pot ware)
12. Large flat dishes with upright sides (cooking pot ware)
13. Plates (cooking pot ware)
14. Baking plates (cooking pot ware)
15. Jugs with cutaway spout
16. Small spouted bowl-jars: (A) teapots with vertical handle, (B) with horizontal side-handles
17. Large spouted bowls or jars with horizontal side-handles
18. Large bowls or jars with inward curving, often carinated and thickened rims (cooking
 pot ware)
19. Collar-necked jars with horizontal side-handles
20. Suspension pots
21. Flat lids with handles
22. Cover lids
23. Tripod cooking pots (cooking pot ware)
24. Horned stands (cooking pot ware)
25. Incense burners
26. Theriomorphic vessels
27. Pithoi

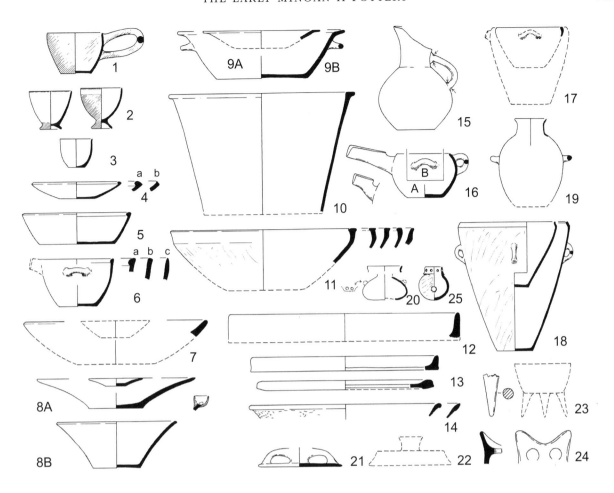

FIG. 5.1. Areas A and B. EM II and III pottery types: type 1A cups with large loop handle; type 1B cups with vertical handle; type 2 footed goblets; type 3 goblets; type 4 shallow bowls or plates with rim thickened internally: (**a**) rounded rims; (**b**) bevelled rims; type 5 shallow bowls with upright sides and rim thickened internally: (**a**) rounded rims; (**b**) flat-topped rims; type 6 deep bowls with trough spout and horizontal side-handles: (**a**) rims thickened internally; (**b**) bevelled rims; (**c**) tapered rims; type 7 shallow bowls with straight or inward curving sides; type 8 bowls with flaring rim: 8A shallow; 8B deep; type 9 bowls with everted rim: 9A shallow; 9B steep-sided; type 10 large bowls with straight sides and thick everted rim: 10A shallow; 10B deep; type 11 large bowls with curving, often carinated sides, and thickened rim (cooking pot ware); type 12 large flat dishes with upright sides (cooking pot ware); type 13 plates (cooking pot ware); type 14 baking plates (cooking pot ware); type 15 jugs with cutaway spout; type 16 small spouted bowl-jars: 16A teapots with vertical handle; 16B with horizontal side-handles; type 17 large spouted bowls or jars with horizontal side-handles; type 18 large bowls or jars with inward curving, often carinated and thickened rims (cooking pot ware); type 19 collar-necked jars with horizontal side-handles; type 20 suspension pots; type 21 flat lids with handles; type 22 cover lids; type 23 tripod cooking pots (cooking pot ware); type 24 horned stands (cooking pot ware); type 25 incense burners.

FEATURES

Spouts: (**a**) trough, (**b**) nozzle and tubular, (**c**) teapot, (**d**) bridge
Handles
Carinations
Bases

DECORATION

Painted: (a) dark-on-light, (b) light-on-dark
Pattern burnish
Incision
Relief
Wiping or scoring

Types

TYPE 1A. CUPS WITH LARGE LOOP HANDLE

Large handles in general appear to be an early feature in Minoan pottery.[44] The Kyparissi pottery illustrates this well: many vessels there of various shapes, including jugs and bowls, are distinguished by the size of their handles. Cups of type 1A with flat bases are evidently descended from the large-handled cups with rounded bases whose existence was inferred in the Palace Well material (see p. 36); and some round-based cups come from Pyrgos.[45]

Cups of type 1A with large handles have long been regarded as characteristic of EM II, but they do not in fact appear to have been common. Only four are reported from the WCH,[46] to which we can add from Knossos: **1186** in light grey ware from a 1928 test pit w of the North Lustral Area (E.I.9 622); an EM IIA dark-on-light cup with a round bottom from Warren's excavations in RRS;[47] and **1301**, shown by Evans with EM IIB pottery that he found in the Early Houses[48] — but it may be earlier than the other vessels in the photograph (see pp. 267–8).[49] One of coarse plain ware comes from Ayia Kyriaki,[50] and two small cups from Koumasa approximate perhaps to this type rather than to type IB.[51] A large-handled cup in Vasiliki ware from Vasiliki III[52] should be EM IIB. A cup of similar shape with a large handle rising above the rim from Sphoungaras is assigned to EM II.[53]

Some cups from Fournou Korifi II approximate to this type,[54] but others have smaller handles akin to type 1B. Type 1A, Pendlebury's 'cup with high swung handle', is well represented at Trapeza;[55] but most cups there have smaller handles like type 1B. A small cup from Drakones with a relatively large handle like type 1A was assigned to MM I.[56]

At Vasiliki cups of type 1A were called dipper cups. The large handle would have kept the hand dry when ladling,[57] as would have been case too with LM/LH III dippers (FS 236) (where the handle is at a much steeper angle).

TYPE 1B. CUPS WITH VERTICAL HANDLE

This type merges into type 1A. It seems rare at Knossos in EM II (and is not shown in FIG. 5.1), but is well represented in eastern Crete. Seager noted that this shape first appeared in early EM II and continued into EM III.[58] Such cups were common in Fournou Korifi II.[59] Many were found at Trapeza, and several at Ayia Kyriaki, some of which may be later than EM II.[60] None was noted in the EM II deposits in our Area A. Three rims, however, with strap handles assignable to cups of this type come from B2 (pp. 201–2: **913**), but they are of Vasiliki ware and may be imports from eastern Crete or local Knossian versions of the ware.

TYPES 2 AND 3. FOOTED GOBLETS AND GOBLETS

The rim fragments of these are indistinguishable, and they are considered together under type 2 below. Simple goblets of type 3 seem curiously rare during Early Minoan II. None appears in A1, and none either in the WCH. Our EM IIB deposits produced possible fragments of about eight simple goblet bases (over 1/2 of them from B2), as against over 90 of the distinctive eggcup bases of footed goblets of type 3. EM III is a sharp contrast: in B3 the bases of simple type 3 goblets actually outnumber the fragments of eggcup feet from type 2 goblets.

TYPE 2. FOOTED GOBLETS

Ht c. 7–10. Rims attributable to this type or type 3 appear to range in diameter from c. 5 to 12. They are usually more or less pointed, but some flattened rims occur. In one or two cases the goblet was

[44] Cf. Zois 1967a, 711–13.
[45] Xanthoudides 1918a, 147, fig. 7, 149: 28, also perhaps assignable to EM I.
[46] Wilson 1985, 301: P55.
[47] Catling 1973, 27–8, fig. 59.
[48] PM I, 73, fig. 40 top right.
[49] As Wilson (2007, 58, table 2.3; 65, table 2.4) seems too to suggest in listing the type, as dipper/cup, in EM IIA Early and Late, but not in EM IIB.
[50] Blackman and Branigan 1982, 28, fig. 9: 9.
[51] Xanthoudides 1924, 38, pl. 27: 4134, 4248, assigned by Zois (1967a, 719) to his 'Koumasa' style of EM IIA.
[52] Seager 1905, 216, fig. 6 (Maraghiannis 1911, pl. 23: 6;

Betancourt 1979, 40).
[53] Betancourt 1983, 47, fig. 13, pl. 11: 118.
[54] Warren 1972a, 125–6, 180, fig. 64, pl. 45: P348–352.
[55] H. W. Pendlebury et al. 1936, 56–8, fig. 13; Pendlebury 1939, 67.
[56] Xanthoudides 1924, 79, pl. 42: 5031.
[57] Boyd Hawes et al. 1908, 50, pl. 12: 17. Wilson (1985, 301) suggests use also for skimming, but the typical large and deep bowl of these cups is not suited for that.
[58] Seager 1912, 52, fig. 22: VI. 6.
[59] Warren 1972a, 125–6, 180, fig. 64: P357–361.
[60] H. W. Pendlebury et al. 1936, 56–9; Blackman and Branigan 1982, 39–40, fig. 14, table 3: C4.

evidently made with a flattened rim; but a few rims had been ground down to a flat top after firing, perhaps to eliminate chipping which the original thin, sharp rims may have suffered in use.

The foot tends to be higher, and the goblet larger and broader (with the diameter of the rim wider in relation to the height) than for the equivalent goblets of EM III and MM IA. Over time the diameter of the rim seems to suffer a gradual diminution from an average of $c.$ 10 in A1 to $c.$ 7.5–9 in A3 and 6–9 in A4. Meanwhile, the feet decrease in size and height until they approach the low type of eggcup foot that is standard in EM III–MMIA. Feet in A1 appear to be distinctly larger than ones in later levels: both higher and wider, with an average diameter of $c.$ 7. But large eggcup feet still occur in A3 where, out of 24 examples, three have a diameter of just over 6. However, 21 feet from A3 and all seven from A2 seem to range between $c.$ 4 and 5.2 in diameter. Some eggcup feet from A2 are high and solid, reminiscent of the solid pedestals assigned to EM I or IIA (cf. pp. 33, 253–4); but others are already quite low like many in EM III and MM IA.

Pendlebury suggested that footed goblets of our type 2 (his eggcups or pedestalled cups) might be descended from the chalices of EM I.[61] But in Fournou Korifi I and the WCH early varieties of footed goblets of our type 2 appear alongside what are clearly chalices of EM I descent. These later versions have tall stems, and bowls which often tend to a conical shape; they are different from the early footed goblets found with them, and there seem to be no real intermediary forms linking them to the footed goblets of our type 2. What may be two of the earliest examples of Minoan footed (or stemmed) goblets, of dark burnished ware from Pyrgos, have exceptionally low feet like those standard on such goblets in EM IIB.[62]

An important feature which distinguishes the goblets of type 2 from the chalices of EM I is their relatively small size. Other contemporary descendants of EM I chalices are also small.[63] In general the goblet appears to represent not only a new but a distinctly smaller type of drinking vessel. Perhaps this innovation marks the introduction of a stronger kind of drink to be consumed in smaller and/or individual vessels, namely wine. Although wine is now reported from EM I Aphrodite's Kephali, from gas chromotography analysis of residues in pithoi,[64] and Vagnetti has suggested that the introduction of wine drinking should be referred back to the time of FN at Phaistos on the grounds that pouring vessels with narrow necks already existed then[65] (narrow-necked and easily sealed vessels were required to keep wine from turning into vinegar), it may be that wine production and consumption did not begin to be frequent until EM II, leading to the appearance of cups of convenient shapes and sizes for imbibing it.[66] If EM II was the time that it became widespread — and the earliest substantive evidence for wine being made from grapes in Crete dates to EM II at Fournou Korifi,[67] where there is also the possibility that it was retsinated[68] — the footed goblets of our type 2 may have been copied from a similar type of goblet at home in the area from which the knowledge of making wine was derived. The possibility of a metal prototype for the shape is not to be excluded: two silver goblets of this type from a rich grave on Amorgos are assignable to EC II.[69]

Some footed vessels of the goblet shape appear to have had spouts and handles (e.g. **1181**) — but these may nevertheless have been used for drinking, like the spouted cups found later in Crete, notably in MM IB and IIA. The spouted and footed sauceboats of EH II were evidently the standard type of drinking vessel of the time in mainland Greece and on some of the islands.[70]

Fabric and decoration

From the earlier levels, notably in A1, come a few goblet rims of dark grey burnished ware. But most of the footed goblets of type 2 are of fine buff burnished ware with decoration in dark-on-light, or of dark washed ware with decoration in light-on-dark. It is interesting to see the way in which, in the sequence of deposits in Area A, light surfaced goblets are gradually replaced by those with a dark wash: light surfaced goblet rims outnumber dark wash rims by 2:1 in A2, but are in a minority of 1:5

[61] H. W. Pendlebury *et al.* 1936, 59, 85. Cf. *PM* I, 58; Hood 1971*a*, 38. Likewise, Wilson (1985, 297–9, 357) pointed to chalices like those at Pyrgos as their more immediate ancestors. See also Wilson 2007, 58, 65, for the contrast between the stemmed goblets of EM IIA early and the footed goblets (eggcups) starting in EM IIA late.

[62] Xanthoudides 1918*a*, 157, fig. 12, 159: 89–90.

[63] E.g. from Sphoungaras: Hall 1912, 47, fig. 21D (Betancourt 1979, 26, fig. 8D); 45: 'a conical cup on a very tall pedestal', of Vasiliki ware, only $c.$ 6–7 high to judge from the scale; cf. H. W. Pendlebury *et al.* 1936, 85, fig. 19: 808–09.

[64] Betancourt 2008*b*, 106; 2010.

[65] Vagnetti 1973*a*, 134.

[66] Renfrew 1972, 281–5.

[67] J. M. Renfrew 1972, 315–16.

[68] Tzedakis and Martlew 1999, 142–5 (with comments by Warren); McGovern *et al.* 2008, 179–80. There may also have been a form of beer: Tzedakis and Martlew 1999, 159–61 (with comments by Warren); McGovern *et al.* 2008, 181.

[69] Duemmler 1886, 24, Beil. 1. 4.

[70] Weinberg 1969, 5–8; Renfrew 1972, 284; Hood 1978, 33.

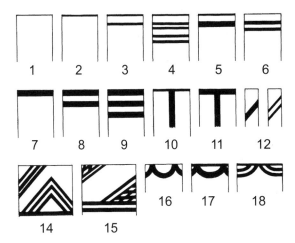

FIG. 5.2. Areas A and B. Dark-on-light decoration on EM II goblet rims of types 2 and 3: 1, plain outside; 2, thin line round top of rim; 3, as 2, but with one or two lines below; 4, as 2, but with two pairs of lines below; 5, as 2, but with band below; 6, pair of lines below rim; 7, band round top of rim; 8, as 7, but with band below; 9, as 7, but with pair of bands below; 10, vertical band descending from line round top of rim; 11, as 10, but from band round top of rim; 12, diagonal band on body; 13, pair of diagonal lines on body; 14, group of three diagonal lines and triple chevrons above band; 15, diagonal groups of lattice (cross-hatching) on body above pairs of bands; 16, loops pendent from rim; 17, loops pendent from line round top of rim; 18, double loops pendent from line round top of rim.

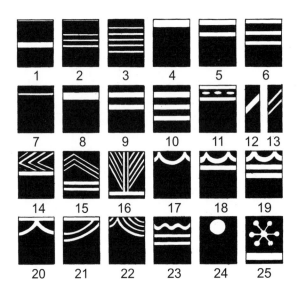

FIG. 5.3. Areas A and B. Light-on-dark decoration on EM II goblet rims of types 2 and 3: 1, thin line round top of rim and band below; 2, as 1, but with three lines below; 3, five lines on or below rim; 4, band round top of rim; 5, as 4, but with band below; 6, as 4, but with pair of bands below; 7, line below rim; 8, band below rim; 9, pair of bands below rim, or below line on rim; 10, three or four bands below rim; 11, row of dashes between bands round top of rim; 12, diagonal band on body; 13, pair of diagonal lines on body; 14, group of chevrons in a row round top of rim above band or bands; 15, triple chevrons above a pair of bands; 16, pair of vertical lines flanked by diagonal ones; 17, loops pendent from rim; 18, as 17, but above band; 19, as 17, but above pair of bands; 20, large loops pendent from band round top of rim; 21, pair of large loops pendent from band round top of rim; 22, group of four large loops pendent from rim with band below; 23, wavy band round top of rim with pair of bands below; 24, large spot below rim; 25, flower-like design above band.

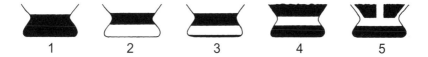

FIG. 5.4. Areas A and B. Decoration on EM II goblet feet of type 2: 1–3, dark-on-light; 4–5, light-on-dark.

in A3, and virtually absent from A4. In B1, light surfaced rims are already in a minority of 2:3, dropping to 1:3 in B2.

Light surfaced goblets are normally of fine buff ware. The outsides have vertical stroke burnishing, which to some extent seems meant to be decorative. The insides are usually less well burnished, and may be merely smoothed. Decoration, when it occurs, is typically in red paint, but sometimes in red-brown, or shades of brown, or even black. Sometimes, the outside is smoothed rather than burnished. Often it is pared, as is common on MM IA goblets. The rims with this less careful outside finish tend to be those which are undecorated.

When there is a dark wash, it may cover all the cup, including the foot, and also continue under the base; or the wash may cover all the outside of the goblet, but only extend round the top of the rim inside. Sometimes the underneath of the base is left plain. The wash may range from red or black through shades of purple-brown and dark and light brown. Any decoration is in creamy (yellowish) white paint.

Some fragments of goblets of Vasiliki ware appear atypical in various ways. Their rim sections tend to be thicker than those of goblets of other fabrics. Small rivet-like warts sometimes occur on or below their rims and may be an indication, as they are not found elsewhere on the island, of local, Knossian manufacture (see p. 99 and n. 40). But even so, the Vasiliki ware of Knossos appears rather set apart from other contemporary fabrics at the site.

Goblets normally seem to have had painted decoration, whether in dark-on-light or light-on-dark (FIGS. 5.2–5.3, TABLES 5.1–5.2). Some light surfaced goblets may have been plain, and those of Vasiliki ware were always, it seems, undecorated. In general, the motifs and systems of decoration which are found in dark-on-light are repeated in light-on-dark, although there is perhaps a tendency for the designs in light-on-dark to be more varied and elaborate.

There is a greater variety in decoration, with a wider range of motifs, on EM II goblets than on those of EM III, when a degree of standardisation seems to have set in. Designs include horizontal stripes and bands on or below the rim, diagonal and sometimes vertical stripes on the body, rows of loops depending from the rim, and chevrons. **426** (A3) seems to have been decorated with stylised rosettes in white paint identical with those found in MM IA. It comes from a late EM II deposit, like the unique fragment **924** (B2) with a zone of incised jabs.

The feet (FIG. 5.4, TABLE 5.3) of light surfaced goblets of type 2 are often painted solid: e.g. **1309–1315** from Evans's excavations in Area B; or they have a band round the neck of the foot, which may be combined with a thin stripe round its edge, e.g. **294** (FIG. 7.6).

There is a curious series of marks painted on the underneath of some bases of goblets of types 2 and 3 (FIG. 5.5, TABLE 5.4). These marks occur both in dark-on-light and light-on-dark.[71] The marks (see also below p. 275) include: a circle round the edge of the underside of the base; short lines or dashes, single or in groups, often forming a triangle; and solid spots in various arrangements. Their purpose is not clear. Their occurrence is sporadic, and their repertory too limited, to suit the idea that they are owner's marks. Perhaps they were potter's marks, as a mark akin to FIG. 5.5: 1–2 (and FIG. 10.12: **1301**) on the base of an EH II sauceboat from Tiryns is likely to be.[72]

Footed goblets appear to have been in use throughout Crete in EM II,[73] and are one of the commonest types in Vasiliki ware.[74] They are attested in Fournou Korifi I, and well represented in II.[75] No footed

[71] A light-on-dark mark is found also under the base of a type 1 cup, from Evans's excavations in Area B: **1301** (FIG. 10.12).

[72] Weisshaar 1983, 337, fig. 6: 15; 342. Note also an isolated example of an incised mark on an amphora of Fournou Korifi II (Warren 1972a, 110, fig. 36: P88; Branigan 1969, 12–13, fig. 3a). It is not stated whether the mark was made before or after firing; there is nothing to suggest the jar was an import from overseas. A jug from Mochlos with a somewhat comparable sign is of MM

I shape, according to Seager (1912, 39: III m).

[73] Warren 1972a, 127, n. 2 for references. Add Hazzidakis 1934, pl. 20.3a, certainly EM II (cf. Andreou 1978, 173, n. 1, 177, n. 9, for other possible EM II vessels from Tylissos).

[74] Betancourt 1979, 42–4: VII A.

[75] Warren 1972a, 103, 157, fig. 41: P44–45 (I); 127–8, 181, fig. 65 (II).

TABLE 5.1. Areas A and B. Occurrences of dark-on-light decoration on EM II goblet rims of types 2 and 3.

Deposit	1	2	3	4	5	6	7	8	9	10	11	12	13	14	15	16	17	18	TOTAL
B2		7	1				10	3	2	1				1		3			28
B1		1	1				2				1				1		3	1	10
A4							1												1
A3				1	1	1	1					(1)	(1)		1				5
A2	1	8		1	1	1	8												20
A1		8					7					(2)							15
																			79

TABLE 5.2. Areas A and B. Occurrences of light-on-dark decoration on EM II goblet rims of types 2 and 3.

Deposit	1	2	3	4	5	6	7	8	9	10	11	12	13	14	15	16	17	18	19	20	21	22	23	24	25	TOTAL
B2	11			14	1	1		6	1	1	1		2	2	1		8	2	1		1					52
B1	3	1	1													2				1		1	1	1		11
A4			3					2	1			1														7
A3	4		1					13	1	2		(1)	3	2					1						1	31
A2	1		1	2	1		1					(1)		1												9

TABLE 5.3. Areas A and B. Occurrences of decoration on EM II type 2 goblet feet: 1–3, dark-on-light; 4–5, light-on-dark.
TABLE 5.4. Areas A and B. Occurrences of marks underneath feet of EM II type 2 footed goblets (1–9) and base of type 3 goblet (10): 1–5, dark-on-light; 6, reserved; 7–10, light-on-dark.

| | TABLE 5.3 | | | | | TABLE 5.4 | | | | | | | | | |
Deposit	1	2	3	4	5	1	2	3	4	5	6	7	8	9	10
B2		5		24		2		1	1	1	6	1			
B1		5		8			1				2				
A4				3							4		1	1	
A3	3	4		6							2				1
A2		2	1		1	1	1					1			
A1	1	1													

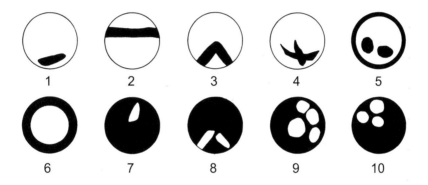

FIG. 5.5. Areas A and B. Marks underneath feet of EM II type 2 footed goblets (1–9) and base of type 3 goblet (10): 1–5, dark-on-light; 6, reserved; 7–10, light-on-dark.

goblets, however, assignable to EM II have been illustrated from the tholoi in the Mesara; but they seem attested at Ayia Kyriaki in various fabrics including Vasiliki ware.[76] A related type occurs in the Cyclades, unless the few examples there are imports from Crete.[77]

TYPE 3. GOBLETS

Rims of this type are indistinguishable from those of footed goblets of type 2, and rims assignable to types 2 and 3 have already been considered. **425** (A3), the sole profile of type 3, is 5.8 high with the rim 7 in diameter. This simple type of goblet appears to have been distinctly rare in EM II, but is common in EM III and MM IA. As with the footed goblets of type 2, the diameter of the rim seems to be greater in relation to the height than is usual in later periods, when such goblets tend to be taller and thinner with a narrow base.

Some of the smaller deep bowls of Fournou Korifi II might pass for type 3 goblets,[78] as might a deep conical bowl in Vasiliki ware from the cemetery area at Sphoungaras.[79]

[76] Blackman and Branigan 1982, 39, fig. 14: C2.
[77] Tsountas 1899, pl. 8: 13; Zervos 1957, 152, pl. 189 right.
[78] E.g. Warren 1972a, 117, 169, fig. 53: P223.

[79] Hall 1912, 47, fig. 21.I; Betancourt (1979, 26, fig. 8.I; 33) sees 'a deep conical bowl'.

TABLE 5.5. Areas A and B. Occurrences of EM II type 4 bowls with (**a**) rounded, (**b**) bevelled rims.

	Deposit	*(a)*	*(b)*	*TOTAL*
EM III	B3	1		1
EM IIB	B2	100	11	111
	B1	28	3	31
EM IIA late	A8 LA 94	4	6	10
EM III	A7.2		3	
	A7.1	2	3	
	A7 Floor III?			8
	A6 Floor III		1	1
	A5 Floor IV	3	5	8
EM IIB	A4 Floor V	4	5	9
	A3 Floor VI ? mixed + V	39	4	43
	A2 Floor VI	46	15	61
EM IIA	A1 Floor VII	11	7	18
TOTAL		238	63	301

TYPE 4. SHALLOW BOWLS OR PLATES WITH RIM THICKENED INTERNALLY

This type with decoration in dark-on-light is extremely common at Knossos throughout mature EM II,[80] but seems to have gone out of fashion by EM III. It is therefore a most valuable dating fossil for EM II at Knossos, and more especially for EM IIB. However, the internally thickened rim of this kind first appears on dark grey burnished chalices and other shapes in grey or light brown burnished ware of EM I.[81] The EM II bowls with this distinctive rim seem almost invariably of buff ware with red, or more rarely brown or black, decoration.[82]

Rims (TABLE 5.5)
These are of two classes, with the top either (**a**) rounded, or (**b**) bevelled. The rims of class **b** always have a sharp outer edge; those of class **a** may have the outer edge sharp or rounded, and sometimes they are thickened externally as well as internally. Rims of class **a** are by far the more common, outnumbering class **b** by 5:1. A few class **a** rims have a slight outwards projection (e.g. **317**), which in the case of **205–206** (A1) is formed by a groove round the outside.

Size
The bowls of this type are in general small, from *c.* 11 to 25 in diameter. Some rims, however, of class **b** appear to come from larger bowls with a diameter of up to *c.* 30. One or two bowls were evidently very small, virtually miniatures, with diameters as little as 6.5 and 8.5, but most rims of class **a**, which form the great majority, seem to fall between 16 and 18. Fourteen rims of class **a** from B1, which were measured as a sample, range in diameter from 12 to 24, with an average of 17.8.

[80] Beginning in EM IIA late (Wilson 2007, 65).
[81] E.g. Wilson and Day 2000, 28–9, fig. 1: P3; 31–32, fig. 2: P43.
[82] For a light grey ware example see **1196**.

There is no evidence for handles or spouts on these bowls; but a very few appear to have had a pair or pairs of string-holes made below their rims before firing, perhaps for handles of string to hang them from pegs on the wall.

Fabric

It seems that bowls of type 4 were apt to be rather irregularly made. They are of fine buff ware: the clay orange or buff, very occasionally greenish, with the surface usually a paler shade. The inside surfaces may be smoothed, but are more commonly burnished; the burnishing is often quite thorough, but at times very superficial. The outsides of these bowls would have been virtually hidden from sight when they were in use, and are therefore as a rule subjected to a less careful finish than the insides: they are superficially stroke burnished, or often merely wiped or even pared, e.g. **323** (A2).

Out of some 270 bowls or fragments of bowls of this type only about three rims, all of class **a**, appear to have belonged to bowls with a dark wash. One of these rims is from A1, the others from A2 (**234**) and B2 (**946**, decorated with hatching along the top in creamy white paint).

Decoration

The standard light surfaced bowls are almost invariably decorated. Only one scrap of rim of class **a** from A3 may come from a plain bowl. The decoration is most characteristically in red paint, less commonly in dark brown or black. There is normally a band round the inside of the bowl just below the rim, whether it is of class **a** or **b**. Sometimes, another band, or a thin stripe, is found below the rim round the outside of the bowl as well. But the standard decoration for the top of the rim is different between classes **a** and **b**. On class **a** rims, the top is usually left plain except for one or more pairs of confronting diagonal bands, normally broad and closely spaced (e.g. **322**), but sometimes (doubtless when only one pair of bands is involved) widely spaced, as on **323**, where the confronting diagonals are at opposite sides of the rim. Each pair normally consists of single diagonals; but double diagonals are also found, as on **945**. The tops of rims of class **a** are occasionally painted solid, like those of rims of class **b**. A large example **834** (B1) of class **a** with the top of the rim painted solid in this way has traces of a band painted right across the inside of the bowl.

The top, that is the outside bevelled edge, of rims of class **b** is normally painted solid: the paint sometimes lapping over the edge of the rim to form a thin stripe below it. Occasionally the top of the rim is hatched; and once at least (**840**, B1) it appears to have been left plain.

Bowls with rims of this distinctive type appear largely confined to later EM II at Knossos, and only two fragments were recognised in the WCH.[83] Although this type of bowl is well represented at Knossos in EM IIB, it does not seem to have been common elsewhere in Crete. A bowl of this type (or the allied type 5) with at least one pair of string-holes below the rim is illustrated from Tylissos,[84] but these bowls do not appear at home at Phaistos or in the Mesara tombs. A rim of this type, in profile closely akin to **278** (A2), was found at Kaminospilio;[85] but no such rims are illustrated from Ayia Kyriaki, and none seems to be recorded from any of the Mesara tombs or other sites in the area.

In eastern Crete the dearth of rims of this type is equally apparent. None seems recorded from Trapeza, and none is illustrated among the EM pottery from Vasiliki in Philadelphia, with the exception of one markedly inturned rim of type 5.[86] Fournou Korifi, however, presents a striking contrast. Bowls with this type of rim occur there in periods I and II;[87] some have holes through the rim or perforated lugs.[88] The bowls of this kind in I seem closer to the standard Knossian type than those of II — which might support a suggestion that this settlement was originally founded by a family of immigrants from central Crete, if not from the Knossos region.[89]

TYPE 5. BOWLS WITH UPRIGHT SIDES AND RIM THICKENED INTERNALLY

Three profiles of such bowls were found together with rims that may belong to bowls of this type or to the deeper variety (type 6). It would seem that the sides of bowls of types 5 and 6 may curve inwards, or rise more or less straight to the rim, or splay slightly outwards. The rims grouped here are of two classes: (**a**) rounded, and (**b**) flat-topped, which correspond to the two classes of rim on shallow bowls

[83] Wilson 1985, 329–30, fig. 27: P247; also P248.
[84] Hazzidakis 1934, 82, pl. 20.3c.
[85] Blackman and Branigan 1973, 201, pl. 4: 6.
[86] Betancourt 1983, 55, fig. 14, pl. 13: 138, with decoration in dark-on-light, assigned to EM IIA.
[87] Warren 1972a, 100, 155, fig. 39: P23–28 (I); 115, 166, fig. 50: P181–182, pl. 40a: P183; 117, pl. 41c: P217.
[88] Warren 1972a, 100, 155, fig. 39: P26, P28.
[89] Warren 1972a, 272.

of type 4. One or two of these rims are thickened on the outside as well as inside, and therefore approximate to the rims of large bowls of cooking pot ware of type 11, which are themselves descended from the large bowls with hammer-headed rims of EM I type 7.

The bowls of type 5 seem in general larger than those of type 4, although some of the rims grouped here are of comparatively small diameter. The diameters of the three complete profiles of type 5 are c. 14, 24, and 36. The diameters of upright rims assignable to bowls of this or of the following type 6 seem to range from as little as 10 to as much as 40. Several of these rims have horizontal side-handles like **1327** of type 6. Some or all of the shallow bowls of type 5 may then have had such handles, and some perhaps had spouts like bowls of type 6. In one case a handle rises from the top of a rim.

Rims assignable to types 5 or 6 are very much less common than rims of shallow bowls of type 4, by about 1:7. Nearly 1/2 the upright rims assigned to types 5 and 6 come from A2. The great majority of these rims belong to bowls with a light surface, which is often well burnished, and normally decorated in red or brown to black. By contrast, four out of five of the rims of this kind from B2 have a black or red wash with traces of decoration in white.

Decoration includes bands or stripes below the rim inside and outside. The top of the rim may be hatched with groups of straight or diagonal lines, or may have a series of opposed diagonals forming a zigzag, as on many rims of class **a** from bowls of type 4. Bodies are sometimes decorated with diagonal bands or stripes, single or in pairs. At least one bowl of type 5 (**1326**) has a red cross under the base; and the bases of other bowls of this type may have been decorated in this manner.

An EM IIA bowl of dark grey ware with a pair of perforated lugs from the WCH approximates to this type.[90]

TYPE 6. DEEP BOWLS WITH TROUGH SPOUT AND HORIZONTAL SIDE-HANDLES

The rims may be: (**a**) thickened internally, as **1327**; (**b**) bevelled, as **1329**; or (**c**) tapered. The only complete profile of a bowl of this type is **1327** from Evans's excavations in Area B. The larger bowl **1329** from there may have had a similar spout and so is discussed now. Some of the upright rims of fairly small diameter considered under type 5 may belong to deep bowls akin to **1329**. Rim **337** (A2) is perhaps best placed with this type, despite its unusual fabric. Some rather atypical rims assigned to type 6 are of distinctive fabric, with a dark wash outside, and very finely burnished inside and outside. A few rims of cooking pot ware grouped here may come from tripod cooking pots (type 23).

Bowls with spouts of various types and various handle arrangements are well represented in Fournou Korifi II.

TYPE 7. SHALLOW BOWLS WITH STRAIGHT OR INWARD CURVING SIDES

A few rims of all sizes ranging in diameter from c. 10 to 50 seem to come from bowls of this shape. The rims occur in a variety of fabrics including cooking pot ware, for instance **454** (A3).[91]

TYPE 8. BOWLS WITH FLARING RIM: (A) SHALLOW, AND (B) DEEP

These do not seem common. Shallow bowls (A) of this type evidently range in size from very small (D. 10 or less), such as **212** (A1), to large (D. 35 or more), such as **1330** (D. c. 34). The rims assignable to this type merge into those of type 9, and some of them may have been counted with those of that type. The deep form (B) is represented by **344** (A2) with a red cross underneath the base. One or two rims, thickened internally and therefore assigned to type 4, may belong to bowls in shape more akin to deep or shallow varieties of type 8, such as **319** (A2).

Normally, at least the bowls of this type appear to be of fine buff ware. One or two large examples are evidently quite plain, with an unusually high and distinctive burnish, such as **520C** (A4). When decoration occurs, it is sometimes elaborate in character (e.g. **212**, A1; **1330**). The outside surfaces of these bowls may be scraped, as is often the case with bowls of types 4 and 9. Rims assignable to this type also occur in cooking pot ware, such as **214** (A1).[92]

[90] Wilson 1985, 296–7, fig. 8, pl. 30: P1. Blackman and Branigan 1982, 30, fig. 10: 75, in 'ash-tray' ware, might also correspond to it.

[91] Cf. Fournou Korifi II (e.g. Warren 1972a, 115, 165, fig. 49: P165), and Ayia Kyriaki (Blackman and Branigan 1982, 39, fig. 14: B1, B10, in various fabrics including Vasiliki ware).

[92] This type corresponds to Blackman and Branigan 1982, 39, fig. 14: B4. A number of bowls from Fournou Korifi approximate

to the shallow variety of the type (8A): Warren 1972a, 115, 165, fig. 49: P164, 166, fig. 50: P169 (period II); 100: P20–21 (period I); cf. Lebena T. I: Alexiou and Warren 2004, 28: 14, and Marathokefalo: Xanthoudides 1918b, 19, fig. 4, bottom row, centre — but these may be later in date). For the deeper variety (type 8B), cf. Warren 1972a, 101, 156, fig. 40: P31 (period I); 118, 169, fig. 53: P231 (period II).

TYPE 9. BOWLS WITH EVERTED RIM: (A) SHALLOW, AND (B) STEEP-SIDED

This is evidently the standard shape for large bowls of fine ware, in the same way that type 4 is the standard shape for small shallow bowls. Some 117 rims of fine ware are assignable to this type, which represents a proportion of about 2:5 to the rims of the normally smaller bowls of type 4. The rims of bowls of types 8 and 9 merge into each other; but the bowls of type 9 appear to have been for the most part steeper walled and deeper than those of type 8. Some at any rate of the steep-sided versions of type 9 have horizontal handles, such as **1331**. The fine ware rims assignable to this type seem to range in diameter from *c.* 20 to 40 or more, with most of them between *c.* 25 and 30.[93]

Most bowls of type 9 appear to have a dark wash with decoration in white. This is in sharp contrast to the shallow bowls of type 4 which are characteristically of fine buff ware with decoration in dark-on-light. The proportion of rims assignable to bowls of type 9 with light-on-dark as opposed to dark-on-light decoration rises from about 2:1 in A2 to all rims bar one in A3, and all rims in A4. Similarly, rims of type 9 with a wash are about equal in number to those with a light surface in B1, but outnumber them by over 3:1 in B2.

TYPE 10. LARGE BOWLS WITH STRAIGHT SIDES AND THICK EVERTED RIM: (A) SHALLOW, AND (B) DEEP

This seems to be the standard shape for large bowls in coarse ware. A group of distinctive rims, over 20 in all, is assignable to this type of bowl, which may have been in general deep and bucket-like as **975**; but some large shallow bowls also have rims of this kind. Bowl **976** (B2) of type 10 evidently had an open, perhaps short, trough-like spout. Some of these bowls may have had horizontal side-handles, although no evidence for them was found.

The fabric of these bowls is usually coarse, the clay gritty with a lighter slip decorated in dark paint. In a few cases the inside only of the bowl appears to have had a dark wash, such as **358** (A2) and **862** (B1). Decoration normally consists of bands round the inside and outside of the rim, and round the base; and diagonal bands or stripes on the outside of the body. There is a pair of diagonal stripes on **976**, while **975** has bold loops dependent from a band round the outside of the rim, and bold lattice scoring on the inside like some large bowls or jars from the Palace Well.

One or two short everted rims from small steep-sided bowls are grouped here for convenience, e.g. **473**. These are of fine ware, with a dark wash outside, or inside and outside, and very well burnished. In fabric and finish they resemble some upright rims discussed under type 6.

TYPE 11. LARGE BOWLS WITH CURVING, OFTEN CARINATED SIDES AND THICKENED RIM (COOKING POT WARE)

The rims assignable to bowls of this type (FIG. 5.6) appear to range in diameter from *c.* 25 to 40 or more. They are usually more or less flat-topped, and (a) thickened inside and outside; occasionally (b) only thickened outside; and rarely (c) only inside. Some amorphous flat-topped thickened rims of cooking pot ware may come from bowls of this type. One or two rims with (d) rounded tops also seem to be from such bowls. Some of the bowls to which these rims belong evidently had horizontal side-handles, such as **363** (A2).

The bowls of this type were normally it seems of cooking pot ware. Their outside surfaces below the rim (or below the carination when there is one) are generally wiped, following the tradition of LN and EM I coarse wares (cf. the related type 18). But rim **475** (A3) assignable to this type is of ordinary fine buff ware with a light surface and decoration in dark paint. The type is well represented in the WCH.[94]

A distinctive class of thick rounded rims (FIG. 5.6: B) that may come from deep bowls (rather than jars) seems complementary to the carinated rims of the standard type assignable to type 11 bowls (FIG. 5.6: A). These thick rounded rims appear to increase in numbers during the course of EM IIB at the expense of the type 11 carinated rims. Rims as FIG. 5.6: B are first attested in A2, where there are three of them as opposed to eight of the type 11 carinated rims (i.e. 1:2.6). In A3, the situation is reversed, with 37 rims of this class as against eight of the standard type 11 carinated rims (4.5:1). Similarly in B1, the rims of this class are outnumbered by standard type 11 rims in the proportion of 1:2, while in B2 the situation is reversed (2:1) (see TABLE 5.6). The thick rounded rims (FIG. 5.6: B) in their turn appear to be replaced by a new class of thick cooking pot bowl rims (FIG. 5.6: C) in EM III.

[93] This type seems to correspond to Blackman and Branigan 1982, 39, fig. 14: B2, B11.

[94] Wilson 1985, 334–5, fig. 30: P280–286. However, Wilson (pers. comm.) sees these as comparanda for our types 17 and 18.

TABLE 5.6. Areas A and B. Occurrences of type 11 cooking pot ware bowl rims.

		A	B
EM III	B3	1	
EM IIB	B2	2	4
	B1	28	13
EM III	A6 Floor III	1	
	A5 Floor IV	2	7
EM IIB	A4 Floor V	3	7
	A3 Floor VI	8	37
	? mixed + V		
	A2 Floor VI	8	3
EM IIA	A1 Floor VII	6	

FIG. 5.6. Areas A and B. Evolution of rims of cooking pot ware bowls akin to type 11: A, EM IIA and IIB early; B, EM IIB late; C, EM III.

TYPE 12. LARGE FLAT DISHES WITH UPRIGHT SIDES (COOKING POT WARE)

We found just a few rims assignable to this type, from deposits of later EM II, such as **989** (B2). Some tripod feet (see under type 23) may come from dishes of this type or plates of type 13 which merges into it. Shallow tripod cooking dishes and plates are attested in MM IA, but may have been in use before then.[95]

TYPE 13. PLATES (COOKING POT WARE)

The only rim of this type is **990** (B2).

TYPE 14. BAKING PLATES (COOKING POT WARE)

A few rims of these occurred in deposits of every phase of EM II (TABLE 5.7). The rims fall into two classes: (a) rolled, and (b) elongated.[96]

TYPE 15. JUGS WITH CUTAWAY SPOUT

The only jugs for which there is any evidence in the EM II levels have cutaway spouts. Jugs with pinched-in or trefoil spouts of the kind found on PW type 12 do not seem to occur.[97] There appears to be a considerable range in the size of these EM II jugs, and some were quite large. From Evans's

[95] Cf. Blackman and Branigan 1982, 39, fig. 14: B12, in cooking pot ware; also a few dishes of comparable shape in Fournou Korifi I and perhaps later (Warren 1972a, 102, 127, 156, fig. 40: P36–38).

[96] Cf. Wilson 1985, 337–8, fig. 32: P307–309; some rims from Trapeza appear to be of this type (H. W. Pendlebury et al. 1936, 50–

1, fig. 11: 306–07, assigned to EM II). Rims of baking plates from Fournou Korifi have very different profiles: Warren 1972a, 98, 154, fig. 30: P1 (period I); 111–13, 161–3, figs. 45–7 (period II).

[97] These seem rare in EM IIA but there are two from the WCH: Wilson 1985, 322, pl. 35: P193–194.

TABLE 5.7. Areas A and B. Occurrences of EM II type 14 baking plates, tripod feet, and type 24 horned stands.

Deposit		Baking plates	Tripod feet				Horned stands
			Circular section	Thick oval	Thin oval	TOTAL	
EM III	B3				3	3	1
EM IIB	B2	5	9	2	1	12	3
	B1	1	1			1	2
EM IIA late	A8 LA94	12	2	1		3	
EM III	A7 Floor III?						
	A7.2			1	1	2	
	A7.1	1					
	A6 Floor III						
	A5 Floor IV	1		1	2	3	?1
EM IIB	A4 Floor V		2		3	5	
	A3 Floor VI ? mixed + V	4	4		2	6	
	A2 Floor VI	5	2	1		3	1
EM IIA	A1 Floor VII	4	1			1	

excavations in Area B, one complete example **1334** (dark wash) has a low shoulder, but others like **1332–1333** (dark-on-light) evidently have higher shoulders — like jugs of EM III and MM IA. A few jug bodies may have been carinated, but the evidence for this is ambiguous.

Some jug spouts seem to have been long and elegant. Spouts and necks are not infrequently pared. Evans noted that in many cases the surfaces of cups and bowls of EM II at Knossos showed signs of having been pared with a knife,[98] a technique still more emphasised in EM III and MM I.

Handles are usually if not always round or very thick oval in section. Some jug handles are found set to the rim like those of the PW jugs. But it would seem that in EM II the handles of jugs were normally attached below the rim with a clear space between the rim and the top of the handle. This may not have been the case, however, at the beginning of EM IIA, to judge from the fragments of jugs with painted decoration from the WCH: most of the handles appear to be set to the rim, although a few are below it.[99] Contrast Debla II, where most of the jugs illustrated have handles set to the neck below the rim.[100] The setting of the handle on the neck in this way instead of to the rim appears to be a change of fashion which in the Northeast Aegean begins in the horizon of Troy I and becomes stronger in that of Troy II.[101]

Fabric

Most jugs were evidently of fine buff ware with decoration in dark paint continuing the tradition of EM I. The clay is orange or pale orange, with a slip outside that may be orange or buff or whitish, and which sometimes has a slight greenish tinge. The evidence from A1 suggests that at the beginning of EM II the outsides of jugs were normally well smoothed or burnished, but even at the beginning of the period jugs may have a dark wash in red or red-brown to black, such as **239** (A1) or **1335**.[102]

[98] *PM* I, 74–5.
[99] E.g. Wilson 1985, 317, pl. 34: P158; 322, pl. 35: P192.
[100] Warren and Tzedakis 1974, pls. 54c–d, 5 a–c — but

contrast pl. 54b: P7 with handle to rim.
[101] Hood 1981, 188.
[102] Cf. Wilson 1985, 312; 2007, 61.

Decoration

(1) Dark-on-light

Jugs of fine buff ware are decorated in red, shades of red-brown, or more rarely black paint. The necks of these jugs are characteristically adorned with parallel stripes or bands; or with a triple chevron combined with a thin stripe on the rim of the mouth. One jug neck has a large solid spot on it. The bodies of such jugs may be decorated with horizontal or diagonal bands and stripes, or with chevrons. Latticed triangles are a very characteristic motif of decoration on jug bodies, and evidently descend from the crossing diagonals which form a lattice pattern on EM I jugs.

Handles may have a stripe or a group of two or three parallel stripes running down their length. On **238** (A1) the stripe is flanked by diagonal lines to make a branch-like design. Broad diagonal hatching is also found on handles, such as **877** (B1).

(2) Light-on-dark

Decoration in creamy white paint on a dark wash includes horizontal bands, such as **239** (A1), and diagonal ones as seen on **994** (B2), which has a good lustrous black wash and a row of incised decoration at what was evidently the base of the neck.[103]

TYPE 16. SMALL SPOUTED BOWL-JARS: (A) TEAPOTS WITH VERTICAL HANDLE, AND (B) WITH HORIZONTAL SIDE-HANDLES

Most of the fragments of small jars of fine ware, whether of buff ware with decoration in dark paint or of dark washed ware with decoration in white, appear to belong to pouring vessels with cutaway spouts of the teapot class **c** or more rarely of classes **a** and **b** (FIG. 5.7). There seem to have been two main varieties of these jars: (A) teapots with a vertical handle opposite the spout; (B) jars with horizontal handles, which are ancestors of the similar jars with class **c** (teapot) spouts or class **d** bridge spouts that are common in EM III–MM IA and later — but **1288** (below) is an unique early example of a bridge spout, of EM IIA. For examples of type 16 in the SMK, see pp. 260–1, 274. Wilson and Day, in their full discussion of this type in fine painted ware (much of which appears to have been imported from the Mesara), call it 'rounded bowls (side-spouted bowls/one-handled cups)'.[104]

There is a wide variety in the rims of these jars (FIG. 5.8). Thickened rims of class **b** are common; and those of class **b2**, which are thickened internally and often have a distinct metallic look, seem very characteristic. These rims of class **b2** appear to be the equivalent on jars of the distinctive internally thickened rims found on bowls of types 4–6. Rims of class **b2** are much less in evidence in the levels assigned to EM III, and appear altogether absent in the B3 deposit.

The distinctive rims of class **e** with an internal ledge for a lid come from deep bowls and from jars of various types and sizes. Six rims of this class come from EM II levels; **245**, the earliest (A1), is somewhat atypical with the ledge not so well marked. This and two other ledged rims of this class **500–501** (A3) are in cooking pot ware.

Four teapots of type 16A with spouts of class **c** and dark-on-light painted decoration were taken by Zois as characteristic of his 'Koumasa' style of EM IIA.[105] Fragments in fine painted ware including spouts of class **c** from the WCH probably come from teapots of this type brought to Knossos from the Mesara;[106] there is an EM II teapot of type 16A with a class **c** spout from Palaikastro–Patema;[107] and teapots with class **c** spouts are typical at Fournou Korifi and may have existed there in period I.[108] Some teapots of type 16A from the Trapeza cave have tubular spouts of class **b**; one with a class **c** spout was assigned by Pendlebury to EM III.[109] Teapots with spouts of class **c** were still in use in MM I.[110]

A large vessel from the WCH is akin to type 16B but more bowl-like; it has a thickened rim and a spout like class **b**.[111]

[103] Cf. Wilson 1985, 316–17, fig. 19: P158.

[104] Wilson and Day 1994, 25–30. See also Wilson 2007, 61 for EM IIA early examples in fine painted ware; and cf. 65 (EM IIA late, in dark-on-light ware) and 73–4, fig. 2.16: 6 (EM IIB, in light-on-dark ware).

[105] Zois 1967a, 714–16, pls. 3, 18 (Xanthoudides 1924, pl. 26: 4107–08, 4118, 4147; Wilson and Day 1994, 39: FP 164–8).

[106] See n. 104.

[107] Dawkins and Currelly 1904, 197–8, fig. 1h (Bosanquet and Dawkins 1923, 6, fig. 3h).

[108] Warren 1972a, 107–08, 150–1: P648–670. Cf. Wilson and Day 1994, 42 and n. 121–2.

[109] H. W. Pendlebury et al. 1936, 44–6, fig. 10, pl. 8: 207.

[110] E.g. Xanthoudides 1924, pl. 41: 4962, 4964, 5682. See Todaro 2009a, 133, fig. 14e–g; 135–6 (Phaistos X), and discussion in relation to Patrikies.

[111] Wilson 1985, 307–08, fig. 14, pl. 32: P93. Wilson (pers. comm.) suggests a better term for this vessel would be krater.

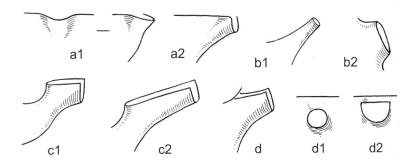

FIG. 5.7. Areas A and B. Spouts of types found in EM II–III deposits: (a) trough: (a1) short; (a2) long; (b1) nozzle; (b2) tubular; (c) teapot: (c1) short; (c2) long; (d) bridge, with: (d1) circular hole, or (d2) D-shaped hole.

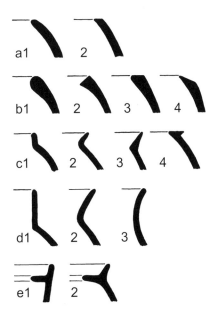

FIG. 5.8. Areas A and B. Jar rims of EM II–III type 16 etc.: (a) simple incurving: (a1) rounded; (a2) flattened on top; (b) thickened: (b1) rounded; (b2) flattened or bevelled internally; (b3) flattened on top; (b4) flattened or bevelled externally; (c) short differentiated: (c1) upright; (c2) everted; (c3) thickened and sharply pointed; (c4) flat topped; (d) tall differentiated: (d1) upright; (d2) everted; (d3) outward curving; (e) with ledge inside for lid: (e1) inward leaning; (e2) everted.

TYPES 17 AND 18

There are many fragments belonging to large deep bowls or jars with inward curving rims. These are almost entirely of cooking pot ware. Most of the rims are markedly thickened. Only two shapes could be distinguished, spouted jars with horizontal side-handles of type 17, and jars with vertical handles of type 18; but some of the rims may come from other types that cannot be reconstructed. Most rims of class **a** may be from jars of type 17, and rims of classes **b1**, **b2**, **b3** and **c** mostly from jars of type 18. A distinctive group of large rounded and thickened rims of class **b1** may belong to a type of deep bowl or jar with characteristics to differentiate it from types 17 and 18.

TYPE 17. LARGE SPOUTED BOWLS OR JARS WITH HORIZONTAL SIDE-HANDLES

We have no complete profile of a jar of this type; but rim fragments, occasionally with horizontal side-handles and simple tubular spouts of class **b**, evidently come from jars of this kind which are standard in EM III–MM I. The EM II jars of this shape are normally of cooking pot ware; and any decoration is therefore in white paint on a red or brown surface. But one or two rims from jars of this type are of ordinary coarse ware with a light slip and decoration in dark paint. Decoration may consist of a band

round the outside of the rim and diagonal bands or stripes on the body of the jar. Sometimes warts are found on these rims; it may have been normal to put a wart on the part of the rim opposite the spout.

TYPE 18. LARGE BOWLS OR JARS WITH INWARD CURVING, OFTEN CARINATED AND THICKENED RIMS (COOKING POT WARE)

The greater part of a large example of this type **392** comes from A2. It stood 54 high, and appears to have had four vertical handles of which three survive. The profile of a smaller vessel **1339**, of the same shape but more bowl-like with the diameter greater than the height, was restored from fragments in the SMK.

The type only occurs in cooking pot ware. The outside surface below the carination (or below the swelling of the shoulder where a carination is absent) is characteristically wiped as in the case of the large bowls of the related type 11. Type 18 is represented in the WCH deposits.[112]

TYPE 19. COLLAR-NECKED JARS WITH HORIZONTAL SIDE-HANDLES

This type of jar evidently goes back to EM I, and includes a fairly complete example **1294** in the SMK. Rims belonging to this type from EM II deposits occur in varieties of fine and coarse ware, and also in cooking pot ware.

The type occurs in the WCH[113] and Fournou Korifi I, and is very prominent in Fournou Korifi II.[114]

TYPE 20. SUSPENSION POTS

These are few in our EM II levels, although **195** (A1) is a largely complete small example. It is of fine red burnished ware, and in shape recalls the suspension pots of the Palace Well, but the lugs evidently had double perforations instead of the single perforations in the Well examples. At Lebena, likewise, a large group of globular or sub-globular suspension pots with double perforated lugs has been assigned to EM II.[115] Rim **280** (A2) is of the same red burnished fabric as **195**. A few small jar rims of fine ware may belong to suspension pots.

TYPES 21 AND 22. LIDS

Lid fragments were curiously rare in the EM II levels. The two we noted are from A1, including part of a flat lid with two handles **196** (type 21) and pattern burnish that looks back to EM I. A scrap with black burnished surface may come from a lid of the cover type 22.

Two scraps of possible flat lids of cooking pot ware are reported from the WCH,[116] where parts of several cover lids were also found: all of these had traces of burning on the outside surface, and one fragment inside as well.[117] Cover lids of this type were at one time regarded as characteristic of EM II,[118] but they are well represented in the Palace Well (see pp. 49–50 for fuller discussion); and it looks as if lids of this kind were still being made and used at Knossos into MM IB, to judge from an example in fine cooking pot ware from a deposit on Gypsades.[119]

TYPE 23. TRIPOD COOKING POTS (COOKING POT WARE)

While it was long thought that tripod cooking pots occurred for the first time in Crete in EM II, they can now be seen to appear probably a little earlier, at Ayia Fotia (Siteia) in Cycladic-style marble-tempered ware — and the shape may well derive from the Cyclades.[120] We need to be sure that the occurrences there are exclusively EM I: Betancourt sees the cemetery as being *mainly* late in EM I,[121] but there seems to be a little evidence for its continuing into EM II:[122] see further p. 284. At Knossos tripod cooking pots seem still relatively uncommon in EM IIA; Warren implies that none was identified

[112] E.g Wilson 1985, 333–5, fig. 30, pl. 41: P273–274, P276.

[113] Wilson 1985, 339–40, fig. 33: P326–327, 346, 348–349; fig. 37, pl. 50: P395–396.

[114] Warren 1972a, 141–3: P563–595.

[115] E.g. Alexiou and Warren 2004, pls. 76, 78, 80–6. Cf. Alexiou 1962, 89–90, who notes that Xanthoudides had assigned similar vessels with double perforated lugs to EM I.

[116] Wilson 1985, 342–3, fig. 34: P353–354.

[117] Wilson 1985, 353: P428–434. Cf. Wilson 2007, 58 and 54 (EM I).

[118] *PM* I, 75; H. W. Pendlebury *et al.* 1936, 53–4. Cf. Pendlebury 1939, 65–6.

[119] Aqueduct Well (Hood and Smyth 1981, 56: 290): AQW/58/P41. For date of the deposit, see MacGillivray 2007, 108.

[120] Betancourt 2008, 34–6 ('uncommon in EM I'), fig. 4.1; 69–71, fig. 5.32 (Davaras and Betancourt 2004, 24–5, fig. 42: 17.20); 103.

[121] E.g. Betancourt 2008, 5, 7.

[122] Including a Myrtos style (formerly Myrtos ware) flat-bottomed jug with fan decoration (Davaras and Betancourt 2004, 9–10, fig. 9: 2A.32), that should be EM IIA in this context. Cf. Warren 2007, 212.

in RRS,[123] and only seven cooking pot feet come from the WCH.[124] Large numbers, however, were found in Fournou Korifi I and II.

Some 28 feet of cooking pot ware come from our EM II deposits (TABLE 5.7), belonging probably to deep bowls with simple rims like those of type 6 class c, as well as dishes and plates akin to types 12 and 13. Most of these feet are round in section; a few are thick oval, and some thin oval. The sole foot from A1 is round, but one of the three from A2 is thick oval, and two of the six from A3 thinnish oval. Five of the seven feet from the WCH are round to oval, and two flattened oval (one of them with a vertical rib — cf. Fournou Korifi II [125]). In general, however, cooking pot feet at Fournou Korifi seem to follow a different path of development from Knossos: in periods I and II their sections are predominantly flattish oval to oval, and just a few thick oval to round.[126]

At Knossos in EM III and MM IA round section feet seem to be replaced by feet with oval or thin oval sections. Later at Knossos, tripod feet gradually tend to become thicker; in MM III–LM I they are as a rule thick oval, becoming round again in LM III.

TYPE 24. HORNED STANDS (COOKING POT WARE)

Fragments of five or six of these enigmatic objects were found, all in definite EM II contexts, except for two likely scraps in EM III contexts, one in A5 and **1135** in B3 (TABLE 5.7). Plenty of fragments were noted in the SMK, and are discussed below (pp. 264–6). They seem restricted to EM IIA, and do not occur in EM IIB or III except as occasional strays.[127] All these are of standard cooking pot fabric.

TYPE 25. INCENSE BURNERS

404 (A2) appears to come from a vessel of this distinctive type.[128] The only restorable early examples are from Fournou Korifi II;[129] but the type may have been quite widespread in Crete during this period. Two pieces from Trapeza are comparable to **404**, but were classified as globular pots.[130] A small bowl-like object with holes round the rim from Krasi also appears to be of this type,[131] which may be ancestral to the later vessels variously interpreted as fire boxes, incense burners or vessels for the manufacture of perfumes.[132]

TYPE 26. THERIOMORPHIC VESSELS

Two probable feet from theriomorphic vessels are from EM II levels: **405** (A2) and **548** (A4). **405** has many parallels from other EM contexts. These vessels were popular in EM II, and appear to go back to EM I.[133]

TYPE 27. PITHOI

Some pithos fragments come from A1, two or three of them with trickle ornament, which remained the most characteristic type of decoration for pithoi and other large store jars through the rest of EM and MM into LM I. One piece has a false or vestigial strap handle. Trickle ornament is found elsewhere on pithoi from EM IIA onwards.[134]

FEATURES

SPOUTS (FIG. 5.7)

Examples of spouts of classes **a**, **b** and **c**, were noted, but none of class **d**.

Trough spouts
Simple open spouts of class **a1** are curiously rare, but **254** comes from A1. Open cutaway spouts of class **a2** are standard on jugs.

[123] Warren 1972b, 394.
[124] Wilson 1985, 341–3.
[125] Wilson 1985, 342–3, fig. 34, pl. 46: P352. Cf. Fournou Korifi II: Warren 1972a, 125, 179, fig. 63: 1.
[126] Warren 1972a, 102, 123–5, 179, fig. 63.
[127] Cf. Wilson 2007, 61, 68–9, fig. 2.13: 10; 73.
[128] Discussed by Warren 1972a, 122–3 (noting **404**).
[129] Warren 1972a, 123, 175, fig. 59, pl. 44e–f: P314–318.
[130] H. W. Pendlebury et al. 1936, 34, fig. 8, 40, pl. 8: 124; 37, fig. 9, 40–1: 125.

[131] Marinatos 1929b, 115, fig. 9: 7; cf. H. W. Pendlebury et al. 1936, 36.
[132] Warren 1972a, 122. See also Georgiou 1973; 1986, 46; earlier discussions: Demargne and Gallet de Santerre 1953, 87–8; Deshayes and Dessenne 1959, 45–6.
[133] EM I examples from Lebena T. II: Alexiou and Warren 2004, 113–14, fig. 31, pls. 106C–D: 506, 508; 107A–B: 507.
[134] E.g. Wilson 1985, 353–4, pls. 52, 55: P436, P440, P459–460; Warren 1972a, 107, 143–9; Laviosa 1973, 511–12, figs. 11–12 (Ayia Triada, West House).

Nozzle and tubular spouts

The plain tubular spout of class **b2** appears to be a development from the nozzle of class **b1**, which was already known in EM I if not earlier at Knossos. Tubular spouts of class **b2** now occur on small jars of type 16 and commonly on large jars of type 17.

Teapot spouts

These distinctive spouts of class **c** appear to have been confined to small jars of type 16. Some of them are comparatively long and elegant, e.g. **498** (A3) and **1337**. They do not seem attested in Crete before EM II. There are no spouts of this kind from the Palace Well, and none is reported from Pyrgos or Kyparissi; side-spouts on vessels from these burial caves are all of class **b**. Teapot spouts of class **c** are well represented, however, in EM IIA. There are many from the WCH, and they are found on the teapots from Ayia Kyriaki and Koumasa.[135]

Spouts like those of class **c** are found on metal vessels in Anatolia and the Near East in early times. Possibly the fashion for teapot spouts on clay vessels originated in Crete from the imitation of imported metal ones with spouts of this kind.

Bridge spouts

No example of a bridge spout of class **d** was found in our EM II deposits at Knossos; but there is one (**1284**) of EM IIA in the SMK. At present, it is unique among the EM I–II pottery of Knossos. Bridge spouts of class **d1** occur in Vasiliki III,[136] and there are many bowls and jars with spouts of this class, if not in some cases with true bridge spouts as class **d2**, in Fournou Korifi II.[137] In the Neolithic, bridge spouts first appear in FN IB (Stratum IIIA) at Knossos.[138]

HANDLES

Vertical and horizontal handles occur, and are normally round or thick oval in section; but **509** (A3) has a thick rectangular section; and one from A4 is a true strap handle with thin oval section. **1044** (B2), of sub-rectangular section and peculiar fabric, may belong to an imported vessel. Handles with perforations at both ends may be something peculiar to EM II (see pp. 116, and 134: **195**). Jug **1339** has a handle with such holes, and a similar handle **256** (A1) may also be from a jug. These holes may have been intended for string (which would have had to be thin), or made to improve the firing by letting the heat penetrate at places with unusually thick clay where the handle joins the wall of the vessel.

CARINATIONS

Many bowls and jars of cooking pot ware of types 11 and 18 have a sharp carination below the rim. Isolated instances of other types may have had carinated bodies but, apart from types 11 and 18, carinations seem rare.[139]

BASES

These are in general flat, but sometimes concave, or slightly convex like bases in EM I. Pellet (lug) feet resembling those from the Palace Well (p. 57: **154**) occurred in A1, and the only other foot of this kind was from A2. Such feet on roughly flattened bases appear to have been the norm for jugs in the RRS EM IIA deposits.[140] See also **1263**.

Ring bases occur on what may be imports of Vasiliki ware; and **262** (A1), of fine burnished ware, may also be from an import. Fragment **261** of a small pedestal from A1, in shape like those from the Palace Well, has an orange-buff burnished surface with red encrusted decoration. A more complete pedestal of similar size and fabric with the same type of decoration is in the SMK (B.II 405: cf. p. 242, FIG. 10.1: 13). In the technique of decoration these fragments recall the FN painted ware of Phaistos. These pedestals may come from chalices, but **1045** (B2) of rough fabric almost certainly belongs to some other shape.

[135] Cf. Blackman and Branigan 1982, 31, fig. 11, assigning all the examples of such spouts from Ayia Kyriaki with dark-on-light decoration to their 'Ayios Onoufrios II' ware, which they suggest may be the equivalent of the EM IIA Koumasa style of Zois.
[136] E.g. Boyd Hawes *et al.* 1908, pl. 13: 11.
[137] E.g. Warren 1972*a*, 119: P251–252; 120–2: P279–312.
[138] Tomkins 2007, 33–4, fig. 1.9: 44 (bowl-jar with everted rim); cf. also J. D. Evans 1964, 178, 201–02, figs. 42: 1, pl. 43: 5, and 43: 2, pl. 43: 6 (fenestrated vessels).
[139] Cf. an EM IIA carinated bowl with decoration in dark-on-light from RRS: Warren 1972*b*, 394, fig. 5.
[140] Warren 1972*b*, 395. Cf. the WCH: Wilson 1985, 314–17, fig. 19: P144, P158; 323–5, figs. 22–3: P218.

DECORATION

PAINT

Painted decoration occurs on pottery at Knossos in both dark-on-light and light-on-dark from the start of EM II. Both modes are found on burnished surfaces as well as on smoothed or washed ones, especially at the beginning of EM II, when burnished wares are more in evidence.

Dark-on-light

This painted decoration is similar in character and technique to that noted in the Palace Well. The buff surface of the vessel is usually well smoothed or burnished, with the stroke marks of a burnishing instrument often clearly visible. The paint is most commonly red, but may be red-brown, or shades of light or dark brown; it is normally matt, or has only a slight lustre.

Light-on-dark

Decoration in white paint occurs, although it is rare, on red and black washed surfaces of vessels in the WCH,[141] and on fragments from A1.

Mackenzie thought that white paint might have been used for decoration at Knossos already in EM I,[142] although no certain examples of white painted decoration appear to have come from the lowest Minoan stratum of the West Court Section on which he based this view. There is no evidence for white painted decoration in the Palace Well, and no sign of it elsewhere at Knossos in EM I.

Pendlebury suggested that the fashion for light-on-dark decoration was first developed in eastern Crete in EM II in connection with dark surfaced Vasiliki ware.[143] Betancourt has isolated an early cycle of light-on-dark painted decoration in eastern Crete, and assigns it to a late stage of EM II.[144] No white painted decoration was identified in Fournou Korifi I and very little in II,[145] where it was concentrated in one house, presumably reflecting the predilections of one family.[146]

The evidence suggests that the fashion for decorating pottery with designs in white may have been established in southern Crete before it was at home in the north or east of the island. Several vessels in the EM I level in Lebena T. II have decoration in white paint on a red surface;[147] while some examples of white painted decoration from Trapeza may date from an EM I horizon or even earlier: one came from an undisturbed deposit with Trapeza ware.[148] But decoration in red paint, more rarely white, or occasionally both combined together, is found on burnished surfaces in Class C ware from the earliest FN stage of Phaistos.[149] It seems possible then that the light-on-dark tradition continued in this part of Crete into the beginning of Early Minoan and spread from there.

Although there is no light-on-dark decoration from the Palace Well, it is found at Knossos in EM IIA and became increasingly dominant alongside the growing fashion for dark washed fine wares during EM IIB. This suggests that, even if the fashion for light-on-dark decoration was ultimately derived from southern Crete, it may have spread to the Knossos region before reaching the east of the island from there. The white paint used for light-on-dark decoration at Knossos in EM II is characteristically thick, and creamy white in colour, and looks quite yellowish when it is wet. It is easily distinguishable from the thin chalky white of MM I–II at Knossos.

Designs of painted decoration

The same motifs are found in dark-on-light and in light-on-dark. As time passes, the designs tend perhaps to become more elaborate. The most elaborate ones seem to occur on dark surfaced vases, which may reflect the fact that, during the course of EM II, dark surfaces became increasingly prevalent on fine wares. Motifs are still recognisably skeuomorphic in their antecedents, as they were in EM I; but they have moved further away from their original prototypes. Thus the intersecting diagonal stripes recalling string nets on gourd-shaped jugs of PW type 12 crystallised into formal cross-hatched triangles on the bodies of the equivalent jugs of type 15 by EM IIA.

Designs include horizontal and vertical stripes and bands. Diagonal lines adorn the rims of bowls, and appear on the sides of bowls and jars, where they often intersect, recalling the net-slings from

[141] Wilson 1985, 312.
[142] Mackenzie, in Evans 1904, 22; cf. Mackenzie 1903, 165.
[143] Pendlebury 1939, 80–1.
[144] Betancourt 1984, 21.
[145] Warren 1972*a*, 94.
[146] Whitelaw 2007, 73–4, fig. 8.5b.

[147] Alexiou and Warren 2004, 62–3, fig. 18, pl. 31B: 4; 92, fig. 26, pl. 70A–B: 298; 94, fig. 27, pl. 75A: 325; 107, fig. 30, pl. 97B: 454; 123–4.
[148] H. W. Pendlebury *et al.* 1936, 28 and n. 1; 56. For FN IV at Trapeza, see Tomkins 2007, table 1.6; 44.
[149] Vagnetti 1973*a*, 80.

which this motif may derive; lattice work, especially when it appears on the sides of jugs of type 15, reflects the same origin. Chevrons adorn some goblets and small jars of fine ware of type 16.

Pedestal **261** (A1) appears to have been decorated with loops in red. Small loops in dark-on-light and light-on-dark, usually single but sometimes double or multiple, hang from EM IIB goblet rims, which were mostly found in Area B.[150] We did not find this as a decorative motif in EM III.

Multiple concentric loops appear in dark-on-light on the flat rim of an unique EM II bowl.[151] Vertical rows of loops in dark-on-light flank a solid mass on the body of a jug from Fournou Korifi II.[152] Multiple loops in white on a dark wash hang from the shoulder of a jug from Palaikastro.[153] In general, however, painted loops seem rare in the EM II repertory outside Knossos. The rich assemblage from Ayia Kyriaki, for instance, has only one example of this motif: a row of simple inverted loops in dark-on-light at the base of a jar neck.[154]

It is true that multiple concentric loops or semicircles are a standard motif of incised decoration on Cretan light grey ware vessels. But the loops of the contemporary painted decoration may derive from a different source, some lingering version perhaps of the Ubaid tradition of the Near East, as seen for instance in Mersin XIIB.

Loops are not in evidence on any of the painted pottery from our EM III deposits at Knossos, but they appear in various forms in East Cretan EM III light-on-dark. Some of these approximate to the simple versions of EM II Knossos;[155] but in general they are large and arc-like, incorporated in complex designs or used as filling ornament.[156]

A solid spot appears in isolation on jug neck **228** (A1). Spots are flanked by lines or stripes on **512** (A3) and **549** (A4), both in light-on-dark and from EM IIB deposits. Spots appear to have formed the terminals of a diagonal net pattern in light-on-dark on **513** (A3). The rosette in light-on-dark on goblet rim **426** (A3) is surprising, since the design is more at home in MM IA; but the rim appears to be in context and EM II in date.

Other elaborate designs attested by single examples are the hatched band in dark-on-light on the shoulder of a jug or jar **411** (A2); bands of short dashes in light-on-dark on **1012** (B2); and the bisected oval chain in dark-on-light on **412** (A2). This fragment had been worn by use as a rubber; the fabric of it is exceptionally fine, and the vase may have been an import, perhaps from one of the Cyclades, where the same motif is found on EC pottery (see pp. 154–5). The motif seems ultimately derived from the repertory of the Halafian culture of northern Mesopotamia via Syria or Cilicia.

Crosses were sometimes painted underneath bases, mostly it seems of bowls. These are usually simple, made with a pair of fairly wide crossing bands (e.g. PLATES 25: **330**, **417–418**; 27: **344**). A few more elaborate versions, however, are attested.[157] Such crosses occur in light-on-dark (p. 155) as well as dark-on-light. A fragment with part of an elaborate eight-armed cross or star in white comes from B1 (PLATE 39: **852**). There are several examples of simple red crosses on bases in the WCH.[158]

This decoration suggests that the bowls were intended to be viewed, when not in use, either upside down on a flat surface or, more likely perhaps, hanging from pegs on the wall — which would explain why many EM II bowls have string-holes, some of them we may imagine with cruciform decoration underneath.

At Fournou Korifi red crosses appear on six jug bases in period I, and on spouted bowl bases in II.[159] A two-handled jar from Pyrgos, assignable perhaps to EM IIA, has a cross under the base.[160] Red crosses also come on the insides of pedestal bowls, apparently of EM II date, from Ayia Kyriaki.[161]

Boldly painted red crosses like those of EM II do not seem to occur on the rounded bases of EM I vessels; but a small jug from Kyparissi, which may date from mature EM I, has its nearly flat base decorated with lines cutting across it in the form of a cross;[162] and an elaborate cross formed by the

[150] Such as PLATES 26: **307** (A2), 29: **425** (A3), 38: **832–834** (B1), 41: **941–944** (B2). In a magnified version single loops depend from the rim of a large bowl of type 10: **975** (B2).

[151] HM 5556, of type 9 from Mochlos (Seager 1912, 25, figs. 7, 13: II.l; Zois 1967a, pls. 10, 32). Zois (1968a, 84–5) refers it to the end of his EM IIA 'Koumasa' style.

[152] Warren 1972a, 134, 186–7, figs. 70–1: P460.

[153] Dawkins and Currelly 1904, 201, fig. 3a, from an early deposit in Δ 32 unlikely to be later than EM II; cf. Bosanquet and Dawkins 1923, 4.

[154] Blackman and Branigan 1982, 33, fig. 12: 150.

[155] E.g. Zois 1967b, pl. 22: 69, from Gournia.

[156] Zois 1967b, pls. 21–2 and passim.

[157] E.g. Zois 1967a, pls. 9, 33: 10800; and below PLATE 39: **1347**.

[158] They include a jug thought to be a (Mesara) import: Wilson 1985, 307, 311–12, fig. 16: P123 (Wilson and Day 1994, 27, pl. 2: FP 23); also 322, pl. 36: P209–210.

[159] Warren 1972a, 12, 105, pl. 35A (Fournou Korifi I); 120: P281.

[160] Xanthoudides 1918a, 144, fig. 5, 147: 4; Zois 1967a, 726, pl. 25: 7524.

[161] Blackman and Branigan 1982, 34, fig. 13, 36: 171.

[162] Alexiou 1951, 277, pl. 2.5: 7.

intersection of two groups of three parallel lines and enclosed within a circle appears near the rounded base of the well known jug from Ayios Onouphrios.[163]

The fashion for decorating bases with simple red crosses is also attested on the Greek mainland during EH II: such crosses, for instance, are found on the insides as well as under the bases of some bowls at Korakou.[164]

Marks, whether in dark-on-light or light-on-dark, are found on the underneath of a few bases and feet of cups and goblets of types 1–3 (FIG. 5.5). These marks are composed with one or more short strokes or spots, and are clearly deliberate. Their purpose, however, is obscure; see further pp. 105 above and 275.

Trickle ornament appears on large jars including pithoi. This type of decoration remained very common on pithoi and store jars until LM. Pithos fragments with trickle come from A1 and the West Court House.

PATTERN BURNISH

This distinctive type of decoration scarcely occurs at all in the elaborate form in which it appears on the fine wares of EM I. The only example of true pattern burnish from our EM II deposits is lid **196** (A1). Vertical stroke burnishing on light surfaced goblets of type 2 may have had decorative intention, but hardly qualifies as pattern burnish.

INCISION

Evans's excavations produced a fair amount of incised decoration assignable to EM II, but it is extremely rare in our EM II deposits. Only eight fragments with incised decoration of any kind were found. They are not confined to any particular phase of EM II.

One or two of these fragments may come from imports, like the pieces of jar **419** with a red wash, which looks Cycladic. But incised decoration mostly seems to occur on vessels in cooking pot ware of local manufacture, including jug neck **484** (A3). Jug fragment **994** (B2) has a row of diagonal or herring-bone incisions around the base of the neck. This foreshadows the ribs with incised decoration commonly found round the necks of jugs of fine ware in EM III and MM IA. On **994**, however, there is no rib: the incised decoration is on the flat surface of the shoulder. But a rib with incised decoration occurs on the side of a jar of cooking pot ware **390** (A2).

Rim **271** (A1) of a goblet or small bowl with a dark wash has an incised arrow-like design, and an unique fragment of a goblet **924** (B2) a diagonal zone of short jabs. Bold criss-cross scoring of the insides of large bowls or open jars as found in EM I continues, such as **390**: see pp. 30, 59.

RELIEF

Ribs or bands

The two examples of this type of decoration are: on jar **390** in cooking pot ware, combined with incisions, and **901**, a scrap from a suspension pot with a dark burnished surface.[165]

Warts

There are five examples of warts on the shoulders of large jars of cooking pot ware of type 17: **389** (A2); **537–538**, **543** (A4); **1026** (B2). Warts are also found on one or two smaller, type 15 jars in fine ware: **487** (A3) and **530** (A4). Small rivet-like warts occasionally appear on the tops of rims: on a large bowl in cooking pot ware **865** (B1), and on two goblets or small bowls of imported Vasiliki ware **286** (A2) and **820** (B1). One such rivet occurs on the side of Vasiliki ware goblet **420** (A3).

[163] Evans 1895, 113–14, fig. 106.
[164] Blegen 1921, 6, fig. 5: 3.
[165] The latter may come from a vessel like one at Koumasa

assigned by Xanthoudides (1924, 9, pls. 1, 18: 4193) to EM I or the beginning of EM II.

Chapter 6

The Early Minoan III pottery

Two main deposits assignable to EM III were identified in our excavations: A5 in Area A, and B3 in Area B.

Some notable differences in the character of these deposits may reflect a difference in date between them. A5 appears to be the earlier, and closer to EM IIB; it was above a floor (Floor IV) sandwiched between A4 (Floor V, mature EM IIB) and a later deposit of EM III (A6, Floor II) with pottery which, as far as could be judged from its relatively small amount, is more or less comparable in character to B3. The difference in the relative preponderance of type 2 footed goblets and type 3 goblets between A5 and B3 — 15:13 in A5, 70:90 in B3 — suits the view that A5 is earlier.

The B3 deposit was separated from the underlying EM IIB deposits by a plaster floor (see pp. 86, 90). It seems to correspond to what Evans recovered from the area and called Early Minoan III.[1] Other substantial EM III deposits in various parts of the Palace site[2] include the Upper East Well (UEW),[3] from which a group was illustrated by Mackenzie as a sample of early pottery at Knossos.[4] In his 1904 report Evans assigned the 'hoards of vases' from this well to a group labelled EM III,[5] but later he put it in MM IA,[6] presumably following Mackenzie's placing it in MM I.[7] (See too p. 12 and n. 109).

EM III at Knossos is essentially a phase of transition between EM IIB and MM IA.[8] At the same time some marked changes from EM II can be detected. One notable change is the striking predominance of bowls of type 8/9, another the rise into favour of type 3 goblets at the expense of footed goblets of type 2. Many of the types characteristic of EM II (such as bowls of types 4 and 5) seem to have disappeared by EM III. The various dark burnished fabrics of EM I descent, which lingered into EM IIA late,[9] have also vanished. A scrap of light grey ware and some Vasiliki ware from A5 might be EM II strays, although a survival of Vasiliki ware into a period around the beginning of EM III at Knossos seems on the face of it not impossible.[10]

In many respects Knossian EM III is closer in character to MM IA than to EM IIB, and the footed goblets of type 2, and many of the type 3 goblets, can be difficult to distinguish in isolation from MM IA ones. In particular, the low footed goblets of type 2, in both their shapes and their simple, rather standardised decoration, are very close to those of MM IA, and innovations like the use of barbotine decoration also align this Knossian EM III horizon more closely with MM I rather than EM II. It might indeed seem tempting to classify this as an early phase of MM IA, as we were inclined at first to do.[11] Once, however, we had studied the A5 and B3 pottery in detail, there could no longer be any doubt about its being EM III, and between EM II and MM IA.[12] It is therefore clearly desirable, even essential, to retain the traditional nomenclature for this horizon at Knossos. An overlap here with what is called EM III in eastern Crete is confirmed by the East Cretan EM III white-on-dark import **1124** in B3.

The fashion for white painted decoration already attested in EM I in the south could have spread from there to Knossos, where a growing taste for it can be traced, our excavations show, throughout EM II into EM III: it could well have spread from the region of Knossos to the east. (See also pp. 11, 97, 119, 287). Likewise, there is a good possibility that polychrome decoration in red and white reached Knossos from the Mesara during EM III, to judge from a few unusual and probably imported pieces in

[1] *PM* I, 108.

[2] Listed by Momigliano (2007c, 81–93).

[3] Hood and Taylor 1981, 21: 198. The pottery was studied first by Lee (1974) who recognised it as EM III, and has since been fully discussed by Andreou (1978) and Momigliano (1991, 155–63; 2007c, 81–93).

[4] Mackenzie 1903, 167, fig. 1; 1906, 252, for the provenance.

[5] Evans 1904, 20. But it also includes the MM IA pottery from the Monolithic Pillar Basement and the Vat Room deposit of MM IB: see above p. 11.

[6] *PM* I, 213, n. 2; III, 254.

[7] Mackenzie 1906, 252–3.

[8] Andreou (1978, 24) emphasises that the EM III horizon of pottery at Knossos evolves imperceptibly and without any sign of a break from that of EM IIB.

[9] Cf. Wilson 2007, 64.

[10] See Betancourt 1979, 21–2.

[11] E.g. Hood 1962, 93.

[12] Hood 1966. This was soon followed by Zois (1967b).

UEW Group EM III late contexts.[13] The East Cretan EM III style continued rather later, certainly after the beginning of MM I at Knossos, and perhaps overlapping all of (Knossian) MM IA, as Pendlebury suggested.[14] Other East Cretan EM III jars in MM IA contexts in RRS add weight to this argument.[15]

Both in the Knossos region and in eastern Crete the EM III horizon is characterised by the predominance of simple goblets of type 3 at the expense of type 2 footed goblets, but those of eastern Crete tend to be a good deal wider in relation to their height than those of Knossos, continuing in this respect the tradition of EM II type 3 goblets. In both regions EM III is also marked by the predominance of painted decoration in light-on-dark on the finer wares. The earlier white painted pottery of eastern Crete assigned to EM III may continue the simple linear designs fashionable in EM II at Knossos.[16]

In the absence of well stratified settlement deposits, no clear picture has yet emerged of the pottery of this horizon in the south and west of Crete.[17] In the west, the careful analysis of the pottery from Lera by Guest-Papamanoli dates it to EM I and II and to MM, but places nothing in EM III.[18] A vessel from Platyvola assigned to EM III by Warren and Tzedakis is of a type that Pendlebury set in MM I.[19] In the Mesara Phaistos has now produced levels stratified between EM IIB and MM IA that may be contemporary with Knossian EM III,[20] while a knobbed jug from the UEW is almost certainly from the Mesara.[21] However, decoration in red (and more rarely in white) paint on a dark surface is attested at Phaistos from the beginning of FN; and in a very few instances red and white paint are used in combination.[22]

Barbotine decoration, which suddenly appears at Knossos at the beginning of EM III as in A5, may also be a fashion derived (ultimately) from the south, where a form of it (granulation) was at home in Phaistos FN.[23] But intermediary examples have not so far been recognised in any part of Crete in EM I–II to suggest a survival of such a tradition. Re-invention, or the borrowing of ideas from Anatolia or the Levant, where comparable decoration is attested, are among other possible explanations for its appearance at Knossos in EM III.

FABRICS

The EM III categories of fabrics have been added to the sequence of those for EM II, which have been included for convenience in TABLE 6.1, although several of them are no longer attested, or are only represented by what appear to be earlier strays.

There was a simple evolution in fabric between EM II and III. But some fabrics, which reflect a continuation of EM I or LN traditions into EM II, evidently went out of use by EM III: e.g. dark grey, red, and light brown burnished wares.

FINE WARES

LIGHT SURFACED WARES

Buff ware
This is still a standard fine ware, especially for larger vessels, but smaller vessels now usually have a dark wash. A burnished finish for buff or orange-buff surfaces is less in evidence than in EM II. But at

[13] Momigliano 2007c, 84, 87–91, citing: two jugs from House B (Momigliano 1991, 221, 231, pl. 47: 38, 42), a bowl from the SFH (Momigliano 1991, 204, fig. 14, pl. 40: 19), and two sherds from a deposit at the Theatral Area (Batten 1995, 78–9).
 Pendlebury (1939, 84–5) allowed for the appearance of polychrome before EM III citing, however, a cup and a jar from Palaikastro (Bosanquet and Dawkins 1923, 8–9, fig. 5d, pl. 30) that have to be MM IA, and a teapot from Knossos (PM I, 110, fig. 78) that looks MM IB.
 [14] Pendlebury 1939, 94, 109 (amplifying PM I, 108). Cf. Warren 1965, 25–6; 1980, 491; Cadogan 1983, 509; Betancourt 1985, 71–2; Warren and Hankey 1989, 20.
 [15] See under 1124; also: S406 (level F30a), with crosshatched circle decoration; S428 (level F33), internally thickened jar rim like 1124 (with another from level F34); S697 (level BCE5), another; and possibly (level F35) a large jar with horizontal rib, and diagonal decoration of crosshatched band with flaring lines. Two type 3 goblets from House B are interesting evidence of the impact of the East Cretan EM III style on Knossian potters: one (Momigliano 1991, 222, fig. 23; 227, 230, pl. 45: 26; 2007, 82)

for its wide, conical shape and decoration — it may be an import; the other (Momigliano 1991, 226, 233, fig. 27, pl. 51: 67) for its decoration on a regular Knossian type 3 goblet.
 [16] Cf. Betancourt 1984, 21–34: his Middle Phase (his Early Phase of light-on-dark being EM IIB).
 [17] Cf. Momigliano 2007c, 93.
 [18] Guest-Papamanoli and Lambraki 1976.
 [19] Tzedakis 1966, 428, pl. 466γ; Warren and Tzedakis 1974, 340, n. 84; H. W. Pendlebury et al. 1936, 83, fig. 18: 704–05. See also Momigliano 2007c, 93, with references to eggcups and rounded cups in the Chania Museum.
 [20] La Rosa 2002, 643, 740–1; Todaro 2005, 41–2; Momigliano 2007c, 93; and Todaro forthcoming. Note also the 'early' and pre-Patrikies MM IA without polychrome or barbotine (Todaro 2005, 42), which may correspond to EM III late (UEW Group) at Knossos (Momigliano 2007c, 93).
 [21] Momigliano 2007c, 93; 1991, 159, 163, pl. 21: 41.
 [22] Vagnetti 1973a, 80, 83, fig. 74: 2, pl. 3: 5.
 [23] Vagnetti 1973a, 86, 113, figs. 120–1, pl. 1: 5.

TABLE 6.1. Areas A and B. EM III fabrics.

Attested in EM III	Only represented by what appear to be earlier strays	No longer attested
1. FINE WARE		
A. LIGHT SURFACED WARES		
(a) Buff ware	*(c) Light grey ware*	*(b) White burnished ware*
B. DARK SURFACED WARES		
(d) Dark (red and black) washed wares	*(e) Vasiliki ware*	*(a) Dark grey burnished ware*
		(b) Red burnished ware
		(c) Light brown burnished ware
2. COARSE WARES		
Soft sandy ware		
3. COOKING POT WARE		

the beginning of EM III at any rate some vessels of buff ware, and even some with dark washes, are burnished. By the time of the B3 deposit, however, burnishing seems to be virtually confined to jugs with cutaway necks of type 15, where it may be for the better retention of liquids.

White burnished ware
No example of this rare EM II fabric was noted in our EM III deposits.

Light grey ware
This EM IIA fabric appears as one scrap in A5: it may well be an earlier stray.

DARK SURFACED WARES

Dark grey, red, and light brown burnished wares
These wares, which are at home in EM IIA and less in evidence in EM IIB, do not appear at all in our EM III deposits.

Dark (red and black) washed wares
These are the standard wares for the finest decorated vessels, as is seen clearly in B3. Black is the dominant colour, but it still merges into red with intermediary shades from uncertainties in the firing. In general, however, the washes tend to be a more even black or red, and of better quality, less flaky, and more lustrous (often with a distinct metallic sheen), perhaps from improved firing methods.

Vasiliki ware
Three scraps come from A5. They may be earlier strays, but B3 produced two fragments also. It is possible that Vasiliki ware continued to be made in the Mirabello area for a time after the beginning of EM III.[24]

COARSE WARES

Coarse wares are much the same as in EM II with the addition of soft sandy ware.

Soft sandy ware
The soft fabric and sandy clay of this ware are unmistakable. It was very prominent at Knossos in MM I–II and later. It does not occur in our EM II deposits, but we have examples in B3.

[24] *PM* I, 108.

SHAPES, FEATURES, AND DECORATION

(EM II types that only appear to be represented by stray fragments in EM III deposits are marked with an asterisk)

TYPES (FIG. 5.1):

- *1A. Cups with large loop handle
- 1B. Cups with vertical handle
- 2. Footed goblets
- 3. Goblets
- *4. Shallow bowls or plates with rim thickened internally
- *5. Bowls with upright sides and rim thickened internally
- 6. Deep bowls with upright sides
- 7. Shallow bowls with straight or inward curving sides
- 8/9. Bowls with flaring or everted rims
- 10. Large bowls with straight sides and thick everted rims
- *11. Large bowls with curving, often carinated, sides and thickened rim (cooking pot ware)
- 12. Large deep bowls or jars with thick triangular-sectioned rims
- 13. Fruit stands
- 14. Baking plates
- 15. Jugs with cutaway spout
- 16. Small spouted bowl-jars
- 17. Large spouted bowls or jars with horizontal side-handles
- *18. Large bowls or jars with inward curving, often carinated and thickened rims
- 19. Large jars with narrow neck and wide everted mouth
- 20. Tripod cooking pots (cooking pot ware)
- 21. Braziers
- 22. Pithoi

A number of the types listed are identical with ones current in EM II. If marked above with an asterisk (*), these were only present in EM III as scraps, perhaps earlier rubbish incorporated into the EM III deposits. The types that were actually current in EM III at Knossos are likely to be confined to those without an asterisk.

TYPES

*TYPE 1A. CUP WITH LARGE LOOP HANDLE

A large handle of circular section from A5 appears to belong to a cup of this type, which may have continued in use, if becoming rare, in EM III at Knossos.[25]

TYPE 1B. CUPS WITH VERTICAL HANDLE

A base that may belong to such a cup comes from A5, and five or six fragments from B3. This suggests that the type began to be less uncommon at Knossos towards the end of EM III.

TYPE 2. FOOTED GOBLETS

These are described in detail under A5 and B3. EM III footed goblets clearly evolve from those of EM II and merge into those of MM IA. Those from Yiofyrakia look comparable to ours.[26]

TYPE 3. GOBLETS

The increased popularity of goblets at the expense of footed goblets of type 2 is one of the features that distinguishes EM III from EM II at Knossos. The goblet becomes increasingly prominent during the course of the period, as is clear from comparing the relative numbers of type 2 feet and type 3 bases in A5 with those in B3. Many of the Knossian EM III goblets appear to have been relatively

[25] For an example from the UEW, see Andreou 1978, 18, pl. 1: 9, and Momigliano 1991, 158, fig. 2: 21; 162: 21.

[26] Marinatos 1935, 51, fig. 4: 1–8.

squat like those of East Cretan EM III,[27] but some later examples are tall and elegant, like **661** (A7) and **1055–1056** (B3). Goblets from Yiofyrakia resemble Knossian EM III ones.[28] A number from the Idaian Cave, where the lower strata are said to go back to the end of EM, look very comparable with the squatter varieties of type 3 from Knossos.[29]

*TYPE 4. SHALLOW BOWLS OR PLATES WITH RIM THICKENED INTERNALLY

This very common EM II type is represented by 18 rims, of which six are of the rounded class **a**, and 12 of the bevelled class **b**. This reverses the situation in the EM II deposits where class **a** rims outnumber those of class **b** by 5:1. A5 produced eight rims (three of class **a** and five of class **b**), while only one class **a** rim comes from B3. This might suggest that bowls of this type, or at any rate ones with class **b** rims, continued in use into early EM III at Knossos. Andreou notes that 'no bowls with thickened inside rims, so characteristic of the EM II deposits at Knossos', occur in the UEW.[30]

*TYPE 5. BOWLS WITH UPRIGHT SIDES AND RIM THICKENED INTERNALLY

This EM II type is represented by one rim from A5.

TYPE 6. DEEP BOWLS WITH UPRIGHT SIDES

Bowls of this general type appear to have existed, but only three rims from A5 could be assigned to it.

TYPE 7. SHALLOW BOWLS WITH STRAIGHT OR INWARD CURVING SIDES

This type is relatively well attested, especially in B3. It merges into the common and characteristic type 8/9.

TYPE 8/9. BOWLS WITH FLARING OR EVERTED RIMS

This type of bowl seems a hallmark of EM III at Knossos, where such bowls are very common in the UEW.[31] The bowls tend to have thicker rims and be of heavier fabric than their equivalents of types 8 and 9 in EM II. Some bowls from A5 seem to have had small round section horizontal handles;[32] but there is no evidence of them in B3. A bowl of this type with elaborate light-on-dark decoration was found in an EM III deposit in Mochlos town.[33]

TYPE 10. LARGE BOWLS WITH STRAIGHT SIDES AND THICK EVERTED RIM

Some 15 rims are assignable to this type.

*TYPE 11. LARGE BOWLS WITH CURVING, OFTEN CARINATED, SIDES AND THICKENED RIM (COOKING POT WARE)

Four rims assignable to this type are probably EM II strays.

TYPE 12. LARGE DEEP BOWLS OR JARS WITH THICK TRIANGULAR-SECTIONED RIMS

A number of rims are attributable to this type, which does not seem attested in EM II.

TYPE 13. FRUIT STANDS

One possible fragment of a fruit stand comes from B3.

TYPE 14. BAKING PLATES

These must have been in general use, as in earlier and later periods; but only one rim was recorded, from A5.

[27] E.g. **560** (A5); **634** (A6); **689** (A7); **1058** (B3); Andreou 1978, fig. 1: 4, 8, and Momigliano 1991, 157, fig. 1: 4; 162: 17–18 (UEW): cf. Seager 1912, 84, fig. 49: M.58–60; 86, fig. 50: M.89.

[28] Marinatos 1935, 51, fig. 4: 9–13.

[29] Sakellarakis 1983, 485, pl. 276α.

[30] Andreou 1978, 14.

[31] Andreou 1978, 18; Momigliano 1991, 158–60, figs. 2: 22–4, 3: 25–6; 162: 22–6.

[32] Like Hazzidakis 1934, pl 20.3b.

[33] Seager 1909, 284, figs. 8, 13.

TYPE 15. JUGS WITH CUTAWAY SPOUT

These are in evidence, as in earlier and later periods. Most of the fragments of such jugs from A5 are coated with a dark wash and show traces of decoration in white.

TYPE 16. SMALL SPOUTED BOWL-JARS

These are much in evidence in A5, and far lesss frequent in B3.[34]

TYPE 17. LARGE SPOUTED BOWLS OR JARS WITH HORIZONTAL SIDE-HANDLES

These are much in evidence, especially in B3.

*TYPE 18. LARGE BOWLS OR JARS WITH INWARD CURVING, OFTEN CARINATED AND THICKENED RIMS

This EM II type is only represented by one or two scraps (which may be earlier strays), in A5.

TYPE 19. LARGE JARS WITH NARROW NECK AND WIDE EVERTED MOUTH

Although this type is not well attested from our excavations, it appears to have been at home in EM III at Knossos, when it may have replaced EM II type 19.

TYPE 20. TRIPOD COOKING POTS (COOKING POT WARE)

Like baking plates (type 14) these must have been in general use at Knossos in EM III, but only three feet are recorded, all from B3 and of thin oval section.

TYPE 21. BRAZIERS

Two scraps of these come from B3.

TYPE 22. PITHOI

Pithos fragments with trickle ornament are **687** (A7) and **1099–1101** (B3).

FEATURES

SPOUTS

Trough spouts
Two examples were noted.

Nozzle and tubular spouts
These are in evidence in all our EM III deposits.

Teapot spouts
These evidently continued at Knossos throughout EM III and into MM IA and later. Several examples were noted in B3.

Bridge spouts
B3 has several fragments: class **d1** with a circular hole through the wall of the vessel. Andreou notes that bridge spouts of this kind are relatively common in the UEW, while bridge spouts with a semi-circular hole (as class **d2**) are more common in the EM III of eastern Crete.[35]

HANDLES

These are in general round or sometimes thick oval in section. A double round section handle **656** comes from A6. Several handles with more or less rectangular sections were noted, mostly in A5. Horizontal handles appear to have a rounded outline; none is of the pointed shape found in MM I.

[34] Cf. Momigliano 2007c, 90, fig. 3.8: 4–6. [35] Andreou 1978, 20.

CARINATIONS

These are in evidence on fragments of jugs of type 15 or bowl-jars of type 16 in A5. Only one example was noted in B3.

BASES

Bases are in general flat.

DECORATION

PAINT

The ascendancy of light-on-dark over dark-on-light painted decoration, which is such a recognised feature of EM III, merely reflects the predominance of dark (black or red) washes on the fine table ware. Decoration, whether in light-on-dark or dark-on-light, is still for the most part simple and linear. The use of diagonal lines, singly or in groups of three or more, appears very popular by the time of B3. This may be an expression of that feeling for torsion or spiralling movement that Matz noted in Cretan Bronze Age art.[36]

Dark-on-light

Decoration in dark-on-light is still attested throughout EM III at Knossos, even on some of the smaller vessels in fine ware. Lattice and large solid spots are among the motifs. A row of solid spots adorns base **555** (A5). A type 2 footed goblet **1052** (B3) has solid semicircles hanging from the rim. As in earlier and later periods, pithoi and large jars are decorated with trickle ornament.

Light-on-dark

The earlier history of decoration in white paint in Crete has already been discussed (p. 123). It is much more in evidence than dark-on-light decoration in our EM III deposits. The paint used for this light-on-dark decoration at Knossos ranges in colour from fairly white to creamy white with a distinctly yellowish tinge as found on East Cretan EM III White-on-Dark ware.[37]

Motifs include lattice, a row of solid triangles **566** (A5), and diagonal lines in various combinations: with solid spots **640** (A6), and flanking a single wavy line **1106** (B3), or a spiraliform motif **663** (A7). Solid spots linked in the form of a running spiral appear on **657** (A6). The spiraliform motifs of this and the somewhat comparable **663** seem to be a new departure at Knossos during this period, despite a spiral in pattern burnish on EM I chalice **1183** and a presumably EM IIA spiral in dark-on-light painted ware **1299**. Yet it is interesting to note that there is nothing exactly like these early Knossian spiraliform motifs in the extensive repertory of East Cretan Early Minoan III White-on-Dark,[38] although true spirals and running quirks are at home there.[39]

The paint used for this light-on-dark EM III decoration at Knossos ranges in colour from fairly white to creamy white with a distinctly yellowish tinge as found on the equivalent East Cretan ware.[40] The fine chalky white paint, the 'new white' as Evans called it,[41] current in MM I–II at Knossos, does not appear to be at home there in EM III.[42]

The neat character of the spiraliform decoration on **657** and **663** contrasts with the bold spiral on **1124** (B3), imported from eastern Crete. The general impression made by the EM III light-on-dark decoration of Knossos is indeed one of restraint — if not austerity — when compared with the rich, ebullient style of its East Cretan counterpart. The Knossian pottery of subsequent Minoan periods appears to reflect this same capacity for tasteful restraint when compared with the products of other Cretan centres.

INCISION

This is rare, but is attested in deposits of early and later phases of EM III at Knossos. Incised hatching appears on a raised band **658** (A6), and on the ribs at the base of jug necks **1094–1097** (B3). The bodies of two small bowl-jars **1140–1141** of type 16 (B3) have reserved zones with fine incised lattice.

[36] Hood 1978, 234, 274, n. 2, with references.
[37] For the paint used for this ware, see Betancourt 1984.
[38] Betancourt 1984, 22, 26, fig. 3–5: 7 (quirks), 8 (J-spirals); 32.
[39] Betancourt 1984.

[40] For the character of the paint on East Cretan EM III light-on-dark ware, see Betancourt 1984 with a full analysis.
[41] *PM* I, 111.
[42] Cf. Andreou 1978, 21.

RELIEF

Ribs decorated with incision are noted above, but we have come upon an apparently early instance in Vasiliki ware (**1336**), which is presumably of EM IIB date (see p. 274). Warts occur on the bodies of jugs and below the rims of large bowls or jars of type 17.

BARBOTINE

Barbotine as a form of decoration seems to be attested for the first time at Knossos at the beginning of EM III. Four fragments from A5 and one from B3 illustrate two varieties: naturalistic 'barnacle work'[43] on **629** (A5) and **1102** (B3); and fish scales on **571** and **627–628** (A5).[44] White painted decoration appears in the area not occupied by the fish scales on **571**. In the Mesara barbotine does not seem to appear until later MM IA.[45]

Fish scale barbotine seems unusual in Crete. Some of the few examples listed by Foster are MM III–LM I in date,[46] and others are not strictly comparable with our EM III pieces.[47] Fish scales resembling ours appear, however, on some fragments from Patrikies,[48] where some of the pottery may fall within EM III at Knossos.[49] Fish scales of this type also adorn two-handled jars of unusual shape from Beycesultan XVIII and XVIIb of EB I, thought to be contemporary with Troy I.[50] Some jars of the same shape 20 from Beycesultan XVII are decorated with ordinary 'prickle' barbotine.[51] Foster suggests that 'fish-scale surface manipulation' may be an anticipation of 'irregular polygonal ridge slip manipulation',[52] that is to say, of barnacle work barbotine.

RIPPLING

Rippled decoration was noted on a fragment from A5.

[43] As Evans called it (*PM* IV, 100, 102, figs. 67–8).

[44] For other EM III barbotine from Knossos (and Archanes) see Momigliano 2007c, 84–5, fig. 3.3: 1 (Mackenzie 1903, 167, fig. 1: 6; 1906, 252, for the provenance); Momigliano 1991, 156–7, fig. 8: 9; 161: 9); 87, 91, fig. 3.9: 1. Mackenzie (1903, 167, fig. 1: 5–6) showed two goblets with barnacle work. One of these was then illustrated twice by Evans, first as MM IB, and later as MM IA (*PM* I, 180–1, fig. 129a; IV, 100, 102, fig. 68). Foster discusses these goblets as examples of her exaggerated polygonal ridge type of barbotine, but wrongly assigns them to houses below the Kouloures in the West Court (Foster 1982, 16, 52, 58, 148, pl. 13: AM 1938.415).

[45] Todaro 2005, 42.

[46] Foster 1982, 50.

[47] E.g. Palaikastro: Zois 1965, 103, pl. 13: 4715, who considered this the only example of barbotine decoration in eastern Crete;

Kastri, Kythera, deposit β: Coldstream and Huxley 1971, 84–5, pl. 18: 13–15. Piece β15 is now considered an import from western Crete, possibly from around Chania (Broodbank and Kiriatzi 2007, 252–4, fig. 5e), where many examples of such scale barbotine have been found (Coldstream and Huxley 1972, 85; Chania–Kastelli: Tzedakis 1969, 428, pl. 435δ).

[48] Bonacasa 1968, 45, fig. 34, top left: bottom row, left and second from left.

[49] Zois (1968b, 122) for instance assigned it to transitional EM III–MM IA. But see Todaro 2005, 42, 45, assigning it to late MM IA.

[50] Lloyd and Mellaart 1962, 127, 130–1, fig. P.20: 2, 6, and pls. 17b, 18c.

[51] Lloyd and Mellaart 1962, 127, 130–1, fig. P.20: 1, and pl. 18a.

[52] Foster 1982, 148.

Chapter 7

Area A. Royal Road: North
The Early Minoan II–III deposits

EARLY MINOAN II

DEPOSIT A0: BELOW FLOOR VII

Level LA115

Just 21 sherds come from the very small area opened. Two of them are EM, the rest clearly Neolithic.[1] The Neolithic sherds belong to vessels of all sizes, some large but others very small; their surfaces are well burnished, shades of light and dark brown and black and red-brown, the clay tempered with distinctive angular lumps of white grit, apparently gypsum, which in many cases shows in the surface. This distinctive white grit appears to match Tomkins's fabric 1d, which appears in MN and is a characteristic of LN I at Knossos.[2]

The two EM sherds may be EM II. They are both from closed vessels; one is a scrap of fine white burnished ware: orange clay, plain inside, but a thick, warm, well burnished white slip outside; the other has a hard fabric: orange clay with fine black and white grit, with a buff slip outside and traces of decoration in black. It does not, however, appear to be a Mirabello product.

DEPOSIT A1: FLOOR VII

EARLY MINOAN IIA[3]

Levels LA114, LA116–LA117; LA111, LA113; LA109–LA110 (which may be mixed with material from deposit A2). Amount about 1 table.

The amount of pottery from this deposit is small, and nearly 1/2 of it belongs to lots that may have been mixed with material from deposit A2 above it. All the same, the pottery of A1 is markedly different from that of A2, which is definable as EM IIB. In A1, burnished ware is much more in evidence than in later levels. It includes both fine buff ware, often with painted decoration in red, and a fair amount of dark grey burnished ware continuing the EM I tradition, with some light brown and red burnished ware.

Several lug (pellet) feet like those in the Palace Well (see p. 57) come from this deposit — and also occur on jugs from the WCH.[4] They are very rare in later EM levels in our excavations. This may be fortuitous; but it is interesting that these feet do not appear at either Fournou Korifi I or II, although they are quite well represented in Debla II.

The deposit may date to a later stage of EM IIA than the WCH,[5] since it has a scrap or two of Vasiliki ware in apparently pure contexts, and already decoration in white paint on a dark surface on **239**. Fragments of pithoi are adorned with the trickle that is such a characteristic system of decoration for pithoi and large vessels of every shape in subsequent Minoan periods. The chalice bases have shrunk to a stage immediately ancestral to the classic EM IIB goblet bases of deposits A2 and B2, and can be classed as stemmed (footed) goblet bases. What is most significant is the appearance here side by side of identical bases: **186** in fine dark grey burnished ware in the EM I tradition, and **201** in fine buff burnished ware with decoration in red, like the EM IIB goblet bases in A2 and B1; while **261** is a small example of a high pedestal, in shape like those of EM I, but of buff burnished ware with decoration in red in the EM II tradition.

[1] Tomkins (pers. comm.) notes five EM IIA sherds and 15 EN/MN.
[2] Tomkins 2007, 21, 25, 27.
[3] This deposit was for a long time mismarked as 'Floor VI',

leading to some confusion: see p. 75, and TABLE 4.1.
[4] Wilson 1985, 314, 316–7, fig. 19: P144, P158; 357.
[5] See Wilson 1985, 292.

FABRIC

Fine ware

Light surfaced ware
This is more in evidence than dark surfaced ware. The vessels in standard buff ware are often, and in the case of the characteristic drinking goblets of type 3 almost invariably, burnished, with the stroke marks of the burnishing implement normally quite visible. Decoration is in linear designs in matt or slightly lustrous paint, red, red-brown, light brown or shades of dark brown to black.

Dark surfaced ware
Some fragments come from vessels with a dark wash, either burnished or unburnished, and decoration, when it occurs, in white; but dark grey burnished ware continuing the EM I tradition is the chief representative of dark surfaced ware in A1. There are also examples of the allied fabrics: red and light brown burnished wares. Over 60 fragments of dark grey burnished ware were noted. These mostly belong to small vessels, notably footed goblets of various types and bowls. Some of these vessels are of very fine fabric with thin walls.

 Several sherds with a dark burnished surface may be Neolithic strays (e.g. **190**), although only one or two scraps were certainly identified as Neolithic. Vasiliki ware is represented by four scraps (PLATE 26: **273–274**), two of them from levels which may have been mixed with material from A2. The outside of one scrap from a closed vessel has very fine stroke burnishing. On a fragment of a small cup or goblet, and on the two sherds from the possibly mixed levels, the surfaces appear merely well smoothed. Some vessels are scraped, both in fine ware, light or dark surfaced, and cooking pot ware.

Cooking pot ware
This is by now clearly differentiated from standard coarse ware. The clay is red, with fine grit, and well fired; the surface is often wiped (PLATE 24: **272**). This wiping, which was very common on coarse ware vessels from the Palace Well, seems confined in A1 to vessels of cooking pot fabric. The surfaces, whether wiped or not, often have a red wash. Sometimes they have a thick white slip with decoration in red (PLATE 24: **265**).

TYPES IN DARK GREY AND RED BURNISHED WARES

The shapes of vessels in dark grey and red burnished ware are so different from those in other wares that it seems best to consider them separately.

Dark grey burnished ware
Where the shapes in this fabric can be inferred, they are evidently small cups or bowls with high feet or pedestals, descendants of the much larger chalices and food vessels of Palace Well types 1 and 2; but true pedestals of the EM I type are less common than high feet like **186**. This is the only fairly complete example of such a foot, but fragments of at least five others were noted. There is a considerable variety in rim shapes: some are inward curving, others straight or outward curving, and others internally thickened. An unique rim **189**, and the scrap **190** with a ribbed or fluted surface, are probably Neolithic.

180 (N1) FIG. 7.1. Goblet rim. D. *c.* 8.5. Finest dark grey burnished ware; orange clay, grey-black at surface, which has fine burnish outside, like polish; inside less well burnished.
 For the carinated profile of the rim cf. Wilson 1985, 299–300, fig. 10: P34 (similar fabric) and, in a more general way, Vagnetti 1973a, 62, fig. 61: 6 (class B (grey burnished) ware at home in her earlier FN horizon at Phaistos).
181 (N2) FIG. 7.1, PLATE 28. Bowl rim, with stump of horizontal (?) handle, with scoring to key handle to vessel. D. *c.* 15. Orange clay with grey-brown burnished surface.
182 (N3) FIG. 7.1, PLATE 28. Goblet rim. D. *c.* 10. Orange clay with grey-brown burnished surface; burnishing not so

fine as on outside of **180**, and stroke marks visible.
 This may come from a goblet on a high foot like one in dark grey burnished ware from Pyrgos (Xanthoudides 1918a, 151, fig. 9; 159: 60).
183 (N4) FIG. 7.1, PLATE 28. Goblet rim. D. 11. Orange clay with fine grey-brown to black burnished surface.
 Two footed goblets of dark grey burnished ware from Pyrgos have similar rims (Xanthoudides 1918a, 157, fig. 12; 159: 89–90).
184 (N5) FIG. 7.1, PLATE 28. Goblet rim. D. *c.* 13. Very fine fabric, as **180**. Fragment **184A** (PLATE 28) may be from the same vessel.

Pedestals
Fragments of two or three pedestals evidently belong to cups or bowls of fine dark grey burnished ware. Only on **185** is the original edge preserved.

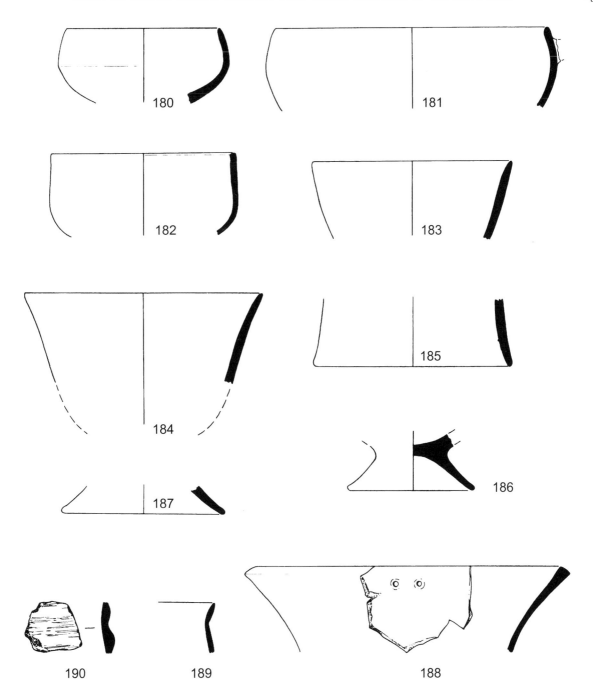

FIG. 7.1. Deposit A1 (EM IIA). Dark grey burnished ware: type 2 goblets **180–187**; bowls **188–190**. Scale 1:2.

185 (N8) FIG. 7.1. Pedestal frags. D. base 11. Very fine fabric, as **180**, but not burnished inside.

High feet
Fragments of six of these in dark grey burnished ware range in base diameter from 5 to 9.

186 (N9) FIG. 7.1. High foot. Original edge missing. D. base *c.* 7 (?). Orange-red clay with grey-brown burnished surface.

187 (N10) FIG. 7.1. Frag. of high foot. D. base 9. Description as **186**.

Miscellaneous[6]

188 (N6) FIG. 7.1, PLATE 28. Thickened bowl rim with pair of string-holes made before firing. D. *c.* 18. Very fine fabric, as **180**.

189 (N7) FIG. 7.1. Rim frag. of bowl with offset rim. D. 12. Fine grey-brown burnished surface with pin-holes showing in it. LN?

190 (N12) FIG. 7.1, PLATE 28. Scrap of bowl with offset rim; bold horizontal ribbing and fluting. Atypical fabric: coarse grey-brown clay with grit and some straw; inside grey-brown burnished; red wash outside, burnished and much worn. Neolithic, non-local.

Horizontal ribbing and fluting of this kind are very much at home on the standard, class C black or brown burnished ware of Phaistos FN. Vagnetti illustrates many examples and suggests that this form of decoration may show imitation of metalwork.[7]

Red and light brown burnished wares

Red burnished ware is less in evidence than dark grey burnished ware. The proportion is about 1:3. There are parts of a small suspension pot **195**, and about 20 other fragments of red burnished ware from a variety of goblets or bowls of different shapes and sizes. Five of these are of exceptionally fine fabric with the red surface highly burnished like some of the finest dark grey burnished ware. The fragments of this fine red burnished ware come from both open and closed shapes, all evidently of small size.

Light brown burnished ware shades into red burnished ware. Our few fragments of it include part of a lid **196** with pattern burnish.

See also pp. 256–8 below.

191 (N14a) FIG. 7.2, PLATE 23. Goblet rim with stump of open (?) spout. D. *c.* 8. Orange clay, well burnished, red inside, light orange-brown outside.

192 (N17) FIG. 7.2. Rim of small carinated goblet or bowl (from mixed [?] deposit). D. *c.* 9. Orange clay, surface much worn, but with traces of red burnished slip.

193 (N15) FIG. 7.2. Bowl rim, everted and thickened. D. *c.* 18. Orange clay, surface red shading to light brown, well burnished.

194 (N16) FIG. 7.2, PLATE 23. Bowl rim, bevelled. D. 30. Orange clay, surface light brown with superficial (scribble) burnish, stroke marks clearly visible.

195 (LA/61/P1) FIG. 7.2, PLATE 23. Body frags. of suspension pot, squat globular, with twin vertically perforated lugs. Base seems to have been sunk. Ht pres. *c.* 5. D. body *c.* 11. Soft fabric: rather sandy dark orange clay, with finely burnished red slip outside.

A small suspension pot from Pyrgos is closely comparable in shape and size and also has red burnished wash (Xanthoudides 1918*a*, 145, fig, 6; 149: 25). Another from Koumasa that seems comparable in shape and size is assigned by Xanthoudides (1924, 36, pl. 25: 4173) and Zois (1967*a*, 719) to the start of EM II. Cf. Boyd Hawes *et al.* 1908, 56, n, 2: f, fig. 37: 2, from Rock Shelter A. Lugs with double perforations appear at home in Crete by EM II, but are not attested in the Palace Well.

196 (LA/61/P12) FIG. 7.2, PLATE 23. Lid with two handles. About 1/3 pres. D. 17.5. Reddish orange clay, light brown to reddish surface, well burnished on top; pattern burnish underneath of groups of lines radiating from centre. There is an identical lid in SMK B.I.8 226. (A cover lid with a single handle in the centre of the top comes from RRS: Warren 1974, 903, pl. 672 *c*).

TYPES IN OTHER FABRICS

TYPE 2. FOOTED GOBLETS ETC. **197–203**

These occur in a variety of fabrics. Fragments of goblets of this or allied types in dark grey or red to light brown burnished ware have already been discussed. Rims **202–203** from mixed (?) deposit and another scrap, all apparently from goblets, have remains of an overall wash in red to dark purple-brown. But goblets of the standard type are most commonly of light surfaced buff ware, burnished and with decoration in red.

Of 13 rims of goblets of this buff burnished ware, eight (over 1/2) come from what may be a mixed deposit; but the other five are apparently from pure levels of A1. Goblet rims of buff burnished ware mostly seem to be *c.* 10 in diameter; but two are 11, and one like **198** is only 7. The surfaces of these rims, shades of orange or buff, are burnished with vertical strokes outside and often inside as well. The vertical stroke burnishing on the outsides of these goblets is often careful and appears decorative in intent. The rims are characteristically painted red, more often (eight examples) with a thin stripe

[6] We thank Peter Tomkins for advice on **189–190** and **341** below.

[7] Vagnetti 1973*a*, 79–80.

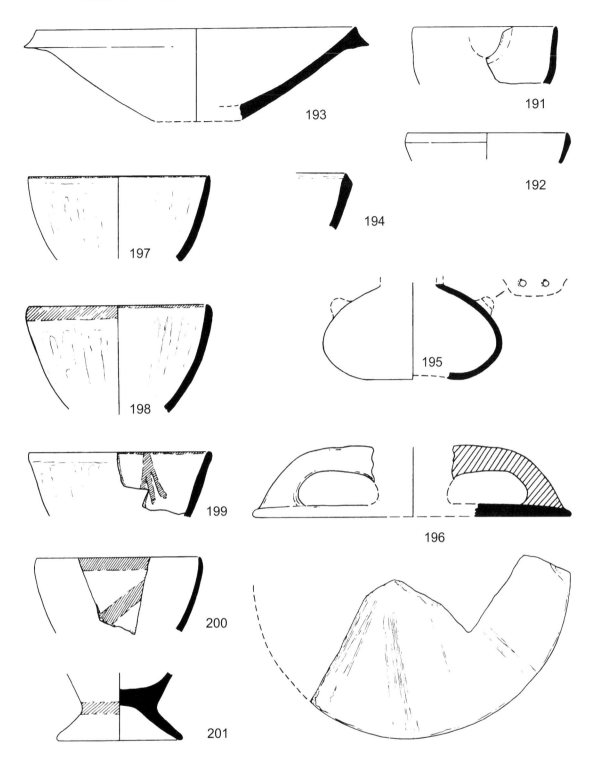

Fig. 7.2. Deposit A1 etc. (EM IIA). Red and light brown burnished wares: type 2 goblets **191–192**; bowls **193–194**; type 20 suspension pot **195**; type 21 lid **196**; other wares: type 2 goblets **197–201**. Scale 1:2.

round the outside (**197**), but sometimes (five) with a thicker band (**198**). Rim **199** has a flower-like pendant dropping from a red stripe round the top of the inside. Two other rims (e.g. **200**) have a thick red band round the top of the outside and traces of a diagonal band on the body as well.

We found only one fairly complete goblet foot **201**. This is of the high type like **186** in dark grey burnished ware. It comes from mixed (?) deposit; but a scrap of another similar foot comes from what appears to have been a pure context of A1.

197 (N19) FIG. 7.2. Rim. D. 10. Buff ware, burnished. Thin red stripe on top of rim inside and outside.
198 (N20) FIG. 7.2, PLATE 23. Rim. D. 10. Buff ware, burnished. Thin red stripe round top of rim inside, wider band round outside. From mixed (?) deposit.
199 (N18) FIG. 7.2, PLATE 23. Rim. D. 10. Buff ware, burnished. Thin red stripe round inside of rim, with triple flower-like pendant.
200 (N95) FIG. 7.2, PLATE 23. Rim. D. c. 9. Buff ware, burnished. Decoration in dark brown to black; band round outside of rim, diagonal band on body.
201 (N21) FIG. 7.2, PLATE 23. Foot. D. base c. 7. Orange clay with a buff slip. Inside of bowl of goblet orange-buff, burnished. Band of dark red-brown paint round waist outside. From mixed (?) deposit.
202–203 PLATE 24. Rims of goblets or small bowls. D. c. 11, 14. Fine orange clay with overall wash, shades of red and dark purple-brown, and superficial stroke burnish. From mixed (?) deposit.

TYPE 3. GOBLETS

Some of the rims described under type 2 may belong to goblets without a foot, but no bases of such goblets were found.

TYPE 4. SHALLOW BOWLS OR PLATES WITH RIM THICKENED INTERNALLY **204–208**

Out of 20 rims, 11 are assignable to class **a** and seven to class **b**; two are indeterminate. One or two rims of class **a** (e.g. **205–206**) have a slight groove round the outside which gives the profile of the rim the appearance of being thickened externally as well as internally. Almost all the fragments of these bowls come from mixed (?) deposit; only two rims, one of each class, are from pure levels of A1. In fabric the bowls of this type are indistinguishable from those of A2; all rims except one are of fine buff ware with decoration usually in red. The exception — from mixed (?) deposit — appears to have had a black wash. Rim **204** of class **a** from mixed (?) deposit has a pair of string-holes made before firing, like **322** (A2).

204–207 (N96–9) Rims of class **a** (FIG. 7.3; PLATE 24: **206–207**). **204**: D. 24. **205**: D. 16. **206**: D. 17. **207**: D. 18. Fine buff ware, with decoration in red: band below rim inside; diagonal bands on top of rim.
208 (N101) Rim of class **b** (FIG. 7.3). D. 24. Orange clay with surface carefully wiped inside. Broad red band covering inside and bevelled outside edge of rim.

TYPES 5 OR 6. BOWLS WITH UPRIGHT SIDES **209–211**

Four rims are assignable to these types. Three of them are from mixed (?) deposit.

209 (N102) FIG. 7.3. Orange clay, carefully wiped (not smoothed or burnished). Decoration in slightly lustrous dark brown: band outside continuing along top of rim.
 Cf. Wilson 1985, 334, 336, fig. 31: P291 (cooking pot ware).
210 (N100) FIG. 7.3. Rim with stump of horizontal handle. D. c. 20. Orange clay, well burnished inside, smoothed outside. Decoration in dark brown shading to black: band below rim inside, two stripes outside. From mixed (?) deposit.
211 (N105) FIG. 7.3. D. c. 32. Orange clay with dark brown to black wash. From mixed (?) deposit.

TYPE 8. BOWLS WITH FLARING RIM **212–214**

Two or three atypical rims are grouped here: **212** is from a very small bowl of exceptionally fine fabric, and **214** of cooking pot ware.

212 (N116) FIG. 7.3, PLATE 31. Fine buff ware; orange clay with orange-buff surface, well burnished, especially inside. Decoration in matt red-brown: neat lattice outside; band to rim inside and probably outside (worn), and blobs on rim inside. From mixed (?) deposit. Fine painted ware. Wilson and Day 1994, 34.
213 (N104) PLATE 24. Fine buff ware; orange clay with surface orange-buff surface, smoothed or burnished. Decoration in matt red: band inside and opposed diagonals on top of rim.
214 (N136) FIG. 7.3. D. c. 12. Cooking pot ware; coarse reddish clay with red wash.

TYPE 9. BOWLS WITH EVERTED RIM **215–216**

An atypical rim **215** of a shallow bowl of coarse burnished ware, and rim **216** from a steep-sided bowl, are assignable to this type.

215 (N106) FIG. 7.3, PLATE 24. Very coarse fabric with large grey grit; clay grey at core, orange towards surface, which is red to red-brown with high burnish inside, but wiped outside.
216 (N103) FIG. 7.3, PLATE 30. D. c. 35. Fine clay; buff surface with somewhat superficial stroke burnish inside and outside. Decoration in red to red-brown: bands below rim inside and outside, broad diagonal on top of rim. From mixed (?) deposit.

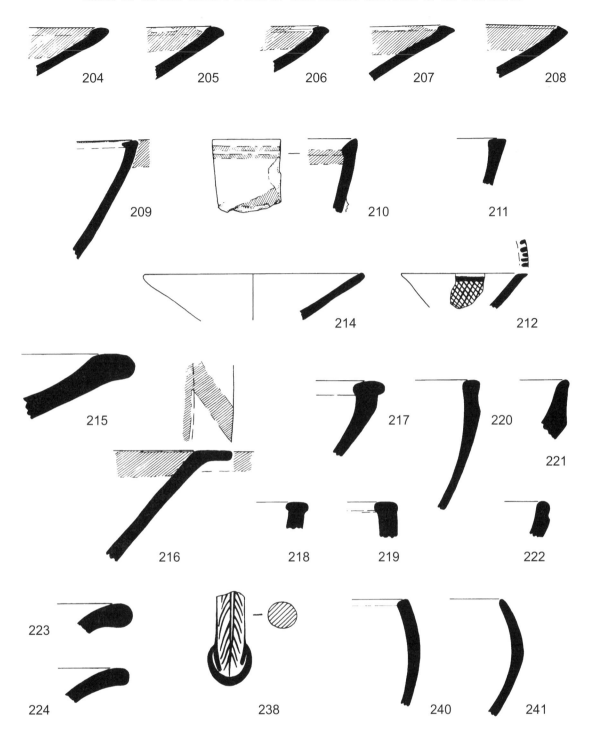

FIG. 7.3. Deposit A1 etc. (EM IIA). Type 4 shallow bowls or plates **204–208**; types 5 or 6 bowls **209–211**; type 8 bowls **212, 214**; type 9 bowls **215–216**; type 11 large bowls **217–222**; type 14 baking plates **223–224**; type15 jug **238**; type 17 large spouted bowls or jars **240–241**. Scale 1:2.

TYPE 11. LARGE BOWLS WITH CURVING, OFTEN CARINATED SIDES, AND THICKENED RIM (COOKING POT WARE) **217–222**

We found rims of six or more of these. All the bowls are evidently very large, although the diameters of the rims are not usually ascertainable. All except **218** apparently come from pure levels of A1.

217　(N143) FIG. 7.3. Reddish cooking pot ware with overall black wash; white paint on top of rim, and band of white paint round outside; red paint inside.

218　(N141) FIG. 7.3. Reddish cooking pot ware with grey-brown surface. Traces of red wash inside. From mixed (?) deposit.

219 (N142) FIG. 7.3. Grey cooking pot ware. Clay reddish at edges, with red wash.

220 (N139) FIG. 7.3, PLATE 24. D. *c.* 40 or more. Coarse reddish cooking pot ware; surface outside below carination wiped diagonally and then coated with creamy white slip inside and outside. Decoration over the slip in thin red-brown: top of rim painted solid; broad band outside rim.

Red-brown paint thinly brushed over other parts of body inside and outside.

221 (N144) FIG. 7.3. Reddish cooking pot ware, surface worn. Traces of possible red wash.

222 (N140) FIG. 7.3. Coarse gritty cooking pot ware; clay grey-brown to black.

TYPES 12 AND 13. DISHES AND PLATES (COOKING POT WARE)

One base fragment may be from a large plate or dish. Its fabric is akin to cooking pot ware: soft blackish clay, red-brown at the edges, burnished inside, rough under the base.

TYPE 14. BAKING PLATES 223–224

A few rims of cooking pot ware seem to approximate to this type, although they are not so clearly differentiated as the baking plates of succeeding levels. **223** and **224** are from mixed (?) deposit, but two scraps of rim like **223** come from pure levels of A1.

223 (N147) FIG. 7.3, PLATE 30. Gritty red cooking pot ware; outside below rim very rough.

224 (N148) FIG. 7.3, PLATE 30. Fabric and finish as **223**.

TYPE 15. JUGS WITH CUTAWAY SPOUT 225–239

There are a good many fragments of jugs, presumably of this type, mostly in fine buff ware with decoration in dark-on-light: orange or pale orange clay, with an orange or buff or whitish surface, or with a slight greenish tinge, tending to be well burnished outside. Some fragments, however, come from jugs with a dark wash, once with traces of decoration in white. All the fragments below are of fine orange clay unless otherwise stated. **225–238** are illustrated on PLATE 25, and **239** on PLATE 24.

225 Neck and rim. Buff slip of greenish tinge; decoration in dark red-brown to black, worn. From mixed (?) deposit.

226 (N111). Like **225**. From mixed (?) deposit.

227 (N112) Neck and rim. Outside orange-buff, well burnished. Decoration in red to red-brown.

Cf. Wilson 1985, 320–2, fig. 21, pl. 35: P179–181, P191. This simple scheme of striped decoration for jug necks continues the tradition already established in EM I.

228 (N113) Side of rim near spout. Outside buff, well burnished. Decoration in red.

Large solid spots like this are already attested as a motif of decoration on jugs in EM I. One example comes from the Palace Well: **81** (PLATE 9).

EM IIA examples include: WCH: Wilson 1985, 323–4, fig. 22: P218 (flanking a handle of a jug and on the spout); also 330, pl. 40: P244 (shoulder frag. with vertical row of spots); Koumasa (on necks of jugs assigned to EM IIA): Zois 1967*a*, pls. 15–17: 4109, 4113–14; Phaistos (in sounding below pavement of West Court): Levi 1958*a*, 180, fig. 361 top centre; Ayia Kyriaki: Blackman and Branigan 1982, 33, fig. 12: 141–4; Fournou Korifi I and II (on handles): Warren 1972*a*, 158, fig. 42: P49, and 134, 185, fig. 69, pl. 52A: P443; also 134, pl. 53B: P461.

229 Body frag. Outside orange-buff. Decoration in matt red-brown. From mixed (?) deposit.

230 Body frag. Outside orange-buff, well burnished. Decoration in red to dark red-brown.

231 Neck frag. Buff slip outside with slight greenish tinge. Decoration in dark red-brown.

232 Body frag. Outside orange, smoothed. Decoration in red-brown.

233 (N125) FIG. 9.1, PLATE 51. Triangular frag. used as rubber. Outside orange-buff, burnished. Decoration in black. See further pp. 227–8.

234 Shoulder (?) frag. Greenish slip outside. Decorated with chevrons in dark red-brown to black.

235 (N110) Body frag. with handle. Outside orange-buff, well burnished. Decoration in red to red-brown: groups of vertical lines; vertical line below handle and ring round base of handle; bar(s) or stripe on handle. From mixed (?) deposit.

The scheme of decoration seems to correspond to the Myrtos style fans of Fournou Korifi and elsewhere: Warren 1972*a*, 104, pl. 34 B: P47, 133–134; 185, fig. 69: P443–444 ('Myrtos ware'); cf. Cadogan 2010, 43 and n. 28.

236 Body frag. Outside orange-buff. Decoration in red to red-brown. From mixed (?) deposit.

237 (N115) Body frag. Outside orange-buff, burnished. Decoration in dark red-brown.

238 (N119) FIG. 7.3. Handle. Rather coarse orange clay with buff surface. Decoration in red.

Elaborately decorated jug handles from the WCH: Wilson 1985, 322, pl. 36: P196–199 (dark-on-light) and 314–17, fig. 18: P149 (light-on-dark).

239 (N114) PLATE 24. Shoulder frag. Reddish clay, well fired; dark red-brown wash outside, very well smoothed or burnished. Decorated with horizontal bands in creamy white.

TYPE 16. SMALL SPOUTED BOWL-JAR?

See **212** above.

TYPE 17. LARGE SPOUTED BOWLS OR JARS WITH SIDE-HANDLES **240–241**

Two or three rims may belong to jars of this type or of type 18.

240 (N145) FIG. 7.3, PLATE 24. Coarse orange clay like cooking pot ware; brown surface with possible traces of red wash; outside wiped below rim area.

241 (N146) FIG. 7.3, PLATE 24. Reddish cooking pot ware; inside dusky, outside orange perhaps due to a wash. Outside of rim has bold horizontal scraping.

TYPE 19. COLLAR-NECKED JAR **242**

One rim of this type was found.

242 (N127) FIG. 7.4. Gritty reddish orange clay with thick buff slip outside. Decoration in red to light brown: bands inside and outside rim, and round base of neck. From mixed (?) deposit.

A jar neck from the WCH (Wilson 1985, 330, 332, fig. 29: P254) has a comparable profile but is narrower.

TYPE 20. SUSPENSION POTS ETC. **243–245**

The squat gobular suspension pot of red burnished ware with twin perforated lugs **195** has already been discussed (p. 134). Two other rims evidently come from suspension pots or small jars of similar shape: **243** is of light grey ware.

243 (N14) FIG. 7.4, PLATE 28. D. *c.* 11. Light grey ware: very fine clay, well burnished outside. Wilson and Day 1994, 12.

244 (N107) FIG. 7.4. Rim with slight ledge inside, to hold lid (?). D. *c.* 8. Orange clay with dark red-brown band on outside of neck, which has the stump of a lug or vertical handle.

One other rim from a jar of uncertain shape has an internal ledge for a lid.

245 (N108) FIG. 7.4. D. 24. Orange clay with decoration in dark red-brown: top of rim painted solid, band below rim outside. From mixed (?) deposit.

TYPE 21. FLAT LID WITH HANDLES

196, the only example of this type, has been discussed above (p. 134).

TYPE 22. COVER LID **246**

There is one possible fragment from the projecting edge of a lid of this type.

246 (N133) D. *c.* 15. Gritty brown clay, with black upper surface, well burnished.

TYPE 23. TRIPOD COOKING POTS **247–249**

The only tripod foot in cooking pot ware **247** (N149) (PLATE 24) is of round section and comes from mixed (?) deposit; but rims **248–249** from deep bowls in cooking pot ware may also belong to tripod vessels.

248 (N137) FIG. 7.4. D. 20. Coarse cooking pot ware. Gritty grey clay, reddish at edges; red wash to shades of dark brown; outside wiped.

249 (N366) FIG. 7.4, PLATE 24. D. 28. Fine cooking pot ware. Gritty reddish clay, fired an even colour throughout; dark brown wash outside.

TYPE 26. THERIOMORPHIC VESSEL **250**

250 (N132) PLATE 26. Horn of animal-shaped vessel (?). Fine orange clay, grey at core; orange-buff smoothed surface. Tip of horn painted in dark brown.

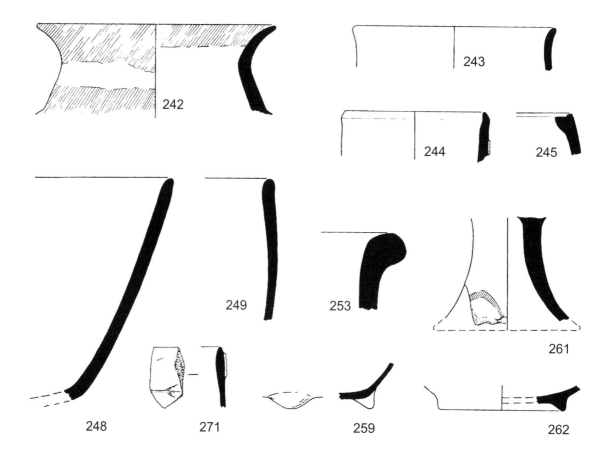

FIG. 7.4. Deposit A1 etc. (EM IIA). Type 19 collar-necked jar **242**; type 20 suspension pots **243–244**, and **245**; type 23 tripod cooking pots (?) **248–249**; type 27 pithos **253**; bases **259**, **261–262**; incised decoration **271**. Scale 1:2.

TYPE 27. PITHOI **251–253**

Some four or five fragments of pithoi with trickle ornament were found in pure levels of A1. **251** has a false or vestigial vertical handle.

251 (N118) PLATE 23. Frag. with false or vestigial vertical handle, like **904** (B1). Very thick walled (Th. 2.8). Coarse orange clay with large grit and straw showing in surface; orange slip. Decoration in thick red: trickle outside, inside splashed, apparently in deliberate fashion (continuing a tradition noted on pithoi and large jars from the Palace Well).

252 (N117) PLATE 23. Frag. Coarse orange clay with grit and straw showing in surface; dusky white slip; trickle in black.

253 (N109) FIG. 7.4. Rim of large jar or pithos. D. *c.* 26. Coarse orange clay with paler surface. From mixed (?) deposit.

SPOUTS **254**

The sole spout **254** (N126) is of the open trough type with a wash, red inside and shades of brown outside. Rim **191** evidently belongs to a goblet with a small trough spout.

HANDLES **255–256**

These are round or thick oval in section. Most are from jugs decorated in dark-on-light, or from cooking pot ware vessels, like **255** (PLATE 24) which is round in section, of fine cooking pot ware with a red to red-brown wash. The base of an apparently vertical handle **256** (N130) from an open vessel (not a jug) is perforated with a string-hole; the surface has a burnished wash in shades of dark and reddish brown outside, and red inside.

CARINATIONS

These are much in evidence on bowls of cooking pot ware of type 11.

BASES **257–263**

These are normally flat. But one or two bases appear to have been deliberately sunk, e.g. **195**. Three fragments of bases with pellet feet come from pure levels of A1. It is curious that only one other base of this type was noted in the later EM II levels, from A2. These feet all seem to belong to small closed vessels, which may have been jugs, and are of fine buff ware, with the outside surface smoothed or burnished, e.g. **259**. Fragments of two or three pedestal bases of dark grey burnished ware were found (see pp. 132–3). Pedestal **261** has decoration in red paint, reminiscent of Phaistos FN, but there is a sound parallel from the WCH. Ring base **262**, evidently from a bowl, is of the type found in Vasiliki ware, and may be an import.

257 PLATE 23. Base of small bowl. Fine orange clay with light brown wash, well burnished inside and outside.

258 (N135) PLATE 26. Small flat base of closed vessel. Fine orange clay, orange-buff outside, smoothed. Decoration in dark brown to black: bottom of base painted solid with vertical bands rising from it.

259 (N123) FIG. 7.4, PLATE 26; **260**. Frags. of bases with pellet feet, probably from jugs. Fine orange clay, orange-buff outside, smoothed or burnished; decoration in red and red-brown.

261 (N124) FIG. 7.4, PLATE 26. Pedestal base frag. Fine grey clay, orange towards outside, which is orange-buff, with fine vertical stroke burnishing: like EM I pedestal bases. Traces of decoration in thick red applied after burnishing: loops rising from edge of pedestal.

Part of a closely similar pedestal base comes from the WCH (Wilson 1985, 309, 311, fig. 16: P116). A more complete example, of the same fabric and with the same type of decoration, is in the SMK (B.II 405).[8] If both the fabric and thick red decoration of **261** are reminiscent of the fine, class C burnished ware with encrusted decoration in red ochre of FN at Phaistos, the surface colour of the Phaistos FN painted ware is usually dark.

262 (N11) FIG. 7.4. Ring base, evidently of bowl. D c. 7. Hard, well fired grey clay; apparently with slip, black to red-brown under base, which is burnished; inside of vessel black, with very high burnish like polish.

263 PLATE 24. Frag., apparently underside of a base, perhaps of flat dish or plate of types 12 or 13. Cooking pot ware: red-brown clay, with apparent a red wash; bold straw impressions showing in surface.

DECORATION

Paint **264–267**

Dark-on-light, in red or red-brown, or black

This is the most common type of decoration, which appears in its most elaborate form on jugs of type 15 (see p. 138). The motifs are linear: lines, or thicker stripes and bands, horizontal, vertical and diagonal, predominate. On deep bowls and jars interlacing diagonal lines seem characteristic, and are reminiscent of the string nets from which they are no doubt derived. Lattice, which may also be ultimately derived from string-work, is found not only on jugs of type 15, but in a very neat form on the rim of miniature bowl **212**.

Triangles or other areas of lattice flanked by thick bands as seen on jug fragment **237** occur on a few jugs from the WCH.[9] Areas of lattice outlined by thick bands in this way also appear on various types assignable to EM II in southern Crete.[10]

Small loops hang from the rims of goblets, and larger ones rise from the bottom edge of pedestal base **261** described above. A solid spot adorns jug neck **228**.

Vessels of cooking pot ware with a white or buff slip may have decoration in red paint (e.g. **265**). One bowl base from mixed (?) deposit has a simple red cross on the underneath. Pithoi have trickle ornament.

264 PLATE 30. Two frags. of deep bowl. Fine orange clay with buff surface, stroke burnished inside and outside; outside decorated with interlacing diagonals in red-brown.

265 PLATE 24. Fine cooking pot ware. Reddish clay, grey at core. Thick buff slip outside, with decoration of a broad vertical band in thin red-brown.

266 PLATE 25. Underneath of bowl base with parallel lines which may be part of elaborate cross. Buff surface, burnished inside and outside; decoration in red-brown. From mixed (?) deposit.

Light-on-dark

This occurs in creamy white paint, but is rare. For the jug shoulder **239** with a dark burnished surface and bands in white, see p. 138. The decoration on bowl fragment **267** is more elaborate.

[8] In the Cyclades vessels of various types are found with pedestals in EC II, which overlaps with EM II (cf. Wilson 2007, 70, 77); and some EC II high feet have decoration comparable with that on **261** (e.g. Zervos 1957, figs. 229, 240). Cf. a high foot or low pedestal from Arapi in Thessaly assigned to the Arapi (Dimini 2) phase of LN (Hauptmann and Milojčić 1969, pl. 13: 6).

[9] Wilson 1985, 326–8, figs. 24–6: P221–222.

[10] E.g. Blackman and Branigan 1982, 33, fig. 12: 146–9, 151.

White decoration is also attested in the WCH,[11] and the EM I, early levels of Lebena T. II.[12]

267 (N128) PLATE 24. Bowl frags. Pale orange clay, with dark brown to black slightly lustrous wash. Decorated outside with chevrons in white. From mixed (?) deposit.

Pattern burnish **268**

True pattern burnish as found in the Palace Well is virtually absent, apart from the lid of light brown burnished ware **196**. It is notably absent from the vases of grey burnished ware, which in shape and fabric continue the EM I tradition. An isolated scrap of light greyish brown ware **268** (N 13) from mixed (?) deposit, with rough horizontal stroke burnishing like pattern burnish, may be an EM I stray. The vertical stroke burnishing on goblets of fine buff ware of type 2 was perhaps decorative in intent, but is not strictly pattern burnish.

Incision **269–271**

Incised decoration is rare.

269–270 (N121–2). Fragments of coarse gritty cooking pot type ware; orange surface, smoothed. Decorated with finely incised parallel lines.
271 (N120) FIG. 7.4, PLATE 24. Thickened rim of goblet (?) with stump of open spout or handle. Overall red-brown to dark purple-brown wash. Incised arrow-like, or simple branch, sign made before wash applied. From mixed (?) deposit.
 Cf. Warren 1972*b*, 394, fig. 4, for an elaborate branch in dark-on-light on a fine bowl from the lower EM IIA occupation level in RRS.

Scoring **272**

Vessels in cooking pot ware, notably bowls and jars of types 11 and 18, often have their surfaces boldly scored (or wiped), continuing the practice of EM I and earlier — see pp. 28–30.

272 PLATE 24. Jar frags. Thin walled. Fine red cooking pot ware; outside neatly scored.

IMPORTS **273–275**

Four scraps of Vasiliki ware (e.g. PLATE 26: **273–274**) may be from imports from eastern Crete, and see above for light grey ware and **212** for fine painted ware. A scrap of coarse ware **275** (N134) is reminiscent of East Aegean fabrics of Troy I or earlier: it is of soft fabric with abundant straw, with grey clay grey at the core, orange at the surface, and traces of a red wash outside, much worn.

DEPOSIT A2: FLOOR VI

EARLY MINOAN IIB[13]

Levels LA106, LA108, LA105B. Amount: about 2 tables.

This deposit represents the pottery found above the floor of the EM II house and the contemporary ground level outside it. Accordingly, a good many complete vessels come from this horizon, together with large fragments of others. The presence of these might suggest a destruction level, as may apply also for the presumed floor(s) in Area B that produced the whole pottery that Evans found in 1908 (see chapter 10).

Strays which appear to be intrusive, either fallen from the sides of the trench during excavation or subsequently working their way into the baskets of pottery before it was studied, include two scraps of LM I plain conical cups, one thin strap handle and another bit of a MM II cup of fine black washed ware, and the flaring rim of a wheelmade bowl of soft sandy pale orange clay, its wheel marks clearly visible, of MM IB–II: **276** (N58).

[11] Wilson 1985, 295–7, fig. 8: P4 (dark grey burnished ware); 312, 317 (red and black washed and red burnished wares).
[12] Alexiou and Warren 2004, 123: ware 4 (EM I red burnished, including white painted).
[13] See n. 3 above.

FABRIC

The smaller vessels are still predominantly of fine buff ware, with burnished or well smoothed surfaces; but several now have a wash (dark washed ware) and decoration in thick creamy white paint. Even the fine ware vessels are apt to be irregular in their manufacture. Some fragments of dark grey burnished ware were found, but they are all scraps and may be earlier strays, and not contemporary with the deposit, as would apply also to a scrap of light grey ware. Even if some or all of this dark grey burnished ware is contemporary, it is certainly much less in evidence than in A1. On the other hand some fragments of fine red burnished ware appear to be contemporary with the rest of the deposit. Red burnished ware may have been the fabric selected for making small jars or suspension pots. Vasiliki ware is a good deal in evidence.

Vessels of dark grey and red burnished wares, and of Vasiliki ware, are considered separately from the rest, since many of the types or characteristics of vessel in these wares appear to be special to them.

Dark grey burnished ware **277–279**
We have 10 to 12 scraps of this fabric: some or all may be strays from A1 levels. Most belong to goblets or bowls, including a fragment from the top of a pedestal of EM I type; two scraps are from the edges of small pedestals or goblet bases like **187** (A1); there are also two or three rims as **277** (N84) (FIG. 7.5), a scrap of an internally thickened bowl rim as type 4 class **a**, and another more steep-sided **278** (N25) (FIG. 7.5; D. *c.* 20).[14] A short everted bowl rim **279** (N85) (FIG. 7.5) has a wart-like projection. There is a scrap of a round section handle.

Red burnished ware **280–281**
There are some 10 fragments of this, of fine orange clay with a red to light brown surface with a very high burnish (outside only in the case of closed vessels). One scrap comes from a bowl; the rest are from closed vessels — most if not all perhaps suspension pots, including rim **280** (N66) (FIG. 7.5) (D. *c.* 8), a fragment of a carination (D *c.* 15), and a small rounded base **281** (N64) differentiated by a carination like many EM I bases but only *c.* 4 in diameter.

(Number **282** was not used.)

Light brown burnished ware
Bowl rim **287** has a light brown burnished surface but may be a variety of Vasiliki ware and is included below.

Vasiliki ware **283–290**
About a dozen fragments come from at least six vessels, of typical Vasiliki ware with the washed surface orange-red mottling to shades of dark brown and black, smoothed but not obviously burnished; at least no stroke marks are visible. Goblet **283** looks like Vasiliki ware, but may be of Knossian manufacture. On the other hand it has no trace of decoration in white, which usually appears on the dark washed goblets of local make. Two beaded jar rims are suggestive of metal prototypes. Beaded rims like these are characteristic in Vasiliki ware and allied fabrics, but do not seem to occur on jars of local Knossian fine buff or dark washed ware.

283 (LA/61/P8) FIG. 7.5. Goblet. Base and fragment of rim, apparently from same vessel, with three other frags. that may belong. D. 7.6. D. base 5.2. Fabric akin to Vasiliki ware; the clay orange with a light brown mottling to black wash, well smoothed. Betancourt 1979, 43: VII.A.2 Knossos 2.

This is a standard shape in Vasiliki ware. Many of the numerous examples from all parts of Crete listed by Betancourt (1979, 42–4) under shape VII. A. 2 correspond to it: e.g. Malia: Chapouthier and Charbonneaux 1928, 49, pl. 25.4 left; Platyvola: Tzedakis 1967, 505, pl. 378δ. Several from Vasiliki itself are illustrated by Betancourt (1983, fig. 16, pl. 15).

284 (N 75) FIG. 7.5. Goblet rim. D. 8. Vasiliki ware.
285 (N60) FIG. 7.5. Rim of goblet or small bowl. D. 11. Vasiliki ware.
286 (N59) FIG. 7.5, PLATE 26: outside. Everted bowl rim. D. 16. Vasiliki ware.
287 (N63) FIG. 7.5, PLATE 26. Everted bowl rim with projecting lug and perforation made before firing. Pale orange clay, dusky at core; light brown slip, well burnished inside and outside. In shape this is reminiscent of bowls of Vasiliki ware such as **286** and **288**; but the surface is burnished and unmottled. Cf. WCH: Wilson 1985, 297–8, fig. 9: P9, in dark grey burnished ware; and **1239** below.

[14] Like Blackman and Branigan 1973, 201, pl. 4: 6.

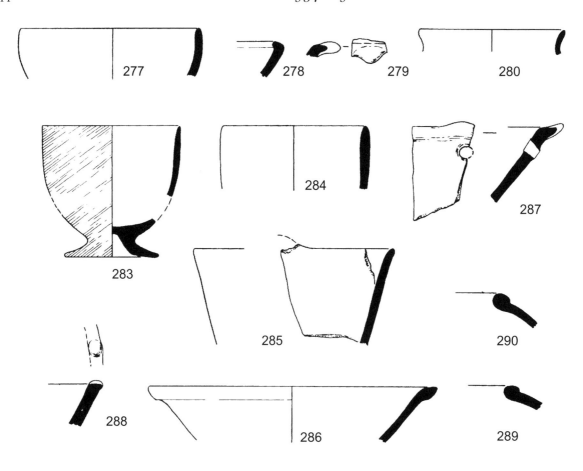

FIG. 7.5. Deposit A2 (EM IIB). Dark grey burnished ware **277–279**; red burnished ware **280**; Vasiliki ware etc. **283–290**.
Scale 1:2.

288 (N61) FIG. 7.5. Flat-topped bowl rim with neat rivet-like wart. Vasiliki ware (?).

It is uncertain whether this is really Vasiliki ware from eastern Crete: Betancourt (1979, 27) regards the appearance of small rivet-like pellets of this kind on or near rims as characteristic of Vasiliki ware found at Knossos and suggestive of a local centre of manufacture. For similar warts or pellets cf. **279**, **285**, **287**.

289 (N62) FIG. 7.5, PLATE 26. Beaded jar rim. D. 14. Vasiliki ware; mottled slip outside.

290 (N82) FIG. 7.5. Beaded jar rim. D. 15. Not typical Vasiliki ware, although perhaps imported from eastern Crete. Fine orange clay with wash outside and inside the rim, light brown to reddish in colour, and well smoothed or burnished.

Cf. **822** (B1). Beaded rims like these and **289** occur on jars of Vasiliki ware in eastern Crete in EM IIB (e.g. Warren 1972*a*, 151, 202, fig. 86, pl. 64B: P667; Betancourt 1979, 51: X.D Myrtos 1), but are already found there in other fabrics in EM IIA (e.g. Warren 1972*a*, 101, 156, fig. 40, pl. 33A: P32).

TYPES

TYPES 2 AND 3. FOOTED GOBLETS AND GOBLETS **291–311**

Just one base of a simple goblet of type 3 comes from A2. It is *c.* 3.5 in diameter, with traces of dark wash outside. On the other hand there are over a dozen feet of goblets of type 2 with diameters between 4 and 5.2. These (FIG. 7.6) range from high examples like **291** (N71), through medium high like **292** (N72), to low like **293** (N70) (PLATE 23). One low foot **294** (N69) is reminiscent of the low feet with upturned rims that are characteristic of MM IA. The solid high foot **295** (N68) is of exceptional fabric, with rather gritty buff clay, plain (without decoration) outside but well burnished inside. Of the other feet of goblets of type 2, about 2/3 are of fine buff ware with decoration in red: these are either painted solid red, or have a red band round the waist, or a band round the waist and a stripe round the lower edge (FIG. 5.4). Of the remaining four goblet feet, which have an overall dark wash, **310** has a white band round the waist, and **293** a band round the waist and four broad stripes rising vertically from it.

Several feet have marks on the underneath. Thus **310** shows a stroke in white on a dark wash. Two other feet with a dark wash outside have the underneath of the foot plain except for a band round the

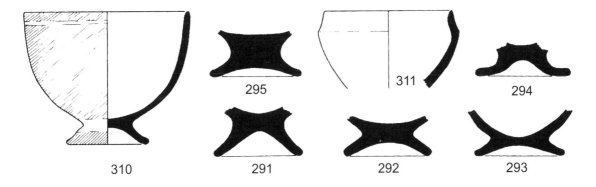

FIG. 7.6. Deposit A2 (EM IIB). Type 2 footed goblets **291–295**, **310** and **311** (?). Scale 1:2.

edge as **293**. **292** with a red wash outside has two strokes in dark-on-light meeting at an angle on the underneath; **296** (N206)[15] of buff ware has a single such stroke across one edge.

Rims of types 2 or 3
There are about 37 rims assignable to these types with diameters between 7 and 13, but mostly it would seem between *c.* 9 and 10. Most of these rims are more or less pointed or rounded; but one is flat-topped. About 2/3 of them (25) are of light surfaced buff ware. They have simple decoration (FIG. 5.2) of horizontal stripes or bands in red or shades of brown to black (PLATE 23: **297–301**, where **297** has decoration in black). One exception, however, is plain buff outside, with a solid red wash inside. The outsides of the remaining 1/3 of the rims (about 12) have a red or black wash, shading to purple-brown and dark and light brown. Decoration in the characteristic thick creamy white paint includes a variety of motifs (PLATE 26: **302–308**): single, double or multiple stripes or wider bands on or below the rim; small loops hanging from the rim, and chevrons (**308**); once a diagonal band on the body below the rim (**305**).[16] An atypical rim **311** in this dark washed ware has a carination. Fragment **309** (N73) from a vessel with a black lustrous wash has a similar carination.

310 (LA/61/P9) FIG. 7.6. Goblet. Foot and part of rim pres. Ht *c.* 7.1. D. *c.* 9. Orange clay with dark wash, red shading to dark brown outside, purple-brown inside, light brown under foot. Decorated in thick creamy white: thin stripe below rim, band round waist of foot, stripe round its edge and a short single stroke underneath.
311 (N67) FIG. 7.6. Carinated rim, apparently from small goblet. D. 7. Black wash.

TYPE 4. SHALLOW BOWLS OR PLATES WITH RIM THICKENED INTERNALLY **312–329**

These are very common. The shape could be restored for **322–323** and **329**; and many rims were found. Bowls of this type seem rather irregularly made, of fine buff ware with orange or buff clay and usually a paler surface. The insides are smoothed or, more often, burnished, sometimes quite well but on other occasions in a very superficial manner (scribble burnish). The outsides are in general less carefully treated than the insides, with scribble burnish, or wiped or pared, e.g. **323**. Rims of the rounded class **a** outnumber those of the bevelled class **b** by about 3:1.

(a) Rounded rims like **312–324**, **312A** (N22–34) (FIG. 7.7: **312**, D. 26; **313**, D. 13; **314**, D. 11; **315**, D. 22; **316**, D. 18; **317–320**, D. 17; **322–323**; PLATES 24: **313**, **316**, **318**, **321**, 27: **312A**). About 44 examples. Diameters range from *c.* 11 to 25, with most between 15 and 25 and a large number between 16 and 18. Rim **317** is markedly everted on the outside like **205–206** (A1). Flaring rim **319** may come from a bowl more akin to type 8B than to type 4. A pair of string-holes was made before

[15] Also marked in pencil 'N106'.
[16] Another goblet rim from Knossos with comparable chevrons in light-on-dark in this position is Zois 1967*b*, 152 and n. 2, pl. 30: 3. Cf. a rim from Tylissos (Hazzidakis 1934, pl. 17.1b, of the First Period, which included EM II as well as EM III and later material: Andreou 1978, 173, n. 1; 177, n. 9). Chevrons are also found on EM III goblet rims. Andreou notes a goblet assigned to EM III from the Premier Charnier at Malia with a row of chevrons flanked by pairs of bands (Demargne 1945, 6–7, pls. 8, 29: 8529; Andreou 1978, 123). Zois (1969, 45–6) sets it in his transitional EM III–MM IA phase of Vasiliki House B.

firing just below the top of the rim in three cases: e.g. **322**; cf. **204** (A1). All rims of this class are from light surfaced bowls of buff ware, except **324**, which appears to belong to a bowl of type 4 but has a dark wash. Decoration is normally in red paint, and the motifs are standardised: a broad band just below the inside of the rim, or on top of the rim confronting diagonal stripes or bands, usually broad and more or less closely spaced to form a chevron; but on **323** the diagonals are spaced at opposite sides of the bowl rim. These diagonals may ultimately derive from string lashed round the rims of bowls of some other material.

322 (LA/61/P2) FIG. 7.7, PLATE 27. About 1/2 pres. Pair of string-holes made below rim before firing. Ht 18.4. D. 4. Orange clay, with orange-buff surface, stroke burnished inside and outside. Decoration in thick red slightly lustrous paint, applied after burnishing: broad band below rim inside; diagonals forming chevrons on top of rim.

323 (LA/61/P3) FIG. 7.7, PLATE 27. About 1/2 pres. Ht *c.* 3. D. *c.* 16. Orange clay, with buff surface, smoothed but not burnished inside, roughly pared all over outside. Decoration in dark brown to black, much worn: broad band below rim inside; opposed diagonals widely separated on top of rim.

324 (N34). Scrap of rim of class **a**. Orange clay, greyish at core, with lustrous black wash.

(b) Bevelled rims like **325–328** (N23, N36–8) (FIG. 7.7: **325–326**, D. 30; **327**, D. 22; **328**, D. 18). About 14 examples of rims of this class range in diameter from *c.* 18 to 30. The bowls from which these come seem in general to be somewhat larger than the bowls with rims of class **a**. All the rims of class **b** are from bowls of fine buff ware with decoration in dark-on-light, normally in red, consisting of a broad band round the inside of the rim which continues on its bevelled outer edge. In one or two cases the paint has spread over the bevelled edge of the rim to form a narrow stripe on the outside of the bowl below it. **325** has a broad band round the outside as well as round the inside of the rim.

329 (LA/61/P4) FIG. 7.7. *C.* 1/3 of rim and parts of side and base pres. Ht *c.* 4. D. *c.* 16.5. Rather soft fabric: orange clay, well smoothed inside, wiped outside. Traces of decoration in red: broad bands inside rim and on its bevelled edge.

TYPES 5 AND 6. BOWLS WITH UPRIGHT SIDES AND RIM THICKENED INTERNALLY **330–340**

There is one profile **330** of a small bowl of type 5, together with over 16 rims of bowls of this type or of type 6, ranging in diameter from *c.* 14 to 25. Most of these rims are flat-topped, but some rounded.

330 (LA/61/P6) FIG. 7.7, PLATE 25. Profile. Ht *c.* 3.6. D. 15. Orange-buff clay with buff surface; fine stroke burnish inside and outside. Decoration in matt dark brown: bands below rim and round bottom of base inside and outside. Rim evidently had groups of thin diagonal stripes on it. Base appears to have had cross painted underneath.

331 (N39) FIG. 7.7, PLATE 27. D. 16. Rim with horizontal side-handle, probably from bowl of type 6. Orange clay with orange-buff surface, smoothed rather than burnished. Decoration in red: bands round rim, diagonal stripes outside, solid circles round bases of handle; group of diagonal stripes on top of rim: cf. **330**.

332 (N41) FIG. 7.7. D. 20. Orange clay with buff surface, burnished inside and outside. Broad bands, red inside rim, red-brown outside; traces of diagonal (?) hatching on top of rim.

333 (N42) FIG. 7.7. D. 25. Dusky orange clay, surface smoothed. Decoration in dark brown: broad bands round inside of and on top of rim.

334 (N45) PLATE 24. Rim as **333**, but with round section handle rising above it. Orange-buff clay, with decoration in red: bands inside and outside rim; stripe along handle.

335 (N43) FIG. 7.7. D. 15. Orange clay with buff surface, smoothed. Top of rim painted solid in dark brown, worn.

336 (N129) FIG. 7.7, PLATE 24. D. 30. Large rim with stump of horizontal side-handle (?). Orange clay, grey at core. Outside has thin dark brown to black wash; inside splashed with thick red paint like some large bowls from the Palace Well. Possibly EM I stray.

One exceptional rim from a deep bowl or open jar is almost straight.

337 (N78) FIG. 7.7, PLATE 27. Orange clay, wiped inside; outside has fine vertical stroke burnish. Decoration in matt dark red: wide band round outside of rim.

One or two rims are slightly splayed and may have belonged to bowls in shape more like type 8B.

338 (N40) FIG. 7.7. D. 20. Orange clay with buff surface, burnished. Decoration in dark brown to black, worn: bands on outside of rim and below it inside; group of lines on top of rim.

339 (N44) FIG. 7.7, PLATE 27. D. 25. Orange clay with smoothed orange-buff surface. Decoration in dark brown with reddish tinge: rim solid inside and outside; band outside below rim.

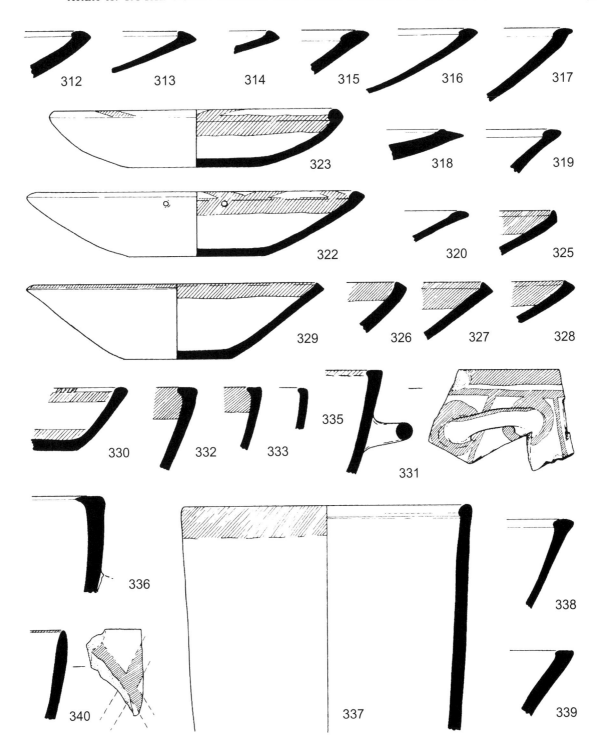

FIG. 7.7. Deposit A2 (EM IIB). Type 4 shallow bowls or plates: (**a**) rounded rims **312–320, 322–323**; (**b**) bevelled rims **325–329**; types 5 or 6 bowls **330–333, 335–340**. Scale 1:2.

One unthickened upright rim may belong to a deep spouted bowl of type 6.

340 (N57) FIG. 7.7. D. 14. Fine buff ware; orange clay with buff surface, smoothed. Decoration in dark brown: top of rim painted solid; broad intersecting diagonals outside.

TYPE 7. SHALLOW BOWLS WITH STRAIGHT OR INWARD CURVING SIDES 341–343

Bowl rim **342** of cooking pot ware is assignable to this type. The large rim **343** with a bold rib round the outside is reminiscent of some bowl rims from the Palace Well.

341 (N56) FIG. 7.8. D. 22. Fine orange clay; surface has very high burnish like polish: light red-brown inside, shades of darker brown outside.
342 (N153) FIG. 7.8. D. 15. Cooking pot ware: gritty red-brown clay with possible traces of red-brown wash.

343 (N152) FIG. 7.8. Cooking pot type ware: clay grey at core, red-brown at edges. Inside once smoothed or burnished, but now much worn. For the shape cf. type 11 from the Palace Well.

TYPE 8. BOWLS WITH FLARING RIM 344–350

One large complete bowl **344** of the deep variety B of this type was found. It has a cross in red under the base.

344 (LA/61/P5) FIG. 7.8, PLATE 27. C. 1/3 missing. Ht c. 10. D. 26.7. Rather soft fabric: orange clay, well smoothed inside, less well outside and with signs of paring.

Decoration in thick red: rim solid, with bands inside and outside; band round outside of base; cross under base: cf. **853** (B1) (p. 196).

Two large rims may come from similar bowls, unless they belong to wide shallow dishes akin to type 12.

345 (N46) FIG. 7.8. D. 40. Flaring rim, thickened internally. Fine orange clay with buff surface, very well burnished all over. No decoration.
 Cf. Warren 1972a, 121, 174, fig. 58, pl. 43F: P291 for a

complete Period II spouted bowl with rim like this.
346 (N47) FIG. 7.8. D. 40. Flaring rim with bevelled edge. Fabric as **345**.

A few rims evidently belong to shallow bowls of type 8A. Some of these are thickened: e.g. **347–348**.

347 (LA/61/P13) FIG. 7.8, PLATE 25. D. 27. Non-joining frags.: about 1/2 of flaring bowl rim thickened to a bead D. c. 26. Cooking pot ware: gritty red-brown clay, wiped and with red wash, which ranges from red to dark brown and black (apparently from fire).
348 (N48) FIG. 7.8. D. 40. Flaring and thickened rim.

Fabric as **345–346**. Orange clay with orange-buff surface, very well burnished. No decoration.
349 (N176) FIG. 7.8. D. 32. Reddish orange clay with purple-brown wash; even surface, neither smoothed nor burnished. Other fragments of this rim or one like it.

Miniature bowls set on bowl rims are discussed here. **350** is a complete example from A2 and there is a fragment of another: it is uncertain from what type of bowl these come. A fine example **1347A** in the SMK appears to be from a bowl of type 8 or 9 (see p. 276): it has a dark wash, and may date to EM IIB or EM III.

350 (LA/61/P7) FIG. 7.8, PLATES 24, 27. D. of miniature bowl c. 3.3. Orange clay with orange-buff surface, smoothed. Decoration in red inside and outside rim.

TYPE 9. BOWLS WITH EVERTED RIM 351–354

Of 12 rims, about seven belong to shallow bowls of type 9A (e.g. **351**) and five to bowls of the deep type 9B, e.g. **353**. They range in diameter from c. 22 to over 40; several appear to come from bowls c. 30 across. Those with a dark (red or black) wash and decoration in white outnumber those of buff ware with decoration in dark-on-light by about 2:1. The bowls of buff ware are burnished and have decoration in red. The standard scheme of decoration is a band below the rim inside and outside, with alternate diagonals forming chevrons on top of the rim. On **351** the diagonals on top of the rim are double. **354**, with a wash, has traces of two thin parallel white stripes running along the top of it.

351 (N49) FIG. 7.8, PLATE 30: inside. D. 40. Orange clay with burnished buff surface. Decoration in red shading to purple-brown: one band below rim outside, two parallel bands inside; double chevrons on top of rim.

352 (N51) FIG. 7.8, PLATE 30: inside. D. 27. Orange clay with black shading to dark purplish wash. Decoration in thick creamy white: bands below rim inside and outside; opposed diagonals on top of rim.

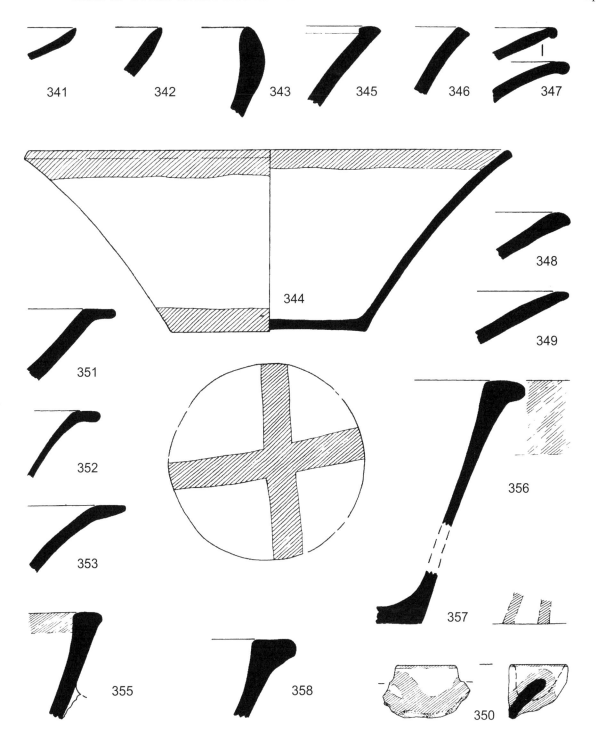

FIG. 7.8. Deposit A2 (EM IIB). Type 7 shallow bowls **341–343**; type 8 bowls **344–349**; miniature bowl **350**; type 9 bowls **351–353**; type 10 large bowls **355–358**. Scale 1:2.

353 (N50) FIG. 7.8, PLATE 30: inside. D. 35. Orange clay with purple-brown to reddish wash. Decoration in thick creamy white: bands below rim inside and outside; chevrons on top of rim.

354 (N52) Scrap of rim with wash in shades of light and dark brown to reddish inside, red outside; outside very well burnished. Traces of two thin parallel stripes in white along top of rim.

TYPE 10. LARGE BOWLS WITH STRAIGHT SIDES AND THICK EVERTED RIM **355–362**

Rims **355–356** and **358**, and base fragment **357** (which may belong with **356**), are assignable to this type. The rims are of coarse ware, from bowls *c.* 40 or more in diameter.

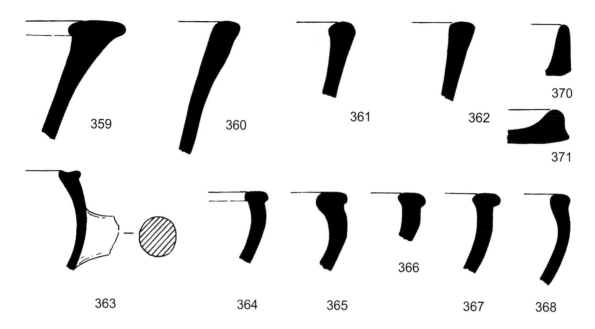

FIG. 7.9. Deposit A2 (EM IIB). Type 10 large bowls **359–362**; type 11 large bowls **363–368**; type 12 large flat dish **370**; type 13 plate **371**. Scale 1:2.

355 (N55) FIG. 7.8. Rim with stump of horizontal side-handle. D. 40. Gritty orange clay with pale greenish slip. Rim painted solid on top, and round inside and outside, in dark brown to black.
356 (N76) FIG. 7.8. Rim. Gritty orange clay with buff slip. Outside of rim has wide band in dark brown.
357 (N77) FIG. 7.8. Base frag. Fabric as **356**. Decoration in dark brown: band round inside of the base, and diagonal or vertical bands outside.
358 (N54) FIG. 7.8. Rim. D. 40. Coarse gritty orange clay; inside has black wash, continuing on top of rim and forming band below it outside; rest of outside has pale greenish slip.

Four rims belonging to large bowls of cooking pot ware of similar composition may also be assigned to this type.

359 (N154) FIG. 7.9. Clay grey at core, red-brown at edges; possible traces of red or red-brown wash. Outside wiped below with diagonal strokes (in LN–EM I tradition).
360 (N155) FIG. 7.9. D. 30. Outside well smoothed, if not burnished.
361 (N156) FIG. 7.9. D. 30. Red wash; well smoothed, especially outside, if not burnished.
362 (N157) FIG. 7.9. D. 25. Traces of red-brown wash.

TYPE 11. LARGE BOWLS WITH CURVING, OFTEN CARINATED SIDES, AND THICKENED RIM (COOKING POT WARE) **363–369**

About 10 rims appear to belong to bowls of this type: **363** preserves the stump of a horizontal side-handle; only **365** and **369** show any distinct carination. The rims seem to range in diameter from as little as *c.* 25 to 50 or more. Most of these rims approximate to class a, one to class b. The following are all in cooking pot ware.

363 (N174) FIG. 7.9. D. 25. Red clay, with red wash.
364 (N175) FIG. 7.9. Red-brown clay, with wash (?) in shades of light and dark brown.
365 (N171) FIG. 7.9. D. 60. Clay grey at core, red-brown at edges, with light brown wash.
366 (N172) FIG. 7.9. Red-brown clay, with light brown wash outside.
367 (N173) FIG. 7.9. D. 45. Clay grey at core, red-brown at edges, with dark wash outside.
368 FIG. 7.9. Gritty red-brown clay. Red surface inside, shading to black outside and smoothed.
369 (N170) PLATE 25: outside. Clay grey at core, red-brown at edges, with red wash.

TYPES 12 AND 13. LARGE FLAT DISHES WITH UPRIGHT SIDES AND PLATES OF COOKING POT WARE **370–371**

One rim is assignable to each of these types.

370 (N151) FIG. 7.9. Rim of type 12. Fabric akin to cooking pot ware: clay grey at core, red-brown at edges, well smoothed or burnished inside.

371 (N150) FIG. 7.9. Rim of type 13. Fabric as **370**.

TYPE 14. BAKING PLATES **372**

Some five rolled and thickened rims of large shallow dishes in cooking pot ware with the under sides rough are evidently akin to the baking plates of later periods. The rims are all of class **a**.

372 (N165) PLATE 30: outside. Clay red-brown with red wash inside; outside rough below rim.

TYPE 15. JUGS WITH CUTAWAY SPOUT **373-383**

There are fragments of several jugs of fine buff ware with decoration in dark-on-light. Handles appear to be set just below the rim and differentiated from it, as on **1339**, and are round or very thick oval in section. Necks and spouts are decorated with parallel stripes or chevrons, e.g. **374**; shoulders typically with upright hatched triangles, e.g. **373**. Handle **383** has broad diagonal stripes.

The motif of triple chevrons as seen on the neck of **374** appears to be standard on jug necks at Knossos in EM IIB (e.g. **375–376**, **379**). It is also found at Tylissos on jug necks of period I, which includes a good deal of EM IIB material.[17] The motif is not represented, however, on jug necks from A1 or the WCH. A jug from Vasiliki II has this motif on the neck combined with cross-hatched triangles with single spots between them on the shoulder above a pair of thick bands.[18] **373** is probably closely similar to this or, better still, jugs such as **1332–1333** from Evans's excavations in Area B, but its decoration is not so complete as theirs. Cf. also **995–998** (B2).

Unless otherwise stated, the surface of the fragments described below is buff and the decoration is in shades of dark brown. Fragments **373–383** are all shown on PLATE 25.

373 (LA/61/P11). Frags. from upper part of body. Fine orange clay; with buff slip with slight greenish tinge outside. Decoration in slightly lustrous dark purple-brown to black: two broad horizontal bands with upright cross-hatched triangle(s) above.

374 (N86). Neck and rim. Orange clay with buff, well smoothed surface; neck pared as on MM IA jugs. Decoration in rather matt dark brown to black: upright cross-hatched triangles on shoulder, triple chevrons on neck, thin stripe along top of rim.

375 Neck and rim. Decorated with triple chevrons, as **374**.
376 Back of neck with stump of handle.
377 (N88) and **378**. Tips of cutaway spouts.
379 Neck frag.
380 Shoulder frag. Surface buff with decoration in red.
381 Body frag. with spring of handle.
382 Shoulder frag. Surface buff with decoration in black.
383 (N87). Handle. Fabric as **374**, and possibly from it. Decorated with broad diagonal stripes.

TYPE 16. SMALL SPOUTED BOWL-JARS **384-387**

A few rims appear to come from small spouted bowl-jars. Two (e.g. **384**) have the stumps of horizontal side-handles as type 16B. Most bowl-jars, whether small of type 16 or large, appear to be light surfaced with decoration in dark-on-light; but **385** has a dark wash and traces of decoration white; and there are fragments of other similar bowl-jars.

384 (N83) FIG. 7.10. Rim, thickened internally: cf. class **b3**. D. 11. Fine buff ware.
385 (N81) FIG. 7.10. Rim: class **c1**. D. 15. Orange clay with black wash outside continuing round inside of rim.
386 (N168) FIG. 7.10. Rim: cf. class **c1-2**. D. 14. Fine buff ware.

One large rim with a ledge for a lid of class **e** may be grouped here.

387 (N79) FIG. 7.10. Large rim with wide internal ledge for lid, and stump of horizontal side-handle. D. 20. Orange clay with dark red-brown, slightly lustrous wash outside. Cf. **1017** (B2) for another rim with an internal ledge for a lid.

TYPE 17. LARGE SPOUTED BOWLS OR JARS WITH HORIZONTAL SIDE-HANDLES **388-391**

A number of rims, mostly of coarse ware with decoration in dark-on-light, but others of cooking pot ware or fabric akin to it, may come from vessels of this kind. The rims are normally more or less

[17] Hazzidakis 1934, pl. 18b, e.
[18] Boyd Hawes *et al.* 1908, 50, pl. 12: 20A, 20B (Zois 1967a, pl. 29: 3725). Zois (1968a, 89–90) assigns this jug to his Koumasa group of EM IIA; but Vasiliki II appears to fall within EM IIB (Wilson 2007, 76).

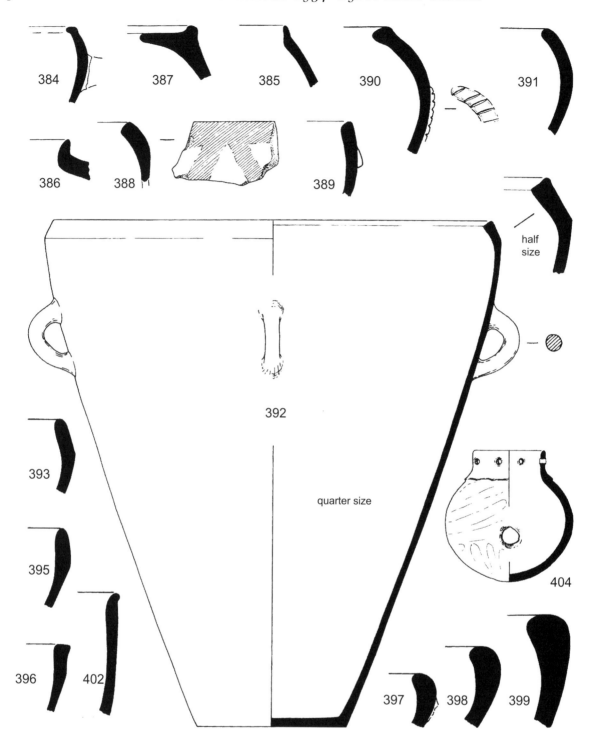

FIG. 7.10. Deposit A2 (EM IIB). Type 16 small spouted bowl-jars **384–387**; type 17 large spouted bowls or jars **388–391**; type 18 large bowls or jars **392–393**, **395–399**; type 23 tripod cooking pot **402**; type 25 incense burner **404**. Scale 1:2.

thickened, those of coarse ware being mostly rounded as **388** but often flattened; while those of cooking pot ware are usually flattened. **390** of fabric akin to cooking pot ware has an unique curving rib in relief slashed with diagonal cuts; **389** has a wart on the shoulder and an overall red wash with decoration in white. On vessels in this type of coarse ware decoration is in dark-on-light: bands round the top of the rim; horizontal bands (PLATE 28: **408**) or intersecting diagonals (PLATES 28: **409**; 30: **410**) on the body. There are possible fragments of two tubular spouts of class **b** which may come from bases of this type, both in cooking pot ware, one with decoration in white.

388 (N80) FIG. 7.10, PLATE 30. D. 22. Coarse ware: orange clay with orange-buff slip. Decoration in matt thick light red-brown: band round top of rim, and wide diagonal bands on body below.

389 (N164) FIG. 7.10, PLATE 25. Rim with wart high on shoulder. D. 40. Fabric cf. cooking pot ware: clay reddish, with as much grit as normal cooking pot ware; red wash. Decoration in thick creamy white: top of rim painted solid, band below rim on outside, and diagonal band on body.

390 (LA/61/P14) FIG. 7.10, PLATE 25. Several frags. of same rim, one with stump of horizontal side-handle. D c. 22. Fabric cf. cooking pot ware: gritty red-brown clay with red wash, finger-wiped inside; outside well smoothed or burnished, and mottled, red shading to dusky and black:

cf. Vasiliki ware. Decorated with curving band in relief with diagonal cuts or slashes on it.

Raised bands or ribs with slashes across them are attested at the base of jug necks in EM IIB at Knossos and are not uncommon in EM III. But a slashed rib like **390** on the body of a jar appears to be unusual in EM Crete. It recalls the ribs with slashes or cuts on some pottery of Phaistos FN, but the vessel shapes are different and the ribs are straight, not curved (e.g. Vagnetti 1973a, 54–6, fig. 57: 13, 19; 92, fig. 82: 3; 100, fig. 94: 9; 107, fig. 108: 4).

391 (N163) FIG. 7.10. D. 15. Cooking pot ware: clay grey at core, red-brown at edges. Red wash, shading to dusky brown in places outside. Two or three other similar rims were found.

TYPE 18. LARGE BOWLS OR JARS WITH INWARD CURVING, OFTEN CARINATED AND THICKENED RIMS **392–399**

A restorable example **392** and about six other rims are assignable to this type. The rims, which are all more or less thickened, appear to range in diameter from c. 20 to 45 or more. In general they seem large. A smaller example is **1339** from the Early Houses.

392 (LA/61/P15) FIG. 7.10, PLATE 28. Tall jar with carinated rim. C. 3/4 of rim pres. as two large non-joining frags.; also three of probably four handles, all apparently vertical, and base. Ht 54. D. 44; D. base 18. Fine cooking pot ware: red-brown clay with red wash, carefully wiped inside, and round outside of rim; rest of outside including under base well smoothed.

393 (N169) FIG. 7.10. D. 45.

394 PLATE 25. Fine cooking pot ware with light brown surface, wiped outside below carination.

395 (N158) FIG. 7.10. D. 40. Cooking pot ware with red-brown surface, wiped outside below carination.

396 (N158A) FIG. 7.10. Fabric akin to cooking pot ware, with light grey-brown surface, finger-wiped inside; strongly wiped outside, probably with bunch of twigs, like some EM I coarse wares.

A distinctive group of large thickened rims of cooking pot ware may be discussed here. The rims seem to come from deep bowls or jars c. 40 to 50 or more in diameter. In shape these vessels may have resembled type 18, but rim **397** has the stump of an horizontal side-handle — cf. type 17. Possible traces of fire on the inside of **398** and the outside of **399** suggest that the vessels to which these rims belong were used for cooking.

397 (N162) FIG. 7.10. D. 35. Three rim frags., one with stump of horizontal (?) side-handle. Clay red-brown at edges, with red-brown wash.

398 (N161) FIG. 7.10. D. 40. As **399**; but surface shades

of brown to dusky, and black inside, apparently from fire.

399 (N160) FIG. 7.10. D. 60. Clay grey at core, red-brown at edges, with red wash, smoothed; outside dusky, perhaps from fire.

TYPE 20. SUSPENSION POTS

A rim and other fragments of fine red burnished ware may belong to suspension pots (see pp. 143–4, FIG. 7.5: **280–281**).

TYPES 21 AND 22. LIDS

Lids of any kind are curiously absent. No fragments of them were recognised.

TYPE 23. TRIPOD COOKING POTS **400–402**

Three fragments of tripod feet (two round, one thick oval section) (PLATE 25: **400–401**) are all in fine red-brown cooking pot ware. Beaded rim **402** may belong to a tripod vessel.

402 (N138) FIG. 7.10. D. 18. Red wash, very clear inside; outside discoloured as from use over fire.

TYPE 24. HORNED STAND **403**

One fragment **403** (N167) (PLATE 42) of cooking pot ware, with grey-brown clay at the core, red-brown at the edges, and a red wash.

TYPE 25. INCENSE BURNER **404**

Fragment **404** evidently comes from a vessel of this distinctive type.[19]

404 (LA/61/P10) FIG. 7.10, PLATE 25. Frag. Ht *c.* 7. D. rim 4. D. body 7. Sandy orange-red clay with paler surface, evenly finger-wiped inside, not smoothed or burnished. Outside, apart from neck, looks scraped. Holes, apparently eight in all of which only five are pres. (D. *c.* 3 mm), made through neck before firing. One larger, rather irregular hole (D. 9 mm), made after firing through body of vessel, may also be ancient.

TYPE 26. THERIOMORPHIC VESSEL **405**

Fragment **405** (N94) (PLATE 29) may be the foot (or head ?) of an animal: of fine orange clay with buff, well smoothed surface; decoration in bright red paint. Cf. foot **548** (PLATE 29) (A4).

SPOUTS

Two or three fragmentary spouts of cooking pot ware appear to have been tubular as class **b2**. One or two fragments of fine ware may come from similar spouts, or from cutaway ones of the teapot class **c**.

HANDLES **406**

These continue round or thick oval in section, as in A1. The curious fish-tail handle **406** (N166) (PLATE 25) may belong to a lamp or brazier. It is of cooking pot ware, the clay dark brown at the core, red-brown at the edges; the surface has a red wash. The shape is like **1260** in dark grey burnished ware (see p. 256 below, with parallels from Lebena and Ayia Triada).

CARINATIONS

These are much in evidence below the rims of large bowls and jars of cooking pot ware of types 11 and 18. Some fine ware vessels like goblets **309** and **311** are also apparently carinated.

BASES **407**

These are in general flat, but sometimes slightly concave. One or two may have been convex and rounded like many characteristic EM I bases; but this rounding of the base was not perhaps intentional as it clearly was in EM I. A small lug foot **407** (N90) may belong to a suspension pot of type 20. This is of soft fabric with dark orange clay, dusky at the core, and wiped inside. The outside is much worn.

DECORATION

Paint **408–418**

Dark-on-light in red, shades of brown, or black
This is more common than light-on-dark. The designs are simple and geometrical; they appear to be most elaborate on goblets (types 2 and 3) and jugs (type 15). Loops may hang from goblet rims; upright cross-hatched triangles characteristically appear on the shoulders of jugs; diagonals interlace to form an embryo network on the sides of bowls or jars large and small (types 16 and 17) (see PLATES 28: **409** and 30). Fragment **411** from the shoulder of a small jug or jar has a design of hatched bands, and **412** of exceptionally fine fabric, which appears to have been used as a rubber, has unique decoration consisting of rows of open circles bisected by lines; as this design appears in the Cyclades, this may be from an import. Simple crosses are painted underneath the bases of bowls, and also of some jars (PLATE 25). Occasionally the crosses under the bowls are elaborate (cf. PLATE 39: **1347**).

408 PLATE 28. Body frag. of large jar. Coarse ware; gritty, dark reddish-orange clay with orange-buff slip outside. Decorated with horizontal bands in dark red-brown.
409 PLATE 28. Base of jar or large bowl. Coarse ware: gritty orange clay with orange-buff surface. Decorated with interlacing diagonals in red-brown.
410 PLATE 30. Frags. of large jars. Orange clay with fine grit, and buff slip. Decorated with interlacing diagonals in dark red-brown.

411 (N89) PLATE 31. Frag. from shoulder of small jug or jar. Fine orange clay, with decoration in thick red-brown.
412 (N92) FIG. 9.1. Sherd used as rubber, *c.* 2.9 across. Th. 0.5. Fine fabric: orange well fired clay, appearing light grey at core, smooth inside, and well burnished orange-buff outside. Decoration in dark brown to black: diagonal rows of open circles intersected by lines.
 The motif of open circles or ovals bisected by a line may be derived from the cycle of decoration of vases of the Halaf

[19] Like Warren 1972*a*, 122–3: P314–318.

culture of northern Mesopotamia through Syria or Cilicia (e.g. Von Oppenheim 1943, pl. 50: 4). Wilson (1984, 302–3, pl. 63: E. I.l 593) illustrates an EC II imported vessel in the SMK with this motif.[20] An elegant framed version of it seems to occur on a fragment of a jug shoulder from the WCH (Wilson 1985, 327, pl. 39: P240), and likewise on one end of an unique barrel-shaped theriomorphic vessel from Koumasa: Zois believes this may come from Tholos B and assigns it to EM IIA: Zervos 1956, pl. 267 left (called MM I); Zois 1967a, 721 and n. 1, pls. 7, 22: 4162).

The same motif appears in dark-on-light in the Cyclades and Attica (e.g. Kea, Ayia Irini: Wilson 1999, 80, pl. 68: II–689; Syros: Zervos 1957, 182, fig. 241; Keros: Zapheiropoulou 1975, 81, fig. 4ζ, ν–ξ; Koropi: Kakavogianni

1993, 166, pl. 18a). **412** could then well be from an import of EC IIA (Wilson, pers. comm.).

413 (N93) PLATE 28. Bowl base. Similar fabric, except that buff surface is well burnished inside and outside; decoration in slightly lustrous dark brown to black.

414 PLATE 25. Bowl base. Buff surface buff, burnished inside and outside. Underneath with simple cross in light red-brown.

415 PLATE 25. Jug (?) base. Pale greenish slip outside. Underneath with simple cross in black.

416 PLATE 25. Bowl base. Orange-buff burnished surface inside and outside. Underneath with elaborate cross in dark purple-brown.

Light-on-dark decoration in creamy white paint

This is much less in evidence than dark-on-light, but predominates in the case of bowls of type 9. On the rims of goblets of types 2 and 3 the designs in light-on-dark are perhaps more varied and elaborate than those in dark-on-light. When decoration occurs on cooking pot ware it is normally in creamy white paint on a red washed surface. Bases with a dark wash may have crosses painted in white underneath.

417–418 PLATE 25. Bowl bases, with red (**417**) or black (**418**) wash, and simple cross in creamy white underneath.

Pattern burnish

No example of true pattern burnish was noted.

Incision

Incised decoration is rare. **419** with bold grooves may be from an import; but bowl **390** (see p. 153) with a slashed band in relief on it appears to be of local manufacture.

419 (N91) PLATE 28. Two frags. from large jar (?) of rather coarse reddish clay, smoothed inside; outside has red wash, well burnished. Decorated with chevrons made by bold U-shaped grooves. Perhaps import from the Cyclades.

Relief

The curving rib on **390** is unique. Warts evidently occurred on the shoulders of large bowls or jars of type 17 (e.g. **389**), and perhaps on smaller ones of fine ware as type 16.

Wiping

The surfaces of bowls and jars of cooking pot ware (types 11, 18) are often wiped.

Deposit A3: Floor VI mixed (?) with V

EARLY MINOAN IIB

Levels LA105–LA105A. Amount: about 1 table.

This material comes from the upper part of the deposit above Floor VI. It may be contemporary with the material from A2, and it certainly looks earlier than the material from A4 above it. But in view of the possibility of contamination from A4, it was studied separately from the rest of the A2 material.

FABRIC

Along with the standard coarse wares and fine light surfaced buff ware there is a good deal of dark (red and black) washed ware in A3. As in the case of earlier examples of this ware, the wash is apt to flake and come away from the surface of the vessel.

[20] For a recent review of EC II imports to EM II Knossos, see Wilson 2007, 69–70, 77.

Dark grey burnished ware

Only some 10 scraps of this were recovered, and most of them may be strays of earlier periods. Two or three sherds, including one with incised decoration, are certainly Neolithic. It would therefore be natural to expect an even larger number of strays dating from EM I or earlier EM II. But some of the fragments of dark grey burnished ware may come from EM IIB vessels. Among these is the rim of a goblet **435**, thin-walled and sharp-pointed like **427**, and *c.* 10 in diameter.

Red and light brown burnished wares

One or two fragments are assignable here. They include: a fragment of a pedestal of fine grey-brown clay, light reddish-brown and well burnished outside (perhaps an earlier stray); and a scrap of a bowl of fine red-brown sandy clay like cooking pot ware, with a red wash and fine stroke burnish, and probably contemporary with the deposit.

Vasiliki ware etc. **420–424**

We recognised some 18 fragments coming from at least 10 different vessels, all apparently open bowls or goblets, except for one scrap from a closed vessel. One large fragment **420** and five rims are from goblets or small deep bowls; four rims are from shallow bowls, and five fragments from bases of bowls or goblets. All seem to be of more or less typical Vasiliki ware: rather pale orange, well refined clay, the surface with a well smoothed or burnished red or orange mottling to black wash. Betancourt is doubtful about several of our attributions, as noted below.

420 (LA/61/P16) FIG. 7.11, PLATE 29. Goblet or deep bowl, with wart below rim and, probably, eggcup foot, which is missing. *C.* 1/2 rim pres. D. 9.5. Vasiliki ware: pale orange clay with wash, red inside where surface badly flaked, red mottling to pink with black splodges outside.

Betancourt has suggested to us that this may be an import from eastern Crete. Betancourt 1979, 43: VII.A.2 Knossos 4.

421 (N182) FIG. 7.11. Goblet or deep bowl rim with stump of handle (whether vertical or horizontal uncertain). D. 9.5. Not Vasiliki ware, according to Betancourt.

422 (N183) FIG. 7.11, PLATE 26. Bowl rim. D. 18. Vasiliki ware: red mottling to black surface outside. Two other scraps of similar rims were noted.

423 (N184) FIG. 7.11. Large bowl rim. D. 30. Red surface outside, dark brown inside. Not Vasiliki ware, according to Betancourt.

424 (N217) FIG. 7.11. Bowl rim with string-hole perforations, as **193** (A1). D. *c.* 17. Vasiliki type ware: orange clay with orange to reddish shading to purple-brown surface. According to Betancourt, it is marginal if it is Vasiliki ware.

TYPES

TYPES 2 AND 3. GOBLETS **425–437**

Simple goblets of type 3 are still rare. One complete profile **425** was found together with a scrap from a base. In contrast to this about 24 eggcup feet from goblets of type 2 were noted. Three of these are large with a diameter of over 6, but the diameter of the rest seems to lie between 4.7 and 5.2. Most of these feet (some 20 or 5/6 of the total) have a wash (11 red, nine black) outside; and of these six or seven show traces of a white band round the waist. In about five cases (1/4 of the total) the underneath of the foot is painted solid; in another four (1/5 of the total) it has a circular band round the edge. One tall foot with a light brown to black wash is unusual in having the light brown inside surface of the bowl of the goblet burnished. Only four feet (1/6 of the total) are plain, without any wash; all of these have a red band round the waist as FIG. 5.4: 2.

Rims of types 2 and 3 (PLATE 29)

About 60 rims are assignable to goblets of these types with a diameter ranging from 5 to 11, but mostly it seems between *c.* 7.5 and 9. These rims are normally thin and pointed; but one or two flat-topped rims appear to be deliberately made like that. The outsides in many cases bear traces of having been scraped or pared. Most rims, about 50 or 5/6 of the total, have a wash (20 red, 30 black) inside and outside. But **428** with anomalous decoration is entirely plain inside; and others may have been plain inside except for a wash round the inner edge of the rim, since one or two eggcup feet with an outside wash have the inside of the goblet plain. One scrap of rim of fine grey-brown burnished ware **434** (FIG. 7.11) may be a stray from EM I.

There is considerable variety in the decorative motifs on these goblet rims, including combinations of horizontal bands and stripes, chevrons, and diagonals (FIGS. 5.2–5.3). The rosettes on **426** are surprising from such an early horizon as this, but the fragment seems to be in context.

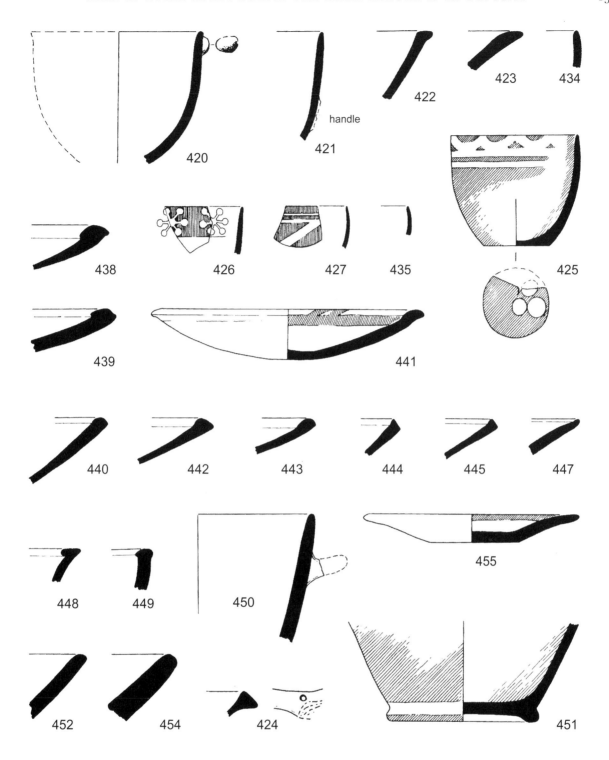

FIG. 7.11. Deposit A3 (EM IIB). Vasiliki ware etc. **420–424**; types 2 and 3 goblets **425–427, 434–435**; type 4 shallow bowls or plates: (**a**) rounded rims **438–443**; (**b**) bevelled rims **444–445, 447**; type 5 shallow bowls or plates **448–449**; type 6 deep bowls **450–451**; type 7 shallow bowls **452, 454**; type 8 bowl **455**. Scale 1:2.

425 (LA/61/P18) FIG. 7.11, PLATE 29. Type 3. 1/2 pres. Ht 5.8. D. 7. Orange clay with red wash including under base, and signs of paring outside. Decoration in creamy white: loops hanging from rim above two bands. Three large white spots under base.

For similar looped decoration from other EM IIB deposits, see **832–834** (B1) and **941–944** (B2) (PLATES 38,

41); also Zois 1967*b*, 152 and n. 2, pl. 30: 9, from Knossos in HM without further provenance.

426 (N179) FIG. 7.11, PLATE 29. D. 9. Dark red-brown wash. Decoration in white: row of six-petalled rosettes above wide band. Rosettes of this type composed from dots characteristically occur in MM IA.

427 (N181) FIG. 7.11, PLATE 29. D. *c.* 6. Dark red-brown

wash. Decoration in white: stripe (?) on rim, with pair of stripes below and single diagonal.

428 (N178). PLATE 29. D. *c.* 11. Clay grey throughout, with black wash outside; inside plain. Decoration in white: thin stripe on rim, and broad area of white below.

429 PLATE 29. Red-brown wash. Decoration in creamy white: band below rim.

430 PLATE 29. Purple-brown wash. Decoration as **429**.

431 (N177). PLATE 29. D. *c.* 7.5. Fine buff ware with buff surface. Decoration in red: band on rim and diagonal below.

432 (N180). PLATE 29. D. 8. Fine buff ware with buff surface. Decoration in dark red-brown: stripe on rim and two pairs of stripes below.

433 PLATE 29. Orange clay. Decoration in red: pair of bands below rim.

434 (N316) FIG. 7.11. Scrap of rim. D. 11. Dark grey burnished ware; clay red-brown at core, with well burnished grey-brown surface. Probably EM I stray.

435 (N364) FIG. 7.11. Scrap of rim. D. 10. Fabric as **434**. Possibly EM II rather than earlier stray.

436 PLATE 29. Frag., apparently type 2 with spring of eggcup foot. Red wash. Decoration in white: diagonal band rising from band round foot.

Rim **437** is unusual, and seems to come from a cup of some kind rather than a goblet.

437 PLATE 29. Cup (?) rim. Black wash. Decoration in white: band below rim, with group of chevrons above.

TYPE 4. SHALLOW BOWLS OR PLATES WITH RIM THICKENED INTERNALLY 438–447

Bowls of this type, especially those with rounded rims of class **a**, are very common (see FIG. 7.11).

(a) Rounded rims **438–443** (N209–14) (FIG. 7.11: **438**, D. 15; **439**, D. 13; **440**, D. 20; **441–442**, D. 15; **443**, D. 13; PLATE 30: **439**, **441**). About 39. These seem to range in diameter from *c.* 12 to 20, with many between 13 and 15, which may suggest that the bowls of this type in A3 were considerably smaller than those in A2; but this impression may be false. The rims tend to have the outer edge sharp rather than a rounded one. The outsides mostly show pronounced traces of having been scraped or wiped. All the rims are of fine buff ware, with decoration in dark-on-light (normally red, but in a few cases dark brown or black) consisting of a band round the inside of the rim, and on top of the rim broad diagonal bands, whether single or in pairs, and usually it seems confronted.

(b) Bevelled rims **444–445** (N215–6) (FIG. 7.11). Only four. D. *c.* 20. Fine buff ware with decoration in dark-on-light: a band in red or black on the inside of the rim; the edge of the rim hatched, or in one instance solid red.

Bowl **446** (N221) (PLATE 30), of which we have two fragments, has a band in purplish red round the inside of the rim and a group of parallel stripes running across the centre of the inside. One rim is plain. One scrap, which appears to come from a bowl of this type, has a black wash. Rim **447** (N208) (FIG. 7.11, D. 14) is exceptional; it has a slight internal bead, and a dark brown to black wash outside which is well smoothed, but the inside is plain buff, smoothed.

TYPE 5. SHALLOW BOWLS WITH UPRIGHT SIDES AND RIM THICKENED INTERNALLY 448–449

Two rims are assignable to this type, both in fine buff ware.

448 (N218) FIG. 7.11. D. 14. Decoration in red: bands inside and outside; broad diagonal band on top of rim.

449 (N219) FIG. 7.11. D. 26. Decoration in dark brown, worn: band below rim outside.

TYPE 6. DEEP BOWLS WITH TROUGH SPOUT AND SIDE-HANDLES 450–451

Two fragments may be grouped here.

450 (N314) FIG. 7.11, PLATE 29. Rim of deep straight-sided bowl with stump of small horizontal side-handle of circular section. D. 13. Fine orange clay, with buff surface inside with high stroke burnish; outside has black wash, smoothed.

451 (N315) FIG. 7.11, PLATE 29. Ring base, but apparently not from same vessel as **450**. Fine orange clay with black wash (worn inside), continuing under base. Decoration in thick creamy white: band round foot, and large spots which depend from interlacing pairs of diagonal stripes: cf. **513**.

TYPE 7. SHALLOW BOWLS WITH STRAIGHT OR INWARD CURVING SIDES 452–454

A few rims are assignable to this type.

452 (N312) FIG. 7.11. Fine orange clay, dusky at core, with red wash inside, to shades of red and brown outside, well smoothed.

453 As **452**. Fine red burnished ware. Soft fabric: red-brown clay, dusky at core, with red wash finely stroke burnished inside and out.

454 (N266) FIG. 7.11. D. 40. Cooking pot ware with red wash, well burnished inside.

TYPE 8. BOWLS WITH FLARING RIM **455**

There are rims of some eight shallow bowls like **455** (N220) (FIG. 7.11, PLATE 30) assignable to the shallow variety A of this type or to type 7. The diameter is from *c.* 13 to 16. They are of fine buff ware with orange or buff surfaces, scraped or smoothed outside, and decorated with a red band inside the rim.

TYPE 9. BOWLS WITH EVERTED RIM **456–469**

These are evidently common and characteristic. Of some 33 rims assignable to bowls of this type, about 2/3 come from shallow (A), and about 1/3 from deep (B), varieties of such bowls. The rims (FIG. 7.12) range from (1) sharply differentiated like **456** (N223), to (2) slightly differentiated like **457** (N224), and (3) undifferentiated and outward curving like **458** (N225). Rims of class 3 merge into those of bowls of type 8; but most of the rims assigned to type 9 more or less approximate to class 1.

These bowls are apt to be thin-walled, but very uneven and irregular in their manufacture, e.g. **459–461**, especially on the outside. The rim diameters are therefore difficult to ascertain, but in general they seem to fall between *c.* 20 and 30. In three cases the stump of a small horizontal round section handle is preserved on the side of the bowl below the rim, as shown in FIG. 5.1: type 9B. One of these rims with the stump of a handle **462** is unique, as the only rim in fine buff ware with decoration in dark-on-light assignable to type 9. But one or two other fragments of dark-on-light, including scraps of bases with a red band round the inside, may come from bowls of this shape. All other type 9 rims, however, apart from **462**, have traces of a black or red wash, black washes outnumbering red by 4:3. The tendency of the paint to flake off the surface, which is apparent in the EM II wares of Knossos, is very marked on these rims.

Decoration in white normally consists of a band round the inside of the rim, and often it seems round the inside of the base as well; once at least there is a white band round the outside of the base. On the rim itself are found broad opposed diagonal bands, groups of parallel diagonal stripes **460**, and crossed stripes **461**. **459** from the side of a bowl has interlacing diagonals in white. A few scraps from bases that may come from bowls of this type have crosses underneath, once in dark-on-light (red on buff), once in light-on-dark (white on a red wash). Once it seems there is a white cross painted on the *inside* of the base.

459 PLATE 30. Frag. Fine orange clay with purple-brown wash. Decoration in creamy white outside.

460 PLATE 30: inside. Rim. As **459**, but wash tending to black.

461 PLATE 30: inside. Rim. Red-brown wash.

462 (N222) PLATE 30. Rim with stump of horizontal side-handle. Fine buff ware: orange clay with buff surface, smoothed outside, stroke burnished inside. Decoration in red: band below rim outside; four thin stripes on outside of rim.

463 PLATE 30: outside. Rim. Red wash. Decoration in creamy white.

464 PLATE 30: outside. Rim. As **463**.

465 PLATE 30: outside. Rim. As **459**.

Three shallow rims (FIG. 7.12) of class 1 are of fine cooking pot ware. The bowls to which these belonged were evidently of good fabric and, although comparatively thick walled, neatly and evenly made. **466** (N264) (D. 30) and **467** (N265) (D. 25) have a red wash. **468** (N226) is unusually small: of gritty reddish clay with a well smoothed or burnished orange-brown surface, decorated in white with a group of thin diagonal stripes on the flat top of the rim and a thin band round its inside.

One other anomalous bowl rim of cooking pot ware may be grouped here (FIG. 7.12): **469** (N267) (D. 26) has a burnished wash, red outside, light brown inside.

TYPE 10. LARGE BOWLS WITH STRAIGHT SIDES AND THICK EVERTED RIM **470–473**

Three rims of coarse ware together with two fragments of bases are assignable to standard bowls of this type. Both the bases have a band, in black or dark brown, round the inside; and **472** also has crossing diagonal stripes outside.

470 (N310) FIG. 7.12, PLATE 32. D. 30. Coarse ware: clay grey at core, red-brown at edges, with orange to buff slip. Decoration in thin red-brown: rim painted solid outside and inside; wide band below rim outside. Another similar rim was noted.

471 (N228) FIG. 7.12. Coarse ware: well fired orange

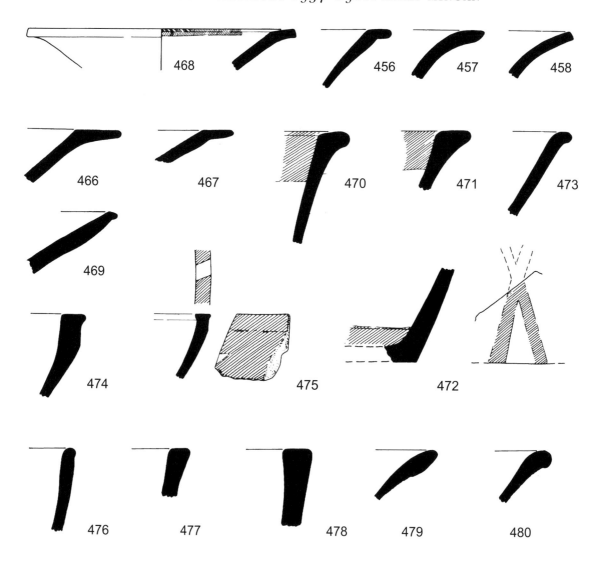

FIG. 7.12. Deposit A3 (EM IIB). Type 9 bowls **456–458**, **466–469**; type 10 large bowls **470–473**; type 11 large bowls **474–478**; type 14 baking plates **479–480**. Scale 1:2.

clay, with buff slip, smoothed inside and outside. Decoration in dark brown: bands below rim inside and outside; opposed diagonals on rim.

472 (N311) FIG. 7.12, PLATE 30. Base frag. Coarse ware:

orange clay with buff slip inside, well smoothed or burnished; outside orange-buff. Decoration in dark brown: band round inside, crossing diagonals outside.

One smaller bowl rim of finer ware is grouped here. It may be a stray from an earlier horizon.

473 (N227) FIG. 7.12. Fine orange clay with red wash outside, smoothed; inside very well burnished.

TYPE 11. LARGE BOWLS WITH CURVING, OFTEN CARINATED, SIDES AND THICKENED RIM
474–478

There are some nine rims from bowls of this type, at least six of them carinated. All are of cooking pot ware except the small rim **475**.

474 (N277) FIG. 7.12. D. 50. Cooking pot ware with red-brown wash; outside wiped below carination.

475 (N313) FIG. 7.12. D. 25. Fine orange clay with buff

surface, carefully wiped or smoothed. Decoration outside in dark reddish paint, which appears black on top of rim.

A few other rims of bowls or jars of cooking pot ware may be grouped here.

476 (N268) FIG. 7.12, PLATE 30. D. 35. Red wash, turned dark brown outside and red mottling to black inside, which is well smoothed or burnished. Another rim (D. 18) is of similar shape and fabric, but wiped inside.

477 (N269) FIG. 7.12. D. 25. Red wash; outside wiped. There is one other similar rim.

478 (N270) FIG. 7.12. D. 40. Red wash; inside well smoothed or burnished.

TYPE 14. BAKING PLATES **479–480**

There are four rims, of which two **479–480** (N278–9) (FIG. 7.12, PLATE 30) have a red wash inside.

TYPE 15. JUGS WITH CUTAWAY SPOUT **483–484, 510–511**

Only fragments of jug necks and handles were found. All spouts appear to be of the cutaway type, and some of them distinctly elongated, like jar spout **498**. Handles are round section; in the two cases where the rim is sufficiently preserved, the handle is set below it (as shown in FIG. 5.1: type 15). One or two spouts are markedly scraped or pared. Several fragments of jug spouts and necks have traces of a wash in black, or shades of brown and red. Most are of fine buff ware, the surface orange or buff, or not infrequently pale greenish in colour. Decoration on these light surfaced jugs is in red or shades of brown and black; necks may be decorated with multiple stripes or chevrons, handles with a stripe or stripes down their length. Some fragments with decoration in dark-on-light, apparently from jugs, may be strays of an earlier phase of EM II or even of EM I (e.g. PLATE 31: **510**, of orange clay with a buff burnished outside surface, decorated in red-brown; and **511**[21] with an orange surface decorated in black). Jug neck **483** (PLATE 30) of fine cooking pot type ware with a brown wash has traces of decoration in white. Another apparent jug neck fragment **484** (N280) (PLATE 30) is of fine cooking pot ware, burnished red shading to brown outside, with three irregular horizontal shallow grooves running round it.

TYPE 16. SMALL SPOUTED BOWL-JARS **485–501**

Some if not most of the rims of small jars of fine ware grouped here evidently come from spouted bowl-jars of type 16. Most characteristic seem to be the rims of class **b** of which 11 were found; eight as class **b2**, three as class **b3**. One of class **b3** has the stump of a horizontal handle of round section, as type 16B. Six (3/4 of the total) of the rims of class **b2** have a dark wash, in most cases black but once red-brown, and traces of decoration in white. The wash in almost every case extends over the whole of the inside of the rim as well as over the outside. The two rims of class **b2** with decoration in dark-on-light are both unusually small, as **488**. The two rims (including **491**) assignable to class **c1** are rather carelessly made and uneven with a red or black wash outside, but not inside.

485 (N298) FIG. 7.13, PLATE 30. D. 12. Cf. class **a1**. Black wash outside and decoration in white; inside orange-buff with fine stroke burnishing.

486 (N365) FIG. 7.13. D. 15. Class **b2**. Fine orange clay with black wash, much worn; traces of decoration in white. Five other similar rims include one with stump of spout.

487 (N299) FIG. 7.13, PLATE 30. D. 18. Class **b2**. Carinated shoulder carinated, with wart on carination. Fine orange clay with black shading to dark red wash outside, purple-brown inside. Decoration in thick, very creamy white.

488 (N300) FIG. 7.13, PLATE 31. D. 11. Class **b2**. Fine orange clay with buff slip. Decoration in red to red-brown: top of rim painted solid inside, band of lattice round outside.

489 (N301) FIG. 7.13, PLATE 30. D. 20. Class **b3**. Fine orange clay with black wash. Decoration in white, much worn: group of three diagonal bands outside.

490 (N302) FIG. 7.13. D. 15. Class **b3**. Fine pale orange clay with red-brown to dark brown and black wash outside, much worn; inside plain, smoothed.

491 (N303) FIG. 7.13, PLATE 30. D. 9.5. Class **c1**. Rather carelessly made and uneven. Dark brown to black wash outside, and round inside of rim. Broad white band round neck.

492 (N304) FIG. 7.13, PLATE 30. D. 11. Class **c2**. Fine orange clay with brown wash outside, and round inside of rim. White band round neck.

493 (N305) FIG. 7.13, PLATE 30. D. 10. Class **c2**. Fine orange clay, well smoothed before application of dark red-brown wash (much flaked away) outside, and round inside of rim. Decoration in white on outside edge of rim, and band round neck.

494 (N306) FIG. 7.13. D. 15. Class **c3**. Fine orange clay, with overall black wash.

495 (N307) FIG. 7.13. D. 14. Class **c3**. Fine orange clay with red-brown wash outside, continuing deep round inside of rim.

496 (N308) FIG. 7.13. D. 15. Class **d2**. Fine pale orange clay with dark brown to black wash.

497 (N309) FIG. 7.13, PLATE 30. Jar frag. with vertical handle on shoulder. Fine pale orange clay with red-brown wash outside. Decoration in creamy white: band round body and circle round lower attachment of handle.

498 (N317) PLATE 30. Spout. Fine orange clay with black wash outside, continuing round inside of rim.

499 Frag. of carinated body of jar or jug. Purple-brown shading to red-brown wash outside. Traces of much worn decoration in white: row of chevrons above carination.

[21] **510** was also at one time **481**, and **511** was **482**. **481** and **482** are not now in use.

Two rims with internal ledges for lids are listed here. Both are of fine cooking pot ware.

500 (N271) FIG. 7.13, PLATE 30. D. 40. Class **e1**. Orange wash.

501 (N273) FIG. 7.13, PLATE 30. D. 30. Class **e2**. Red wash outside.

TYPE 17. LARGE SPOUTED BOWLS OR JARS WITH HORIZONTAL SIDE-HANDLES **502–505**

Some 22 rims of cooking pot ware appear to belong to jars of this type. Two of these have horizontal side-handles, such as **502** (N272) (FIG. 7.13, D. 25), and two others tubular spouts of class **b**. There are traces of decoration in white paint on at least eight of these rims: four examples are on PLATE 30 row *a*. Three other rims, which may also come from such jars, are of orange clay with fine grit, the surface orange or buff and decorated in shades of red-brown or black, e.g. PLATE 30: **503–505**.

TYPE 18. LARGE BOWLS OR JARS WITH INWARD CURVING, OFTEN CARINATED AND THICKENED RIMS **506–508**

Four or five scraps of carinated rims may have belonged to jars of this kind. But some 37 other rims of cooking pot ware, mostly thickened and from vessels of larger diameter with high shoulders, may be grouped here. These are not associated with handles or spouts; and none of them has traces of decoration in white. **506** (N274) (FIG. 7.13, D. 50) and **507–508** (N275-6) (FIG. 7.13, D. 35) have a reddish-brown or red wash; the inside of **508** is dusky.

TYPE 23. TRIPOD COOKING POTS

Of six fragments of tripod feet, four are round and two thinnish oval in section.

SPOUTS

Spouts from jars are of both classes **b** and **c**. Those belonging to large jars all appear to be of class **b**.

HANDLES **509**

Handles in general seem to be more or less round in section. But there are fragments of five small strap handles of more or less flat section that appear to come from cups or jars of fine ware. All except one have a black, red or red-brown wash. The exception **509** (N391), of rather thick kidney-shaped section, is of fine buff ware with decoration in black of bands down each side with diagonals between them.

BASES

Bases are mostly flat. But one base of a jug or jar with a dark brown to black wash and decoration in white has been deliberately sunk.

DECORATION

Paint **510–513**
Dark-on-light, in red, shades of brown, or black
Simple linear designs include parallel lines and lattice. Some fragments with this style of decoration may be strays of EM I or early EM II date (e.g. PLATE 31: **510–511**, both apparently from jugs).

Light-on-dark, in creamy white paint. Bands, stripes, parallel lines and lattice
From jars of fine ware come fragments with large dots in rows, e.g. **512** (N319) (FIG. 7.13, PLATE 32). In two examples the dots depend from intersecting pairs of diagonals: **451** (FIG. 7.11) and **513** (N318) (FIG. 7.13, PLATE 32).

A version of the design on **512**, with diagonal lines flanked by solid spots, appears in light-on-dark on **911** (B1). There is a similar design on the rim of a footed goblet from Building 19 at Archanes–Fourni; the wide relatively high foot and shape of this suggest a date in EM IIB.[22] The same scheme of decoration is seen, however, on the unique bowl rim **640** (PLATE 32) (A6) assigned to EM III.[23]

Incision
The only example is the jug neck **484** with grooves round it (PLATE 30).

[22] Sakellarakis and Sakellaraki 1976, 384, fig. 17.
[23] This might be an import from eastern Crete, although no

comparable design is recorded by Betancourt (1984).

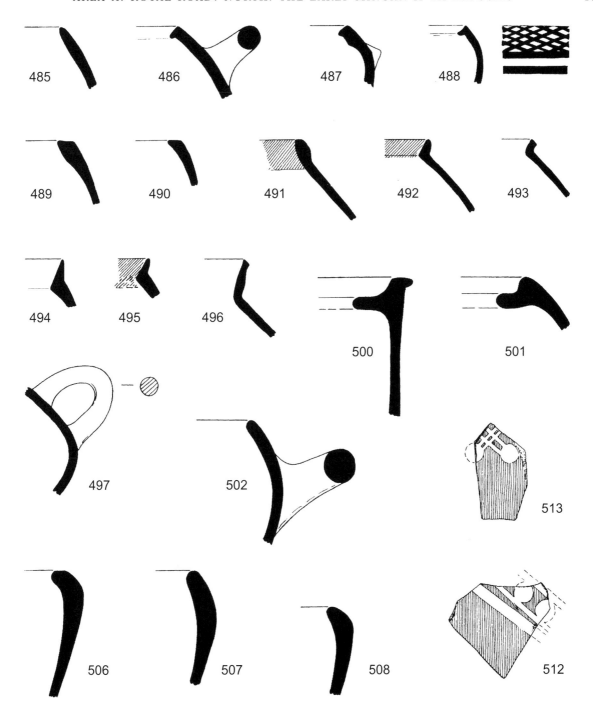

FIG. 7.13. Deposit A3 (EM IIB). Type 16 small spouted bowl-jars **485–497, 500–501**; type 17 large spouted jar **502**; type 18 large bowls or jars **506–508**; light-on-dark decoration **512–513**. Scale 1:2.

Relief
Warts appear on the shoulders of one or two jars.

DEPOSIT A4: FLOOR V

EARLY MINOAN IIB

Levels LA104–LA104A. Amount: *c.* 1/2 table.

FABRIC

There is a certain amount of pottery with a black or red wash; but fragments with a buff surface and decoration in dark-on-light are still much in evidence.

Vasiliki ware **514**

Three fragments include **514** (N363) from a large closed vessel.

TYPES

TYPES 2 AND 3. GOBLETS **515–519**

No bases of simple goblets of type 3 were found, and only seven eggcup feet of type 2: **515–519** (N201–5) (FIG. 7.14), ranging in diameter from 4.5 to 5.5. All the feet have a wash (six red or light brown, one black) and three a band of white paint round the waist, as FIG. 5.4: 4. In two cases the under side of the foot is left plain; in the other five the wash covers it. Two of these five feet with the wash underneath have also marks in white: **515–516** (PLATE 31).

Rims of goblets. Some 19 have diameters from 6 to 9. All are more or less pointed. Wiping or scraping of the outside is very marked. All except one have a wash (nine black, nine red).

TYPE 4. SHALLOW BOWLS OR PLATES WITH RIM THICKENED INTERNALLY

Of nine scraps of rim, four belong to class **a**, five to class **b**. Those of class **a** are of fine buff ware, with an orange, buff or greenish surface, smoothed or scraped outside, and a band in red or black round the inside of the rim. Once there is a broad diagonal on the rim; once the rim is painted solid. Four of the rims of class **b** have a similar band round the inside. The remaining rim, which may come from a steep-sided bowl as type 8B, has a red band round the outside continuing on its bevelled edge, but not inside.

TYPE 8. BOWLS WITH FLARING RIM **520–521**

A few rims are assignable to bowls of this type. Most belong to shallow bowls as type 8A; but **521** is steep-sided (cf. type 8B). It is noteworthy that most of these rims have plain surfaces, with a high stroke burnish but no trace of painted decoration. All are of fine buff ware unless otherwise stated.

520 (N234) FIG. 7.14, PLATE 31. D. 11. Buff surface, smoothed outside, well smoothed or burnished inside. Decoration in dark red: two bands round inside of rim.
520A (N233) FIG. 7.14. D. 12. Soft fabric: clay grey at core, with finely burnished buff surface.
520B (N232) FIG. 7.14. D. 36. Orange-buff surface, with fine stroke burnishing.

520C (N231) FIG. 7.14, PLATE 31. D. 34. Orange clay with buff surface, with very fine stroke burnishing inside; outside diagonally scraped and then smoothed.
521 (N237) FIG. 7.14. Fabric akin to soft red burnished ware of MM I–II. Orange clay, with orange buff slip inside, well smoothed or burnished; outside with red wash, very well smoothed or burnished, but much worn.

Some bowl bases may be considered here. One of these at least from its size and fabric appears to belong to a bowl of type 8; it is large, with an surface orange-buff burnished surface, and has a cross in dark brown underneath. A small base has the inside surface orange-buff, finely stroke burnished, while the outside has a black wash, well smoothed, continuing to form a black circle round the underneath of the base.

TYPE 9. BOWLS WITH EVERTED RIM **521A–521C**

Of 23 rims assignable to bowls of this type, about 18 come from the shallow variety 9A and five from the deep variety 9B. Diameters are mostly between *c.* 20 and 30, with several *c.* 26. The rims from this deposit show the same range of variation as those from A3. All of them have traces of a wash (10 black, 13 red). Most are decorated with a white band round the inside, one at least with a band round the outside as well. Broad diagonal bands or groups of parallel lines appear on the flat tops of the rims. PLATE 30: **521A–521C** shows the insides of three rims with a red or purple-brown wash and decoration in creamy white. One base of a black wash bowl of this type has a white band round the inside.

TYPE 10. LARGE BOWLS WITH STRAIGHT SIDES AND THICK EVERTED RIMS **522–523**

There are three rims of coarse ware from such bowls.

522 (N235) FIG. 7.14. D. 42. Orange inside surface; buff wash outside. Broad red band round outside of rim.
523 (N236) FIG. 7.14, PLATE 32. D. 26. Buff wash.

Decoration in brown: band below rim and diagonal stripe outside; top of rim painted solid.

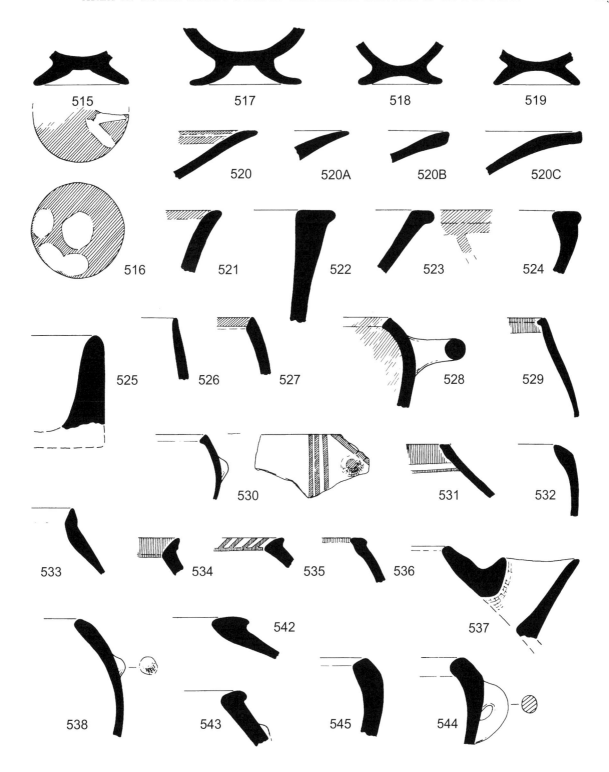

FIG. 7.14. Deposit A4 (EM IIB). Type 2 goblets **515–519**; type 8 bowls **520–521**; type 10 large bowls **522–523**; type 11 large bowl **524**; type 12 large flat dish **525**; type 16 small spouted bowl-jars **526–536**; type 17 large spouted jars **537–538**, **542–543**; type 18 large bowls or jars **544–545**. Scale 1:2.

TYPE 11. LARGE BOWL WITH CURVING, OFTEN CARINATED SIDE AND THICKENED RIM **524**

Two or three rims of cooking pot ware belong to such bowls.

524 (N282) FIG. 7.14. Very fine cooking pot ware with worn red wash outside, but apparently not inside.

TYPE 12. LARGE FLAT DISH WITH UPRIGHT SIDE **525**

Rim **525** (N281) (FIG. 7.14, D. 50) with burnished red wash inside belongs to this type. A fragment of a large flat base of fine cooking pot ware may come from a similar dish or from a plate of type 13; its under side is plain, the upper has a dark purplish-red wash with a high burnish.

TYPE 15. JUGS WITH CUTAWAY SPOUT

Only a few scraps from jugs were recognised. Two handles with the rim preserved are both set to the rim, not below it; one of these is from a small jug, the other is somewhat anomalous.

TYPE 16. SMALL SPOUTED BOWL-JARS **526–536**

About 18 rims of fine ware are grouped here. Most of these rims belong to class **b**, and 1/2 of them (nine out of 18) to the distinctive class **b2**. All except **530** have a dark wash outside.

526 (N334) FIG. 7.14. D. 10. Cf. class **c1**. Fine orange clay with black shading to red-brown wash inside, well smoothed.
527 (N323) FIG. 7.14. D. 16. Cf. class **b2**. Stump of handle (?) or spout. Fine orange clay with buff inside surface, well burnished; black wash outside, well smoothed.
528 (N324) FIG. 7.14. D. 24. Class **b2**. Horizontal side-handle on shoulder. Fine orange clay with dark brown to black wash inside and out, much flaked away. Traces of decoration in white. There are six other similar rims, mostly with overall wash.
529 (N326) FIG. 7.14. D. 10. Class **b2**. Fine orange clay with buff surface; black wash outside, continuing round inside of rim. Decoration in white: group of three diagonal stripes.
530 (N325) FIG. 7.14, PLATE 31. D. 12. Class **b2**. Wart on shoulder. Fine orange clay with orange-buff surface. Decoration in dark brown to black: spot on wart, which is flanked by one diagonal and group of three vertical stripes.

531 (N327) FIG. 7.14. D. 15. Cf. class **b3**. Fine orange clay, smoothed inside; black wash outside, continuing round inside of rim with thin stripe below.
532 (N328) FIG. 7.14. D. 23. Class **b4**. Rim of irregular shape. Fine orange clay with dark brown to black wash.
533 (N329) FIG. 7.14. D. 10. Class **c1**. Rim of irregular shape. Orange clay with greenish tinge, plain inside; traces of black wash outside, much flaked away.
534 (N331) FIG. 7.14. D. 12. Class **c2**. Fine orange clay with black wash outside, continuing on top of rim inside. White band round neck.
535 (N330) FIG. 7.14. D. 11. Class **c2**. Fine orange clay with black wash outside, continuing on top of rim, which is neatly hatched in white. There is one other similar rim.
536 (N332) FIG. 7.14. D. 15. Class **c4**. Fine orange clay with overall red-brown wash outside and on top of rim, which may have been hatched in white. White band round neck.

TYPE 17. LARGE SPOUTED BOWLS OR JARS WITH HORIZONTAL SIDE-HANDLES **537–543**

There are 14 rims of cooking pot ware from jars of this type, one or two of them with what may be the stumps of horizontal handles, and **537** with a spout of class **b**. Another complete spout (PLATE 31: **539**) was noted, and fragments of two or three others similar. About 1/2 the rims show traces of decoration in white, and three or four have warts (PLATE 31: **540**; cf. **538**).

537 (N285) FIG. 7.14. Rim with spout of class **b**. D. 20. Light brown wash. Decoration in white.
538 (N286) FIG. 7.14. Rim with wart on shoulder. D. 35. Light brown wash outside; inside wiped.

Two flat-topped rims of class **c4**, and one rim with an internal ledge for a lid as class **e2** (PLATE 31: **541**) may have belonged to jars of this kind.

542 (N287) FIG. 7.14. D. 20. Very fine cooking pot type ware. Hard fabric: clay grey at core, red-brown at edges; outside shades of red and brown with high stroke burnish.
543 (N288) FIG. 7.14. D. 30. Wart below rim. Fine cooking pot ware with red shading to brown wash outside, smoothed.

TYPE 18. LARGE BOWLS OR JARS WITH INWARD CURVING, OFTEN CARINATED AND THICKENED RIMS **544–545**

There are seven rims of cooking pot ware as **544–545** (N283–4) (FIG. 7.14, D. 40). **544** has a slight carination and a small vertical handle set below it, and a reddish brown wash. **545** has a red wash.

TYPE 23. TRIPOD COOKING POTS **546–547**

Of five tripod legs, two are of round and three of thinnish oval section (PLATE 31: **546–547**).

TYPE 26. THERIOMORPHIC VESSEL 548

One foot **548** (N333) (PLATE 29) was found. It is of fine buff ware, with orange clay with a buff surface, scraped and well smoothed outside, and has traces of decoration in black. Cf. the possible foot fragment **405** (A2).

SPOUTS AND HANDLES

Cf. A3. Handles are in general of round section, but one strap handle is of oval section like some from A3.

DECORATION 549–550

Three fragments which may come from bowls of type 9 have a dark wash inside and outside and are decorated with groups of diagonal stripes in white. On **549** (N238) (PLATE 32) the stripes are combined with alternate rows of small dots. This has a red wash, while another of the three **550** (N239) (PLATE 32) has a black wash.[24]

EARLY MINOAN III

DEPOSIT A5: FLOOR IV

Levels LA99–LA99A. Amount: about 1 table.

This material includes a fair amount characteristic of EM II, but also much that corresponds to what appears to be peculiar to EM III in B3. There was some intrusion of later material, notably about 12 sherds of wheelmade pots, including some LM I (mostly LM IA, but one that could be LM IB) and four or five that seem MM II. Earlier strays include one or two scraps of Neolithic, and some that may be EM I.

FABRIC

Fine ware
There seems to be an improvement in the fabric compared with earlier levels in area A. Much of the pottery now has a black or red wash, which is apt to be of better quality, more stable and less flaky, and also more lustrous, than the washes in the earlier levels. But there is still a certain amount of fine buff ware with a buff or orange-buff burnished surface.

Cooking pot ware
Some of the cooking pot ware has a red wash, as is usual in EM II; but in general brown surfaces are now more dominant.

Vasiliki ware **551–553**
One scrap of a bowl rim **551** (N259) (FIG. 7.15, PLATE 26; D. 15) is of true Vasiliki ware. Scrap **552** (N356), apparently of Vasiliki ware, comes from a cup or goblet, and a similar fragment **553** (N361) from a larger open vessel or bowl.

Light grey ware **554**
A scrap of rim **554** (N354) (FIG. 7.15; D. 18) is of this fabric, and stroke burnished.[25]

TYPES

TYPE 1A. CUP WITH LARGE LOOP HANDLE

One long handle of round section may come from a cup of this characteristic EM II type. It is of fine orange clay, with a red wash inside and out.

[24] Rows of dots flanked by lines occur in light-on-dark in the repertory of East Cretan EM III. These rows may be straight or curving, and some of the straight examples are diagonal like **549** (e.g. Zois 1967*b*, pls. 12: 32; 13: 47; 17: 6, 8; 19: 31). The motif is usually single; a double version, however, reminiscent of **549**

but curving, appears on the lower part of a teapot from Vasiliki: Seager 1907, 121–2, 129, fig. 13 (= *PM* I, 109, fig. 76 top left). Cf. Zois 1967*b*, pl. 22: 72.
[25] Mentioned by Wilson and Day (1994, 12).

TYPE 1B. CUP WITH VERTICAL HANDLE 555

Base **555** with a row of large solid spots in dark-on-light may belong to a cup of this type, which is represented in B3.

555 (N348) FIG. 7.15, PLATE 32. Base, perhaps of straight-sided cup. D. base 9. Fine orange clay with well smoothed or burnished buff surface, including under base. Decoration in red-brown: row of large solid spots between bands.

TYPES 2 AND 3. FOOTED GOBLETS AND GOBLETS 556–571

There are about 15 eggcup feet of goblets of type 2 as opposed to about 13 simple goblet bases of type 3. Goblets of type 3 would therefore seem to be nearly as common as footed goblets of type 2. This clearly links this deposit with B3 rather than the EM II phase(s) in which simple goblets of type 3 appear extremely rare.

(a) Eggcup feet of type 2

Examples include **556–559** (N190–3) (FIG. 7.15): about 15 exist (D. base 4.5–5.5). Nearly all have a wash (five black, eight or nine red or light brown) outside, and in all bar two of these the wash also covers the inside of the bowl of the goblet. In no case, however, does the wash extend to cover the underneath of the foot; but four feet have a band of paint round the edge of the underneath (e.g. **558**: N192), and **559** (N193) (PLATE 31) has a large solid spot in the centre of the underside. One **556** (N190) of the two feet with a wash outside but with a plain (without a wash) inside to its bowl, may be an EM II stray. It is exceptionally high; the plain inside surface is burnished.

(b) Simple bases of type 3

About 13 exist, including one complete profile (D. base c. 4.5–5). All have an overall wash (six black, seven red) covering the whole of the inside as well as the outside and continuing underneath the base. Rims of goblets of this type are normally indistinguishable from those of type 2.

560 (N200) FIG. 7.15, PLATE 32. Frags. of rim and base. D. 8. D. base 4.6–4.7. Fine orange clay, with dark red wash inside, dark brown to black outside. Decoration in white with groups of vertical stripes. There are frags. of another similar (PLATE 32: **561**).

Goblet rims of types 2 and 3

About 65 exist (D. 7–10, but mostly between 8 and 9.5). One or two are somewhat S-shaped, as **562** (N199) (FIG. 7.15; D. 8). About five rims were evidently made with their tops deliberately flat, e.g. **563** (N195); but **564** (N194) (PLATE 32) appears to have been cut flat at some later stage, presumably after the rim had been chipped in use. The outside surfaces of many of the rims show clear traces of having been wiped or scraped.

Only rim **565** (N196) is light surfaced, of orange clay with a thin red stripe round the top; it may be a stray from an EM II horizon. All the other rims have an outside wash (41 black, 23 red), and in all except two of these the wash covers the inside of the bowl as well; but even these two exceptions have a band of red or black wash round the inside edge of the rim. **566** (N 197) (FIG. 7.15, PLATE 32; D. 7) has a black wash, and decoration in white consisting of a row of solid triangles set between groups of horizontal stripes.

Rows of solid triangles are already attested as a motif of decoration in dark-on-light in EM IIA.[26] The motif seems to be rare in the light-on-dark of East Cretan EM III, but occurs as a fill ornament on a fragment from Gournia.[27]

One or two rims have a narrow white band round the outside, but 19 have a band (10 black, nine red) below the rim (e.g. PLATE 32: **567**). **568** (N198) with a black wash as a white stripe on top of the rim and three narrow horizontal bands below it. A black washed fragment **569** (N207) from a goblet body has a pair of horizontal stripes and a diagonal band beneath them (PLATE 32). Several rims, some 10 to 12, bear traces of such diagonals, either single broad bands (PLATE 32: **570**), or groups of two or even three narrow stripes. The remarkable rim **571** (N350) (FIG. 7.15, PLATE 32; D. 7), apparently from a goblet, has groups of thin diagonal stripes in white flanking a zone of barbotine scales in relief (see p. 174 below).

[26] E.g. Wilson 1985, 323–5, figs. 22–3, pl. 38: P218. [27] Zois 1967b, pl. 13: 67.

TYPE 4. SHALLOW BOWLS OR PLATES WITH RIM THICKENED INTERNALLY **572–573**

(**a**) *Rounded rims*
Only three scraps of rounded rims were found. All are of fine buff ware, with an orange or buff surface and a characteristic red band round the inside. **572** (N242) appears to have solid semi-circles on top of the rim.

(**b**) *Bevelled rims*
Five of these include the flaring rim **573** (N241) (FIG. 7.15; D. 21). All are of fine buff ware, with an orange or buff surface and a band round the inside of the rim in red or dark red-brown.

TYPE 5. BOWL WITH UPRIGHT SIDE AND RIM THICKENED INTERNALLY **574**

Only rim **574** (N240) (FIG. 7.15, PLATE 32; D. 15) is assignable to this type. Of fine buff ware, it has decoration in red of a pair of narrow red bands outside, and one below the rim inside; on the rim itself crossing diagonals form a thick lattice.

The comparatively few rims of types 4 and 5 may be EM II strays but, if they are contemporary with the deposit, they would reflect its position as intermediary between EM IIB and EM III as defined in B3.

TYPE 6. DEEP BOWLS WITH UPRIGHT SIDES **575–577**

Three straight upright rims of small bowls or bowl-jars with fine burnished surfaces are grouped here. **575–576** have the top of the rim hollowed as if to form a rest for a lid, and **576** preserves the stump of what may be a horizontal side-handle. **577** has a large wart set below the rim.

575 (N251) FIG. 7.15. Rim with neat hollow ledge inside, perhaps to hold lid. D. 16. Fine orange clay; buff slip inside, well smoothed or burnished; outside and top of rim have dark brown to black wash, also well smoothed or burnished.
576 (N252) FIG. 7.15. Rim with neat hollowing of top, perhaps for a lid. D. 16. Stump of possible horizontal side-handle set well below rim. Buff inside surface with fine stroke burnishing; outside and top of rim have red-brown wash, very well smoothed or burnished.
577 (N253) FIG. 7.15, PLATE 32. Rim with large wart set below it. Fine orange clay, pale grey at core, with buff inside surface with fine stroke burnishing; outside and top of rim have dark red to black wash, well smoothed or burnished.

TYPE 7. SHALLOW BOWL WITH STRAIGHT OR INWARD CURVING SIDE **578**

Five or six rims of fine buff ware (D. between *c.* 15 and 20) are assignable to this type. All are scraped outside and decorated with a wide band in red or black round the inside of the rim. Rim **578** (N289) with bevelled edge in cooking pot ware appears to come from a large bowl of this shape.

TYPES 8/9. BOWLS WITH FLARING OR EVERTED RIM **579–594**

Bowls of this kind are evidently common. About 65 rims are assignable to these types, including **579–586** (N254–61) (FIG. 7.15: **579–580**, D. 26; **581**, D. 40; **582**, D. 27; **583**, D. 30; **586**, D. 20). Some 45 of these (over 3/4 of the total) apparently come from deep bowls of class A, and about 20 (less than 1/4) from shallow bowls of class B. Rim diameters range between 12 and 36, mostly between 20 and 30.

These rims appear to be in general thicker, and the bowls to which they belong are evidently of heavier fabric, than their equivalents in EM II. There is great variety in the profiles of rims. Several are markedly turned down, as **579**. This feature is also noticeable on rims of the equivalent bowls from EM II levels, and may have been deliberate.[28] One or two rims have a bead on the outside edge as **587** (N246) (FIG. 7.15; D. 35). Two rather small round section horizontal handles may come from bowls of this kind. In contrast, the equivalent bowls from B3 appear to be handleless.

Fabric
The firing tends to be good and, in spite of the comparatively thick walls of the bowls, the clay is apt to be an even colour throughout. Rim **588** (N245) (FIG. 7.15; D. 20), assignable to this type, is of cooking pot ware with a red-brown wash. Over 1/2 of the rims (35) have an inside wash (13 black, 22 red); and nearly all of these have an outside wash as well. Only three or four (about one in 10) are

[28] Cf. **968** (B2), and Tylissos: Hazzidakis 1934, 82, pl. 20.3b.

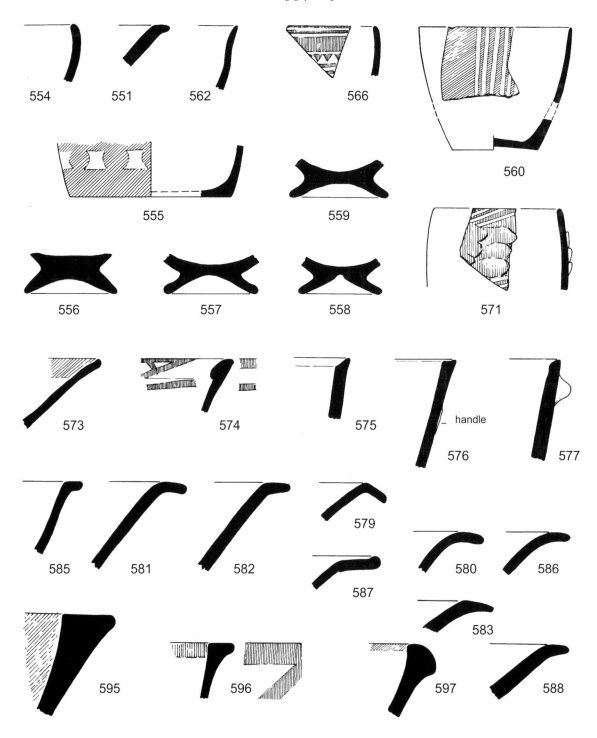

FIG. 7.15. Deposit A5 (EM III). Vasiliki ware **551**; light grey ware **554**; EM III type 1B cup with vertical handle **555**;
type 2 footed goblets **556–559**; type 3 goblet **560**; types 2 or 3 goblet rims **562**, **566**, **571**; type 4 shallow bowl or plate:
(**b**) bevelled rim **573**; type 5 bowl **574**; type 6 deep bowls **575–577**; type 8/9 bowls **579–583**, **586–588**; type 10 large
bowls **595–597**. Scale 1:2.

light surfaced with no wash outside. This is in striking contrast to B3, where the equivalent bowl
rims with a wash on the inside alone outnumber by more than two to one those with a wash on the
outside and inside.

Some seven or eight (over 1/5) of the rims with wash inside and outside have a mottled surface like
Vasiliki ware, e.g. **589** (N389); in most of these the washed surface is well smoothed or burnished, or
the wash itself is lustrous. The large number of these rims, and their orthodox shape, contrasting with

the short everted rim of a bowl of standard Vasiliki ware **551** from the same deposit, suggest that they are from bowls of local make: the resemblance of the fabric to Vasiliki ware may be fortuitous, or the bowls may be local imitations of that ware, rather than late and degenerate examples of it imported from eastern Crete. On the other hand it is noteworthy that all except one of these seven or eight rims evidently come from class B deep rather than the more common class A shallow bowls.

One exceptional short everted rim of a deep bowl **590** placed here has a small solid triangular lug projecting horizontally from it. Its fabric is akin to the soft red burnished ware of MM II, and it may be a later stray: the clay is soft, under-fired and dusky at the core; the inside surface is buff, burnished; the outside has a burnished red wash.

Decoration

Of the nine rims (apart from **590**) that are plain inside, six are from class A shallow bowls, three from class B deep bowls. The rims from the deep bowls have a band (one black, two red) on the inside continuing on top of the rim, which is painted solid; on the two rims decorated in red, the outside is well stroke burnished. Four of the six shallow rims belong to bowls of somewhat small size with diameters between 12 and 20. These, and one other rim from a shallow bowl, have a top painted solid. Finally, the rim of a shallow bowl **591** (PLATE 30; N262) is irregular, like some of the rims from the EM IIB A4 deposit; it has a buff surface and is decorated with bands in black below the rim inside and outside, and on top of the rim with a pair of diagonal stripes. A diagonal stripe in dark red-brown appears on top of rim **592** (N243), which comes from an exceptional bowl; it has a wash over the rest of the inside, but the area of the rim is reserved.

Diagonal bands in white are found on several of the bowl rims that have an inside wash; usually these white bands are single, but once at least, on the rim of cooking pot ware **593** (N245), they are double. These diagonals on the rim continue the EM II tradition: diagonals are virtually absent (there is only one possible instance) from the rims of the equivalent bowls in B3. One rim with a wash **594** (PLATE 30; N244) has what appears to be part of a solid semi-circle in white on top of it; semi-circles in dark-on-light may have adorned the top of bowl rim **572** of type 4 (see above).

These rims with decoration in white (and a few other rims with an overall wash but no decoration) have traces of white bands below the rim inside; and there are white bands round the insides of two or three bases which evidently come from such bowls. Only one or two of the rims with a wash outside as well as inside have possible traces of white bands below the rim outside. But indications of horizontal bands or stripes in pairs appear on the outsides of three fragments from the walls of such bowls.

TYPE 10. LARGE BOWLS WITH STRAIGHT SIDES AND THICK EVERTED RIMS **595–597**

Six rims of various sizes are assignable to this type. Of the coarse gritty fabric that appears to have been usual for such bowls, they have a buff slip inside, or on both the inside and outside. Two rims appear to be from bowls with a red wash inside, e.g. **595**. All these rims are painted solid inside and outside and along the top.

595 (N249) FIG. 7.15. D. 40. Red wash inside, continuing as wide band round outside of rim.
596 (N250) FIG. 7.15, PLATE 32. D. 20. Rim painted solid, and diagonal band outside, in dark red-brown.

597 (N353) FIG. 7.15. Angle and diameter uncertain. Coarse orange clay, dusky at core, with orange-buff slip. Rim painted solid in red-brown.

TYPE 11. LARGE BOWLS WITH CURVING, OFTEN CARINATED, SIDES AND THICKENED RIMS **598–599**

Two scraps of rim **598–599** were recognised as coming from cooking pot ware bowls of this characteristic EM II type.

598 (N290) Rim: cf. class **a**. D. very large. Purple-brown to reddish wash.

599 (N295) Rim: cf. class **b**. D. *c*. 40. Red wash.

TYPE 12. LARGE DEEP BOWLS OR JARS WITH THICK TRIANGULAR-SECTIONED RIMS **600–601**

Rim **600** belongs to this distinctive type of which several examples come from B3: cf. **1088**. There are also about seven rims like **601**.

600 (N291) FIG. 7.16, PLATE 30. Rim with wart below. D. 30.Cooking pot ware, brown outside, inside red-brown.
601 (N292) FIG. 7.16. D. 50. Cooking pot ware with

red to light brown wash. There are about six other similar rims, two of them with sharply carinated shoulders.

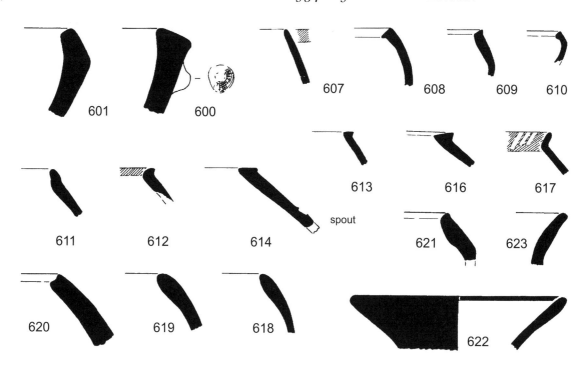

FIG. 7.16. Deposit A5 (EM III). Type 12 large deep bowls or jars **600–601**; type 16 small spouted bowl-jars **607–614,
616–617**; type 17 large spouted bowls or jars **618–620**; type 18 large jar **621**; type 19 large jars **622–623**. Scale 1:2.

TYPE 14. BAKING PLATE **602**

The only baking plate rim **602** (N296) (PLATE 30) is of rounded profile with a dark brown wash.

TYPE 15. JUGS WITH CUTAWAY SPOUTS **603–606**

There are fragments of seven or eight spouts from jugs, many of them with remains of a wash and one
or two of these with traces of decoration of stripes or bands in white. This prominence of washed jugs
with decoration in light-on-dark in A5 contrasts with the apparent popularity of jugs of fine buff ware
with a burnished surface and decoration in dark-on-light in B3.

Jug fragments with a light surface from A5 include two bits of spouts: one is of orange clay with a
greenish slip, decorated in red-brown with triple chevrons in the characteristic EM II style (PLATE 32:
603). Another fragment, which may come from the neck of a jug, is of fine buff ware, with orange clay
with a buff surface, vertically pared and afterwards well smoothed or burnished, and decorated in
black with a group of stripes and a large solid spot below (PLATE 32: **604**) (N347). A scrap, apparently
from the body of a jug, has lattice in red (PLATE 31: **605**).

Fragment **606** (PLATE 32) with the stump of a handle appears to come from the body of a jug; it is
of fine buff ware, the clay orange with a worn black wash outside; the lower part of the body
below the handle is decorated with incisions. Similar incised decoration occurs on one or two fragments
of jugs from B3.

Only three handles of jugs are preserved to the rim: two are set to the rim like the jug handles in
the Palace Well, one to below the rim.

TYPE 16. SMALL SPOUTED BOWL-JARS **607–617**

The rims assignable to these seem to correspond to rims from EM II levels rather than to those from
B3. Of 18 rims, five (over 1/4) are of the characteristic EM II class **b2**, while another five are flat-
topped as class **c4**. Two rims, one of class **a**, the other of class **c4**, are associated with the stumps of
spouts. All except three of the 18 rims evidently come from vessels with an outside wash, most commonly
black, but sometimes red. The three remaining rims are of fine buff ware with light surfaces; of these
609–610, both EM II class **b2**, belong to vessels with a very fine burnish but evidently with no
painted decoration. Carinations are much in evidence. All the nine carinated fragments, coming from
small jars of this type or perhaps jugs of type 15, have an outside wash (seven black, two reddish).

607 (N360) FIG. 7.16. D. 11. Class **a1**. Fine buff ware: orange clay with buff slip. Band in red-brown round outside of rim. Three other rims similar, but with outside wash.

608 (N366) FIG. 7.16, PLATE 32. D. 20. Class **b2**. Fine orange clay with black wash of good quality with metallic sheen. Decorated with groups of neat diagonal bands in white.

609 (N340) FIG. 7.16, PLATE 32. D. 10. Class **b2**. Fine buff ware: orange clay with orange-buff surface with fine stroke burnishing.

610 (N337) FIG. 7.16, PLATE 32. D. 8. Class **b2**. Fine buff ware with well burnished orange-buff surface: cf. **609**.

611 (N338) FIG. 7.16. D. 7. Class **c1**. Fine orange clay with black wash outside, continuing inside of rim.

612 (N339) FIG. 7.16. D. 10. Class **c2**. Fine orange clay with black wash outside, continuing round inside of rim. White band round neck.

613 (N344) FIG. 7.16. D. 6. Class **c4**. Fine orange clay with black wash outside, continuing on rim and as band round inside.

614 (N342) FIG. 7.16, PLATE 32. D. 10. Class **c4**. Stump of spout. Fine orange clay with red-brown wash outside, continuing on top of rim. Inside buff, smoothed. White band round neck; rim hatched in white. A similar rim **615** has triple diagonal stripes in white (PLATE 32).

616 (N343) FIG. 7.16, PLATE 32. D. 10. Class **c4**. Fine orange clay with dark brown to black wash outside, continuing on top of rim. Traces of decoration in white.

617 (N341) FIG. 7.16, PLATE 32. D. 10. Cf. class **d2**. Fine orange clay with buff slip, and red wash outside, continuing round inside of rim. Outside of rim painted white; groups of three short diagonal strokes in white inside rim.

TYPE 17. LARGE SPOUTED BOWLS OR JARS WITH HORIZONTAL SIDE-HANDLES **618–620**

There are about a dozen rims of jars of this type, the majority being of cooking pot ware, but one or two of coarse ware as **618**. One rim of cooking pot ware has a tubular spout of class **b**; two others have warts. Several of the rims of cooking pot ware have their tops flattened or bevelled on the inside like **620**.

618 (N335) FIG. 7.16. D. 22. Class **b1**. Rather coarse gritty clay, dusky at core. Outside with poor black wash. Decorated with broad diagonal bands in white.

619 (N294) FIG. 7.16. D. 30. Class **b1**. Fine cooking pot ware. Outside (but apparently not inside) with red to light brown wash.

620 (N293) FIG. 7.16. D. 16. Cooking pot ware with dark brown to reddish wash.

TYPE 18. LARGE BOWLS OR JARS WITH INWARD CURVING, OFTEN CARINATED AND THICKENED RIMS **621**

One or two scraps of rim of cooking pot ware were recognised as coming from this characteristic EM II type.

621 (N362) FIG. 7.16. D. 25. With carination. Fine cooking pot ware with red wash, well smoothed or burnished outside.

TYPE 19. LARGE JARS WITH NARROW NECKS AND WIDE EVERTED MOUTHS **622–623**

Two scraps of rim were recognised from jars of this type. Fragments of jars like this were found in B3, but there is no evidence for them in EM II levels.

622 (N346) FIG. 7.16. D. 12. Orange clay with fine grit, and greenish buff slip. Traces of black wash outside, continuing round inside of rim.

623 (N359) FIG. 7.16. D. 13. Fabric like **622**, but with red-brown wash.

SPOUTS

The only spout recovered is a large example of class **b** belonging to a jar of type 17.

HANDLES **624**

Handles are normally of more or less round section, but there are six thick strap handles (e.g. PLATE 32: **624**) ranging in size from medium to small: all are of thick rectangular section, one or two more or less concave.

BASES

Bases are in general flat. A fragment of a fairly large pellet foot may be an earlier stray: it is of fine orange clay, dusky at the core, with a well smoothed buff slip, and has a red stripe round the base of the foot.

DECORATION

Paint

Dark-on-light

Thin stripes appear on one or two scraps, which may be earlier strays. There is lattice in red on **605** (PLATE 31), apparently from the body of a jug. Large spots occur twice: on fragment **604** (N347) (PLATE 32), probably a jug neck, and on what may be a cup base **555** (FIG. 7.15, PLATE 32). Solid semi-circles appear to have adorned bowl rims in two instances, in dark-on-light on **572** (N242), and light-on-dark on **594** (N244).

Light-on-dark

Stripes and bands occur singly or in groups; they are often and characteristically diagonal, especially on the bodies of small jars of type 16. One scrap, perhaps from a cup, has lattice in white. Diagonals may cross to form a bold lattice, as on **624**.

Incision **625–626**

Incision is rare, but occurs on jug fragment **606** (PLATE 32) and on a jar fragment in fine cooking pot ware with a red to light brown surface **625** (PLATE 32). A fragment of fine cooking pot ware, flat and perhaps from a lid of some kind, has boldly grooved chevrons **626** (N349) (PLATE 32). Similar bold incised chevrons seem to have adorned the base of jug neck **994** (B2).

Relief

Warts occur, notably on the shoulders of large spouted jars of type 17.

Barbotine **627–629**

Sophisticated barbotine in such an early horizon is surprising; but the isolated example **629** of fine 'barnacle work' barbotine is paralleled by **1102** (PLATE 46) from B3; and a couple of goblets with decoration of this type were found in the UEW.[29]

 The three fragments with fish scales in relief **571** (which has been introduced above) and **627–628** are of great interest. As already noted (p. 130), Foster has suggested[30] that 'barnacle work' barbotine might have developed from relief work of this kind, and fish scales like those of our examples appear on vessels from levels at Beycesultan assigned to EB I, which overlaps with Troy I.

571 (N350) FIG. 7.15, PLATE 32. Rim of goblet (?). D 7. Fine orange clay with black wash outside, continuing round inside of rim. Zone of fish scales three deep in relief, flanked above and below by fine diagonal stripes in white.
627 PLATE 32. Frag. of jar or jug with fish scales in relief. Fine orange clay with dark brown wash outside.

628 PLATE 32. As **627**, but with black lustrous wash outside.
629 (N351) PLATE 32. Frag. of large jug or jar with fine barnacle work barbotine. Fine cooking pot type ware, with black wash outside.

Rippling **630**

One fragment **630** has a rippled surface. The rippling appears to be deliberate, made with an instrument for decorative effect, like the rippling of FN I(A) at Knossos.[31]

630 (N352) PLATE 32. Body frag. of jug or jar. Fine orange clay with buff inside surface; outside rippled, apparently for decorative effect, before application of good quality red-brown wash.

IMPORT **631**

The only certain import recognised was **631**, which may come from the Cyclades.

631 (N355). Frag. of large jar. Fine hard sandy ware: cf. **1143** (B3). Greenish clay, dusky at core; outside with good quality black wash, soapy to the feel.

[29] Momigliano 1991, 156–7, 161, pl. 18: 8; 156–7, fig. 1, pl. 18: 9 (Momigliano 2007c, 84–5, fig. 3.3: 1).

[30] Foster 1982, 148.
[31] Cf. Tomkins 2007, 32–3.

Deposit A6: Floor III

Levels LA103, LA102. Amount: about 1/4 table.

This small group of material, from above the latest of the series of early floors beneath Floors II and I of LM IA and IB, seems to correspond in a general way to our B3 deposit. There is no hint of polychrome decoration to suggest MM IA. Two scraps of wheelmade cups or bowls are evidently strays from LM I levels above.

TYPES

TYPE 2. FOOTED GOBLETS **632–633**

Only seven eggcup feet from goblets of this type were found, ranging in diameter from 4.5 to 5.5. They have an outside wash (one red, six black) which for all bar one covers the inside of the bowl as well; but in no case is there any sign of a wash under the foot. Foot **632** (N185) is decorated with a broad white band immediately above the waist, but not round it as was common in EM II. The end of a wide diagonal band in white appears on the body of a goblet attached to foot **633** (N186).

TYPE 3. GOBLETS **634–638**

One complete profile **634** and seven bases were found, the bases ranging in diameter from 3.5 to 4.5. All are of fine ware except one of cooking pot ware. All except one have a wash (three black, four red) inside and outside, and continuing under the base. One has a wash only on the outside.

634 (LA/61/P17) FIG. 7.17, PLATE 33. 1/2 pres. Ht *c.* 5.8. D. *c.* 8. Fine orange clay with lustrous black mottling to red-brown and red wash, including under base. Decoration in white: band below rim, worn. Cf. Yiofyrakia (Marinatos 1935, 51, fig. 4: 9).

Rims of goblets of types 2 and 3: about 29 (D. 8–10, mostly between 8 and 9). These rims are rather thick in comparison with those from EM II deposits and from A5. **635** (N187) (FIG. 7.17; D. 9) was apparently made with a flat top: it has a wash, red inside and light brown outside, with a narrow white band to the rim. Two other rims were deliberately cut flat, doubtless after the original rim had become chipped in use, e.g. **636** (N367) (PLATE 32). All these rims have an outside wash (18 black, 11 red) and all except one a wash inside as well. The exception **637** (N188) shows a narrow band of wash round the inside of the rim, while the rest of the inside has a buff slip, well smoothed. Decoration in white includes a band round the outside of the rim or below it; a band below the rim is sometimes combined with a thin stripe on its top edge. Two instances were noted of white diagonal bands on the body of a goblet, e.g. **638** (N189).

TYPE 4. SHALLOW BOWL OR PLATE WITH RIM THICKENED INTERNALLY **639**

One scrap of rim is assignable to a bowl of this characteristic EM II type, and is of the less common class **b**.

639 (N368) Rim of class **b**. D. *c.* 15. Fine buff ware: orange clay with buff surface, scraped outside. Band in light brown round top of rim inside.

TYPE 7. SHALLOW BOWL WITH STRAIGHT OR INWARD CURVING SIDES **640**

The only rim assignable to a bowl of this type **640** is exceptional. It is somewhat reminiscent of Vasiliki ware both in shape and fabric, and may then be an import from eastern Crete, although the scheme of decoration does not exactly correspond to anything illustrated by Betancourt[32] and can be paralleled in EM IIB deposits at Knossos — e.g. **512** (A3) and **911** (B1).

640 (N369) FIG. 7.17, PLATE 32. D. 22. Fine orange clay with red mottling to dark brown wash. Inside decorated in thick very creamy white: groups of diagonal stripes alternating with large solid spots between horizontal bands.

[32] Betancourt 1984.

TYPES 8 AND 9. BOWLS WITH FLARING OR EVERTED RIM **641–644**

Large bowls of this type seem to be common and characteristic, as in B3. Some 10 rims were found (D. *c.* 20–30): about four of these are apparently from sub-type B (deep), and six from sub-type (A) shallow, bowls. One or two rims are (a) differentiated; most are (b) slightly differentiated, a few (c) undifferentiated. Only three or four of the rims have a wash, usually black, inside and outside; two of these bear decoration in white. Rim **644**, of true soft sandy ware, may have had a red wash. The other six rims are light surfaced, of orange clay with a buff slip, **641** with fine stroke burnishing inside and outside. All these light surfaced rims have a wide band (four red, two light brown) on top of the rim inside.

641 (N370) FIG. 7.17. D. 30. Orange clay with well stroke burnished orange-buff surface. Traces of red band on top of rim.
642 (N371) FIG. 7.17. D. 26. Orange clay with some grit; surface with paler slip. Band on top of rim in light red-brown.

643 (N372) FIG. 7.17. D. 24. Hard fabric: rather sandy orange clay with paler slip. Red band on top of rim.
644 (N373) FIG. 7.17. D. 22. Soft sandy ware: sandy orange clay, surface much worn. Traces of red paint — remains of a band or overall wash — on top of rim.

TYPE 10. LARGE BOWL WITH STRAIGHT SIDE AND THICK EVERTED RIM **645**

One rim of a bowl of this kind was found.

645 (N374) FIG. 7.17, PLATE 32. D. 30. Gritty orange clay, grey at core, with paler slip. Decoration in red: band round outside and on top of rim, with pair of diagonal bands

below. For rim profile cf. Blackman and Branigan 1982, 34, fig. 13: 173; 36.

TYPE 11. LARGE BOWL WITH CURVING, OFTEN CARINATED, SIDE AND THICKENED RIM **646**

One rim is assignable to a bowl of this type.

646 (N384) FIG. 7.17. Rim of class **a**, with slight carination. D. 40. Fine cooking pot ware with red wash.

TYPE 12. LARGE DEEP BOWLS OR JARS WITH THICK TRIANGULAR-SECTIONED RIM **647–648**

Rim **647** with a wart below it conforms to this type, which is well represented in B3. Another large rim **648** is grouped here; it is internally thickened in the way that was much in favour on vessels of many different types in EM II. Both are in cooking pot ware.

647 (N382) FIG. 7.17, PLATE 30. D. 45. Large wart below rim. Fabric as **648**.
648 (N381) FIG. 7.17. D. 40. Coarse gritty grey clay,

red-brown at edges, with wash in shades of dark brown to reddish.

TYPE 15. JUGS WITH CUTAWAY SPOUT

No fragments of jugs were recognised.

TYPE 16. SMALL SPOUTED BOWL-JARS **649–653**

Five rims are assignable to vessels of this kind. Two of them approximate to class **b2**, which was very common and characteristic in EMII levels, but not represented in B3. **651** has part of a vertical strap handle: cf. type 16A. There is a hole for a spout below the rim on **653**. All five rims have outside wash (four black, one red).

649 (N375) FIG. 7.17. D. 16. Class **a1**. Orange clay with light-brown to reddish wash outside, red inside.
650 (N376) FIG. 7.17. D. 16. Class **b2**. Orange clay with black wash. Traces of diagonal stripes in white outside.
651 (N379) FIG. 7.17. Cf. class **b2**. Vertical strap handle of oval section set below rim. Fine orange clay with buff slip inside, which is smoothed. Outside with black shading to dark brown and reddish wash. Decoration in white: band

round neck, and hatching on top of rim.
652 (N377) FIG. 7.17. D. 10. Cf. class **c1**. Fine pale orange clay with greenish tinge. Slight remains of black wash, much flaked away.
653 (N378) FIG. 7.17 . D. 5.5. Cf. class **c2**. Hole for spout. Fine orange clay with black wash outside, continuing on top of rim. Decoration in white: band round neck and horizontal stripes below.

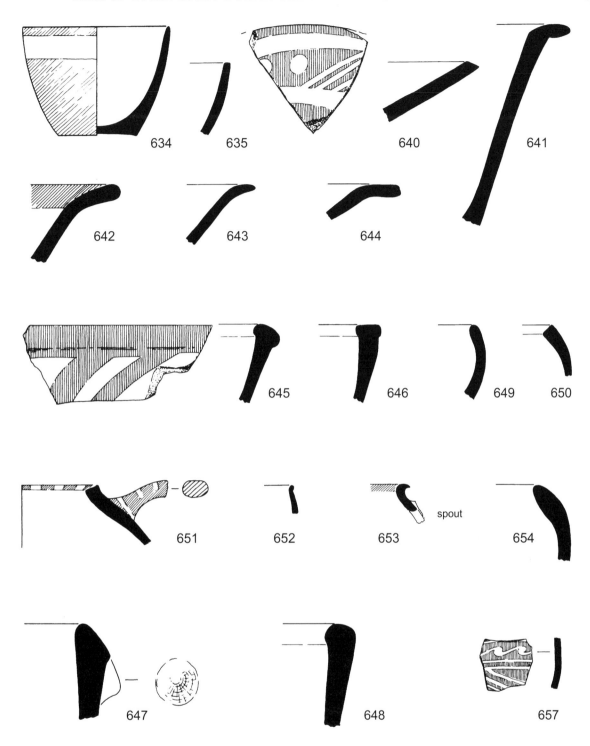

FIG. 7.17. Deposit A6 (EM III). Type 3 goblets **634–635**; type 7 shallow bowl **640**; types 8 and 9 bowls **641–644**; type 10 bowl **645**; type 11 large bowl **646**; type 12 large deep bowls or jars **647–648**; type 16 small spouted bowl-jars **649–653**; type 17 large spouted bowl or jar **654**; decoration in light-on-dark **657**. Scale 1:2.

TYPE 17. LARGE SPOUTED BOWL OR JAR WITH HORIZONTAL SIDE-HANDLES **654**

There is one possible rim, of cooking pot ware.

654 (N383) FIG. 7.17. D. 40. Clay grey, red-brown at edges. Outside with dark brown to black wash.

TYPE 19. LARGE JAR WITH NARROW NECK AND WIDE EVERTED MOUTH **655**

A possible fragment from the rim of a jar of this type, which is represented in A5 and B3, is **655** (N380), of gritty orange clay with a buff slip, and the top of the rim painted solid inside and outside in light brown.

SPOUTS

One open trough spout from a bowl or jar rim has a black wash on the outside, continuing round the inside of the rim. A fragment of a nozzle spout of class **b2** was also found.

HANDLES **656**

Handles are normally round in section but one vertical strap handle of oval section **651** (N379) is preserved to the rim of a jar of type 16. **656** (N386) (PLATE 32) is a fragment of a double round section handle of fine buff clay with traces of decoration in red-brown.[33]

CARINATIONS

A fragment from the carinated body of a jar, probably of type 16, has a black wash.

Bases were evidently flat.

DECORATION

Paint **657**

Two fragments with decoration in light-on-dark are remarkable: bowl rim **640**, which may be an import (see above); and **657** with a row of solid spots linked like spirals, a design that continued in fashion throughout MM I and into MM IIA.

657 (N388) FIG. 7.17, PLATE 32. Cup or goblet frag. Fine orange clay with dark brown and black shading to reddish wash. Decoration in white: horizontal and diagonal stripes, with row of solid spots linked like spirals. Linked spots of this type occur as part of a more elaborate design on Betancourt 1984, 27, fig. 3–6: 15 (Sackett *et al.* 1965, 251, pl. 27d), assigned to his Late Phase of East Cretan White-on-Dark which overlaps with MM IA at Knossos.

Incised **658**

One scrap in fine cooking pot ware **658** (N 385) (PLATE 32) has a raised band with incised hatching on it.

Relief

The incised band on **658** above, and a wart below the rim of **647**, are the only examples of this type of decoration from this deposit.

DEPOSIT A7 (A7.1, A7.2): FLOOR III?

A7.1: level LA54; A7.2: level LA51.

These two small groups of pottery excavated in 1960 came from the middle of the sounding that was made in depth in 1961. Some later intrusions were found in both groups; but the material is basically EM III in character, and may have been associated with Floor III of that date. Several large pieces of vessels from the smaller group 2 (level LA51) are reminiscent of debris above a floor. An admixture of EM IIB material in the larger group A7.1 (level LA54, stratified below LA51) suggests that it cut down into the deposit of Floor V.

A7.1: level LA 54. Amount about 1 1/4 tables.

Well over 1/2 the fragments of pottery of all kinds, including coarse and cooking pot ware, has an overall wash, more commonly a shade of black than of red by about 3:2. Much of the washed pottery

[33] For early examples of handles of this kind cf. Beycesultan: Lloyd and Mellaart 1962, 76–7, fig. P. 3: 9; 80, from level XXXVI (LCh I); Arad: Amiran 1978, pl. 11: 11, from level IV assigned to the latter part of Palestinian EB I; Jericho: Kenyon 1965, 16, fig. 4: 15–16, from phase I of tomb K 2 assigned to Proto-Urban A.

has traces of decoration in light-on-dark, but none of it has designs in red combined with white in the manner of MM IA.

A certain number of fragments appear to come from earlier (EM IIB) vessels. These include about seven rims from bowls of various types (including five of type 4) with decoration in dark-on-light, mostly in red, but in two cases in black. A fragment of a base with part of a red cross underneath may come from an EM II bowl of type 4. A solitary piece from a jug or jar has a dark wash mottled in the manner of Vasiliki ware, but the surface has not been smoothed or burnished in the classic Vasiliki manner.

One or two fragments appear to be intrusions from the LM I deposits immediately above the sounding here. These include two small strap handles, and the everted rim of a handleless cup of one of the types standard in LM I at Knossos, of plain orange clay with a paler surface.

TYPES

TYPE 2. FOOTED GOBLET 660

Some 15 fragments of feet come from the deposit, but over 1/2 are scraps. Diameters seem to range between 4.8 and 5.3. The feet are clearly not as high as those from EM II deposits. One foot has an upturned edge like FIG. 8.9: 3, suggesting it is of EM III date.

All but three of the feet (1/5 of the total) have an outside wash, and this (as far as it is possible to judge) covered the inside of the goblet bowl as well; but the feet are either plain underneath, or have a ring painted round the outer edge. Two or three feet are plain outside as well as underneath, apart from a red band round the waist as commonly found in EM II.

660 (N463; PLATE 33) from the body of a footed goblet has a red-brown to red wash and is decorated with a torsional design in white.

TYPE 3. GOBLET 661

Simple goblets without feet also occur: a virtually complete example is **661**; there are also two profiles and 21 base fragments. All bar three of these pieces have an outside wash: black for one profile and 10 other fragments, red on **661**, the other complete profile and eight base fragments. The wash normally appears to cover the underneath of the base, but on **661** and in two other cases the base is plain or has only a slight ring of paint round the outer edge. In most cases, but not on **661** which is unusual in this respect, the wash extends over all the inside as well as the outside of the goblet. Three fragments of bases are plain.

661 (N472) FIG. 7.18, PLATE 33. Complete except for part of rim. Ht 7.4. D. 7.8. Hole in base made after firing, perhaps to use goblet in libations. Outside wiped and coated with red to red-brown wash, continuing deep inside rim, but not over whole of underneath of base. Decoration in white: band below rim, and apparent stripe on top of rim.

TYPES 2 AND 3. FOOTED GOBLETS AND GOBLETS 662–667

Some 90 rims are assignable to one or other of these types. **662** is exceptional in having a flat top; and another was deliberately ground down to a flat top, perhaps after being chipped during use. All except three rims have an outside wash: two of these exceptions (including **664**) may be EM II strays, but the third, with a plain surface, may belong with one of the plain type 3 goblet bases noted above.

Black washes are commoner than red by 2:1 (some 58 rims black outside, 30 red). The wash normally seems to cover the inside of the rim as well, but in some two or three instances it only continues for a short distance into the inside of the rim. The rims with a wash are mostly scraps often with worn surfaces, but several retain traces of simple decoration in white, as on FIG. 7.19. More elaborate decoration as **662** and **663** seems rare.

662 (N465) PLATE 33. Flat-topped rim. Dark red-brown wash. Broad diagonal band in white on outside.
663 (N466) FIG. 7.18. D. c. 8. Red-brown wash. Decoration in white: diagonal stripes flanking what may be meant for a row of dots.
664 (N464) PLATE 33. D. c. 9. Orange clay. Decoration in red: thin band round outside, and diagonal band leading down from it. Possibly EM II.

665 PLATE 33. Dark red-brown wash. White band below rim, and stripe round inside of rim.
666 PLATE 33. Dark red-brown to black wash. Decoration in thick creamy white: band below rim and stripe on top of rim.
667 PLATE 33. Dark brown to black wash outside, red inside. Decoration in white, worn: pair of bands below rim.

TYPE 4. SHALLOW BOWLS OR PLATES WITH RIM THICKENED INTERNALLY **668**

Five rims of these appear to be EM II strays. Two scraps are of the characteristic EM II variety **a** with a red band round the inside, while the other three are of variety **b** as **668**.

668 (N467) FIG. 7.18. D. 18. Pale orange clay; buff surface. Outside scraped. Decoration in black: band round

inside of rim, continuing on bevelled outside edge. Two other similar rims with decoration in red.

TYPES 8 AND 9. BOWLS WITH FLARING OR EVERTED RIM **669–672**

Such bowls are evidently characteristic of EM III. Of about 18 rims, two or three belong to large bowls. The insides of all except three (about five in six) have a wash in shades of red, red-brown, or black. Traces of a white band were noted on the inside just below the rim in four or five instances. On **669** and **671** this is associated with a diagonal band of hatching along the top of the rim.

The other three rims are plain, except for their tops which are painted solid; the paint sometimes continues as a band below the rim inside and round its outside edge.

669 (N469) FIG. 7.18, PLATE 33. D. 18. Dark red-brown wash. Decoration in white: band below rim inside, and hatching along top of rim.
670 (N470) FIG. 7.18. D. 25. Orange clay. Red to dark red-brown lustrous wash. Traces of worn decoration in white: as **671**.

671 (N468) FIG. 7.18, PLATE 33. D. 30. Red-brown wash. Decoration in white: band below rim inside, and wide diagonal band along top of rim.
672 (N471) FIG. 7.18. D. 18. Orange clay; surface orange-buff, scraped and then burnished outside, wiped and smoothed inside. Rim painted solid in red to red-brown.

Several fragments of flat bases evidently come from bowls of these types. They have a wash inside and outside, and a broad white band around the inside.

JUGS

Only one or two scraps that might come from jug spouts were noted.

JARS **673–680**

(1) Some four rims of a simple type like **673** may belong to EM II vessels.

673 (N473) FIG. 7.18. D. 12. Stump of vertical handle to rim. Black wash outside continuing as band on inside of rim.
674 (N474) PLATE 33. Scrap with circular hollow-topped wart below rim. Dark red-brown wash.

675 (N475) PLATE 33. Scrap with oval wart just below rim. Orange clay with paler surface. Vertical stripes in red outside.

(2) The incurving and thickened rim **676** may also be of EM II date.

676 (N476) FIG. 7.18. D. 15. Purple red-brown wash.

(3) Flat-topped rims (FIG. 7.18) as **677** (N477) (D. 10) and **678** (N478) (D. 6) appear characteristic of EM III. Such rims may have been inspired by prototypes in metal. Six rims of this kind come from the deposit. All are from comparatively narrow-mouthed vessels, and have a wash (mostly black, but once at least red) outside and continuing on top of the rim and round its inside. Decoration in white seems to have been usual on the jars from which these rims come: a band around the neck, and hatching, either straight or diagonal, on top of the rim.

(4) The scrap of rim **679** (N479) (FIG. 7.18) (D. *c.* 12) is probably from a collar-necked jar of type 19, of orange-buff clay with fine grit, with a black band to the rim inside and out.

(5) Four rims like **680** come from large jars, probably with tubular spouts (as **680**) and side-handles. All have a dark brown or dark reddish brown wash.

680 (N480) PLATE 34. With spout. D. *c.* 20? Coarse grey clay akin to cooking pot ware; matt dark wash. Decoration

in white: thin band round outside of rim and group of three diagonal stripes descending from it.

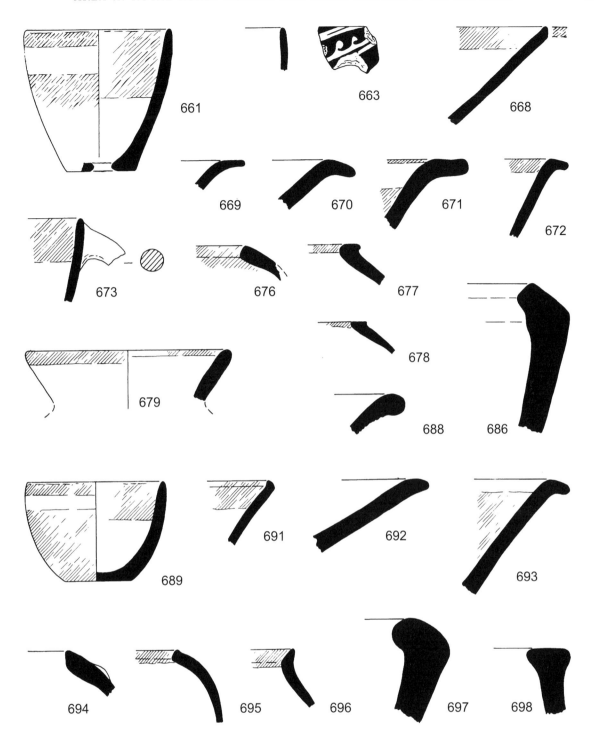

FIG. 7.18. Deposit A7.1 (EM III). Type 3 goblets **661**, **663**; type 4 shallow bowl or plate **668**; types 8 and 9 bowls **669–672**; jars **673**, **676–679**; cooking pot ware **686**; type 14 baking plate **688**. Deposit A7.2 (EM III). Type 3 goblet **689**; type 4 shallow bowl or plate **691**; types 8 and 9 bowls **692–693**; jars **694–696**; cooking pot ware **697–698**. Scale 1:2.

SPOUTS **681**

A large tubular spout is associated with **680**; a fragment of a cutaway spout **681** (PLATE 33) has a dark brown to black wash outside with white stripes across it.

HANDLES **682**

These are in general round in section, tending in one or two cases to a thick oval. **682** (N 481), perhaps from a jug, with a black wash, has a thick rectangular section. Two small strap handles may

be later intrusions: one is of rather sandy orange clay with a paler surface; the other to the rim of a cup, perhaps of the Vapheio type, is of fine orange clay with a worn red wash.

CARINATIONS

Two fragments with a black wash and traces of decoration in white outside appear to come from the carinated bellies of closed vessels (jugs or jars).

BASES

Bases are in general flat. When the outside of a vessel has a wash this seems often, but not always, to continue over the underneath of the base.

DECORATION

Paint 683–685

Dark-on-light
Several scraps have decoration in shades of red, red-brown, dark brown and black. Some of these may be EM II strays; they include the fragment of a bowl base **683** (PLATE 33) of orange clay, with well smoothed or burnished surfaces and part of a red cross underneath. Trickle ornament appears on two or three pieces of large jars or pithoi, like **684** (N486) (PLATE 34) of hard orange clay with grit, its surface a paler shade of orange with black trickle outside.

Light-on-dark
This seems to be the most common form of decoration, with simple linear designs including groups of parallel stripes and bands and chevrons. The parallel stripes may be diagonal as on **685** (PLATE 33). The diagonal stripes which appear to be flanking a row of dots on **663** are exceptional.

COOKING POT WARE 686–688

Only scraps of cooking pot ware were recovered. The dominant type appears to be a large deep bowl or open-mouthed jar with a thickened and carinated rim. The six rims assignable to such vessels are of coarse cooking pot ware with the surfaces shades of light or dark brown and red, such as **686** (N483) (FIG. 7.18) and **687** (N484). A number of side-handles of round section may come from the same vessels. The one rim of a baking plate (type 14) **688** (N 485) (FIG. 7.18) is of fine reddish brown cooking pot ware and resembles EM II examples; it may be a stray of that period.

A7.2: level LA51. Amount about 1/5 of a table or less.

TYPES

TYPE 2. FOOTED GOBLETS

Three feet of these have a wash that continues as a ring of paint round the edge of the underneath of the foot.

TYPE 3. GOBLETS 689

Profile **689** and four bases have a wash inside and out (three black, two red), except for **689**.

689 (N488) FIG. 7.18, PLATE 34. C. 1/2 pres. Ht 5. D. 7. Orange clay with paler surface, slightly scraped on outside. Lustrous wash in shades of red-brown, brown and black, continuing underneath base, but only around top of rim inside. Worn decoration in white: band below rim, and possible stripe on top of rim as well.

TYPES 2 AND 3. FOOTED GOBLETS AND GOBLETS 690

Some eight rims assignable to these types have a wash, and white bands round the outside in the EM III manner (cf. FIG. 7.19).

690 PLATE 34. Red-brown shading to black wash. Band in white set well below rim.

FIG. 7.19. Deposit A7.1 (EM III). Rims of types 2 and 3 goblets with light-on-dark decoration: 1, band around top of rim; 2, band below rim; 3, thin stripe round top of rim and band below; 4, band around top of rim and band below.

TYPE 4. SHALLOW BOWLS OR PLATES WITH RIM THICKENED INTERNALLY **691**

Three rims as **691** may be EM II strays.

691 (N489) FIG. 7.18. D. 20. Orange clay with paler surface. Outside scraped and well burnished; inside smoothed. Red band round inside of rim continuing on bevelled outer edge.

TYPES 8 AND 9. BOWLS WITH FLARING OR EVERTED RIM **692–693**

Five rims are assignable to these types, as well as large parts of bowls **692–693**. The fragments of **692** and another rim have a plain surface with decoration in dark-on-light; **693** and the remaining four rims have a wash with decoration in white.

692 (N490) FIG. 7.18, PLATE 34. Shallow bowl with flaring rim. D. 23. Several frags. include two from base. Rather coarse grey clay with grit; grey to light grey-brown surface, not smoothed or burnished. Decoration in black: hatched triangles on rim, with pair of bands just below rim inside, and band round inside of base.

693 (N491) FIG. 7.18, PLATE 34. Bowl with everted rim. D. 25. Large frag. of rim and body. Orange clay with red wash. Decoration in creamy white: opposed diagonals on rim; band below rim inside.

JARS **694–696**

Four out of six rims grouped here appear to be from large wide-mouthed jars with side-handles. **695** with a slight bead of metallic inspiration may be a later, MM II–III intrusion. This and another rim have a wash. The other two rims of large wide-mouthed jars including **694** are decorated in dark-on-light; and **694** has a wart. The remaining two rims are like **696** with smaller diameters.

694 (N492) FIG. 7.18, PLATE 34. D.15. Circular wart below rim. Rather coarse orange clay with grit; paler surface. Decoration in black: diagonal band from rim; wart painted solid.

695 (N493) FIG. 7.18, PLATE 34. D. 20. With slight bead. Orange clay with grit; black wash. Possibly MM II–III intrusion.

696 (N494) FIG. 7.18, PLATE 34. D. 12. Orange clay; red-brown wash outside, continuing round inside of rim. Band in thick creamy white round neck.

COOKING POT WARE **697–698**

Rims (FIG. 7.18) from large bowls or jars **697** (N495) and **698** (N496) (D. 40) are of cooking pot ware with red-brown surfaces. **697** is a characteristic EM III shape: cf. **1092** (FIG. 8.13). Two fragments of round section handles were also noted. There are two pieces of tripod feet, one evidently oval, one thin oval in section.

(Number **699** was not used.)

DEPOSIT A8: SOUNDING BETWEEN WALLS αγ AND αη (EM II)

Level LA94. Amount about 1 1/4 tables.

Deposit A8 comes from the lowest levels reached in the space between the later walls αγ and αη to the south of the main EM sounding in RRN (FIG. 4.1). The latest material from the deposit seems to be assignable to a relatively early phase of EM II, but one later than deposit A1 (Floor VII). The fragmentary character of the pottery suits the idea of a fill that may have included some earlier pieces, which could explain the high proportion of dark grey, red and brown burnished wares. Dark grey

burnished ware is more abundant than it was in A2 (Floor VI) by about 5:1, and both red and brown burnished ware are similarly about five times better represented in A8 than in A2. At the same time the red and light brown burnished wares are more reminiscent of what was found above A2 than of what was above A4 (Floor V).

We see A8 as coming in the ceramic sequence between A1 and A2, and probably to be assigned to EM IIA late.

FABRIC

A fair amount, as much perhaps as 1/5 of the standard fine ware, appears to have a wash, sometimes red, but more commonly (2:1) black or dark in colour.

Light grey ware
One fragment seems assignable to this fabric. It is from the lower part of a goblet bowl where it joined the foot. The clay is fine, light grey throughout; the surface is worn.

Dark grey burnished wares
About 40 fragments were found, a proportion of 5:1 when compared to A2. They include rims assignable to types 2 or 3 (**701**), 5 (**702–706**) and 9 (**707**). One or possibly two fragments (**708, 710**) appear to be from lids. One scrap from a bowl has a string-hole made before firing.

Red and light brown burnished wares
These shade into each other. Of 23 fragments assignable to these wares, about 18 have reddish, the other five light brown burnished surfaces. This represents about five times as much (in relation to the total amount of material) as from A2. Rims are assignable to types 2 or 3 (**711**), 4 (**712–714**) and 9 (**716–718**).

Vasiliki ware
Some four or five fragments of this distinctive ware were recognised, two of these certainly from jugs or jars. One, apparently from a bowl base, has a burnished surface. The washed surface of another had been well smoothed. The fabric does not obviously suggest that any of the fragments belong to imports, and the vessels may therefore be of local make.

One scrap of rim **700** looks as if it may be wheelmade. It could have strayed from a later level, unless it comes from a vessel imported from some part of the Near East where the fast wheel was already in use, such as the wheelmade vessel of Syrian origin from a Troy I deposit.[34]

700 (N462) FIG. 7.20. Rim of cup or small bowl. D. 13.
Thin-walled. Possibly wheelmade. Fine orange clay. Traces of dark brown to black lustrous wash.

Cooking pot ware
This is clearly differentiated from the ordinary run of fine and coarse wares. A surprisingly large proportion, about 1/4 of the total number of fragments from the deposit, appears to be of cooking pot ware. Surfaces are in general shades of light brown and red; but some black surfaces are evidently due to the application of a wash, and not merely to use over a fire. In several cases the surfaces are wiped or scraped; sometimes they are burnished (e.g. on plates like **764**), but this appears exceptional. In view of the large amount of cooking pot ware, it is described and illustrated separately after the rest of the material.

TYPES IN BURNISHED WARES **701–719**

Dark grey burnished ware **701–710**

701 (N392) FIG. 7.20. Goblet rim (type 2 or 3). D. c. 12. Outside grey-brown, burnished; inside lightish brown. Another rim, similar but much thicker, and a scrap of a type 2 goblet foot (D. c. 8), were also found.
702 (N397) FIG. 7.20. Bowl rim cf. type 5. Lightish brown, burnished.

703 (N395) FIG. 7.20. Bowl rim cf. type 5, with fine incision round outside. Fabric as **706**.
704 (N398) FIG. 7.20. Bowl rim cf. type 5. D. c. 20. Outside light brown, inside grey-brown, burnished.
705 (N396) FIG. 7.20. Bowl rim cf. type 5, with bold groove round outside. D. c. 25. Grey-brown, burnished.

[34] Hood 1979, 126, with references.

706 (N394) FIG. 7.20. Bowl rim cf. type 5. D. 20. Clay red-brown at core; outside grey-brown, inside lightish brown.
707 (N393) FIG. 7.20. Bowl rim cf. type 9. D. 14. Clay red-brown at core; surface grey-brown, burnished.
708 (N400) FIG. 7.20. Rim of bowl or of cover cf. type 22. Surface grey-brown, equally well burnished

inside and out.
709 (N399) FIG. 7.20. Frag. of pedestal foot. D. *c.* 12. Surface grey-brown; outside finely burnished; inside smoothed, with finger-marks clearly visible.
710 (N401) FIG. 7.20. Frag. of lid cf. type 21 (?). D. *c.* 10. Grey-brown, burnished.

Red and light brown burnished wares **711–719**

711 (N402) FIG. 7.20. Goblet rim (type 2 or 3). D. *c.* 12. Light brown burnished.
712 (N405) FIG. 7.20. Rim cf. type 4. D. *c.* 10. Light brown burnished.
713 (N409) FIG. 7.20. Rim cf. type 4. D. *c.* 16. Red burnished.
714 (N404) FIG. 7.20. Rim cf. type 4. D. *c.* 25. Light brown burnished. Some three other scraps of rim from similar bowls.
715 (N413) FIG. 7.20. Rim, atypical, but cf. types 4 and

9; with wide shallow groove round outside. D. 15. Fine orange clay with red wash, well smoothed or burnished.
716 (N406) FIG. 7.20. Rim cf. type 9. Light brown shading to red, burnished.
717 (N407) FIG. 7.20. Rim cf. type 9. D. *c.* 28. Outside light reddish brown, inside dark brown, burnished.
718 (N408) FIG. 7.20. Rim cf. type 9. D. *c.* 26. Surface worn; outside light brown, inside dark red-brown, burnished.
719 (N403) FIG. 7.20. Jar (?) rim. D. *c.* 15. Orange clay with dark red-brown surface, burnished.

TYPES IN STANDARD FINE AND COARSE WARES

TYPE 2. FOOTED GOBLETS **720–721**

Six feet between 5 and 6 in diameter evidently belong to these. Such feet tend to be high like **720–721** (FIG. 7.20). Three of them are light surfaced with a red band round the top on the outside where they once joined the bowl. Two have a dark wash including underneath, while the remaining scrap has an outside wash only, and just a thin band round the edge of the foot underneath.

TYPES 2 AND 3. FOOTED GOBLETS AND GOBLETS

Of around 16 fragments of rim assignable to one or other of these types, some 10 have a wash, mostly in shades of light brown or reddish, but occasionally darker and approximating to black, and once or twice mottling after the manner of Vasiliki ware. The other six are decorated in dark-on-light: three with a thin line (two red, one black) along the top, three with a wider band round the outside.

TYPE 4. SHALLOW BOWLS OR PLATES WITH RIM THICKENED INTERNALLY **722–725**

Four of the 10 rims grouped here are typical examples of the rounded class **a** with a red band round the inside, as **722** (N412) (FIG 7.20; D. 25). The other six rims are of the bevelled class **b**: three of the standard variety with a red band round the inside as **723** (N414) (FIG. 7.20; D. 20); the other three as **724** and **725**.

724 (N416) FIG. 7.20. D. *c.* 16. Fine orange clay with buff surface. Broad hatching on top of rim.

725 (N415) FIG. 7.20. D. *c.* 24. Fine orange clay. Rim painted solid inside and outside in dark brown to black.

TYPE 5 OR 6. BOWLS WITH UPRIGHT SIDES **726–728**

Three scraps of rim are assignable to these types.

726 (N418) FIG. 7.20. D. *c.* 14. Orange clay; surface much worn, but rim evidently painted red outside. Inside burnished.
727 (N417) FIG. 7.20. D. *c.* 20. Orange clay; surface

with black wash outside, red inside.
728 (N419) FIG. 7.20. Hard orange clay; surface pale buff, well burnished.

TYPE 9. BOWLS WITH EVERTED RIM **729–732**

Some 12 rims, two with complete profiles as **729**, are assignable to this type. Seven including **729** have a wash in shades of dark red-brown inside and out. The other five are decorated in dark-on-light: two in red, three in dark brown to black.

Seven rims are differentiated as **729**: six of these have a wash, and one is decorated in dark-on-light. Five rims are undifferentiated as **730**; two of them have an overall wash, the other three decorated in dark-on-light.

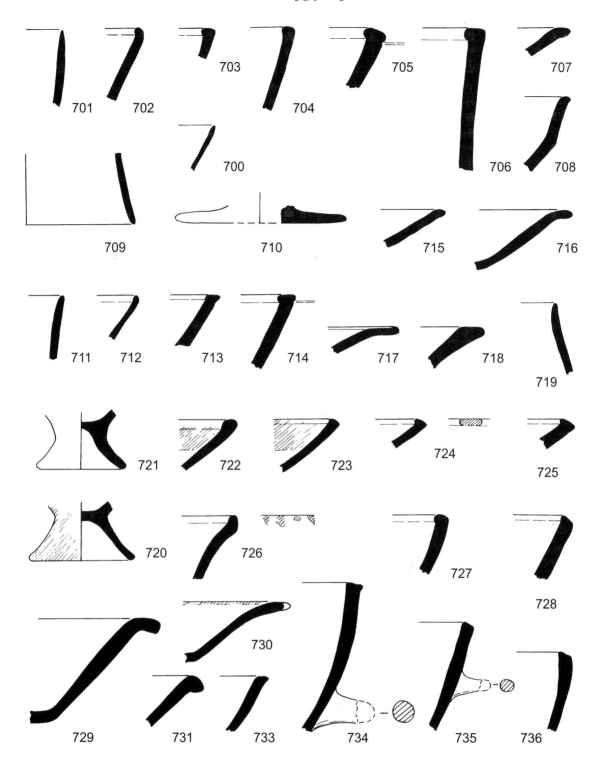

FIG. 7.20. Deposit A8 (EM IIA). Vasiliki ware **700**; dark grey burnished ware **701–710**; red and light brown burnished ware **711–719**; type 2 goblets **720–721**; type 4 shallow bowls or plates **722–725**; type 5 or 6 bowls **726–728**; type 9 bowls **729–731**; bowls **733–736**. Scale 1: 2.

One or two washed rims are unusually short and stumpy as **731**. The fragment of an undifferentiated rim **732** has a pair of triangular projections.

FIG. 7.3: **216** and PLATE 24: **267** show motifs of decoration in light-on-dark on other type 9 bowl rims of EM IIA.

729 (N420) FIG. 7.20. Profile. D. *c.* 30. Wash in shades of dark red-brown.

730 (N421) FIG. 7.20, PLATE 35: inside. Profile, with single triangular projection from rim. Fine orange clay with

paler surface, smoothed or burnished. Edge of rim painted red inside and outside.

731 (N422) FIG. 7.20. Rim. D. *c.* 20. Fine orange clay

with light red-brown wash, smoothed or burnished.

732 (N436) PLATE 35: inside. Rim has pair of triangular projections. Orange clay with red to dark red-brown wash.

MISCELLANEOUS BOWLS WITH MORE OR LESS UPRIGHT SIDES 733–737

Five rim fragments:

733 (N424) FIG. 7.20. D. *c.* 25. Fine orange clay with dark red-brown wash outside, inside plain; not smoothed or burnished.

734 (N423) FIG. 7.20. D. 26. With stump of horizontal side-handle set well below it. Fine orange clay with light red-brown wash, not smoothed or burnished.

735 (N425) FIG. 7.20. D. 20. With stump of horizontal

side-handle as **734**. Fine orange clay with dark red-brown to black wash.

736 (N426) FIG. 7.20. D. 20. Fine orange clay with red wash; slight scribble burnish inside.

737 (N427) PLATE 35: inside. With handle rising above rim. Angle uncertain. Fine orange clay with black wash.

MISCELLANEOUS LARGE BOWLS 738–740

Three rim fragments:

738 (N429) FIG. 7.21, PLATE 35. D. *c.* 35. Orange clay with paler surface; outside well smoothed or burnished. Decoration in dark brown to black: wide band round top of rim with diagonal band below.

739 (N430) FIG. 7.21. D. *c.* 35. Orange clay with rather

thin reddish wash. Outside below rim wiped or scraped before wash applied.

740 (N431) FIG. 7.21. D. 42. Coarse orange clay with paler surface. Top and outside edge of rim painted solid black.

JUGS 741

Fragments of jugs are not much in evidence, but five rims with attachments for a handle appear to come from them; in two cases the handle is set to the rim, in the other three below it. Two of the fragments with the handle below the rim have a black wash; the other three fragments (including both of those with handles set to the rim) have remains of decoration in dark-on-light. The handles are round section, except for the large handle **741** (N437) (PLATE 35) set to the rim: this has a thick oval section and is surmounted by a wart. A fragment, apparently from the side of the neck of a large jug, with a red-brown wash also seems to have remains of a wart. There is a small oval wart on a similar fragment with a smoothed black wash and traces of decoration in white. One fragment of a jug neck is akin to fine cooking pot ware in fabric, but has a well burnished light brown slip outside.

JARS 742–746

Relatively few rims appear assignable to jars.

742 (N439) FIG. 7.21. D. 24. From large jar. Orange clay with fine grit. Decoration in dark brown to black.

743 (N434) FIG. 7.21. D. 15. Orange clay with paler surface. Decoration in red-brown.

744 (N435) FIG. 7.21. D. 15. Orange clay with paler surface; inside smoothed. Decoration in dark purplish red-

brown: wide band round outside continuing on top of rim.

745 (N433) FIG. 7.21. D. 9. Orange clay with a greenish tinge. Outside has worn black wash continuing round inside of rim.

746 (N432) FIG. 7.21. D. 25. Orange clay. Outside has black wash continuing round inside of rim.

(Number **747** was not used.)

SPOUTS

An open trough spout with a red-brown wash appears to be from a bowl.

HANDLES 748

These are in general round in section; but **741** (PLATE 35) from a large jug is thick oval. One scrap of a small strap handle, evidently from a cup with a red wash, looks MM in fabric and may be intrusive. The unusual **748** seems to be EM II and is therefore included here, although it comes from level LA93 above.

748 (N487) PLATE 35. Frag., round section, with double or triple relief band round one end. Fine orange clay with paler surface.

Another handle with relief bands **878** was found in B1 (p. 198), and others that appear assignable to EM II in the SMK include one with a group of three relief bands like **748** that has been identified as an import from southern Crete;[35] one similar from Phaistos is evidently from a deposit of EM II.[36] All these handles probably come from jugs like those with applied relief bands (whether single or in groups of two or three) from the WCH and Fournou Korifi I, of EM IIA date.[37] But more examples of such handles seem to have been recorded from Knossos than from any other part of Crete, while similar handles appear to be attested at Knossos in later deposits. Thus a handle, apparently from a jug, in a LM I deposit in the excavations by Hogarth's Houses on Gypsades, has a pair of applied bands above a metal-imitating rivet.[38] In this case the applied bands are round the base of the handle, while on the EM examples the band or bands often at any rate appear to be applied to the top end. The bands in these instances seem to reflect imitations of cord wound round a handle to strengthen it; but some of the applied strips on handles from Fournou Korifi clearly have other derivations.[39]

BASES **749–750**

These are in general flat. **749** (PLATE 35) from a closed vessel, probably a jug, has a lug (pellet) foot of the type common in EM II, of fine orange clay, buff to the outside and decorated in red. Two other base fragments, both apparently from closed vessels, may have traces of red crosses underneath. On vessels with a dark wash, the underneath of the base is sometimes coated too, but it is often left plain. A strainer base fragment **750** (N461) is of coarse cooking pot type ware with a red-brown wash outside, which is smoothed (PLATE 36).

DECORATION

Paint **751–756**

Dark-on-light
This is by far the most common form of decoration. Simple geometrical patterns are the rule and include wide bands, groups of parallel stripes, and latticed triangles (on the bodies of jugs). The small rim **751** (N438) (FIG. 7.21, PLATE 35) from a bowl or open jar, of orange clay with a buff surface well burnished inside and out, is decorated with a diagonal chequer pattern in dark red-brown. Two other fragments on PLATE 35 appear to be from the shoulders of jugs: **752** has a buff surface and decoration in dark brown; **753** is of orange clay with a greenish slip and decoration in dark brown to black. Three more fragments on PLATE 35 may also be from jugs: the surface of **754** is orange with decoration in red; **755** and **756** have buff surfaces decorated in red-brown and dark red.

Light-on-dark
Only three or four fragments have traces of decoration in white paint on a dark wash.

Pattern burnish **757**
Pattern burnish is extremely rare. One or two scraps of dark grey burnished ware have traces of simple pattern burnish consisting of parallel stripes; these may be EM I strays. Fragment **757** (N441), apparently from the base of a bowl (perhaps of type 9), seems EM II; it has a red wash with groups of thin parallel strokes in pattern burnish.

TYPES IN COOKING POT WARE **758–759**

RIMS OF LARGE BOWLS LIKE TYPE 9

758 (N443) FIG. 7.21. D. 28. Red-brown wash.
759 (N444) FIG. 7.21. D. 38. Dark wash inside, light brown outside. Outside wiped below rim.

[35] K.I.7 911: Wilson and Day 1994, 32, pl. 4: FP 78 (with discussion of metallic features).

[36] Levi 1958a, 179, fig. 360, middle row right, pl. 18e (Wilson and Day 1994, 42: FP 195).

[37] Wilson 1985, 314–17, fig. 18, pl. 33: P149; 322, pl. 36: P198; Warren 1972a, 12, 104, pls. 30A bottom right, 34A, 35A top right.

[38] HH/58/72. See pp. 2–3, FIG. 0.1: 297 and TABLE 0.1 for location and references.

[39] Warren 1972a, 104, pl. 34A centre. Handles with applied strips or bands like those on EM II examples occur in Palestine in Proto-Urban and EB I, e.g. Kenyon 1965, 16, fig. 4: 20; Amiran 1978, pl. 11: 8–9, from Arad IV assigned to late EB I.

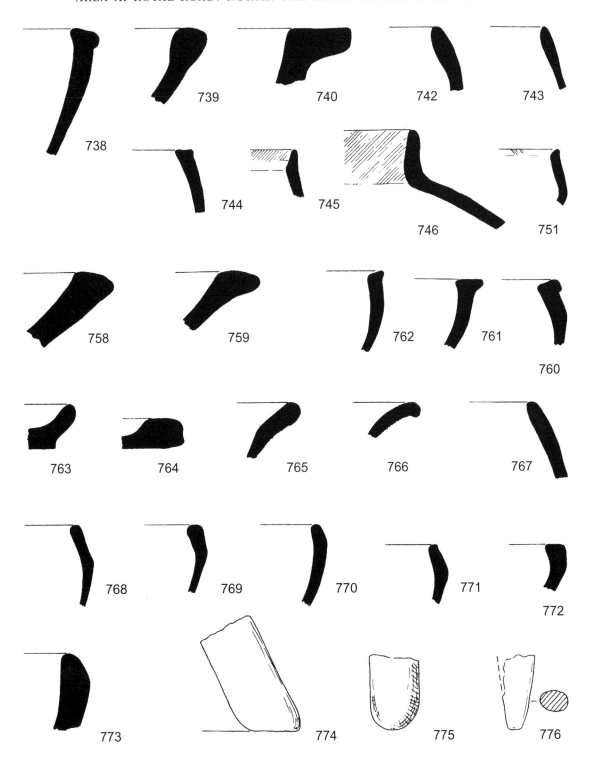

FIG. 7.21. Deposit A8 (EM IIA). Large bowls **738–740**; jars **742–746**; bowl **751**; large bowls (cooking pot ware) **758–759**; type 11 large bowls **760–762**; type 12 large flat dish **763**; type 13 plate **764**; type 14 baking plates **765–766**; jar **767**; type 18 large bowls or jars **768–773**; type 23 tripod cooking pots **774–776**. Scale 1:2.

TYPE 11. LARGE BOWLS WITH CURVING, OFTEN CARINATED SIDES, AND THICKENED RIM
760–762

About 16 rims including **760–762** (N450-2) (FIG. 7.21: **760**, D. 35; **761**, D. 30; **762**, D. 24) are assignable to this type. Most are carinated, as **760**. One rim, apparently from a vessel of this shape, has the stump of an horizontal side-handle set just below it.

TYPE 12. LARGE FLAT DISH WITH UPRIGHT SIDE **763**

763 (N428) FIG. 7.21. D. 30. Rim. Coarse brown clay
akin to cooking pot ware; black wash.

TYPE 13. PLATE **764**

764 (N442) FIG. 7.21 Rim. Fine cooking pot ware with
red-brown wash, smoothed. Another similar but larger, with
black wash inside, well burnished.

TYPE 14. BAKING PLATES **765–766**

There are about 12 rims of these, mostly as **765** (N454) (FIG. 7.21; D. 34), but some more rolled over
like **766** (N455) (FIG. 7.21; D. 40).

JAR LIKE TYPE 17 **767**

767 (N453) FIG. 7.21. Rim. D. 26. Coarse cooking pot
type ware with large grey grit; surface reddish inside, dark
red-brown outside.

TYPE 18. LARGE BOWLS OR JARS WITH INWARD-CURVING, OFTEN CARINATED AND THICKENED RIMS **768–773**

The distinctive carinated rims of this type (FIG. 7.21) as **768** (N445; D. 24), **769** (N446; D. 36),
770 (N447; D. 34), **771** (N448; D. 24) and **772** (N449; D. 30) are much in evidence. About five of
these are like **768–770**, and **771** is similar but slightly everted; while three or four other rims are
thicker, as **772**.

The large rim **773** (N460) (FIG. 7.21) with a light brown wash, apparently from a bowl, but of
uncertain angle, has been grouped here.

TYPE 23. TRIPOD COOKING POTS **774–776**

Of three tripod feet (FIG. 7.21, PLATE 36), **774–775** (N457-8) are round, and **776** (N459) oval,
in section.

TYPE 24. HORNED STANDS **777**

777 (N456) is a complete horn from a horned stand (PLATE 36). There are fragments of two more.

HANDLES

The 11 handles in cooking pot ware are all round in section.

A9: EARLY MINOAN POTTERY FROM LATER OR MIXED DEPOSITS

Some pottery assignable to EM II or III was found in later or mixed deposits in RRN and RRS, and
is interesting enough to present here despite its lack of contemporary context.

Fragments from RRN include:

778 (N419) (level JK37: LM IB) FIG. 7.22. *Bowl* rim of
classic Vasiliki ware. D. 16. Fine orange clay with red wash,
mottling outside to black, burnished. EM II.

779 (LA unstratified) PLATE 36. Type 2 or 3 *goblet* rim.
Orange clay. Decoration in red: rim solid, with crossing
chevrons below it outside. EM II.

780 (N413) (level H99: LM IB) FIG. 7.22, PLATE 36. Type
2 or 3 *goblet* rim. D. 8. Orange clay with orange-buff
burnished surface. Decoration in dark brown to reddish:
three stripes round outside of rim with spots hanging from
chevrons below. EM II.

781 (N414) (level LA20: MM IA and later) PLATE 36.
Type 2 or 3 *goblet* rim. Design as **780**, but in light-on-dark.
Black to dark purple-brown wash. Decoration in thick
creamy white: motifs as **780**. EM II.

782 (level LA70: mixed) PLATE 36. Type 2 or 3 *goblet*
rim. Orange clay with red to red-brown wash. Decoration
in thick creamy white: loops pendent from top of rim above
pair of stripes. Probably EM II.

783 (level LA6: LM IB) PLATE 36. Type 2 or 3 *goblet*
rim. Orange clay with dark red-brown to black wash.
Decoration in thick creamy white: triple chevrons above
pair of stripes. Probably EM III.

784 (level H100: MM and some LM) PLATE 36. Type 2 or
3 *goblet* rim. Purple red-brown wash. Decoration in white:
multiple chevrons above pair of bands below rim. Probably
EM III.

785 (level H75: MM and some LM) PLATE 36. Type 2 or
3 *goblet* rim. Purple-brown wash. Decoration in white: band
of crosshatching between stripes. Probably EM III.

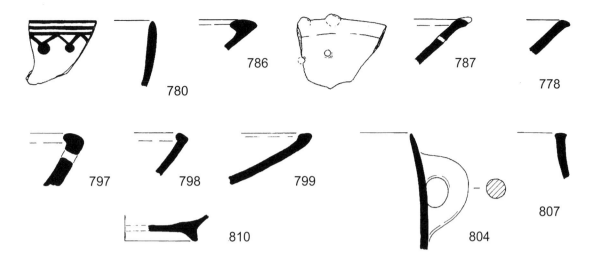

FIG. 7.22. A9. Miscellaneous EM pottery: from later levels of RRN **778**, **780**, **786–787**; and RRS **797–799**, **804**, **807**, **810**. Scale 1: 2.

786 (N415) (level LA74: MM IA and LM IB) FIG. 7.22. Type 4 *bowl* rim. D. 25. Black wash with slight reddish tinge. Decoration in creamy white: three bars pres. on rim. EM IIB.

787 (N416) (level JK85, Pit F: MM IA and later) FIG. 7.22. Type 4 *bowl* rim. Fabric as **786**. Two warts on rim, with pair of string-holes corresponding to them through side of bowl. EM II.

788 (N418) (level LA74: MM IA and LM IB) PLATE 36. Rim of shallow type 9 *bowl*. Dark brown to black wash with distinct metallic sheen outside. Decoration in thick creamy white: band of chevrons on top of rim. EM II or III.

789 (N417) (level LA8: LM IB with some earlier) PLATE 36. Rim, apparently of type 9 *bowl*, with flat triangular perforated lug projecting from it. Fine buff clay. Decoration in red-brown: lattice on top of rim; diagonal hatching on lug. EM II.

789A (N88) (level LA83: LM IB). Body frag. of *bowl*, with ear-like horizontal lug Fine buff clay. Decoration in red-orange: solid wash inside; lines around lug.

790 (N421) (level LA83: LM IB) PLATE 36. *Jar* rim. Cf. class **a**. Rather sandy orange clay with black wash with reddish tinge. Decoration in thin white: diagonal band of chevrons flanked by stripes. EM II (?).

791 (N420) (level LA53: LM IB) PLATE 36. *Jar* rim. Cf. class **b2**. Fine buff clay. Decoration in dark red-brown to black: bands, horizontal round outside of rim and diagonal below, with lattice. EM II.

792 (N422) (level HJK below 20: LM IB [?])PLATE 36. *Jar* rim with top somewhat thickened. Rather sandy orange-buff clay; thick red wash outside. Decoration in thick creamy white: three horizontal bands below rim, with group of four vertical stripes descending from them; diagonal hatching on flat top of rim. EM II (?) or EM III.

Two fragments of EM IIA light grey ware type 20 suspension pots come from later deposits in RRN, and there is a bowl rim from RRS (level D15; D. 22?). In addition, the excavations at Hogarth's Houses have produced a handle fragment of probably another: **819**.

793 (level JK29: MM with LM and later) FIG. 10.4, PLATES 36, 53. Rim with short collar and shoulder. Ht pres. 2.55. D *c.* 3. Two incised lines on shoulder, above alternating panels of punctuation and vertical lines.

794 (level LAH11: LM II–III) PLATES 36, 53. Shoulder frag. of large suspension pot or jar. Hard dark grey clay with light grey core, burnished outside. Bold incised or grooved concentric semi-circles in (at least) two zones, with five horizontal lines between, and field of lower zone filled with panels of triangular punctuation.

This motif is found also on an unpublished sherd (HM study collection) from the Zakros early cave burials: cf. Hogarth 1901, 142–4 and fig. 52.

Two fragments of closed vessels, one from RRN and one from RRS, have an outside wash which is decorated with herringbone incisions: both appear to be from the shoulders of jugs. Jugs with this type of decoration are attested at Knossos in EM IIA deposits, notably one from the WCH and the sole instance we know at Knossos of a pushed-through handle.[40] One such handle comes from Fournou Korifi I, but they are common there on period II (EM IIB) jugs there.[41]

[40] Wilson 1985, 316–17, fig. 19, pl. 34: P158 (Wilson 2007, 59, fig. 2.6: 18; 61).

[41] Warren 1972*a*, 104.

795 (RRS level E39: MM III) PLATE 36. Shoulder and neck of small jug. Hard rather sandy dark red-brown clay. Dark red-brown wash outside.

796 (RRN level JK64: LM IB) PLATE 36. Probably from jug shoulder. Fabric like **795**, but clay is orange. Wash outside, light and dark red-brown mottling to black; cf. Vasiliki ware.

Other fragments from RRS include:

797 (level B35: MM IA) FIG. 7.22. Type 5 *bowl* rim with string-hole. Fine sandy light reddish brown to grey clay. Surface shades of lightish grey, very well burnished. EM II.

798 (level CG15A: LM 1A) FIG. 7.22. Type 5 *bowl* rim. Light brown burnished ware. Angle of drawing uncertain. EM II.

799 (level CG 22: MM IA) FIG. 7.22, PLATE 37. Inturned rim of shallow *bowl* akin to type 4. D. 25. Fine reddish brown clay with red wash, shading to light brown mottling to purplish. EM II.

800 (S817) (level E41B: MM I–II) PLATE 37. Type 4 *bowl* rim. EM II. Fine orange-buff clay with buff burnished or smoothed surface. Decoration in red: band to inversion of rim inside, and band below; fine lattice triangles on rim; band to rim outside. Its high quality might suggest that it is an import from the Mesara. EM IIA.

801 (S1232 (level E54: MM IA) PLATE 37. Type 4 *bowl* rim with string-hole made before firing. D. *c.* 22. Fine orange clay. Inside solid red. Decoration in red: zig-zag on top of rim. EM II.

802 (S819) (level BCE1: mixed) PLATE 37. Type 8/9 *bowl* rim. Orange clay with dark red-brown wash. Decoration in thick creamy white: crossing chevrons making diamond pattern on top of rim. EM III.

803 (S333) (level F33: MM IA) PLATE 37. Type 8/9 *bowl* rim. D. *c.* 12. Fine orange clay with paler surface inside. Outside has black shading to red-brown wash. Decoration in white. EM III.

804 (level F27A: MM IA) FIG. 7.22, PLATE 37. *Deep bowl* or *jar* rim with vertical handle set below it. D. 20. Reddish clay, with surface red inside, light red-brown outside, stroke burnished. EM II (?).

805 (S1234) (level E48: post-Minoan) PLATE 37. *Jar* rim. D. 12. Crescentic lug with vertical perforation through top. Orange clay with paler surface. Thin red stripe along top of rim. EM II.

806 (levels BCE3–5: post-Minoan) PLATE 37. Type 2 or 3 *goblet* rim. Orange clay with paler surface, well smoothed.

Decoration in dark red-brown: band of lattice round outside of rim with stripe below. EM II.

807 (MM IB Basements) FIG. 7.22, PLATE 37. *Jar* rim. D. 10. Fine orange clay, well smoothed or burnished. Decoration in dark red-brown: lattice. EM II.

808 (S1038) (level F25A: MM IIIA) PLATE 37. *Jar* rim. Fine orange clay with red-brown wash. Decoration in thick creamy white: vertical chevrons flanked by five stripes. EM III.

809 (level F25A: MM IIIA) PLATE 37. *Jar* rim. EM III (?).

810 (level B40: MM IA) FIG. 7.22. Ring base of *closed vessel.* Fine light grey to red-brown clay. Outside has black wash, including under base. EM II (?).

811 (level F32: MM IA) PLATE 37. Frag. apparently of large *bowl.* Fine orange clay with well smoothed or burnished buff surface. Decoration in dark red-brown to black: latticed areas. The angle of the fragment appears to be as shown in the photograph. EM II.

812 (S816) (level CE19A: MM III) PLATE 37. Frag. apparently from *jar.* EM II (?).

813 (level B33A: MM IIA) PLATE 37. Frag. of *closed vessel.* Orange clay with buff outside surface. Decoration in dark red-brown: cross-hatching above area painted solid: cf. Boyd Hawes *et al.* 1908, 56, fig. 38. 3. EM II.

814 (level F27: MM IA) PLATE 37. Frag. of *closed vessel.* Fine orange clay, well smoothed or burnished outside, inside smoothed. Decoration in dark red-brown: lattice. EM II (?).

815 (level E35C: MM I–III) PLATE 37. *Bowl* base. Orange clay, burnished inside and outside. Decoration in red under base: double cross making eight-armed star. EM II.

816 (level F28A: MM IA) PLATE 31. Type 2 *goblet* foot. Red wash. Band round edge of under side of foot with solid spots projecting from it. EM II.

817 (level F33: MM IA) *Horned stand* frag. 5.5 x 6.1 x 1.1. See pp. 264–6 and PLATE 57. EM IIA.

818 (level E54: MM IA). D. *c.* 14. Type 2 *goblet* rim. Light grey ware. Incurving and slightly bevelled. EM IIA.

For East Cretan EM III imported jars in MM IA contexts in RRS, see p. 124 and n. 15.

A clay roundel cut from a sherd of dark grey burnished ware has been discussed above with **165** and **165A** from the Palace Well.

We may add here a handle fragment from Hogarth's Houses on Gypsades:

819 (N140) (HH level EE3). Handle frag. L. pres. 3.6. Max. W. 1.7. Fine dark grey clay with brownish tinges on surface; but probably to be classed as light grey ware. Oval section. Incised decoration of thick grooves. From large vessel such as from Vasiliki (*PM* I, 61, fig. 22; Wilson and Day 1994, 21: FG 126).

Chapter 8

Area B. The Early Houses
The Early Minoan II–III deposits

EARLY MINOAN II

DEPOSIT B1

EARLY MINOAN IIB

Levels A14–A13, B10–B9. Amount: about 1 table.

B1 is the deposit from the lowest levels assignable to Early Minoan II in Area B (the Early Houses to the s of the Palace) and includes pottery from pit B, the foundation trench for wall δ in trenches A and B. The deposit was superimposed on, and/or cut into, Neolithic occupation debris, and some stray Neolithic sherds were incorporated with the pottery in the deposit. This deposit may be contemporary with the complete vessels that Evans and Mackenzie found in 1908, which look as if they were a floor deposit (see pp. 81, 93, 266–74).

B1 appears to belong to the same early stage of EM IIB as A2 in RRN, although they may not be exactly contemporary. If there is a difference in date, it looks as if A2 may be a shade earlier than B1. B1 has no dark grey burnished ware, just one worn scrap of light grey ware, and only five fragments of the red or light brown burnished ware that is still conspicuous in A2.

FABRIC

This is in general as in A2 (see p. 143). The vessels in fine ware mostly have light surfaces, usually or invariably with a slip, which may be smoothed or occasionally burnished. There are also some fine ware vessels with a dark wash.

Light grey ware
One, much worn, scrap is assignable to this rare fabric: cf. B2.

Red and light brown burnished wares
Just five fragments are assignable to these wares. Two, including part of a flat base, come from small jugs, or from jars, perhaps suspension pots. Two of light brown burnished ware may belong to similar vessels: one of light grey clay, the inside surface light grey, outside light red-brown with a very fine burnish; the other a base with a light brown wash inside and outside, but burnished only outside. One bowl base has a very fine stroke burnished surface, red outside, black inside.

Vasiliki ware **820–823**
This is well represented. Of 16 fragments, nearly 1/2 (seven, including rim **822** and three typical ring bases as **823**) come from closed vessels with no wash inside. The other nine fragments, including four rims and one base, have a wash inside as well as outside. The washed surface is usually well smoothed or burnished, which gives it a lustrous appearance and soapy feeling; but two fragments that seem to be of typical Vasiliki fabric have no signs of smoothing or burnishing over the wash.

820 (N93) FIG. 8.1, PLATE 40: inside. Flat-topped rim with small rivet on it. D. 12. A rim of Vasiliki ware from B2 has a similar rivet (p. 202).
821 (N92) FIG. 8.1. Bowl rim. D. 22. Streaky light brown surface outside, well mottled inside.
822 (N94) FIG. 8.1, PLATE 40. Bead rim from jar. D. 12. Some fine silvery mica showing in clay. Inside surface orange, smoothed. Cf. similar jar rims **289–290** (A2).
 Wilson and Day 1999, 3, 37, 39–40, 59–61, pl. 10c:

sample KN 92/178, fabric group 9 (with fine metamorphic rock fragments), perhaps from a central Cretan production centre; they note the biotite mica (1999, 60).
823 (N91) FIG. 8.1, PLATE 40. Small ring base. D. 4. Roughly wiped inside; outside has very typical mottling.
 There are two bases similar but larger (D. 9, 10), perhaps from jugs. The larger base has clear marks of stroke burnish. One of these two bases is Wilson and Day 1999, 3, 37, 39–40, 59–61: sample KN 92/179, fabric group 9.

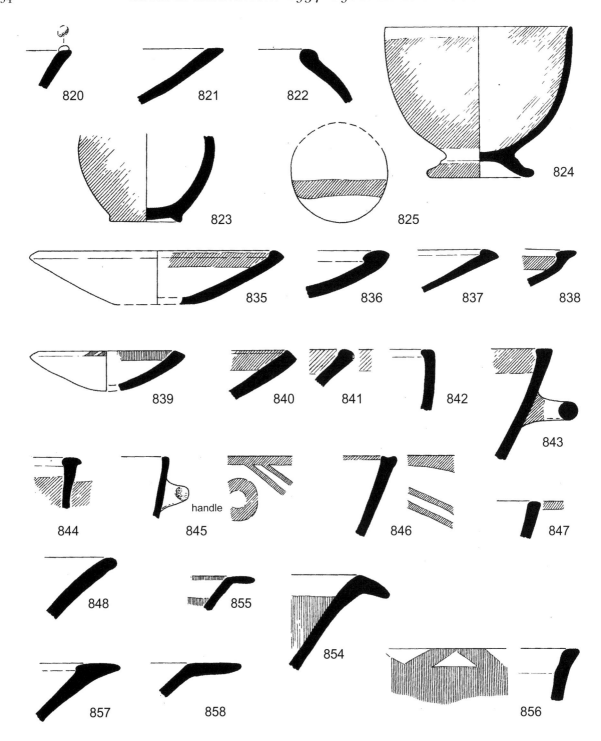

FIG. 8.1. Deposit B1 (EM IIB). Vasiliki ware **820–823**; type 2 goblet **824**; type 4 shallow bowls or plates: (**a**) rounded rims **835–839**; (**b**) bevelled rim **840**; types 5 and 6 bowls **841–847**; type 8 bowl **848**; type 9 bowls **854–858**. Scale 1:2.

TYPES

TYPES 2 AND 3. GOBLETS **824–834**

No base is assignable to simple goblets of type 3, but profile **824** and about 14 eggcup feet belong to goblets of type 2. The feet range in diameter from 4 to 6. Nine (about 2/3) have a wash (five black, four red) outside and inside the bowl of the goblet as well; in six cases the underneath of the foot is left plain, but two of these have a ring round the edge underneath, as FIG. 5.5: 6. Only five feet (about 1/3 of the total) are of fine buff ware, contrasting with about 2/3 of the similar feet in A2; **825** (N90) (FIG. 8.1) has a mark in red paint underneath, and all have red bands round the waist, as FIG. 5.4: 2. The waists of most, if not all, of the feet with a dark wash have an equivalent band in white.

Among 52 rims of goblets there is the same proportion of about 2/3 (35) with an overall wash as against 1/3 with a light surface. Some five rims (four with a wash) are flat-topped. On **826–834** on PLATE 38, the wash is black on **826**, red on **828**, and red-brown on **827**, **830** and **833**.[1]

There is great variety in the decoration of these rims, whether in dark-on-light or light-on-dark. We find bands and stripes, horizontal and sometimes vertical, multiple chevrons, single or double loops hanging from the rims, and once a large spot in light-on-dark set below the rim (**828**). Once diagonal zones of lattice appear in dark-on-light (**829**). Rim **831** with triple chevrons below it has an exact, if unprovenanced, parallel from Knossos.[2] A pair of vertical stripes flanked by diagonals in light-on-dark gives a tree-like effect on **830**.[3]

824 (PEM/60/P30) FIG. 8.1, PLATES 38, 59. Footed goblet. Most of rim and body missing. Ht *c.* 8. D. rim 10.5. D. base 5.9. Orange clay with paler surface; dark brown to black shading to reddish wash all over except under foot; much flaked away, especially inside. Decoration in thick creamy white: narrow band round rim outside, and band round waist. From level A14.

TYPE 4. SHALLOW BOWL OR PLATES WITH RIMS THICKENED INTERNALLY **835–840**

Bowls of this type are evidently common.

(**a**) Rounded rims: *c.* 28. Diameters appear to range from 8.5 to 24, but all except two of a sample of 14 are between 12 and 18; the average for the 14 is 17.8. For the fabric, cf. A2 (p. 145). All are of fine buff ware; with orange clay (once, **836**, with a greenish tinge), with a paler well smoothed or burnished surface inside, but outside less carefully finished, and sometimes markedly scraped, e.g. **835**. Decoration is normally in red, but in dark red-brown to black in four cases. All the rims have a wide band round the inside; and are decorated on top with broad opposed diagonals, except for the large rim **834** (N78; D. 22), which is painted solid and has a diagonal stripe descending from it across the inside of the bowl. The outsides are normally plain; but one scrap has a red band, and rims **837–838** have a thin red line round the outside edge.

835 (N81) FIG. 8.1. Profile. D. 14. Fine orange clay with paler surface, scraped outside. Decoration in dark red: band inside rim, and broad diagonal (?) on top of rim.
836 (N80) FIG. 8.1. D. 18. Fine orange clay with greenish tinge, smoothed. Decoration in very dark red-brown: band inside rim, and broad diagonal on top of rim.
837 (N82) FIG. 8.1. D. 16. Fine orange clay with paler surface, well smoothed. Decoration in red: band inside rim, line along edge of rim, and apparently broad diagonal on top of rim.

838 (N79) FIG. 8.1. Large rim of exceptional shape. D. 25. Fine orange clay, with pale buff surface, well smoothed inside, scraped outside. Decoration in dark brown: band inside rim, line along edge of rim, and apparently broad diagonal on top of rim.
839 (N83) FIG. 8.1. D. 8.5. Orange clay with orange surface. Decoration in dark red: band inside rim, and pair of diagonal stripes on top of rim.

(**b**) Bevelled rims: only three, one of which is exceptionally large and marginal. The other two are also somewhat marginal, e.g. **840**.

840 (N84) FIG. 8.1. D. 20. Orange clay, paler at surface, which is smoothed inside, scraped outside. Decoration in red: band round inside of rim, but outside edge of rim plain.

TYPES 5 AND 6. BOWLS WITH UPRIGHT SIDES **841–847**

About seven rims may be grouped here; **843** has a horizontal side-handle. Most are of fine buff ware with decoration in dark-on-light; but two have a red wash, one being the metallic-looking hammer-headed rim **844** with traces of decoration in white.

841 (N85) FIG. 8.1. Scrap of rim, in shape like **330**, of shallow bowl Fine dusky orange clay, outside surface burnished with vertical strokes. Decoration in red: bands below rim inside and outside. Outside decoration evidently applied after burnishing.
842 (N86) FIG. 8.1. D. 25. Fine orange clay with buff

[1] One of the goblets, probably **833**, is Wilson and Day 1999, 3, 37, 39, 55–57: sample KN 92/166, red or black slipped ware including light-on-dark painted, fabric group 7 (fine grained with few siltstones), probably from (north) central Crete.

[2] Zois 1967*b*, 152 and n. 2, pl. 30: 5.
[3] A less elaborate version of the motif: Zois 1967*b*, pl. 30: 7, from Knossos, without further provenance.

surface , smoothed. Decoration in red: band below rim outside, much worn. There are two rims similar, but with a red band inside as well as outside; a third rim has a red wash.

843 (N88) FIG. 8.1, PLATE 38. Rim with horizontal side-handle. D. 17. Fine orange clay with paler surface, stroke

burnished inside and outside. Decoration in red: bands round rim inside and outside; broad diagonal on rim; stripe on outside edge of handle, and circles round its stumps.

844 (N87) FIG. 8.1. Rim with 'metallic' thickening outside and inside. D. 17. Fine orange clay with paler surface. Red wash. Rim painted solid white, worn.

Three other rims may come from bowls akin to type 6; **845** has the stump of a horizontal side-handle.

845 (N155) FIG. 8.1. D. 11. Fine orange clay with paler surface, well smoothed inside and outside. Decoration in dark brown: band round outside of rim and pair of diagonal stripes; circle round stump of handle. A base fragment that may belong with this is described below.

846 (N154) FIG. 8.1, PLATE 39. D. 10. Fine orange clay

with paler surface, well smoothed inside and out. Decoration in dark red-brown to black: rim painted solid; pair of diagonal stripes. A base fragment that may belong with this is described below.

847 (N89) FIG. 8.1. D. 15. Fine orange clay with paler surface. Top of rim and outside painted solid dark brown.

Two bases of small bowls with upright sides of fine orange clay are well smoothed or burnished inside, and less well outside. One of them, which may belong with rim **846**, is decorated with three stripes in dark brown to black on the outside. The other, which may belong with rim **845**, has a band in dark brown to black inside, and crossing pairs of diagonals in dark red outside.

TYPE 8. BOWLS WITH FLARING RIM **848–849**

Only three rims, all of cooking pot ware, are assignable to this type. **848** (N124; FIG. 8.1, PLATE 39; D. 40)[4] is of fine cooking pot ware, with a red wash, well smoothed or burnished. Another rim is of similar fabric but smaller (D. *c.* 20); and **849** (N145) is a large rim of fabric akin to fine cooking pot ware with a red-brown slip, well burnished inside.

TYPE 9. BOWLS WITH EVERTED RIM **850–858**

There are about 14 rims, mostly it seems from bowls of the deep variety 9B. Out of five rims well enough preserved to judge, two are light surfaced, while three have a dark wash. On two of these it is on both sides, and on one only on the inside. A base that appears to come from a bowl of this type similarly has a red wash inside, while the outside is plain but decorated with three stripes in red to red-brown (PLATE 38: **850**). A fragment with purple-brown wash from the side of a typical thin-walled bowl like **854–855** has a horizontal side-handle. Base fragments that may come from bowls of type 9 include several with a red or purple-brown wash and a white band round the inside (PLATE 38: **851**). One from a very steep-sided bowl has a thin white band round the outside, and traces of a cross in white underneath.

Another scrap **852** (N104) evidently comes from a base with an eight-armed cross design in white underneath. **853** (N103) from a large thick base with an orange-buff surface, stroke burnished on both sides, has a simple cross in dark red underneath. PLATE 39 shows **852–853** together with **1347** (see pp. 275–6).

854 (N97) FIG. 8.1. D. 40. Fine orange clay, outside surface boldly scraped. Dark purple-brown to black wash. Decoration in thick creamy white: bands below rim inside and outside; broad opposed diagonals on top of rim.

855 (N98) FIG. 8.1, PLATE 41. D. 20. Fine orange clay with purple-brown to reddish wash. Decoration in thick

creamy white: band below rim inside; stripe on outside edge of rim; group of parallel stripes on top of rim.

856 (N99) FIG. 8.1, PLATE 41. D. 40. Fine orange clay with reddish wash inside. Inside of rim plain, with opposed wide diagonal bands on it; outside plain, with band below rim continuing on top of its outside edge.

Two rims of cooking pot ware belong to large shallow bowls of type 9A.

857 (N125) FIG. 8.1. D. 30. Fine cooking pot ware; red wash, smoothed or burnished.

858 (N126) FIG. 8.1, PLATE 39. D. 30. Cooking pot ware: clay rather coarse, dusky at core; red wash, smoothed.

Decoration in creamy white: neat diagonal stripes on top of rim.

Wilson and Day 1999, 3, 38–9, 50–2: sample KN 92/190, white painted red coarse ware, fabric group 4. Cf. **848** and n. 4.

[4] Wilson and Day 1999, 3, table 1, 38–9, 50–2: sample KN 92/202, cooking pot ware, of fabric group 4 (coarse red with

metamorphic rock), frequent at Knossos and Poros. They thought this might be a baking plate. A Pediada origin is possible.

TYPE 10. LARGE BOWLS WITH STRAIGHT SIDES AND THICK EVERTED RIM **859–871**

Seven rims, mostly of coarse ware, are assignable to this type. Two large rims **859–860** with a wash inside evidently come from comparatively shallow bowls as type 10A. **865** is unusual in being of fabric akin to cooking pot ware, with what appears to be a deliberate wart on top of the rim.

859 (N106) FIG. 8.2. D. 50. Coarse orange clay with buff slip outside. Inside black shading to reddish wash, continuing on rim and as wide band below it outside.
 Wilson and Day 1999, 3, 37–8, 44–6: sample KN 92/207, dark-on-light painted coarse ware, fabric group 1 (fine calcareous clay with dolerite and basalt), known in the Knossos region from EM IIA to EM III.
860 (N107) FIG. 8.2. D. 50. Coarse orange clay with greenish slip outside. Inside black wash, continuing on top of rim and as wide band below it outside, as on **859**.
 Wilson and Day 1999, 3, 37–8, 44–6: KN 92/194, like **859** in ware and fabric.
861 (N100) FIG. 8.2. D. 50. Very coarse gritty orange clay, with paler surface. Dark red band round outside of rim.
862 (N108) FIG. 8.2, PLATE 38. D. 35. Neat, evenly made. Fairly fine although gritty clay with paler orange slip.

Rim painted solid red, shading to dark brown outside, which has diagonal band.
863 (N111) FIG. 8.2. D. 30. Fairly fine orange clay with buff slip. Rim painted solid in dark brown to black, as **862**.
864 (N110) Base of large bowl, as **859** etc. Coarse orange clay with buff slip. Wide band in dark red round inside; broad diagonal bands in dark brown to black outside.
 Wilson and Day 1999, 3, 37–8, 44–6: sample KN 92/193, like **859–860** in ware and fabric.
865 (N109) FIG. 8.2, PLATE 41. D. 30. Rim with a lump on top, which appears to be a deliberate wart. Fabric akin to cooking pot ware; gritty reddish clay, with surface red-brown shading to dark brown and black, very well stroke burnished inside and outside. Top of rim has neat cross-hatching in white.

Fragments of one or more deep bowls of fine ware may be grouped here.

866–867 (N101–2) FIG. 8.2. Rim, and base which may belong with it. Possible stump of handle set well below rim. Fine orange clay, dusky at core; outside including top of rim has red-brown wash; inside plain buff. Very fine stroke burnishing both sides.

A few atypical rims of large and apparently deep bowls of cooking pot ware are described here; but some, such as **868**, may belong to very large shallow bowls akin to type 11.

868 (N127) FIG. 8.2, PLATE 39. D. 40. Cooking pot ware; clay dark brown, reddish at edges, with red to light brown wash. Outside wiped.
869 (N129) FIG. 8.2. Cooking pot ware, with red-brown wash. Outside wiped.

870 (N128) FIG. 8.2. D. 30. Cooking pot ware, with red wash.
871 (N130) FIG. 8.2. D. 17. Fine cooking pot ware; clay reddish, brown at core, with red-brown wash.

TYPE 11. LARGE BOWLS WITH CURVING OFTEN CARINATED SIDES, AND THICKENED RIM (COOKING POT WARE) **872–875A**

About 16 rims of very large diameter are assignable to this type. Several of these are more or less carinated. Most are as **872–874**.

872 (N131) FIG. 8.2, PLATE 39. D. 40. Fine cooking pot ware, with red-brown wash.
873 (N132) FIG. 8.2, PLATE 39. Fine cooking pot ware; outside diagonally scraped below slight carination. Red wash inside, purple-brown outside.
 Wilson and Day 1999, 3, table 1, 38–9, 50–2: KN 92/201, fabric group 4; cf. **848** (and n. 4 above) and **858**.

874 (N133) FIG. 8.2. Cooking pot ware, with red wash inside, brown outside.
875 (N134) FIG. 8.2 Cooking pot ware: clay grey at core; red-brown wash.
875A PLATE 39. Base frag., possibly from bowl of this type. Fine cooking pot ware: clay red at edges, grey-brown at core; outside wiped.

TYPE 14. BAKING PLATE **876**

One large fragment of a rim of unusual shape may be placed here.

876 (N142) FIG. 8.2. D. 50. Cooking pot ware: grey clay, red-brown at edges; red-brown wash inside, purple-brown outside.

TYPE 15. JUGS WITH CUTAWAY SPOUT **877–882**

Only fragments of these were found. The one handle preserved to a rim **877** (N 123; PLATE 39) is set well below it. Handles appear to be round or very thick oval in section. The handle with a pair of

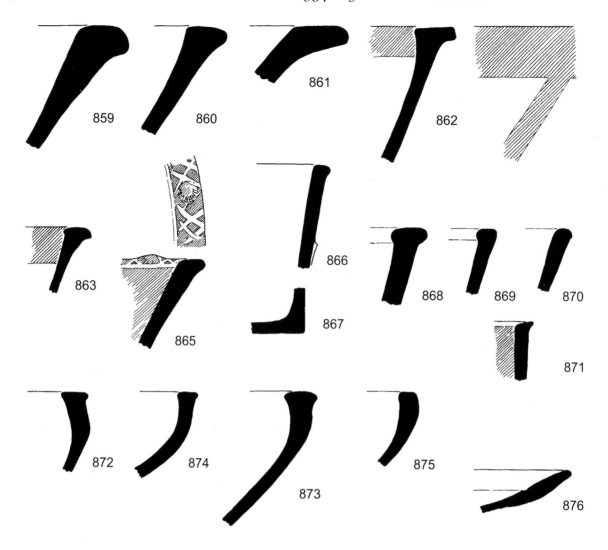

FIG. 8.2. Deposit B1 (EM IIB). Type 10 large bowls **859–863, 865–871**; type 11 large bowls **872–875**; type 14 baking plate **876**. Scale 1:2.

applied ribs or strips **878** (N151; PLATE 38) almost certainly belonged to a jug on the analogy of similar handles from other EM II contexts (see p. 187: **748**). It is of fine orange clay, grey at the core, with traces of decoration in thick red.

Some jugs no doubt had a dark wash, but most seem to have been of fine buff ware and often smoothed or even burnished outside. Decoration in dark-on-light is predominantly in shades of red-brown, or dark brown to black. Necks are characteristically decorated with triple chevrons and a thin stripe on the rim (e.g. PLATE 39: **877, 879**); bodies, with groups of stripes and latticed triangles (PLATE 39: **880–882**); handles, with wide diagonal bands (**877**).

TYPE 16. SMALL SPOUTED BOWL-JARS **883–889**

A number of rims of fine ware may be grouped here.

883 (N115) FIG. 8.3. Cf. class **a1**. Fine orange clay, dusky at core; black wash, much flaked away.
884 (N152) FIG. 8.3. Cf. class **b2**. Fine orange clay with black wash, much worn. Decoration in white: horizontal band of chevrons below rim.
 Wilson and Day 1999, 3, 37, 39: sample KN 92/167, of fabric group 7 (fine grained with few siltstones) from central Crete.

885 (N153) PLATE 39. Cf. class **b2**. Fine orange clay with paler surface. Decoration in dark red: top of rim solid; band of lattice below.
886 (N117) FIG. 8.3. D. 7. Orange clay with greenish tinge. Dark brown to black wash outside, much flaked away. Decoration in thick white: pair of horizontal stripes below rim, and opposed diagonals on body.
887 (N118) FIG. 8.3. Rim with stump of handle below.

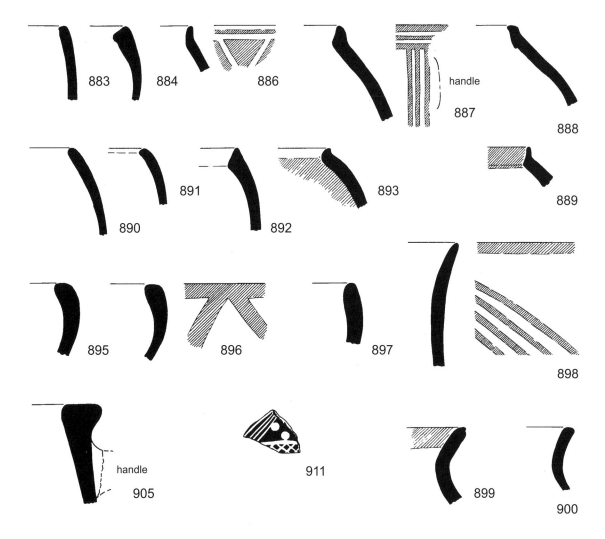

FIG. 8.3. Deposit B1 (EM IIB). Type 16 small spouted bowl-jars **883–884, 886–889**; type 17 large spouted jars **890–893**; type 18 large bowls or jars **895–897**; type 19 collar-necked jars **898–900**; large jar **905**; light-on-dark decoration **911**. Scale 1:2.

Orange clay with buff slip. Decoration in dark brown to black, much worn: triple bands below rim, and vertical stripes on body.
888 (N120) FIG. 8.3. D. 9. Fine orange clay with buff

slip. Outside smoothed; inside roughly wiped. Top and outside of rim painted red.
889 (N119) FIG. 8.3. D. 16. Fine orange clay, with dark red-brown wash outside, continuing round inside of rim.

TYPE 17. LARGE SPOUTED BOWLS OR JARS WITH HORIZONTAL SIDE-HANDLES **890–894**

Some 16 rims are assignable to vessels of this kind, all except two of them of cooking pot ware. A large spout of class **b** of cooking pot ware may belong with **893**.

890 (N136) FIG. 8.3. D. 20. Cf. class **a1**. Fine cooking pot ware, with red to light brown wash. There are about three other similar rims.
891 (N137) FIG. 8.3. D. 25. Cf. class **a1**. Cooking pot ware: clay grey-brown to black, red-brown at edges, with red shading to red-brown and dusky wash. There are about two other similar rims.
892 (N140) FIG. 8.3, PLATE 39. D. 30. Cf. class **b3**. Cooking pot ware: clay grey, red-brown at edges, with red wash. Outside strongly wiped.

893 (N138) FIG. 8.3. D. 30. Class **c4**. Fine cooking pot ware, with red-brown wash. Decoration in thick creamy white: groups of diagonal bands, worn. A spout of class **b**, and fragments with diagonal bands in white, may belong with this.
 Of about four other similar rims, **894** (N139; PLATE 39; Wilson and Day 1999, 3, 37–9, 50–2: sample KN 92/189, plain red coarse ware, fabric group 4: cf. **848, 858, 873**) is of fine cooking pot ware with a red wash but overpainted in white, and has a wart on the shoulder.

TYPE 18. LARGE BOWLS OR JARS WITH INWARD CURVING, OFTEN CARINATED AND THICKENED RIMS **895–897**

There are only two scraps of rim with a carination strictly assignable to this type. But some 11 other large thickened rims may be grouped here: cf. A2 (p. 153). All except **896–897** are of cooking pot ware.

895 (N135) FIG. 8.3. Cooking pot ware: clay grey at core, with brown wash outside, purple-brown inside. There are about nine other similar rims.
896 (N113) FIG. 8.3, PLATE 38. D. 30. Coarse orange clay with dark grit; surface with paler slip. Decoration in black: band round outside of rim, continuing on top; opposed diagonal bands on body.

Wilson and Day 1999, 3, 37–8, 44–6, pl. 8a: sample KN 92/195, dark-on-light painted coarse ware, fabric group 1: cf. **859–860, 864**.
897 (N114) FIG. 8.3. D. 30. Orange clay, dusky at core, with fine grit. Buff slip, burnished inside and outside. Rim painted black.

TYPE 19. COLLAR-NECKED JARS WITH HORIZONTAL SIDE-HANDLES **898–900**

One or two rims may belong to jars of this kind.

898 (N112) FIG. 8.3, PLATE 39. D. 17. Coarse orange clay with white grit; orange slip. Decoration in dark brown to black: thin band round outside of rim; group of diagonal stripes on neck.
899 (N121) FIG. 8.3. D. 20. Very irregular, and

perhaps not from a jar of this type. Fine orange clay with paler surface. Red wash outside, continuing round inside of rim.
900 (N141) FIG. 8.3. D. 12. Cooking pot ware, with red wash.

TYPE 20. SUSPENSION POT **901**

Fragment **901** (N150; PLATE 39) with unique decoration of vertical ribs in relief may come from a suspension pot of some kind (see p. 201). Cf. in light grey ware **1255**, and references.

TYPE 23. TRIPOD COOKING POT **902**

Only the pointed tip of one tripod foot of cooking pot ware was found (PLATE 39: **902**). It is round in section.

TYPE 24. HORNED STANDS **903**

Two fragments are in cooking pot ware with a red wash (PLATE 42: **903**; N143).

TYPE 27. PITHOI **904–905**

There is one fragment from what must have been a truly massive pithos **904** (N149; PLATE 40) with walls nearly 3 thick and a large false strap handle like that on **251** (PLATE 23) from A1. It is of very coarse fabric, with gritty, reddish to orange clay with a paler orange surface. An isolated rim **905** appears to come from an exceptionally large jar.

905 (N105) FIG. 8.3. Rim with stump of round handle, which may have been vertical. D. 26. Fairly fine

orange clay, dusky at core. Rim solid with black shading to reddish paint.

SPOUTS **906**

Spouts seem to be of both classes **b** and **c**. One fine elongated class **c** spout **906** (N148; PLATE 38) evidently comes from a small jar of type 16. This has a red-brown shading to purple and dark brown lustrous wash with a distinct metallic sheen; the wash continues as a band round the inside of the rim and of the spout.

HANDLES

Handles are in general round section, but one large handle is thick oval. There are also a strap handle of flattened oval section, and a scrap of a small thin strap handle, triangular in section on the under side, the upper side with a black wash. **878** (above) with a pair of ribs or strips in relief at the top evidently comes from a jug: cf. **748** with references for similar handles from Knossos and elsewhere.

BASES are flat.

DECORATION

Paint 907–912
Dark-on-light, in shades of red, dark red, red-brown, brown and black
Designs include groups of lines, straight or diagonal, or making chevrons. The following are shown on PLATE 39.

907 (N146) Jar (?) frag. Fine orange clay with orange-buff surface, well burnished outside, less well inside. Decoration in dark purple-red: zone of chevrons flanked by horizontal bands.
908 Lower part of bowl. Fine buff ware, decorated

with pairs of diagonals in red.
909 Bowl frag. Fine buff ware, burnished both sides. Decoration in red.
910 Bowl frag. Fine buff ware, burnished both sides. Decoration in red.

Light-on-dark
This is less in evidence than dark-on-light, but the designs are similar. Several vases of cooking pot ware have simple decoration in white, such as **911–912**.

911 (N147) FIG. 8.3, PLATE 39. Bowl or jar frag. Very fine cooking pot type ware; reddish clay with red wash, well smoothed or burnished outside, less well inside. Decoration in white: diagonal stripes, solid spots and lattice.

For decoration with solid spots, cf. **512** (A3).
912 PLATE 39. Jar frag. Fine red cooking pot ware; outside has light red-brown wash and decoration in white.

Relief
Warts occur on the shoulders of jars. Fragment **901** (above), which may come from a suspension pot, has an unique decoration of vertical ribs of sharp triangular section. It is of very hard fabric, perhaps through overfiring; the clay is black on the outside surface, which is well smoothed or burnished, dark red on the inside.[5]

DEPOSIT B2

(1) Floor 2: levels A12, A10, A8–A7. (2) Floor 3: level A6. (3) Pit C: levels A11, A9.
Amount: about 2 tables.

This deposit includes the material from above Floors 3 and 2 in Area B, together with that from pit C, originally thought to be a hearth, at the NE corner of trench A. The whole deposit was sealed by the EM III floor 4. Most of the pottery from trench B probably belongs to this horizon, and was studied in connection with trench A. No pottery, however, from trench B has been included in the statistics and, where fragments from trench B are described or illustrated, this is indicated.

Light grey ware
There are two small scraps, one of them with a carination: cf. B1.

Dark grey burnished ware
The only fragments are two stray rims of EM I chalices.

Red and light brown burnished wares
About seven fragments are assignable to these fabrics, including a goblet rim and the internally thickened rims of one large and one small bowl akin to type 4. All these may be earlier strays, belonging to late EM I or early EM II. But two bases of bowls of good fabric with a red or light brown wash, well stroke burnished both sides, appear contemporary with the deposit. One large internally thickened bowl rim is unique in having a black burnished surface: it may be an earlier stray.

Vasiliki ware 913–920
Over 30 fragments were noted, more or less evenly distributed throughout the deposit. They include three rims of cups of type 1B with strap handles, for example **913** (N 210; FIG. 8.4),[6] two goblet rims

[5] Cf. the suspension pot from Koumasa, which appears to be of similar fabric: Xanthoudides (1924, 9, pl. 93: 4193) assigned it to EM I or the beginning of EM II. Vertical ribs already occur as decoration on vases of class C fine burnished ware of Phaistos

FN (Vagnetti 1973a, 69, fig. 68: 9–10).
[6] Betancourt 1979, 40: VI.A Knossos 1; Wilson and Day 1999, 3, 37, 39–40, 59–61, pl. 10a–b: KN 92/173, fabric group 8 (Vasiliki ware, of fine fabric with biotite mica and epidote).

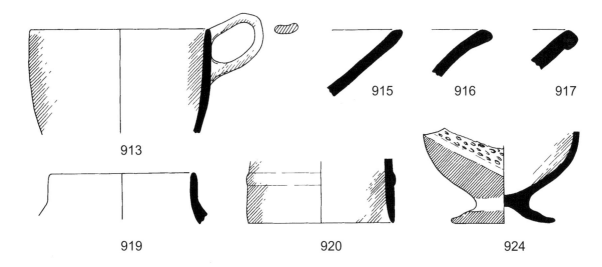

FIG. 8.4. Deposit B2 (EM IIB). Vasiliki ware etc. **913**, **915–917**, **919–920**; type 2 goblet **924**. Scale 1:2.

(e.g. **914**, PLATE 40; unstratified from trench B), a goblet base and some half a dozen fragments of goblets or bowls.[7]

Five or six bowl rims include **915** (N195; FIG. 8.4, PLATE 40: inside; D. 18) and **917** (N198; FIG. 8.4; D. 30);[8] **916** (N197, FIG. 8.4; D. 20) is not true Vasiliki ware, according to Betancourt. One bowl rim has a clay rivet on top like **820** (B1). Two bases, e.g. **918** (PLATE 40), evidently belong to bowls, but some eight or nine fragments of bases and five body fragments come from closed vessels. Jar rim **919** (N211; FIG. 8.4, PLATE 40)[9] from level B1, and therefore not well stratified, is included here; it has a bead somewhat like **822** (B1) (FIG. 8.1, PLATE 40). **920** (N196; FIG. 8.4, PLATE 40) may be from the edge of a lid with a rib running round the side.[10]

TYPES

TYPES 2 AND 3. GOBLETS **921–944**

Just four or five bases of goblets of type 3 come from the higher levels (one from level A7, three from A6). The evidence from Area A also suggests that simple goblets of type 3 were extremely rare in EM II, although common in EM III. All these bases have a wash (red, dark red or black) both sides. One or two other scraps of bases, however, from levels A8 and A6, with only an outside wash, may also come from goblets of type 3.

Eggcup feet from goblets of type 2: about 34 range in diameter from 4.2 to 5.7. Of these, seven (about 1/5) are of fine buff ware, the surfaces for the most part burnished, sometimes even on the underneath of the foot. The majority of these seven feet has a band in red (once in black) round the waist as FIG. 5.4: 2. The remaining 27 eggcup feet (about 4/5 of the total) have a wash (12 red, 15 black), and most of these, some 20 or more, are decorated with a white hand round the waist as FIG. 5.4: 4. In almost every case the wash appears to have covered all the inside of the goblet as well as the outside; there are only three examples where the inside is plain.

In nine cases (1/3 of the total) the underneath of the foot is painted solid. In six others it has a ring of paint round the outer edge as FIG. 5.5: 6, once combined with a pair of large spots **921** (N157; FIG. 5.5: 5, PLATE 40). In one case a diagonal stripe in white has been added on top of the ring. Several other bases have similar marks on the underneath: in four cases a single short stroke, once in white on a dark wash, in the other three instances in dark (red or red-brown) on a light surface, as **922** (N156; PLATE 40). In one case two short strokes are combined to make a cross in red on the underneath of the

[7] Cups of Vasiliki ware akin to our type 1B seem not uncommon: Betancourt 1979, 40: VI.A Ayia Triada 1 (35, fig. 10: 17) and Porti 1 (23, fig, 5: 2B; 35, fig. 10: 18), to which add Blackman and Branigan 1982, 34, fig. 13: 157.

[8] Wilson and Day 1999, 3, 37, 39–40, 59–61: sample KN 92/176, fabric group 9 (Vasiliki ware, with fine metamorphic rock

fragments), perhaps from a production centre in (north) central Crete.

[9] Wilson and Day 1999, 3, 37, 39–40, 59–61: sample KN 92/175, fabric group 9, as **917**.

[10] For the rib, cf. **1208** in light grey ware, and SMK D.III.1 503 with red pattern burnish decoration, both of which are earlier than **920**.

foot **923** (N 158; PLATE 40). A scrap of a high eggcup foot of anomalous fabric may be an earlier stray: it is of soft grey-brown to black clay, and worn; the outside, it seems, was once black burnished.

An unique fragment **924** (N 159; FIG. 8.4, PLATE 40) has a dark brown to black wash outside, dark purple red-brown inside. On the outside is part of a reserved diagonal zone decorated with irregular rows of jabbed incisions and flanked by white stripes. On the underneath, which is plain, is a pair of vague and perhaps fortuitous marks in very thin brown paint.[11]

Rims assignable to goblets of types 2 and 3: about 119, of which about 1/4 (31) is of fine buff ware, while 3/4 (88) have a dark wash. The proportion of washed rims to those with a light surface rises significantly from about 1:2 in level A12 to 1:4 in levels A10, A8 and A7, and to 1:5 in level A6.

Decoration is varied, and often quite elaborate, especially in white paint on the larger number of washed rims. PLATE 41 shows goblet rims with decoration in dark-on-light: on **926** in red, on **925** and **927** in red-brown, on **928–930** in black, on a buff or orange surface which has been smoothed or burnished. PLATE 41 also shows goblet rims with decoration in white on a dark wash, which shades from red **938** to light red-brown **931** through dark red-brown and purple-brown to black **942**.

Motifs of decoration on goblet rims include horizontal bands and stripes in different combinations; and groups of chevrons, both horizontal and vertical (PLATE 41: **930**, **938–940**). Pendent loops are much in evidence, mostly in the form of rows of small single loops hanging from the top of the rim; these occur both in dark-on-light and in light-on-dark (e.g. PLATE 41: **941–943**). There are also one or two examples of large double loops from level A10, and one case of large quadruple loops from level A6 (PLATE 41: **944**). A rim with a horizontal wavy band in white on an overall red wash, unstratified from trench B, appears to be EM II (PLATE 41: **934**). Another rim from level A7 has a row of short dashes between stripes on an overall red wash (PLATE 41: **937**). Some goblet bodies were evidently decorated with vertical stripes, others with diagonal.

TYPE 4. SHALLOW BOWLS OR PLATES WITH RIM THICKENED INTERNALLY **945–950**

Bowls of this type are common, as in other EM II deposits. Rounded rims of class **a** outnumber bevelled rims of class **b** by 10:1.

(**a**) Rounded rims: about 100, including the miniature bowl **947**. Rims of this class are as equally plentiful in the later as in the earlier levels of the deposit; no less than 19 come from level A6, and seven from pit C (level A9). **946** is exceptional in having a dark wash both sides and decoration in white. The others are of fine buff ware, with decoration in dark-on-light of a band below the rim inside, and once outside as well, normally in red, but in 10 cases in black. One rim has a string-hole below it.

945 (PEM/60/P32) FIG. 8.5. Complete profile. Ht 2.5. D. 15. Fine orange clay, surface scraped outside, orange-buff burnished inside. Decoration in red shading to dark red, almost black: band inside rim, and pair of diagonals pres. on rim. From level B6, which appears to be a continuation of this deposit.

946 (N161) FIG. 8.5, PLATE 41. D. 22. Fine orange clay, with purple-brown wash both sides. Hatching on top of rim in thick creamy white. From level A8.

947 (N239) FIG. 8.5, PLATE 41. Miniature bowl. Cf. **950**. Fine orange clay with surface orange-buff. Decoration in red: band below rim inside, and hatched inverted triangle on rim. Unstratified (level B1), but evidently EM II.

(**b**) Bevelled rims: only 11, including the profile of a miniature bowl **950**. Some large examples of these rims are more or less everted as **948–949**. Rim **949** has a black wash inside. The rest are of fine buff ware, with bands of paint (normally red, sometimes black) inside and on the bevelled outside edge.

948 (N163) FIG. 8.5. D. 30. Fine orange clay with paler surface, smoothed. Bands in red inside and outside rim. From level A10.

949 (N164) FIG. 8.5. D. 30. Fine orange clay with paler surface. Outside apparently scraped; black wash inside. From level A10.

950 (N162) FIG. 8.5. Profile of miniature bowl: cf. **947**. Fine orange clay with buff slip. Decoration in dark brown to black: band inside rim, and hatching on outside edge of rim. Underside of bowl decorated with some design, of which only a scrap is preserved.

[11] A footed goblet from Ayia Triada has a scheme of decoration of an horizontal reserved band with four rows of small vertical incisions reminiscent of **924**: Banti 1931, 179, fig. 36: 59. Banti noted that the shape suggests a date in EM II, but the decoration led her to assign it to EM III. A footed goblet from Koumasa, which she compared for the shape, looks EM IIB (*CVA* Denmark 1, Copenhagen 1, pl. 30: 10). Among other examples of this system of decoration assignable to EM II are: Betancourt 1979, pl. 5c (Seager 1912, 83, fig. 48: M.44), on a spouted jar of Vasiliki ware; H. W. Pendlebury *et al.* 1936, 79, pl. 11: 616.

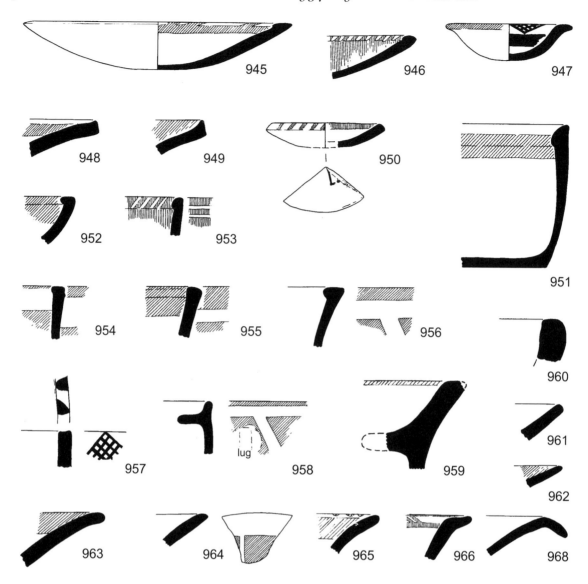

FIG. 8.5. Deposit B2 (EM IIB). Type 4 shallow bowls or plates: (**a**) rounded rims **945–947**; (**b**) bevelled rims **948–950**; type 5 bowls **951–956**; type 6 deep bowls **957–959**; type 7 shallow bowls **960–962**; type 8 bowls **963–965**; type 9 bowls **966, 968**. Scale 1:2.

TYPE 5. BOWLS WITH UPRIGHT SIDES AND RIM THICKENED INTERNALLY **951–956**

A complete profile **951** of a bowl of this type comes from level B5. From trench A there are only five rims which may be grouped here. Of these one is of fine buff ware, while four have a wash.

951 (PEM/60/P31) FIG. 8.5. Two frags. include profile. Ht *c.* 7.8. D. *c.* 2.6 (?). Hard fabric. Fine orange clay with paler surface, smoothed. Decoration in dark brown to black, worn: bands below rim and round base inside and outside. Likely trace of cross in black under base. From level B5.

952 (N179) FIG. 8.5. Fine orange clay with black wash, much flaked away and worn. From level A6.

953 (N177) FIG. 8.5. D. 12. Fine orange clay with dark purplish-red wash. Decoration in white: band inside, and fine diagonal hatching on top of rim; pair of stripes below rim outside. From level A10.

954 (N175) FIG. 8.5. D. 15. Fine orange clay with purple-brown to black wash. White bands below rim inside and outside. From level A8.

955 (N178) FIG. 8.5. D. 30. Fine orange clay with buff slip, which is well smoothed, especially on inside. Decoration in dark purple-brown: rim painted solid; band below rim outside. From level A10.

956 (N176) FIG. 8.5. D. 30. Fine orange clay with red wash and decoration in white: bands below rim inside and outside, and diagonals on body. Some decoration in white on top of rim, but much worn. From level A8.

TYPE 6. DEEP BOWLS WITH TROUGH SPOUT AND HORIZONTAL SIDE-HANDLES **957–959**

One or two rims may come from bowls of this type.

957 (N187) FIG. 8.5. D. 30. Fine orange clay with paler orange surface. Decoration in matt red: latticed hatched triangle outside, and broad hatching on top of rim. From level A10.

Two rims with an internal ledge for a lid appear to come from deep bucket-shaped bowls which may have been akin to this type.

958 (N209) FIG. 8.5. D. 12. Possible stump of vertically perforated lug below rim. Fine orange clay; wash both sides in shades of red-brown. Decoration in thick creamy white: band below rim, and a diagonal descending from it. From level A9.
959 (N242) FIG. 8.5. D. c. 40 (?). As **958**, but larger. Edge of internal ledge for lid, broken. Rather sandy orange clay, grey at core. Decoration in red to dark red: stripe on top of rim and (?) band on ledge; broad diagonal band outside. From level B5.
 Wilson and Day 1999, 3 (calling it a 'pedestalled bowl'), 37, 40, 61–2, pl. 10e: sample KN 92/196, fabric group 10 (frequent sand grains), reminiscent of fabrics imported to Knossos from the Mesara in EM IIA. **959** is the sole component of their group 10.

TYPE 7. SHALLOW BOWLS WITH STRAIGHT OR INWARD CURVING SIDES **960–962**

A few rims evidently belong to bowls of this shape.

960 (N185) FIG. 8.5. D. 40. Fine orange clay, grey at core; good quality red-brown wash, well smoothed. From level A10.
961 (N186) FIG. 8.5. D. 50. Gritty orange clay with buff slip. Outside rough with grit showing; inside very fine buff burnished. From level A9.
962 (N188) FIG. 8.5. D. 10. Fine orange clay; dark red wash, very well smoothed or burnished. From level A6.

TYPE 8. BOWLS WITH FLARING RIM **963–965**

A few rims are assignable to this type. Two are of cooking pot ware, e.g. **965**.

963 (N170) FIG. 8.5, PLATE 41: inside. D. 20. Fine orange clay with buff surface; outside scraped. Broad red band round inside of rim. From level A6.
 Wilson and Day 1999, 3, table 1, 53–5: sample KN 92/158, in dark-on-light ware, fabric group 6 (fine-grained with quartz), known at Knossos in EM IIA and in a related fabric in MM.
964 (N218) FIG. 8.5. D. 30. Fine cooking pot ware; light brown wash inside, red outside. Decoration in creamy white: band round outside of rim, vertical stripe descending from it. From level A6. There is another similar rim from level A9.
965 (N174) FIG. 8.5. Fine orange clay with paler surface, smoothed inside, well stroke burnished outside. Decoration in red to red-brown: band inside rim, and fine hatching on outer edge of rim. From level A10.

TYPE 9. BOWLS WITH EVERTED RIM **966–974**

There are about 32 rims coming from both A shallow and B steep-sided varieties of such bowls. Over 3/4 of them (some 26) have a dark wash (16 red, 10 black), with decoration in white of bands or stripes inside, and often outside the rim as well, and round the inside of the base. On the rim itself are found broad wide diagonal bands (**973**), and once (**970**) bold lattice; once chevrons combined with large solid spots occur (**969**). A large spot also appears on **971** with the stumps of a horizontal side-handle. The six-odd remaining rims are light surfaced, **968** apparently plain, but the others decorated in dark-on-light. Most of these light surfaced rims come from the later levels of the deposit.

966 (N169) FIG. 8.5, PLATE 41. Two rims from same bowl. D. 30. Fine orange clay with buff surface, smoothed. Decoration in red: bands outside, and below rim inside; stripe on outside edge of rim, and fine multiple diagonal lines (chevrons ?) on top of rim. From levels A6, A7.
967 PLATE 41. Fine buff ware: orange clay. Decoration in red: band inside rim, traces of chevrons (?) on top of rim.
968 (N168) FIG. 8.5. D. 30. Fine orange clay with buff slip, well smoothed inside. Surface apparently plain, undecorated. From level A6.

For rims with this profile, cf. Tylissos: Hazzidakis 1934, 82, pl. 20.3 b, which may be EM II; and **579** (p. 169) from A5 of EM III, when this variety seems to have been more at home.
969 (N166) PLATE 41. D. c. 17. Purple to red-brown wash. Decoration in white: pair of stripes inside, and stripe on outside edge of rim; double chevrons flanked by large solid spots on rim.
970 (N165) PLATE 41. D. c. 30. Red to red-brown wash. Decoration in white: band inside rim, and bold lattice formed by crossing diagonal stripes on top of rim.

971 (N167). Frag. with stump of horizontal side-handle, as type 9B. Purple-brown wash. Decoration in white: bands below rim either side; circles round stumps of handle and large solid spot between them.

972 PLATE 41. Lustrous purple-brown to red wash.

Decoration in creamy white: band round inside of top of rim.

973 PLATE 41. Wash as **972**. Decoration in creamy white: band round inside of rim, wide diagonal bands on top of rim.

A rim in cooking pot ware is from a shallow bowl as type 9A.

974 (N219) PLATE 44. Cooking pot ware with red-brown wash outside, dark brown inside. Decoration in white: opposed groups of three diagonal stripes on rim.

TYPE 10. LARGE BOWLS WITH STRAIGHT SIDES AND THICK EVERTED RIM 975–983

Large parts of a bowl of this type **975** were found, together with eight other rims. Rim **976** has the stump of an open trough spout.

975 (PEM/60/P33) FIG. 8.6, PLATE 42. Several non-joining frags. of rim and body. Ht est. *c.* 27. D. *c.* 40. Thin-walled. Orange clay with fine grit, and orange-buff slip. Decoration in dark red to red-brown and black: rim painted solid, with deep pendent loops outside. Inside splashed with paint, and scored before firing with criss-cross of grooves made with broad blunt-ended instrument. From level A12, with some frags. from level A13. One other frag. from this or a similar bowl from level A8.

976 (N173) FIG. 8.6, PLATE 42. Rim with stump of open trough spout. D. 40. Gritty brown clay with overall red-brown wash outside, continuing round inside of rim.

Outside decorated with pairs of diagonal stripes, apparently painted in white.

977 (N172) FIG. 8.6, PLATE 42. D. 50. Coarse orange clay with buff slip. Decoration in red-brown: rim painted solid, band below rim outside.

978 (N171) FIG. 8.6. Large pithos-like rim. Clay with fairly fine grit, grey at core, red-brown at edges. Pale buff slip outside. Black wash inside, continuing on rim and as band round outside of rim.

Wilson and Day 1999, 3, 37–8, 44–6: sample KN 92/208, dark-on-light painted coarse ware, fabric group 1, like **859–860, 864, 896**.

A group of rims which appear to come from deep bowls with more or less upright sides is described here. The rims are all of distinctive fine burnished ware. The insides are characteristically plain and very well burnished, while the outsides are also well smoothed or burnished, but have a dark wash. **980** preserves the stump of an open trough spout, or it may have been a vertical handle rising above the rim. The stumps of large vertical handles of thick oval section appear on two rims of this fabric (from levels A6 and A9) which have a black wash outside. **983**, although from a bowl of a different shape, is included here owing to its similar fabric: Wilson and Day assign it to one of their Vasiliki ware groups.[12]

979 (N180) FIG. 8.6. D. 25. Soft fabric cf. soft red burnished ware of MM I. Orange clay; surface with red shading to light brown wash, very finely burnished. From level A10.

980 (N212) FIG. 8.6. Rim with stump of spout (?) or handle rising above it. Fabric like **982**. Inside surface stroke burnished; outside has red wash. From level A6.

981 (N181) FIG. 8.6. D. 30. Fine orange clay. Inside surface orange-buff, finely stroke burnished; outside has red-brown wash. From level A10.

982 (N182) FIG. 8.6. D. 30. Fine dusky orange clay, grey at core. Inside surface orange-buff, well burnished; outside including top of rim has dark red wash, well smoothed or burnished. From level A6.

983 (N183) FIG. 8.6. D. 18. Fabric like **982**. Inside surface orange-buff, well stroke burnished. From level A6.

TYPE 11. LARGE BOWLS WITH CURVING, OFTEN CARINATED SIDES AND THICKENED RIM (COOKING POT WARE) 984–988

About 40 rims may be grouped here, but only five of these preserve traces of a carination. Most of the rims are thickened externally, and flat-topped as class b. But two have rolled tops as class d, e.g. **988**; and one of these is carinated. These rolled rims, and some of the others included here, may come from bowls or jars akin to type 18. The exceptional rim **986** of class a has the stump of what may have been a vertical handle as with type 18, and traces of decoration in white.

[12] Wilson and Day 1999, 3, 38, 57–9: sample KN 92/174, of fabric group 8: Vasiliki ware, fine fabric with biotite, mica and epidote.

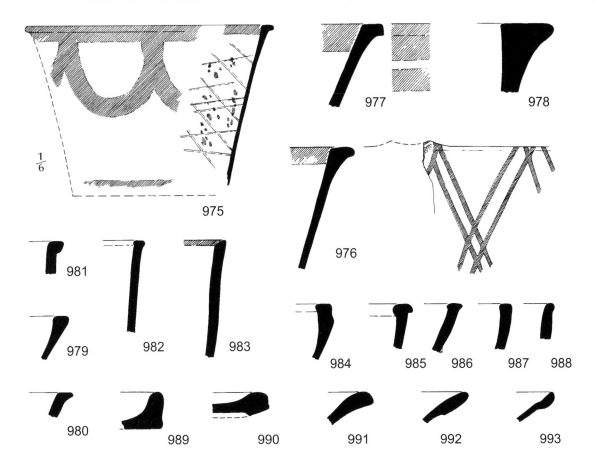

FIG. 8.6. Deposit B2 (EM IIB). Type 10 large bowls etc. **975–983**; type 11 large bowls **984–988**; types 12 and 13 large flat dishes **989–990**; type 14 baking plates **991–993**. Scale 1:3 (**975**: 1:6).

984 (N223) FIG. 8.6. D. 25. Class a1. Cooking pot ware, with red-brown wash. From level A9.
985 (N221) FIG. 8.6. D. 25. Class a1. Cooking pot ware, with red wash. From level A10.
986 (N220) FIG. 8.6. Rim with stump of vertical (?) handle. D. 30. Cooking pot ware. Fabric as **985**. Red wash. Traces of decoration in creamy white on top of rim. From

levels A7, A10.
987 (N224) FIG. 8.6. D. 40. Class a2. Cooking pot ware, with red-brown wash inside; outside smoothed or burnished. From level A9.
988 (N222) FIG. 8.6. D. 30. Class b. Fine cooking pot ware, with dark brown shading to black wash. From level A8.

TYPES 12 AND 13. LARGE FLAT DISHES WITH UPRIGHT SIDES AND PLATES (COOKING POT WARE) **989–990**

Five rims assignable to these types all appear to come from large vessels in cooking pot ware as **989–990**.

989 (N216) FIG. 8.6. D. 40. Dark red wash inside, well smoothed or burnished; underneath rough. From level A12.

990 (N217) FIG. 8.6. D. 40. Dark red wash, stroke burnished. From level A8.

TYPE 14. BAKING PLATES (COOKING POT WARE) **991–993**

There are five rims of these.

991 (N234) FIG. 8.6. Red wash inside. Outside rough, and black as if from fire. From level A9.
992 (N232) FIG. 8.6, PLATE 30: underneath. D. 50. Dark red-brown to dusky wash. Outside dusky, perhaps

from fire. From level A8.
993 (N233) FIG. 8.6, PLATE 30: underneath. D. 40. Fine cooking pot ware, with red wash. From level A6.

TYPE 15. JUGS WITH CUTAWAY SPOUT **994–999**

Only fragments of these were found; many seem to belong to relatively large jugs. All spouts appear to be of the cutaway type. One or two spouts are pared outside. In the one case where a handle is preserved with a section of rim (from level A10) it is set below it. This, and about 1/2 the fragments of jug necks and spouts, have a dark, in most cases black, wash.

Fragment **994** from the shoulder of a jug with a lustrous black wash has decoration in white paint, and what appears to be the lower part of a row of incised chevrons round the base of the neck. This is reminiscent of the raised bands with incised decoration which characteristically appear at the base of jug necks in EM III, but are found at least once in Vasiliki ware (**1336**): compare the boldly grooved chevrons on **626** (A5; PLATE 32), which may come from a lid.

Two necks of large jugs (e.g. **995**) of fine buff ware have characteristic decoration in dark-on-light of a thin stripe on top of the rim with triple chevrons below it. Bodies of jugs of fine buff ware may be decorated in dark-on-light with cross-hatched triangles (e.g. **997–998**). Cf. **374–375** (A2) and **1332–1333**.

The unique fragment **999**, which appears to come from the rim of a jug of cooking pot ware, has a vertically perforated lug, doubtless one of a pair, set on the inside.

994 (N189) PLATE 43. Shoulder frag. Fine orange clay; outside with good lustrous black wash. Decorated with diagonal band in thick creamy white. Line of short diagonal incisions at top edge may be part of row of incised chevrons round base of neck. From level A8.

995 (N190) PLATE 43. Neck of large jug. Orange clay, with buff slip outside. Decoration in dark brown to black: thin stripe on rim with triple chevrons below. From level A7. Another similar from level A6 (PLATE 43: **996**).

997–998 PLATE 43. Body frags. Fine orange clay with buff slip outside. Decorated in dark red-brown with cross-hatched triangles between two bands. One of these is Wilson and Day sample KN 92/157.

Wilson and Day list two jug fragments (1999, 3, 37, 39, 53–5: sample KN 92/156 from level A6; and pl. 9d: sample KN 92/157 from level A12), of fabric group 6 (fine grained with quartz), probably from (north) central Crete. **997** or **998** is KN 92/157 and **996** KN 92/156.

999 (N243) FIG. 8.7. Rim, apparently from side of mouth, with what appears to be stump of handle on outside. On inside face of rim: stump of lug with vertical perforation, probably one of a pair of lugs set opposite each other. Fine cooking pot ware, with red wash, which seems smoothed or burnished outside. From level A12.

TYPE 16. SMALL SPOUTED BOWL-JARS **1000–1025**

Some 33 rims of fine ware may be grouped here. Of these, about 2/5 (13) are of the characteristic EM II class **b2**: two (**1003–1004**) are associated with spouts, two with horizontal side-handles, as type 16B. The tops of rims **1007–1008** look as if they had been deliberately hollowed to receive a lid. Seven rims are of the simple class **a**; and one of these (from level A7) is associated with the stump of a spout which may have been of class **c** like the isolated spout **1028** (PLATE 44); another preserves the stump of a vertical handle, as type 16A.

Over 2/3 of the rims considered here have a wash outside and many of them one inside as well. The wash is in shades of red or black in the proportion of c. 2:3. Over 3/4 (10) of the 13 characteristic rims of class **b2** have a wash, and 1/2 of these (five) have the wash inside as well as outside. Rims of class **b** in general appear to come from comparatively wide-mouthed vessels. But those of classes **c** and **d** seem to belong to narrow-mouthed jars; when they have a wash outside, it only continues inside round the edge of the rim.

The decoration on the rims and fragments of these jars of fine ware, whether in dark-on-light (PLATE 44) or in the more common light-on-dark (PLATE 43), is apt to be elaborate. **1005** (PLATE 43) and **1002–1003** have a red wash, the others a wash which is shades of dark purple-brown or black; on **1020–1021** the wash is inside as well as outside, and these fragments may therefore come from wide-mouthed jars with rims of class **b** or even from bowls.

1000–1019 are rims.

1000 (N202) FIG. 8.7. D. 10. Class **a1**. Thin-walled. Fine orange clay; inside plain, wiped; outside has dark red-brown to black wash.

1001 (N214) FIG. 8.7. D. 10. Class **a 1** with carination. Fine orange clay, with lustrous red wash, worn. From level A8.

1002 (N238) FIG. 8.7. D. 20. Cf. class **a2**. Fine orange clay, with good quality black wash, inside and out, well smoothed or burnished outside. From level A10.

1003 (N203) FIG. 8.7. Class **b2** with spout of class **c**. D. 11. Orange clay with a greenish tinge; spout pared. Black wash inside, including round inside of spout, and out, much flaked away. From level A10.

1004 (N206) FIG. 8.7, PLATE 43. Class **b2** with hole for spout (missing). D. 14. Fine orange clay with black wash inside and out. Decorated in creamy white with rows of chevrons between narrow bands. From level A6.

For the scheme of decoration on this and **1005** (PLATE 43), which has red wash, cf. Tylissos: Hazzidakis 1934, 82, pl. 19.2a, c, below rims of jars with horizontal side-handles

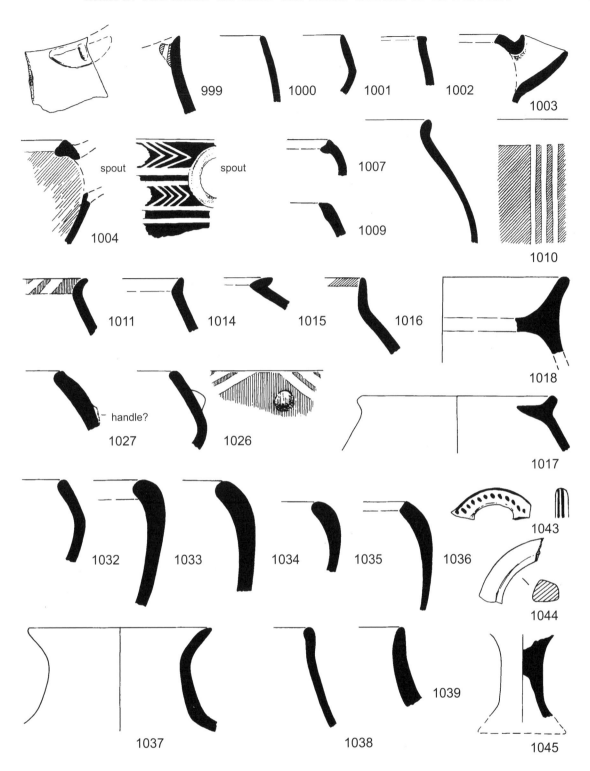

FIG. 8.7. Deposit B2 (EM IIB). Type 15 jug **999**; type 16 small spouted bowl-jars **1000–1004**, **1007**, **1009–1011**, **1014–1018**; type 17 large jars **1026–1027**; type 18 large bowls or jars **1032–1036**; type 19 collar-necked jars etc. **1037–1039**; handles **1043–1044**; pedestal **1045**. Scale 1:2.

and spouts of class **b2**. These may be EM III and represent the type of jar from which our fragments come; but Zois (1969, 30–1, pls. 38–9) assigns them to MM IA, while noting that the decoration is comparable to East Cretan EM III light-on-dark.

1006 PLATE 44. Class **b2**. Fine orange clay, with buff surface, smoothed or burnished outside. Decoration in dark

brown: band below rim and group of three diagonal stripes descending from it. From level A6.

1007 (N201) FIG. 8.7, PLATE 44. Class **b2**, hollowed on top as if to receive a lid. D. 16. Fine orange clay, with decoration in dark red-brown to black; rim painted solid; lattice outside. From level A7.

1008 (N204) PLATE 44. Rim as **1007**. Fine orange clay

with paler orange surface. Decoration in red: top and outside of rim painted solid; pairs of intersecting diagonal stripes outside. From level A10.

1009 (N205) FIG. 8.7. D. 15. Cf. class **b3**. Fine orange clay with buff surface. Red band round outside of rim. From level A7.

1010 (N191) FIG. 8.7, PLATE 43. D. 9. Class **c2**. Fine orange clay, with purple-brown to black wash outside. Decoration in thick creamy white: band round outside of rim, and group of three vertical stripes descending from it. From level A10.

1011 (N200) FIG. 8.7. D. 10. Class **c2**. Fine orange clay, with lustrous red wash outside, continuing round inside of rim, which is decorated with diagonals in white. Broad white band round neck. From level A10.

1012 (N207) PLATE 43. Class **c2**. Fine orange clay, with dark purple-red wash outside, continuing round inside of rim. Decoration in creamy white: band round outside of rim; alternate diagonal stripes and rows of dashes on body. From level A10.

1013 PLATE 44. Class **c3**. Orange clay with paler surface. Decoration in red: band below rim with what appears to be cross-hatched triangle beneath it. From level A12.

1014 (N208) FIG. 8.7. D. 12. Cf. class **c3**. Fine orange clay, with dark brown wash outside. From level A10.

1015 (N215) FIG. 8.7. D. 12. Cf. class **c4**. Rather soft fabric: clay orange, with thick red wash outside, continuing on top of rim. Outside well smoothed or burnished. From level B5.

1016 (N199) FIG. 8.7. D. 15. Class **d1**. Rather coarse dusky orange clay with fine grit which shows in surface; buff slip with greenish tinge. Decoration in black: wide band round outside of rim, continuing inside it. From level A12. There are one or two other similar rims of cooking pot ware.

1017 (N192) FIG. 8.7. Class **e** with ledge for lid. D. c. 11. Fine orange clay. Outside of rim has band in dark paint which continues on top of ledge inside; paint much worn. From level A10.

Cf. **387** (A2). A somewhat comparable rim from Trapeza is assigned to EM III (H. W. Pendlebury *et al.* 1936, 37, 42, fig. 9: 145).

1018 (N240) FIG. 8.7. Two frags.; as **1017**, but larger; edge of ledge inside broken. D. c. 14 (?). Cooking pot ware with red wash. Inside of rim finely burnished. From level A6.

1019 (N241) As **1018**. D c. 20 (?). Cooking pot ware with red wash. From level B6.

Rim **1020** and fragments **1021–1025** also appear to be from jars akin to type 16.

1020–1021 PLATE 43. Rim and frag. Dark purple brown to black wash. Decoration in white: pairs of diagonal lines. From levels A10, A8.

1022–1023 PLATE 43. Frags. Red wash as on **1005**. Decoration in white: groups of diagonal lines. From levels A7, A10.

1024 PLATE 44. Frag. Orange-buff outside, well smoothed or burnished. Decoration in thick dark red-brown: multiple chevrons. From level A12.

1025 PLATE 44. Frag. Buff outside. Decoration in dark brown to black: crossing pairs of diagonal lines. From level A10.

TYPE 17. LARGE SPOUTED BOWLS OR JARS WITH HORIZONTAL SIDE-HANDLES **1026–1031**

Some 30 rims may come from jars of this kind, nearly 1/4 of them more or less beaded, like **1027**, with what seems to be the stump of a horizontal side-handle. Four or five other rims like this show traces of decoration in white, on **1026** associated with a wart on the shoulder. Several other rims assigned to jars of this type have warts on the shoulder or traces of decoration in white: e.g. **1029–1031**, from levels A10, A7, A9.

1026 (N229) FIG. 8.7, PLATE 44. D. 18. Fine cooking pot ware, with red to red-brown and dusky wash. Shoulder has wart, flanked by groups of diagonal bands in white. From level A6.

1027 (N230) FIG. 8.7, PLATE 44. Rim with incipient bead and stump of horizontal side-handle (?). D. 30. Cooking pot ware with red wash. White band round outside of rim. From level A8.

1028 PLATE 44. Spout of class **c**. Black wash with decoration in white. Cf. Tylissos (Hazzidakis 1934, pl. 20.2

top) for one similar with same scheme of decoration.

1029 PLATE 44. Rim of fine cooking pot ware, with red wash. Decoration in white: pair of diagonal bands. From level A9.

1030 PLATE 44. Rim of fine cooking pot ware, with black wash. Decoration in white: group of diagonal bands. From level A10.

1031 PLATE 44. Rim of fine cooking pot ware, with dark red-brown wash and wart on shoulder. From level A7.

TYPE 18. LARGE BOWLS OR JARS WITH INWARD CURVING, OFTEN CARINATED AND THICKENED RIMS **1032–1036**

About seven carinated rims may come from bowls of this kind.

1032 (N231) FIG. 8.7, PLATE 44. D. 35. Cooking pot ware with dark brown wash. From level A10.

A distinct group of some 13 large thickened rims belonging to deep bowls or jars of cooking pot ware is included here: cf. A2 (p. 153). Most of these are round-topped, but one (from level A6) is pointed, and **1036** is bevelled.

1033 (N 225) FIG. 8.7. D. 45. Reddish shading to brown and dusky wash. From levels B 6, B5. Wilson and Day sample KN 92/203.
1034 (N227) FIG. 8.7. D. 45. Fabric as **1033**. From level A6.

1035 (N226) FIG. 8.7. D. 40. Red wash. From level A7.
1036 (N228) FIG. 8.7. D. 40. Dark red-brown to dusky wash. From level A6.

TYPE 19. COLLAR-NECKED JARS WITH HORIZONTAL SIDE-HANDLES 1037–1039

A single rim **1037** of cooking pot ware appears to come from a jar of this kind.

1037 (N237) FIG. 8.7. D. 10. Light brown wash. From level B6.

One or two other jar rims of cooking pot ware may be placed here.

1038 (N235) FIG. 8.7. D. 11. Thin-walled. Probably had red or red-brown wash, but blackened inside and outside as by fire. From level A10.

1039 (N236) FIG. 8.7. D. 8. Reddish clay, fired an even colour throughout, with light brown wash. From level A8.

TYPE 23. TRIPOD COOKING POTS 1040–1041

Of 12 tripod feet, 3/4 (nine) are round section (e.g. PLATE 44: **1040–1041** from levels A10, A 8), two (levels A12, A10) thick oval, and one (level A7) is thin triangular in section.

TYPE 24. HORNED STANDS 1042

Of three fragments, two from level A10, of coarse cooking pot ware with a red outside wash, purple-brown inside, may belong to the same object (PLATE 42: **1042**). The third piece is from level A6.

SPOUTS

Spouts of classes **b** and **c** were found. Those of class **c** may be more or less elongated, e.g. **1028**. There are no examples of bridge spouts of class **d**.

HANDLES 1043–1044

Handles are normally more or less round in section. **1044** of sub-rectangular section is probably from an imported vessel. The exceptional **1043** with elaborate decoration may come from a bowl.

1043 (N194) FIG. 8.7, PLATE 41. Handle, apparently rising from bowl rim. Fine buff ware: clay orange with greenish buff slip. Decorated in black with two stripes down top flanked by hatching on each face of handle. From level A7.

1044 (N213) FIG. 8.7, PLATE 44. Handle of sub-rectangular section, evidently horizontal, from side of jar (which may have been an import). Dark brown clay with fine grit. From level A8.

CARINATIONS

Carinations were only noted in connection with rims of cooking pot ware assignable to bowls or jars of types 11 and 18.

BASES 1045

Bases are in general flat. Ring bases only seem to occur on jugs or jars of probably imported Vasiliki ware. The fragment of a small pedestal foot **1045** may be EM II rather than a stray of an earlier period.

1045 (N160) FIG. 8.7. Frag. of small pedestal foot. Bowl broken away and missing; thus, this may belong to a small jar of some kind rather than a chalice. Foot unevenly made and irregular: fine orange clay; outside scraped; dark red to black wash, much worn.
 Cf. Trapeza: H. W. Pendlebury *et al.* 1936, 85–6, fig. 19: 805 ('EM I–II'), 806 ('EM III').

DECORATION

Paint
Painted decoration occurs in dark-on-light and light-on-dark, with a wide variety of motifs, especially in the now relatively common light-on-dark. The most elaborate decoration is found on goblets of

type 2, small jars of fine ware of type 16 — as on PLATES 44 (dark-on-light) and 43 (light-on-dark) — and jugs of type 15. Motifs include bands and stripes, single or in groups, horizontal, vertical and diagonal; rows of short dashes, cross-hatched triangles, and chevrons; loops, normally small and single, but occasionally double or even quadruple, hanging from the rims of goblets or bowls; and large solid spots. Bowl bases may be decorated with crosses on the underneath in red on a light ground (examples from levels A12 and A9) or in white on a dark wash (examples from levels A10 and A6).

Incision

Incision is extremely rare, but occurs in the form of short jabs on goblet **924** of type 2, and on jug shoulder **994** where it appears to foreshadow the incised relief bands round the necks of jugs in EM III and MM IA.

Relief

Relief decoration seems confined to warts on the shoulders of some jars, especially those of cooking pot ware of type 17.

EARLY MINOAN III

DEPOSIT B3

Levels A3, A3a. Amount: about 3 tables.

This deposit from between the two red plaster floors 4 and 5 has a relatively large amount of pottery considering the size of the deposit. The material seems homogeneous, and differs from that assignable to MM IA, most notably in the complete absence of polychrome decoration. But in the case of the bulk of the material (that from level A3) there is a slight possibility of contamination from Pit A, the foundation trench of wall β. The much smaller amount of material from level A3a is from uncontaminated deposit. Unless otherwise stated, however, the pottery described and illustrated is from level A3. There is little doubt that this B3 material corresponds to what Evans intended by EM III at Knossos, even if it seems more akin to pottery of MM IA than of EM II. It has recently been assigned to EM III late (the Upper East Well Group).[13]

At the same time the material from sites in eastern Crete that has been defined as EM III appears in many respects very different from this Knossian EM III. Rim **1124** of a jar with spiral decoration belongs to an import from eastern Crete, where it would clearly pass as 'EM III'. This suggests that the by now traditional view is substantially correct: that EM III at Knossos overlaps with the so-called EM III of eastern Crete, but evolves into MM IA while in eastern Crete what is defined there as EM III continues.[14]

While this B3 pottery is distinguished from that of MM IA by the lack of polychrome ware, it differs in many respects from that of EM II. There is only one scrap of an internally thickened rim from a bowl of the distinctive EM II type 4, and that is damaged and worn. At the same time simple goblets of type 3, extremely rare in levels assignable to EM II, now appear to outnumber eggcup footed goblets of type 2.

FABRIC

Fine ware

Vessels are in general well fired, although the clay is still often dusky at the core. About 1/3 of the fragments of closed types and, to judge from their rims, the vast majority of the numerous goblets of types 2 and 3 have a dark wash: shades of black or red, black washes being more common than red by about 2:1, although there is no rigid line of division between them, red merging through shades of light and dark brown or purple-brown into black. The washed surfaces of the vessels are often mottled, as is common in EM II, but the mottling does not appear to have had any decorative intention — unlike Vasiliki ware. The washes in general tend to be slightly lustrous in contrast to the matt appearance normal in washes of EM II. When the wash, whether red or black, is thick, it may have a high metallic sheen, as is common in MM IIA. This tendency towards a more lustrous quality in the washes may simply reflect improvements in firing the pottery.

[13] Momigliano 2007c, 83: 8. [14] Andreou 1978; Betancourt 1984; Momigliano 2007c, etc.

Surfaces in fine buff ware, without an overall dark wash, are shades of orange or buff, sometimes greenish, as in EM II; occasionally there is a greenish slip or wash. One base of a large shallow bowl is of a very soft whitish clay. Burnishing of fine ware, whether light surfaced buff ware or dark washed ware, appears more restricted than in EM II, and virtually confined to jugs, where it may have had the practical objective of proofing them to retain liquids.

Decoration for vessels with a dark wash is in white. There is no evidence for the use of red, nor for combining white and red to give a polychrome effect. The white ranges from a fairly whitish to a creamy white and/or distinctly yellowish white, as found on the EM III pottery of eastern Crete. The white never seems to correspond, however, to the fine chalky white apparent in the decoration of many MM IIA vessels. Many vessels, however, of MM I–II at Knossos are decorated with a white with a distinctly yellowish tinge, rendering it indistinguishable from some of the whites used in this EM III phase and perhaps earlier still.

Vasiliki ware 1046–1048

This is extremely rare. Only three possible fragments of it were recognised. Scrap **1046** from a closed vessel is of standard Vasiliki ware; rim **1048** of a deep bowl or small jar is of anomalous shape and fabric, and not true Vasiliki ware according to Betancourt. The surface in this case has not been smoothed or burnished, although the wash has a metallic sheen. Assuming, as seems likely, that this fragment belongs to an import from eastern Crete, it may represent an ultimate stage in the development of Vasiliki ware, when the surface was no longer smoothed or burnished but was covered with a lustrous wash. The same tendency to refrain from smoothing or burnishing pottery surfaces as the lustrous quality of washes improved is already apparent at Knossos in EM II and becomes more emphatic there in EM III.

1046 (N74) PLATE 45. Scrap of closed vessel. Vasiliki ware. Fine dark orange clay; outside wash seems lustrous from smoothing, and mottling in typical fashion from black through a band of orange to a red centre. Wilson and Day sample KN 92/231.

1047 (N13) FIG. 8.8. Bowl rim cf. type 8–9, class **c**. D. 25. This appears to be true Vasiliki ware, with red wash outside; plain inside.

1048 (N55) FIG. 8.8, PLATE 45. Rim of deep bowl or jar. D. 15. Fine orange clay with paler surface; inside plain, outside with red-brown mottling to light brown and black wash, which has high metallic sheen but does not seem smoothed or burnished. Not true Vasiliki ware, according to Betancourt. Wilson and Day sample KN 92/230 (not published).

Coarse ware

Coarse gritty clay was used for making large vessels, notably bowls with flaring rims of type 8A, bowls of type 10, and spouted bowls or jars of type 17.

Soft sandy ware

This distinctive fabric with soft sandy clay is common alongside other wares in MM I–II and later. It now appears for the first time, and is used for making some jars (e.g. **1116**) and a few bowls with flaring rims of type 8A.

Cooking pot ware

This accounts for rather under 1/6 (1/2 a table or less) of the pottery from the deposit. It shows considerable variety. Some smaller vessels are thin-walled and of comparatively fine fabric, with the clay fired an even colour throughout in shades of orange-brown or reddish. Even with larger vessels the clay is often fired an even colour throughout, but may be dusky at the core. Some very large vessels are of coarse crumbly fabric with large grit, and several of these and other vessels in cooking pot ware are burnished. One or two fragments, perhaps earlier strays, have wiped surfaces (in the EM I tradition that continues in cooking pot ware into EM II). Several fragments show a red wash, but in general brown washes appear to have replaced the red washes normal in EM II.

TYPES

TYPE 1B. CUPS WITH VERTICAL HANDLE **1049–1051**

These seem to be characteristic, but are rare, like the cups of type 1A in EM II from which they are no doubt descended. Fragments of some five or six were recognised. Three bases are differentiated like **1051**, but at least one cup base **1050** is simple. Handles, to judge from **1049**, are of thick oval section like some handles in EM II that may come from cups. No thin strap handle with concave section was noted like those common in MM IA.

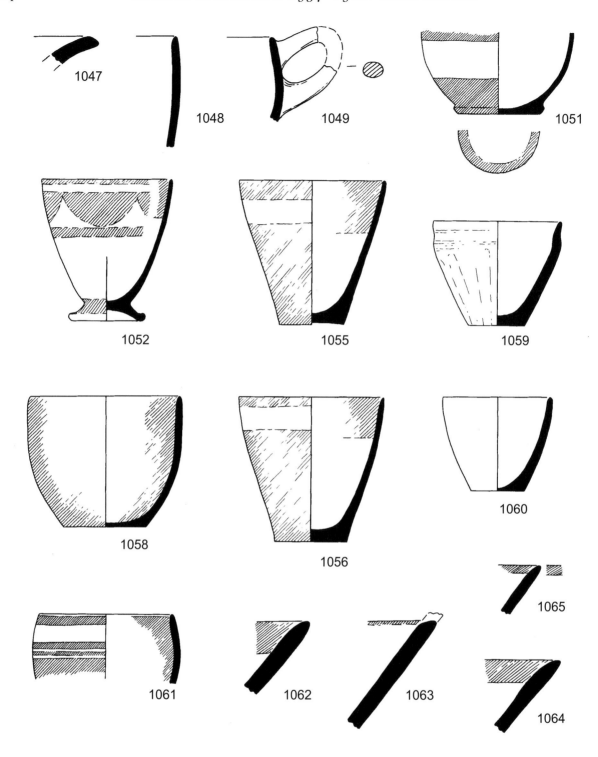

FIG. 8.8. Deposit B3 (EM III). Vasiliki ware **1047–1048**; type 1B cups **1049, 1051**; type 2 goblet **1052**; type 3 goblets **1055–1056, 1058–1060**; type 2 or 3 rim **1061**; type 7 shallow bowls **1062–1065**. Scale 1:2.

1049 (N40) FIG. 8.8. Rim with handle of thick oval section. D. 15. Fine orange clay; dark red-brown to black wash. From level A3a.

A fragment of a simple flat base **1050** (N41; D. base *c.* 6) may belong with this. It has a wash with a high metallic sheen, light brown inside, shades of dark red-brown to black outside.

1051 (N43) FIG. 8.8, PLATE 46. Differentiated base. D. base 5. Fine buff ware; orange clay, buff outside, burnished all over including under base. Decoration in red: inside solid; wide horizontal bands round outside, continuing as ring round edge of base underneath. Two other similar bases (D. bases 5–6) were painted solid underneath.

FIG. 8.9. Deposit B3 (EM III). Type 2 goblet feet: 3 = **1053**.

TYPE 2. FOOTED GOBLETS **1052–1053**

In a comparison of the footed goblets alone, the B3 horizon is clearly demarcated from both EM II and MM IA. The only complete profile recovered is **1052**, which is unique in this deposit for being virtually complete, as well as for the fineness of its fabric and its elaborate and striking scheme of decoration, which is matched on a goblet of the same shape but smaller of MM IA date from RRS: see below.

Some 70 eggcup feet belonging to goblets of this type were found. Diameters range from 4.5 to 6, but most are around 5. These feet tend to be low; but some are quite high, like a number of goblet feet in EM II. Some feet are low-waisted as seen from the outside, but show a high gap between the ground and the underneath of the bowl inside. About 12 feet, mostly low-waisted, but one or two of them high, have the edges upturned in a way that is very common and characteristic in the eggcup feet of MM IA. In height, there would seem to be no very great difference between the feet of this EM III horizon and those of EM II; but the EM III feet appear to be in general thicker-waisted than the earlier ones.

In finish there is a very marked contrast with EM II. All except three of the 70 feet from this EM III horizon evidently come from goblets with a dark wash on the body, but the foot is left plain, e.g. FIG. 8.9: 1. One upturned foot **1053** (N10; FIG. 8.9: 3) is plain except for a thin stripe round the outside edge. Only six out of the 70 have traces of a wash covering the whole of the outside of the foot, as FIG. 8.9: 2. On the other hand in most cases the wash evidently once covered the inside of the bowl of the goblet as well as the outside; in only about 20 cases is there no trace of an inside wash. Also in striking contrast to the fashion in EM II is the complete absence of a white band round the waist of the foot: among the 70 feet no example was seen with such a band. In contrast to the not uncommon practice in EM II, no foot is painted solid on the underneath. The under sides of the feet are left plain, apart from one or two isolated examples of feet with a band forming a circle round the outer edge of the under side as on EM II examples like FIG. 5.5: 6.

1052 (PEM/60/P19) FIG. 8.8, PLATE 45. Broken, but virtually complete. Ht 7.5. D. rim 7–7.4. D. base 4.3. Edge of foot upturned. Orange clay, grey at core; marked vertical paring outside, perhaps intended as ornamental. Decoration in slightly lustrous dark brown to black: wide band round inside of rim; outside, four solid semi-circles pendent from band round rim, and thin band below; stripe in added white on band below rim. Foot painted solid outside, continuing as band to edge underneath.

A similar but smaller goblet with the same decoration (RR/59/P414) comes from the RRS MM IA rubbish deposit. This might suggest that **1052** was a MM IA intruder in A3. Some EM II material, however, had been incorporated in the RRS MM IA rubbish fill, and it is therefore reasonable to assume the presence of EM III pottery that would be difficult to distinguish from that of MM IA. There are also parallels for the shape of **1052** from the UEW (Andreou 1978, 17, fig. 1: 1–3, pl. 1: 1–4; Momigliano 1990, 480–1, fig. 2: 1–3; cf. Momigliano 1991, 84–5, fig. 3.3: 1–3).

The style of the decoration on the other hand seems easier to parallel in MM IA. It is true that solid semi-circles like those on **1052** hang from the rim of a type IB cup from Mochlos, assigned to EM II (Seager 1912, 52, fig. 22: VI.6). But a squat handmade goblet from Apesokari with similar decoration may not be earlier than MM IA (Matz 1951, 17, pls. 4: 3, 20: 5). A row of inverted solid semi-circles adorns the shoulder of a jug with an incised rib at the base of the neck found north of the Knossos Palace along with other pottery that Mackenzie (1906, 249–50, pl. 10: 4; better illustrated: Zois 1965, pl. 18: 2739) assigned to MM I. The same inverted version of the motif appears round the bottom edge of a bowl on a high pedestal from a chamber beneath the West Court also assignable to MM I (Evans 1905, 17, fig. 9: 12; Mackenzie 1906, 250, pl. 11: 12).

These parallels and the unusually complete state of **1052** might seem to favour the view that it is in fact an intruder of MM IA, as mentioned above; but we see A3 as a whole deposit and prefer to see **1052** as a contemporary part of it and thus EM III, with EM III parallels at least for the shape.

TYPE 3. GOBLETS **1054–1061**

Simple goblets of this type are extremely rare in deposits assignable to EM II. But in this EM III horizon they appear to outnumber footed goblets of type 2. Some 90 bases of such goblets, including six profiles, were recognised, as opposed to only about 70 eggcup feet of type 2. In diameter these

bases range from *c.* 3.5 to 7, but most of them seem to be between *c.* 3.5 and 5. The six complete profiles (see below) vary in height from 5 to 7.7, with rims between 6 and 8.5 in diameter. These examples are probably smaller than the average, and the existence of a complete profile in these cases is no doubt due to this. Two small goblets **1059–1060** are evidently exceptional, for their size and their complete lack of painted decoration.

Some 20, less than 1/4, of the bases assignable to goblets of type 3 are plain inside and out: the clay is shades of orange or buff or greenish, wiped outside or sometimes markedly pared. The rest, about 70, over 3/4 of the total, have a dark, red or black, wash outside; and in the case of just over 1/2 of these, about 38, the wash evidently covered all the inside as well. In a few examples the underneath of the base has a wash, but usually it is left plain. The underneath of base **1054** (N11) has a ring of paint round the edge and a large solid spot in the centre: cf. **559** (A5; FIG. 7.15, PLATE 31). Another base fragment shows traces of some kind of decoration in dark-on-light underneath.

1055 (PEM/60/P21) FIG. 8.8, PLATE 45. Parts missing. Ht *c.* 7.7. D. rim 8.1. D. base 3.6–3.8. Base slightly sunk. Pale orange clay; surface with greenish tinge. Outside pared. Black wash, much worn, outside (but not under base), continuing as wide band inside rim. Broad stripe in white below rim outside.
1056 (PEM/60/P20) FIG. 8.8, PLATE 45. Broken, but complete except for part of rim. Ht *c.* 7.7. D. rim 8.2. D. base 4.2. Orange clay, smoothed inside. Dull purple-brown to reddish wash outside (but not under base), continuing as wide band inside rim. Broad stripe in white below rim outside.

The UEW has goblets exactly like this and **1055** (Andreou 1978, pl. 1: 5–8; Momigliano 1991, 156–7, fig. 1: 10–13; 161–2: 10–15, pl. 19: 10, 12, 14–15).
1057 (PEM/60/P24) PLATE 45. Broken, most of rim

missing. Ht 7.6. D. rim *c.* 7. D. base 4.1. Orange clay, outside pared. Red wash outside (but not under base), continuing as wide band inside rim. Decoration in thick creamy white: thin stripe on top of rim, broad stripe below rim outside.
1058 (PEM/60/P25) FIG. 8.8. Broken, about 1/3 pres. Perhaps handled cup (cf. type 1) rather than goblet. Ht *c.* 7. D. *c.* 8.5. Orange clay, with diagonal paring outside. Red-brown wash inside, black outside (much worn) continuing under base. From levels A3 and A3a.

For goblets of this shape cf. **634** (level A6) with references.
1059 (PEM/60/P29) FIG. 8.8. Base and part of rim pres. Ht *c.* 5.6. D. 7.5. Orange clay with plain buff surface; outside pared below area of rim.
1060 (PEM/60/P22) FIG. 8.8. Profile frag. Ht *c.* 5. D. *c.* 6. Plain orange clay.

Rims of goblets of types 2 and 3: about 265 (D. *c.* 7–12, most between *c.* 8 and 9). The rims tend to be rather thick when compared with those from the EM II levels. Only about one in 15 is of fine buff ware with a light surface, and of these virtually all have a band of paint on or sometimes below the rim (see FIG. 8.8): in black (six) or red (10). The only two plain rims are those of goblets **1059–1060**, whose exceptionally small size has been noted.

The great majority of goblet rims has a dark wash outside, and most of them (over 3:1) inside as well. Black washes outnumber red by about 3:2. The difference in the colour of the wash appears to be deliberate. The paint used for the wash may be the same in each case, and the difference in colour may depend upon the method or degree of the firing. Shades of colour intermediate between red and black occur, however, and on the same rim the red may merge through shades of purple-brown into black. Two rim fragments, which may come from the same goblet, have a light brown wash both sides. The exceptional rim **1061** with unusually careful and deliberate decoration may belong to a very small cup of type 1A rather than a goblet.

1061 (N44) FIG. 8.8, PLATE 45. Frag. of incurving rim. D. *c.* 7.5. Very fine fabric. Black wash outside, dark red-

brown inside. Decoration in white: stripe on rim, with band and two thin stripes below.

TYPE 4. SHALLOW BOWL OR PLATE WITH RIM THICKENED INTERNALLY

There is one scrap of a bowl rim of this familiar EM II type. It is damaged and worn.

TYPE 7. SHALLOW BOWLS WITH STRAIGHT OR INWARD CURVING SIDES **1062–1065**

About 12 rims are assignable to this type, which merges into the very common and characteristic type 8/9. Of these rims nine evidently come from large bowls with a diameter of *c.* 30 or more, as **1062–1063**. Three rims like these are plain; a fourth has a black wash inside, continuing as a band round the outside of the rim, and decoration in white. Three other rims are plain outside: two of these have a red band round the inside, but the inside of the third has a purplish wash. Three, including **1064–1065**, of the 12 rims apparently come from bowls of a much smaller size (D. *c.* 13–14) than the rest.

1062 (N61) FIG. 8.8. D. 30. Gritty orange clay, with orange-buff slip. Decoration in lustrous dark brown to black: rim painted solid inside and outside.
1063 (N16) FIG. 8.8. Rim with possible stump of a handle that rose above it. Sandy orange clay with orange-buff slip. Decoration in lustrous dark brown: band round

outside of rim, continuing on top of it.

1064 (N17) FIG. 8.8. D. 14. Orange clay, well fired, with orange-buff slip. Outside wiped. Broad band in dark

red-brown inside rim.

1065 (N18) FIG. 8.8. D. 13. Orange clay with orange-buff surface. Rim painted solid red inside and outside.

TYPES 8 AND 9. BOWLS WITH FLARING OR EVERTED RIMS 1066–1081

Large bowls of these types are common and characteristic. The bowls seem to be in general shallow with flat bases, and there is no evidence that any had handles. The rims are mostly thick, and divide into three main classes: (**a**) differentiated; (**b**) slightly differentiated; (**c**): undifferentiated, as type 8 (FIG. 8.10: **a–c**). A few of the rims grouped here approximate to those of the thin-sided bowls of type 9B which are characteristic in EM II. Some or all of these rims may then be EM II strays.

There are altogether about 85 rims from bowls of this kind. Over 1/2 of these (around 45) are assignable to class **b**, and nearly 1/4 (around 20) each to classes **a** or **c**. Diameters range from 18 to 40 or more, but most appear to be between 22 and 28.

The bowls, although thick-walled, are mostly of quite good fabric: the clay orange or buff, or occasionally greenish, well fired. Some bowls of this kind are of coarse, gritty soft clay; a few of soft sandy ware and cooking pot ware. The outsides in a large number of cases (including several of those with a wash) are markedly pared, e.g. **1076**. One fragment from a bowl of this kind is of soft orange clay with a dark red-brown surface (due to wash?), very finely stroke burnished (virtually polished) inside and out.

Over 1/2 the rims (48 in all) and 11 base fragments have a wash inside: black (21 rims, seven bases) or red (27 rims, four bases). Less than 1/3 (14) of these 48 rims, and six base fragments, have a wash outside as well as inside: black (five rims, three bases) or red (nine rims, three bases), e.g. **1066** (PLATE 45). On the remaining 34 rims and five base fragments the wash is only on the inside. But on two rims (both with a black wash inside, and perhaps from the same bowl) the wash laps over to form a broad band round the outside. In nine or 10 cases (about 1 in 5) the rims with a wash have one, or sometimes two or three, broad white bands round the inside (**1073–1074**). **1067** (N 12) (PLATE 45) with a black wash inside has traces of a wide diagonal in white between the white band and the rim. **1047** of class **c** with a red wash outside seems true Vasiliki ware (see above).

Some 35 rims of light-surfaced bowls of these types, including **1068** (N15; FIG. 8.10) of soft sandy ware, have a broad band of paint (black or red in the proportion of 3:4) inside the rim; on two rims there are double bands, e.g. **1069** (N 14; PLATE 46), and in six cases (two black, four red) a band round the outside of the rim as well as round the inside.

Several bases, which evidently belong to bowls of this kind, have a broad band round the inside, either in dark-on-light, or in light-on-dark (white on a black/red wash). Some bases have bands or stripes on the outside, like **1066** with a red wash and three stripes in white.

1070 (PEM/60/P23) FIG. 8.10. Profile and *c.* 1/5 of rim pres. Ht *c.* 5.6. D. 28.5. Coarse orange clay, grey at core, surface orange. Decorated with broad dark brown-black to reddish band round inside of rim, and dark red band inside base.

1071 (PEM/60/P27) FIG. 8.10. Profile. Ht *c.* 6.3. D. *c.* 28. Rather coarse gritty, dull orange clay; poor streaky dark reddish-brown wash inside. Decorated with horizontal hands in white, two below rim and one inside base.

1072 (PEM/60/P26) FIG. 8.10. Profile. Ht *c.* 7.5. D. *c.*

26. Orange clay, outside pared. Lustrous red wash, including under base. Two white bands on and below rim.

1073 PLATE 46. Class **a**. Black wash inside; two white bands below rim.

1074 FIG. 8.10, PLATE 46. Class **c**. Black wash inside; white bands on and below rim.

1075 FIG. 8.10, PLATE 46. Class **a**. Light surfaced, with black band round inside of rim.

1076 PLATE 46. Class **c**. Purple red-brown wash; outside markedly pared.

Two rims of small bowls **1077–1078** (N45–6; FIG. 8.10; D. 15) may be grouped here. Both are of fine buff ware, with buff surfaces, well smoothed inside but scraped outside, and dark red-brown bands round the inside of the rim. A profile and two rims of cooking pot ware belong to small bowls of this shape.

1079 (N62) FIG. 8.10. Profile. D. *c.* 13. Cooking pot ware; clay grey-brown at core, red-brown at edges. Surface shades of light and dark brown, apparently with wash.

1080 (N63) FIG. 8.10. D. 14. Cooking pot ware, as **1079**.

1081 (N64) FIG. 8.10. D. 20. Cooking pot ware; clay grey at core, reddish at edges. Red to light brown wash.

TYPE 10. LARGE BOWLS WITH STRAIGHT SIDES AND THICK EVERTED RIM 1082–1086

Some eight rims may be grouped here. In diameter they seem to range from *c.* 30 to 50 or more. The clay is rather coarse and gritty, especially in the larger examples. The insides of the bowls tend to be

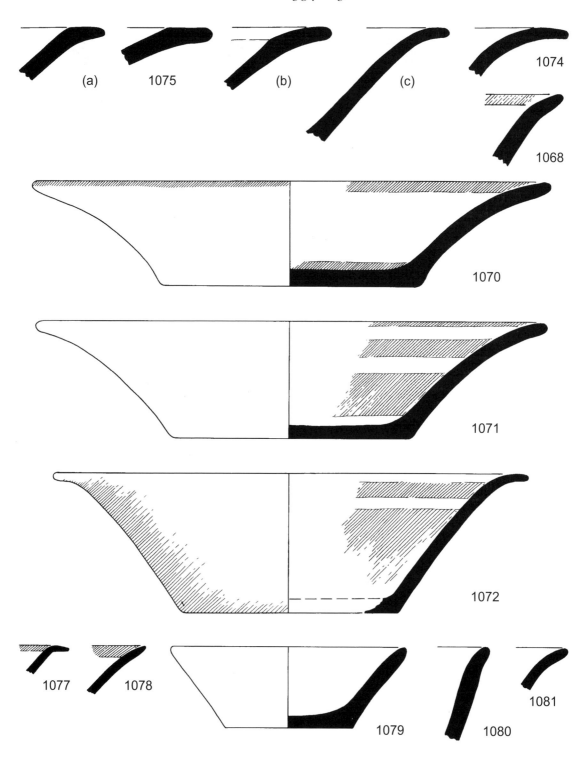

FIG. 8.10. Deposit B3 (EM III). Types 8 and 9 bowls **1068, 1070–1072, 1074–1075, 1077–1081**. Scale 1:2.

well smoothed or burnished. The rims usually appear to be painted solid, with a band inside and outside. There are fragments of two bases, apparently from bowls of this type: both thick-walled and steep-sided, of coarse gritty fabric like cooking pot ware, with burnished surfaces in dark red or shades of light and dark brown. One of two rims of similar fabric **1084** evidently belongs with one of these bases.

1082 (N22) FIG. 8.11. Rim thickened internally: cf. EM II. Sandy orange clay with fine grit; inside well smoothed or burnished. Large shallow channel on outside may be part of a scheme of decoration.

1083 (N19) FIG. 8.11. D. 50. Coarse gritty orange clay, grey at core; orange-buff slip, well smoothed or burnished inside. Rim painted solid in shades of red. Wilson and Day sample KN 92/253.

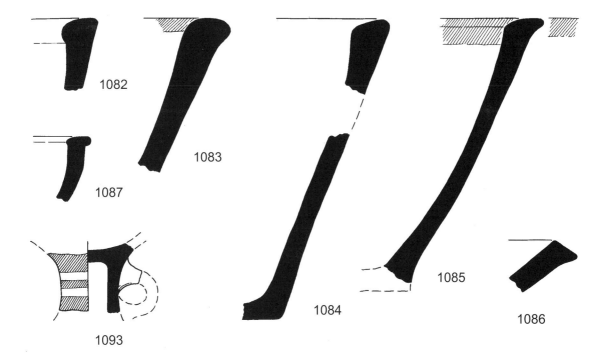

FIG. 8.11. Deposit B3 (EM III). Type 10 large bowls **1082–1086**; type 11 large bowl **1087**; type 13 fruit stand **1093**. Scale 1:2.

1084 (N76) FIG. 8.11. Rim and frag. of base. D. base 25. Crumbly fabric akin to cooking pot ware. Gritty reddish clay, red-brown outside, with very fine stroke burnish; purple-brown inside, which is less well burnished.
1085 (N20) FIG. 8.11. D. 52. Coarse gritty orange clay, dusky at core, with abundant large grit showing in surface. Inside stroke burnished.
1086 (N21) FIG. 8.11. D. 28. Orange clay with inside surface orange-buff, well smoothed or burnished; outside buff. Rim painted solid in black, worn.

TYPE 11. LARGE BOWL WITH CURVING SIDES AND THICKENED RIM (COOKING POT WARE) **1087**

The only rim assignable to this distinctive EM II type may be an earlier stray. This type and the corresponding EM II type 18 appear to have been replaced by the bowl-jars with massive thickened rims of type 12.

1087 (N65) FIG. 8.11. D. 35. Cooking pot ware; gritty red-brown clay with traces of possible red wash.

TYPE 12. LARGE DEEP BOWLS OR JARS WITH THICK TRIANGULAR-SECTIONED RIMS **1088–1092**

Some eight or nine large thickened rims of cooking pot ware, or a very coarse fabric allied to it, are of distinctive profile and evidently belonged to deep bowls or jars whose shape we could not reconstruct. These rims seem to range from *c.* 25 to 50 or more in diameter. **1090** has the stump of a small horizontal side-handle set immediately below it, and **1091** a large flat disc-like wart. The vessels from which these rims come appear to replace the bowls of type 11 and the bowls or jars of type 18 characteristic in EM II. These EM III rims are more massive, and the vessels to which they belonged thicker walled and of coarser fabric, than their EM II counterparts.

1088 (N67) FIG. 8.13. D. 50. Very coarse red-brown clay, grey at core; outside brown with wash.
1089 (N68) FIG. 8.13. D. 35. Very coarse gritty dark brown to black clay. Red wash inside, black outside, which is well smoothed or burnished. Black may result from use of vessel over fire: cf. **1090**.
1090 (N69) FIG. 8.13. Rim with stump of horizontal side-handle. D. 30. Fabric as **1089**.
1091 (N71) FIG. 8.13, PLATE 47. Flat disc-shaped wart below rim. D. 23. Cooking pot ware: clay grey at core, red-brown at edges. Red-brown wash inside, dark brown outside.
1092 (N70) FIG. 8.13. D. 40. Very coarse crumbly fabric, clay black throughout. Black wash inside, red outside.

TYPE 13. FRUIT STAND **1093**

1093 may come from a fruit stand. These are attested from period IIb at Myrtos–Pyrgos assigned to MM IA.

1093 (N52) FIG. 8.11. Top of stem of pedestal bowl or fruit stand with stump of small handle of round section on one side. Fine orange clay, with lustrous red to red-brown wash on outside of stem and inside bowl. Stem decorated with horizontal stripes in white.

TYPE 15. JUGS WITH CUTAWAY SPOUT **1094–1103**

Only fragments of these are preserved, but they give a picture of a distinctive type of jug, markedly different in details of decoration from the type fashionable in EM II. Some 10 fragments are all apparently from spouts of the cutaway kind. A few round section handles probably come from jugs, but none is preserved to the rim, so that it is not clear whether they are set to the rim or below it. Bases were evidently flat.

In six cases the necks of jugs are encircled by a distinctive rib in relief, and five out of six of these ribs are decorated with diagonal cuts (PLATE 46: **1094–1097**). Raised ribs with diagonal cuts like this seem a characteristic feature of the jugs of this horizon, although the first example we know is **1336** in Vasiliki ware from Evans's excavations in the Early Houses (see p. 274).

Warts on the swelling of the body may also be characteristic. Some eight fragments, apparently from jug bodies, have bold warts on them. It looks as if some jugs may have been adorned with three warts on the swelling of the body, one below the spout opposite the handle, and one in the middle of each side. This system of adorning jugs with warts was very fashionable in Troy I and the corresponding periods V–IV at Emporio in Chios.[15]

Fabric

The smaller jugs at any rate normally appear to have been of very fine buff ware, stroke burnished outside. The spouts of such jugs show marked signs of having been pared with vertical strokes of a knife before the burnishing of the surface. All six fragments of jug necks with ribs in relief round them, and most of the body fragments with warts, are of this characteristic buff burnished ware. But some jugs are evidently of coarser fabric: the clay gritty, with the surface unburnished.

Decoration

Paint

Four or five fragments of spouts with a fine buff burnished surface have a thin red or black stripe along the top of the rim: e.g. **1098** (N37; PLATE 46). Horizontal stripes are found round the base of the neck, and/or below the neck on the shoulder: such stripes characteristically flank the raised ribs round necks. Several fragments with a fine buff burnished surface, which appear to come from jug bodies, have trickle ornament: **1099–1101** (PLATE 47).

Incision

Incision was noted only as diagonal cuts on the ribs round the base of jug necks (see above).

Relief

(a) Barbotine. One fragment of fine buff ware **1102** (N 38; PLATE 46), which may come from a small jug, is decorated with barbotine. (b) Warts appear on a number of body fragments from jugs (see above). On **1103** (N 39; PLATE 46) a wart occurs below the rim, on the side of a jug spout of coarse gritty fabric. The clay is pale orange, covered by a slip with a slight greenish tinge.

TYPE 16. SMALL SPOUTED BOWL-JARS **1104–1116**

Almost all these jars appear now to have a dark wash (see below). They are of fine ware; but three scraps of small rims of class **a1** are of cooking pot ware, e.g. **1112**. The small profile **1105** (N24; Ht to rim 6.7; PLATE 46) has a vertical teapot handle, as type 16A. There is one other fragment of a large vertical handle, and a complete handle of this kind **1139** (N47; FIG. 8.12) has traces of incised decoration.

[15] Hood 1981, 239, 386–8, fig. 174.

A profile with a spout of class **c** — **1104** (N23; PLATE 47) — evidently comes from a jar with horizontal side-handles as type 16B.[16] Three other horizontal handles from jars of this type were found, e.g. **1106** (N25; FIG. 8.12).

Rims

These are mostly simple, S-shaped and thickened inside: cf. class **c1**, as in **1104–1106**. **1107** (N26; FIG. 8.12), with black wash both sides is of class **a1**. **1108** (N27; FIG. 8.12), with red wash outside, is flat-topped, like class **c4**. There seems to be less variety in the shapes of rims than with small jars assignable to type 16 in EM II; but this impression may be false. On the other hand rims of class **b2**, which appear to be very common and characteristic in EM II, are conspicuous by their absence.

Spouts

The spout of **1104** is of the teapot class **c** which is characteristic in EM II, but continues until the end of MM IA, if not into MM IB, at Knossos. There are fragments, however, of six or seven bridge spouts of class **d** which did not occur in any EM II context; all of these have a circular hole as class **c1**, and none it seems is of class **c2**, which may be more at home in eastern Crete.

Handles

These are all more or less round in section. None of the horizontal side-handles is markedly pointed in shape, as such handles are apt to be in MM IA; all are more or less rounded. Seen in profile, they may reach either below the rim (as **1106**) or above it.

Bases

In general bases appear to be flat. Two fragments of differentiated bases may belong to type 16 jars: **1115**, and **1109** (N28; FIG. 8.12, PLATE 45).

Carinations

Fragment **1110** (PLATE 45), which appears to be from the body of a jar of this type, is carinated.

Fabric

Virtually all the jars of fine ware assignable to this type have an outside wash in black to purple-brown or red. Sometimes the wash shades from black to red on the same vessel. The wash often, it seems, covered the underneath of the base and normally, but not in every case, continued round the inside of the rim. The isolated rim **1113**, and base fragment **1114** which may belong with it, are of fine buff ware with a light surface, very well burnished as in the vase of the jugs of type 15. Three small rims of class **a1**, including **1112**, are of cooking pot ware; and there are fragments of a base with the stumps of horizontal side-handles belonging to a small jar of coarse gritty reddish clay akin to cooking pot ware with a wash, well smoothed or burnished outside. Base **1116**, of soft sandy ware, is placed here, although the type of vessel is uncertain: it may come from a small jar or perhaps a jug.

Decoration

Paint

(a) Dark-on-light. See under **1113–1114**. (b) Light-on-dark. On spouts, stripes; on bodies, groups of diagonal lines, three to five in number — on **1139** enclosing a wavy band; on bases, horizontal stripes, once at least triple on **1109**.

Relief

Warts appear on the atypical base **1116** of soft sandy ware.

Only unusual or exceptional fragments are described in detail below (FIG. 8.12).

1111 (N56) FIG. 8.12. Rim of small bowl or jar. D. *c.* 10. Grey-brown clay, with rather thin matt wash, shades of brown; outside wiped.

1112 (N66) FIG. 8.12. Rim of class **a1**. D. 16. Fine cooking pot ware; clay grey-brown at core, red-brown at edges, with possible traces of red wash. There are two other similar rims.

1113 (N35) FIG. 8.12. Rim like class **c1**, apparently

[16] Type 16A = Momigliano 2007*c*, 90, fig. 3.8: 4, and 16B = Momgliano 2007*c*, 90, fig. 3.8: 5.

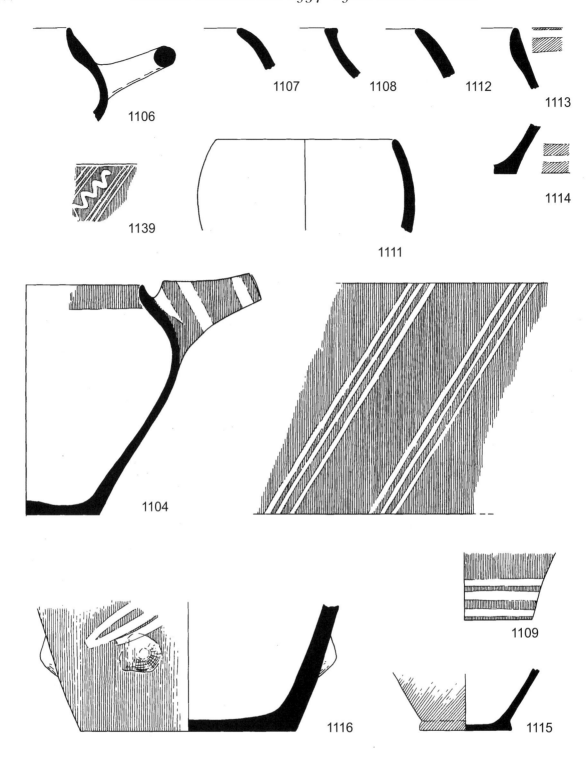

FIG. 8.12. Deposit B3 (EM III). Type 16 small spouted bowl-jars **1104**, **1106–1109**, **1111–1116**; light-on-dark decoration **1139**. Scale 1:2.

from jar of type 16. D. 20. Fine buff ware: orange clay with orange-buff surface, very well burnished. Decoration in dark red-brown: band below rim and stripe on rim.

1114 (N75) FIG. 8.12. Base frag. D. base *c.* 10. May belong with **1113**: buff burnished outside, with two bands in red-brown.

1115 (N48) FIG. 8.12. Differentiated base. D. base 5. Fine orange clay; black wash outside, continuing

underneath. Another similar but larger base (D. base 8) has black wash outside, continuing as ring round edge underneath.

1116 (N57) FIG. 8.12, PLATE 47. Base with two large warts pres. on side. D. base *c.* 12. Soft sandy ware; orange clay. Rough inside, well smoothed outside, which has reddish wash and decoration in white: the end of a group of three diagonal white stripes is visible.

TYPE 17. LARGE SPOUTED BOWLS OR JARS WITH HORIZONTAL SIDE-HANDLES **1117–1124**

Vessels of this type seem common. Many fragments assignable to them were found including 43 rims. Rim diameters appear between *c.* 23 and 40, with most around 25. Three rims have large horizontal side-handles springing from the shoulder; other large handles of more or less round section apparently belong to vessels of this kind. Their shoulders are in general high, in three cases with a sharp carination: **1118** has a large horizontal side-handle springing from it, and **1119** a wart set immediately above it. Two fragments of large spouts of class **b** evidently come from vessels of this type.

Fabric

It is noticeable that the vessels of this kind no longer seem to be made in cooking pot ware as was usual in EM II. The fabric is in general rather coarse, with sand or grit in the clay. About eight rims (less than one in five), and one or two bases which evidently belonged to such vessels, have a black/red wash outside. But over 4/5 of the rims are light surfaced.

Decoration

This occurs in both the more common dark-on-light, and in light-on-dark, normally consists of a band round the outside of the rim, which may sometimes continue inside the rim as well; while the body, whether there is a band round the rim or not, may be decorated with diagonal stripes, single or in groups of two or three, e.g. **1122** in dark-on-light; cf. **1118** and **1121** in light-on-dark. The unique thickened rim with a spiral **1124** is from a jar imported from eastern Crete.

1117 (N30) FIG. 8.13, PLATE 47. D. 40. Orange clay with paler surface. Decoration in black: band round outside of rim and pair of diagonal stripes descending from it.
1118 (N31) FIG. 8.13. Carinated shoulder with horizontal side-handle. D. 23. Orange clay with black to reddish wash outside. Decoration in white: opposed groups of three diagonal stripes each side of handle.
1119 (N32) FIG. 8.13. Carinated shoulder with a wart set above it. D. 23. Orange clay with grit, some very large. Decorated with diagonal stripes in dark red-brown.
1120 (N33) FIG. 8.13. High carinated shoulder. D. 28. Orange clay, grey at core. Decorated with band on top of rim in black shading to dark red-brown.
1121 PLATE 48. Rim of standard type: cf. class **a1**. Lustrous purple-brown to reddish wash outside. Decoration in creamy white: group of three diagonal stripes. From level A3a.
1122 PLATE 47. Rim as **1121**. Orange clay with fine grit. Decoration in black: band round rim and three diagonal bands descending from it.
1123 PLATE 47. Scrap of shoulder with wart. Dusky orange clay with fine grit, and whitish slip. Decorated in black.
1124 (N29) FIG. 8.13, PLATE 48. Thickened rim of East Cretan EM III style bridge-spouted jar. Sandy orange clay with some biotite (gold mica). Fired an even colour throughout. Inside plain, evenly smoothed; outside with thick, but somewhat flaky, dark red wash. Decorated in thick creamy white with what appears to be running spiral linked to its neighbour by double stripes with wavy stripe between them.
Wilson and Day sample KN 92/234 (not published):

Mirabello fabric (pers. comm.).
The fabric, decoration and thickened rim show this to be an import from eastern Crete, where single spirals linked by multiple lines are standard in EM III White-on-Dark, e.g. Betancourt 1984, 26, fig. 3–5: 8: 6; 32; Gournia, North Trench: Boyd Hawes *et al.* 1908, 57, figs. 41e, 42: 10 (*PM* I, 113, fig. 80a: 10); Zois 1967*b*, pls. 13: 60, 27: 1; Mochlos: Forsdyke 1925, 78–9, fig. 96: A451.2; Palaikastro: Bosanquet and Dawkins 1923, pl. 3m. Our fragment is unusual in having a wavy stripe between the two stripes linking the spirals, but there are parallels: Gournia, North Trench (Zois 1968b, pls. 13: 71, 27: 2; Betancourt 1984, 30, fig. 3–9: 3); and Malia, on a fragment apparently of a large handle (Chapouthier and Joly 1936, 28, pl. 9h; Charbonneaux 1928, 368–9, fig. 7d, seeing it as from a foot of a vessel; Zois 1967*b*, pl. 26: 28). Phaistos has an EM II (probably IIB) dark-on-light antecedent for the wavy stripe between stripes: Levi 1958*a*, 180, fig. 361, top middle, pl. 18B, second row from bottom, middle. An East Cretan EM III version from Gournia is Zois 1967*b*, pl. 12: 43.
At Knossos other East Cretan EM III style jars (with thickened rims) come from Evans's backfill at the SFH: Momigliano and Wilson 1996, 51–2, fig. 30: P193; and Room 1 of House A (PLATE 65: **1361** = Momigliano 1991, 209, fig. 18; 216, 219, fig. 22; Andreou 1978, 3: 13); and MM IA levels in RRS: p. 124 and n. 15.
Outside Crete note an example from Lerna VA: Zerner 1978, 171, 175, fig. 13: BD409/2; 1993, 50, 56. n. 70 (and cf. Rutter and Zerner 1984, 81); Cadogan 1983, 509.

TYPE 19. LARGE JARS WITH NARROW NECK AND WIDE EVERTED MOUTH **1125**

Only three rims, and three or four scraps from shoulders, are assignable to jars of this type. Such jars may have had horizontal side-handles like the jars of EM II type 19 which they appear to have replaced. No example of these distinctive jar rims comes from the EM II deposits, but such rims occur in the RRS MM IA rubbish deposit. The B3 rims have a diameter of *c.* 13–14. The fabric is rather coarse, with grit in the clay, and an orange-buff or pale greenish surface. All three rims have a band of black paint round the top inside and outside.

1125 (N36) FIG. 8.13. Gritty clay, orange with greenish tinge; pale greenish slip. Rim painted solid inside and outside in black, worn.
Wilson and Day sample KN 92/237 (not published).

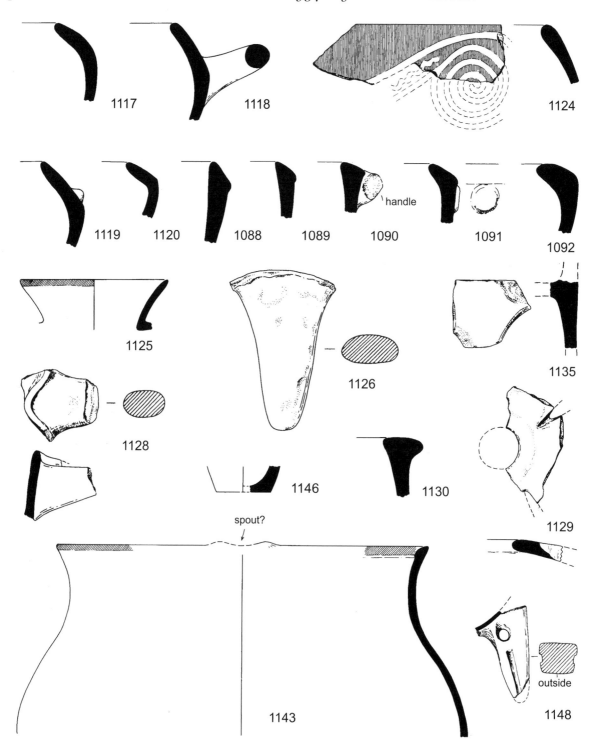

FIG. 8.13. Deposit B3 (EM III). Type 12 large deep bowls or jars **1088–1092**; type 17 large spouted bowls or jars **1117–1120**, **1124** (East Cretan EM III import); type 19 large jar **1125**; type 20 tripod cooking pot **1126**; type 21 braziers **1128–1129**; type 22 pithos **1130**; type 24 horned stand **1135**; Cycladic imports (?) **1143**, **1146**; foot of tripod vessel (?) **1148**. Scale 1:3.

TYPE 20. TRIPOD COOKING POTS **1126–1127**

Three tripod feet are of fairly thin oval section: **1126** (N72) (FIG. 8.13, PLATE 47) is complete, and **1127** (PLATE 47) may come from the same pot.

TYPE 21. BRAZIERS **1128–1129**

Two scraps appear to belong to braziers or lamps of some kind.

1128 (N50) FIG. 8.13. Handle of large brazier or lamp. Fabric like soft sandy ware; gritty orange clay. Inside dusky, as if from fire.

1129 (N51) FIG. 8.13, PLATE 48. Frag. of brazier (?), with hole in centre from which bold slits radiate. Rather coarse orange clay.

TYPE 22. PITHOI **1130–1134**

One small rim **1130** was found, together with several fragments, some of them with trickle ornament in black. Fragments **1131–1132** have raised horizontal ribs combined with trickle ornament.

1130 (N58) FIG. 8.13. D. 35. Gritty orange clay, with black wash outside, continuing on rim.

1131 (N59) PLATE 49. Frag. with horizontal relief band closely imitating rope. Wilson and Day sample KN 92/254.

1132 (N60) PLATE 49. Frag. with horizontal relief band with boldly incised chevrons. Two frags. with trickle ornament (PLATE 49: **1133–1134**) may come from the same pithos. Wilson and Day sample KN 92/255.

TYPE 24. HORNED STAND **1135**

1135 is most likely part of an EM IIA horned stand.

1135 (N73) FIG. 8.13, PLATE 47. Fine cooking pot ware; clay grey at core, red-brown at edges, with red wash; inside of bowl dark chestnut-brown with high, polish-like burnish.

SPOUTS

Spouts include classes **b** and **c**. There are also fragments of six or seven bridge spouts of class **d** from jars of type 16; these all approximate to class **d1**, none to class **d2** (see FIG. 5.7).

HANDLES **1136**

Handles are in general round or thick oval in section. What may be a rough strap handle from level A3a is of sandy orange clay with fine grit, decorated in lustrous dark brown to black: PLATE 48: **1136**.

DECORATION

Paint 1137–1139

Painted decoration is dark-on-light, in shades of red, brown or black; and light-on-dark, in white on a red or black wash. No example of polychrome decoration was noted. A scrap from a jar of fine ware **1137** (N 49; PLATE 45) was at first thought to preserve a trace of a thin stripe in the Indian red that Evans said was sometimes used at Knossos in EM III;[17] but on further examination it was seen to be a natural variation in the colour of the otherwise black wash.

Designs in both dark-on-light and light-on-dark are for the most part simple and linear. Diagonal lines, whether single or in groups of two or three or more, are very popular and may reflect that feeling for torsion, or spiralling movement, which Matz noted as characteristic of MM decoration. **1138** (N77; PLATE 48) from a very large jar of fine dusky orange clay, greyish and well smoothed outside, is decorated with lattice in black. Trickle ornament in dark-on-light occurs on pithoi and on some small vessels, apparently jugs, in fine buff burnished ware. Single wavy lines in white occur twice: **1124** (FIG. 8.13) in conjunction with the spiral on the rim of an East Cretan jar (see above) and **1139** (FIG. 8.12), where a diagonal wavy line is flanked by straight ones, appears on a fragment from the North Trench at Gournia.[18]

Incision 1140–1141

Fine incised lattice is found on the bodies **1140–1141** of two small jars of type 16. Incision also occurs on raised ribs on pithoi (see above) and at the base of the necks of jugs (see p. 220).

1140 (N47) PLATE 46. Frag. of rim with vertical handle to it, apparently from jar of teapot shape as type 16A. Fine orange clay with black wash outside; blob of white paint on top of handle; at base of handle, horizontal reserved zone with fine lattice incised on it.

1141 (N53) PLATE 46. Frag. from body of jar of type 16; red wash outside, below reserved zone with fine lattice incised on it: cf. **1140**.

For these small jars with incised lattice on a reserved band, cf. at Knossos: the Early Houses: H.I.2 788 (if

[17] *PM* I, 110–11, fig. 78.

[18] Zois 1967*b*, pl. 12: 43.

predominantly EM IIB); the Area of the Open Stone Drain (Hood and Taylor 1981, 21: 208): M.II.1 1113; the UEW: Andreou 1978, 22, fig. 1: 13, pl. 2: 23. Cf. too: Archanes–Fourni: Burial Building 9: Sakellarakis 1973, 183, pl. 181β, right — see also Sakellarakis and Sakellaraki 1997, 387–91, figs. 339–40, 342; Lakhanas 2000, 166, figs. 2, 4; Krasi: Marinatos 1929b, 112–13, figs. 9: 24, 10ε; 118, around the body of a small two-handled jar with black wash;

Mochlos, assigned by Seager (1912, 86, fig. 50: M.92) to transitional EM III–MM I, but to MM IA by Zois (1969, 28–9, 94, pl. 46: 5475); and other examples: Zois 1969, 29, n. 1; and probably Phaistos: Levi 1958a, 184, fig. 365, top row, second right (Levi 1965, 228, pls. 52b: 14, A: 10). Cf. also **1355** for similar latticework on a reserved band, but on a goblet.

Relief **1142**

(a) Ribs in relief occur associated with incisions around the necks of jugs (see above), and on pithoi (see above).

(b) Warts seem to be characteristic on the bodies of jugs (type 15), and are found set below the rims of large bowls or jars of type 17. On **1091** the wart is flat, disc-shaped. The wart on **1142**, a fragment of fine orange clay with buff surface, is painted black (PLATE 47); this fragment may be an EM II stray, to judge from the fabric and the character of the decoration.

Barbotine

Fragment **1102** (above) of fine buff ware, perhaps from the body of a jug, has elegant 'barnacle work' barbotine of a type common in MM IA: cf. **629** (A5; p. 174, with references).

IMPORTS **1143–1147**

A comparatively large number of fragments appear to be from imports. The three bits of Vasiliki ware have already been discussed (p. 213). In addition, there are fragments of about six other likely imports. The most interesting are jar **1143**, probably from the Cyclades, and the spiral-decorated jar rim **1124** of East Cretan EM III (above).

1143 (PEM/60/P28) FIG. 8.13, PLATE 48. Frags. of large jar with internally thickened S-shaped rim and traces of open trough spout; stump of possible handle low on shoulder. Ht pres. c. 15. D. c. 30. Hard fabric, well fired; clay grey, with abundant fine white grit; surface dull orange, rough and sandy to touch, wiped inside, more or less smoothed outside. Rim painted solid in dark matt brown. Shape and fabric suggest an import, perhaps from the Cyclades; but Wilson (pers. comm.) is not sure of this.

Wilson and Day sample KN 92/245.

Cf. **631** (A5). An imported Cycladic jar from the SFH is Momigliano and Wilson 1996, 44–5, fig. 27, pl. 8: P158.

1144 PLATE 49. Frags. of large vessel of cooking pot type ware. Fabric very flaky: reddish clay, with abundant fine white grit (cf. **1143**) showing in surface, which is orange;

outside has neat diagonal wiping or combing. Imported, perhaps from the Cyclades.

1145 (N34) PLATE 49. Scrap of jar rim of class **a1**. Clay grey throughout, with abundant mica sparkling in surface, which is light grey-brown, burnished but much worn.

1146 (N54) FIG. 8.13. Base frag. D. base c. 4.5. Grey-brown with greyish slip, smoothed or burnished. The fabric seems reminiscent of the fine light grey burnished ware found in periods X–II at Emporio in Chios and apparently imported there (Hood 1981, 166–7, 245; 1982, 434).

1147 Frag. of base with large lug foot, as found in A1 and Palace Well. Hard gritty fabric like cooking pot ware, with some fine mica shining in surface, which has thin dark brown to red-brown wash. Imported, perhaps from the Cyclades.

MISCELLANEOUS

One or two unstratified fragments from Area B may be EM II, or later. They include the curious foot **1148**, perhaps from a tripod vessel. For two early sherds from level E4, see p. 92.

1148 (PEM/60/P34) FIG. 8.13, PLATE 49. Foot of vessel (?), probably bowl. Rectangular in section, with large rectangular-sectioned groove down each side; large circular perforation made before firing through top. Broken. L. pres. 6.5. Fabric apparently EM: coarse grey clay; red wash

inside, well burnished. Foot surface orange-buff to dusky, burnished. Unstratified (level E1).

1149 PLATE 49. Frag. of jug or jar. Handmade: red wash outside, with decoration in white. Unstratified (level C1).

Chapter 9

Early Minoan II–III: other artefacts and bioarchaeological remains

AREA A. ROYAL ROAD: NORTH

PLASTER

Three scraps, datable to EM IIA, of wall plaster were found. Two are from A0 (level LA115): one of them has black to brown paint, and had received two skims (or washes) of plaster, indicating replastering, whether immediate or after an interval. The third piece (RR/61/370), from A1 (level LA113), has been discussed by Cameron *et al*. It is important for confirming that black was used as a colour in EM II wall painting as well as the better known red.[1] Two other fragments from A1 catalogued as painted wall plaster seem now to be pieces of burnished Neolithic pottery.

CLAY 1150–1157; 233; 412

Artefacts other than pottery vessels in the excavations in Area A were few and mainly of fired clay. The most interesting is the head of a figurine **1150** from the late EM IIB A4 deposit. Indeed, Higgins noted that its neck is tongued for insertion into a body, and assigned the piece to MM II in spite of the context which, he wrote, 'must surely be disregarded'.[2] But we can compare a head from Fournou Korifi II, which is similar in appearance and fabric, and also has a tongue at the bottom for affixing it to a body.[3] The date of these pieces is important, since it raises the possibility that the earliest figurines from some of the peak sanctuaries assigned to MM I–II are in fact EM II–III in date. Other apparent EM II anthropomorphic figurines come from the WCH.[4] **1151** (A5: EM III) appears to be from a model of some kind, perhaps of a building, perhaps a human or near-human. **1152** (A3: EM IIB) is part of a phallus, and likewise probably **1152A** from the same deposit; see also **1363** below.

The pieces of pottery of roughly triangular shape **233** (A1: EM IIA) and **412** (A2: EM IIB) seem to have been used as rubbers or pot burnishers. Three others are known at Knossos from the WCH,[5] and one from B.I.16 279.[6] Warren interpreted some neat triangular sherds of comparable size from Fournou Korifi as counters,[7] noting that fragments with incised or painted patterns on them had evidently been chosen for these. This seems to have been the case too with **412** made from a fragment of what may have been an imported vessel with elaborate decoration of rows of open circles bisected by lines. The triangular counters at Fournou Korifi are mainly of period I, but some are of II. Sherd rubbers were also recognised in Fournou Korifi II: one at least of these is triangular.[8] They are also known from EM IIB Phaistos, where Todaro suggests that they may represent fractions of a unit.[9]

Sherds **1153–1154**, of EM III date, had been rubbed or cut into roundels. Similar roundels are known from Ayia Triada, where it is suggested that they were gaming pieces: they appear to date to EM II (and perhaps EM I),[10] and from EM IIB and EM III Phaistos,[11] where they appear to be counters connected with pottery production — which may also have been the case at Ayia Triada. At Knossos **1171** is an EM IIB example from Area B, **165–165A** are EM I from the Palace Well, and there are nine known of EM IIA from the WCH;[12] but such discs go back to MN at Knossos (discussed above, p. 60).

A piece of clay **1155** (A3: EM IIB) which may come from the base of a large vessel has an impression of a vine leaf: compare **166H** from the Palace Well and **1364–1365** in the SMK (the four impressions are shown on PLATE 19). Two clay balls **1156–1157** from EM III deposits are matched by **1160** in stone from A1 (EM IIA).

[1] Cameron *et al*. 1977, 125, 140–1, table 6; 146–8, table 7; 159, 174–5, pl. 11: 3; also Cameron in Warren 1972*a*, 310, n. 2.
[2] †Reynold Higgins, pers. comm.
[3] Warren 1972*a*, 219–20, 242, fig. 95: 70.
[4] Wilson 1984, 212–3 and pls. 54: SF661 (male, sitting in boat ?), 55: SF625 (human) and SF1111 (clothed human).
[5] Wilson 1984, 221, pl. 58B top right and bottom row.
[6] Wilson 1984, 221, pl. 43D bottom right. For the context see p. 241: primarily EM IIA early.
[7] Warren 1972*a*, 217–8, 239, 254, fig. 107, pl. 79E. They are neatly shaped and evidently cut (not rubbed).
[8] Warren 1972*a*, 228, 244, fig. 97: 135.
[9] Todaro 2009*b*, 341–2, fig. 6c.
[10] La Rosa 1984, 131, fig. 213.
[11] Todaro 2009*b*, 341–3, figs. 6c, 7d; 347.
[12] Wilson 1984, 219–20, pl. 58A.

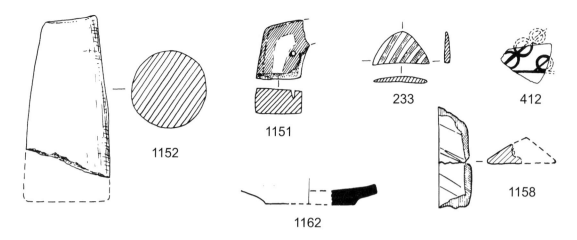

FIG. 9.1. Area A. Clay model **1151** (A5); phallus **1152** (A3); rubbers **233** (A1), **412** (A2). Worked bone **1158** (A1). Stone bowl **1162** (A7.1). Scale 1:2.

1150 (RR/61/180) (A4) PLATE 50. Head of figurine, apparently female, wearing a tall hollow-topped head-dress. Damaged; most of head-dress and one side of face missing. Ht 4.6. Orange clay with burnished buff surface. Decorated in lustrous dark brown to black.

1151 (N357) (A5) FIG. 9.1, PLATE 50. Frag., apparently from a model. Small hole made before firing to depth of *c.* 0.5 on one flat side. Fine orange clay with buff slip, well smoothed. Decoration in dark brown to black.

1152 (N320) (A3) FIG. 9.1, PLATE 50. Phallus. Broken, bottom part missing. Ht pres. 10. Fabric as for pithoi: coarse orange clay, dusky at core, with large grits. Paler orange slip. Hollow sinking in top.

1152A (N321) (A3) PLATE 50. Probably from flat base of similar phallus. Fine cooking pot ware with red wash.

233 (N125) (A1) FIG. 9.1, PLATE 51. Triangular sherd, apparently from jug, used as rubber: cf. **412**. See further p. 138.

412 (N92) (A2) FIG. 9.1. Another, probably from imported EC IIA jug, of fine ware with elaborate decoration, used as rubber. See further pp. 154–5.

1153 (N297) (A5) PLATE 51. Roundel: frag. of bowl, worn, apparently from use as a rubber. D. roundel *c.* 2.5. Red wash inside and out.

1154 (N387) (A6) PLATE 51. Roundel cut from frag. of bowl. D. roundel *c* 3. Black wash inside and out.

1155 (N322) (A3) PLATE 19. Frag. of clay with bold vine leaf impression, probably from base of large jar or pithos. Fabric like pithos ware. Identified by Warren.

See PLATE 19 also for **166H** (EM I: pp. 61, 68–9, with discussion of the practice in the EB Aegean) and **1365–1366** from the SMK (p. 279).

1156 (RR/61/251) (A5). Clay ball. D. *c.* 1.6. Orange clay with dark brown to black lustrous wash.

1157 (RR/60/398) (A7). Another, with slight chipping. D. 2.85. Fine orange clay.

We should mention here that we did not find any clay 'sheepbells' in either area, although they occur in the UEW.[13] The type continues into MM IA at Knossos and, like eggcups, is of no use in distinguishing EM III from MM IA when found in isolation.[14]

BONE 1158–1159

A fragment of worked bone **1158** with fine incised lines is from A1. **1159** is from A4 (EM IIB late).

1158 (RR/61/326) (A1) FIG. 9.1. Frag. of worked bone. Damaged, and broken away on three sides. L. 2.7. W. 0.9. One surface incised with fine parallel lines running diagonally

from the surviving edge. Possible traces of burning.

1159 (RR/61/334) (A4). Another. L. 2.1. W. 0.5. Th. 3.5.

STONE 1160–1166

Peter Warren

Two scraps of stone vases **1161–1162** are from EM III deposits, which agrees with the observed rarity of stone vases in settlements in Prepalatial times, at Fournou Korifi for instance and Vasiliki. The stones of **1161–1162** (banded tufa and serpentine) were quite commonly used for vases from later EM II onwards.[15] The two lumps of pumice **1165–1166** are from EM IIB levels, as is the whetstone **1164**.

[13] Andreou 1978, 21, pl. 1: 29–31; Mackenzie 1903, 167, fig. 1: 1–2

[14] For a summary of sheepbells at Knossos, see Morris and

Peatfield 1990, 31.

[15] Warren 1969, 126–7, 138–40.

1160 (RR/61/328) (A1) PLATE 51. Ball. D. *c.* 1. Blue-grey stone. Pot boiler?

1161 (RR/61/252) (A5) PLATE 51. Body frag. of bowl or other open shape. 2 x 1.6. Pinkish to white banded tufa.

1162 (RR/60/413) (A7.1) FIG. 9.1, PLATE 51. Moulded base frag. of bowl. Ht pres. 1.1. Grey-black serpentine with green-grey patches. Warren 1969, 79: type 32A.

1163 (RR/61/248) (A8) PLATE 51. Small pointed stone,

perhaps a sandstone rubber or sharpener. L. 5.3.

1164 (A2, level LA108). Flat, triangular whetstone of grey limestone. L. 11.4. W. 5.2. Th. 1.8.

1165–1166 (RR/61/185, 188) (A3; A2) PLATE 51. Two lumps of pumice. 3.5 × 3.1; 3.8 × 3.5. These appear to have one edge flattened, as if from use: cf. pumice used for rubbing in Fournou Korifi II (Warren 1972*a*, 52, 240: 237).

OBSIDIAN

Doniert Evely

The EM II and III structures in Area A produced around 300 pieces of obsidian:[16] 216 are from the main EM II, and 73 from the EM III deposits, while A8 (EM II) yielded 16 pieces. Four cores, six crested blades, three platform rejuvenation flakes, 148 flakes (73 with cortex) and 134 blades are represented, together with sundry chips. FIG. 9.2 *a–h, l–m, p–w* shows a sample of the obsidian from Area A.

As with the EM I Well, there is generally some slight direct evidence for manufacture somewhere nearby. The basic method of blade removal still seems to have been pressure-flaking, with some forms of percussion (probably both direct and indirect) being reserved for first preparing the core itself.[17] In view of the level of regularity in the shape of the blades themselves, D'Annibale observes that the work was done not with the core held in the hand, but immobilised in some device.[18] The manner in which the work progressed across 1/2 to 2/3 of the core's periphery also leads to the same inference.[19]

Prismatic blades are again the tool-of-choice, but flakes are as frequent, with over 1/2 showing evidence for on-site adjustment, if not full core preparation. Signs of use on the blades are slight — mostly edge damage rather than retouch, even less so for the flakes; second stage tool making is so rare as to be invisible. The presence of obsidian believed to be from 'Anatolian' sources is a minor element (4 pieces).[20]

With respect to size,[21] one can at once distinguish these domestic groups at Knossos from the funerary ones where a Cycladic influence is suspected, but not from more 'purely' Cretan burial contexts where, as Carter remarks, 'all the Cretan (funerary) assemblages … are composed of blades which are to all extents and purposes the same as those seen in contemporary Minoan domestic contexts'.[22]

There are no immediately obvious discrepancies in the evidence of the obsidian for this range of EM II–III contexts. One can probably safely assume that at Knossos, and no doubt in Crete generally, the manufacturing techniques for blades required in everyday domestic and craft milieux became standardised well back in the third millennium BC.

FAUNAL REMAINS

Valasia Isaakidou

The Early Minoan deposits in Area A yielded a modest quantity of mammalian remains.[23] A total of 976 specimens was selected for detailed recording (1020 MaxAU and 927 MinAU).[24] The sample is large enough to explore species representation[25] and the taphonomic history of the assemblage. Due to the limited extent of the deposits, however, it cannot be treated in isolation as representative of animal exploitation at the site during EM.[26] Thus, the present section discusses only certain results of the analysis, with an emphasis on how the deposits were formed.[27]

The assemblage consists overwhelmingly of fragmented bones of all parts of the skeleton of the usual Knossian suite of farmyard animals (sheep, goat, pig and cattle), as well as a few bones of dog and badger[28] (TABLE 9.1). The commonest species is sheep, followed by goat, pig and cattle.

[16] For the background to this study, and that of the obsidian from Area B, see p. 62 above.

[17] For a relatively recent account of recreating knapping, see D'Annibale and Long 2003.

[18] D'Annibale 2008, 198–9.

[19] Carter (2004, 279, fig. 22.8) reproduces an image of some of the proposed schemes.

[20] Two smoky (EM II) and two translucent (EM II and EM III) pieces comprise only just over 1% of the total.

[21] Figures extrapolated from Carter 1998, 69–70, figs. 4.7–4.8.

[22] Carter 1999, 10.7.8. He specifically excludes here those of the Ayia Fotia (Siteia) sort from this comment.

[23] For recovery methods and how representative the samples

may be, see p. 63 above.

[24] See p. 63, n. 304 for analytical protocols.

[25] Van der Veen and Fieller 1982.

[26] For this reason, demographic (dental development, epiphyseal fusion, sex ratio) and biometric data are not presented here.

[27] For discussions of management and consumption practices at Knossos, see Isaakidou 2004, 2006, 2007. More extensive analysis will be presented in Isaakidou in preparation.

[28] Although badgers are burrowing animals, the fact that, according to the excavators, we are dealing with stratified and undisturbed floor deposits makes it unlikely that their bones are intrusive.

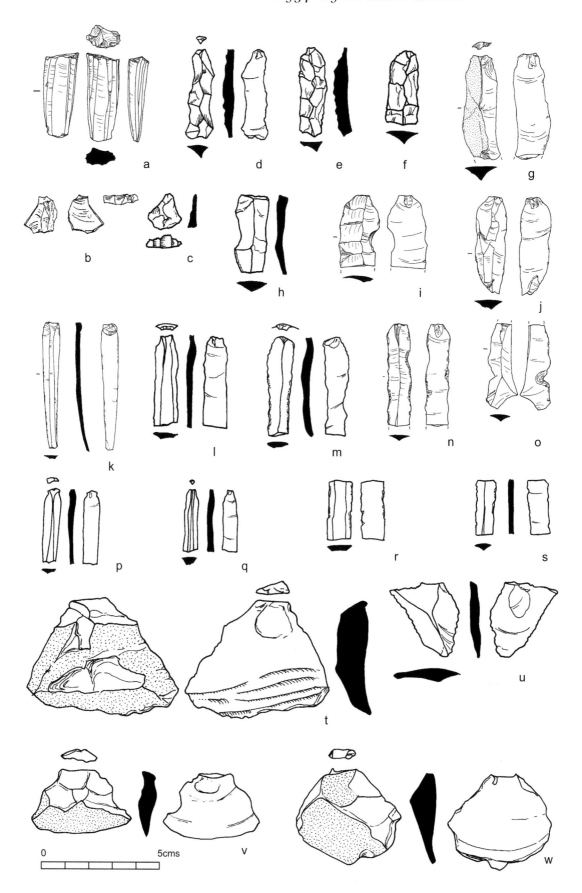

FIG. 9.2. Areas A and B. Obsidian: *a*, core (A7.2); *b–c*, platform rejuvenation flakes (A3); *d–f*, crested blades (*d, f* A2; *e* A1); *g–j*, first series and similar blades (*g–h* A1; *i–j* B1); *k–n, p–s*, second series blades and segments (*k* A2; *l–m, r* A1; *n* = B2 (level B4); *p* A4; *s* A 7.2); *o*, (disturbed) level B11; *t–w*, flakes with cortex except *u* (*t* A7.2; *u* A3; *v–w* A4).

TABLE 9.1. Area A. MinAU counts of species/taxa from deposits A1–A8 grouped by ceramic phase.

	EM IIA	EM IIB	EM III
Cattle	2	11	19
Pig	7	38	48
Sheep/Goat	17	201	196
Sheep	10	157	108
Goat	9	53	46
Dog	0	1	0
Badger	0	3	1
TOTAL	45	464	418

Species composition, fragmentation patterns and butchery marks (TABLE 9.2) suggest that the assemblage is made up of skeletal material discarded after carcasses were processed, *primarily* for consumption by humans, as was the case with the bones from the Palace Well.[29] The presence of dog and badger bones is not incompatible with this interpretation. Although butchery marks and fragmentation characteristic of human consumption are absent in our small sample, butchered bones of dogs and badgers have been identified from earlier and later contexts, both at Knossos[30] and at other Cretan sites.[31] These species appear to have been used — at least in some periods — as food and for their pelts,[32] but larger samples are needed to explore this issue definitively for Early Minoan Knossos.

TABLE 9.2. Area A. Butchery marks observed on the major taxa (MaxAU counts, excluding loose teeth; 'Sheep/Goat' includes speciated sheep and goat and non-speciated sheep/goat specimens).

		Cattle	Pig	Sheep/Goat	Total
A1	Uncut	2	2	23	27
A2	Uncut	2	8	42	52
	Dismembering	0	0	1	1
		2	8	43	53
A3	Uncut	4	16	205	225
	Dismembering	0	1	10	11
	Filleting	0	0	1	1
	Other	1	0	0	1
		5	17	216	238
A4	Uncut	5	12	145	162
	Dismembering	0	0	7	7
		5	12	152	169
A5	Uncut	13	35	225	273
	Chop	0	0	1	1
	Dismembering	1	1	8	10
	Filleting	0	0	1	1
	Saw	0	0	1	1
		14	36	236	286
A6	Uncut	2	5	26	33
	Dismembering	0	0	3	3
		2	5	29	36
A7	Uncut	2	9	115	126
	Dismembering	0	0	4	4
	Filleting	0	0	1	1
		2	9	120	131
A8	Uncut	0	5	13	18
	Dismembering	0	0	3	3
		0	5	16	21

[29] See p. 63 above.
[30] Isaakidou 2004, 207, table 6.18.
[31] See for example Snyder and Klippel 1996, 2003. At Kavousi–Kastro, the larger size of the dog and badger assemblages allowed detailed analysis of fragmentation and butchery patterns, which provide firm evidence for human consumption (Snyder and Klippel 2003, 223–4).

[32] Today badgers are mainly bred for their hair, which is used for brushes, but they were occasionally eaten in rural areas of Europe until recently (e.g., Konjević 2005; I thank D. Urem-Kotsou for translating this paper from Croatian). On Crete itself, badger pelts hung for sale in Chania market early in the 20th century (Trevor-Battye 1913, 9).

High frequencies of gnawed specimens (TABLE 9.3) and long bone 'cylinders' (TABLE 9.4), characteristic of bones gnawed by dogs and the like, were observed in samples from all phases and indicate a period of exposure on the surface after discard. A few burnt specimens were also identified (TABLE 9.3). There was no evidence for primary deposition, such as matching or articulating elements, and the material appears to have been quite heavily modified by scavengers after discard.

TABLE 9.3. Area A. Gnawed (excluding loose teeth) and burnt specimens by deposit (MaxAU counts).

	A1	A2	A3	A4	A5	A6	A7	A8	Total
				MaxAU					
None	21	39	134	116	190	18	64	16	598
Gnawed	6	15	106	55	97	18	67	5	369
	27	54	240	171	287	36	131	21	967
				% MaxAU					
None	77.8	72.2	55.8	67.8	66.2	50	48.9	76.2	61.8
Gnawed	22.2	27.8	44.2	32.2	33.8	50	51.1	23.8	38.2
				MaxAU					
None	28	59	246	184	303	37	137	21	1015
Burnt	0	1	1	0	2	1	0	0	5
	28	60	247	184	305	38	137	21	1020
				% MaxAU					
None	100	98.3	99.6	100	99.3	97.4	100	100	99.5
Burnt	0	1.7	0.4	0	0.7	2.6	0	0	0.5

TABLE 9.4. Area A. Fragmentation of 'long bones' by fragment type (long bones = humerus, radius, femur, tibia, metacarpal and metatarsal; MaxAU counts, excluding foetal/neonatal specimens and loose unfused epiphyses; 'Sheep/Goat' includes speciated sheep and goat and non-speciated sheep/goat specimens).

		Cattle	*Pig*	*Sheep/Goat*	*Total MaxAU*	*% MaxAU*
A1	Whole	0	0	0	0	0
	End & shaft	0	1	2	3	37.5
	Cylinder	0	0	5	5	62.5
Total					8	
A2	Whole	0	4	2	6	18.2
	End & shaft	0	0	14	14	42.4
	Cylinder	0	3	10	13	39.4
Total					33	
A3	Whole	0	0	2	2	1.9
	End & shaft	2	3	56	61	57.0
	Cylinder	0	1	43	44	41.1
Total					107	
A4	Whole	0	0	2	2	2.7
	End & shaft	0	1	33	34	45.9
	Cylinder	0	1	37	38	51.4
Total					74	
A5	Whole	0	0	0	0	0
	End & shaft	3	8	42	53	57.0
	Cylinder	0	7	33	40	43.0
Total					93	
A6	Whole	0	0	0	0	0
	End & shaft	0	1	8	9	60.0
	Cylinder	0	1	5	6	40.0
Total					15	
A7	Whole	0	0	4	4	7.3
	End & shaft	1	4	25	30	54.5
	Cylinder	0	2	19	21	38.2
Total					55	
A8	Whole	0	0	0	0	0
	End & shaft	0	0	4	4	50.0
	Cylinder	0	0	4	4	50.0
Total					8	

Given the excavators' interpretation of the contexts as probable domestic floor surfaces, it appears that dogs had free access to outdoor and indoor spaces, in which debris was allowed to accumulate from all stages of carcass processing and final discard after consumption. The presence of long bone 'cylinders' implies that the floors were not hard surfaces subject to regular cleaning, but that debris accumulated quickly or bones were trampled into a soft substrate which allowed them to be preserved whole — on a hard substrate, trampling would have reduced 'cylinders' into shaft fragments. If the latter interpretations are correct, it may be tentatively suggested that (some of) these spaces were not living, but storage or processing areas. Alternatively, the deposits may represent fills consisting of midden materials, brought into buildings as substrates to raise floor surfaces. Larger exposures and assemblages as well as taphonomic analyses of other bodies of material are required to choose between alternative interpretations.

In terms of the nature of the deposits, the range of species, body parts and taphonomic markers are compatible with all sub-assemblages representing 'domestic' debris from all stages of processing and consumption of animal carcasses. Of interest is the presence of a sawn sheep or goat femur, possibly a by-product of artefact manufacture.[33] This, albeit scant, evidence may imply no spatial segregation of the various stages of processing and consumption of carcasses, and so offers no hint of the existence of specialist butchers and the like.

Finally, given discussions concerning the extent of continuity in economic practices from Early Minoan into the Palatial period, it is worth commenting briefly on the taxonomic composition of the assemblage. The preponderance of sheep in the EM IIB and EM III deposits (TABLE 9.5; the EM IIA sample is too small for evaluation of taxonomic composition) is a diachronic feature of Knossian faunal assemblages,[34] but its 'economic' meaning may be different in different periods of the site's occupation.

TABLE 9.5. Area A. Relative frequency (% MinAU) of major farmyard animals (sheep and goat frequencies were calculated including proportionally attributed unspeciated sheep/goat specimens).

| | EM IIB | | EM III | |
	Raw counts	%	Raw counts	%
Cattle	11	2.4	19	4.6
Pig	38	8.3	48	11.5
Sheep	307	66.7	245	58.8
Goat	104	22.6	105	25.2
TOTAL	460		417	

In Neolithic assemblages, this predominance may reflect integration of sheep into a predominantly intensive 'garden' farming regime, in which sheep were probably managed to provide a variety of produce (meat as well as dairy products and wool) and as an adjunct to intensive cereal cultivation.[35] This interpretation is supported by the adult sex ratios of sheep (with adult breeding females dominating Neolithic assemblages) and by the culling profiles (with 75–85% of animals culled between six months and four years of age). Conversely, during the later Bronze Age, when textual evidence suggests an emphasis on wool production, ageing evidence shows that animals were kept to an older age and sex ratios of adult males/females were more balanced, both compatible with an emphasis on achieving higher yields of wool and larger carcasses. As Prepalatial sex ratios and culling profiles approximate those of Palatial assemblages, it may cautiously be argued that already in the Prepalatial period management goals were similar to those of Palatial economies.[36]

VINES

For Jane M. Renfrew's discussion of **1155** (and **166H** and **1364–1365**) and other vine leaf impressions in the EBA Aegean, see pp. 68–9.

[33] Analysis of the use of tools in processing bones during the Bronze Age at Knossos suggests that use of saws is most probably related to use of bone as a raw material for manufacturing artefacts, rather than processing of carcasses for consumption as food (Isaakidou 2004).

[34] Isaakidou 2008, 95, fig. 6.2.
[35] For a recent discussion of the integration of sheep in intensive 'garden' farming based on ethnographic evidence, see Halstead 2006.
[36] Isaakidou 2007, 101–3.

AREA B. THE EARLY HOUSES

The small find number in the catalogue below is the number given to an object on its excavation. Level numbers are also given to help identification and/or chronology. The find spots of objects appear in FIGS. 4.5–4.6.

PLASTER

A fragment of pale blue wall plaster from level B1 may, or more likely may not, be EM III. It has been analysed by Cameron *et al.*, who note that the plaster seems unusually fine, whiter and higher in lime content than seems normal for EM — 'and did the Minoans yet know of blue?'[37] It is probable that it had fallen down from the Palace, or it may have been scattered from the South House.

CLAY 1167–1171A

The principal find is the EM III jar stopper **1167** from B3 with several seal impressions. It was recognised during excavation as in an uncontaminated find-spot (FIGS. 4.5–4.6), with no possibility of the admixture of later material. Since it is rare for seals and sealings to come from settlement contexts, this stopper is of considerable importance for dating and interpreting the early seals of Crete — and has been much discussed. And for Knossos it is probably the only Minoan jar stopper ever found there, and certainly the only Prepalatial one.[38]

Shaped like a champagne cork, it has three or four seal impressions made by the circular face of an ivory seal. Only one impression can be made out entirely, showing three circling or parading lions, in a border of leaves, as identified by Pini,[39] who also indicates that (i) there is, perhaps, a spider in the centre, and (ii) the type of seal used was a stamp cylinder. Why did the original seal show Parading Lions? Weingarten, pointing to another ivory seal with 'contorted lions' from Archanes–Fourni Tholos T. Γ, Stratum II (EM III), and others from that cemetery and the Mesara datable to MM IA, identifies them as material markers of a specific social group: a 'symbol of chiefdom, perhaps even of an emergent royalty', and a mark of power that the Minoans intentionally adapted/adopted from Egyptian originals.[40]

Earlier, she reviewed the possible uses of this stopper.[41] Its sealings may have been intended for some domestic use only;[42] but they could have had some outside function, 'or if *two* seal-owners were involved', then we should think of some more public purpose. And if, she suggests, such a purpose was connected with exchange or tax, or both, then we can see an emerging late third millennium practice of documentation and administration at Knossos — for which, as yet, no other evidence is available. How systematised this would have been is unclear: we do not have enough evidence for a formalised administrative system in Prepalatial times.[43] Schoep agrees in general, but stresses that, while this sealing and its companions point to increasing social complexity, there is no need that they imply 'a centralised authority'. Indeed, its having been found outside the later Palace may be another sign of more heterarchical administrative practice(s) at Knossos (until well on in the Old Palace period).[44] Krzyszkowska, classing the piece as a 'direct object sealing', is sceptical that it was just of limited household use, but equally sees uncertainty in the dates for other sealings that are cited as evidence for administration.[45] And most recently Relaki has emphasised the domestic contexts — and thus character — of most Prepalatial sealings, which she relates to personal and collective identity and the allocation of resources.[46]

[37] Cameron *et al.* 1977, 125, 131, n. 15; 140–1, table 6 ('Egyptian blue'); 148, 158, 174–5: 3 *bis*.

[38] We thank Judith Weingarten for most helpful advice on **1167** and emphasising its (near) uniqueness. She notes (pers. comm.) that '*CMS* II.8 no. 26, if a stopper, is later. Ditto *CMS* II.8 Add. 2 from the WCH — which I do not agree is a stopper anyway'. Krzyszkowska (2005, 78) similarly doubts the EM II date and context of the seals that impressed the WCH sealings (the other is *CMS* II.8. Add. 1). See I. Pini, in *CMS* II.8 p. 5, with comment by Wilson (n. 17).

[39] *CMS* II.8 no. 6 (with earlier references). D. of original seal face *c.* 1.9 × 2.0.

[40] Weingarten 2005, 764–5 and n. 34 (for quotation). The seal in an EM III context that she identifies as having lions is: Sakellarakis 1981, 520, 522–5, fig. 5: 8, pl. 169: 8 (Papadatos 2005, 43, fig. 26: S4, where the motif is classed as 'leaves'; Sakellarakis and Sakellaraki 1997, 672, fig. 743).

[41] Weingarten 1994, 175–7, fig. 2; 187, table 1: 9: a robust discussion.

[42] As proposed earlier by both herself (in Pini 1990, 56) and Poursat (*ibid.* 55).

[43] Pini 1990, 34–7.

[44] Schoep 2004, 285–6, tables 23.1–23.2; 290; cf. also 2006, 44–8.

[45] Krzyszkowska 2005, 77–8, no. 134; and cf. Weingarten 1990, 105, n. 1. Krzyszkowska, however, notes (with references) a *nodulus* from Malia as evidence for administration/an administrative system in MM IA. In fact it was found in a fill with a majority of EM IIB sherds: Poursat 2010, 259. For other certain or probable Prepalatial *noduli* and sealings, see also Weingarten 1994, 176–7, and Andreadaki-Vlazaki and Hallager 2000, esp. 253, table 1, and 268–70. Add now a direct object sealing from an EM IIB context in the Area of the North Propylon at Knossos: Wilson 2010, 149–50, figs. 36–7. See also p. 294 below.

[46] Relaki 2009, 362–9.

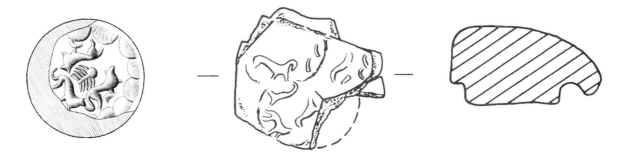

FIG. 9.3. Area B. Clay jar stopper with seal impressions **1167** (B3). Scale *c.* 1:1. Drawing of impression (*CMS* II.8 no. 6) *c.* 3:2 (courtesy *CMS* Archive).

It is hard to know what vessel this would have stoppered. It had a very narrow mouth, which suggests that it may have had a tall(ish) upright neck like a bottle, or possibly a gourd. There is no necessity that it stoppered a clay vessel. If it did, we have not found any example of a suitable shape among the EM III pottery we have studied.

As it has already been published,[47] only a short description of the fabric follows, together with further bibliography.

1167 (HMs 1099; PEM/60/9; B3, level A3, small find 1; FIGS. 4.5–4.6) FIG. 9.3, PLATE 52. Stopper of narrow-mouthed jar or bottle, with seal impressions. 4.14 × 3.8. Ht pres. 1.97. D. of rim of stoppered vessel *c.* 3.2; inner D. 2.8. Broken, most pres. Rather coarse gritty dark brown to black clay with red to brown core; loose, holed and fragile texture.

Further references include: Yule 1981, 127–9, 208–09, pl. 6: motif 7 — 'Parading Lions/Spiral complex'; Sbonias 1995, 90, 147, n. 76; 1999, 44; Perna 1999, 64, 68, tables 1–2; Schoep 1999, 269, table 1; 272; 2006, 44, n. 68; Andreadaki-Vlazaki and Hallager 2000, 253, table 1; Krzyszkowska 2005, 77–8 no. 134; Relaki 2009, 363, 365–6, table 1: 5; Macdonald forthcoming.

Two broken spindlewhorls date to EM IIB: **1168**, the earlier one, is of dark grey burnished ware (cf. p. 96). Both fit into the truncated conical group of spindlewhorls at Fournou Korifi, in period II or mixed contexts.[48]

1168 (PEM/60/5; B1, level A13, small find 6; FIG. 4.5) PLATE 52. Frag. Ht 3.9. D. *c.* 4. 1/2 pres. Dark red sandy clay, with red grit and black flecks. Well burnished wash of light to dark grey-olive-brown. Rounded cone.

1169 (PEM/60/11) (B2, level A6) cf. p. 60. Another. Ht *c.* 4.5. D. *c.* 7.5. W. pres. *c.* 6.5. Very soft coarse light greyish brown clay. Rounded rectangular shape.

Also EM IIB are a triangular sherd **1170**, which seems to have been used as a rubber like **233** and **412**, and roundel **1171**, like **1153–1154** (which are, however, dated to EM III).

1170 (N194) (B2, pit C, level A11; FIG. 4.5). Triangular sherd used as rubber. 3.9 × 2.7. Worn orange clay.

1171 (N122) (B1, level A13). Roundel, roughly cut from bowl sherd. D. *c.* 3. Black wash inside and outside.

Part of an animal figurine **1171A** was found unstratified in cleaning trench B. It may be EM II, as is an animal figurine that was attached to a pithos from the WCH.[49]

1171A (PEM/60/6) PLATE 52. Back part only. L. pres. 2.5. Buff sandy clay with some grit.

[47] Originally by Hood and Kenna 1973 (who also saw an insect in the centre). For a new drawing of the motif (here FIG. 9.3, left) and photographs (reproduced here on PLATE 52) see coverage at *CMS* II.8 no. 6.

[48] Warren 1972*a*, 228–9, 246, fig. 99, pls. 77F, 78A: 149–52.
[49] Wilson 1985, 354, pls. 54, 56: P458.

BONE 1172–1175

These are all of EM IIB date.

1172 (PEM/60/8) (B1, level A13, small find 7; FIG. 4.5). Frag. of spoon or spatula. L. 8.2. W. 1.55. Polished at end and along left upper edge at thumb grip: cf. a Neolithic spatula (J. D. Evans 1964, pl. 60.3: 1) rather than the chisels (pl. 61: 4).

1173 (PEM/60/7) (B2, level A6, small find 2; FIGS. 4.5–4.6). Tip of pin, broken. L. 2.95. Max. W. 0.8. Two flat surfaces, bevelled. Polished.

1174 (B2, level A6, small find 3; FIG. 4.5) Frag. of strip, from sheep or goat rib (Wall-Crowther). L. 6.2. W. 1.1.

1175 (B2, level A6, small find 5; FIG. 4.5) Frag. of point, from sheep or goat rib (Wall-Crowther). L. 6.2. W. 1.1. One polished surface only pres. Shaped like an emery board, end rounded.

STONE 1176–1178C

Peter Warren

Stone artefacts include a piece of an EM III serpentine vase **1176** (for other stone vessels from the 1908 excavations in Area B see **1367–1368** below). This must be one of the earliest uses — if not the earliest — of serpentine for a vase; but Knossians had already been using it for axes since MN (Stratum VII).[50] Phyllite disc **1178A** is like those identified as pot lids and may be Neolithic;[51] **1177–1178** are EM IIB.

1176 (PEM/60/1; B3, level A3a; FIG. 4.5) Vase frag. 5 × 4 × 1.6. Green-grey mottled serpentine with white flecks; large vessel, highly polished inside and out.

1177 (PEM/60/10; B1, level A14). PLATE 52. Pounder. L. 7.8 × 4.2 × 2.7. Hard grey sandstone. Roughly oval section. Worn at both ends.

1178 (also PEM/60/10; B1, level A14). PLATE 52. Rubber (?). 3.2 × 2.8 × 1.5. Small pebble of hard greenish stone with black veins and brown and white inclusions, probably serpentine. Roughly oval section. Worn, smooth and polished.

1178A (PEM/60/4; level B1: no certain date) PLATE 52. Disc. 7 × 6.6 × 0.8–1.3. Grey phyllite. Roughly discoid, rim chipped. Perhaps pot lid, and Neolithic.

Also found were:

1178B (PEM/60/2; level E4: no certain date) PLATE 52. Frag. of dark grey sandstone, perhaps from a quern. 4.5 × 4.8 × 3.

1178C (PEM/60/3; level D3: no certain date) PLATE 52. Frag. of grey-buff limestone. 5.5 × 5 × 2.8.

OBSIDIAN

Doniert Evely

Torrence records some 110 specimens from Area B: 30 blades and 80 flakes with sundry chips and chunks. 75 come from the more extensive EM IIB contexts, 26 from the EM III deposit. In addition, there are seven flakes from the disturbance/pit A along the N face of wall β in trench A. The mix is much as seen elsewhere, with hints of production in the crested blades (three) and flakes (58 + six or so chunks), but relatively few blades (c. 30) or other tools now remain.

Although the blades from Area B (FIG. 9.2: *i–j, n–o*) are not many (as in the Palace Well), the later examples here are shorter in their preserved state by an average 0.5 cm than those in the Well. Neither set attains the lengths of the Cycladic-influenced pieces at coastal sites in northern Crete such as, par excellence, Ayia Fotia (Siteia);[52] they seem closer to the blades found in the Prepalatial tholos tombs.[53]

For the flakes, the pattern is more what one would expect: primary flakes (14) are fewest, with secondary (20) and tertiary (24) only a little more numerous. Sundry chips and chunks (over half a dozen) make up the total.

Two fragments of the smoky, transparent obsidian that is probably of 'Anatolian' origin were found in one EM IIB deposit. There are two possible fragments from the upper levels in trench B, and two more from the pit A disturbance. In the EM III B3 deposit, four out of nine pieces seem of this smoky variety — a quite high rate of occurrence. The smoky obsidian shows less secondary working, and makes better long primary flakes.[54]

[50] Warren 1968.
[51] Cf. J. D. Evans 1964, 231, pl. 64.
[52] Carter 1999; Davaras and Betancourt 2004.
[53] E.g. Carter 1998.
[54] But Xanthoudides (1924, 105, pl. 54: 1908–09) already

noted it (two blades and a core) in Platanos T. B, although suggesting that it was from Yiali. The earliest occurrence, however, of Yiali obsidian at Knossos is in the Vat Room deposit: *PM* I, 169, fig. 220; Panagiotaki 1999, 25–6 (obsidian), 22–3 (date in MM IB).

Faunal Remains

Valasia Isaakidou

A very small number of bones was recovered from Area B, of which 66 specimens were selected for recording (67 MaxAU and 61 MinAU). These come principally from levels associated with deposit B2. The assemblage shares similar characteristics with that from Area A. Species composition and relative frequencies are comparable, with sheep predominating, while no importance should be attributed to the absence of rare species (i.e., dog and badger), most probably because of the small sample size (TABLE 9.6). Taphonomically also, the two assemblages are similar, with high frequency of gnawing marks (TABLE 9.7) and presence of long bone 'cylinders' (TABLE 9.8).

TABLE 9.6. Area B. MinAU counts of species/taxa by deposit.

	B1	B2	B3	TOTAL
Cattle	0	1	1	2
Pig	0	4	0	4
Sheep/Goat	1	20	0	21
Sheep	1	23	1	25
Goat	2	7	0	9
Total	4	55	2	61

TABLE 9.7. Deposit B2. Gnawed specimens (counts of gnawed and ungnawed exclude loose teeth).

	B2	
	Raw counts	% MaxAU
None	41	74.5
Gnawed	14	25.5
Total	55	

TABLE 9.8. Deposit B2. Fragmentation of 'long bones' by fragment type (long bones = humerus, radius, femur, tibia and metapodials; MaxAU counts; foetal/neonatal specimens and loose unfused epiphyses excluded; 'Sheep/Goat' includes speciated sheep and goat and non-speciated sheep/goat specimens).

	Cattle	Pig	Sheep/Goat	Total	% MaxAU
Whole	0	0	0	0	0
End & shaft	1	1	14	16	39
Shaft splinter	0	0	8	8	19.5
Cylinder	0	1	7	8	19.5

The available evidence (range of species; presence of all parts of the skeleton of, at least, the commonest species, i.e. sheep and goat; long bone fragmentation; presence of butchery marks; TABLE 9.9) is compatible with this assemblage representing carcass processing and food consumption debris, in a secondary context of deposition.

TABLE 9.9. Area B. Butchery mark frequencies for all deposits combined (MaxAU counts; loose teeth excluded).

	Cattle	Pig	Sheep/Goat	Sheep	Goat	Total
Uncut	2	4	22	18	6	52
Dismembering	0	0	0	4	1	5
TOTAL	2	4	22	22	7	57

Chapter 10

Other Early Minoan pottery from Knossos

A search in the then (1964–65) being re-boxed SMK for Early Minoan pottery excavated by Evans to compare with that described above soon showed that several classes of pottery occur at Knossos of which our excavations have produced few examples, including light grey ware and fine painted ware. This pottery seemed worthy of publication, as did a few isolated fragments of exceptional interest and some pottery, mainly whole vessels, from the 1908 excavations at the Early Houses that we restored from sherds in the SMK boxes or could identify in the Herakleion Museum (HM) and the Ashmolean Museum (AM), together with a little EM pottery from Knossos in other museums, including the Musées Royaux d'Art et d'Histoire in Brussels (MRAH), the National Museum in Copenhagen (NMC), Liverpool Museum (LM), the British Museum in London (BM) and the Metropolitan Museum of Art in New York (MMA).[1]

In the long gap, however, between the original study and the present publication, there has been intensive research into, and publication of, Evans's EM (and MM IA) pottery in the SMK, and discussion of its historical implications, principally by Andreou, Wilson, Momigliano, Day, Whitelaw and Tomkins (in the rough order of their starting work).[2] Wilson has also studied and published J. D. Evans's EM IIA West Court House[3] and is publishing pottery that Platon found during conservation;[4] Momigliano and Wilson have published their 1993 excavation at the Early Houses;[5] and Warren has produced preliminary accounts of his RRS excavations.[6] These reports and papers, the recent general accounts by Tomkins of the Neolithic ceramic sequence of Knossos and by Wilson (EM I–II) and Momigliano (EM III–MM IA) of the Prepalatial sequence,[7] and other articles that include discussion of the pottery and circumstances of Poros,[8] all in varying degrees analyse, discuss or allude to Evans's EM pottery in the SMK. Thanks to this surge of study and the many fresh understandings of the pottery and history of Early Minoan Knossos, it is clear that we are approaching a far fuller picture of its ceramic development. Likewise, there has been a recent surge in studying, and re-defining, the ceramic sequence, culture and history of Neolithic Knossos, with important results.[9]

It is otiose to publish again in detail material that others have already published very well — except in so far as there is material (notably in the museums outside Crete but also in the HM in Crete) that we can add, or there are new or better illustrations (whether drawings or photographs), or other useful references, or even detailed comments that are worth making. What we present below is then to be seen as supplementary to what our colleagues have already presented. One of the more valuable elements will, probably, be the (new) drawings we provide of sherds and vessels that have been illustrated only in photographs or drawings of the early 1900s.

THE STRATIGRAPHICAL MUSEUM AT KNOSSOS

There is plenty of Early Minoan pottery in the SMK. This is not, however, intended to be a comprehensive survey of it, but rather a selective account of some easily definable classes that are important as they have been rare in EM excavations at Knossos — a choice that Wilson and Day have also made in their papers on their research. The most obvious instances are light grey ware and

[1] There is also EM pottery in the Boston Museum of Fine Arts (Fairbanks 1928) and the Gothenburg Museum (*CVA* Sweden 3, Göteborg 1), but nothing to show that any of it has to be from Knossos — although Gothenburg has a little Neolithic pottery from Knossos, as does Copenhagen (*CVA* Denmark 1, Copenhagen 1).

[2] Monographs, papers and chapters include: Andreou 1978; Day and Wilson 1998, 2002, 2004; Day *et al.* 1997, 1999, 2006; Momigliano 1990, 1991, 2000*a*, 2000*b*, 2007*c*; Tomkins forthcoming *a*; Whitelaw forthcoming; Wilson 1984, 1985, 1987, 1994, 2007; Wilson and Day 1994, 1999, 2000; Wilson *et al.* 2004. To these we should add MacGillivray (1998, 2007) on the Protopalatial pottery of Knossos, and Furness (1953) on its

Neolithic pottery — both of whom have also added to our knowledge of its Prepalatial pottery.

[3] Wilson 1984, 1985.

[4] Wilson 2010.

[5] Momigliano and Wilson 1996; and pp. 81–2 above.

[6] Warren 1972*b*, 1973, 1974, 1981.

[7] Momigliano 2007*c*; Tomkins 2007; Wilson 2007.

[8] Poros: Dimopoulou-Rethemiotaki 2004; Dimopoulou-Rethemiotaki *et al.* 2007; Wilson *et al.* 2004, 2008.

[9] Conolly 2008; Efstratiou *et al.* 2004; Isaakidou 2008; Mina 2008; Strasser 2008; Tomkins 2007, 2008, forthcoming *a*. All these papers have further references.

fine painted ware, which we include below; there is also dark washed ware, which has been well covered by Wilson.[10] We also include classes that have been rare in our excavations, such as dark grey burnished ware and brown burnished ware; or because they were (in 1964) a then unrecognised type-fossil — the EM IIA horned stands in cooking pot ware.

Isolated pieces include an EM I dark grey burnished ware chalice rim with patterrn burnished spiral decoration **1182**; a large EM IIA amphora **1294** with painted decoration, which we restored from many sherds; and bases with mat or vine leaf impressions **1364–1366**.

We cannot claim that any accounts are exhaustive as we did not examine all the boxes in the SMK from the earlier excavations at Knossos. We looked at those which Pendlebury said had EM sherds[11] and a considerable number of others — which sometimes produce surprising examples of EM pottery. Wilson and Day and other colleagues have examined much of this material independently; and we have all come upon pieces that others had missed. It is likely that yet more pieces of EM pottery will be found, but unlikely that they will alter the account significantly.

SMK: Boxes and Contexts

The SMK boxes are arranged by two systems. The first is that of Pendlebury and his colleagues. They gave each part of Knossos a letter designation, with a Roman numeral for further precision and an Arabic figure for the exact place of excavation. Thus for 'K.II.5', 'K.II' refers to the Area of the North-East Hall[12] and '5' to the test pit on the E side. The boxes of sherds from the layers within K.II.5 are separated as '1st. m.', '2nd. m.', etc., following the divisions of Evans and Mackenzie.

The second system is that of the re-boxing in the 1960s, after the boxes of pottery had been moved out of storage in the Palace to the new Stratigraphical Museum, which was built in 1962–63[13] and inaugurated in 1966 by †Dame Joan Evans, who gave generously for its building, as did †Marc Fitch. In the meantime †Elizabeth Schofield, to whom †Mervyn Popham as Assistant Director of the British School had entrusted the work, had started re-boxing the collection. She followed Pendlebury's order but added a reference number in continuous sequence for each box. Thus 'K.II.5 1st. m.' could be referred to as K.II.5 931. As far as possible, we follow this method, which is now standard for Evans's material. But readers should note that a few sherds are *not* any longer in the boxes that they were in in 1964–65, but are now to be found in neighbouring boxes from the same deposit and the same depth: this is not of material significance. Furthermore, some of the boxes we examined were still Pendlebury's original SMK boxes that had not yet been re-boxed and re-numbered. This means that for some deposits we can give only a sequence of box numbers, which is usually short: again it should not be difficult to find the sherd(s).

Pendlebury listed the provenances of the boxes in *A Guide to the Stratigraphical Museum at Knossos* and explained the limits of their accuracy.[14] He and his colleagues dated the pottery in *Dating of the Pottery in the Stratigraphical Museum* 1–3: the third part of their work presents plans of the deposits,[15] from which it will be clear why we looked at particular boxes. In many cases we were looking for stray EM sherds that had survived among later material, as also happened in the RRN and RRS excavations (see pp. 190–2).

Many of the boxes with Early Minoan pottery have suffered some degree of contamination — or have the same range of pottery even if it is stated that they are divided by levels and/or floors — and appear highly selected. Other boxes, however, contain plenty of coarse ware, which suggests that the excavators may have kept a high proportion of sherds from these early deposits. Among the groups where more seems to have been kept we might place the Early Houses (H.I.2), the trials in the North-East Magazines (K.I.4–8) and probably the Upper East Well (L.I.4).

The pottery from Knossos that we present here is almost all in the SMK, with some pieces in the Herakleion Archaeological Museum. We also include or mention pieces in the Ashmolean Museum, British Museum, Liverpool Museum, Metropolitan Museum of Art, Musées Royaux d'Art et d'Histoire, and National Museum in Copenhagen. Some of these museums have only a sherd or two of Early Minoan pottery from Knossos. There may be other such collections that we have overlooked. Most of the whole vessels discussed below are from the Early Houses (our Area B) and probably from EM IIB

[10] Wilson 1985, 312–17: 'red and black washed ware'; 2007, 58–61: 'red/black slipped ware'.
[11] Eccles *et al.* 1933; Money-Coutts and Pendlebury 1933; Pendlebury and Pendlebury 1933.
[12] Hood and Taylor 1981, 20: 181, 185.

[13] Cadogan and Chaniotis 2010, 291 (with references).
[14] Pendlebury 1933.
[15] Pendlebury and Pendlebury 1933 = part 1; Eccles *et al.* 1933 = part 2; Money-Coutts and Pendlebury 1933 = part 3.

floor deposits, although a few vessels that are supposed to be from the Early Houses may perhaps be EM IIA (and may even come from other contexts in the Palace area). We also present some EM I and EM III (and EM III/MM IA) pottery. The pottery is in the SMK unless stated otherwise.

The contexts for the pieces in the SMK from Evans's excavations that we list below have been numbered and appear on FIG. 10.1. We wish to emphasise that this is a selective list, the contexts being included only when they have the relevant pieces of pottery that we mention below. Other important contexts can be found in the *Knossos Pottery Handbook*.[16] Many of the dates given for the contexts are those of Wilson and Momigliano in the *Handbook*. We use 'hs' as an abbreviation for horned stand(s): those that we noted are listed on p. 264 below.

A.II. NORTH-WEST TREASURY (Hood and Taylor 1981, 17: 98)

1) A.II.51–52 Kouloura in North-West Kamares Area (= North-West Treasury) (Hood and Taylor 1981, 17: 97). Mainly MM deposit.

 A.II.2 51 **1204**

B.I. WEST COURT (Hood and Taylor 1981, 14: 10)

2) B.I.4 170–171 West Court 1904 Test Pit 1. 1.40–3.0 m below Court. Wilson 2007, 57, fig. 2.5: 2: EM IIA early.

 B.I.4 171 **1218 1222** hs

3) B.I.6 193–195 West Court 1904 Test Pit 3. 194–5: 3rd m. below Court. EM II–MM I and ? later. Note also B.I.6 211b (2.85 floor–3.0 floor): early EM IIA + 5% N (Wilson 2007, 57, fig. 2.5: 4).

 B.I.6 194 hs

4) B.I.8 225–226 West Court 1904 Test Pit 5. 226: 1.75 m floor–2.75 m floor below Court. Wilson 2007, 50, fig, 2.1: 2: N–EM IIB, including EM I.

 B.I.8 226 hs

5) B.I.10 235–236 West Court 1904 Test Pit 7: 1.50 floor–2.50/2.60 below Court. Wilson 2007, 57, fig. 2.5: 6: EM IIA early + 5% N.

 B.I.10 235 hs

6) B.I.15 275–276 West Court 1904 Test Pit 12. Andreou (1978, 178–9, n. 3) notes that its position on Money-Coutts and Pendlebury 1933, plan 4, should be exchanged with that of Test Pit 14 (B.I.17). 1.75 m floor–2.80/2.95 floor below Court. Wilson 2007, 57, fig. 2.5: 7: EM IIA early + 5% N.

 B.1.15 275 **1256A** hs

7) B.I.16 278–280 West Court 1904 Test Pit 13. 1st and 2nd m below Court. Wilson 2007, 57, fig. 2.5: 8: EM IIA early + 5% N.

 B.I.16 279 **1279**
 B.I.16 280 **1189 1254**
 B.I.16 279–280 hs

8) B.I.17 307b–c West Court 1905 Test Pit 14 (for position see on B.I.15 above). 1.85 floor–2.20 floor below Court. Wilson 2007, 57, fig. 2.5: 9: EM IIA early + 5% N, also MM. See also for 307a Wilson 2007, 64, fig. 2.10: 1, and for 302–306: Momigliano 2007c, 82, fig. 3.2: 4.

 B.I.17 307b **1193**
 B.I.17 307b–c hs

9) B.I.18 320–321 West Court 1905 Test Pit 15. 320: 1.50 m floor–1.70 m floor below Court. EM I (?)– MM I, including EM IIA.

 B.I.18 320 hs

10) B.I.31 371–373 EM III Well (Hood and Taylor 1981, 14: under 42).
 B.I.31 371 **1359 1365**
 B.I.31 372 **1363–1364**
 B.I.31 372–373 **1360**
 B.I.31 373 **1357–1358**

[16] Tomkins 2007; Wilson 2007; Momigliano 2007c. See also the other references in n. 1 above.

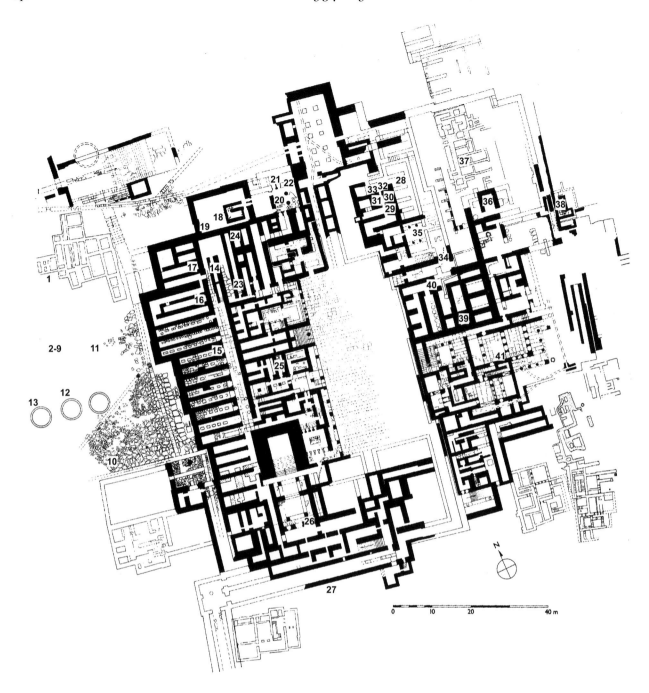

FIG. 10.1. Plan of Knossos Palace and surrounds, showing find spots of EM pottery in the SMK.

11) B.I.377 West Court 1922 Test Pit. 5th m.
 B.I 377 hs

B.II. HOUSES BELOW THE KOULOURES (Hood and Taylor 1981, 16: 88–9)

12) House A below Kouloura 2. 378: Momigliano 2007c, 82, fig. 3.2: 1: EM III late.
 B.II.1 378 **1361**
 B.II.2 380 **1362**
 B.II.3 386 **1346** (Area of Kouloura 2)

13) House B below Kouloura 3 (Hood and Taylor 1981, 16: 89). Possibly MM IA stratified over EM III: see
 Momigliano 2007c, 82, fig. 3.2: 3, with references. Also little EM IIA. B.II 405–406 marked 'Best sherds'.
 B.II.10 398 **1269**
 B.II 405 **1270 1273** hs

D.III. HIEROGLYPHIC DEPOSIT (Hood and Taylor 1981, 19: 147)

14) D.III.1 502–503 Hieroglyphic Deposit (Area of Pictographic Tablets). Wilson 2007, 50, fig. 2.1: 5: 70%
 EM IIA, 5% N, 25% EM I.
 D.III.1 502 hs
 D.III.1 503 **1198**

D.V–XXII. MAGAZINES 1–18 (Hood and Taylor 1981, 15: 53)

15) D.XIV.1 547 Magazine 10 below floor (Hood and Taylor 1981, 17: 111). EM includes EM I and EM IIA.
 D.XIV.1 547 **1209 1290**

16) D.XX.2 560 Magazine 16 1903 Test Pit (Hood and Taylor 1981, 18: 119). Wilson 2007, 50, fig. 2.1:
 6: 85% EM I, 10% N, 5% MM.
 D.XX.2 560 **1183**

17) D.XXII.2 563–564 Magazine 18 below floor (Hood and Taylor 1981, 18: 122). Some EM I–II includes EM IIA.
 D.XXII.2 563 **1192 1241 1274 1278**

E.I. NORTH FRONT AND LUSTRAL AREA (Hood and Taylor 1981, 19: 160)

18) E.I.7 617–620 Initiatory Area (Hood and Taylor 1981, 19: 159) 1928 Test Pit. 0.80–1.60 m. Wilson
 2007, 57, fig. 2.5: 10: EM IIA early + 5% N.
 E.1.7 617–620 hs
 E.I.7 618 **1230 1292 1300** (hs)
 E.I.7 620 **1194 1220 1225 1237 1262 1369**

19) E.I.9 622–624 Initiatory Area 1928 Test Pit: 622: 0–0.80 m; 623–624: 0.80–1.20 m. Wilson 2007, 57,
 fig. 2.5: 10: EM IIA early + 5% N.
 E.I.9 622 **1186** hs
 E.I.9 623 **1215 1253**
 E.I.9 623–624 **1221**
 E.I.9 624 **1261 1263**

E.II. NORTH-WEST PORTICO (Hood and Taylor 1981, 19: 152)

20) E.II.6 645–648 North-West Portico: 646–648 (1908) (below floor): general, some N and EM I and EM IIA.
 E.11.6 646 hs

21) E.II.7 649–654b North-West Portico 1905 Test Pit 2. 649–650: 0–0.50/55 m floor); 651–654b: 0.55–
 1.15 m. 649–652: Wilson 2007, 64, fig. 2.10: 2: EM IIA late. But NB: joins between
 upper and lower boxes.
 E.II.7 651 hs
 E.II.7 653 **1284**
 E.II.7 654b **1189**

22) E.II.8 657–659 North-West Portico 1905 Test Pit: 657–658 (0.40–0.75); 659 (0.75–1.10). Some EM II.
 E.II.8 657 hs
 E.II.8 659 **1264** hs

E.III. EARLY KEEP COMPLEX (Hood and Taylor 1981, 18: 139; Branigan 1992, 1995)

23) E.III.1 660 Second corridor E of N end of the Long Corridor. Includes EM IIA early.
 E.III.1 660 hs

24) E.III.2 663 SW of North Lustral Basin. Includes EM IIA early.
 E.III.2 663 **1255 1347**

F.II. SHRINE AND PILLAR CRYPT AREA (Hood and Taylor 1981, 16: 74–5)

25) F.II.3 750–751 Vat Room. MacGillivray 2007, 107–08, fig. 4.1: 2: MM IB; but **1267** seems EM IIA.
 F.II.3 751 **1267**

G.II. SOUTH PROPYLAEUM (Hood and Taylor 1981, 14: 32)

26) G.II.1 770 South Propylaeum 1925 below paving, to 0.40: includes EM IIA; EM II also in 771
 (0.40–0.90).
 G.II.1 770 **1290**

H.I. SOUTH FRONT CENTRAL

27) H.I.2 788–803 South Front. Early Houses 1908. Rooms 1–3 (Hood and Taylor 1981, 13: 2): mainly EM IIB; and much of the pottery presented by Day and Wilson (1999). 788, 791–803: EM IIB (Wilson 2007, 70–1, fig. 2.14: 1); also EM III (Momigliano 2007c, 82–3, fig. 3.2: 7). See also pp. 80–94.

H.I.2 788	**1234 1309 1316 1327 1335 1367**
H.I.2 792	**1336 1338**
H.I.2 792–793	**1326**
H.1.2 793	**1329**
H.I.2 794	**1368**
H.I.2 799	**1339**

All, or nearly all, of the following are also from the Early Houses: **1301–1308, 1310–1315, 1317–1325, 1328, 1330–1334, 1337.**

K.I. NORTH-EAST MAGAZINES AND AREA (Hood and Taylor 1981, 20: 184)

28) K.I.1 874 'North-East Rubbish Heap — Area of Dustbins': 874 (1902 'deep excavation').
29) K.I.4 879–885
30) K.I.5 886–893
31) K.I.6 894–909
32) K.I.7 910–916
33) K.I.8 917–919

These deposits from test pits in the North-East Magazines form the core material of Wilson's North-East Magazines Group of EM IIA late (Wilson 2007, 61, 64, fig. 2.10: 3–6). The amount of pottery, especially in K.I.6, suggests that all the sherds were kept: a sign of this may be that they include many horned stands.

North-East Magazines Bays 2–4 1905 and 1908 Test Pits. The depth divisions of the pottery indicate two main levels: from surface to a floor at about 0.60 m down (912–913: 0.65; 902–906: 0.70); and beneath that to another floor at between 1.25 and 1.40 m down (890–893, 916–916: 1.25; 879–882: 1.30; 907–909: 1.40). There are also 'general' and 'first metre' boxes.

	General	1st metre	0–c. 0.60	c. 0.60–1.25/1.40
K.I.4 (Bay 2 E end)		883–885	887–888	879–882
K.I.5 (Bay 3 E end)			886–889	890–893
K.I.6 (Bay 3 W end)	894–896		897–906	907–909
K.I.7 (Bay 4 E end)	910–911		912–914	915–916
K.I.8 (Bay 4 W end)	917–919			

K.I.1 874	hs
K.I.4 878	**1265**
K.I.4 879	**1238**
K.I.4 880	**1236**
K.I.4 884	**1280,**
K.I.5 886	**1260**
K.I.5 887–888	hs
K.I.5 890	hs
K.I.5 892	hs
K.I.6 894	**1256 1271 1288 1296** (hs)
K.I.6 894–896	**1191 1196 1211 1223 1226 1244–1245 1260 1268 1297** (hs)
K.I.6 895	**1195 1282**
K.I.6 896	**1272 1281**
K.I.6 897–906	**1186–1187 1197 1235 1239–1240 1242 1259 1298** (hs)
K.I.6 899	**1201 1210**
K.I.6 907–909	**1212 1214 1217 1247 1249 1260** hs
K.I.6 909	**1291**
KI.7.910	**1229 1231 1233 1280 1297**
K.I.7 910–911	**1219 1246 1250**
K.I.7 913	**1287**
K.I.7 914	**1200 1283**
K.I.7 915	**1299**
K.I.8 917–919	**1213 1248**
K.I.8 918	**1232**

K.II. AREA OF THE NORTH-EAST HALL (Hood and Taylor 1981, 20: 181, 185)

34) K.II.1 920–922 Area E of the North-East Hall 1904: 0–1.45 m. Wilson 2007, 50, fig. 2.1: 9: 90%
 EM I + 10% N, EM IIA, MM.
 K.II.1 921–922 **1216**
 K.II.1 922 **1182 1251–1252**

35) K.II.5 931–932 North-East Hall 1903 Test Pit. 931: 1st m. EM IIA early.
 1294 was restored from about 150 sherds that comprised most of box 931, with one sherd
 from 932 (2nd m), which is N, as are all subsequent boxes from K.II.5 (Furness 1953, 100).
 K.II.5 931 **1203 1294** (+ one frag. from 932) **1299** (hs)

L.II. MAGAZINES OF THE GIANT PITHOI (Hood and Taylor 1981, 20: 188)

36) L.II.2 990 Magazines of the Giant Pithoi ('East Threshing Floor Area') 1902. Includes EM IIA.
 L.II.2 990 **1227**

L.III. ROYAL POTTERY STORES (NORTH-EAST KAMARES AREA) (Hood and Taylor 1981, 20: 178)

37) L.II.11 1055–1057 North–South Corridor Kamares floor to 0.50. Includes one EM IIA.
 L.III.11 1055–1057 **1277**

L.IV. EAST BASTION (Hood and Taylor 1981, 21: 200)

38) L.IV.1103–1104 East Bastion. 1103 (1923): mostly EM III; also one EM IIA.
 L.IV 1104 **1228**

M. II. AREA OF THE OPEN STONE DRAIN (Hood and Taylor 1981, 21: 208)

39) Room of Olive Press 1905 Test Pit. Includes EM IIA.
 M.II.2 1148 **1276**

40) M.II.4 1150 Area of the Stone Drain-Heads (Room of the Olive Press) 1908 Test Pit (to 0.50):
 EM IIA–MM II.
 M.II 4 1150 **1202**

N.IV. HALL OF THE DOUBLE AXES (Hood and Taylor 1981, 22: 228)

41) N.IV.8 1298 West Hall (Hood and Taylor 1981, 22: 231). Includes one EM IIA.
 N.IV. 8 1258 **1289**

EARLY MINOAN I

A few EM I sherds from Knossos, including chalice sherds in dark grey burnished ware, supplement those in the SMK that Wilson and Day have published. We also present a drawing of **1182**.

We have already discussed dark grey burnished ware in its EM I (p. 27) and/or EM II (p. 96) contexts, as have Wilson and Day and, recently, Betancourt.[17] There is little to add to their excellent accounts. We note below how it can be seen to differ from light grey ware in very much the way that Middle Helladic Argive Minyan ware differs from Grey Minyan ware.

TYPE 1. CHALICES **1179–1183**

The bell shape of pedestal **1179** is an interesting addition to the repertoire of EM I chalices. We do not know of parallels either at Knossos or elsewhere in Crete. It is somewhat reminiscent of a woman's skirt (to which there could be an allusion). **1181** has a trough spout, comparable with those on bowl-jar **1267** in brown burnished ware and on light grey ware carinated goblets from the WCH and Mochlos.[18] As these are all EM IIA, we could perhaps assign **1181** to EM IIA rather than EM I.

1179 (AM 1909.342b). Bell shaped pedestal base, c. 1/3 pres. Ht of base 8. D. base c. 13. Dark red sandy clay, with some large dark limestone and gypsum (?) grits in clay, which has red-brown-black surface. Inside burnished; pattern burnish outside: thick vertical bands, with band to base, and horizontal lines filling reserved panels. Betancourt 1985, 28,

pl. 2H; 2008b, 56, fig. 5.12.
1180 (AM 1909.342a). Frag. from bottom of bowl and top of stem. Red clay with dark olive grey-green surface.
1181 (AM AE.737.4). Frag. probably of chalice, with open trough spout at rim. Dark grey clay with red core.

[17] See for EM I: Wilson and Day 2000, 27–31; Wilson 2007, 51–4; Betancourt 2008b.
[18] WCH: Wilson 1985, 297, fig. 9, pl. 31: P14 (Wilson and

Day 1994, 8: FG 9), and also 304, pl. 31: P64–P66; Mochlos: Seager 1912, 52, figs. 22–3: VI.11 (Wilson and Day 1994, 18: FG 96). See too p. 55: **150**.

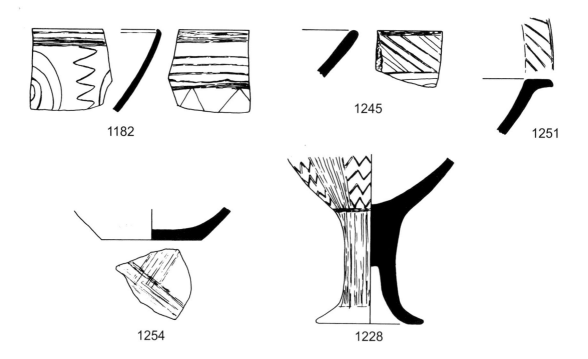

FIG. 10.2. EM I–IIA dark grey burnished ware with pattern burnish: EM I type 1 chalice **1182**; EM IIA: type 2 goblet **1228**; type 6 bowl **1245**; type 9 bowl **1251**; type 16 bowl-jar **1254**. Scale 1:2.

Rim **1182** has an unusual interior pattern burnish motif of concentric circles that seem to form spirals separated by a vertical wavy line (or chevrons). This has a remarkably close parallel in a pattern burnish chalice from Arkalochori, with decoration that Hazzidakis described as 'irregular spiral ornament'.[19] Evans, presumably thinking of the knots in wood, saw it as showing wood graining, which Pendlebury accepted tentatively.[20] Frankfort regarded it as a (carelessly executed) 'purely geometrical design'.[21]

Both this chalice and that from Arkalochori have the spiral(s) on the inside of the bowl. On the outside, the Arkalochori chalice has pattern burnish decoration of horizontal lines below the rim and then vertical lines. It is not impossible that they were made in the same workshop, as companion pieces or even a matching pair. At any rate these chalices, together with the EM IIA dark-on-light fragment (probably of a jug) **1295** and a bowl base from the WCH,[22] are probably the earliest representations of the spiral in the long history of the motif in Minoan Crete, taking it back through EM IIA to EM I.

1182 (K.II.1 922) FIG. 10.2, PLATE 53. Rim frag. Ht pres. 4. D. *c*. 10; but Wilson and Day (2000, 28, pl. 1: P1) suggest D. 15. Well fired fine dark grey clay with some sand and fine grit. Rim slightly beaded inside, slightly carinated outside; thin walls. Dark reddish-brown surface inside, dark grey outside. Pattern burnish: band to rim outside, with four lines and band above zigzag line; inside, band to rim with spirals separated by vertical zigzag line. First noticed by Furness (1953, 132).

Wilson classes chalice stem **1183** as a rare instance of EM I light grey ware at Knossos,[23] its date being determined by its context — as is the case with **109** from the Palace Well. It has a slight swelling or rib at the top of the stem.

1183 (D.XX.2 560) FIG. 10.3, PLATE 53. Ht pres. 7. Incipient rib at junction of body and stem; hollow right up inside stem. Wilson and Day 1994, 8: FG 21; Wilson 2007, 56.

[19] HM 7077: Hazzidakis 1913, 38–40, figs. 3, 4d. Ht rest. 18. D. 22. Two small wart-like lugs below rim, one only pres. Four ribs on stem; hollow inside stem goes all the way up.
[20] *PM* I, 59–60; Pendlebury 1939, 49 and n. 2.
[21] Frankfort 1927, 88 and n. 5.

[22] Wilson and Day 1994, 44: PFC 9 (Wilson 1985, 351, fig. 39, pl. 51: P422): their sample KN 92/301; and 83–4, suggesting its probable production in the western Mesara.
[23] For others and discussion, see Wilson 2007, 50, 56, 61.

EM I TYPE 2. LARGE PEDESTAL BOWLS **1184**

1184 (AM 1938.823–4). Two rim frags. of dark grey burnish ware large bowls with pattern burnish: with wavy or zigzag bands below rim and above horizontal stripes. 1938.823: D. *c.* 29. Cf. **8**, **14–15** and **17–18** (PLATES 4–5).

In addition, a fragment of an EM I open vessel from Knossos with pattern burnish is reported in the Liverpool Museum.[24]

EM I TYPE 11. JUGS WITH CUTAWAY SPOUT **1185**

1185 (AM AE.753.5, 757.1). Two neck frags. of jugs, with short beaks and handles to rim, and dark-on-light horizontal stripes. AE.757.1 has a diagonal cross below the handle: cf. **82** (PLATE 9).

AE.757.11 is a similar neck frag. of a jug, but perhaps EM IIA rather than EM I.

EARLY MINOAN IIA

LIGHT GREY WARE

This distinctive, self-slipped fabric, where the surface is (normally) the same light grey as the clay, makes a strong contrast with dark grey burnished ware. Thorough descriptions and petrographic characterisations of it already exist; and many pieces in the SMK have been published, as 'fine grey ware', a hall mark of EM IIA.[25] Among the rare EM I examples of this ware are **1183** above and the suspension pot fragment **109** from the Palace Well. We present below some pieces from Knossos that have not been published or barely published (such as **1194**), or have appeared with photographs but not drawings, or where other information can be added.

Light grey ware has been known by various names. Evans called it 'grey ware',[26] as did Pendlebury, who described the fabric at Trapeza as 'powdery', and remarked that it is 'either so soft that it crumbles to nothing or so brittle that it flakes away like slate', and that 'the surface is sometimes polished to a blacker tone'.[27] Xanthoudides similarly remarked on the dark surface of two suspension pots in Koumasa T. B: 'blacker than the clay in the break, so that it looks as if the potter had enhanced the surface by some application of black or by smoking the pots in the baking.'[28] Another possibility is that they had been darkened by fumigations in the tomb.[29] Warren called the fabric 'fine grey ware' at Fournou Korifi,[30] but it is 'pale grey burnished ware' in the catalogue.[31] At Ayia Kyriaki Blackman and Branigan used 'incised grey ware', emphasising that there it is not burnished but lightly polished.[32] Some of their 'grey burnished ware', which they distinguish from 'dark burnished ware', is almost certainly light grey ware.[33]

We believe that light grey ware is the best term: it both emphasises the homogeneous colour of both surface and body (which is its most immediately striking characteristic, as with Grey Minyan ware), and at the same time separates it from dark grey burnished ware — which, with its typical red core and olive green to dark grey or black surface, is comparable to so-called Argive Minyan pottery.

Light grey ware is an instantly recogisable product of high quality, with its well finished (finely burnished) appearance, rarity at Knossos and elsewhere, and small range of shapes. In every respect except for its grey colour and a tendency to be somewhat soft, it is like the fine painted ware of EM IIA discussed below. Wilson and Day have established that it comes from probably a neighbouring (or not too distant) production centre to the centre(s) that produced the fine painted ware,[34] both in the Mesara. Consequently, the light grey ware vessels at Knossos are imports, as holds for almost all of the fine painted vessels.[35] All were probably high-value products, especially as many of the shapes in light grey ware were also being produced in dark grey burnished ware[36] — making the light grey ware versions something different and special, of high quality and relatively exotic origin.

[24] LM 51.105.73: Mee and Doole 1993, 25: 276.
[25] Wilson and Day 1994, esp. 4–23, 77–81; cf. Wilson 2007, 61.
[26] *PM* I, 61, fig. 20.
[27] H. W. Pendlebury *et al.* 1936, 33–6; cf. Wilson and Day 1994, 21.
[28] Xanthoudides 1924, 9, pls. 1, 18: 4188 (Wilson and Day 1994, 14: FG 67), 4193 (Wilson and Day 1994, 15: FG 73 — pedestalled suspension pot).
[29] Cf. Xanthoudides 1924, 6.

[30] Warren 1972a, 95; likewise Betancourt (1985, 40; 2008, 7): 'fine gray ware'.
[31] E.g. Warren 1972a, 98–100: P5, P20, P25–26. Cf. Wilson and Day 1994, 18–20.
[32] Blackman and Branigan 1982, 32, 37, table 1.
[33] Blackman and Branigan 1982, 29, 32.
[34] Wilson and Day 1994, esp. 82.
[35] Wilson and Day 1994; cf. Wilson 2007, 56, 61, 69.
[36] Wilson and Day 1994, 80.

To Wilson and Day's 1994 list of find spots[37] we may add the following, while expecting that there are more locations that we do not know of: Ayia Fotia (Siteia);[38] Ayios Antonios;[39] Gournes (?);[40] Juktas, Ano Karnari cave;[41] Juktas, Stavromytis cave;[42] Kalo Chorio;[43] Kavousi village;[44] Palaikastro–Kastri;[45] Salami.[46]

Shapes in light grey ware at Knossos include: cups with large loop handles; goblets; bowls (with incurving rim and strainer base; carinated; with rim thickened internally; flaring; and like EM I/EM II type 9); pedestalled bowls; pedestalled stands; jars; spouted bowl-jars; suspension pots; and lids.[47] Suspension pots (EM I type 14/EM II type 20) with incised decoration are the best known shape in the ware as they have been preserved whole in tombs, whose ceramic repertoire is so much better known than that of settlements. They are also the most frequent shape at Knossos[48] — and with other light grey ware from Debla, Mochlos, Myrtos–Fournou Korifi and Pyrgos, Trapeza and Vasiliki, as well as at the least Kalo Chorio and Palaikastro–Kastri in the list above, demonstrate that the ware (i) has a variety of shapes, (ii) is often without incised decoration, and (iii) does occur in settlement contexts.

The suspension pot and its lid form the predominant shape with incised decoration; but, outside Knossos, other incised shapes are pedestalled suspension pots (essentially the suspension pot on a stand) as from Koumasa T. Γ,[49] a side-spouted jar that might belong with type 16 bowl-jars,[50] and large collar-necked jars such as from Vasiliki.[51] This last type seems to be an expanded suspension pot, but none is complete beyond the neck and shoulder. Lug handle **1204** (a bow-handle vertically pierced at either end) may come from such a large vessel, as it is like the lugs on the Vasiliki jar and is too big to have come from a typical small suspension pot.

Vessels with incised decoration were burnished, like the non-incised shapes, and also incised before firing.

Our list below of pieces from Knossos in no way supersedes that of Wilson and Day,[52] but should be taken together with theirs, which includes the finds from the WCH[53] and Warren's RRS excavations.[54]

EM II TYPE 1A. CUP WITH LARGE LOOP HANDLE **1186**

For full discussion of this infrequent type — the dipper cup — see pp. 102 and ns. 44–57; 167 (a possible example in EM III deposit A5), and **1301** below (which may go back to EM IIA, despite its likely EM IIB context in the Early Houses). **1186** seems at present unique in light grey ware, at Knossos or anywhere else in Crete, although similar cups are known in dark grey burnished ware from the WCH,[55] and from Warren's excavations on RRS in EM IIA dark-on-light painted ware with, apparently, a rounded base.[56] Cup **1186** has an incurving rim, rounded body and a large handle that describes an oval loop. The handle is pierced at both junctions with the body, a feature also of the lug handles of suspension pots and of EM II jugs: these holes were made probably to ensure more consistent firing at such thick points.

1186 (E.I.9 622) FIG. 10.3 PLATE 53. Probable D. 24. Handle and a little of rim and body pres. Round handle, horizontally pierced at attachments to body. Wilson and Day 1994, 5, pl. 1: FG 1, suggesting D. as '*c.* 18 (?)'.

EM II TYPE 2. GOBLETS **1187–1195**

This is a selection of rims, to which we can add **818** above (from RRS in a MM IA context). **1191** could perhaps be classed better as dark grey burnished ware.

[37] Wilson and Day 1994, 5–22. Our additions do not include two sherds with incised decoration from the Lera cave (Guest-Papamanoli and Lambraki 1976, 203–04, fig. 7, pl. 43: D17–D18). Their clay is said to be homogeneous grey, and they are described as totally Cycladic in character. It is unlikely that they are of light grey ware. D17 may be akin to **1209**, which is probably a Cycladic import.

[38] Davaras and Betancourt 2004, 190, fig. 469: 210.1 (Betancourt 2008*b*, 10, fig. 1.6). Cf. Day *et al.* 2000, 344.

[39] Haggis 1993, 15, 18–19, fig. 5: 137, pl. 3.2b; 2005, 49, 99, fig. 31: 6.3.

[40] Galanaki 2006, 230, pl. 4: 2α–β look to be light grey ware.

[41] HM 10070. We thank Georgia Flouda for identifying the location.

[42] Marinatos 1950, 256.

[43] From the Kourinos terrace site: Haggis 1996, 669, fig. 30; 674: KT 89, 91, 95; 679.

[44] Bowl rim, in Mirabello fabric: Haggis 2005, 49, 109, fig. 39: 24.38.

[45] A few sherds from Area KA, trench 3: Cadogan in preparation.

[46] Xanthoudides 1924, 74.

[47] Cf. Wilson and Day 1994, 5–11; also Wilson 2007, 61, 69.

[48] Wilson and Day 1994, 6, table 1.

[49] Xanthoudides 1924, 34–5, pl. 25: 4194.

[50] Trapeza: H. W. Pendlebury *et al.* 1936, 43–6, fig. 10, pl. 8: 205 (Wilson and Day 1994, 21: FG 125).

[51] Boyd Hawes *et al.* 1908, 50, pl. 12: 13 (Wilson and Day 1994, 21: FG 126).

[52] Wilson and Day 1994, 5–12.

[53] Including FG 2–10, 23–38, 49, 52–3 (Wilson and Day 1994, 6–11, and table 1).

[54] Wilson and Day 1994, 11.

[55] Wilson 1985, 301, 303, fig. 12: P55.

[56] Catling 1973, 27–8, fig. 59.

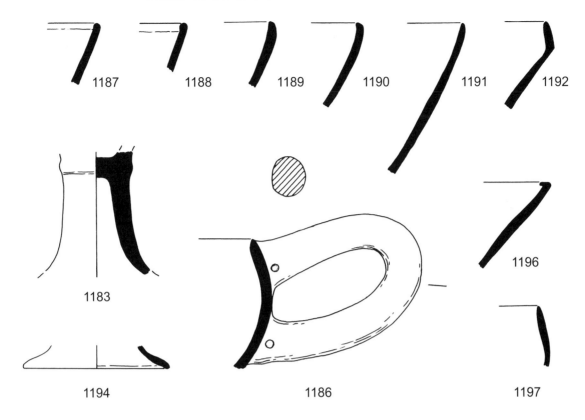

FIG. 10.3. EM I–IIA light grey ware: EM I type 1 chalice **1183**; EM IIA: type 1A cup **1186**; type 2 goblets **1187–1192**, **1194**; type 5 bowl **1196**; type 16 bowl-jar **1197**. Scale 1:2.

1187　(K.I.6 897–906) FIG. 10.3. D. 10. Straight-sided and slightly beaded.
1188　(K.I.6 897–906) FIG. 10.3. Straight-sided, with more pronounced bead.
1189　(B.I.16 280) FIG. 10.3, PLATE 53. D. 12. Incurving and thickened.
1190　(E.II.7 654b) FIG. 10.3, PLATE 53. D. 16. Incurving and bevelled. The burnished surfaces have separate vertical strokes over horizontal burnishing.

Pedestals/stems
1193　(B.I.17 307b). Ht pres. 4.1. D. base 13. Slightly spreading at base. Probably Wilson and Day 1994, 7–8, fig. 1: FG14, where identified as rim.
1194　(E.I.7 620) FIG. 10.3. D. base 8. Bead to edge of base; spreading foot.

1191　(K.I.6 894–6) FIG. 10.3. D. 12. Doubtful as light grey ware: reddish clay with light olive green surface, which may suggest a light example of dark grey burnished ware.
1192　(D.XXII.2 563) FIG. 10.3, PLATE 53. D. 16. Carinated. Cf. esp. WCH: Wilson 1985, 297–8, fig. 9, pl. 31: P14 (Wilson and Day 1994, 8: FG 9), and Mochlos: Seager 1912, 52–3, figs. 22–3: VI. 11 (Wilson and Day 1994, 18: FG 96).

1195　(K.I.6 895) PLATE 53. Ht pres. 6.3. Wilson and Day 1994, 8, pl. 1: FG 17.
There are some four other stems from K.I.6 (one at least with a rib): cf. Wilson and Day 1994, 8.

EM II TYPE 5B. SHALLOW BOWL WITH UPRIGHT SIDES AND RIM THICKENED INTERNALLY: (B) FLAT-TOPPED RIM **1196**

1196 conforms to EM II type 5**b**. Its flat rim is rounded on the outside. The thickening on the inside is more pronounced than on the buff or dark wash bowls of this type from our excavations. Cf. e.g. **1239** in dark grey burnished ware.

1196　(K.I.6 894–896) FIG. 10.3. Rim frag. D. 20. Grey clay with darker core, slightly reddish, and black and white flecks. Well fired. Grey burnished surfaces.

EM II TYPE 16. SMALL SPOUTED BOWL-JAR **1197**

1197 appears to be the rim of a small jar or bowl-jar of type 16, which is not a common shape in light grey ware. The vessel is burnished on the outside only, which supports the idea that it was (primarily)

a jar. A bowl from the WCH (see below) has a similar incurving and thickened rim, but is burnished on both sides. A probably less likely alternative is that it is from a goblet and thus similar to **1220–1221** (below) in dark grey burnished ware.

1197 (K.I.6 897–906) FIG. 10.3. D. 12–13. Fine grey clay, slightly redder at edges, with black and white flecks. Light grey surfaces, burnished outside only, where mottled light grey to grey. Rim slightly thickened.
Cf. WCH: Wilson 1985, 305–06, fig. 13: P88 (Wilson and Day 1994, 9: FG 25).

EM II TYPE 20. SUSPENSION POTS ETC. **1198–1210**

One of the earliest light grey ware suspension pots known from Crete is **109** from the Palace Well (EM I type 14). If it seems to have an unusually high collar (in relation to its presumed body diameter), similarly proportioned collars are a feature of these vessels in this ware.[57] More frequently, however, the collar necks are low, and either vertical or with a concave profile, splaying slightly at the top (as do the large type 13 collar-necked water jars from the Palace Well). Often there is an indentation (or groove) at the base of the collar-neck and/or a horizontal ledge (as on **1199**), to hold the lid more firmly.

Two types of lug-handles occur. The common type (the bow-handle) is horizontal and describes a bow (or shallow arch) shape, and is vertically pierced at either end where it joins the body of the vessel.[58] The purpose of this was to tie down a lid. The alternative is found on **1199**: a horizontally pierced lug, of a wart shape known also in the cave of Eileithyia.

These pots were both burnished and incised before firing. Sometimes the burnishing was a second stage, where the incisions are as smooth and shallow and burnished as, in general, the unincised surface: e.g. **1201**. But the incisions can also be deep and straight, and done with a sharp but fairly thick-pointed instrument through the already burnished surface. If there is then no further burnishing, it counteracts the original burnishing and can lead to flaking of the surface; and on several fragments the original surface has now vanished for this reason. Marks were also stamped with a wedge-shaped instrument — the *Kerbschnitt* punctuation technique found both as short, often triangular jabs (e.g. **1198**) and, with the steady application of more hand pressure, as longer triangles with a tail that becomes shallower (e.g. PLATE 53: **793**). Wilson and Day suggest the use of a combed stamping tool,[59] which we believe is unlikely for these triangular jabs but not, of course, impossible: it would be quite cumbersome and difficult to cut a multiple implement with such relatively complicated marks out of wood. On the other hand, a combed tool might well have been used for incising multiple horizontal and vertical lines and semicircles.

The usual decorative schemes consist of: bands of diagonal lines, herring-bone and cross-hatching/latticework, often defined by thin lines; punctuation, in both triangular (wedge-shaped) and simpler rectangular forms; and concentric semicircles with the field filled with punctuation. The most interesting example of the latter is the large fragment **1203** first noticed by Pendlebury, which has concentric semicircles above and *below* a central line: these overlap to give a somersaulting effect, paralleled on a small globular suspension pot from Pyrgos.

Decoration in vertical panels is not so common as the horizontal schemes: examples include **793** (FIG. 10.4, PLATE 53) from a later level in RRN (p. 191), and **1199**.

A suspension pot with incised decoration from Thera seems the sole known export in Cretan light grey ware.[60]

1198 (D.III.1 503) FIG. 10.4, PLATE 53. Body frag. with bow-handle, doubly pierced. Wilson and Day 1994, 10, pl. 1: FG 41.
For the incised lines on the outside surface of the handle, cf., e.g., **1204**, and Ayia Fotia (Ierapetra) (Boyd Hawes *et al.* 1908, 56, fig. 38: 3).
1199 (HM 5727) FIGS. 10.4–10.5, PLATE 54. 1/2 rim and body pres. Ht pres. 5.4. D. rim 6.5. D. body 10. Fine light grey clay, flakey, with light grey burnished surface. Vertical collar with ledge for lid (which is probably **1208**), tall globular to piriform body, and two horizontally pierced wart-like lugs: cf. Eileithyia cave: Marinatos 1929*a*, 96–7,
fig. 1 middle left (Zervos 1956, 121, fig. 81); and Betancourt *et al.* 2000, 196, fig. 12; 198: 46. Decoration of wedge-shaped punctuation in freestanding vertical (slightly curving) bands: Find spot at Knossos unknown. *PM* I, 60–1, fig. 20.
1200 (K.I.7 914) PLATE 53. Shoulder frag. For decoration of zones of long thin chevrons with central line, separated by zone of small chevrons, cf. Koumasa T. B: Xanthoudides 1924, 35, pl. 25: 4186 (Wilson and Day 1994, 14: FG 65, with references). Wilson and Day 1994, 10, pl. 1: FG 45.
1201 (K.I.6 899) PLATE 53. Body frag. The combination of incised decorative motifs on the belly of the pot (chevron

[57] See p. 46 and n. 192.
[58] Wilson and Day's (1994, 9) term for these is: arched handles with double perforation.
[59] Wilson and Day 1994, 9.
[60] Zervos 1957, 34, 84, fig. 59.

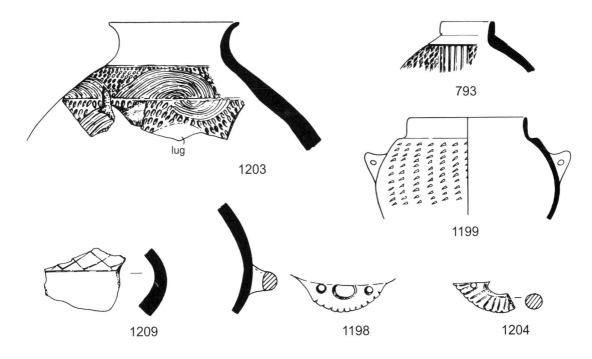

FIG. 10.4. EM IIA light grey ware type 20 suspension pots **793**, **1198–1199**, **1203–1204**; Cycladic (?) jar **1209**. Scale 1:2.

zone and cross-hatched zone, separated/enclosed by horizontal lines) seems rare: cf. Gournia North Cemetery for the cross-hatching (Boyd Hawes *et al.* 1908, pl. A5; Wilson and Day 1994, 17: FG 85, with references); Sphoungaras (Boyd Hawes *et al.* 1908, 56, fig. 37: 9; Wilson and Day 1994, 17: FG 91) and Vasiliki (Boyd Hawes *et al.* 1908, pl. 12: 13; Wilson and Day 1994, 17: FG 91, with references) for the chevrons. Finely burnished *after* incisions. Wilson and Day 1994, 10, pl. 1: FG 44.

1202 (M.II 4 1150) PLATE 53. Body frag. Diagonal decoration with two lines and start of likely chevrons (with another diagonal line). Cf. Malia: Chapouthier and Charbonneaux 1928, 48, fig. 12b. Wilson and Day 1994, 11, pl. 1: FG 47 (sample KN 92/261).

1203 (K.II.5 931) FIG. 10.4, PLATE 54. Rim and shoulder frag. of large example. Short everted collar and very thick body; probably had doubly pierced bow-handles (like **1198** and **1204**); crude, untidily incised bands and multiple semicircles rising and pendent from an horizontal line, the field filled with punctuation in horizontal rows or following the curve of the semicircles. The pendent semicircles of the lower zone overlap the rising semicircles

of the zone above, for a somersaulting effect: cf. Pyrgos (Xanthoudides 1918*a*, 157, fig. 12: 104; not visible in the photograph). Wilson and Day 1994, 10–11, pl. 1: FG 46. Other references include: Pendlebury 1939, 52, n. 1; Wilson 1985, 305, n. 32; 2007, 60–1, fig. 2.7: 5.

1204 (A.II.2 51) FIG. 10.4, PLATE 53. Frag. of doubly pierced bow-handle. L. pres. 3.5. Soft light grey clay with black and white flecks. Round section. Incised herring-bone decoration. Cf. Wilson and Day 1994, 10, pl. 1: FG 40.

1205 (AM AE.737.2). Collar and shoulder frag. (rim not pres., but D. est. *c.* 3) of small, bottle-shaped suspension pot. Standard light grey ware. Ledge at base of collar for lid; broken lug/handle seems to have been doubly pierced bow-handle. Burnished after incising of decoration: zone of diagonal dashes between lines; two bands; multiple semicircles and punctuation in field. Needs cleaning.

1206–1207 (AM AE.737.5–6, 8, 12, 14) Miscellaneous body frags. generally in light grey ware seem to be from suspension pots: total of vessels uncertain. AE.737.6, 12 could be dark grey burnished ware with incised decoration: cf. **1257**. All need cleaning.

Suspension pot lids

1208 (HM 5727) FIG. 10.5. Frag. D. *c.* 7. Grey clay, smoothed inside; well burnished outside, black mottling to shades of dark and light brown and reddish. Horizontal rib. Probably lid of **1199**, which it fits: when fitted, the rib sits at, or just above, the level of the rim of **1199**. Like **1199**,

find spot at Knossos unknown.

Other ribbed lids from Knossos appear to be: (1) with red pattern burnish decoration (D.III.1 503) and perhaps EM I; (2) **920** (B2) in Vasiliki ware and presumably EM IIB.

Finally, we may mention here two sherds in grey fabric that we have thought to be imports. **1209** is remarkable for its blackish matt smoked appearance, a micaceous fabric that also has carbonised (?) inclusions, and for the open lattice-work incision which was made with a sharp, thin instrument of a

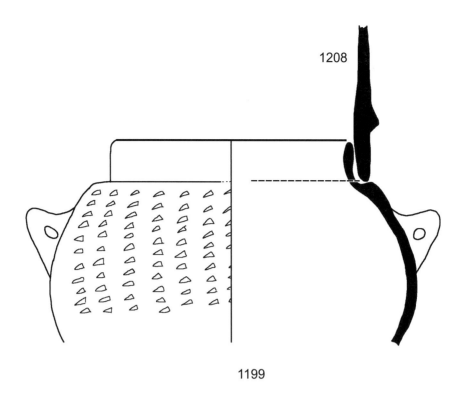

FIG. 10.5. EM IIA light grey ware suspension pot lid **1208** with suspension pot **1199**.

sort hardly discernible, if ever, in light grey ware with incised decoration. **1209** may well be from the Cyclades. **1210**, however, is now far from being a certain import. This shoulder fragment of a globular jug of EM II type 15, decorated with zones of incised herring-bone, is of an unusual fabric, grey ash-coloured clay with a pink to grey outer surface and traces of a black to dark red wash.

1209 (D.XIV.1 547) FIG. 10.4, PLATE 54. Frag. of closed vessel/jar (suspension pot?). 3.5 × 4.2. Light ashey grey clay, micaceous, with some small grits and carbonised (?) inclusions, becoming dark ashey red towards the outside surface. Smokey blackish outside. Slight flaking inside and outside. Open lattice-work incision, by finely-pointed instrument, above horizontal line.

1210 (K.I.6 899) PLATE 54. Shoulder frag. of jug. Ht pres.

5. Est. body D. 12+. Well fired ashey grey clay, with some fine grit, and pink to grey outer surface. Blistering inside. Had vertical handle and probably globular body. Traces of black to dark red wash. Irregular bands of herring-bone and horizontal lines. Wilson 2007, 68–9, fig. 2.13: 12 (with handle), noting the type, in red slipped and burnished ware, as rare. Wilson and Day sample KN 92/371.

DARK GREY BURNISHED WARE

Dark grey burnished ware has already been discussed in EM I (pp. 27, and 245–7) and EM II (p. 96) contexts, to which we can add the discussion by Wilson and Day in presenting EM I pottery from Knossos, and Wilson's discussions in his report on the WCH pottery and in the *Knossos Pottery Handbook*.[61] What we present below is a selection to complement the other accounts.

TYPE 2. STEMMED GOBLETS **1211–1235**

Rim **1216**, despite coming from a predominantly EM I context, on stylistic grounds (including its comparanda) is more likely to be EM IIA.

Stem **1228** is unusual for its decoration of alternating panels of vertical burnished strokes and horizontal pattern burnished chevrons, which can be compared to pattern burnish at Pyrgos and, more remotely, on Samos.[62]

[61] Wilson and Day 2000, 27–31; Wilson 1985, 295–304; 2007, 51–4, 58, 64.

[62] Furness 1956, 187, pl. 17: 1 (lattice work on bowl), 2–3

(reserved panels with zigzag pattern burnish, but on narrow-necked jars).

Goblets: rims and profile

(i) Conical (these should probably include **1191** above)

1211 (K.I.6 894–896) FIG. 10.6. D. 13.
We have noted 13 more in the SMK, 10 of them from K.I.6, mostly with an unburnished (reserved) line immediately below the rim outside, which makes the rim appear slightly beaded. Cf. WCH: Wilson 1985, 299, 302, fig. 11: P31–32.

(ii) Conical with rim thickened internally

1212 (K.I.6 907–909) FIG. 10.6. Ht pres. 5.6. D. 9.5. Low carination; very finely polished outside. For carination at base of bowl, cf. **1235**.
1213 (K.I.8 917–919) FIG. 10.6. Similar rim, but more clearly defined. D. 10.25.
Two more similar rims noted in the SMK, one of them from K.I.6.

(iii) Conical with bevelled rim

1214 (K.I.6 907–909) FIG.10.6. D.12. Bevel left unburnished and rough.
1215 (E.I.9 623) FIG.10.6. Slight thickening inside. D. 12. Horizontal stroke burnishing below rim outside, and zone or panels (?) of vertical stroke burnish, alternating with reserved panels.
Three more rims of this shape noted in the SMK. Cf. also WCH: Wilson 1985, 299, 302, fig. 11: P33.

(iv) S-rimmed

1216 (K.II.1 921–922) FIG. 10.6. S-rim with curving side. D. 10. Horizontal stroke burnish below rim outside and above differentiated vertical stroke burnish; horizontal stroke burnish to 2.5 below rim inside.
A similar rim (E.I.9 623) has pattern burnish outside: differentiated horizontal lines. Cf. also **1215**.

(v) With curving profile

1217 (K.I.6 907–909) FIG. 10.6. D. 9.5.
Eight more rims of this shape noted in the SMK, five from K.I.6. Cf. also WCH: Wilson 1985, 299–300, fig. 10: P29.

(vi) With flat top and curving profile

1218 (B.I.4 171) FIG. 10.6. D. c. 14. Internal thickening to rim, flattened on top.
1219 (K.I.7 910–911) FIG. 10.6. D. 7.5. Clay dark red at core and grey to finely burnished grey surfaces, darker outside: ? light grey ware variant. String-hole below rim.

(vii) With thickened rim and curving profile

1220 (E.I.7 620) FIG. 10.6. D. 12.5.
1221 (E.I.9 623–624) FIG. 10.6. D. 10.
1222 (B.I.4 171) FIG. 10.6. D. 10.5. Hint of carination.
1223 (K.I.6 894–6) FIG. 10.6. D. 9.75. Virtually profile of bowl. Bevelled rim.

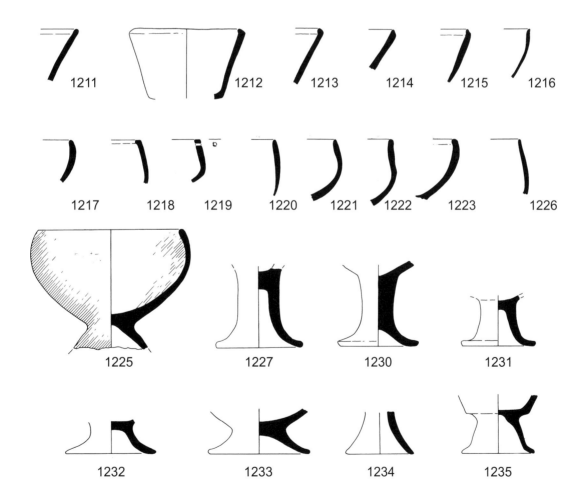

FIG. 10.6. EM IIA dark grey burnished ware type 2 goblets **1211–1223, 1225–1227, 1230–1235**. Scale 1:3.

1224 (AM 1909.966). Almost complete, but edge of base missing. Ht pres. 7.4. D. 9.7. Well fired dark red sandy clay, with some fine grit, perhaps slightly micaceous, with olive to grey- to dark grey-brown surface, burnished outside and inside except in centre of bowl and inside pedestal; wheel-like smoothing marks on pedestal. Incurving bowl. Closely similar to **1225**.

1225 (E.I.7 620) FIG 10.6, PLATE 54. Rest. 1/2 of rim and part of base missing. Ht pres. 9.6. D. 12. Fine dark grey-red clay, light grey to edges, with a little sand. Grey wash burnished all over except lower waist and outside of

pedestal, with fine mottled finish outside.

Seven more such rims noted in the SMK, four from K.I.6. Cf. also WCH: Wilson 1985, 299–300, fig. 10: P34, P36.

(viii) With thinned rim

1226 (K.I.6 894–6) FIG. 10.6. D. 11.75. Hard sandy grey clay with some grit. Greenish grey surface, stroke burnished.

Two more noted in the SMK from K.II.1.

Goblets: stems and bases, with height measured (unless stated otherwise) to the waist

(i) Tall; hollow all way up stem

1227 (L.II.2 990) FIG. 10.6. Ht. pres. 6.5. D. base 7.

Four more noted in the SMK, one of them from K.I.6. Cf. WCH: Wilson 1985, 301–2, fig. 11: P38, P40.

(ii) Tall; hollow half way up stem

1228 (L.IV 1104) FIG. 10.2, PLATES 54–55. Ht 6. D. base 5.8. Alternating panels in pattern burnish of horizontal chevrons and vertical strokes; vertical stroke burnish on stem; foot smoothed/lightly burnished; smoothed inside stem. For pattern burnish chevrons in reserved panels, cf. WCH: Wilson 1985, 299–300, fig. 10: P25 (Wilson 2007, 59, fig. 2.6: 1 right); Pyrgos: Xanthoudides 1918a, 155, fig. 11: 77; 159, pl. 2.

Five more examples (of this type of stem) noted in the SMK. Cf. WCH: Wilson 1985, 301–02, fig. 11: P37, P39. Another sherd (**1229**) with chevron pattern burnish is in K.I.7 910.

(iii) Tall; shallow hollow

1230 (E.I.7 618) FIG. 10.6, PLATE 55. Ht. pres. 5.5. D. base 6.8. Burnished vertically on stem and ? body, horizontally inside bowl.

One more noted in the SMK.

(iv) Low-medium height; hollow all way up

1231 (K.I.7 910) FIG. 10.6, PLATE 55. Ht. pres. 3.8. D. base 6.8.

One more noted in the SMK. Cf. WCH: Wilson 1985, 301–02, fig. 11: P43.

(v) Low, conical and spreading

1232 (K.I.8 918) FIG. 10.6. Ht. pres. 2.5. D. base 6.8.
1233 (K.I.7 910) FIG. 10.6. Ht. pres. 2.3. D. base 8.4. Low base. Burnished inside, on waist, and underneath.

Nine more noted in the SMK, five from K.I.6, eight of them also burnished underneath. Cf. WCH: Wilson 1985, 301–02, fig. 11: P42 (with pattern burnish); and another (from Knossos) in the HM.

(vi) Conical and small

1234 (H.I.2 788) FIG. 10.6. Ht. pres. 3.4. D. base 5.5. Small, conical base.

Two more noted from K.I.6. A larger example is from the WCH: Wilson 1985, 299, 302, fig. 11: P31.

(vii) Low-medium height, conical

1235 (K.I.6 897–906) FIG. 10.6. Ht. 3.55. D. base 6. Low to medium height, with carination at base of bowl. Sandy grey to buff clay with grey to red burnished surface (possibly classed better as dark washed ware (= red/black slipped ware in Wilson 2007, 58–61), stroke burnished inside and out; body pared above waist. For low carination cf. **1212**.

Eight more noted in the SMK, six from K.I.6, seven of them also burnished underneath.

EM II TYPE 4. SHALLOW BOWL WITH RIM THICKENED INTERNALLY (?); OR EC II LID **1236**

1236 (K.I.4 880) FIG. 10.7. D. 18. Shallow bowl (or lid ?). Gritty rather coarse reddish clay, with mica (silver and a little gold) flecks; not noticeably sandy. Dark grey surface,

finely burnished on top and around. Probably EC II import (Wilson, pers. comm.), and a lid, being burnished on the exterior side. If correct, the drawing is upside down.

EM II TYPE 5. BOWLS WITH UPRIGHT SIDES AND RIM THICKENED INTERNALLY: (B) FLAT-TOPPED RIM **1237–1239**

Bowls are the second most frequent type, but far fewer than goblets — as is the case also in the burial contexts of, for example, Ayia Triada and Pyrgos. **1238** is an angled variant of the standard flat-topped rim of type 5**b**.

1237 (E.I.7 620) FIG. 10.7. D. 25. Rim grooved (scalloped).
1238 (K.I.4 879) FIG. 10.7. D. 32. Rim grooved, like above; groove also below (everted) rim outside.

1239 (K.I.6 897–906) FIG. 10.7. D. 18? Grooved rim, angled internally; string-hole below rim, where rim pulled out to form a small projection and nicked. Cf. **287** (A2) above; and WCH: Wilson 1985, 297–8, fig. 9: P9.

EM II TYPE 6. DEEP BOWLS **1240–1245**

(**a**) Rims thickened internally

1240 (K.I.6 897–906) FIG. 10.7. D. 20.
1241 (D.XXII.2 563) FIG. 10.7. D. c. 26.5.
1242 (K.I.6 897–906) FIG. 10.7. D. 29. Rim thickened inside and out.

(**b**) Bevelled rims

1243 (K.I.8 917–19) FIG. 10.7. D. 16. Pair of string-holes below rim, either side of break.

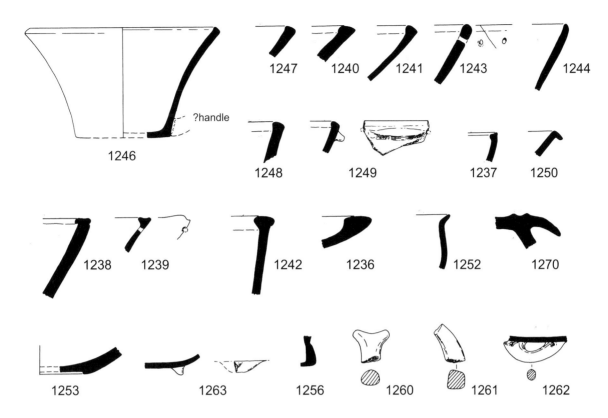

FIG. 10.7. EM IIA: dark grey burnished ware: type 4 bowl (?) (or EC II lid ?) **1236**; type 5 bowls **1237–1239**; type 6 bowls **1240–1244**; type 8 bowls **1246–1249**; type 9 bowl **1250**; type 16 bowl-jars **1252–1253**; type 20 suspension pot **1256**; handles **1260–1262**; base **1263**; light brown burnished ware (?) type 22 cover lid (?) **1270**. Scale 1:3.

(c) Tapered rims

1244 (K.I.6 894–6) FIG. 10.7. D. 14.
1245 (K.I.6 894–6) FIG. 10.2, PLATE 54. D. *c.* 40 ?

Pattern burnish decoration of diagonal lines (hatching) between line on rim and lines below.

EM II TYPE 8. BOWLS WITH FLARING RIM: (B) DEEP **1246–1249**

1246 (K.I.7 910) FIG. 10.7. Ht. 8.7. D. 16. Rim slightly thickened internally; apparently flat base, and traces of handle (?) immediately above base. Was this used as a lid? E.I.9 623 has a similarly shaped bowl, with a string-hole below the rim.
1247 (K.I.6 907–909) FIG. 10.7. D. 18. Like above.

Two more like **1246–1247** were noted in the SMK.
1248 (K.I.8 917–919) FIG. 10.7. D. 18. Rim rounded and thickened internally and (slightly) externally.
1249 (K.I.6 907–909) FIG. 10.7, PLATE 55. D. 19. Rim rounded and thickened internally; horizontal lug below rim with string-hole at either end of lug.

EM II TYPE 9. BOWLS WITH EVERTED RIM **1250–1251**

1251 is a surprisingly early example of a bowl with a flat, everted rim, a shape well known from MM II onwards,[63] if then usually of smaller size. **1250** may as yet be without parallels.

1250 (K.I.7 910–911) FIG. 10.7. D. 14. Angled everted rim.
1251 (K.II.1 922) FIG. 10.2, PLATE 54. D. 14. Horizontal

stroke burnish inside and vertical outside; pattern burnish of diagonal lines (hatching) on rim. Cf. WCH: Wilson 1985, 296–7, fig. 8: P10 (D., however, 22).

EM II TYPE 16. SMALL BOWL-JARS **1252–1254**

1252 (K.II.1 922) FIG. 10.7. D. 14. Soft, flakey and sandy grey clay, with grit; burnished grey wash. S-shaped rim, more evolved than a goblet from the WCH: Wilson

1985, 299–300, fig. 10: P36 (D. 10).
1253 (E.I.9 623) FIG. 10.7. D. base 8. Sunken base may come from a type 16 vessel. Finely burnished outside.

[63] MacGillivray 2007, 131–3, fig. 4.20: 1–2 (MM IIA); 141, fig. 4.29: 2 (MM IIB).

1254 (B.I.16 280) FIG. 10.2, PLATE 55. D. base 5.5. Flat base with cross in pattern burnish underneath, perhaps from a type 16 bowl-jar. Cf. **1265** (type 2 goblet in light brown burnished ware).

EM II TYPE 20. SUSPENSION POTS **1255–1258**

1255 (E.III.2 663) PLATE 55. 5.8 × 5.5. Ledge, and traces of collar; vertical ribs down body: cf. Koumasa T. B (Xanthoudides 1924, 9, pls. 1, 18: 4193) and Mochlos (Fairbanks 1928, 10, pl. 1: 12). For ribbing, cf. also **901** (B1).
1256 (K.I.6 894) FIG. 10.7. Hard sandy grey clay with dark grey burnished surface: very well fired light grey ware?
1256A (B.I.15 275) PLATE 53. Dark grey surfaces with reddish core, and fine dark grit. Punctuated decoration (six rows) above two incised lines. Wilson and Day 1994, 23, pl. 2: DG 8.

Besides four suspension pots from the WCH and **1256A** that Wilson and Day list in their discussion of 'dark grey burnished incised ware',[64] **1257–1258** are probably two more examples from Knossos of this rare combination: see also **1206–1207** above. Other shapes in their list for this ware are bowls and jars.

1257 (AM AE.737.1, 3, 7, 9–11, 13). Seven frags. AE.737.3 is rim frag. D. est. c. 7. Hard, well fired greyish-red clay with fine dark grits, grey to surface in places; smoothed grey surface. Low vertical collar; probably baggy shape to body; at least two doubly-pierced horizontal lugs above incised line at belly. Fairly deep incised decoration (with pointed instrument): chevrons forming triangles below collar, filled with (mostly) vertical and (occasionally) almost horizontal dashes.
1258 (AM 1938.407). Frag. of large jar, probably suspension pot. Reddish-brown clay with dark greyish-red core; some dark grits; well smoothed (rather than burnished) grey surface outside. Incised (pre-smoothing) decoration: horizontal lines, multiple semicircles and punctuation in field(s).

HANDLES **1259–1262**

The horned handle **1260** is unusual, with rare parallels from Lebena and Ayia Triada.

1259 (K.I.6 897–906) PLATE 55. Frag.: apparently vertical handle of double bowl. Ht. pres. 5.5.
1260 (K.I.5 886) FIG. 10.7, PLATE 55. L. 2.5. Max. W. 3. Horned handle, perhaps from a tripod pyxis: cf. Lebena T. II (Alexiou and Warren 2004, 79, fig. 30, pl. 91C: 166) and Ayia Triada (Zervos 1956, 142, fig. 118).

1261 (E.I.9 624) FIG. 10.7. Handle frag. of trapezoidal section.
1262 (E.I.7 620) FIG. 10.7. Handle of lid (or vertical side-handle of bowl?). Round section handle has perforations at attachments with body.

BASE **1263**

Besides **1253–1254**, we include **1263** with its lug (pellet) feet: cf. pp. 57, FIG. 3.11, PLATE 16: **154**; 118.

1263 (E.I.9 624) FIG. 10.7. Base D. 5.5. Burnished outside only; probably from a jug.

BROWN BURNISHED WARES

Brown burnished ware comes in two fabrics that are probably related to two different ceramic traditions. In both cases, the pottery is rare and quite distinctive. One fabric is light brown burnished ware, a soft, light red-brown or tan coloured clay with a similar surface, which is probably akin to light grey ware; the other is brown burnished ware, a harder reddish clay, akin to that of dark grey burnished ware, with a dark red-brown or dark tan coloured surface, which is burnished, usually with the stroke marks apparent.

A few pieces from Area A are presented above. The most interesting is lid **196** (A1) in the soft, light brown version of the ware: it is identical to one in the SMK (B.I.8 226). Other pieces include **191**, **193–196** and, perhaps, **268** (A1); also perhaps **287** (A2); and **711–714** and **716–717** (A8). There are very few pieces from B1 and B2.

SMK examples of soft, light brown burnished ware also include goblet **1264**, with a slight beading at the rim, which is also found on a similar conical pedestal base (but does not occur in dark grey burnished ware); goblet **1265** with what seems to be an indented (or sunken) base, or possibly a ring base, with a pattern burnish cross in the hollow; and bowl **1266** with internally thickened rim. Everted rim **1268** (D. 20) may come from a jar with a baggy body shape like suspension pots or from a type 19 collar-necked jar.

[64] Wilson and Day 1994, 22–3.

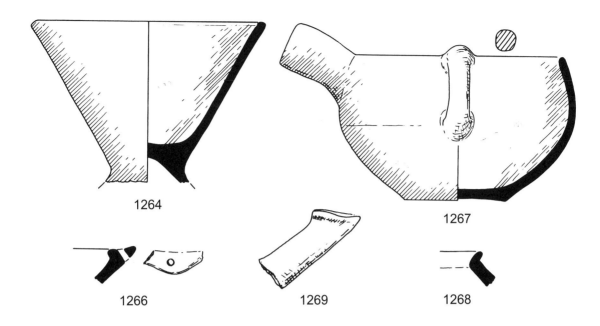

FIG. 10.8. EM IIA brown burnished wares: type 2 goblet **1264**; type 5 bowl **1266**; type 16 bowl-jars **1267–1269**.
Scale 1:2.

In the darker version we have nozzle spout **1269**, presumably from a type 16 bowl-jar, and the restored **1267**. This hybrid vessel, which comes from the Vat Room, was found already mended and plastered, presumably at the instigation of Evans: it has an open trough spout, and vertical handles as with type 16A, but there are two of them and they are in the position of the horizontal handles of type 16B.[65] We presume that it is EM IIA, and most likely EM IIA early, even if the Vat Room deposit is primarily MM IB.[66]

Brown burnished ware belongs to EM IIA — and, most likely, to EM IIA early — but, like other fabrics of that period, may well occur or have its roots in EM I.

EM II TYPE 2. GOBLETS **1264–1265**

1264 (E.II.8 659) FIG. 10.8. Profile frag. of goblet bowl. Ht pres. 8.6. D. 12.8. Soft sandy tan clay with burnished tan surface. Broad, spreading pedestal.

1265 (K.I.4 878) PLATE 55. Indented (?) base frag. of goblet. D. base *c.* 5. Very flakey soft chestnut-red clay, to dark brown at edges. Burnished tan surface, veering to black outside, and darkened inside. Under base: pattern burnish cross in reserved zone. For base, cf. Wilson 1985, 361–2, fig. 42: FF4.

EM II TYPE 5. BOWL WITH UPRIGHT SIDE AND RIM THICKENED INTERNALLY: (B) FLAT-TOPPED RIM **1266**

1266 is very similar to **1239** in dark grey burnished ware, with its pierced lug; but the thickened rim here is slightly angled.

1266 (K.I.6 907–909) FIG. 10.8, PLATE 55. Rim frag. of bowl. D. ? Soft, flakey tan clay with burnished surface, brown inside, dark red outside. Rim pulled out to form lug, vertically pierced.

EM II TYPE 16. BOWL-JARS (?) **1267–1269**

We include here **1268**, whose body profile may have been more like a large example of a suspension pot rather than a bowl-jar. Note its diameter of 20. For **1267** see above.

[65] For a bowl with two vertical handles in fine painted ware, see Wilson and Day 1994, 26, fig. 2: FP 29; 28 (K.I.7 910).

[66] Momigliano 1991, 167–75; MacGillivray 2007, 107–08, fig. 4.1: 2.

1267 (F.II.3 751) FIG. 10.8, PLATE 55. Small amphoroid spouted bowl. Rest. and *c.* 1/3 plastered. Ht to rim 7.8, to top of spout 9.2. D. 11.5. Somewhat flakey red clay with dark and white grits, traces of straw, and small holes on surface (from blistering during firing?); burnished to rich tan colour. Incurving profile; open trough spout: cf. **1181** and references (p. 245 and n. 18 above). Evans 1903, 95, fig. 65s; Momigliano 1991, 174, pl. 23: 32, reporting it as missing.

1268 (K.I.6 897–906) FIG. 10.8, PLATE 55. Rim frag. of jar. D. 20. Soft, sandy brown clay with darker core and some grit. Brown surface, burnished outside and on rim.

1269 (B.II.10 398) FIG. 10.8, PLATE 55. Nozzle spout, of class **b1**, but with a horizontal lip. L. 5.6. Max. D. spout 2. Tan clay with somewhat cracked brown to dark brown burnished surface. At junction with body, spout's section forms a true ring.

EM II TYPE 22. COVER LID (?) **1270**

A fragment of a cover lid that looks similar to the EM I lids of types 17 and 18 is probably to be included here as light brown burnished ware.

1270 (B.II. 405) FIG. 10.7. D. to edge of flange *c.* 28. Red clay with grit, like fine cooking pot ware. Grooved (or ribbed) on top; pronounced curved flange. Surface chestnut red-brown, well burnished on top, less well inside.

FINE PAINTED WARE (BUFF WARE)

Fine painted (buff) ware of EM IIA is among the most distinctive ceramic products of third millennium Crete, and the quality of the best pieces of this handmade ware is as high as that of any Late Minoan pottery. We have discussed the ware briefly above (p. 96) while, with light grey ware, it has received a thorough study from Wilson and Day.[67] They argue that both this ware and light grey ware are likely imports into Knossos from the Mesara, and that they are especially frequent in deposits of EM IIA early. The remarks that follow are some small additions to what they have written, together with further illustrations.

Fine painted ware appears to be of the same clay as light grey ware but, having been fired in oxidising conditions, has often a pale yellow-buff to greenish colour. The difference of colour and firing between the two wares, taken with the similarity of the clay, is comparable to that between the Yellow Minyan and Grey Minyan wares of Middle Helladic;[68] and these two EM wares are comparable in the quality of their production to the MH wares. It appears, however, that, although light grey ware and fine painted ware are closely akin, they were probably produced in different, but presumably nearby, workshops rather than both coming out of the same workshop(s).[69]

This ware has often been known as 'Koumasa ware',[70] as Koumasa has produced well known examples of it,[71] and there is a concentration of it in the Mesara, where this pottery was most likely produced.[72] The number of pieces, however, from the WCH and in the SMK show that more of this fine ware has been found at Knossos — in settlement contexts — than used to be thought.

There may also have been a locally produced version of the ware, which stands out for not having a greenish tinge to the clay but, if anything, a pinkish tinge instead, and for not being of quite the same fine quality as the best examples of fine painted ware, although still sharing their repertoire of shapes and decoration. As with Vasiliki ware, there were then probably other workshops besides the central ones, and these may well have included Knossos or somewhere nearby in north-central Crete. But it is sometimes hard to know whether to assign vessels to the Mesara workshop(s) or if they are of extra-Mesara manufacture.

A well levigated clay fired to shades of pale lemon yellow, buff and pale green is typical. A few fragments have a green fabric throughout. Others have a pale yellow to buff core, sometimes with shades of red, pink or grey (which may indicate a local variant). More fired examples tend to be pinkish-yellow outside, and may have a dark grey core, while the paint (normally black, deep brown or brown) may change to red.

There does not seem to be an applied slip.[73] More likely, the potters smoothed the vessels with their hands when wet from working the clay, in the 'self-slipped' technique. The vessels were then burnished with horizontal strokes, which have usually been so finely done that the individual strokes are visible only on close examination.

[67] Wilson and Day 1994, 23–42; see also Wilson 2007, 61, 69. Other sites to add to their list include: Eileithyia cave (Marinatos 1929*a*, 96–9, fig. 1) and Kyparissi (Serpeditsaki 2006, 246, 256, fig. 2γ).
[68] Jones 1986, 414.

[69] Cf. Wilson and Day 1994, 82.
[70] Since Zois 1967*a*.
[71] Xanthoudides 1924, 37–8, pls. 26b, 27.
[72] Wilson and Day 1994, 23–42.
[73] *Pace* Wilson 1985, 307.

The most frequent shape in the SMK examples is the small spouted bowl-jar or teapot (EM II type 16). Other shapes are: a likely goblet of EM II type 2 or 3; bowls assignable to EM II types 6 and 8; collar-necked jars, probably of EM II type 19; and a lid, probably of EM II type 21.[74] To these Wilson and Day add suspension pots ('pyxides'), citing two examples that do not seem completely convincing as canonical fine painted ware, partly for their shape, partly since neither has the indicative decorative fashion of blobs along the inside of the rim.[75] To this pair we can, however, probably add one more example, from K.I.6 909,[76] and then group this trio with **1289–1290**, which we have placed as type 19 collar-necked jars, while not ruling out the possibility that some or all of them may be from (large) suspension pot-like vessels (as may be the case for **1268** in brown burnished ware).

Lattice or crosshatching is the usual decorative motif, either as a continuous zone or inside triangles, and defined by horizontal, and sometimes vertical, bands. Crossing isolated diagonal lines also occur, usually as pairs. An horizontal band below the rim outside is normal, while small blobs along the rim on the inside seem to be standard, especially on the Mesara pieces. The decoration often becomes untidy near the base.

EM II TYPE 2. FOOTED GOBLET (?) **1271**

1271 is an incurving rim sherd probably best assigned to a footed goblet of EM II type 2 (but Wilson and Day, if they are referring to this piece, regard it as from a bowl; see also below). Note its green fabric.

The WCH has produced similar rims (one with a green fabric), and one pedestal stem from a kylix-like footed goblet.[77] Stem **261** (A1) (p. 141) is probably not of Mesara manufacture on account of its grey fabric and orange surface, and may be from the Knossos region. Likewise, E.I.7 620 has a goblet fragment with thickened rim in buff burnished ware, with profile like Wilson and Day's FP 1 (see n. 77) but a red line (not blobs) on the rim inside: it does not look like an import from the Mesara.

1271 (K.I.6 894) FIG. 10.9. D. 9.5. Notably green fabric, with marked sand in the green core. Probably Wilson and Day 1994, 30: FP 56 (unillustrated); but the decoration on

1271 of crossing diagonals is like **1280** below rather than the parallel they cite (Wilson and Day 1994, 29–30, fig. 3: FP 55) for their FP 56. The box also has a likely body frag.

EM II TYPE 6. DEEP BOWLS: (C) TAPERING RIM (?) **1272–1273**

Two unusual bowl rims are probably best grouped here. **1272** stands out for the 'fringing' style in its untidy decoration: Wilson and Day suggest that it may be a 'rather free' Cretan imitation of EC decorated sauceboats.[78] **1273** appears to come from an early, and perhaps unique for Early Minoan, example of a basket-shaped vessel or kalathos with handles rising above the rim.[79] Its fabric is like **1293**, which might suggest that it is not of sufficient quality to count as fine painted buff ware. It does, however, have blobs inside the rim; and perhaps it is is best to see it as a local variant of the canonical ware.

1272 (K.I.6 896) FIG. 10.9, PLATE 56. Incurving rim internally thickened. Wilson and Day 1994, 30, pl. 3: FP 60.
1273 (B.II 405) FIG. 10.9, PLATE 56. D. 14 (?). Flaking orange-buff-pink-brown clay, with orange core; burnished; one vertical handle pres. Handle decoration in dark red to

brown/black paint: lattice panels between bands. An indentation in the side to the left of the handle may indicate a (rounded) corner — a possibly rectangular vessel possibly with rounded corners, perhaps a pyxis.

EM TYPE 8. BOWL WITH FLARING RIM **1274**

Rim fragment **1274** is probably from a type 8A shallow bowl with flaring rim, and probably a Knossos-region product, on the grounds of its grey-pink core and pink burnished outside surface; but the buff burnished interior is reminiscent of the Mesara.

[74] Not in Wilson and Day's (1994) lists for the shapes of fine painted ware at Knossos are types 2/3 (if that is what **1271** is), 6 (the likely basket-shaped vessel or kalathos **1273**), and perhaps 19 (but see discussion above).
[75] Wilson and Day 1994, 32: FP 96 (Wilson 1985, 311–12, fig. 16, pl. 32: P 120); 32–3, fig. 4: FP 97.
[76] Wilson 1984, 191, pl. 51C top, calling it a collar-necked jar.
[77] Wilson 1985, 309, 311, fig. 16: P110–116, esp. rim P114 (Wilson and Day 1994, 25: FP 1), with green fabric, and

stem P116; cf. too Wilson and Day 1994, 29–30, fig. 3: FP 55 (K.I.7 911).
[78] For an interim review of EC II imports at Knossos, with references, see Wilson 2007, 69–70.
[79] Possible later parallels could include, for example: MM IIB Malia, Quartier Mu: Poursat and Knappett 2005, 77, fig. 23: 4a–b; 85–6, pls. 30, 52: 1174–5; or the MM IIIA West Polychrome Deposits at Knossos (MacGillivray 1998, 138, pl. 10: 306; 2007, 144–9 for date).

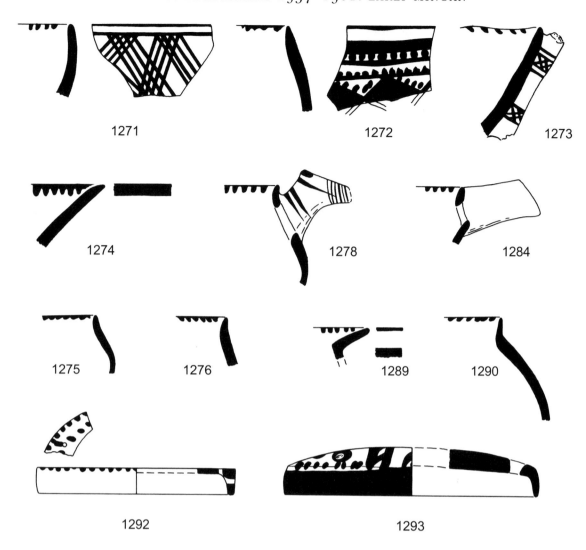

FIG. 10.9. EM IIA fine painted ware: goblet **1271**; type 6 bowls **1272–1273**; type 8 bowl **1274**; type 16 bowl-jars **1275–1276, 1278, 1284**; type 19 jars (?) **1289–1290**; lids **1292–1293**. Scale 1:2.

1274 (D.XXII.2 563) FIG. 10.9, PLATE 56: inside. D. 22.
Purplish-brown paint inside, red outside: line to rim inside
and row of dots; band to rim outside.

EM II TYPE 16. SMALL SPOUTED BOWL-JARS **1275–1288**

There are no complete examples of these teapots among Evans's material in the SMK, and so we cannot measure their full heights. The rim diameter generally ranges from 12 to 14. Bridge spout **1284** is, as Wilson and Day remark (see below), 'unique in the Knossos corpus', and seems to come from a teapot with a carinated profile.

1275 (K.I.4 884) FIG. 10.9, PLATE 56. Wilson and Day 1994, 30, pl. 3: FP 54 (who find the D. to be 10). D. 13.5.
1276 (M.II.2 1148) FIG. 10.9. D. 11. Creamy buff surface; outside decoration of close latticework from band below rim.
1277 (L.III.11 1055–1057) PLATE 56. D. 12. Rather thick body. Pink sandy clay. Greenish surface outside, pale yellow inside. Black to dark brown paint: diagonal hatching, sloping from upper left to lower right, with crosshatching of groups of five lines.
1278 (D.XXII.2 563) FIG. 10.9, PLATE 56. D. 9.5. Two

frags. Pale yellow surfaces. Black to dark brown paint: outside, band below rim; latticework, which leaves a pendent reserved triangle around the spout; four bands on top of spout and six lines around mouth; inside, line to rim and row of blobs.
1279 (B.I.16 279) PLATE 56. Ht pres. 6.1. D. 13. Wilson and Day 1994, 28–9, fig. 3: FP 32; Wilson 2007, 60–1, fig. 2.7: 6; 63, fig. 2.9: 12.
1280 (K.I.7 910) PLATE 56. D. 13. Wilson and Day 1994, 28–9, fig. 3: FP 36.

1281 (K.I.6 896) PLATE 56. D. 14. Wilson and Day 1994, 26, fig. 2: FP 31; 28.
1282 (K.I.6 895) PLATE 56. D. 12. Wilson and Day 1994, 28–9, fig. 3: FP 34; Wilson 2007, 60–1, fig. 2.7: 6; 63, fig. 2.9: 10.
1283 (K.I.7 914) PLATE 56. D. 14. Wilson and Day

1994, 29–30, fig. 3: FP 57 (sample KN 92/281); 57–8; Wilson 2007, 61, 63, fig. 2.9: 8 (lower).
1284 (E.II.7 653) FIG. 10.9. Bridge spout. L. spout 4.3. Apparently carinated profile. Wilson and Day 1994, 27: FP 24.

Rim **1285** from Knossos in the Liverpool Museum can be included here. Like **1341–1342**, it reached the Museum from J. P. Droop.

1285 LM 51.105.80. Mee and Doole 1993, 25, pl. 8: 279.

We may also mention three body and base sherds from this type. **1286** is interesting for having the row of blobs as a decorative motif on the body of the vessel rather than immediately below the rim inside.

1286 (D.XIV.1 547) PLATE 56. Body frag. Smoothed pale yellow to buff surfaces. Dark brown paint. Latticework triangles below horizontal band and row of blobs.
1287 (K.I.7 913) PLATE 56. Base frag. Wilson and Day

1994, 28, pl. 3: FP 51. Latticework.
1288 (K.I.6 894) PLATE 56. Base frag. D. base c. 10. Wilson and Day 1994, 28, pl. 3: FP 39.

EM II TYPE 19. COLLAR-NECKED JARS WITH HORIZONTAL SIDE-HANDLES (?) ETC. **1289–1291**

Two rim fragments **1289–1290** can probably be included here, although their collars/everted rims are low and their bodies look curving or baggy. They seem comparable in rim shapes to two fine painted ware jars from the WCH (also surviving as only rim or rim and shoulder fragments), if slightly larger.[80] These two WCH jars differ, however, from **1289–1290** in not having the canonical row of blobs along the inside of the rim; instead, they have triangles (blank or latticework) pendent from the rim. Alternatively, one might see **1289–1290** as (large) suspension pots — which would mirror our uncertainty about typing **1268** (above) in brown burnished ware.

1289 (N.IV.8 1258) FIG. 10.9, PLATE 56: inside. From jar with everted rim. D. 14. Orange-brown clay with reddish core; dark buff surface well stroke-burnished on inside of rim; outside surface matt. Traces of decoration: inside, line along rim with row of blobs; outside, line to rim and band at neck-body junction.

1290 (G.II.1 770) FIG. 10.9, PLATE 56. Apparently from baggy jar, with low collar. D. 22. Greenish surface outside, greenish buff inside. Burnishing visible on rim: originally perhaps burnished overall outside. Paint fugitive, originally black: inside line and row of dots to rim; outside band below rim and cross-hatching.

Body fragment **1291** is unusual for its vertical decoration of zones of chevrons. Perhaps it is from a jug, perhaps a suspension pot?

1291 (K.I.6 909) PLATE 56.

LIDS **1292–1293**

Lid **1292** with its vertical sides and neat appearance could fit easily onto a collared type of jar such as **1289** (although that particular example has a greater diameter); and the two concentric rows of blobs are a distinctive feature. The fabric might suggest that it is another local variant.

1292 (E.I.7 618) FIG. 10.9, PLATE 56. Ht 1.4. D. 11. Well fired, well levigated fine pink-buff clay, burnished on top, smoothed on side. String-hole pierced through top and

side. Decoration in often fugitive red-brown: two concentric bands of blobs.

Lid **1293** of EM II date, as its decoration shows, is typologically derivative from the larger, flanged lids of EM I type 16 (pp. 48–9): like them it is domed, but it does not have the projecting flange at the

[80] Wilson 1985, 309–12, fig. 16: P119 (for rim shape cf. **1289**) and P120 (for rim shape cf. **1290**). Cf. also Ayia Kyriaki: Wilson and Day 1994, 33, fig. 4: FP 124–6; 35–6.

junction of the top with the side of the lid. It was probably intended, like the EM I type 16 lids, to cap jars with low vertical collars or necks and would have been tied down through a pair (or, more likely, two pairs) of string-holes. We have not given this shape an EM II type number nor does it appear in the EM II–III type chart (FIG. 5.1), as we found no example of it in our excavations.

1293 comes from a test pit of 1905 at the E end of Bay 4 of the North-East Magazines, which Wilson placed in 2007 in EM IIA late.[81] In publishing this lid in 1994, Wilson and Day assigned it to fine painted ware,[82] but it may be safer to see it as a borderline case — as one might also extrapolate from Wilson's 2007 discussion of the coarser fabrics in dark-on-light ware. Certainly, the clay of this lid is not so well levigated as the best EM IIA fine painted ware, and its decoration, even if it includes a row of blobs, is cruder: it is hard to see it as a high quality product of the Mesara. All the same, it is burnished inside and out and, if not of the best execution, must have been intended for a jar of some quality. It is probably sensible to move it from fine painted ware to the class of painted semifine to coarse ware, following Wilson and Day's 1994 classification.[83]

Parallels are hard to find for the decorative motif of radiating 'ladders' (albeit with diagonal crossbars), of which there may originally have been eight. The concentric semicircles rising on the shoulder have many parallels in light grey ware with incised decoration and, in painted ware, on a bowl from Mochlos,[84] to which this lid is similar in its combination of free-standing cicrular and linear motifs.

1293 (K.I.7 910; NB. In 1965 it was among the pottery from 0–0.65 m, which became boxes 912–914.) FIG. 10.9, PLATE 56. Ht pres. 2.5. D. 14. Dark orange to red clay with grit, flakey and grained on top, denser on side; blister visible in clay. Pair of string-holes. Dark brown to light buff burnished surface inside and out. Decoration in black matt-textured but lustrous paint: segmental design divided by diagonally hatched ladder pattern, with concentric semicircles or blobs alternating in (triangular) zones; thick band round side. Wilson and Day 1994, 34, pl. 5: FP 98.

DARK-ON-LIGHT WARE

EM II TYPE 19. COLLAR-NECKED JAR WITH HORIZONTAL SIDE-HANDLES **1294**

A large collar-necked jar or amphora **1294** with a flaring rim, tall neck, piriform body, and horizontal handles set at more or less its widest part (just below the shoulder) was found in many pieces in 1964. It is among the earliest more or less complete Minoan amphorae, lacking only its base — which may have been flat, as on a similar vessel with similar decoration from Pyrgos.[85] It comes from K.II.5 931, the top metre beneath the later floor at the E end of the North-East Hall tested in 1903: this box also produced the light grey ware suspension pot **1203** and a horned stand **1299**. We assign **1294** to EM IIA.

The amphora has a hard, gritty fabric. Its shape is like EM II type 19, but seems also closely related to, or derived from, our EM I type 13 — although only a few jar necks could be identified in the Palace Well: **101–104** (pp. 44–5). **1294** seems to have a more evolved shape: its neck has a flaring profile, and a larger body than we could expect on the EM I jars. In shape and decoration it is close to the jar from Pyrgos, and fairly close to two jars (P326–327) from the WCH;[86] but its handles are set slightly higher on the belly than on P327, and the lower body appears more curved. It also has a relatively shorter neck than the Pyrgos jar, which is however considerably smaller (total Ht 22) and has a decoration of crossing broad stripes (and a cross on its flat base) as against the curving broad bands pendent from a broad horizontal band on **1294**. Also comparable, in flaring shape and banded decoration, is another jar neck from the WCH, but that too is from a smaller vessel.[87] In EM III (and perhaps into MM IA), rims of similar shape in the B3 deposit (p. 223: **1125**) and whole vessels from the 'pit repository' in the Royal Pottery Stores,[88] House B in the West Court[89] and, in the East Cretan EM III style, from Myrtos–Pyrgos[90] emphasise the type's endurance or resurgence[91] — and the continuing utility of this shape (and its oval-mouthed amphora successor). The isolated dot in the shoulder zone is familiar in both EM I and EM IIA.

[81] Wilson 2007, 64–70.
[82] Following Wilson 1984, 195, pl. 49D bottom.
[83] Cf. Wilson and Day 1994, 42–9.
[84] Seager 1912, 25, 36, fig. 13: II.1.
[85] Xanthoudides 1918a, 144, fig. 5: 4; 147 (Zois 1967a, 726, pl. 25α–γ: 7524).
[86] Wilson 1985, 339–41, fig. 33: P326, P327 (Wilson 2007, 61, 63, fig. 2.9: 7), reconstructed with a flat base.

[87] Wilson 1985, 330, 332, fig. 29, pl. 40: P254 (D. 9.5).
[88] UEW Group: Momigliano 2000b, 85–6, fig. 13, pl. 20: 55 (2007c, 84, 86, fig. 3.4: 8, noting the relative rarity of this shape).
[89] Momigliano 1991, 234, pl. 53: 82–3 (with references). For dating, see Momigliano 2007c, 82.
[90] MP/73/P470.
[91] Zois (1967a, 726) saw the amphora from the Pyrgos cave as the archetype of such amphorae in MM IA.

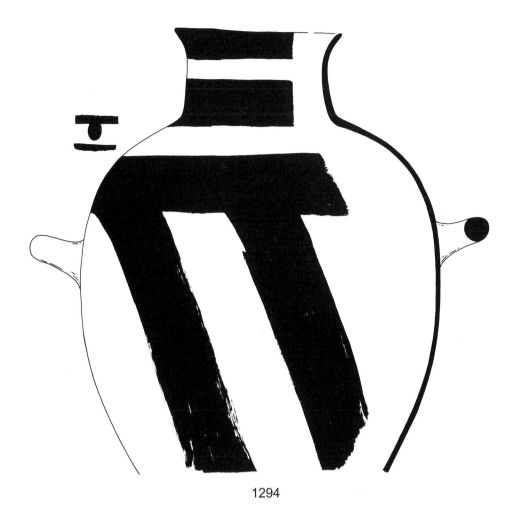

1294

FIG. 10.10. EM IIA type 19 collar-necked jar **1294**. Scale 1:3.

1294 (SMP 2016: K.II.5 931 + 932, one sherd) FIG. 10.10, PLATE 56. Rest. from over 150 frags. About 3/4 complete. Ht pres. 34. D. rim 13.8. D. body 29. D. across handles 37.8. Hard buff clay with much grit; straw marks and holes; in thicker places a pink core. Inside, buff surface; outside and inside neck, creamy pale buff to pale yellow, semi-lustrous. Inside and outside markedly smoothed. Also signs of scraping with a blunt instrument, especially below the handles. Occasional impurities on surface and frequent splashes of black paint. Flaring, concave neck; round section handles. Decoration in thick, flakey matt black to grey: broad bands round rim, at base of neck and round body above handles, with three curving bands in the large zones between the handles; band on outer edge of handle; oval dot in shoulder zone. Paint almost entirely fugitive, best preserved in trickles and other thicker patches. Bands untidy, but executed with dash.

Decoration

A shoulder fragment **1295** from a closed vessel, almost certainly a jug in view of its linear decoration, has one of the first painted spirals in Minoan ceramic art. The fabric, and similarity of the motif of freestanding spirals to the pattern burnish spirals of Arkalochori and Knossos (see **1182** and discussion), may suggest an EM I date; but Wilson and Day assign it, rightly in our view, to EM IIA, where an isolated spiral is also known on the interior base of a tripod bowl from the WCH, that is probably a Mesara import.[92]

1295 (K.I.7 915) PLATE 56. Well fired dark red clay, dark buff to outside edge, with black and some white grit, coarsely finished and finger-smoothed inside. Buff outside, with decoration is semi-lustrous dark brown to black, of two simple coil-spirals between horizontal lines. Wilson and Day 1994, 48, pl. 6: PFC 27.

[92] See n. 22 above.

COOKING POT WARE

EM II TYPE 24. HORNED STANDS **1296–1300**

Horned stands are a distinctive product of EM IIA at Knossos and, to date, have been identified only at Knossos. However, this may not say so much about Knossos as one might first suppose, since their absence elsewhere may reflect their not having been recognised — which at Knossos did not happen until 1964 — rather than their non-existence. It would not be surprising if they should now be found at other sites.

Among Evans's finds, we have noted 76 to 79 fragments in the following boxes:

B.I.4	171	E.I.7	617–620
B.I.6	194	E.I.9	622
B.I.8	226	E.II.6	646
B.I.10	235	E.II.7	651
B.I.15	275	E.II.8	657, 659
B.I.16	279–280	E.III.1	660
B.I.17	307b–c	K.I.2	874–875
B.I.18	320	K.I.5	887–888, 890, 892
B.I	377	K.I.6	894–896, 907–909
B.II	405	K.II.5	931
D.III.1	502		

Chronology

Horned stands have been found throughout EM IIA at Knossos, in both early and late contexts,[93] and were quite probably produced only during that time. From our deposits, **777** (A8) (PLATE 35) is probably EM IIA late. A few examples mentioned above from our EM IIB deposits should probably be seen as strays or antiques:

A2: **403** (PLATE 42).
B1: **903** (two frags.): one in PLATE 42.
B2(1): **1042** (two frags.): one in PLATE 42.
B2(2): one frag.

These stands have not been observed in the EM IIB material from Evans's, or Momigliano and Wilson's, excavations in the Early Houses, when the type 'seems to disappear'.[94] Two examples in yet later contexts are almost certainly strays:

B3 (EM III): **1135** (FIG. 8.13, PLATE 47).
RRS (MM IA): **817**.

Morphology

Horned stands are difficult to describe as, like baking plates, none is complete. More survives of some stands from Evans's excavations than of those from our excavations at Knossos.

The stands are made by hand in cooking pot ware, usually of a red to purple colour. Vertical parts of the stands tend to show the finger marks of vertical smooothing on their exposed sides. Parts that would not have been visible have been left rough, on the inside, or the underside when horizontal. This is a helpful clue in determining which side of a fragment was on top or on the outside.

These horned stands are vertical standing objects whose precise shape we do not know. They have two or more horn-like projections rising from vertical walls which are mainly rectangular but often — if not always — rounded at the corners. For stability it is likely that they were either triangular or rectangular. The 'horns', of which there were probably three or four to a stand (four if rectangular), are slightly concave and curved triangular in outline, with a definite lip to their leading edge. At their base, they join a horizontal surface which has a rounded hole, or holes, in it: this feature is reminiscent of MM 'eggstands'.[95] The vertical walls also have rounded holes, which seem to have been rather larger than those on the horizontal (eggstand-like) surface. **1300** appears to be from the horizontal

[93] Wilson 2007, 61, 68–9, fig. 2.13: 10. WCH examples: Wilson 1985, 343–5, fig. 35, pls. 46–7: P360–368.

[94] Wilson 2007, 73.

[95] *PM* II, 307–08, fig. 178; MacGillivray 1998, 149, pl. 95: 573.

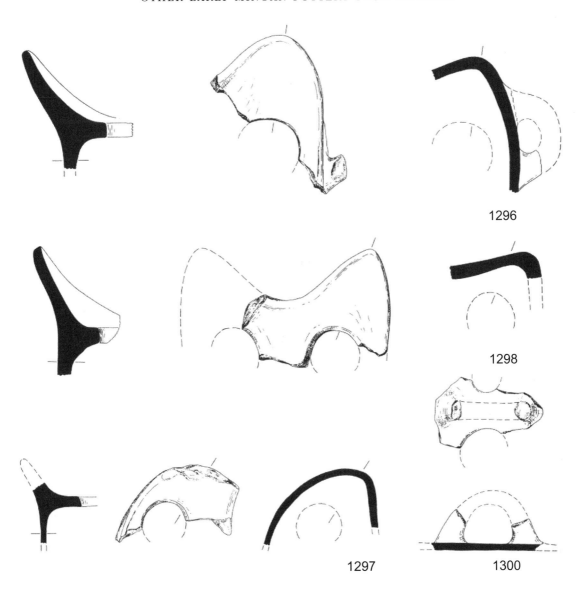

FIG. 10.11. EM IIA type 24 horned stands **1296–1298**, **1300**. Scale 1:4.

(eggstand-like) surface of a horned stand and has the springing of a vertical handle. Vertical handles occur on other fragments.[96] The stands seem to have been portable. None has any signs of burning. No base has been identified. They were probably open underneath.

Since none is complete, it is difficult to ascertain their dimensions: a width of 30 to 50 seems likely. A loose count of those in the SMK suggests that smaller examples are around twice as frequent as larger examples. Some seem small but, as we cannot tell where their horned projections have broken off, may in fact have been large.

FIG. 10.11 shows three views of three horned stands (**1296–1298**): the drawings on the left of each trio show a (normal) section from an horizontal view, those in the middle the plan of the object, and those on the right the section from a vertical view. FIG. 10.11 also shows an apparent example of a vertical handle (**1300**). We look forward to the discovery one day of a complete horned stand. Until then, one reconstruction has been proposed.[97]

[96] Such as from K.I.6 907–909.

[97] Wilson 2007, 68–9, fig. 2.13: 10.

Function

These objects could have been used as stands for ceramic, wooden or skin vessels, or baskets, to keep them off the floor and upright, or possibly to set over a hearth or fire hole to keep the contents warm. It may be, as Lamb suggested (following Özgüc) for somewhat similar stands from Kusura, Kültepe and Tabara el Akrad,[98] that the reason why they do not have signs of burning is that, rather than being placed directly over a hot hearth, they just held embers brought from an oven or hearth nearby. (She then dismissed this explanation for the Kusura stands on the grounds that no source of embers was found nearby.) At any rate, if the stands were put over heat, the fire must have been low.

The lack of signs of burning and the presence of a horizontal surface interrupted by a hole or holes (and in some cases apparently also having a vertical handle) make it most unlikely that horned stands were used for grilling meat placed directly on them — although they could have been used for roasting meat in a domed oven. Soups and stews would presumably have been cooked in tripod pots, whose appearance is another feature of EM II in central and eastern Crete — but note the (still unique) tripod foot from Debla I.[99]

If the stands did hold pots, then the specific purpose of the horns would have been to prevent the pots' toppling over. Lamb favours an explanation of this sort for the stands she discusses;[100] if that is correct, one could disassociate these stands altogether from ash, ovens and cooking or keeping food warm over a gentle heat, leaving these objects as simply pot stands.[101] One comparable object in the EBA Aegean is from EH III Asine from the bothros on the 'pre-Mycenaean terrace', identified by the excavators as a stand for round-bottomed vessels.[102]

There are no obvious ritual links for EM horned stands, or connections with Old Palace or New Palace so-called 'horns of consecration'. They seem to have been a regular part of Knossian domestic life only in EM II, and probably only in EM IIA. We may perhaps explain their appearance as part of the changes and progress in food preparation that seem to have occurred in EM IIA.[103] That they did not continue thereafter makes it unlikely that they were somehow forebears of the horns of consecration.

For the selection below, height and width measurements are as preserved (and so not complete).

1296 (K.I.6 894) FIG. 10.11, PLATE 57. Ht 16.5. W. 10. L. of horn 11.5.
1297 (K.I.6 894–896) FIG 10.11, PLATE 57. Ht 13.3. W. 11.2. L. of horn 9.8. Two eggstand-like holes in horizontal surface. Likely to have had four horns.
1298 (K.I.6 897–906) FIG. 10.11, PLATE 57. Ht 13.3.

W. 9.6. Perhaps semi-circular.
1299 (K.II.5 931) PLATE 57. Ht 12.3. W. 9. L. of horn 9.5.
1300 (E.I.7 618) FIG. 10.11. 11.9 × 7.6. Vertical handle from horizontal surface with holes. Wilson 1984, 185, pl. 46B bottom left.

EARLY MINOAN IIB

(*PM* I, 73, fig. 40, and other EM IIB pottery probably from the Early Houses)

We were able to study in Herakleion, Oxford and New York the mostly whole pots that make up this composite photograph of pottery that Evans and Mackenzie found in the Early Houses and publish them here, in effect for the first time. Their likely context and the EM IIB pottery that we found in the Houses have already been discussed (Chapters 4, 8). It is, however, not always clear which are the pots shown in the photograph; but we have tried to identify them or show the probabilities. It is also not completely certain, but still likely, that all the pots in Evans's photograph are from the Early Houses.[104] Zois seemed to incline towards what would be an EM IIA date for some (or all?) of the pottery photographed.[105] This would be surprising if these pots are all from the Early Houses, but more understandable if Evans introduced a few from other parts of Knossos into the composition.

EM II and other Minoan pottery from Knossos also reached the British Museum, Musées Royaux d'Art et d'Histoire in Brussels and National Musuem in Copenhagen. In the two latter cases at least, as for the Metropolitan Museum of Art, it came from Evans himself and/or the Ashmolean Museum: for the MMA in 1911 in exchange for Cypriot material that had been purchased by subscription,[106] and

[98] Lamb 1956, 90–1, figs. 1–3. For a discussion of EBA hearths in (NE) Anatolia, with references, see Takaoğlu 2000.
[99] Warren and Tzedakis 1974, 323, 329, pl. 52d bottom right.
[100] The vertical handle may have prevented a stand's holding a single large vessel.
[101] Diamant and Rutter (1969) develop the theme of pot stands and hearth furniture.
[102] Frödin and Persson 1938, 231–3, fig. 169: 6–7.

[103] Cadogan 1986*b*, 155.
[104] The AM register lists AM 1910.145–153 (**1332, 1328, 1310–1311, 1303–1304, 1318, 1320–1321**) as 'E. M. II. from floor deposit of E.M. house S. of S. Corridor'; and 1910.157–158 (**1312, 1334**) as simply from Knossos.
[105] Zois 1968*a*, 93.
[106] Richter 1912.

for the MRAH in 1913 in exchange for flints from the Neolithic quarries of Spiennes.[107] The dispersal from Oxford would have been handled by Evans with David Hogarth, who succeeded him as Keeper. Evans probably saw an opportunity here to spread knowledge of the then barely known Minoan pottery of Knossos and its sequence.[108]

It is highly likely that the two EM IIB bowls **1324–1325** and an EM IIB jug **1333** in the MMA come from the Early Houses — and we believe that **1325** is shown in *PM* I, fig. 40. Among the sherds that the MRAH received, **1340** and **1345** would also be at home in the Early Houses, as **1341–1342** in the LM could be too.

A large amount of EM IIB pottery fragments from the Early Houses now in the SMK has already been published by Wilson and Day,[109] and forms one of the three assemblages (together with our deposits B1–B2 and what Momigliano and Wilson excavated in 1993) of Wilson's EM IIB South Front Group.[110] What we present here complements the study by Wilson and Day.

We see *PM* I, fig. 40 as follows, row by row, from left to right:

Top row
1.	Bowl	**1320**	AM 1910.152
2.	Jug	**1334**	AM 1910.158
3.	Jug	**1332**	AM 1910.145
4.	Goblet	**1303**	AM 1910.149
5.	Cup	**1301**	HM 10802

Second row
1.	Goblet	**1302**	AM AE.2236
2.	Goblet	**1318**	AM 1910.151
3.	Goblet	?	
4.	Goblet	**1311**	AM 1910.148
5.	Goblet	**1306**	HM 10807
6.	Goblet	**1310**	AM 1910.147
7.	Goblet	**1312**	AM 1910.157
8.	Bowl	**1322**	AM 1938.410

Third row
1.	Spouted bowl-jar	**1337**	HM 10801
2.	Bowl	**1331**	HM 10800
3.	Jug	? (possibly **1335**)	?

Bottom row
1.	Bowl	**1325**	MMA 11.186.2
2.	Goblet	**1304**	AM 1910.150
3.	Bowl	**1330**	HM 10803
4.	Bowl	**1323**	HM 10804

While most of these vessels seem to be homogeneous, and consistent with the EM IIB pottery published by Wilson and Day from the Early Houses, it remains possible that a few of them are from other deposits (including perhaps EM IIA) at Knossos — or are from an EM IIA deposit in the Early Houses which otherwise has not been noticed. We think this is unlikely, but we cannot exclude some mixing in composing the photograph. In particular, the loop-handle cup **1301** is a candidate for being an EM IIA type like **1186** in light grey ware (see discussions above, and on p. 102). On the other hand, its finish with a smoothed and lustrous thick red wash might suggest a local ceramic product related to Vasiliki ware, and thus support a date in EM IIB. Its undifferentiated base, however, tends to be an earlier feature.

EM II TYPE 1A. CUP WITH LARGE LOOP HANDLE **1301**

Dipper cup **1301** may perhaps be EM IIA rather than IIB. If so, it is likely to come from some place at Knossos other than the Early Houses.

[107] Natacha Massar, pers. comm.

[108] The MMA received a further nearly whole Minoan goblet from Knossos (MMA 21.100.3 = **1350**) in 1921, the gift of George M. Whicher. The museum also has a collection of light grey, dark grey burnished and Vasiliki ware sherds (MMA 07.

232.34–43): these are unlikely to be from Knossos and were acquired four years before the pottery from the AM.

[109] Wilson and Day 1999.

[110] Wilson 2007, 70–1, fig. 2.14.

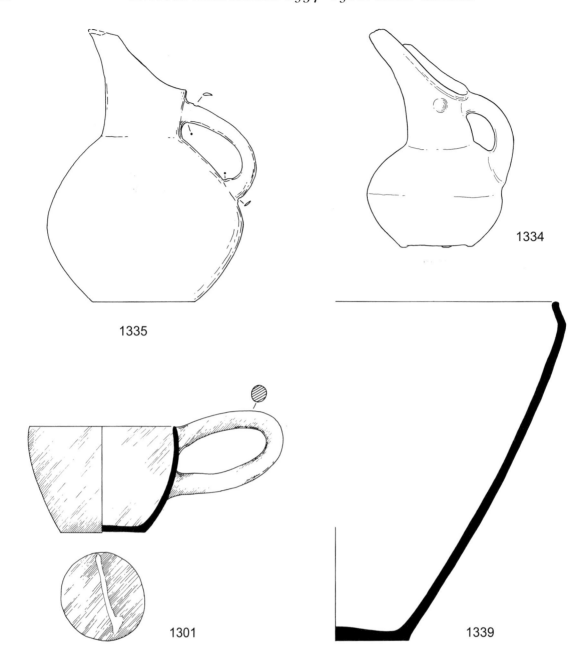

FIG. 10.12. EM II: type 1A cup **1301**; type 15 jugs **1334–1335**; type 18 large jar **1339**. Scale 1:3.

1301 (HM 10802; PEM/60/P8; *PM* I, fig. 40, top row, right) FIG. 10.12, PLATE 58. Ht to rim *c.* 8.5. D. 12. Orange clay with thick red wash, well smoothed and lustrous

outside, and inside rim. Round handle. Under base, thick yellowish line painted after smoothing.

EM II TYPE 2. FOOTED GOBLETS **1302–1319**

These are presented in five groups.

(i) Buff ware, line on rim and bands below

1302 (AM AE.2236; *PM* I, fig. 40, second row, left) FIG. 10.13, PLATE 58. Ht 8. D. 10.1. D. base 5.4. Perhaps pared: low and wide foot. Decoration in red: line on rim; two bands below; band round waist; line round edge of base.

1303 (AM 1910.149; *PM* I, fig. 40, top row, second from right) PLATE 58. Rest. Ht 7.7. D. 9.1. D. base 4.8.

Smoothed: shallow conical foot; vertical and diagonal paring outside. Decoration in red: line on rim; three bands below; band round waist.

(ii) Buff ware; line on rim and band round waist.

1304 (AM 1910.150; *PM* I, fig. 40, bottom row, second from left) PLATE 58. Complete, but base chipped. Ht 7.5. D.

8.7. D. base 5. Pared. Decoration in dark red-brown: line round rim; band round waist. Marked '3' in pencil underneath.

(iii) Buff ware, line on rim and foot painted solid

1305 (HM 10806; PEM/60/P4) FIG. 10.13, PLATE 58. Rest. Ht *c.* 8. D. 9–9.5. Flat rim; smoothed inside and under foot; vertical stroke burnishing outside. Decoration in red: line on rim and foot painted solid.

1306 (HM 10807; PEM/60/P5; *PM* I, fig. 40, second row, fourth from right) FIG. 10.13, PLATE 58. Rest. Ht *c.* 8.6. D. 9.2–9.7. Clay and painted decoration as above, but band to rim (rather than line). Vertical stroke burnishing outside and, more sketchily, inside. The band to rim, as Eirini Galli has kindly told us, makes this a better candidate than **1305** for the cup in this position in *PM* I, fig. 40.

1307 (HM 10808; PEM/60/P6) FIG. 10.13, PLATE 58. Rest. Ht *c.* 8. D. 9–9.7. Clay, burnishing and painted decoration as above.

1308 (HM 10809; PEM/60/P7) FIG. 10.13, PLATE 58. Rest. Ht *c.* 7.5. D. *c.* 8.8. Clay, burnishing and painted decoration as above; also bilobate mark under foot.

1309 (H.I.2 788; PEM/60/P17) PLATE 59. Rest. Ht *c.* 8. D. rim *c.* 8.6. D. base 4.7. Lopsided. Clay, finish and mark under foot like **1308**.

1310 (AM 1910.147; *PM* I, fig. 40, second row, third from right) FIG. 10.13, PLATE 59. Complete, but base chipped. Body pared. Ht 6.7. D. 8.3. D. base 4.5. Marked diagonal paring outside; conical foot. Decoration in red: line on rim; foot painted solid, continuing as band to inside edge of foot, and bilobate mark.

1311 (AM 1910.148; *PM* I, fig. 40, second row, fourth from left) PLATE 59. Rest. Ht 7.9. D. rim 9.1. D. base 4.5. Body pared, and has vertical burnishing inside and outside; more concave foot. Decoration in red: as above; bilobate mark inside foot (but no band to edge).

(iv) Vasiliki and related wares

1312 (AM 1910.157; *PM* I, fig. 40, second row, second from right) FIG. 10.13, PLATE 59. Rest. Ht 9.2. D. 9.2. D. base 5.2. Vasiliki ware, or related: orange clay; mottled black to brown and red burnished surface, except outside of foot which seems virtually unburnished; high foot. Betancourt 1979, 43: VII.A.2 Knossos 5.

1313 (AM 1938.411; not apparent in *PM* I, fig. 40; but the AM register suggests that it, rather than **1312**, is *PM* I, fig. 40, second row, second from right) FIG. 10.13, PLATE 59. Ht 7.2. D. 8. D. base 4.8. Vasiliki ware; low spreading foot. Betancourt 1979, 43, pl. 2.I: VII.A.2 Knossos 6.

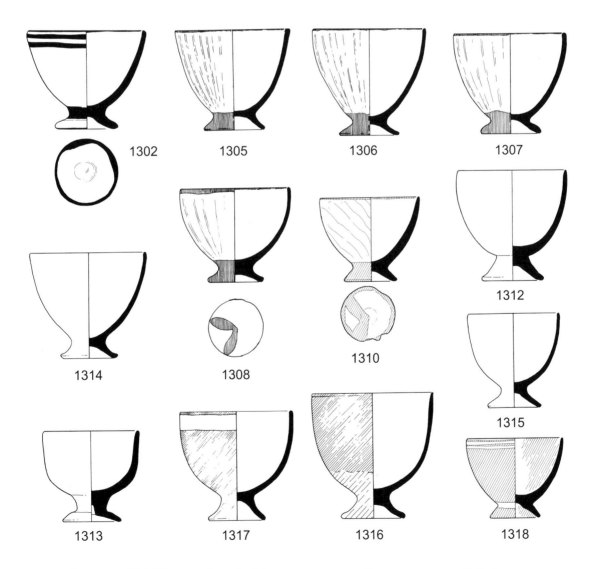

FIG. 10.13. EM IIB type 2 footed goblets **1302, 1305–1308, 1310, 1312–1318**. Scale 1:3.

Marked in pencil underneath: apparently, 'S Front Pot 12' and possibly more, and outside in ink: '5342'.

1314 (HM 10810; PEM/60/P3) FIG. 10.13, PLATE 60. Ht *c.* 8.4. D. *c.* 9.5. Part of body missing. Orange clay with thick red wash all over, on outside well smoothed and lustrous.

1315 (HM 10811; PEM/60/P2). FIG. 10.13, PLATE 60. Ht *c.* 7.5. D. *c.* 7.5. Part of rim missing. Orange clay, with light horizontal burnishing inside; outside dark brown to black shading to reddish wash with metallic sheen (except under base). Betancourt (1979, 43) includes this in the same group as **1317**.

1316 (H.I.2 788; PEM/60/P13) FIG. 10.13, PLATE 59. Most of rim and body missing; possibly had handle and/or spout. Ht *c.* 10. D. *c.* 10. Dark orange clay, orange to red inside with slight stroke burnishing. Dark mottling outside with metallic sheen.

(v) Dark wash ware, with light-on-dark decoration

These two goblets have the same decoration as group (i) etc. but in reverse as light-on-dark.

1317 (HM 10805; PEM/60/P1) FIG. 10.13, PLATE 60. Ht *c.* 8.7. D. 8.6–9.0. Rest. Dark orange clay; high foot; finger smoothed outside. Wash outside: dark brown and black mottled to red, smoothed overall except inside base. Traces of white band below rim outside. Classed as Vasiliki ware by Betancourt (1979, 43: VII.A.2 Knossos 1).

1318 (AM 1910.151; *PM* I, fig. 40, second row, second from left) FIG. 10.13, PLATE 60. Rest. Ht 6.6. D. 8. D. base 4.4. Some vertical and diagonal paring outside. Conical foot. Overall red wash. Decoration in white: line on rim; two lines below; line round waist; possibly thin line round edge of base.

There are several goblet rims in the HM from the original excavations in the Early Houses. **1319** is a selection of these. All except one are decorated in light-on-dark. These rims complement those published by Wilson and Day from the Early Houses.[111] Among other sherds in the HM that may come from the Early Houses are a spout of a type 16 bowl-jar, a bridge spout, two or three jar fragments, and a rim sherd with a horizontal rib below the rim that may possibly come from a sauceboat or local version thereof.

1319 (HM) PLATE 60. Six light-on-dark rim frags. and one dark-on-light. Top row (light-on-dark): left, apparently white band to rim with dark chevrons overpainted, and white line below; middle, white line on rim, two lines below outside, and band; right, white semi-circles to rim outside; two lines below. Bottom row (light-on-dark): left, rim zone outside has (probably) white line on rim with two white vertical lines below, flanked by four diagonal lines, above two horizontal lines; second from left, white line on rim, running triple chevrons (cf. EM IIB jugs) pendent from rim and possibly rising from top horizontal line below, above two horizontal lines; third from left, white line on rim, above crossing pairs of diagonal lines, above two horizontal lines. Bottom row (dark-on-light): probable line on rim, above diagonal lines, above two horizontal lines.

TYPE 4. SHALLOW BOWLS OR PLATES WITH RIM THICKENED INTERNALLY **1320–1325**

(a) *Rounded rims*

Bowls **1320–1321** are in buff ware, with paring and scribble burnishing. Both have a pair of string-holes, as an original part of the vessel. Since there does not seem to have been another pair of string-holes on the opposite side of the bowl, it is more likely that these were for hanging the bowls up by a string from a peg rather than for use as lids.

1320 (AM 1910.152; *PM* I, fig. 40, top row, left) FIG. 10.14, PLATE 60. Ht 4. D. *c.* 19. D. base *c.* 5. Two string-holes below rim, made before firing, 3.3 apart. Decoration in brown: line on rim; five chevrons spaced along rim; band below thickening, with pendent tassel between the string-holes.

1321 (AM 1910.153) PLATE 60. Base and part of rim missing. Ht (as rest.) 3.9. D. 18.3. Two string-holes below rim, made before firing, 1.6 apart. Decoration in red like **1320**, but no pendent tassel. Marked in pencil underneath: 'E.M. II. Floor deposit.'.

(b) *Bevelled rims*

1322 (AM 1938.410; *PM* I, fig. 40, second row, right, where it is incomplete) FIG. 10.14, PLATE 61. Ht 5.8. D. 13.5. D. base 4.2. Dark wash ware: red to dark brown surface, stroke burnished; three wart lugs below rim; ring base. Marked in pencil underneath (visible in 1966): 'EM II EM House S Terrace Knossos'.

1323 (HM 10804; PEM/60/P9) (*PM* I, fig. 40, bottom row, right) FIG. 10.14, PLATE 60. Ht *c.* 4. D. *c.* 18. Buff ware, roughly made; pale orange surface, heavily wiped. Matt purple-red band to rim inside and out. Cf. Wilson and Day 1999, 7, fig. 1; 9: P32.

1324 (MMA 11.186.3) PLATE 61. Rest. Ht 3.3. D. 20.5. D. base 7.4. Buff ware. Two string-holes below rim, made before firing. Decoration like **1320**. Two string-holes below rim, made before firing.

1325 (MMA 11.186.2; best, if not only, candidate for *PM* I, fig. 40, bottom row, left) PLATE 61. D. 16.8. Decoration includes band to rim inside and on rim, and blob in centre. Shape like **1323**.

[111] Wilson and Day 1999, 19–21, fig. 9 and pl. 4 (light-on-dark); 8, pl. 1 (dark-on-light).

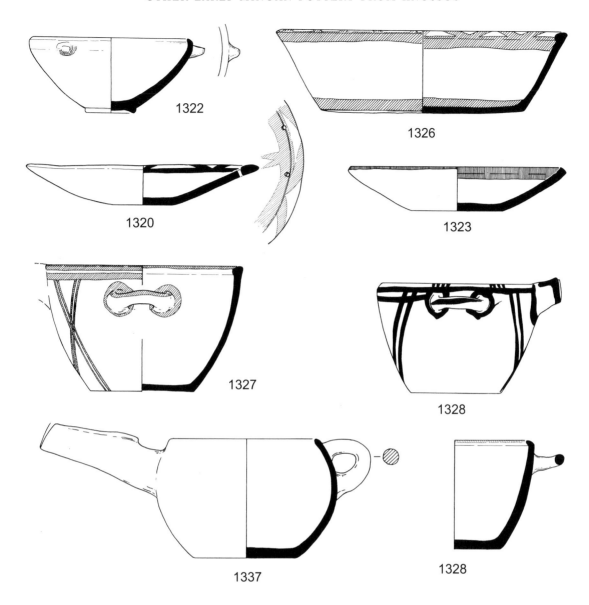

FIG. 10.14. EM IIB bowls: type 4 **1320**, **1322–1323**; type 5 **1326**; type 6 **1327–1328**; EM II type 16 bowl-jar **1337**. Scale 1:3.

TYPE 5A. SHALLOW BOWL WITH UPRIGHT SIDES AND RIM THICKENED INTERNALLY: (A) ROUNDED RIM **1326**

For discussion of **1326–1327** and **1329–1331**, see pp. 110–11 above.

1326　(H.I.2 792+793; PEM/60/P14) FIG. 10.14, PLATE 61. About 1/3 of rim and part of base pres. Ht *c.* 6.6. D. *c.* 24. D. Buff ware, stroke (scribble) burnished. Decoration in thick matt red: running chevrons on rim inside, with band below and band to base; band to rim outside; cross under base. Rim decoration like **1320–1321** and **1324**. Cf. Wilson and Day 1999, 9–12, figs. 3: P43, 4: P54.

TYPE 6A. DEEP BOWLS WITH TROUGH SPOUT AND HORIZONTAL SIDE HANDLES

(**a**) Rim thickened internally **1327**

1327　(H.I.2 788; PEM/60/P16) FIG. 10.14, PLATE 61. Profile, one horizontal round handle and springing of spout pres. Ht *c.* 10. D. *c.* 16. Well smoothed. Decoration in matt red: band around rim; band below rim outside, and pairs of crossing diagonal lines round body; stripe on handle, and circles round springings of handle.

(**b**) Bevelled rims **1328–1329**

1328　(AM 1910.146) FIG. 10.14, PLATE 62. Two horizontal, round handles and small trough spout. Ht 8.4 D. 13.4. D. base 7.9. Smoothed. Decoration in dark purplish-reddish brown: band round inside edge of rim; groups of dashes on rim; band round lip of spout; rest of decoration like **1327**: here, two groups of diagonal lines, below and

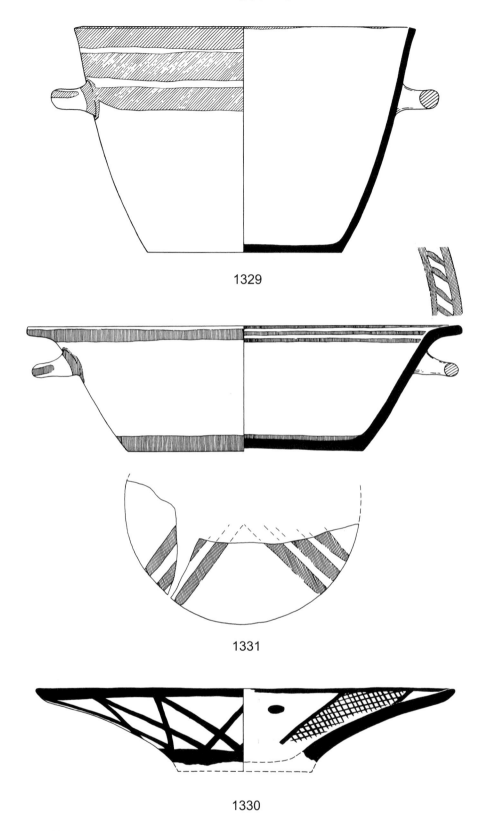

1329

1331

1330

FIG. 10.15. EM IIB bowls: type 6 **1329**; type 8 **1330**; type 9 **1331**. Scale 1:3.

opposite spout, cross each other at base.
1329 (H.I.2 793; PEM/60/P18) FIG. 10.15, PLATE 62.
Incomplete: may have had spout; two horizontal round
handles. Ht 18. D. rim 28. D. base 15.9–16.1 Pared outside,

and well smoothed all over. Decoration in dark brown and
black shading to red and brown: band around rim; two
bands below outside, stripe on handles, and circles round
springings of handles.

TYPE 8A. BOWL WITH FLARING RIM: (A) SHALLOW 1330

1330 (HM 10803; PEM/60/P11; *PM* I, fig. 40, bottom row, second from right) FIG. 10.15, PLATE 63. Frag. D. *c.* 34. Buff ware: grey in break, orange at surface, with abundant fine grits. Surface smoothed (or poorly stroke burnished). Decoration in dark brown and black to reddish brown: bands round rim and round base outside (and probably originally inside [missing]); wide vertical zone of lattice inside; intersecting triangles outside. Zois (1967*a*, 717, n. 2, pl. 33) assigns this to EM IIA. Cf. Wilson and Day 1999, 27–8, fig. 13, pl. 5: P196.

TYPE 9B. BOWL WITH EVERTED RIM: (B) STEEP-SIDED 1331

1331 (HM 10800; PEM/60/P10; *PM* I, fig. 40, third row, middle) FIG. 10.15, PLATE 63. Profile frag. Ht *c.* 10. D. *c.* 36. Roughly burnished all over. Decoration after burnishing in slightly lustrous thick red: bands enclosing hatching on rim; two bands below rim inside and band round inside of base; band to rim outside; triple cross under base; stripe on handles, and circles round springings of handles. Zois 1967*a*, 717, n. 2, pls. 9, 33.

For the triple cross under the base cf. PLATE 39: **1347** and, on the inside of a base, Wilson and Day 1999, 9, 12, fig. 4, pl. 2: P51 (H.I.2 796).

TYPE 15. JUGS WITH CUTAWAY SPOUT 1332–1336

(i) Buff ware, with dark-on-light decoration

Jugs of this type from the Early Houses have been well described and discussed by Wilson,[112] albeit only as fragments and not complete vessels. **1332**, however, is a complete example from the Early Houses, and we imagine that this is the provenance also of **1333**, which is closely similar to it.

For further discussion of **1332–1335**, see p. 113 above; and for **1332–1333** cf. also **373–383** (A2) and **995–998** (B2).

1332 (AM 1910.145; *PM* I, fig. 40, top row, middle). PLATE 64. Ht 21.3. D. body 15.6. Fine buff ware; smoothed buff surface; signs of paring on front of neck. Round handle set to below rim. Decoration in flaking dark purplish-reddish brown: band round rim and below lip, with three chevrons either side, of spout; band at base of neck; shoulder zone: three cross-hatched triangles between (two) sets of a vertical wavy line framed by two vertical lines; two bands above belly; two thick dashes on handle, and base of handle encircled by a knot-like loop that descends to base.

Zois (1968*a*, 93; 1969, 42) assigned this to EM IIA, comparing jugs from Malia, Charnier I (Demargne 1945, 3: 3, pl. 2 centre) and Vasiliki (Boyd Hawes *et al.* 1908, 50, pl. 12: 20; Zois 1967*a*, pl. 29: 3725). One might speculate whether either or both of these are imports from north-central Crete.

1333 (MMA 11.186.1) PLATE 63. Ht (as rest.) 23.25. D. body 17. Fabric and decoration closely similar to above. This jug, however, does not appear to have the motifs of a vertical wavy line btween double vertical lines separating the cross-hatched triangles in the shoulder zone. Richter 1912, 30, fig. 2.

For the broad knot-loop around the handle on **1332** and **1333**, cf. esp. Wilson and Day 1999, 14, pl. 3: P90, and 17–18, fig. 8: P91. These knots are similar, if much larger, to the tassel on bowl **1320**.

(ii) Dark wash ware

If it is correct that pottery that had been kept usually as sherds in the SMK is not included in *PM* I, fig. 40, then there is likely to have been a third jug of this type, which is shown at the left end of the third row. If, however, fig. 40 does include pottery that Evans kept in the SMK, then this jug could be either **1335** or one of two similar, but slightly smaller, jugs discussed below with **1335**.

1334 (AM 1910.158; *PM* I, fig. 40, top row, second from left) FIG. 10.12, PLATE 64. Ht 17.2. D. body 11.3. D. base 6.5. Complete, but spout chipped. Fairly coarse pinkish-buff clay with white and dark grits. Sub-globular body; long high-beaked spout, wide at base; three vestigial lug feet; wart lug either side of spout; round handle set to rim. Well burnished light brown mottled to reddish brown and black wash. For shape etc. cf. the WCH: Wilson 1985, 316–17, fig.19, pl. 34: P158 (with handle, however, set to below the rim). Zois 1968, 93.

1335 (H.I.2 788; PEM/60/P15; ? *PM* I, fig. 40, third row, right — but probably unlikely) FIG. 10.12, PLATE 63. Rest. Ht 21.5. D. body *c.* 16.2. Orange rather crumbly clay, with traces of vertical paring on neck; low baggy shape; handle, set below rim, has a small hole at either end where it joins body. Red-brown mottling to black wash, outside and round inside of spout. Closely similar to, but a little larger than, Wilson and Day 1999, 23–4, fig. 11: P170 (SMP 2013), P171 (SMP 2014), which are both from the Early Houses (including box H.I.2 788) and are nearly complete: in each case much of the handle is missing.

[112] Wilson 2007, 72–3, figs. 2.15: 3–5; 74, fig. 2.16: 3. Cf. Wilson and Day 1999, 14, 17–18, fig. 8: P82, P84, P91.

(iii) Vasiliki ware

Jug fragment **1336** is a surprise in Vasiliki ware, as it seems to be the earliest example (EM IIB) we know of incised diagonal hatching on a rib at the junction of the neck and body — a practice that became regular in EM III (see pp. 130, 220), although **994** (B2) points to something similar and contemporary.

1336 (H.I.2 792) PLATE 63. Neck and shoulder frag. with rib with incised diagonals.

An un-ribbed jug in Vasiliki ware from the Early Houses (H.I.2 789) is Wilson and Day 1999, 35–7, fig. 17: P266.

TYPE 16A. SMALL SPOUTED BOWL-JARS: (A) TEAPOTS WITH VERTICAL HANDLE **1337–1338**

The strap handle **1338** of a Vasiliki ware teapot seems unique at Knossos or anywhere else, and may be a sign of a local Knossian workshop.[113] In functional terms, it would have helped to control pouring.

1337 (HM 10801; PEM/60/P12; *PM* I, fig. 40, third row, left) FIG. 10.14, PLATE 63. Ht to rim *c.* 9.5. D. rim *c.* 12. D. body *c.* 15. D. base 7.5. Orange clay, rather rough and markedly pared. Red to brown slightly lustrous wash

all over outside and band round inside of spout.

1338 (H.I.2 792) Spout in Vasiliki ware with strap handle joining spout to rim. Wilson and Day 1999, 35–6, fig. 17, pl. 7: P268; Betancourt 1979, 27.

TYPE 18. LARGE BOWL OR JAR WITH INWARD CURVING, OFTEN CARINATED AND THICKENED RIM (COOKING POT WARE) **1339**

1339 is a complete profile of a shape otherwise known only as rims in the Early Houses: see also pp. 116, and 200 for this type in B1 and 210 for **1032** (B2).

1339 (H.I.2 799 [and ?796]; SMP 2015; PEM/60/ P35) FIG. 10.12. Large profile frag., rest. 1964–65. Ht *c.* 27. D. *c.* 36. D. base 12.5. Overall wash, red inside, shades of red-brown to brown outside.

Rim sherds from the Early Houses offer parallels. In rim profile and size, **1339** comes between Momigliano and Wilson 1996, 40–1, fig. 25: P141 (D. 38) and Wilson and Day 1999, 29–30, fig. 14: P216 (D. 34).

OTHER EARLY MINOAN II POTTERY FROM KNOSSOS

TYPE 6. DEEP BOWL **1340**

1340 is one of 58 fragments from Knossos received by the MRAH in Brussels in 1913 by exchange with the AM. Evans and Hogarth selected the pieces — which still have their original AM numbers, e.g. AE 758.13.[114] **1340** looks to be the rim of a type 6 bowl, and could easily come from the Early Houses. Among other pieces from Knossos that came to Brussels are also **1343** (grouping three fragments) and **1345**.

1340 (MRAH A2008). *CVA* Belgium 3, Brussels 3, pl. 99: 20.

TYPE 8A. BOWL WITH FLARING RIM: (A) SHALLOW **1341**

EM IIB bowl rim **1341** from Knossos in the LM may be included here: it may (or may not) be from the Early Houses.

1341 (LM 51.105.75). For decoration of chevrons (triangles) on rim, cf. Wilson and Day 1999, 9, 11, fig. 3, pl. 2: P49. Mee and Doole 1993, 25, pl. 8: 277.

TYPE 9B. BOWL WITH EVERTED RIM: (B) STEEP-SIDED **1342**

Bowl rim **1342** from Knossos in the LM looks EM IIB and of this type.

1342 (LM 51.105.77). D. 30. Mee and Doole 1993, 25, pl. 8: 278.

[113] As Betancourt (1979, 27) suggests, who first noticed **1338**. One instance, however, is hardly enough to call this a 'Knossian characteristic'.

[114] We thank Natacha Massar for the information. The 58 fragments are shown in *CVA* Belgium 3, Brussels 3, pl. 99: 1–55, 57–9 (while pl. 99: 56 is from Phaistos).

TYPE 15. JUGS WITH CUTAWAY SPOUT 1343–1344

We group under **1343** three body sherds from Knossos in Brussels of what look to be EM IIA dark-on-light jugs. **1344** in New York is also EM IIA, with good general parallels for the butterfly motif of decoration on this shape from the WCH[115] and a specific parallel for the motif (at a much larger size) on the spouted deep bowl or krater from the WCH.[116]

1343 (MRAH A2009, A2012, A2013). *CVA* Belgium 3, Brussels 3, pl. 99: 22, 21, 19.

1344 (MMA 11.186.25) PLATE 65. Neck and body frag. 11.4 × 11.1. Butterfly motif on shoulder.

TYPE 16A. SMALL SPOUTED BOWL-JARS: (A) TEAPOTS WITH VERTICAL HANDLE 1345–1346

Rim **1345** in Brussels is probably from an EM IIB teapot. Rim **1346** may be included here: it is possibly EM II and, if so, most likely EM IIB, in view of its black wash. It seems to be from a bowl or pyxis.

1345 (MRAH A2010). Rim frag. *CVA* Belgium 3, Brussels 3, pl. 99: 18.
1346 (B.II.3 386) FIG. 10.16. D. *c.* 8. Fine orange clay.

Handmade. Vertical-sided; flat rim, thickened inside; horizontal tab handle. Black wash outside and round inside of rim. Decoration in white, worn.

Marks on footed goblet bases

In EM IIB painted marks are a regular occurrence on the underside of type 2 footed goblets, with more in dark-on-light than in light-on-dark. Wilson and Day suggest they may have been potter's marks.[117] Besides the brief discussions above (pp. 107, FIG. 5.5, TABLE 5.4; 164 and PLATE 31: **515–516**; 202–3 and PLATE 40: **921–924**), we add the following list (which is certainly not complete for Knossos: we are sure it can be extended).

Dark-on-light
Single short line or dash (FIG. 5.5: 1): **922** and two others from B2.
Bar (FIG. 5.5: 2): **296, 825**.
Bilobate (or V-shaped) (FIG. 5.5: 3): **1308–1309, 1310** (with circle round edge of base), **1311**; also H.I.2: Wilson and Day 1999, 6–8, fig. 1: P1–3.
Crossing, or pair of, short lines or dashes (FIG. 5.5: 4): **923**.
Two solid spots inside circle round edge of base (FIG. 5.5: 5): **921**.
Circle round edge of base (FIG. 5.5: 6): **293** and another from A2, four from A3 (p. 156), two from B1 (p. 194), six from B2, and **1302**; also H.I.2: Wilson and Day 1999, pl. 5: P140, P142.

Light-on-dark
Single lobe/stroke (FIG. 5.5: 7): **310**; one from B2; also H.I.2: Wilson and Day 1999, 21, pl. 4: P143 ('thumbprint').
Bilobate (FIG. 5.5: 8).
Three solid spots with central spot (FIG. 5.5: 9).
Three solid spots (FIG. 5.5: 10).
Circle round edge of base: ?**1318**; also H.I.2: Wilson and Day 1999, 21, pl. 4: P137–138, P141 (on dark circle to edge of base) and (with also central dark spot) P144.

Decoration: cross on bowl base 1347

Shallow bowl bases in both dark-on-light ware with crosses painted usually on the underneath, but sometimes on the inside, and often in red, and likewise in light-on-dark are a known feature of EM IIB Knossian tableware.[118] Putting the cross on the underside suggests that such bowls were decorated so as to be noticed, whether hanging on pegs on the wall or placed upside down on a table or shelf.[119] Examples include **344, 852** (and **853** in white-on-dark), **951**, and one from E.II.1–2 639. **1331**, which is one of several from the Early Houses,[120] can be paralleled in **1347**.

1347 (E.III.2 663) PLATE 39. Triple cross in red, like **1331**.

[115] Wilson 1985, 323–8, figs. 22–6, pl. 38; 2007, 61–2, fig. 2.8.
[116] Wilson 1985, 307–08, fig. 14, pl. 32: P93; 2007, 61, 63, fig. 2.9: 1.
[117] Wilson and Day 1999, 6–8, fig. 1: P2–4; 21, pls. 4–5: P137–144.
[118] Wilson and Day 1999, 9–12: P56, and figs. 4–5: P57–58, pl. 2: P52–54. Crosses on the upper (inside) surface include:

Wilson and Day 1999, 9,12, fig. 4, pl. 2: P51 and, in light-on-dark, 21, pl. 5: P151, P153. Cf. Wilson 2007, 73.
[119] Cf. the large straight-sided cups of the MM IIB Malia-Lasithi ceramic workshops (e.g. Cadogan 1978*b*, 75, fig. 13).
[120] See n. 115; also Wilson and Day 1999, 21, 23, pl. 5: P152, P154 (both in light-on-dark).

Cross motifs on the undersides of bases of other shapes are not common but are known back to EM IIA at Knossos.[121] As well as two jugs from the WCH, there is an unusual triple-bodied jug of EM IIA with a cross on the bottom of each of its three parts. It was found in a test pit 30 m north of the Theatral Area, and so not far from our Area A[122] — where our earliest example of the painted motif, albeit in multiple form, is probably **266** (A1). Another example is a cross inside and out on a fine painted ware bowl base.[123] The motif is also found in pattern burnish. To two examples that Wilson cites,[124] we can add (from above) **1254**, a type 16 bowl-jar in dark grey burnished ware,[125] and **1265**, a light brown burnished ware goblet. Other instances from our excavations date to EM IIB: **344** (A2), a type 8 deep flaring bowl, and **853** (B1), a type 9 bowl; and they occurred in B2 contexts in the Early Houses (p. 212 above).

MINIATURE BOWL **1347A**

The miniature bowl **1347A** (PLATE 65) is of unknown provenance at Knossos. It is basically a plain bowl with a dark line around the rim rising from a larger vessel with a dark wash. It may date to EM IIB, as does **350** (A2), or to EM III.

EARLY MINOAN III

We present some Early Minoan III eggcup goblets, now in Copenhagen, London, New York or Oxford, and a very small selection of other pottery from Knossos.[126]

TYPE 2. FOOTED GOBLETS (EGGCUPS) **1348–1352**

While it is difficult to separate EM III from MM IA footed goblets when they are isolated from their original context,[127] we believe that **1348–1352** are likely to be EM III,[128] on the general grounds of their quality. **1348A** is recorded in the AM register as being from the Early Houses — which could favour an EM III date; and **1352** is from the 'pit-repository' in the Royal Pottery Stores, which Momigliano has assigned to EM III (UEW Group), presenting as full a reconstruction as possible of the group, much of which is still in the SMK.[129] Besides goblets, cups, bowls, jugs and jars etc., it includes more eggcups (in the SMK).

In 1905 Evans included an eggcup among various objects he exported from Crete to England. Marked 'F' at the time and sketched, probably by Hazzidakis,[130] it is probably one of **1348**, **1349** or **1352**, but not **1348A**.[131]

1348 (MMA 11.186.5) FIG. 10.16, PLATE 65. Ht 8.25. D. rim 7.5. D. base 4.65. Complete, chipped. Fine buff clay, but with grits and air holes, rather rough and with slight vertical paring. Lustrous black wash all over, except under base. Fairly lustrous creamy white band below rim outside; possibly line on rim. Assigned to MM IA by Betancourt (1985, 75, pl. 5E).
1348A (AM 1910.154). Ht 8.8–9.0. D. rim 8.3. D. base 4.3–4.6. Complete. Fine buff clay. Orange-dark brown wash to waist outside and 1/3 way down inside. Creamy white line on rim, and band below. Like **1348** but larger.
1349 (MMA 11.186.7) FIG. 10.16, PLATE 65. Ht 6.95. D. rim 5.9. D. base 4.25. Complete except for few chips. Buff clay with grits; fairly lustrous surface. Smaller vessel

and more conical foot than **1348**. Lustrous brown-red wash reaching to waist (and spreading below) outside and halfway down inside. Fairly lustrous thick creamy white line on rim; band below rim outside. Richter 1912, 32, fig. 5 left.
1350 (MMA 21.100.3) FIG. 10.16, PLATE 65. Ht 8.1. D. rim est. 7.5. D. base 4. 2/3 pres. Clay as above; probably slightly lustrous pink-buff slip. Brown to black wash outside to waist and inside to one third down. Creamy white fairly lustrous band below rim outside; uncertain if line on rim.
1351 (NMC 6761). CVA Denmark 1, Copenhagen 1, pl. 30: 15.
1352 (BM A466). Ht 10.8. D. rim 9.3. D. base 5. Forsdyke 1925, 80, pl. 7; Momigliano 2000b, 71, fig. 4; 73–4, fig. 6; 82: 39.

We may mention a few, rare occurrences of this typical variety of north-central Crete, in other regions of the island, and beyond Crete, but must repeat that it is often uncertain whether they belong to EM

[121] Wilson 1987, 337, with references.
[122] Wilson 1987. The box in the SMK is V.1908 1767.
[123] Wilson and Day 1994, 27, pl. 2: FP 23.
[124] Wilson 1987, 337, n. 8.
[125] **1254** is probably one of the two pattern burnish examples that Wilson mentions (n. 121).
[126] Those in Copenhagen, London and New York came from Evans and/or the AM, except for **1350**: MMA 21.100.3, the gift of George A. Whicher in 1921.

[127] Momigliano 1990, 483.
[128] Seán Hemingway at the MMA (pers. comm.), however, leans towards MM IA for **1350**, comparing a slightly smaller eggcup from RRS (Momigliano 2007c, 100, fig. 3.14: 3).
[129] Momigliano 2000b, esp. 74–80; 2007c, 82–3, fig. 3.2: 5. The pottery in the SMK comes from L.III.8 1019, 1027–1046.
[130] Panagiotaki 2004, 566.
[131] As possible candidates in the AM seem not to have letter marks (Panagiotaki 2004, 573–4, fig. 53.2 F).

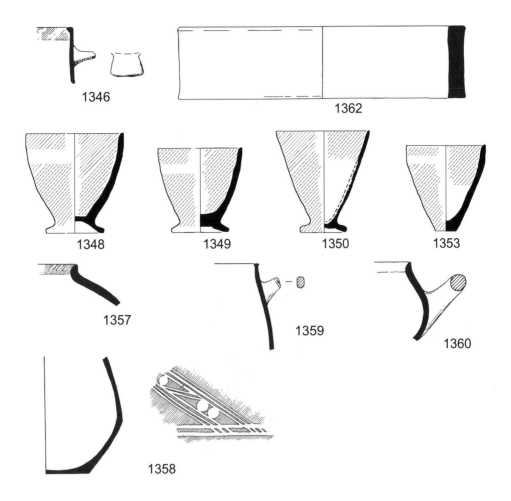

FIG. 10.16. EM IIB (?) bowl or pyxis **1346**; EM III: type 2 goblets **1348–1350**; type 3 goblet **1353**; EM III (?) type 16 bowl-jars **1357–1360**; pot stand **1362**. Scale 1:3.

III or MM IA — unless they should happen to have polychrome decoration. But we know of no examples of polychromy on this shape in its handmade form.[132] Sites with eggcups include:

Crete beyond the north-central region
Chania Museum: 2355, 2358, 2416, 2476.[133]
Monastiraki.[134]
Vorou, outside T. A.[135]
Lebena T. II: HM 15730.[136]
Tsoutsouros, cave of Eileithyia.
Malia, Premier Charnier: 8681.[137]
Ayios Charalambos cave: HCH 45.[138]

[132] Cf. Momigliano 1990, 480–3 (esp. 483) and figs. 2–3; 2007c, 84 and 96–7. For eggcups in north-central Crete, see Cadogan 1994, 61 (to which add for Yiofyrakia: Marinatos 1935, 51, fig. 4); and for Archanes: Lakhanas 2000, 157, 166–7, figs. 2, 6.

[133] Momigliano 2007c, 93, with references.

[134] We thank Athanasia Kanta for information about Monastiraki and showing us an eggcup from Tsoutsouros.

[135] Marinatos 1931, 159–60, figs. 21–2. For Vorou's position on the south side of the pass above Ayia Varvara into the Mesara, and thus its lying outside the natural geographic boundary of the

north-central region, see Cadogan 1994, 59, fig. 1; 61 and n. 15. For its possible cultural position on the boundary: Cadogan 1994, 64 (and n. 34 for the wider distribution of eggcups); Morris and Peatfield 1990, 33.

[136] Alexiou and Warren 2004, 71, fig. 21, pl. 45A: 91.

[137] Demargne 1945, 9, pl. 3: 8681. Momigliano (2007c, 94) favours a Knossian EM III date for this eggcup and notes that the context appears too to be EM III.

[138] Langford-Verstegen 2008, 550–1, fig. 9; 555: 6, assigning it to EM III–MM IA. There may have been more than one (cf. Langford-Verstegen 2008, 550).

Myrtos–Pyrgos: MP/70/P227 (from trench B4/C4 level 4 basket #219).[139]
Palaikastro: several including LM 55.66.121,[140] and one from Block Chi, Room 1.[141]

Argolid
Lerna: L.768;[142] and there may be more.[143]

TYPE 3. GOBLETS **1353–1354**

As with the type 2 eggcups, it can be hard to tell whether these belong to EM III or MM IA. **1354**, however, has two good parallels in the UEW both for its conical shape (Momigliano's footless goblet type 1) and for having a wash halfway down inside and out[144] — which may suggest that these goblets were dipped into the paint while being held by the base; and **1353** would also sit well in an UEW context.

1353 (MMA 11.186.4) FIG. 10.16, PLATE 65. Ht 7.1. D. rim 7.5. D. base 3.55. Complete, rest. Buff clay, with air holes, and vertical paring. Fairly lustrous greenish brown-black wash. Creamy white line on rim; band below rim outside. Assigned to MM IA by Betancourt (1985, 75, pl. 5D).

1354 (MMA 11.186.6) PLATE 65. Ht 7.4. D. rim 7.3. D. base 3.75. Complete but chipped. Pink-buff clay with few red and white grits, pared and crudely wiped on base. Fairly lustrous orange-brown wash reaching half-way down inside and out. Fairly lustrous creamy white line on rim; band below rim outside. Richter 1912, 32, fig. 5 right.

TYPE 2 OR 3. GOBLET **1355**

Rim **1355** is included for its decoration of fine incised latticework on a broad reserved band on a dark wash goblet, a feature encountered on jars **1140–1141** (B3), but rare, if not as yet unparalleled, on a goblet. The fragment is reported in the AM register as coming from the N.E. rubbish heap, which must be the North-East Kamares Area.

1355 (AM 1938.420). Ht. pres. 5.9. Brown to dark brown wash. Broad reserved band with incised latticework, possibly

framed by a white line immediately above the band on the wash, and another immediately below, likewise on the wash.

TYPE 16A. SMALL SPOUTED BOWL-JARS **1356–1360**

It is uncertain whether to place **1356** here as an EM III product or in EM IIB as Vasiliki ware (see below). Forsdyke, aware of the dilemma, saw it as inferior Vasiliki ware that continued into EM III, and wrote of the degeneration of the style: 'Extravagant beaks were curtailed, long tubes cut down to short bridged-spouts.'[145] He saw a close parallel from the UEW that Mackenzie had illustrated. Since that jar/jug cannot now be located, and there were two others like it that are also missing,[146] it is possible that **1356** is one of this trio of bowl-jars with single vertical handles (type 16A). We have one certain instance — **1105** — of this type in the B3 deposit, and up to four of 16B with horizontal handles (see **1104, 1106**). There are several rims of type 16 in A5, almost all with a dark wash: see **607–617**.

1357–1360 may well also be EM III and, in view of their small rim diameters, are probably best grouped here.

1356 (BM A434). Forsyke 1925, 76, fig. 92, comparing Mackenzie 1903, 167, fig. 1: 12 (Momigliano 1991, 163, pl. 18: 38). However, Betancourt (1979, 51: X.C — Teapots with short spouts without pedestal bases — Knossos 1) saw it as Vasiliki ware, albeit with a 'poor surface', classing it with two vessels from Myrtos–Fournou Korifi (Warren 1972a, 151, 202–03, figs. 86–7: P669 (with ring base), P670) and

one from Mochlos (Seager 1912, 83, fig. 48: 44; Betancourt 1979, 51, pl. 5C: X.C Mochlos 1; Maraghiannis 1911, pl. 10 bottom right). The one from Mochlos looks EM III, with its punctuated decoration on reserved zones combined with a Vasiliki ware-like surface for the rest of the outside of the vessel. See also discussion of the Vasiliki ware-like appearance of bowls in A5 (such as **589**: p. 170).

[139] The context is probably MM IA in Knossian terms.
[140] Warren 1965, 26; Dawkins *et al.* 1905, 271; Liverpool cup (source: R. C. Bosanquet): Mee and Doole 1993, 28, pl. 8: 303.
[141] Knappett 2007, 220–1, fig. 7.
[142] The most useful reference with illustration is still Caskey 1956, 160 and n. 28, pl. 43c. See also Zerner 1978, 172; Cadogan 1994, 64, n. 34.
[143] Zerner 1978, 172–3, figs. 10: D 590/4; 11: BD 4 9/4–5.

[144] Momigliano 1991, 156, 161–2, pl. 19: 10, 15 (Momigliano 2007c, 89, fig. 3.7: 5); 246, fig. 30; 248.
[145] Forsdyke 1925, xxxiii.
[146] Momigliano 1991, 163, pl. 18: 36–8; 256–8, fig. 35: 'side-spouted jar type 2' (Momigliano 2007c, 90, fig. 3.8: 4); see also 156, n. 41, suggesting AM AE.978 and HM 2741–2742 as possibilities.

1357 (B.I.31 373) FIG. 10.16. Rim frag. of jar. D. *c.* 7. Fine orange clay. Dark purple to brown and black lustrous wash outside, and as band to rim inside with added white diagonal dashes.

1358 (B.I.31 373) FIG. 10.16. Body and base frag., possibly same jar as **1357**. D. base *c.* 7.2. Fabric as **1357**. Incipient carination to body. Decoration in thick creamy white: pair(s) of solid spots alternating with pair of diagonal lines between groups of three diagonal lines, above two

horizontal lines (just below carination).

1359 (B.I.31 371) FIG. 10.16. Rim frag. D. *c.* 8. Fine orange clay. Horizontal rectangular section side-handle(s). Lustrous black wash outside and as deep band to rim inside. Traces of decoration in red.

1360 (B.I.31 372-3) FIG. 10.16. Rim frag. D. *c.* 11. Sandy greenish buff clay. Dark brown to black lustrous wash inside and out.

TYPE 17. LARGE SPOUTED BOWL OR JAR WITH HORIZONTAL SIDE-HANDLES **1361**

In the entry for **1124**, the East Cretan EM III jar in B3, we mention two other such jars that have been found in Knossian EM III contexts. One of these is **1361**, from Room 1 of House A below the Kouloures, of which we present a photograph. The other is from the SFH.[147] There have also been several East Cretan EM III jars in MM IA levels in RRS.[148]

1361 (B.II.1 378) PLATE 65. D. 18. Momigliano 1991, 209, fig. 18; 216, 219, fig. 22 right; Andreou 1978, fig. 3: 13. Cf. **1124** and references cited there.

POT STAND (?) **1362**

We include **1362** here which, with its vertical sides and diameter of about 24, may have been a ring stand for holding large vessels. It is probably dated best to EM III–MM IA, without attempting to decide between the periods. Todaro has recently published some parallels from Phaistos, which she assigns to MM I and sees as further evidence for pottery production in Prepalatial times and later to the west of the Palace.[149]

1362 (B.II.2 380) FIG. 10.16. Ring stand, probably for pottery, *c.* 1/4 pres. Ht 6.3. D. *c.* 24. Plain rather coarse orange clay with paler surface.

SOME OTHER EARLY MINOAN ARTEFACTS FROM KNOSSOS

A few other Early Minoan artefacts have been noted in the SMK.

CLAY

Already mentioned are: a likely phallus fragment **1363** (in connection with **1152** and **1152A**, both of EM IIB date), and the impression **1364** of a vine leaf on a base. **1365** is another vine leaf impression, probably of MM IA, perhaps EM III, date. The mat impression **1366** on the base of a large vessel is probably EM IIA (late) in view of its provenance. Comparanda are as yet extremely rare in Crete, but there is a mat impression on the base of a larnax from Burial Building 18 at Archanes–Fourni apparently of MM II date.[150] Mat impressions are well known in the Cyclades, from LN (Saliagos) and FN (Kephala, Kea) through EC and MC and into LC, and occur in mainland Greece.[151]

1363 (B.I.31 372) PLATE 50. Frag. of phallus? Ht 8.3. Max. D. 4.1. Cooking pot ware, with light brown to red smoothed surface, perhaps washed. Conical, with flattened projection on top.

1364 (B.I.31 372) PLATE 19. Base frag. of large jar with impression of vine leaf, identified by Warren. Cf. **166H** (Palace Well) (pp. 61, 68-9, with discussion of these impressions) and **1155** (A3) (p. 228).

1365 (B.I.31 371) PLATE 19. Vine leaf impression on the

underside of dish or tray in cooking pot ware, of MM IA type. For the shape, cf. Momigliano 2007c, 102, fig. 3.16: 1 (House C/RRS Fill Group of MM IA) which is, however, a tripod (but it is unlikely that **1365** was part of a tripod vessel); also perhaps **1083** (B3) above.

1366 (K.I.6 894-6) PLATE 65. Base frag. of large jar with mat impression. 15.6 × 11.2 × 2.9-3.6. Thick red clay with grey core, and much red to back grit. Thinner towards centre; smoothed inside.

[147] Momigliano and Wilson 1996, 51-2, fig. 30: P193.
[148] See p. 124 and n. 15 above.
[149] Todaro 2009b, 339, fig. 4.

[150] Sakellarakis and Sakellaraki 1997, 474-5, fig. 456.
[151] Carington Smith 1977, 122-4; Sherratt 2000, 352-5, both with references.

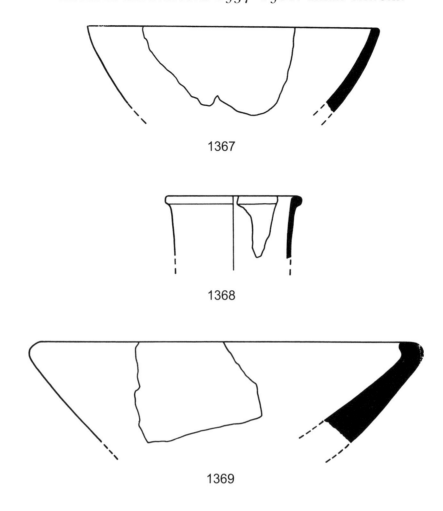

1367

1368

1369

FIG. 10.17. EM stone vessels **1367–1369**. Scale 1:2.

STONE

Peter Warren

From Arthur Evans's material in the SMK come three rim and body fragments of stone vessels of much interest, since they are all imports. **1367–1368** are Egyptian, thus affording contextual proof of Prepalatial links between Crete and Egypt in, almost certainly, EM IIB in view of their coming from the Early Houses.[152] **1369** is part of an Early Cycladic white marble bowl, probably of the EC I Grotta-Pelos culture.[153] I first took this as an EC II, Keros-Syros saucer;[154] but those tend to have a bevelled rather than a markedly inturned rim and to be thinner than this is.[155]

1367 (H.I.2 788) FIG. 10.17. Open bowl. Ht 4.1. W. 8.4. D. *c.* 16. Diorite, dark green/black with white mottling. Egyptian, Dynasties I–II. Warren 1969, 110: C1 (with references), D317; 1981, 633, fig. 3, pl. 205b; Phillips 2009, vol. 2, 79: 135.

1368 (H.I.2 794) FIG. 10.17. Cylinder jar. Ht pres. 3.3. D. *c.* 7.5. Alabaster (calcite). Egyptian, approx. Dynasty VI.

Warren 1969, 125–6; 1981, 633–4, n. 25 (with references), fig. 4, pl. 206a; Phillips 2009, vol. 2, 79–80: 136.

1369 (E.I.7 620) FIG. 10.17. Bowl with rim thickened internally. Ht pres. 5.3. W. 6.8. D. *c.* 21.7. Marble, white, fine grained. Cycladic, probably EC I, Grotta-Pelos culture form; cf. Renfrew 1972, 156, fig. 10.2: 6, 12 (marble); 154, fig 10.1: 4–6, 10 (clay).

[152] For these and other Predynastic–Dynasty VI Egyptian stone vessels from Knossos, see Warren 1980, 493–4; 1981a.

[153] One should also mention the chlorite bowl fragment (B.I.13 253), first noticed by Furness (1953, 132, pl. 32b: 9). I believe this bowl was made in MM I imitating Neolithic ceramic decoration (Warren 1969, 76–7: 'The pattern and firmly incised

grooves are not EM II workmanship.').

[154] Warren 1969, 76–7.

[155] Cf. Doumas 1983, 77–9: 44–51; 82: 59, which seems much more closely comparable to the EC I inturned rim bowls cited; also Warren 1981, 631, n. 14, fig. 2.

Chapter 11

The Early Minoan ceramic sequence of Knossos

Since there has been so much progress over the last quarter-century in defining the Early Minoan ceramic sequence of Knossos, which is now encapsulated in the *Knossos Pottery Handbook* of 2007, we shall not repeat the story. Instead, this chapter will attempt to show how the pottery from our excavations, period by period, fits the sequence proposed in the *Handbook*,[1] and then to pick out some details, issues and trends in the history of the EM pottery of Knossos that either seem to need further discussion or that have become especially apparent to us in studying the pottery of the three excavations. Chapter 12 will then review the Early Minoan history of the settlement of Knossos in the light of our excavations.

We realise that judgements (including those in the *Handbook* and ours in this volume) may have to be revised once several studies and excavations have been fully published. We await (i) Tomkins's definitive study of the Neolithic pottery sequence of Knossos, and the final reports on (ii) the trials made in 1987 by Evely, Fotou and Hood behind the Throne Room and w of the North Lustral Basin with EM I pottery, and by Peatfield by the EM III wall at the NW corner of the Palace, (iii) Warren's EM excavations in RRS, (iv) the excavations in Poros–Katsambas, and (v) the EM ceramic petrography of Knossos.[2] Also in the offing are the reports on various excavations connected with the conservation of the Palace or accounts of the pottery.[3] These will all have important information for the ceramic history and the history of Knossos, which may modify present interpretations.

EARLY MINOAN I

The pottery from deposits 1 and 2 of the Palace Well seems to represent a full range of shapes for a settlement context, with vessels for consuming (chalices and perhaps pedestal bowls), preparing (baking plates), serving (probably pedestal bowls), pouring (jugs), collecting (large jugs) and storing (pithoi), as well as vessels for special purposes such as suspension pots. It was probably a domestic context within the settlement; but one cannot exclude the possibility of the settlement's also having a discrete shrine or shrines, with special pottery of its/their own, of which the fill in the Well is the debris. (This may skew our interpretations.) Any such shrine, of course, would be extremely hard, or impossible, to detect when we have only a fill, as is the case in the Well, but no buildings to connect it with. It is also hard to tell whether the pottery of deposits 1 and 2 represents what one household was using, or several, or the whole community, or whether people from outside Knossos also gathered on the Kephala hill for events.[4] But in view of its quantity, we may be fairly certain that this was the pottery of more than one household on the hill; whether it was for the whole community, and even outsiders, is not so clear. Whatever its purpose in the community, this pottery from some sort of settlement context shows that some shapes, such as the suspension pot and its lid, that had seemed very much part of the Early Minoan cemetery repertoire do also occur in settlements, and in some quantity.

An immediate issue in assessing deposits 1 and 2 of the Palace Well is where to place them in the EM I pottery sequence, which includes the issue of whether to divide EM I at Knossos into an EM IA and an EM IB, or not. Here it seems reasonable to take the two deposits together, although the water jugs and pithoi of deposit 1 are stratigraphically older — how much older in years we can never know — than the large amount of pottery in deposit 2. We can then address the issues of to what extent the pottery from the Well and elsewhere at Knossos shows continuity from the pottery of Neolithic Knossos and/or whether we have evidence for possible extra-Knossian influences in ceramic production or even immigrants, who might have included potters, from elsewhere in Crete or from outside the island.

[1] Tomkins 2007; Wilson 2007; Momigliano 2007*c*.

[2] Preliminary accounts include, Neolithic: Tomkins 2007; trials behind the Throne Room and by the NW Angle of the Palace: Catling 1974, 34; 1988, 68–9; Hood 1994; Wilson 1994, 29, 34, fig. 3; Manteli and Evely 1995, 4; RRS: Warren 1972*b*, 1973*b*, 1974; Catling 1972, 21; 1973, 26–8, fig. 59; 1974, 34, fig. 65; Poros–Katsambas: Dimopoulou-Rethemiotaki 2004; Dimopoulou-

Rethemiotaki *et al.* 2007; Wilson *et al.* 2004, 2008; ceramic petrography: Day and Wilson 2002, 2004; Wilson and Day 1994, 1999, 2000.

[3] Cf. already Batten 1995; Efstratiou *et al.* 2004; Karetsou 2004, 2006; Wilson 2010.

[4] As Todaro (forthcoming) suggests may have happened at Phaistos.

When we first studied the pottery from the Well, we believed that it could be assigned to EM IA principally on the basis of the large pedestalled chalices and bowls, which appeared to represent the earliest phase of EM I that could be recognised at Knossos or anywhere else in Crete. Thereafter we saw a diminution in size of these pedestalled vessels — the chalices especially — and a transition from communal vessels for drinking and eating to individual vessels. The first stage of this shrinking process, which seemed to continue until the goblets and footed goblets of EM III and MM IA, could be observed in the slightly smaller size/capacity of these vessels in deposits such as the Pyrgos burial cave, where several of them have horizontal swellings (or ribs) and/or grooves or channellings on their stems (which are not found in the Well). This appeared on stylistic grounds to represent a phase that we characterised as EM IB.[5]

Such an EM IB phase was accepted by others studying the EM pottery of Knossos; and it was even suggested that the FF4 deposit below the West Court could be assigned there, representing a phase between the Palace Well and the West Court House.[6] However, the study by Wilson and Day of the pottery from Poros–Katsambas at the mouth of the Kairatos river changed perceptions. 'EM IA' and 'EM IB' were found together,[7] which led to their proposing an unitary and comprehensive, if fairly broad-based and somewhat fluid, EM I.[8] For Knossos this has now been called the EM I Well Group.[9]

We accept this new view, and recognise that it it is not possible to define any specifically 'EM IB' deposits from Evans's excavations at Knossos, nor from ours. Hence it is safest at present to speak only of EM I as a whole, while recognising that it has to be a flexible term, at least until the details are published of both the Poros pottery and of that of the 1973 and 1987 trials behind the Throne Room and elsewhere in the north part of the Palace, where the initial reports have been of 'EM IB' pottery.[10] Another cause for caution arises from Todaro's recent research at Phaistos, where she detects an EM IA phase and an EM IB phase,[11] following two FN phases.[12] (In one location an EM I building is set over a FN IV cooking installation.[13]) In her ten phase sequence (Phaistos I–X), Phaistos I corresponds to FN III at Knossos, and Phaistos II to FN IV. Phaistos III of early EM I is described as 'broadly contemporary' with the bottom level of Lebena T. II, and Phaistos IV with the second use level of Lebena T. II and the Piazzale dei Sacelli at Ayia Triada.[14] The Palace Well would seem to match Phaistos IV.

Likewise at the newly excavated site of Petras–Kephala Papadatos has found at least three architectural phases from FN IV into EM I, with 'no evidence for any dramatic event separating the various phases'.[15] These translate into two main phases of occupation: FN IV and EM I. The EM I seems fairly early in the period, with correlations with deposits such as Partira or Palaikastro–Ayios Nikolaos that have often been called Final Neolithic or Sub-Neolithic (but are best placed in EM I)[16] and again the earliest pottery from Lebena T. II rather than the Cycladic-influenced pottery from Ayia Fotia (which is nearby), Pyrgos, Poros–Katsambas, or Gournes. In the end Papadatos, like Todaro for Phaistos, prefers an EM IA and an EM IB division of the period. For Knossos we probably have to stick for the time being with an unitary EM I, although we did originally make the same EM IA–EM IB separation — and, in accord with this view, Room 45 behind the Throne Room was reported as having an EM IB deposit.[17]

The arguments for a unitary EM I must mean that the small FF4 deposit below the West Court belongs to the EM I Well Group,[18] with which it has many similarities. One must emphasise, however, how small a deposit it is, perhaps the debris of a single household deposited at one moment, in comparison with the Well, which surely represents the debris of several households. There are also differences from the Well, notably among the bowls, with an absence of large pedestalled bowls, but also the presence of a deep bowl shape[19] and a shallow bowl shape (the latter at least with a flat base)[20] and an indented (or sunken) base,[21] that do not appear in the Well, nor in the WCH. There are two good parallels from the Well, however, for the rim of the small shallow dish, which appears to have had this flat base (see under 19), while the indented base recalls ones of class C (fine black burnished)

[5] Hood 1966, 1971, 36–8, fig. 14. Cf. Hood 1990b.
[6] Wilson 1985, 359–64; Cadogan et al. 1993, 23–4 (with other groups that were thought mainly or wholly EM IB), 26, table 1; Wilson 1994, 28–30, fig. 1.
[7] For references, see n. 2.
[8] Day and Wilson 2002, 2004; Wilson and Day 2000.
[9] Wilson 2007.
[10] For references, see n. 2.
[11] Todaro 2005, 34–8, 44; forthcoming; Todaro and Di Tonto 2008, 177–9
[12] Confirming Vagnetti's suppositions (1973, 1996; Vagnetti and Belli 1978).

[13] Todaro and Di Tonto 2008, 181–2, fig. 11.2.
[14] Todaro 2003, 2005, 21; forthcoming
[15] Papadatos 2008 (p. 261 for quotation). We look forward to Papadatos in preparation.
[16] Tomkins 2007, 46–8; Papadatos 2008, 265–6 (early in EM)
[17] Manteli and Evely 1995, 4. The pottery included a ribbed goblet stem (Hood, pers. comm.). See too the few grooved stems from Knossos: see p. 33, n. 95.
[18] Wilson 2007, 50, fig. 2.1: 3; cf. Tomkins 2007, 45–6.
[19] Wilson 1985, 361–2, fig. 42: FF5.
[20] Wilson 1985, 361–2, fig. 42: FF6.
[21] Wilson 1985, 361–2, fig. 42: FF7.

ware of Phaistos FN.[22] On the other hand, **1265** is probably an example of such a base in light brown burnished ware of EM IIA date, while a piece of buff burnished ware from FF4[23] is of a fabric that is like that of EM IIA fine painted ware. In FF4 there are then features that look both to the Palace Well and to EM IIA, while its strap handles are seen as similar to FN IV (Stratum IC) handles but not like the handles that occur in the Well — and may just hint at a date in EM I prior to the Well.[24]

The corollary of such comparisons is important. We cannot be strongly *dirigiste* in our assessments but must accept a fluidity, realising that various traits do not always slot easily into our chronological/cultural divisions — but may make earlier or later appearances than the period of their principal popularity. This point is clear enough in the Palace Well, where the piece of a light grey ware suspension pot **109** is the biggest surprise, in view of the ware's being a hallmark of EM IIA, and especially EM IIA early. An effect of this, of course, is that it is not always easy to assign single sherds, divorced from a context to, say, EM I as against EM IIA; but we are on surer ground where there are reasonably secure contexts. We also have to recognise that at a settlement site such as Knossos, where many of the deposits appear to have been fills, there is always the possibility of admixture of earlier or later pieces — which we have tended to call strays in our accounts above of the deposits.

When we turn to the origins of the EM I pottery styles as seen at Knossos, it is a mixed picture. An important, but small, group that needs fuller study comes from the Central Court where Mackenzie rightly observed that the upper level of houses in the Neolithic soundings of 1923–24 was in fact EM I — a view that Evans later discounted.[25] This is then the one place at Knossos where they found EM I overlying Neolithic. Recently, Tomkins has agreed with this interpretation, assigning the EM I structures to Stratum IB and those below to Stratum IC of FN IV.[26] Mackenzie was quite clear on the new character of the pottery in the upper level, comparing 'the advent of a new kind of polished surfaces' with the dark grey burnished ware from Pyrgos;[27] and there were other typical EM I wares, including scored ware.[28]

Stratigraphically, the evidence is not detailed enough to say whether there was complete and uninterrupted continuity of occupation from FN IV into EM I. Tomkins suggests that the first of many levellings and reshapings of the Kephala hill happened in FN IV, that is 'immediately' before Stratum IC, with the creation of a cobbled area which he calls the Southeast Platform, as the first central gathering place at Knossos — or Court. This first phase came to end when an EM I surface was created on top of it, with a mixture of (redeposited) FN III–IV and of EM I pottery — and the creation of a considerably larger Court.[29] We cannot say how these building works happened. Was it a peaceful transition within the same community? Was there a break? Had others arrived? We do not know. If it was a peaceful transition, then the implicit massive change of culture within the community would be most remarkable. Mackenzie, who was in charge of these Central Court excavations, was in no doubt. Not only did the pottery of EM I show a break from the Neolithic, but so too did the construction techniques, the EM I building in the Central Court being much sloppier than the Neolithic building beneath.[30] However, the plaster fragments in deposit 2 of the Well may include the first instance of lime plaster (as well as mud plaster), by contrast with the Neolithic which saw only mud plaster (p. 59 above).

Whatever happened in the transition from FN to EM, there was manifestly continuity in the choice of the location of Knossos, as likewise at Phaistos.[31] There can be no doubt that these places either remained in continuous use, or were (soon) recoccupied, as settlements. Either way, they were still valued presumably for their defensive and agricultural situation etc. and, more than likely, for such ideological reasons as capturing memory and tradition: here were places that had been lived in before, perhaps by known forebears who could be recalled in rituals or by storytelling at feasts and other gatherings, perhaps by enemies who had been vanquished or usurped but whose symbolic former connections were still important enough for the new occupants to claim them.

In pottery terms, continuity may be best observed in the scored jugs and jars, as known from FN III and IV, and also in large strap handles (see above).[32] But there are striking innovations in EM I.

[22] Vagnetti 1973*a*, 77, fig. 70: 3; and 65, 70 fig. 65: 9: this is of the same size as, and has a similar finish to, the FF4 base.

[23] Probably from the base of a goblet (Wilson 1985, 61–2, fig. 42: FF9).

[24] Tomkins 2007, 44–7, fig. 1.16: 3 bottom; cf. Wilson 1985, 363, fig. 43, pl. 57: FF15.

[25] Hood 2006.

[26] Tomkins 2007, 10, fig. 1.1; 13, table 1.2; 16, table 1.3; 45,

47, fig. 1.4: 1, 4.

[27] Hood 2006, 12.

[28] Tomkins 2007, 45.

[29] Tomkins forthcoming *a*.

[30] Hood 2006, 12–13, quoting Mackenzie: 'signs of hurried construction which may indicate new-comers on the spot'.

[31] As too at Petras–Kephala.

[32] Tomkins 2007, 39, 46; cf. Wilson 2007, 54–5.

New styles included dark grey burnished ware with pattern burnishing and painted ware; new shapes (for Crete) ranged from chalices and pedestal bowls to jugs, suspension pots, baking plates and pithoi; ceramic technology, and notably firing technology, leapt forward to produce pottery of high quality;[33] and an important new feature was the appearance of carinated/rounded bases for bowls, which was short-lived: it did not survive into EM IIA.

Pattern burnish ware was used especially for the new shapes — pedestal chalices and bowls, but also suspension pots — that suggest new social and/or cultural needs and ranking, and technical progress (as Mackenzie had noted). While there may have been metal prototypes for the chalices and pedestal bowls,[34] with the sheen of the burnishing mirroring that of copper (whose advent in Crete can now be dated to FN IV–EM I),[35] and while we can note how suited these imposing shapes are for (ceremonial) passing from person to person to partake, there may (also) have been a more mundane reason for the pedestalled shapes: the high stems would have kept the contents well clear of the floor and its dirt. Indeed, one might see the move to smaller drinking vessels and bowls as a sign of more furniture with more flat surfaces off the ground — tables and shelves — in EM II and III. At any rate, the pattern burnish chalices and bowls were high quality products that needed a considerable investment of time and skill to produce, suggesting how important they were for the groups/communities that used them.

Likewise, the suspension pots with pattern burnish must also have been esteemed products. What did they contain that led to their being used so much (whether in pattern burnish or light grey ware) in tombs, but also in settlements? The most likely contents were probably scented oils and unguents, which could have been for anointing the living (to clean up or smell better) as well as the dead. If so, there may be an argument here for a ceremonial use, even at feasts, of the suspension pots together with the chalices and pedestalled bowls, which all complemented each other as performance equipment, even if they did not form specific sets — as was probably the case, since the latticework (or crosshatching) burnished patterns on the suspension pots are quite different from the wavy lines, etc. on the chalices and bowls.

The painted ware in the Well was also new in the ceramic repertoire of Knossos and, occurring mainly as jugs that could have been used to fill the chalices, is another argument for there not having been sets yet of pottery at Knossos in EM I times. Instead, the community seems to have drawn on different products from different workshops for different needs.

There were other important novelties in the EM I pottery of the Well. Perhaps the most fundamental, as it involves eating, is the arrival of the baking plate, suggesting some sort of change, and probably an improvement, in the cuisine. The large size of these dishes would have been ideal for cooking thin flour-based foods, such as pancakes, pitta or chapatis. Another novelty — the tripod cooking pot — appears at Ayia Fotia (Siteia) in the Cycladic repertoire there,[36] which would on Papadatos's arguments put it in his EM IB, but is not found at Knossos until the WCH (where it is rare)[37] and probably a litte later in our A1 deposit (**247–249**: p. 139). Finally, the introduction of pithoi has similarly large implications, both for EM I society and for the advent of the skills to make them, which are part of the great progress of ceramic technology in EM I.[38]

Were there extra-Cretan sources, stimuli or immigrants that could have introduced these developments? Yes there were, has long been Hood's belief.[39] As a preface to a quick re-examination of the evidence, we see the current recognition of Cycladic elements in EM I pottery — and likely settlers bringing their own burial practices — along the north coast of Crete from, at least, Poros to Ayia Fotia (Siteia) as helpful to the argument. Although this movement did not reach Knossos (which is in itself fascinating in view of its being only a few kilometres from Poros), it shows at last in archaeological terms that there is no *a priori* obstacle to incomers into Crete at the start of the Bronze Age. Furthermore, these could well have involved not only people from the Cyclades but others too from other regions, who could have become sufficienttly established on Crete to form and produce the 'Minoan' cultural elements, almost wholly in pottery, that are more or less coeval with the 'Cycladic' elements.

So is there evidence for incomers in EM I from the rest of the Aegean beyond the Cyclades, and/or from the East Mediterranean? The pattern burnish style in itself is not a great help, since this is a phenomenon that occurs widely across the Aegean, although there are some enticing parallels, such as

[33] Betancourt 2008*b*, esp. 16–23, 43–90.
[34] Cf. pp. 33, 44 and 289.
[35] See Betancourt 2008*b*, 100–02, for a recent review of EM I metallurgy, with references; also Papadatos 2007; 2008, 266–7.
[36] Betancourt 2008*b*, 70–1, fig. 5.32 (Davaras and Betancourt 2004, 24–5, fig. 42: 17.20).

[37] Wilson 1985, 341–3, fig. 34, pl. 46: P346–352; 358.
[38] As Betancourt (2008*b*, 78–83, 99; 2010) has emphasised. Cf. too Phaistos, for improvements in pottery and construction techniques (Todaro 2005, 37; forthcoming).
[39] E.g. Hood 1990*a*, 1990*b*, 2003.

on Samos,[40] that seem almost too close for ruling out immigrants arriving in Crete from or via that island. And baking plates and related dietary changes will not help either, that is until we have a very much larger body of culinary information for the EBA Aegean. But the improvements in ceramic technology, the arrival of painted ware, the new types such as jugs, baking plates, suspension pots and pithoi, the technical changes such as hammer rims, and the frequency of lids in a variety of types, and the short-lived appearance of bowls with carinated/rounded bases (which are well suited for sandy habitats), all suggest changes from the FN culture that can be explained probably by the arrival of incomers from overseas, who presumably mixed with the extant people of the island. The ceramic continuity from FN IV to EM I, which amounts to little more than the scored style, is not enough to outweigh this argument[41] — while scoring, as we have seen (pp. 28–30), had a wide vogue (like pattern burnish) around the Aegean and in the East Mediterranean, which may dilute the argument for its necessarily being of indigenous FN origins when it was used in EM I, notably for the new shape of the large water jug. Scoring may be seen instead as just part of the wider Aegean ceramic horizon at the transition from the Neolithic to the Bronze Age.

Alternatively, the radical character of the changes observable between the latest Neolithic pottery of Knossos and that of EM I could be explained if Knossos had been deserted for a considerable length of time after the end of the Neolithic occupation there. On this hypothesis the EM I styles of pottery might have evolved from a FN stage in some other part of Crete during a period when Knossos itself was uninhabited. It is difficult, however, to believe that a prime site like Knossos in the centre of the most fertile part of Crete would have been abandoned for an appreciable time in this way. Desertion of the site on this scale could only have occurred in the wake of some extraordinary event, such as the leading away of the population into captivity as the result of conquest; but such organised depopulation seems improbable in Crete in these early times.

It might be considered necessary to offer an apology for the idea that in Crete at the end of the Neolithic and the beginning of the EBA we are faced with at least one, and perhaps two, waves of immigration by people from beyond the seas establishing settlements there. This is a relatively moderate view compared, for instance, with that of Seager, who suggested that the makers of Vasiliki ware were colonists from abroad, perhaps from Asia Minor, and the settlement of period III at Vasiliki was destroyed by new settlers who introduced light-on-dark ware.[42] The idea that the Early Minoan civilisation was inaugurated by an influx of new people or peoples into Crete is not new. Evans himself thought that some features in the Early Minoan culture were due to refugees from the Delta region of Egypt at the beginning of the Egyptian First Dynasty.[43]

It is the fashion, however, at the moment to interpret the archaeological evidence, which is all we have, as reflecting other factors: in the case of changes of fashion, local evolution is assumed, or at the most local development under the influence of ideas borrowed from other regions. The evidence is admittedly slight and ambiguous, and it can be made to harmonise with more than one interpretation. But the fact that a certain line of interpretation happens to be fashionable does not necessarily mean that it is right. It is heartening that recently Betancourt has written strongly in favour of newcomers in FN–EM I, with more of them coming in EM I but 'spread over several centuries',[44] while Papadatos, comparing Petras–Kephala in the east of Crete and Nerokourou in the west, sees new traditions starting in FN IV at both sites (when 'the wider Aegean world "intrudes" into Crete' — a helpful metaphor), which raises the question, particularly at Kephala–Petras, of how much of the cultural package was really new in EM I and how much was 'the result of increased experience and gradual advancement'.[45]

Finally, it is clear that EM I, despite many local variations in culture and pace of development, is a phenomenon that is recognisable from end to end of the island. We have, however, to admit that, if there were significant groups of newcomers bringing new cultures and practices, there is no agreement, and clues are exiguous, as to where these supposed immigrants might have originated, or how they reached Crete, or where they might have stopped along the way (if they did). The one large exception to this *aporia* is found in the EM I Cycladic element on Crete that lived, died and was buried at several sites along the north coast of the island.

See also a further section on EM IA and EM IB at the end of this chapter.

[40] See p. 252, n. 62.
[41] Hood 1990a, 1990b.
[42] Seager 1905, 207; 1907, 117.

[43] *PM* I, 64–6, 69–70.
[44] Betancourt 2008b, 93–6 (p. 94 for quotation).
[45] Papadatos 2008, 267–9 (p. 268 for quotations).

EARLY MINOAN IIA

Apart from the isolated pieces of pottery that we presented in chapter 10 from Evans's excavations, we have just two deposits in Area A (RRN) to ascribe to EM IIA: the basal deposit A0, which has two likely EM II sherds and another 19 that are Neolithic; and, stratified above it, A1 (Floor VII). However, the upper two excavation levels of this deposit,[46] with about half of the small total amount of pottery in A1, may have been mixed with A2, as was soon recognised; chapter 7 notes what is from possibly mixed deposit. We did not come on EM IIA levels in Area B.[47]

Deposit A1 again illustrates how definitions, especially chronological, of ceramic style cannot be hard edge (to borrow a term from 20th century painting). Thus, anticipating EM IIB, we find a very little Vasiliki ware (cf. **273–274**) in pure A1 contexts[48] and some white-on-dark decoration (**239, 267**) — a style that was known already from the first EM pottery of stage F in Lebena T. II,[49] but is not found in the Palace Well. Looking backwards, we see dark grey burnished ware and scored ware continuing, but the pattern burnish style is very much less than in the Palace Well, or indeed the WCH. The intermediate position of the deposit is encapsulated by two goblets that are of identical shape: one (**186**) however is in dark grey burnished ware, the other (**201**) in buff burnished ware with red decoration that looks forward towards EM IIB. New shapes in A1 include buff ware type 4 bowls with rims thickened internally, two of them from pure contexts, and tripod cooking pots, marking further developments in Early Minoan cuisine.[50] We do not have any type 24 horned stands in this small deposit — but they do occur in the WCH.[51] New decoration includes Myrtos style fans in dark-on-light (**235**). Likely imports from southern Crete are few and a short-lived phenomenon: probably a bowl in fine painted ware **212** and a suspension pot in light grey ware **243**. There is also a scrap of light grey ware in A2. Fine painted ware may have had a variant at Knossos, of a more pink fabric and usually without the row of blobs on the inside of the rim, perhaps a local product.[52]

Apart from the lack of horned stands, A1 seems a fairly complete domestic repertoire that is best compared in general to the WCH, which forms the key deposit for Wilson's West Court House Group of EM IIA early.[53] However, in view of its having Vasiliki ware and light-on-dark decoration, A1 is probably a little later than both the WCH and floor levels in Warren's excavations in RRS (cf. pp. 77, 131). If this makes it tempting to place it with Wilson's North-East Magazines Group of EM IIA late,[54] we must keep in mind that the deposit is not nearly big enough for any certainty.

A better candidate for EM IIA late is the nearby independent A8 deposit excavated a few metres from the main Early Minoan trial (that produced A0–A7). Here again there is a little Vasiliki ware, but the dark grey and red and brown burnished wares are about five times as plentiful as in deposit A2 of EM IIB. A8 also has a larger number of buff bowls with internally thickened rims than A1, and three horned stands. This may suggest that A8 is somewhere intermediate between A1 and A2, and could be assignable to EM IIA late. We await the publication of the EM IIA levels in Warren's RRS excavation to know how A8 and A1 fit into their sequence.

EARLY MINOAN IIB

For EM IIB we have a range of stratified deposits that yield a valuable sequence. In Area A, deposit A2 is associated with a building of some quality, surviving principally as wall απ and Floor VI, which had been built over A1/Floor VII. A2 belongs with the building, and has several complete vessels, and large fragments of others, which may suggest a destruction level. If so, it could be the same as, or be roughly contemporary with, the destruction that we presume can be inferred from the whole pottery that Evans found in Area B in 1908 (which we have presented in chapter 10). A3 (Floor VI mixed with Floor V ?) is the upper fill above Floor VI. Next above that is A4/Floor V, with traces of a wall.

In Area B (the Early Houses), the sequence is not so clean (pp. 86–9) as in Area A, but it is still useful for the ceramic history of Knossos. Deposits B2 and B1 were sealed by the EM III B3 deposit and the architecture of the SFH, as was pit C (even if we excavated it partly with B2 and partly with B1: a misunderstanding that was resolved by Momigliano and Wilson's excavation in 1993).[55] B2 and

[46] LA109–LA110.
[47] But there was EM IIA late nearby (p. 83 and n. 41).
[48] For Vasiliki ware in A1 and A8, cf. Wilson 2007, 69 on its rare occurrence in EM IIA late contexts at Knossos.
[49] Alexiou and Warren 2004, 117–18.
[50] Cf. Cadogan 1986, 155.
[51] See p. 264 (and n. 93 for references).
[52] Cf. p. 258, and Wilson 1985, 307. Wilson and Day (1994,

81–2) keep fine painted ware only for the vessels imported from the Mesara; local Knossian variants are (local) light-on-dark painted ware.
[53] Wilson 2007, 57–61.
[54] Wilson 2007, 61–9.
[55] See Wilson and Day 1999, 40, for the possibility of assigning the pit to 'later(?) EM IIB'.

B1 are linked to two earth floors, which overlay Neolithic remains. What both the 1960 and the 1993 excavations have not revealed, however, is any architecture or any floors, let alone destruction levels, that could have been associated with the whole pottery that Evans found apparently as floor deposits. One may imagine that it would have been architecture of some quality, as we find in the EM III immediately SFH above, to match the quality of the EM IIB whole pottery, and indeed house it.

In the *Knossos Pottery Handbook*, the pottery from the different EM IIB deposits within the Early Houses, including pit C and its continuation in the 1993 excavations, forms collectively the South Front Group that defines EM IIB. It is, however, worth exploring the possibility of developments in the pottery of both areas within EM IIB.

In the Area A deposits we still find some dark grey burnished ware pottery, and red and brown burnished wares, in A2[56] and, to a much lesser degree, in A3; and they have gone by A4. These pieces in the two lower groups may not all be EM IIA strays, but may just be still in contemporary contexts as the last instances of old styles (cf. p. 156 for discussion for A3) — or may indicate that some of the pottery came from fills or dumps. The A2–A4 deposits all have Vasiliki ware, and fine buff ware, but there are observable trends that mark the changes from EM IIA towards EM III. In A2 there is less light-on-dark decoration than dark-on-light (except for type 9 bowls that prefer light-on-dark); by A4 some of the light-on-dark decoration (**549–550**: p. 167) looks to be anticipating EM III. Some of the Vasiliki ware is almost certainly imported — as top quality Vasiliki ware — from the region of the isthmus of Ierapetra, but much could perhaps be called better Vasiliki-style ware, with differences in shape, technique or finish that may suggest local manufacture of the product somewhere near Knossos, as may have happened at other Early Minoan centres.[57]

The story is generally similar in B1–B2 to that in A2–A4. B2 is about twice as big a deposit as B1, which should be kept in mind if comparing frequencies. For instance, B1 has two horned stand fragments (**903**), but B2 three (**1042**):[58] in both cases it is interesting to see that they have such typical EM IIA products which, as with the burnished wares in Area A, may indicate the end of a tradition or that the deposits to some extent came from fills or dumps[59] — which is clearly the case for Pit C and the EM III deposit B3. Thus both B1 and B2 have a few burnished ware fragments, and both Vasiliki ware. From B1 to B2 the dominance of goblet rims with dark washes grows, and dark washes on type 16 bowl-jars become more common. But type 15 jugs such as those that Evans found (**1332–1333**) can be matched in either B1 or B2 — although **995–998** in B2 may just be closer — and would fit well with **374–376** and **379** from A2, pointing to the long use of this type.

EARLY MINOAN III

In Area A EM III is represented by deposits A5 (Floor IV), A6 (Floor III), and A7, which is in two parts A7.1 and A7.2 that appear contemporary with Floor III. The pottery of A5 is stratigraphically clearly older than that of A6, and also probably than that of A7. A6 is a very small deposit, A5 about four times as large and A7 about five times as large. In Area B the most important evidence from this sounding is B3, a fill laid down and sealed between two floors in the South Front House: the upper floor 5 marks at the least a relaying of the lower floor 4, and possibly was part of a more extensive rebuilding of the SFH. B3 is the second largest deposit after the EM I Palace Well of those that we are publishing in this volume, but is still much smaller than the fill of the Well (TABLE 2.1).

In the *Knossos Pottery Handbook* deposit A5/Floor IV[60] is assigned to the SFH Foundation Trench Group of EM III early, and A6/Floor III to the Upper East Well group of EM III late[61] — where B3 in Area B is also placed,[62] and deposits A7.1 and A7.2 should belong too. More problematical in Area B is the part of the fill in pit A, the foundation trench for wall β (see the lengthy discussion of the stratigraphy on pp. 89–91 above) as it was found in our excavation. We have virtually no material from this western part of pit A (which we excavated in trench A) to add to Momigliano's account of

[56] A2 also has a horned stand (**403**); but A3 and A4 do not.

[57] Betancourt (1979, 27–8) suggests some nine production centres including Knossos (cf. Pelon and Schmitt 2003); however, Whitelaw *et al.* (1997, 270) note basically one (Isthmus of Ierapetra) fabric among the Vasiliki ware sampled at Myrtos–Fournou Korifi; while Day *et al.* (1999, 1032–3) report two groups of Vasiliki ware among finds at Knossos (Ierapetra isthmus, and a metamorphic group of unknown source). Cf. Wilson 2007, 73–6, noting how EM IIB red to black burnished ware at Knossos (Wilson and Day 1999, 32–4, 39, 52–3) can look like Vasiliki ware.

[58] And there is one in B3 (**1135**), which may be a stray (cf. discussion of horned stands on pp. 264–6).

[59] As Wilson and Day (1999, 4–5) suggested for Evans's pottery from the Early Houses.

[60] Momigliano 2007c, 81: 3. Although called 'floor iii', it is Floor IV that is intended: see p. 75 and TABLE 4.1.

[61] Momigliano 2007c, 83: 10. Although called 'floor ii', it is Floor III that is intended: see references above.

[62] Momigliano 2007c, 83: 8.

the group, although the part of pit A which she and Wilson excavated in 1993, to the E of trench A, did produce enough pottery to give its name to the EM III early group.[63] In short, the part that we excavated of the Early Houses seems to move straight from advanced EM II (EM IIB) to advanced EM III (Momigliano's EM III late).

In A5 there are features that seem to look back to EM IIB, such as the mottled dark wash of the type 8/9 bowls which is reminiscent of Vasiliki ware, but the resemblance may be fortuitous (see pp. 170–1). It does, however, help to explain the Vasiliki-like appearance of a probably EM III teapot in the British Museum and the uncertainties of where to assign it (**1356**: p. 278). It is noticeable too in A5 that the rims of the type 16 bowl-jars seem closer to the EM IIB shapes than to those of the full EM III of B3 (p. 172).

The pottery of B3 and similar deposits is, as several scholars have remarked, closer to that of MM IA than to that of EM II, and it is often difficult to know where to place isolated finds such as the footed goblets and goblets from Knossos discussed in chapter 10 — or the bridge-spouted jar from Lapithos in Cyprus, which is a product of north-central Crete that could be EM III or MM IA.[64] But a big contrast with MM IA is that neither B3 nor A5–A7 had any polychrome (red and white on black) handmade pottery of MM IA type. Likewise at Phaistos Todaro reports that Phaistos VIII had three phases (Phaistos VIIIA–C) with white-on-dark pottery; we agree with her in keeping the absence of polychromy as an important distinction between EM III and MM IA.[65] Momigliano,[66] however, has pinpointed a few polychrome pieces (less than a dozen) in apparently UEW Group contexts,[67] all of them of unusual fabric or treatment and most likely not local products but probably from southern Crete. While these may suggest that polychromy appeared first on pottery in the Mesara, they are not enough to make polychromy a regular and local feature of Knossian EM III. (They also mark a degree of resumption,[68] after a peak in EM IIA followed by cessation in EM IIB, of the export of pottery from the Mesara to northern central Crete.[69])

It is clear that there is still plenty to do, at Knossos and elsewhere, in refining the sequences of EM pottery and identifying local and regional characteristics so as to produce a temporally and spatially comprehensive account of this pottery that will, absent a wide series of radiocarbon dates, probably remain the principal way of connecting the historical events of Crete — the foundations, expansions, destructions, abandonments, and likely movements of people — in the millennium or so of the Prepalatial period. Furthermore, the pottery will continue to offer rich evidence for new insights into the daily life of the Early Minoan people(s), as the research of the last 20–30 years has demonstrated. It will be interesting to see, and now is too early to tell, to what extent various key features such as light grey ware, or horned stands, or Vasiliki ware, will 'harden' as chronological and cultural markers or whether there will continue to be a certain fluidity in defining phases in ceramic terms, as we believe is now the case. As part of this work, those studying EM pottery will need to evaluate and re-evaluate all deposits across the island to agree on the extent of their primary or secondary nature. We hope that the deposits from Knossos that we have presented in this volume will help the progress of what is fundamental research for understanding EBA Crete.

EARLY MINOAN IA AND EARLY MINOAN IB

Sinclair Hood

The abundant pottery from the Palace Well was originally assigned by us to EM IA. This was because we believed it to reflect a very early phase of EM I which had not previously been identified. But the use of the term EM IA for this might reasonably be considered premature in the absence of any deposit of pottery of comparable size assignable to EM IB.

Our dating of the Well deposits to an early stage of EM I was essentially based upon the difference between the chalices (large footed drinking cups) from it, with their relatively thick waists, and the

[63] See Momigliano 2007c, 81: 1, with references; and they excavated another EM III early deposit nearby to the s (Momigliano 2007c, 81: 2); p. 83 above; and Momigliano and Wilson 1996, 47–52.

[64] Kehrberg 1995, esp. 187, 192–9, with references.

[65] Todaro 2009a, 139–40. Polychromy begins in Phaistos IX.

[66] Momigliano 2007c, 87–90.

[67] Momigliano 1991, 201–02, fig. 14, pl. 40; 204: 19 (Early

Houses); 221, 231, pl. 47: 42 (House B); Batten 1995, 78–9 (Theatral Area). But see Todaro 2009a, 140, with discussion also of Momigliano 1991, 221, 231, pl. 42: 38 (House B).

[68] Todaro (2005, 20 and n. 29) also proposed as other evidence: Momigliano 1991, 159, 163, pl. 21: 41 (UEW); and perhaps *PM* I, 110–11, fig. 78.

[69] Cf. Day *et al.* 2006, 64.

chalices akin to them in size, but with narrow waists, sometimes with a blob of clay added it seems to strengthen them. There were no remains of narrow-waisted chalices of this type from the Well; but a number of them were recovered by Xanthoudides from the early communal tomb at Pyrgos east of Herakleion. There may be remains of such chalices in the SMK, but nobody seems to have drawn attention to them. The only example from Knossos, about which I know, is the fragment of the waist of one from a sounding of an area of the Throne Room of the Palace made in 1987. The soundings here were under my aegis, and I have written a report on the pottery from them; but the excavations were delegated by me to Don Evely with Vasso Fotou as architect. Their reports are not yet to hand, but I have their agreement to my mentioning this discovery here. The pottery from the sounding with this fragment was not abundant, but it seemed to be pure EM I in character. It was not clear, however, whether the deposit was formed then, or consisted of rubbish brought from elsewhere to serve as fill below the earliest Palace floor.

Besides the narrow-waisted chalices, which, it seems widely agreed, should be assigned to EM I, the tomb at Pyrgos also contained pottery of EM II date, some or all of it assignable to EM IIA. This later material included goblets much smaller in size than the chalices found at Pyrgos with them and in the Palace Well. A change in drinking customs may have been responsible for a shift from the use of large chalices to that of small goblets: a change from the custom of all those eating together sharing the same vessel for drink to everyone using a goblet of their own. The custom of sharing the same vessel for drinks at meals may be one of great antiquity, but has no doubt survived here and there into recent times. When I was travelling in the Antalya region of southern Turkey in the 1950s looking for prehistoric sites, it was usual to descend on a village and expect to be fed and accommodated for the night. The sleeping place was often a bench in the local café; but sometimes a family with great generosity offered a meal and a place to sleep on the floor in their house. I remember that on one occasion when this happened, to my great surprise at the family meal in the evening, we all drank water from the same fairly large vessel, some kind of bowl I think it was, not a chalice. This was not the occasion of a feast or part of a ceremony of any kind, but as far as I could see, just the routine of an ordinary family evening meal.

It would be interesting to know the ethnographic evidence for the existence of such a custom of cup-sharing, and what the evidence for it is in the archaeological record elsewhere than in Early Minoan Crete. Like the pottery itself from the Palace Well, with its footed chalices and the bases of other types of vessel rounded and not flat as in Crete later, this might help to suggest the area from which people came to Crete to inaugurate the EM period there, as I believe they did. The boundary between EM I and EM II may coincide with a change from all drinking from the same chalice to using smaller individual goblets.

The chalices with thin waists, with or without a blob of clay on them, look as if they were of shapes copied from contemporary metal vases. These would probably have been of gold or silver, easier than copper to work into drinking vessels like them. The use of vessels of precious metals is attested in the EBA in Greece and the Cycladic islands. Why not also in Crete? Metal chalices like those of the Palace Well may also have existed, but the Palace Well chalices do not display any features which might be considered metallic.

In excavations at Poros, site of the nearest Bronze Age harbour town to Knossos, chalices of both the Palace Well and narrow-waisted types are reported to have been found together. It is not yet clear whether this was in a fill, or above a floor in a destruction deposit. In either case, however, this does not necessarily mean that the Palace Well types was not earlier in its first appearance in Crete than the narrow-waisted type, since with any such change of fashion there is likely to be a period of overlap when the old and the new are in use together. The evidence of the Well certainly suggests that the simple type of chalice so well represented there was in use earlier in Crete than the narrow-waisted one.

Finally, it must be emphasised that the range of different types of vessel from the Well does not support the idea that the chalices were relics of feasting or drinking bouts; which does not of course mean that such activities were not a feature of life in Crete at the time. The range of different types of vessel from the Palace Well is considerable, and consistent with the view that they reflect what was in general use for cooking and eating at Knossos then. It is interesting that the report of Valasia Isaakidou on the animal bones from the Well reaches a similar conclusion about them.

Chapter 12

Conclusions

How do the three excavations we have described contribute to our understanding of Early Minoan Knossos and its culture and history? We shall now attempt to answer these questions, while keeping in mind that, as we said at the start of Chapter 11 (p. 281), there are several reports to come that will add to the picture. In the meantime judgements are necessarily provisional. A further constraint for us in viewing EM II and III at Knossos is that our Areas A and B lay on the fringes of the settlement. While then they can tell us about its growth northwards and southwards, they cannot provide evidence for what was happening in the area of the later Central Court or between that part of the hill and the later West Court, and virtually nothing to add to the debate about possible predecessors of the Palace, or proto-palaces.[1]

EARLY MINOAN I

The EM I Palace Well, the first Bronze Age well of Knossos, and probably the second oldest well known from Crete (after the FN IV well at Fourni)[2], offers valuable evidence for the life and community organisation of the settlement on the Kephala hill at the start of the Bronze Age.[3]

Technically, the Well must surely have been considered a feat when it was dug, a distinction for whoever commissioned it, and a fine achievement by its digger(s). We may imagine that the task (pp. 21, 70) required a water diviner to locate the underground aquifer, and a master well digger in charge of the team that had the hard, perilous task of digging it, to 17.2 m. It is highly probable that both these people were specialists — these are not everyday skills — and quite possible that, one or both, they were itinerant experts who brought their experience to anyone who commissioned them. A single community, even if it was Early Minoan Knossos, is unlikely to have been a large enough body of people to sustain two such occupations within the community.

The Well required also a person in all likelihood, who would have been a 'chief', or perhaps a group, to commission a project of great value for the community, with the skilled labour to carry it through, and then ensure that it was maintained properly, with no animal carcasses thrown in[4] or other pollution. The Well would have been an immediate and most welcome addition to the resources of the community and at the same time a stimulus to social cohesion, since maintaining a well demands discipline and courtesy (for the sake of public health and fair shares of the water) as well as offering opportunities to meet neighbours, or people of the other sex, or outsiders. Since it might have held up to 2 tonnes of water at maximum, to guesstimate from the depth and diameter of the Well in its use levels at the bottom (deposit 1), it is easy to imagine that it was the main source of water for the settlement in EM I, and certainly for more than one household, unless that was the chief's — which might anyway mean that it was still somehow a large communal benefit. For us its having been dug is a strong argument for the community's having had a chief, but one cannot exclude the possibility that this well was the result of a decision by a group within the community. Similar considerations would have applied to the levellings that led to the FN IV–EM I Court which Tomkins has proposed as marking the beginning of the Central Courts of Knossos, with an enlargement in EM IIA.[5]

The Well's going out of action, during EM I and before it became a dump (a frequent fate for old wells), must have been a heavy blow to all or some of the Knossos community. We cannot say what went wrong but there could have been a destruction by fire of the settlement: this is one explanation of why much of the pottery, and some of the animal bones, in the fill (deposit 2) are badly burnt.

[1] But see important discussions, with references in Tomkins forthcoming *a*, and Whitelaw forthcoming; also an overview in Warren forthcoming.

[2] Manteli 1992.

[3] Cf. Warren 1981, 630.

[4] Valasia Isaakidou sees (above p. 66) the small number of animal bones found in the bottom levels that form deposit 1, with most of them coming from the top of the deposit (where they could have percolated from deposit 2), as a sign of the good management of the Well when it was in use as a well.

[5] Tomkins forthcoming *a*.

The Palace Well also gives us evidence of (probably improved) farming in EM I, with the first of several Prepalatial vine leaf impressions from Knossos (the next is EM IIA) and two olive stones, and improved storage in pithoi and what appear to be clay bins. The pithoi and bins are in turn further evidence of improved farming producing higher yields that needed storing, and possibly concentrations of agricultural wealth in the hands of a few people, or one person alone, in the community. These pithoi at Knossos are among several groups of them that appeared in Crete in EM I, which again supports the idea of improved agriculture, but across the island. The fact that any Neolithic predecessors on Crete do not have relief rope patterning (p. 52 and n. 245) may also be telling, as another break with the past, as well as being a sign of the skeuomorphic imagination of the EM I potters, which we see above all in their gourd-like round-bottomed jugs. It may also be a sign of improved transportation in EM I, with its hint of a greater abundance of donkeys for roping the pithoi to.

For diet, the Well offers the first baking plates and also apparent pot boilers — a rarity in Minoan studies — for stew or soup. The animal bones show all the four major farmyard species in deposit 1; a dog joins them in deposit 2.

There is a little evidence for other crafts from the Well (see also pp. 59–62). It may offer the first evidence for using lime plaster (as well as mud plaster); obsidian came from Melos, to be used in one case for a tranchet arrowhead; the first Bronze Age roundels (discs cut from sherds) continued a practice that went back to MN Stratum VII at Knossos, and at Phaistos has been connected with the management of EM pottery production.[6] This tends to suggest specialist potters, for which the technical quality of the chalices, pedestalled bowls and suspension pots, and the appearance of the large water jugs and pithoi are even better evidence, probably with separate workshops specialising at least in different shapes and finishes. No Cycladic-style pottery was found in the Well, by contrast with contemporary (?) Poros–Katsambas down the Kairatos river by the sea, where plenty is reported.[7]

The chalices and pedestalled bowls of Knossos are prestigious and high-quality tableware, which were intrinsically valuable for their quality and the investment of labour and skills to produce them. Since their capacity is too much for one person, they suggest, at the very least, eating together by groups of people, such as for example different households — or commensality. While this does not preclude that this happened principally or solely at feasts involving much alcoholic drink and much meat (as γλέντια do in Crete), such symbolically important events need not have been the sole occasions when the chalices and bowls were used, as has been discussed (cf. pp. 70–1, 284, 289).

Study of the taphonomy of the animal bones from deposits 1 and 2 (pp. 64–7) shows that they had been were lying around for some time, being gnawed by scavengers, and seemed to have accumulated gradually, before being dumped in the Well after it became redundant as a source of water. Some of the bones were burnt, in high temperatures, which does not point to cooking meat on the bone so much as to accidental or destruction fires, or deliberate burning as in bonfires for burning rubbish. But since few bones were burnt — and in one case the burning happened after the bone had been gnawed by a rodent, just as some of the pottery was burnt after it had been broken — it is considerably harder to identify a general destruction by fire (unlike later examples such as in the Palace of Nestor and at Assiros in northern Greece). It is also hard to identify isolated feasts from the bones, but the quality and size of the tableware make it quite possible that these could have happened, perhaps in a familiar pattern of grander occasions breaking the routines of daily or regular eating together. Multiple explanations of the deposit are possible. It is likely that the pottery and animal bones piled up gradually before being cleared away and dumped in the Well, after a fire or fires. This may have been a bonfire to burn the rubbish and purges sources of disease, it may have been a destruction by fire of some or all of the settlement. Or it could be a combination of these, such as a bonfire's getting out of control.

If the burning observable in the Well was occasioned by arson with hostile intent, that would be a further sign of upheaval(s) in EM I, which one might connect with the suggested arrival(s) of incomers over quite a lengthy period, as we have discussed (pp. 284–5). Some may see too big an initial 'If' to make this likely. However, another hint of change and upheaval may come from an apparent contraction in the Kephala settlement in EM I. In Areas A and B we see EM IIA (Area A) and then EM IIB (Area B) people settling in places that had Neolithic scatter and lay presumably at the edges of the the Neolithic settlement; but these same places have no signs at all of any use in EM I and were clearly outside the EM I settlement, which very probably had shrunk from the size of its Neolithic predecessors.[8]

[6] Todaro 2009b, 341–4 and figs. 6d, 7d, in EM IIA, EM IIB and EM III contexts. Cf. Todaro forthcoming.
[7] Wilson et al. 2008.

[8] Wilson (1994, 35–6) raises the question, and emphasises how difficult it is to tell at Knossos in view of the many later terracings and rebuildings.

EARLY MINOAN II

The apparent upheaval(s) of EM I (whether human-made or following natural disasters such as earthquakes) continued in EM II, in the EM IIA destruction that brought down the West Court House and also perhaps, if we are correct, in an EM IIB destruction that could be inferred from the whole pottery that Evans found in Area B and that we found in deposit A2, the first EM IIB horizon (Floor VI) in Area A. However, in view of the evidence of expansion in EM IIA and later on the western side of the later Palace, i.e. between the Central Courts and West Courts, the destruction of the WCH may not have been the result of revolution, war or earthquake, but rather deliberate demolition as part of the long-running building programmes of Knossos, and linked with the terracings and fills of which there was considerable evidence across the site.[9]

Beneath A2, deposit A1 seems a little later than the WCH, revealing how the settlement expanded during EM IIA, when growth may have happened first in a westerly direction, as Warren's excavations in RRS, and a test by Pendlebury below the Palace car park[10] suggest, before spreading to the lower slope of the hill to the north, which was basically virgin territory. As a small deposit, A1/Floor VII otherwise adds little to the current picture of the 'large-scale reorganisation of the settlement in EM IIA'[11] but, because of its position at the bottom of a multi-floor stratigraphic sequence, is valuable for defining the local ceramic history of Early Minoan Knossos. But imports of pottery, whether light grey and fine painted wares from the Mesara or Vasiliki ware from the Mirabello region are few, and from the Cyclades non-existent (although **275** may be from the eastern Aegean).

The triangular clay rubber or pot burnisher **233** from A1 has an EM IIB counterpart **412**, which seems to have been made from a sherd of an imported EC IIA jug. For building and decorating, A1 has evidence that black was used as a colour on wall plaster as well as red.[12]

EM IIB in Area A is marked by an apparently impressive, but vestigial, building associated with Floor VI and wall απ, which may in turn connect with the EM structures under the Armoury (see p. 79). This construction suggests continuing expansion of the Knossos settlement in establishing a building of some importance on its northern fringes. The building, however, may not have lasted for long, if we are right in seeing a destruction that terminated it (and the Floor VI horizon). Rebuilding followed (as A4/Floor V), still within EM IIB.

In Area B on the southern fringes of the settlement the EM IIB Early Houses, which underlie the EM III South Front House, were a development on virgin ground and another sign of the settlement's continuing growth. But here too, as in Area A, there may have been a destruction, of which we found no traces in our excavation but which we infer from the whole pottery that Evans found. If we are correct in associating this proposed destruction with the horizon of B1, then B2 represents reoccupation (and likely rebuilding), which would match both what seems to have happened in Area A and the building events, involving terracing and fills, that Wilson and Day have suggested for the Early Houses from their study of the pottery in the SMK from Evans's excavation.[13]

This EM IIB evidence from the edges of the settlement is tantalising since it is hard to relate it to what happened in the centre, or the settlement as a whole, because our knowledge of EM IIB at Knossos, especially in the centre, is about as scanty as it is for EM I.[14] There may, however, be a clue in the ramp found in 1987 sw of the North Lustral Basin, and datable perhaps to the building programme of EM IIA, perhaps to EM IIB, that seems to have been leading up the Kephala hill from the north.[15] If one allows some turns in the path, this could have been a link with the Armoury and Area A EM II site, especially if the turns meant following any track that was a predecessor of the later Royal Road to reach the ramp. The existence of such a track is highly probable, principally as it would have defined, or helped define, the route of the Royal Road.[16]

Area B has produced a clay roundel (like those from the Palace Well mentioned above), and Area A another two of EM III date, but they remain fewer than the nine from the WCH. (If Todaro is right to connect them at Phaistos with pottery production in the western part of the settlement,[17] is it significant that there was also a (small) concentration of them in the western part of the Knossos settlement? Is this a hint of pottery making nearby in EM IIA?)

[9] Cf. Tomkins forthcoming *a*; Wilson 1994, 36–7.
[10] Whitelaw forthcoming.
[11] Wilson 1994, 36; Tomkins forthcoming *a*.
[12] See p. 227, where also brown or black paint (it is uncertain which) is noted on plaster from Ao.
[13] Wilson and Day 1999.
[14] Wilson 1994, 37. But see Tomkins forthcoming *a* for a most

important discussion of the growth of the (Central) Court and structures around it from FN to MM IA.
[15] Catling 1988, 69, fig. 94; Hood 1994, fig. 1; Wilson 1994, 37–8.
[16] Cf. Warren 1994, esp. 191, fig. 1; 201–02, 204–05.
[17] Todaro 2009*b*.

Vasiliki ware occurred in both areas, some of it probably locally made rather than imported from the Mirabello/isthmus of Ierapetra region. Nothing has been identified as coming from the Mesara or the Cyclades, other than some obsidian from Melos in EM IIA and IIB, with a very small admixture of the smoky 'Anatolian' obsidian — of which there was a relatively larger amount in the EM III B_3 deposit. The arrival of tripod cooking pots suggests continuing improvements in the Knossian cuisine. Two phalli in A_3 are both a curiosity and evidence to include in discussions of gender and the roles of males in Cretan society of the Bronze Age.[18]

EARLY MINOAN III

In Area B the construction of the South Front House was a significant declaration of someone's status in erecting a building of quality on top of the EM IIB Early Houses. Its two distinctive red floors separated by the B_3 fill deposit show that it had at least two building phases, and possibly more. On the basis of the evidence primarily from the 1993 excavation, these can be seen to correspond to Momigliano's EM III early and EM III late. In Area A we came upon two main floor levels (Floors III and IV/deposits A_7–A_5) beneath Floor II of LM IA.

Both areas produced evidence for innovations in the material culture. Area A has two stone vase fragments, still rare in settlements, and a clay model of some kind. The richer evidence is from B_3, the fill that, just because it is made up of discards, may be a further sign of how important the SFH was in that its occupants could afford to dump in a fill the items that we found. This claim rests on a supposition that the B_3 fill came originally from the SFH (which is not unreasonable in view of its function as a fairly thin hard core support for a new floor in remodelling the building) or from somewhere close by. Wherever its original source, B_3 has interesting data for such a small deposit: an East Cretan EM III imported jar; a higher presence than in EM IIB of the more exotic 'Anatolian' variety of obsidian; a very early, if not the earliest known, use of serpentine as the stone for a stone vase; and the bottle or jar stopper that had been stamped repeatedly by an ivory seal — and had become a discard for the persons who remodelled the SFH. Of the Parading Lions group, it is a key part of a continuing debate on the role of early seals and sealings in administration. Did it relate to just one household, or the larger community? What is the significance of the lions, especially since similar beasts occur on seals from tombs? They seem to have been a marker of high status (p. 234) which, one may easily imagine, was royal status of some sort, in view of the centuries-old link of lions and royalty. The consensus at present favours a collective or communal use of the original seal(s) which it is hard to define more closely.

The South Front House must be associated with the major expansion of Knossos in EM III continuing into MM IA, but it is not easy to be more precise about how it was connected. During this time the extent of the settlement at Knossos grew well beyond the Kephala hill to reach an estimated area of between 20 and 33 ha, as compared to 6.5 ha in EM II.[19] These EM III developments[20] include the first known of the built roads of Knossos,[21] houses and a large terrace wall below the level of West Court, the Upper East Well, perhaps the Hypogaeum (pp. 22, 81) and the Keep (p. 243), and, last but not least, the impressive wall —the North-West Terrace — at the NW corner of the Palace that could have been a very large terrace wall or part of the first truly monumental building (palace?) at Knossos, or have served both purposes.[22]

How could the South Front House fit into this expansion? It is tempting to see it as having been built with some protective/ceremonial/liminal purpose, quite apart from being a good place for someone to live. It is likely that the route up to the Kephala hill from the south that can be associated with the Stepped Portico and Viaduct was in use for centuries before — as a little MM IA evidence suggests;[23] but it would not be surprising that there was a path there long before that (which, by EM III–MM IA, would have come directly from any occupation of that time on Lower Gypsades[24]). On ascending the Kephala hill, this route would have passed close to the South Front House, as later it passed very close to the South House; and the SFH would probably have commanded this way up the hill. It may well then have had some purpose on the lines we suggest, to greet, or deter, people intending to proceed to

[18] Cf. Cadogan 2009, esp. 228–9.
[19] Whitelaw forthcoming, seeing for late Prepalatial (i.e. EM III–MM IA) 20 ha as a minimum, and 33 ha as quite possible, rising to 37 ha if one includes likely occupation on Lower Gypsades.
[20] Usefully reviewed, with references, by Macdonald (forthcoming), Momigliano (1999, 71–4), Tomkins (forthcoming a), Whitelaw (forthcoming) and Wilson (1994, 37–8); and cf. MacGillivray 1994, 49–51.

[21] Warren 1994, 202, 205: a N–S road.
[22] The North-West Terrace: Catling 1974, 34; 1988, 69; Hood 1994; Macdonald forthcoming; Tomkins forthcoming a; Whitelaw forthcoming. This wall is now well illustrated, and briefly discussed, by McEnroe (2010, 41–2, figs. 4.16–4.17).
[23] Warren 1994, 204.
[24] Whitelaw forthcoming.

the central area and the major structures that were starting to appear on the top of the hill in EM III? If this is near the truth of what happened, it becomes possible to see it as a potential southern counterpart to what may have been a similar function (perhaps among several different functions) for the Keep on the northern approach to the central area[25] (if, of course, the Keep did go back to EM III). It is also possible to see it as in some way a symbolic predecessor of the South House, (whose construction displaced the earlier approach route from the south),[26] and perhaps too as having a special connection to Juktas, the holy mountain that is so clear from the southern slope of the Kephala hill.[27]

Two final points. We found no clay 'sheepbells' in our EM III deposits, although they are a feature of the UEW deposit.[28]

Equally, we found nothing in either area to suggest a destruction with fire to end their EM III occupations, although Mackenzie did believe that there was an 'universal catastrophe' marking the end of EM III.[29] Nor did we find any evidence for any fire destructions in EM IIB or EM IIA. The sole evidence we have that may indicate a fire destruction dates to EM I, from the Palace Well.

[25] Cf. now Macdonald forthcoming.

[26] *PM* II, 165.

[27] As Evans (*PM* II, 373) wrote, in discussing the South House: 'with the peak of Juktas peering above the opposite hill of Gypsades'.

[28] Andreou 1978, 21, pl. 1: 29–31; Morris and Peatfield 1990,

with other find-spots at Knossos.

[29] Mackenzie 1906, 253; discussed by Momigliano (2007c, 81–2), who emphasises the complete lack of evidence of burning in the UEW Group pottery deposits of EM III late. Cf. too Macdonald forthcoming.

Appendix 1

Petrography concordance

This list shows the pieces with a publication number that Wilson and Day have sampled for petrographic analysis:[1]

Wilson and Day sample number	Publication number	Wilson and Day sample number	Publication number
KN 92/2?	118	KN 92/158	963
KN 92/3	124	KN 92/166	Probably 833
KN 92/4	5	KN 92/167	884
KN 92/5	7	KN 92/174	983
KN 92/6	16	KN 92/175	919
KN 92/7	9	KN 92/176	917
KN 92/10	119	KN 92/178	822
KN 92/11	113	KN 92/179	See under 823
KN 92/12	62	KN 92/189	894
KN 92/13	63	KN 92/190	858
KN 92/15	36	KN 92/193	864
KN 92/16	101	KN 92/194	860
KN 92/23	47	KN 92/195	895
KN 92/24	64	KN 92/196	959
KN 92/25	138	KN 92/201	873
KN 92/26	58	KN 92/202	848
KN 92/28	120	KN 92/203	1033
KN 92/29	127	KN 92/207	859
KN 92/30	130	KN 92/208	978
KN 92/32	84	KN 92/230	1048
KN 92/33	82	KN 92/231	1046
KN 92/34	85	KN 92/234	1124
KN 92/40	141	KN 92/237	1125
KN 92/41	148	KN 92/245	1143
KN 92/45	126	KN 92/253	1083
KN 92/48	70	KN 92/254	1131
KN 92/49	71	KN 92/255	1132
KN 92/50	72	KN 92/261	1202
KN 92/51	73	KN 92/281	1282
KN 92/156	996	KN 92/371	1210
KN 92/157	997 or 998		

[1] See esp. Wilson and Day 1994, 1999, 2000.

Appendix 2

Museum concordance

The lists below apply to the museums other than the Stratigraphical Museum at Knossos, which we know to have Early Minoan pottery from Knossos.

ASHMOLEAN MUSEUM, OXFORD

AM AE.737.1, 3, 7, 9–11, 13	**1257**	AM 1910.148	**1311**
AM AE.737.2	**1205**	AM 1910.149	**1303**
AM AE.737.4	**1181**	AM 1910.150	**1304**
AM AE.737.5–6, 8, 12, 14	**1206–1207**	AM 1910.151	**1318**
AM AE.753.5, 757.1	**1185**	AM 1910.152	**1320**
AM AE.757.11	See under **1185**	AM 1910.153	**1321**
AM AE.2236	**1302**	AM 1910.157	**1312**
AM 1909.342a	**1180**	AM 1910.158	**1334**
AM 1909.342b	**1179**	AM 1938.407	**1258**
AM 1909.966	**1224**	AM 1938.410	**1322**
AM 1910.145	**1332**	AM 1938.411	**1313**
AM 1910.146	**1328**	AM 1938.420	**1355**
AM 1910.147	**1310**	AM 1938.823–4	**1184**

BRITISH MUSEUM, LONDON

BM A434	**1356**	BM A466	**1352**

HERAKLEION ARCHAEOLOGICAL MUSEUM

HM 5727	**1199, 1208**	HM 10806	**1305**
HM 10800	**1331**	HM 10807	**1306**
HM 10801	**1337**	HM 10808	**1307**
HM 10802	**1301**	HM 10809	**1308**
HM 10803	**1330**	HM 10810	**1314**
HM 10804	**1323**	HM 10811	**1315**
HM 10805	**1317**	HMs 1099	**1167**

LIVERPOOL MUSEUM

LM 51.105.73	See p. 247 and n. 24	LM 51.105.77	**1342**
		LM 51.105.80	**1285**
LM 51.105.75	**1341**		

METROPOLITAN MUSEUM OF ART, NEW YORK

MMA 11.186.1	**1333**	MMA 11.186.6	**1354**
MMA 11.186.2	**1325**	MMA 11.186.7	**1349**
MMA 11.186.3	**1324**	MMA 11.186.25	**1344**
MMA 11.186.4	**1353**	MMA 21.100.3	**1350**
MMA 11.186.5	**1348**		

MUSÉES ROYAUX D'ART ET D'HISTOIRE, BRUSSELS

MRAH A2008	**1340**	MRAH A2010	**1345**
MRAH A2009, A2012, A2013	**1343**		

NATIONAL MUSEUM, COPENHAGEN

NMC 6761	**1351**

Bibliography

CORPORA, PERIODICALS AND SERIES

AA	*Archäologischer Anzeiger*
AAA	*Athens Annals of Archaeology. Αρχαιολογικά Ανάλεκτα εξ Αθηνών*
ADelt	*Αρχαιολογικόν Δελτίον*
	Chr. = Χρονικά. Mel. = Μελέται/ες. Par. = Παράρτημα
AJA	*American Journal of Archaeology*
AM	*Athenische Mitteilungen*
AnatStud	*Anatolian Studies*
AR	*Archaeological Reports*
ArchEph	*Αρχαιολογική Εφημερίς*
ASA	*Annuario della Scuola archeologica di Atene e delle Missioni italiane in Oriente*
BCH	*Bulletin de correspondence hellénique*
BAR–IS	British Archaeological Reports — International Series
BICS	*Bulletin of the Institute of Classical Studies*
BMMA	*Bulletin of the Metropolitan Museum of Art*
BSA	*Annual of the British School at Athens*
BSAAR	*Annual Report of the Managing Committee/Council of the British School at Athens*
CMS	*Corpus der minoischen und mykenischen Siegel* (Berlin 1964–2002; Mainz 2002–)
CR	*Classical Review*
CVA	*Corpus Vasorum Antiquorum*
EtCr	Études crétoises
IM	*Istanbuler Mitteilungen*
JAS	*Journal of Archaeological Science*
JFA	*Journal of Field Archaeology*
JHS	*Journal of Hellenic Studies*
KChron	*Κρητικά Χρονικά*
LAAA	*Liverpool Annals of Archaeology and Anthropology*
MonLinc	*Monumenti antichi pubblicati per cura della Accademia Nazionale dei Lincei*
QJA	*Oxford Journal of Archaeology*
PAE	*Πρακτικά της εν Αθήναις Αρχαιολογικής Εταιρείας*
PEQ	*Palestine Exploration Quarterly*
PPS	*Proceedings of the Prehistoric Society*
PZ	*Prähistorische Zeitschrift*
SIMA	Studies in Mediterranean Archaeology (PB = Pocket-Book)
SMEA	*Studi micenei ed egeo-anatolici*
SSAA	Sheffield Studies in Aegean Archaeology
WA	*World Archaeology*

SHORT TITLES

Back to the Beginning	I. Schoep, P. Tomkins and J. Driessen (eds.), *Back to the Beginning. Reassessing Social and Political Complexity on Crete during the Early and Middle Bronze Ages.* Oxford forthcoming.
Cretan Offerings	O. Krzyszkowska (ed.), *Cretan Offerings: Studies in Honour of Peter Warren. BSA* Studies 18. London 2010.
Cretological 1	*Πεπραγμένα του Α΄ Διεθνούς Κρητολογικού Συνεδρίου, Ηράκλειον 22–28 Σεπτεμβρίου 1961. KChron* 15–16 (1961–62).
Cretological 2	*Πεπραγμένα του Β΄ Διεθνούς Κρητολογικού Συνεδρίου, Χανιά 11–17 Απριλίου.* Athens 1968.
Cretological 4	*Πεπραγμένα του Δ΄ Διεθνούς Κρητολογικού Συνεδρίου, Ηράκλειον 29 Αυγούστου–3 Σεπτεμβρίου.* Athens 1980.
Cretological 6	*Πεπραγμένα του ΣΤ΄ Διεθνούς Κρητολογικού Συνεδρίου, Χανιά 24–31 Αυγούστου 1986.* Chania 1990.
Cretological 7	*Πεπραγμένα του Ζ΄ Διεθνούς Κρητολογικού Συνεδρίου, Ρέθυμνον 26–30 Αυγούστου.* Rethymnon 1995.

Cretological 8	Πεπραγμένα Η΄ Διεθνούς Κρητολογικού Συνεδρίου, Ηράκλειον 9–14 Σεπτεμβρίου 1996. Herakleion 2000.
Cretological 9	Πεπραγμένα Θ΄ Διεθνούς Κρητολογικού Συνεδρίου, Ελούντα 1–6 Οκτωβρίου 2001. Herakleion 2006.
Cretological 10	Πεπραγμένα Ι΄ Διεθνούς Κρητολογικού Συνεδρίου, Χανιά 1–8 Οκτωβρίου 2006 (forthcoming).
DM/DB	D. Mackenzie, Day-books of the excavations at Knossos 1902, 1904, 1908.
Escaping the Labyrinth	V. Isaakidou and P. D. Tomkins (eds.), *Escaping the Labyrinth: the Cretan Neolithic in Context.* SSAA 8. Oxford 2008.
GORILA	L. Godart and J.-P.Olivier, *Recueil des inscriptions en Linéaire A* I–V. EtCr 21. Paris 1976–85.
Knossos Labyrinth	D. Evely, H. Hughes-Brock and N. Momigliano (eds.), *Knossos: A Labyrinth of History. Papers Presented in Honour of Sinclair Hood.* London 1994.
KPCS	G. Cadogan, E. Hatzaki and A. Vasilakis (eds.), *Knossos: Palace, City, State. BSA* Studies 12. London 2004.
KPH	N. Momigliano (ed.), *Knossos Pottery Handbook: Neolithic and Bronze Age (Minoan). BSA* Studies 14. London 2007.
PM	A. J. Evans, *The Palace of Minos at Knossos* I–IV. London 1921–35; J. Evans, *Index to the Palace of Minos.* London 1936.

REFERENCES

Alexiou, S., 1951. 'Πρωτομινωικαί ταφαί παρά το Κανλί-Καστέλλι Ηρακλείου', *KChron* 5: 275–94.

——, 1964. 'Περιφέρεια Χανίων', *ADelt* 19, Chr.: 446–7.

——, 1980. 'Προανακτορικές ακροπόλεις της Κρήτης', in *Cretological 4*: Athens: A, 9–22.

Alexiou, S., and P. M. Warren, 2004. *The Early Minoan Tombs of Lebena, Southern Crete.* SIMA 30. Sävedalen.

Amiran, R., 1978. *Early Arad: the Chalcolithic Settlement and Early Bronze City.* Jerusalem.

Andreadaki-Vlazaki, M., 1996. 'Προϊστορικός οικισμός στα Νοπήγεια Κισσάμου — αποσπασματική ανασκαφική έρευνα', *Κρητική Εστία* 5 (1994–96): 11–45.

Andreadaki-Vlazaki, M., and E. Hallager, 2000. 'Evidence for seal use in Pre-palatial western Crete', in I. Pini and J.-C. Poursat (eds.), *Sceaux minoens et mycéniens. CMS* Beiheft 5. Berlin: 251–70.

Andreou, S., 1978. 'Pottery groups of the Old Palace period in Crete' (PhD thesis, University of Cincinnati).

Aposkitou, M., 1979. 'Μίνως Καλοκαιρινός. Εκατό χρόνια από την πρώτη ανασκαφή της Κνωσού', *Κρητολογία* 8: 81–94.

Asouti, E., 2003. 'Wood charcoal from Santorini (Thera): new evidence for climate, vegetation, and timber imports in the Aegean Bronze Age', *Antiquity* 77: 471–84.

Banti, L., 1931. 'La grande tomba a tholos di Haghia Triada', *ASA* 13–14 (1930–31): 155–251.

Barrett, C. E., 2009. 'The perceived value of Minoan and Minoanizing pottery in Egypt', *JMA* 22: 211–34.

Batten, V. F. F., 1995. 'A Pre-palatial pottery deposit from the Theatral Area at Knossos', in *Cretological 7*: A.1, 75–9.

Belli, P., 1999. 'The "Early Hypogaeum" at Knossos: some hints for future investigations', in P. P. Betancourt, V. Karageorghis, R. Laffineur and W.-D. Niemeier (eds.), 1999. *MELETEMATA. Studies in Aegean Archaeology Presented to Malcolm H. Wiener.* Aegaeum 20. Liège and Austin: 25–32.

Bernabò-Brea, L., 1964. *Poliochni: città preistorica nell' isola di Lemnos* I. Rome.

——, 1976. *Poliochni: città preistorica nell' isola di Lemnos* II. Rome.

Betancourt, P. P., 1979. *Vasilike Ware. An Early Bronze Age Pottery Style in Crete.* SIMA 56. Göteborg.

——, 1983. *The Cretan Collection in the University Museum, University of Pennsylvania* I: *Minoan Objects Excavated from Vasilike, Pseira, Sphoungaras, Priniatikos Pyrgos, and Other Sites.* University Museum Monograph 47. Philadelphia.

—— (ed.), 1984. *East Cretan White-on-Dark Ware: Studies on a Handmade Pottery of the Early to Middle Minoan Periods.* University Museum Monograph 51. Philadelphia.

——, 1985. *The History of Minoan Pottery.* Princeton.

——, 2008a. 'Aphrodite's Kephali', *Kentro. The Newsletter of the INSTAP Study Center for East Crete* 11: 12–13.

——, 2008b. *The Bronze Age Begins: the Ceramics Revolution of Early Minoan I and the New Forms of Wealth that Transformed Prehistoric Society.* Philadelphia.

——, 2010. 'The EM I pithoi from Aphrodite's Kephali', in *Cretan Offerings*: 1–9.

Betancourt, P. P., N. Marinatos, T. Albani, C. Palyvou, N. Poulou-Papadimitriou, S. German and S. McPherron, 2000. 'Το σπήλαιο της Αμνισού: η έρευνα του 1992', *ArchEph*: 179–236.

Binford, L. R., 1981. *Bones: Ancient Men and Modern Myths.* New York.

Blackman, D. J., and K. Branigan, 1973. 'An unusual tholos tomb at Kaminospilio, S. Crete', *KChron* 25: 199–206.

Blackman, D. J., and K. Branigan, 1982. 'The excavation of an Early Minoan tholos tomb at Ayia Kyriaki, Ayiofarango, southern Crete', *BSA* 77: 1–57.

Blegen, C. W., 1921. *Korakou: a Prehistoric Settlement near Corinth.* Boston and New York.

____, 1928. *Zygouries: a Prehistoric Settlement in the Valley of Cleonae*. Cambridge, MA.

____, 1937. *Prosymna: the Helladic Settlement Preceding the Argive Heraeum*. Cambridge.

____, 1975. 'Neolithic remains at Nemea: excavations of 1925–1926', *Hesperia* 44: 251–79.

Blegen, C. W., J. L. Caskey, M. Rawson and J. Sperling, 1950. *Troy* I. *General Introduction. The First and Second Settlements*. Princeton.

Blitzer, H., 1993. 'Olive cultivation and oil production in Minoan Crete', in M.-C. Amouretti and J. P. Brun (eds.), *Oil and Wine Production in the Mediterranean Area. BCH* Suppl. 26. Paris: 163–75.

Boardman, J., 1963. *The Date of the Knossos Tablets* (part of L. R. Palmer and J. Boardman, *On the Knossos Tablets*). Oxford.

Bonacasa, N., 1968. 'Patrikiès. Una stazione medio-minoica fra Haghia Triada e Festòs', *ASA* 45–6 (1967–68): 7–54.

Bosanquet, R. C., 1902. 'Excavations at Palaikastro. I', *BSA* 8 (1901–02): 286–316.

Bosanquet, R. C., and R. M. Dawkins, 1923. *The Unpublished Objects from the Palaikastro Excavations 1902–1906* 1. *BSA* Suppl. 1. London.

Bosanquet, R. C., R. M. Dawkins, M. N. Tod, W. L. H. Duckworth and J. L. Myres, 1903. 'Excavations at Palaikastro. II', *BSA* 9 (1902–03): 274–387.

Bottema, S., and A. Sarpaki, 2003. 'Environmental change in Crete: a 9000-year record of Holocene vegetation history and the effect of the Santorini eruption', *The Holocene* 13: 733–49.

Boyd Hawes, H., B. Williams, R. Seager and E. Hall, 1908. *Gournia, Vasiliki and Other Prehistoric Sites on the Isthmus of Hierapetra, Crete*. Philadelphia.

Braidwood, R. J., and L. S. Braidwood, 1960. *Excavations in the Plain of Antioch* I. *The Earlier Assemblages, Phases A–J*. University of Chicago Oriental Institute Publications 61. Chicago.

Brain, C. K., 1981. *The Hunters or the Hunted?* Chicago.

Branigan, K., 1969. 'The earliest Minoan scripts — the Pre-palatial background', *Kadmos* 8: 1–22.

____, 1970a. *The Foundations of Palatial Crete: a Survey of Crete in the Early Bronze Age*. London.

____, 1970b. *The Tombs of Mesara: a Study of Funerary Architecture and Ritual in Southern Crete, 2800–1700 B.C.* London.

____, 1988. 'Some observations on state formation in Crete', in E. B. French and K. A. Wardle (eds.), *Problems in Greek Prehistory*. Bristol: 63–72.

____, 1992. 'The Early Keep, Knossos: a reappraisal', *BSA* 87: 153–63.

____, 1995. 'The Early Keep at Knossos reviewed', in *Cretological* 7: A.1, 87–96.

Broodbank, C., 2000. *An Island Archaeology of the Early Cyclades*. Cambridge.

Broodbank, C., and E. Kiriatzi, 2007. 'The first "Minoans" of Kythera revisited: technology, demography, and landscape in the Prepalatial Aegean', *AJA* 111: 241–74.

Brown, A. (ed.), 2001. *Arthur Evans's Travels in Crete, 1894–1899*. BAR–IS 1000. Oxford.

Cadogan, G., 1978a. 'Dating the Aegean Bronze Age without radiocarbon', *Archaeometry* 20: 209–14.

____, 1978b. 'Pyrgos, Crete, 1970–77', *AR* 24 (1977–78): 70–84.

____, 1983. 'Early Minoan and Middle Minoan chronology', *AJA* 87: 507–18.

____, 1986. 'Why was Crete different?', in G. Cadogan (ed.), *The End of the Early Bronze Age in the Aegean*. Cincinnati Classical Studies n.s. 6. Leiden: 153–71.

____, 1994. 'An Old Palace period Knossos state?', in *Knossos Labyrinth*: 57–68.

____, 2006. 'From Mycenaean to Minoan: an exercise in myth making', in P. Darcque, M. Fotiadis and O. Polychronopoulou (eds.), *Mythos. La préhistoire égéenne du XIXe au XXIe siècle après J.-C., BCH* Suppl. 46. Paris: 39–45.

____, 2009. 'Gender metaphors of social stratigraphy in pre-Linear B Crete' or 'Is "Minoan gynaecocracy" (still) credible?', in K. Kopaka (ed.), *Fylo. Engendering Prehistoic 'Stratigraphies' in the Aeagean and the Mediterranean*. Aegaeum 30. Liège and Austin: 225–32.

____, 2010. 'Goddess, nymph or housewife; and water worries at Myrtos?', in *Cretan Offerings*: 41–7.

____, in preparation. 'Palaikastro–Kastri: early Prepalatial'.

Cadogan, G., and A. Chaniotis, 2010. 'Inscriptions from Crete', *BSA* 105: 291–304.

Cadogan, G., P. M. Day, C. F. Macdonald, J. A. MacGillivray, N. Momigliano, T. M. Whitelaw and D. E. Wilson, 1993. 'Early Minoan and Middle Minoan pottery groups at Knossos', *BSA* 88: 21–8.

Cameron, M. A. S., R. E. Jones and S. E. Philippakis, 1977. 'Scientific analyses of Minoan fresco samples from Knossos', *BSA* 72: 121–84.

Carington Smith, J., 1977. 'Cloth and mat impressions,' in J. E. Coleman, *Keos* I. *Kephala: a Late Neolithic Settlement and Cemetery*. Princeton: 114–25.

Carter, T., 1998. 'Reverberations of the international spirit: thoughts upon the "Cycladica" in the Mesara', in K. Branigan (ed.), *Cemetery and Society in the Aegean Bronze Age*. SSSA 1. Sheffield: 59–77.

____, 1999. 'Through a glass darkly: obsidian and society in the southern Aegean Early Bronze Age' (PhD thesis, University College London, Institute of Archaeology).

____, 2004. 'Transformative processes in liminal spaces: craft as ritual action in the Throne Room area', in *KPCS*: 273–82.

Caskey, J. L., 1956. 'Excavations at Lerna, 1955', *Hesperia* 25: 147–73.

Catling, H. W., 1972. 'Archaeology in Greece, 1971–72', *AR* 18 (1971–72): 3–26.

___, 1973. 'Archaeology in Greece, 1972–73', *AR* 19 (1972–73): 3–32.

___, 1974. 'Archaeology in Greece, 1973–74', *AR* 20 (1973–74): 3–41.

___, 1988. 'Archaeology in Greece, 1987–88', *AR* 34 (1987–88): 1–85.

Chapouthier, F., and J. Charbonneaux, 1928. *Fouilles exécutées à Mallia. Premier rapport (1922–1924)*. EtCr 1. Paris.

Chapouthier, F., and R. Joly, 1936. *Fouilles exécutées à Mallia II. Exploration du Palais (1925–1926)*. EtCr 4. Paris.

Charbonneaux, J., 1928. 'L'architecture et la céramique du palais de Mallia', *BCH* 52: 347–87.

Christakis, K. S., 2005. *Cretan Bronze Age Pithoi: Traditions and Trends in the Production and Consumption of Storage Containers in Bronze Age Crete*. Prehistory Monographs 18. Philadelphia.

___, 2008. *The Politics of Storage. Storage and Sociopolitical Complexity in Neopalatial Crete*. Prehistory Monographs 25. Philadelphia.

Coldstream, J. N., 1960. 'A Geometric well at Knossos', *BSA* 55: 159–71.

___, 1963. 'Five tombs at Knossos', *BSA* 58: 30–43.

___, 1972. 'Knossos 1951–61: Protogeometric and Geometric pottery from the town', *BSA* 67: 63–98.

___, 1973a. 'Knossos 1951–61: Orientalizing and Archaic pottery from the town', *BSA* 68: 33–63.

___, 1973b. *Knossos. The Sanctuary of Demeter. BSA* Suppl. 8. London.

Coldstream, J. N., and G. L. Huxley, 1972. *Kythera. Excavations and Studies Conducted by the University of Pennsylvania Museum and the British School at Athens*. London.

Coleman, J. E., 1977. *Keos* I. *Kephala: a Late Neolithic Settlement and Cemetery*. Princeton.

Conolly, J., 2008. 'The knapped stone technology of the first occupants at Knossos', in *Escaping the Labyrinth*: 73–89.

Crowfoot, G. M., 1938. 'Mat impressions on pot bases', *LAAA* 25: 3–11.

D'Annibale, C., 2008. 'Obsidian in transition: the technological reorganization of the obsidian industry from Petras Kephala (Siteia) between Final Neolithic IV and Early Minoan I', *Escaping the Labyrinth*: 191–200.

___, in preparation. 'The obsidian', in Y. Papadatos, *Kephala, Petras. The Final Neolithic–Early Minoan Settlement*.

D'Annibale, C., and D. Long, 2003. 'Replicating Bronze Age obsidian manufacture: towards an assessment of the scale of production during the Minoan period', in R. Laffineur and P. P. Betancourt (eds.), *METRON. Measuring the Aegean Bronze Age*. Aegaeum 24. Liège and Austin: 425–30.

Davaras, C., 1973a. 'Αρχαιότητες και μνημεία ανατολικής Κρήτης', *ADelt* 28, Chr.: 585–96.

___, 1973b. 'Μινωική κεραμεική κάμινος εις Στύλον Χανίων', *ArchEph*: 75–80.

___, 1980. 'A Minoan pottery kiln at Palaikastro', *BSA* 75: 115–26.

___, n.d. *Μουσείον Αγίου Νικολάου*. Athens.

Davaras, C., and P. P. Betancourt, 2004. *The Hagia Photia Cemetery* I. *The Tomb Groups and Architecture*. Prehistory Monographs 14. Philadelphia.

Dawkins, R. M., 1908. 'Archaeology in Greece (1907–08)', *JHS* 28: 319–36.

Dawkins, R. M., and C. T. Currelly, 1904. 'Excavations at Palaikastro. III', *BSA* 10 (1903–04): 193–231.

Dawkins, R. M., C. H. Hawes and R. C. Bosanquet, 1905. 'Excavations at Palaikastro. IV', *BSA* 11 (1904–05): 258–308.

Day, P. M., L. Joyner, E. Kiriatzi and M. Relaki, 2005. 'Petrographic analysis of some Final Neolithic–Early Minoan II pottery from the Kavousi area', in D. Haggis, *Kavousi* I. *The Archaeological Survey of the Kavousi Region*. Prehistory Monographs 16. Philadelphia: 177–95.

Day, P. M., E. Kiriatzi, A. Tsolakidou and V. Kilikoglou, 1999. 'Group therapy in Crete: a comparison between analyses by NAA and thin section petrography of Early Minoan pottery', *JAS* 26: 1025–36.

Day, P. M., M. Relaki and E. W. Faber, 2006. 'Pottery making and social reproduction in the Bronze Age Mesara', in M. H. Wiener, J. L. Warner, J. Polonsky and E. E. Hayes (eds.), *Pottery and Society: The Impact of Recent Studies in Minoan Pottery. Gold Medal Colloquium in Honor of Philip P. Betancourt*. Boston: 22–72.

Day, P. M., and D. E. Wilson, 1998. 'Consuming power: Kamares ware in Protopalatial Knossos', *Antiquity* 72: 350–8.

Day, P. M., and D. E. Wilson, 2002. 'Landscapes of memory, craft and power in Prepalatial and Protopalatial Knossos', in Y. Hamilakis (ed.), *Labyrinth Revisited: Rethinking 'Minoan' Archaeology*. Oxford: 143–66.

Day, P. M., and D. E. Wilson, 2004. 'Ceramic change and the practice of eating and drinking in Early Bronze Age Crete', in P. Halstead and J. C. Barrett (eds.), *Food, Cuisine and Society in Prehistoric Greece*. SSAA 5. Oxford: 45–62.

Day, P. M., D. E. Wilson and E. Kiriatzi, 1997. 'Reassessing specialisation in Prepalatial Cretan ceramic production', in R. Laffineur and P. P. Betancourt (eds.), *TEXNH. Craftsmen, Craftswomen and Craftsmanship in the Aegean Bronze Age*. Aegaeum 16. Liège and Austin: 275–90.

Day, P. M., D. E. Wilson and E. Kiriatzi, 1998. 'Pots, labels and people: burying ethnicity in the cemetery at Aghia Photia, Siteias', in K. Branigan (ed.), *Cemetery and Society in the Aegean Bronze Age*. SSAA 1. Sheffield: 133–49.

Day, P. M., D. E. Wilson, E. Kiriatzi and L. Joyner, 2000. 'Η κεραμεική από το ΠΜ Ι νεκροταφείο στην Άγια Φωτιά Σητείας: τοπική ή εισαγμένη;', in *Cretological 8*: A.1, 341–52.

Demargne, P., 1945. *Fouilles exécutées à Mallia. Exploration des nécropoles (1921–1933)* I. EtCr 7. Paris.

Demargne, P., and H. Gallet de Santerre, 1953. *Fouilles exécutées à Mallia. Exploration des maisons et quartiers d'habitation (1921–1948)*. EtCr 9. Paris.

Desborough, V. R. d'A., 1964. *The Last Mycenaeans and their Successors*. Oxford.

Deshayes, J., and A. Dessenne, 1959. *Fouilles exécutées à Mallia. Exploration des maisons et quartiers d'habitation (1948–1954)*. EtCr 11. Paris.

Diamant, S., and J. Rutter, 1969. 'Horned objects in Anatolia and the Near East and possible connexions with the Minoan "horns of consecration"', *AnatStud* 19: 147–77.

Dimopoulou-Rethemiotaki, N., 2004. 'Το επίνειο της Κνωσού στον Πόρο–Κατσαμπά', in *KPCS*: 363–80.

Dimopoulou-Rethemiotaki, N., D. E. Wilson and P. M. Day, 2007. 'The earlier Prepalatial settlement of Poros–Katsambas: craft production and exchange at the harbour town of Knossos', in P. M. Day and R. C. P. Doonan (eds.), 2007. *Metallurgy in the Early Bronze Age Aegean*. SSAA 7. Oxford: 84–97.

Doumas, C., 1977. *Early Bronze Age Burial Habits in the Cyclades*. SIMA 48. Göteborg.

____, 1983. *Cycladic Art. Ancient Pottery and Sculpture from the N. P. Goulandris Collection*. London.

Driessen, J. M., 2003. 'An architectural overview', in P. A. Mountjoy, 2003. *Knossos: the South House*. BSA Suppl. 34. London: 27–35.

Duemmler, F., 1886. 'Mittheilungen von den griechischen Inseln. 1. Reste vorgriechischer Bevölkerung auf den Cykladen', *AM* 11: 15–46.

Dunand, M., 1973. *Fouilles de Byblos V. L'architecture, les tombes, le materiel domestique, des origines néolithiques à l'avènement urbain*. Paris.

Eccles, E., M. B. Money-Coutts and J. D. S. Pendlebury, 1933. *Dating of the Pottery in the Stratigraphical Museum 2*. London.

Efstratiou, N., A. Karetsou, E. S. Banou and D. Margomenou, 2004. 'The Neolithic settlement of Knossos: new light on an old picture', in *KPCS*: 39–49.

Emery, W. B., 1949. *Great Tombs of the First Dynasty*. Cairo.

Evans, A. J., 1895. *Cretan Pictographs and Prae-Phoenician Script*. London and New York.

____, 1900. 'Knossos. I. The Palace', *BSA* 6 (1899–1900): 1–70.

____, 1901. 'The Palace of Knossos, 1901', *BSA* 7 (1900–01): 1–120.

____, 1902. 'The Palace of Knossos. Provisional report of the excavations for the year 1902', *BSA* 8 (1901–02): 1–124.

____, 1903. 'The Palace of Knossos. Provisional report for the year 1903', *BSA* 9 (1902–03): 1–153.

____, 1904. 'The Palace of Knossos', *BSA* 10 (1903–04): 1–62.

____, 1905. 'The Palace of Knossos and its dependencies', *BSA* 11 (1904–05): 1–26.

____, 1906. *Essai de classification des époques de la civilisation minoenne*. London.

Evans, J. D., 1964. 'Excavations in the Neolithic settlement at Knossos, 1957–60. Part I', *BSA* 59: 132–240.

____, 1968. 'Knossos Neolithic, part II: summary and conclusions', *BSA* 63: 267–76.

____, 1971. 'Neolithic Knossos: the growth of a settlement', *PPS* 37.2: 95–117.

____, 1994. 'The early millennia: continuity and change in a farming settlement', in *Knossos Labyrinth*: 1–20.

____, 2008. 'Aproaching the labyrinth', in *Escaping the Labyrinth*: 11–20.

Evely, D., 1988. 'The potters' wheel in Minoan Crete', *BSA* 83: 83–126.

____, (ed.), 2006. *Lefkandi* IV. *The Bronze Age. The Late Helladic IIIC Settlement at Xeropolis*. BSA Suppl. 39. London.

Fairbanks, A., 1928. *Museum of Fine Arts, Boston. Catalogue of Greek and Etruscan Vases* I. *Early Vases, Preceding Athenian Black-figured Ware*. Cambridge, Mass.

Faure, P., 1969. 'Sur trois sorts de sanctuaries crétois', *BCH* 93: 174–213.

Felsch, R. C. S., 1971. 'Neolithische Keramik aus der Höhle von Kephalari', *AM* 86: 1–12.

Fitton, L., M. Hughes and S. Quirke, 1998. 'Northerners at Lahun. Neutron activation analysis of Minoan and related pottery in the British Museum', in S. Quirke (ed.), *Lahun Studies*. Reigate: 112–40.

Forsdyke, E. J., 1925. *Catalogue of the Greek and Etruscan Vases in the British Museum* I.1. *Prehistoric Aegean Pottery*. London.

Foster, K. P., 1982. *Minoan Ceramic Relief*. SIMA 64. Göteborg.

Frankfort, H., 1924. *Studies in Early Pottery of the Near East* I. *Mesopotamia, Syria and Egypt and their Earliest Interrelations*. Royal Anthropological Institute Occasional Papers 6. London.

____, 1927. *Studies in Early Pottery of the Near East* II. *Asia, Europe and the Ægean, and their Earliest Interrelations*. Royal Anthropological Institute Occasional Papers 8. London.

French, D. H., 1961. 'Late Chalcolithic pottery in north-west Turkey and the Aegean', *AnatStud* 11: 99–141.

____, 1964. 'Excavations at Can Hasan. Third preliminary report, 1963', *AnatStud* 14: 125–37.

____, 1965. 'Prehistoric sites in the Göksu valley', *AnatStud* 15: 177–201.

Frend, W. H. C., and D. E. Johnston, 1962. 'The Byzantine basilica church at Knossos', *BSA* 57: 186–238.

Frödin, O., and A. W. Persson, 1938. *Asine. Results of the Swedish Excavations 1922–1930*. Stockholm.

Furness, A., 1953. 'The Neolithic pottery of Knossos', *BSA* 48: 94–134.

____, 1956. 'Some early pottery of Samos, Kalimnos and Chios', *PPS* 22: 173–212.

Furumark, A., 1941. *Mycenaean Pottery: Analysis and Classification*. Stockholm.

Galanaki, K., 2006. 'Πρωτομινωικό ταφικό σύνολο στην πρώην Αμερικανική Βάση Γουρνών Πεδιάδος', in *Cretological* 9: A.2, 227–41.

Galili, E., D. J. Stanley, J. Sharvit and M. Weinstein-Evron, 1997. 'Evidence for the earliest olive oil production in submerged settlements off the Carmel coast, Israel', *JAS* 24: 1141–50.

Georgiou, H. S., 1973. 'Minoan "fireboxes" from Gournia', *Expedition* 15. 4: 7–14.

____, 1986. *Keos VI. Ayia Irini: Specialized Domestic and Industrial Pottery.* Mainz.

Goldman, H., 1931. *Excavations at Eutresis in Boeotia.* Cambridge, MA.

____, 1956. *Excavations at Gözlü Kule, Tarsus* II. *From the Neolithic to the Bronze Age.* Princeton.

Gropengiesser, H., 1987. 'Siphnos, Kap Agios Sostis. Keramische prähistorische Zeugnisse aus dem Gruben- und Hüttenrevier II', *AM* 102: 1–54.

Guest-Papamanoli, A., and A. Lambraki, 1976. 'Les grottes de Léra et de l'Arkoudia en Crète occidentale aux époques préhistoriques et historiques', *ADelt* 31, Mel.: 178–243.

Haggis, D. C., 1993. 'The Early Minoan burial cave at Ayios Antonios and some problems in Early Bronze Age chronology', *SMEA* 31: 7–34.

____, 1996. 'Excavations at Kalo Khorio, east Crete', *AJA* 100: 645–81.

____, 1997. 'The typology of the Early Minoan I chalice and the cultural implications of form and style in Early Bronze Age ceramics', in R. Laffineur and P. P. Betancourt (eds.), *TEXNH. Craftsmen, Craftswomen and Craftsmanship in the Aegean Bronze Age.* Aegaeum 16. Liège and Austin: 291–9.

____, 2005. *Kavousi I. The Archaeological Survey of the Kavousi Region.* Prehistory Monographs 16. Philadelphia.

Hall, E. H., 1912. 'Excavations in eastern Crete — Sphoungaras', *University of Pennsylvania Museum Anthropological Publications* 3.2. Philadelphia: 43–73.

____, 1914. 'Excavations in eastern Crete — Vrokastro', *University of Pennsylvania Museum Anthropological Publications* 3.3. Philadelphia: 77–185.

Halstead, P., 1981. 'From determinism to uncertainty: social storage and the rise of the Minoan palace', in A. Sheridan and G. Bailey (eds.), *Economic Archaeology: Towards an Integration of Ecological and Social Approaches.* BAR–IS 96. Oxford: 187–213.

____, 2006. 'Sheep in the garden: the integration of crop and livestock husbandry in early farming regimes of Greece and southern Europe', in D. Serjeantson and D. Field (eds.), *Animals in the Neolithic of Britain and Europe.* Neolithic Studies Group Seminar Papers 7. Oxford: 42–55.

Halstead, P., and V. Isaakidou, 2004. 'Faunal evidence for feasting: burnt offerings from the Palace of Nestor at Pylos', in P. Halstead and J. C. Barrett (eds.), *Food, Cuisine and Society in Prehistoric Greece.* SSAA 5. Oxford: 136–54.

Hansen, J. M., 1988. 'Agriculture in the prehistoric Aegean: data versus speculation', *AJA* 92: 39–52.

Harissis, H. V., and A. V. Harissis, 2009. *Apiculture in the Prehistoric Aegean: Minoan and Mycenaean Symbols Revisited.* BAR–IS 958. Oxford.

Hatzaki, E., 2007. 'Neopalatial (MM III–LM IB): KS 178, Gypsades Well (Upper Deposit), and SEX North House Groups', in *KPH*: 151–96.

Hauptmann, H., and V. Milojčić, 1969. *Die Funde der frühen Dimini-Zeit aus der Arapi-Magula, Thessalien.* Beiträge zur ur- und frühgeschichtlichen Archäologie des Mittelmeer-Kulturraumes 9. Bonn.

Hayes, J. W., 1971. 'Four Early Roman groups from Knossos', *BSA* 66: 249–75.

Hazzidakis, J., 1913. 'An Early Minoan sacred cave at Arkalokhori in Crete', *BSA* 19 (1912–13): 35–47.

____, 1934. *Les villas minoennes de Tylissos.* EtCr 3. Paris.

Hennessy, J. B., 1967. *The Foreign Relations of Palestine during the Early Bronze Age.* London.

Heurtley, W. A., 1939. *Prehistoric Macedonia.* Cambridge.

Higgins, R. A., 1971. 'Post-Minoan terracottas from Knossos', *BSA* 66: 277–81.

Hogarth, D. G., 1901. 'Excavations at Zakro, Crete', *BSA* 7 (1900–01): 121–49.

Hogarth, D. G., and F. B. Welch, 1901. 'Primitive painted pottery in Crete', *JHS* 21: 78–98.

Holmberg, E. J., 1944. *The Swedish Excavations at Asea in Arcadia.* Skrifter Utgivna av Svenska Institutet i Rom 11. Lund and Leipzig.

Hood, S., 1958. 'Archaeology in Greece, 1957', *AR* 4: 3–25.

____, 1959. 'Archaeology in Greece, 1958', *AR* 5: 3–22.

____, 1960a. 'Archaeology in Greece, 1959', *AR* 6 (1959–60): 3–26.

____, 1960b. 'Excavations at Knossos', *ADelt* 16, Chr.: 264–6.

____, 1961. 'Archaeology in Greece, 1960–1', *AR* 7 (1960–61): 3–35.

____, 1962a. 'Archaeology in Greece, 1961–62', *AR* 8 (1961–62): 3–31.

____, 1962b. 'Knossos', *ADelt* 17 (1961–62), Chr.: 294–6.

____, 1962c. 'Stratigraphic excavations at Knossos, 1957–61', in *Cretological 1*: A, 92–8.

____, 1966. 'The Early and Middle Minoan periods at Knossos', *BICS* 13: 110–11.

____, 1971. *The Minoans: Crete in the Bronze Age.* London.

____, 1978. *The Arts in Prehistoric Greece.* Harmondsworth.

____, 1979. 'Dating Troy II — Part 2', *BICS* 26: 126–7.

____, 1981. *Excavations in Chios 1938–1955: Prehistoric Emporio and Ayio Gala* I. BSA Suppl. 15. London.

____, 1982. *Excavations in Chios 1938–1955: Prehistoric Emporio and Ayio Gala* II. BSA Suppl. 16. London.

____, 1990a. 'Autochthons or settlers? Evidence for immigration at the beginning of the Early Bronze Age in Crete', in *Cretological 6*: A.1, 367–75.

___, 1990b. 'Settlers in Crete c. 3000 B.C.', *Cretan Studies* 2: 151–8.

___, 1994. 'Knossos: soundings in the Palace area, 1973–87', *BSA* 89: 101–02.

___, 2003. 'Eastern origins of the Minoan double axe', in Y. Duhoux (ed.), *Briciaka. A Tribute to W. C. Brice. Cretan Studies* 9: 51–62.

___, 2006. 'Mackenzie and the Late Neolithic/Early Minoan I interface at Knossos', in *Cretological* 9: A.2, 9–21.

___, 2010. 'The Middle Minoan cemetery on Ailias at Knossos', in *Cretan Offerings*: 161–8.

___, 2011. 'Knossos Royal Road: North, LM IB deposits', in E. Hallager and T. Brogan (eds.), *LM IB Pottery: Examining New Evidence for Relative Chronology and Regional Differences*. Monographs of the Danish Institute at Athens 11. Athens: 149–70.

___, in preparation. *Knossos. Excavations 1957–61. The Royal Road: North. BSA* Suppl. London.

Hood, S., and J. N. Coldstream, 1968. 'A Late Minoan tomb at Ayios Ioannis near Knossos', *BSA* 63: 205–18.

Hood, S., and V. Kenna, 1973. 'An Early Minoan III sealing from Knossos', in G. Carratelli and G. Rizza (eds.), *Antichità cretesi: studi in onore di Doro Levi* 1. *Cronache di Archeologia* 12. Catania: 103–06.

Hood, S., and D. Smyth, 1981. *Archaeological Survey of the Knossos Area* (2nd ed.). *BSA* Suppl. 14. London.

Hood, S., and W. Taylor, 1981. *The Bronze Age Palace at Knossos: Plan and Sections. BSA* Suppl. 13. London.

Isaakidou, V., 2004. 'Bones from the labyrinth: faunal evidence for the management and consumption of animals at Neolithic and Bronze Age Knossos, Crete' (PhD thesis, University College London, Institute of Archaeology).

___, 2006. 'Ploughing with cows: Knossos and the "Secondary Products Revolution"', in D. Serjeantson and D. Field (eds.), *Animals in the Neolithic of Britain and Europe*. Neolithic Studies Group Seminar Papers 7. Oxford: 95–112.

___, 2007. 'Cooking in the Labyrinth: exploring "cuisine" at Bronze Age Knossos', in C. Mee and J. Renard (eds.), *Cooking up the Past: Food and Culinary Practices in the Neolithic and Bronze Age Aegean*. Oxford: 5–24.

___, 2008. '"The fauna and economy of Neolithic Knossos" revisited', in *Escaping the Labyrinth*: 90–114.

___, in preparation. *Bones from the Labyrinth: Animal Exploitation at Prehistoric Knossos, Crete*.

Isaakidou, V., P. Halstead, J. Davis and S. Stocker, 2002. 'Burnt animal sacrifice at the Mycenaean Palace of Nestor, Pylos', *Antiquity* 76: 86–92.

Jones, R. E., 1986. *Greek and Cypriot Pottery: a Review of Scientific Studies. BSA* Fitch Laboratory Occasional Paper 1. Athens.

Kakavogianni, O., 1993. 'Οι έρευνες στον Πρωτοελλαδικό οικισμό στο Κορωπί Αττικής', in C. Zerner, P. Zerner and J. Winder (eds.), *Wace and Blegen: Pottery as Evidence for Trade in the Aegean Bronze Age 1939–1989*. Amsterdam: 165–7.

Kalokairinos, M., 1990. 'Μίνωος Καλοκαιρινού. Ανασκαφές στην Κνωσό' (ed. K. Kopaka), *Παλίμψηστον* 9–10 (1989–90): 5–69.

Karadimas, N., forthcoming. 'Η προϊστορική Κρήτη μέσα από ερμηνευτικά πρότυπα του 18ου και 19ου αιώνα. Η συμβολή των προτύπων αυτών στο έργο του Sir Arthur Evans', in *Cretological 10*.

Karadimas, N., and N. Momigliano, 2004. 'On the term "Minoan" before Evans's work in Crete (1894)', *SMEA* 46: 243–58.

Karantzali, E., 1996. *Le Bronze Ancien dans les Cyclades et en Crète. Les relations entre les deux regions. Influence de la Grèce Continentale*. BAR–IS 631. Oxford.

Karetsou, A., 2004. 'Knossos after Evans: past interventions, present state and future solutions', in *KPCS*: 547–55.

___ (Ioannidou-Karetsou), 2006. 'Από την Κνωσό μέχρι τη Ζάκρο: η περιπέτεια της προστασίας των ιστορικών αρχαιολογικών χώρων στην κεντρική και ανατολική Κρήτη', in V. Karageorghis and A. Yiannikouri (eds.), *Διάσωση και προβολή της πολιτιστικής και φυσικής κληρονομιάς των μεγάλων νησιών της Μεσογείου*. Athens: 61–76.

Karetsou, A., M. Andreadaki-Vlazaki and N. Papadakis (eds.), 2000. *Κρήτη–Αίγυπτος. Πολιτισμικοί δεσμοί τριών χιλιετιών. Κατάλογος*. Herakleion.

Kehrberg, I. C., 1995. *Northern Cyprus in the Transition from the Early to the Middle Cypriot Period: Typology, Relative and Absolute Chronology of some Early Cypriot III to Middle Cypriot I Tombs*. SIMA PB 108. Jonsered.

Kemp, B. J., and R. S. Merrillees, 1980. *Minoan Pottery in Second Millennium Egypt*. Mainz.

Kenyon, K. M., 1965. *Excavations at Jericho* II. *The Tombs Excavated in 1955–58*. London.

Knappett, C., 1999. 'Tradition and innovation in pottery forming technology: wheel-throwing at Middle Minoan Knossos', *BSA* 94: 101–29.

___, 2003. 'The Early Minoan and Middle Minoan pottery', in P. A. Mountjoy, *Knossos: the South House. BSA* Suppl. 34. London: 41–50.

___, 2007. 'The beginnings of the Aegean Middle Bronze Age: a view from east Crete', in F. Felten, W. Gauss and R. Smetana (eds.), *Middle Helladic Pottery and Synchronisms*. Ägina-Kolonna Forschungen und Ergebnisse 1; Österreichische Akademie der Wissenschaften, Denkschriften der Gesamtakademie 42. Vienna: 215–31.

Konjević, D. 2005. 'Slatka tajna lovačke kuhinje — Jazavac obični (*Meles meles L.)* (Sweet delicacy from the hunter's kitchen — badger)', *Meso* 7: 46–9.

Kopaka, K., 1995. 'Ο Μίνως Καλοκαιρινός και οι πρώτες ανασκαφές στην Κνωσό', in *Cretological* 7: A1, 501–11.

Kosmopoulos, L. W., 1948. *The Prehistoric Habitation of Corinth*. Munich.

Krzyszkowska, O., 2005. *Aegean Seals: an Introduction*. *BICS* Suppl. 85. London.

Kühne, H., 1976. *Die Keramik vom Tel Chuēra und ihre Beziehungen zu Funden aus Syrien-Palästina, der Türkei und dem Iraq*. Berlin.

Lakhanas, A., 2000. 'Συνοπτική παρουσίαση της στυλιστικής εξέλιξης της κεραμεικής των Αρχανών από την ΠΜ έως τη ΜΜ ΙΒ περίοδο', in *Cretological 8*: A.2, 155–68.

Lamb, W., 1936. *Excavations at Thermi in Lesbos*. Cambridge.

____, 1956. 'Some early Anatolian shrines', *AnatStud* 6: 87–94.

Langford-Verstegen, L., 2008. 'Early and Middle Minoan pottery', in P. P. Betancourt, C. Davaras *et. al.*, 'Excavations in the Hagios Charalambos cave', *Hesperia* 77: 549–56.

La Rosa, V., 1984. 'Haghia Triada', in *Creta antica. Cento anni di archeologia italiana (1884–1984)*. Rome: 161–201.

____, 2002. 'Le campagne di scavo 2000–2002 a Festòs', *ASA* 80: 635–869.

Laviosa, C., 1973. 'L'abitato prepalaziale di Haghia Triada', *ASA* 50–1 (1972–73): 503–13.

Lee, P. G., 1974. BLitt thesis, University of Oxford.

Levi, D., 1931. 'Abitazioni preistoriche sulle pendici meridionali dell'Acropoli', *ASA* 13–14 (1930–31): 411–98.

____, 1958a. 'L'archivio di cretule a Festòs', *ASA* 35–6 (1957–58): 7–192.

____, 1958b. 'Gli scavi a Festòs nel 1956 e 1957', *ASA* 35–6 (1957–58): 193–361.

____, 1964. *The Recent Excavations at Phaistos*. SIMA 11. Lund.

____, 1965. 'Le varietà della primitive ceramica cretese', in *Studi in onore di Luisa Banti*. Rome: 223–39.

____, 1976. *Festòs e la civiltà minoica* I. Incunabula Graeca 60. Rome.

Lloyd, S., and J. Mellaart, 1962. *Beycesultan* I. *The Chalcolithic and Early Bronze Age Levels*. London.

Lloyd, S., and F. Safar, 1945. 'Tell Hassuna. Excavations by the Iraq Government Directorate General of Antiquities in 1943 and 1944', *JNES* 5: 255–89.

Logothetis, V., 1970. 'Η εξέλιξις της αμπέλου και της αμπελουργίας στην Ελλάδα κατά τα αρχαιολογικά ευρήματα', *Επιστημονική Επετηρίς της Γεωπονικής και Δασολογικής Σχολής Θεσσαλονίκης* 13: 167–249.

Macdonald, C. F., forthcoming. 'Palatial Knossos: the early years', in *Back to the Beginning*.

Macdonald, C. F., and C. Knappett, 2007. *Knossos. Protopalatial Deposits in Early Magazine A and the South-West Houses*. *BSA* Suppl. 41. London.

McEnroe, J. C., 2010. *Architecture of Minoan Crete: Constructing Identity in the Aegean Bronze Age*. Austin.

MacGillivray, J. A., 1980. 'Mount Kynthos in Delos. The Early Cycladic settlement', *BCH* 104: 3–45.

____, 1984. 'The relative chronology of Early Cycladic III', in J. A. MacGillivray and R. L. N. Barber (eds.), *The Prehistoric Cyclades: Contributions to a Workshop on Cycladic Chronology*. Edinburgh: 70–7.

____, 1994. 'The early history of the Palace at Knossos (MM I–II)', in *Knossos Labyrinth*: 45–55.

____, 1998. *Knossos: Pottery Groups of the Old Palace Period*. *BSA* Studies 5. London.

____, 2007. 'Protopalatial (MM IB–MM IIIA): Early Chamber beneath the West Court, Royal Pottery Stores, the Trial KV, and the West and South Polychrome Deposits Groups', in *KPH*: 105–49.

MacGillivray, J. A., P. M. Day and R. E. Jones, 1988. 'Dark-faced incised pyxides and lids from Knossos: problems of date and origin', in E. B. French and K. A. Wardle (eds.), *Problems in Greek Prehistory*. Bristol: 91–4.

McGovern, P. E., D. L. Glusker, L. J. Exner and G. R. Hall, 2008. 'The chemical identification of retsinated wine and a mixed fermented beverage in Bronze-Age pottery vessels of Greece', in Y. Tzedakis, H. Martlew and K. Jones (eds.), 2008. *Archaeology Meets Science: Biomolecular Investigations in Bronze Age Greece*. Oxford: 169–218.

Mackenzie, D., 1903. 'The pottery of Knossos', *JHS* 23: 157–205.

____, 1906. 'The Middle Minoan pottery of Knossos', *JHS* 26: 243–67.

Manteli, K., 1992. 'The Neolithic well at Kastelli Phournis in eastern Crete', *BSA* 87: 103–20.

Manteli, K., and D. Evely, 1995, 'The Neolithic levels from the Throne Room system, Knossos', *BSA* 90: 1–16.

Maraghiannis, G., 1911. *Antiquités crétoises* II. Herakleion.

Mariani, L., 1895. 'Antichità cretesi', *MonLinc* 6: 157–347.

Marinatos, S., 1929a. 'Ανασκαφαί εν Κρήτη', *PAE*: 94–104.

____, 1929b. 'Πρωτομινωϊκός θολωτός τάφος παρά το χωριόν Κράσι Πεδιάδος', *ADelt* 12: 102–41.

____, 1931. 'Δύο πρώϊμοι μινωϊκοί τάφοι εκ Βορού Μεσαράς', *ADelt* 13 (1930–31): 137–70.

____, 1935. 'Γιοφυράκια', *ADelt* 15 (1933–35), Par.: 49–51.

____, 1946. 'Greniers de l'Helladique Ancien', *BCH* 70: 337–51.

____, 1950. 'Μέγαρον Βαθυπέτρου', *PAE*: 242–57.

Matz, F., 1951. *Forschungen auf Kreta 1942*. Berlin.

Mee, C., and J. Doole, 1993. *Aegean Antiquities on Merseyside: the Collections of Liverpool Museum and Liverpool University*. National Museums and Galleries on Merseyside Occasional Papers. Liverpool Museum 7. Liverpool.

Melas, M., 1999. 'The ethnography of Minoan and Mycenaean beekeeping', in P. P. Betancourt, V. Karageorghis, R. Laffineur and W.-D. Niemeier (eds.), 1999. *MELETEMATA. Studies in Aegean Archaeology Presented to Malcolm H. Wiener*. Aegaeum 20. Liège and Austin: 485–91.

Melena, J. L., 1983. 'Olive oil and other sorts of oil in the Mycenaean tablets', *Minos* 18: 89–123.

Mellaart, J., 1954. 'Preliminary report on a survey of pre-classical remains in southern Turkey', *AnatStud* 4: 175–240.

___, 1963. 'Early cultures of the south Anatolian plateau, II. The Late Chalcolithic and Early Bronze Ages in the Konya plain', *AnatStud* 13: 199–236.

Méry, S., P. Anderson, M.-L. Inizan, M. Lechevallier and J. Pelegrin, 2007. 'A pottery workshop with flint tools on blades knapped with copper at Nausharo (Indus civilization, *ca.* 2500 BC)', *JAS* 34: 1098–116.

Mina, M., 2008. '"Figurin" out Cretan Neolithic society: anthropomorphic figurines, symbolism and gender dialectics', in *Escaping the Labyrinth*: 115–35.

Momigliano, N., 1990. 'The development of the footed goblet ("egg-cup") from EM II to MM III at Knossos', in *Cretological* 6: A.1, 477–87.

___, 1991. 'MM IA pottery from Evans' excavations at Knossos: a reassessment', *BSA* 86: 149–271.

___, 1999. 'Osservazioni sulla nascita dei palazzo minoici e sul periodo prepalaziale a Cnosso', in V. La Rosa, D. Palermo and L. Vagnetti (eds.), επί πόντον πλαζόμενοι. *Simposio italiano di Studi Egei dedicato a Luigi Bernabò Brea e Giovanni Pugliese Carratelli.* Rome: 69–74.

___, 2000*a*. 'On the Early Minoan III–Middle Minoan IA sequence at Knossos', in *Cretological* 8: A.2, 335–48.

___, 2000*b*. 'Knossos 1902, 1905: the Prepalatial and Protopalatial deposits from the Room of the Jars in the Royal Pottery Stores', *BSA* 95: 65–105.

___ (ed.), 2007*a*. *Knossos Pottery Handbook: Neolithic and Bronze Age (Minoan). BSA* Studies 14. London.

___, 2007*b*. 'Introduction', in *KPH*: 1–8.

___, 2007*c*. 'Late Prepalatial (EM III–MM IA): South Front House Foundation Trench, Upper East Well and House C/RRS Fill Groups', in *KPH*: 79–103.

Momigliano, N., and D. E. Wilson, 1996. 'Knossos 1993: excavations outside the South Front of the Palace', *BSA* 91: 1–57.

Money-Coutts, M. B., and J. D. S. Pendlebury, 1933. *Dating of the Pottery in the Stratigraphical Museum 3. The Plans.* London.

Morris, C. E., and A. A. D. Peatfield, 1990. 'Minoan sheep bells: form and function', in *Cretological* 6: A.2, 29–37.

Mountjoy, P. A., 2003. *Knossos: the South House. BSA* Suppl. 34. London.

Mortzos, C. E., 1972. 'Πάρτιρα. Μία πρώϊμος μινωϊκή κεραμεική ομάς', *Πανεπιστήμιον Αθηνών, Επετηρίς Επιστημονικών Ερευνών* 3: 386–421.

Myres, J. L., 1895. 'Some pre-historic polychrome pottery from Kamárais, in Crete', *Proceedings of the Society of Antiquaries of London* (2nd s.) 15 (1893–95): 351–6.

O'Connor, T. P., 1993. 'Process and terminology in mammal carcass reduction', *International Journal of Osteoarchaeology* 3: 63–7.

Palmer, L. R., 1963. *The Find-places of the Knossos Tablets* (part of L. R. Palmer and J. Boardman, *On the Knossos Tablets*). Oxford.

Panagiotaki, M., 1998. 'The Vat Room deposit at Knossos: the unpublished notes of Sir Arthur Evans', *BSA* 93: 167–84.

___, 1999. *The Central Palace Sanctuary at Knossos. BSA* Suppl. 31. London.

___, 2004. 'Knossos objects: 1904, the first departure', in *KPCS*: 565–80.

Papadatos, Y., 2005. *Tholos Tomb Gamma: a Prepalatial Tholos Tomb at Phourni, Archanes.* Prehistory Monographs 17. Philadelphia.

___, 2007. 'The beginnings of metallurgy in Crete: new evidence from the FN–EM I settlement at Kephala Petras, Siteia', in P. M. Day and R. C. P. Doonan (eds.), *Metallurgy in the Early Bronze Age Aegean.* SSAA 7. Oxford: 154–67.

___, 2008. 'The Neolithic–Early Bronze Age transition in Crete: new evidence from the settlement at Petras Kephala, Siteia', in *Escaping the Labyrinth*: 258–72.

___, in preparation, *Kephala, Petras. The Final Neolithic–Early Minoan Settlement.*

Paribeni, R., 1904. 'Ricerche nel sepolcreto di Haghia Triada presso Phaestos', *MonLinc* 14: 677–756.

Payne, S., 1985. 'Zoo-archaeology in Greece: a reader's guide', in N. C. Wilkie and D. E. Coulson (eds.), *Studies in Honor of William A. McDonald.* Minneapolis: 211–44.

Pelon, O., and A. Schmitt, 2003. 'Étude en laboratoire des céramiques dites de Vassiliki (Crète orientale)', *BCH* 127: 431–42.

Pendlebury, H. W., and J. D. S. Pendlebury, 1930. 'Two Protopalatial houses at Knossos', *BSA* 30 (1928–30): 53–73.

Pendlebury, H. W., J. D. S. Pendlebury and M. B. Money-Coutts, 1936. 'Excavations in the plain of Lasithi I. The cave of Trapeza', *BSA* 36 (1935–36): 5–131.

Pendlebury, H. W., J. D. S. Pendlebury and M. B. Money-Coutts, 1938. 'Excavations in the plain of Lasithi II. *BSA* 38 (1937–38): 1–56.

Pendlebury, J. D. S., 1933. *A Guide to the Stratigraphical Museum in the Palace at Knossos.* London.

___, 1939. *The Archaeology of Crete: An Introduction.* London.

Pendlebury, J. D. S., and H. W. Pendlebury, 1933. *Dating of the Pottery in the Stratigraphical Museum 1.* London.

Perna, M., 1999. 'Il sistema amminstrativo minoico nella Creta prepalaziale', in V. La Rosa, D. Palermo and L. Vagnetti (eds.), επί πόντον πλαζόμενοι. *Simposio italiano di Studi Egei dedicato a Luigi Bernabò Brea e Giovanni Pugliese Carratelli.* Rome: 63–8.

Pernier, L., 1935. *Il palazzo minoico di Festòs* I. *Gli strati piu antichi e il primo palazzo.* Rome.

Petrakis, S. L., 2002. *Ayioryitika. The 1928 Excavations of Carl Blegen at a Neolithic to Early Helladic Settlement in Arcadia.* Prehistory Monographs 3. Philadelphia.

Phillips, J., 2009. *Aegyptiaca on the Island of Crete in their Chronological Context: A Critical Review.* Contributions to the Chronology of the Eastern Mediterranean 18; Österreichische Akademie der Wissenschaften, Denkschriften der Gesamtakademie 49. Vienna.

Pini, I., 1990. 'The Hieroglyphic Deposit and the Temple Repositories at Knossos', in T. G. Palaima (ed.), *Aegean Seals, Sealings and Administration.* Aegaeum 5. Liège: 33–60.

____, 2006. 'Die Siegel und die Siegelabdrücke auf Gefässhenkeln aus dem Heiligtum von Symi', *AM* 121: 1–11.

Platon, N., 1957. 'Ἡ αρχαιολογική κίνησις εν Κρήτη κατά το έτος 1957', *KChron* 11: 326–40.

____, 1981. *La civilisation égéenne. Du néolithique au bronze récent.* Paris.

Poursat, J.-C., 2010. 'Malia: palace, state, city', in *Cretan Offerings*: 259–67.

Poursat, J.-C., and C. Knappett, 2005. *Fouilles exécutées à Malia. Le Quartier Mu* IV. *La poterie du Minoen Moyen II: production et utilisation.* EtCr 33. Paris.

Quirke, S., 2005. *Lahun. A Town in Egypt 1800 BC, and the History of its Landscape.* London.

Rackham, O., 1972. 'Charcoal and plaster impressions', in P. Warren, *Myrtos. An Early Bronze Age Settlement in Crete.* BSA Suppl. 7. London: 299–304.

Rackham, O., and J. Moody, 1996. *The Making of the Cretan Landscape.* Manchester.

Reese, D. S., 1987. 'The EM IIA shells from Knossos, with comments on Neolithic to EM III shell utilization', *BSA* 82: 207–10.

Relaki, M., 2009. 'Rethinking administration and seal use in third millennium Crete', *Creta Antica* 10: 353–72.

Renfrew, C., 1964. 'Crete and the Cyclades before Rhadamanthus', *KChron* 18: 107–41.

____, 1972. *The Emergence of Civilisation: The Cyclades and the Aegean in the Third Millennium B.C.* London.

Renfrew, C., J. R. Cann and J. R. Dixon, 1965. 'Obsidian in the Aegean', *BSA* 60: 255–47.

Renfrew, J. M., 1972. 'The plant remains', in P. Warren, *Myrtos. An Early Bronze Age Settlement in Crete.* BSA Suppl. 7. London: 315–17.

____, 1995. 'Palaeoethnobotanical finds of *Vitis* from Greece', in P. E. McGovern, S. J. Fleming and S. H. Katz (eds.), *The Origins and Ancient History of Wine.* Food and Nutrition in History and Anthropology 11. Luxembourg: 255–67.

____, 2006. 'The leaf, mat and cloth impressions', in L. Marangou, C. Renfrew, C. Doumas and G. Gavalas, 2006. *Markiani, Amorgos. An Early Bronze Age Fortified Settlement. Overview of the 1985–1991 Investigations.* BSA Suppl. 40. London: 195–9.

____, 2007 'Leaf, mat and cloth impressions from Dhaskalio Kavos, Keros', in C. Renfrew, C. Doumas, L. Marangou and G. Gavalas (eds.), 2007. *Keros* I. *Keros, Dhaskalio Kavos, the Investigations of 1987–88.* McDonald Institute Monographs. Cambridge: 374–6.

____, forthcoming. 'Impressions of leaves, cloth and matting from Kavos South and Dhaskalio', in C. Renfrew, O. Philaniotou, N. Brodie, G. Gavalas and M. J. Boyd (eds.), *The Sanctuary at Keros. Excavations at Dhaskalio and Dhaskalio Kavos, Keros 2006–2009.*

Richter, G. M. A., 1912. 'Cretan pottery', *BMMA* 7: 28–35.

Riley, F. R., 2004. 'The olive industry of Bronze Age Crete: evidence for volcanic damage to olive groves and property in central and eastern Crete', *Ακρωτήριον* 49: 1–6.

Runnels, C., and J. Hansen, 1986. 'The olive in the prehistoric Aegean: the evidence for domestication in the Early Bronze Age', *OJA* 5: 299–308.

Rutter, J. B., and C. W. Zerner, 1984. 'Early Hellado-Minoan contacts', in R. Hägg and N. Marinatos (eds.), *The Minoan Thalassocracy. Myth and Reality.* Skrifter Utgivna av Svenska Institutet i Athen 4° 32. Stockholm: 75–83.

Sackett, L. H., M. R. Popham and P. M. Warren, 1965. 'Excavations at Palaikastro. VI', *BSA* 60: 248–315.

Sakellarakis, Y., 1973. 'Ανασκαφή Αρχανών', *PAE*: 167–87.

____, 1981. 'Χρονολογημένα σύνολα μινωικών σφραγίδων από τις Αρχάνες', in *Cretological 4:* A, 510–31.

____, 1983. 'Ανασκαφή Ιδαίου Άντρου', *PAE*: 415–500.

Sakellarakis, Y., and E. Sakellaraki, 1976. 'Ανασκαφή Αρχανών', *PAE*: 342–99.

Sakellarakis, Y., and E. Sakellaraki, 1997. *Archanes. Minoan Crete in a New Light.* Athens.

Sbonias, K., 1995. *Frühkretische Siegel. Ansätze für eine Interpretation der sozial-politischen Entwicklung auf Kreta während der Frühbronzezeit.* BAR–IS 620. Oxford.

____, 1999. 'Social development, management of production, and symbolic representation in Prepalatial Crete', in A. Chaniotis (ed.), *From Minoan Farmers to Roman Traders.* Stuttgart: 25–51.

Schachermeyr, F., 1962. 'Forschungsbericht über die Ausgrabungen und Neufunde zur ägäischen Frühzeit 1957–60', *AA*: 105–382.

Schaeffer, C. F. A., 1962. *Ugaritica* IV. Mission de Ras Shamra 15. Paris.

____, 1969. *Ugaritica* VI. Mission de Ras Shamra 17. Paris.

Schliemann, H., 1880. *Ilios: the City and Country of the Trojans.* London.

Schoep, I., 1999. 'The origins of writing and administration on Crete', *OJA* 18: 265–76.

____, 2004. 'The socio-economic context of seal use and administration at Knossos', in *KPCS*: 283–93.

___, 2006. 'Looking beyond the First Palaces: elites and the agency of power in EM III–MM II Crete', *AJA* 110: 37–64.

Seager, R. B., 1905. 'Excavations at Vasiliki, 1904', *University of Pennsylvania, Transactions of the Department of Archaeology, Free Museum of Science and Art* 1: 207–21.

___, 1907. 'Report of excavations at Vasiliki, Crete, in 1906', *University of Pennsylvania, Transactions of the Free Museum of Science and Art (University Museum)* 2: 111–32.

___, 1909. 'Excavations on the island of Mochlos', *AJA* 13: 273–303.

___, 1912. *Explorations in the Island of Mochlos*. Boston and New York.

___, 1916. *The Cemetery of Pachyammos, Crete*. University of Pennsylvania Museum Anthropological Publications 7.1. Philadelphia.

Seiradaki, M., 1960. 'Pottery from Karphi', *BSA* 55: 1–37.

Serpetsidaki, I., 2006. 'Προανακτορικός σπηλαιώδης τάφος στο Κυπαρίσσι Τεμένους', in *Cretological* 9: A.2, 243–58.

Shaw, J. W., A. Van de Moortel, P. M. Day and V. Kilikoglou, 2001. *A LM IA Ceramic Kiln in Southern-central Crete. Function and Pottery Production*. Hesperia Suppl. 30. Princeton.

Sherratt, S., 2000. *Catalogue of Cycladic Antiquities in the Ashmolean Museum: the Captive Spirit*. Oxford.

Snyder, L. M., and W. E. Klippel, 1996. 'The Cretan badger (*Meles meles*) as a food resource at Late Bronze/Early Iron Age Kavousi–Kastro', in D. S. Reese (ed.), *Pleistocene and Holocene Fauna of Crete and its First Settlers*. Monographs in World Archaeology 28. Madison: 283–93.

Snyder, L. M., and W. E. Klippel, 2003. 'From Lerna to Kastro: further thoughts on dogs as food in ancient Greece; perceptions, prejudices and reinvestigations', in E. Kotjabopoulou, Y. Hamilakis, P. Halstead, *et al.*, (eds.), *Zooarchaeology in Greece: Recent Advances*. BSA Studies 12. London: 221–31.

Soles, J. S., 1992. *The Prepalatial Cemeteries at Mochlos and Gournia and the House Tombs of Bronze Age Crete*. Hesperia Suppl. 24. Princeton.

Sperling, J. W., 1976. 'Kum Tepe in the Troad: trial excavation, 1934', *Hesperia* 45: 305–64.

Stefani, E., 1931. 'La grande tomba a tholos di Haghia Triada', *ASA* 13–14 (1930–31): 147–54.

Stefanos, K., 1906. 'Ἀνασκαφαί εν Νάξω', *PAE*: 86–9.

Stewart, J. R., 1962. 'The Early Cypriote Bronze Age', in P. Dikaios and J. R. Stewart, *The Swedish Cyprus Expedition* IV.1A. *The Stone Age and Early Bronze Age in Cyprus*. Lund: 205–300.

Strasser, T. F., 2008. 'Stones of contention: regional axe production and hidden landscapes on Neolithic Crete', in *Escaping the Labyrinth*: 155–64.

Takaoğlu, T., 2000. 'Hearth structures in the religious pattern of Early Bronze Age northeast Anatolia', *AnatStud* 50: 11–16.

Talianis, D., and P. Theodorides, n. d. *The Olive in Greece*. Smyrini.

Taramelli, A., 1897. 'Cretan expedition VIII. The prehistoric grotto at Miamù', *AJA* 1: 287–312.

Todaro, S., 2001. 'Nuove prospettive sulla produzione in stile Pyrgos nella Creta meridionale: il caso della pisside e della coppa su base ad anello', *Creta Antica* 2: 11–28.

___, 2003. 'Haghia Triada nel periodo Antico Minoico', *Creta Antica* 4: 69–95.

___, 2005. 'EM I–MM IA ceramic groups at Phaistos: towards the definition of a Prepalatial ceramic sequence in South Central Crete', *Creta Antica* 6: 11–46.

___, 2009*a*. 'The latest Prepalatial period and the foundation of the first palace at Phaistos: a stratigraphic and chronological re-assessment', *Creta Antica* 10: 105–45.

___, 2009*b*. 'Pottery production in the Prepalatial Mesara: the Artisans' Quarter to the west of the Palace at Phaistos', *Creta Antica* 10: 335–52.

___, forthcoming. 'Craft production and social practices at Prepalatial Phaistos: the background to the first "Palace"', in *Back to the Beginning*.

Todaro, S., and S. Di Tonto, 2008. 'The Neolithic settlement of Phaistos revisited: evidence for ceremonial activity on the eve of the Bronze Age', in *Escaping the Labyrinth*: 177–90.

Tomkins, P. D., 2007. 'Neolithic: Strata IX–VIII, VII–VIB, VIA–V, IV, IIIB, IIIA, IIA and IC Groups', in *KPH*: 9–48.

___, 2008. 'Time, space and the reinvention of the Cretan Neolithic', in *Escaping the Labyrinth*: 21–48.

___, 2009. 'Domesticity by default. Ritual, ritualization and cave-use in the Neolithic Aegean', *OJA* 28: 125–53.

___, forthcoming *a*. 'Behind the horizon. Reconsidering the genesis and function of the "First Palace" at Knossos (Final Neolithic IV–Middle Minoan IB)', in *Back to the Beginning*.

___, forthcoming *b*. 'Landscapes of identity, ritual and memory. Reconsidering the use of caves on Crete during the Neolithic and Early Bronze Age', in H. Moyes (ed.), *Journeys into the Dark Zone. Cross Cultural Perspectives on the Ritual Use of Caves*. Colorado.

Torrence, R., 1986. *Production and Exchange of Stone Tools. Prehistoric Obsidian in the Aegean*. Cambridge.

Trevor-Battye, A., 1913. *Camping in Crete; with Notes upon the Animal and Plant Life of the Island*. London.

Tsountas, C., 1898. 'Κυκλαδικά', *ArchEph*: 137–211.

___, 1899. 'Κυκλαδικά II', *ArchEph*: 73–134.

Tzedakis, Y., 1965. 'Ἀρχαιότητες και μνημεία δυτικής Κρήτης', *ADelt* 20, Chr.: 568–70.

___, 1966. 'Ἀρχαιότητες και μνημεία δυτικής Κρήτης', *ADelt* 21, Chr.: 425–9.

____, 1967. 'Ἀρχαιότητες καὶ μνημεία δυτικῆς Κρήτης', *ADelt* 22, Chr.: 501–06.

____, 1968*a*. 'Ἀνασκαφή σπηλαίου "Μαμελούκου Τρύπα" (Περιβόλια Κυδωνίας)', *PAE*: 133–8.

____, 1968*b*. 'Ἀρχαιότητες καὶ μνημεία δυτικῆς Κρήτης', *ADelt* 23, Chr.: 413–20.

____, 1969. 'Ἀρχαιότητες καὶ μνημεία δυτικῆς Κρήτης', *ADelt* 24, Chr.: 428–36.

____, 1972. 'Ἀρχαιότητες καὶ μνημεία δυτικῆς Κρήτης', *ADelt* 27, Chr.: 635–44.

Tzedakis, Y., and H. Martlew (eds.), 1999. *Minoans and Mycenaeans: Flavours of Their Time*. Athens.

Vagnetti, L., 1973*a*. 'L'insediamento neolitico di Festòs', *ASA* 50–1 (1972–73): 7–138.

____, 1973*b*. 'Tracce di due insediamenti neolitici nel territorio dell' antica Gortina', in G. Carratelli and G. Rizza (eds.), *Antichità cretesi: studi in onore di Doro Levi* 1. Cronache di Archeologia 12. Catania: 1–9.

____, 1996. 'The Final Neolithic: Crete enters the wider world', *Cretan Studies* 5: 29–39.

Vagnetti, L., and P. Belli, 1978. 'Characters and problems of the Final Neolithic in Crete', *SMEA* 19: 125–63.

Van der Veen, M., and N. Fieller, 1982. 'Sampling seeds', *JAS* 9: 287–98.

Van Effenterre, H., 1980. *Le palais de Mallia et la cité minoenne*. Incunabula Graeca 76. Rome.

Van Effenterre, H., and M. Van Effenterre, 1963. *Fouilles exécutées à Mallia. Site et nécropoles* II. *Étude du site (1956–57) et exploration des nécropoles (1915–1928)*. EtCr 13. Paris.

Ventris, M., and J. Chadwick, 1973. *Documents in Mycenaean Greek* (2nd ed.). Cambridge.

Vickery, K. F., 1936. *Food in Early Greece*. Illinois Studies in the Social Sciences 20.3. Urbana.

Vitelli, K. D., 1993. *Excavations at Franchthi Cave, Greece* 8. *Franchthi Neolithic Pottery* 1: *Classification and Ceramic Phases 1 and 2*. Bloomington and Indianapolis.

____, 2007. *Lerna* V. *The Neolithic Pottery from Lerna*. Princeton.

Von Oppenheim, M., 1943. *Tell Halaf* I. *Die prähistorischen Funde*. Berlin.

Warren, P. M., 1965. 'The first Minoan stone vases and Early Minoan chronology', *KChron* 19: 7–43.

____, 1968. 'Knossos Neolithic, part II. Stone axes and maceheads: materials', *BSA* 63: 239–41.

____, 1969. *Minoan Stone Vases*. Cambridge.

____, 1972*a*. *Myrtos. An Early Bronze Age Settlement in Crete*. BSA Suppl. 7. London.

____, 1972*b*. 'Knossos and the Greek mainland in the third millennium B.C.', *AAA* 5: 392–8.

____, 1973. 'Knossos. Excavation in the area of the Royal Road', *ADelt* 28, Chr.: 574–6.

____, 1974. 'Knossos 1973. Royal Road excavations and study season', *ADelt* 29 (1973–74), Chr.: 903–04.

____, 1980. 'Problems of chronology in Crete and the Aegean in the third and earlier second millennium B.C.', *AJA* 84: 487–99.

____, 1981. 'Knossos and its foreign relations in the Early Bronze Age', in *Cretological* 4: A, 628–37.

____, 1994. 'The Minoan roads of Knossos', in *Knossos Labyrinth*: 191–210.

____, forthcoming. '"Back to the Beginning" — an overview', in *Back to the Beginning*.

Warren, P., and V. Hankey, 1989. *Aegean Bronze Age Chronology*. Bristol.

Warren, P., and Y. Tzedakis, 1974. 'Debla, an Early Minoan settlement in western Crete', *BSA* 69: 299–342.

Was, D. A., 1973. 'Olives to pay Minoan labour', *Minos* 14: 7–16.

Watrous, L. V., and D. Hadzi-Vallianou, 2004. 'Emergence of a ranked society (Early Minoan II–III)', in L. V. Watrous, D. Hadzi-Vallianou and H. Blitzer, *The Plain of Phaistos. Cycles of Social Complexity in the Mesara Region of Crete*. Monumenta Archaeologica 23. Los Angeles: 233–52.

Weinberg, S. S., 1965. 'The relative chronology of the Aegean in the Stone and Early Bronze Ages', in R. W. Ehrich (ed.), *Chronologies in Old World Archaeology*. Chicago: 285–320.

____, 1969. 'A gold sauceboat in the Israel Museum', *Antike Kunst* 12: 3–8.

Weingarten, J., 1990. 'Three upheavals in Minoan sealing administration: evidence for radical change', in T. G. Palaima (ed.), *Aegean Seals, Sealings and Administration*. Aegaeum 5. Liège: 105–20.

____, 1994. 'Sealings and sealed documents at Bronze Age Knossos', in *Knossos Labyrinth*: 171–88.

____, 2005. 'How many seals make a heap: seals and interconnections on Prepalatial Crete', in R. Laffineur and E. Greco (eds.), *EMPORIA. Aegeans in the Central and Eastern Mediterranean*. Aegaeum 25. Liège and Austin: 759–66.

Weisshaar, H.-J., 1983. 'Bericht zur frühhelladischen Keramik. Ausgrabungen in Tiryns 1981', *AA*: 329–58.

Welch, F. B., 1900. 'Knossos III. Notes on the pottery', *BSA* 6 (1899–1900): 85–92.

Whitelaw, T. M., 2007. 'House, household and community at Early Minoan Fournou Korifi: methods and models for interpretation', in R. Westgate, N. Fisher and J. Whitley (eds.), *Building Communities: House, Settlement and Society in the Aegean and Beyond. BSA Studies 15*. London: 65–76.

____, forthcoming. 'The urbanisation of prehistoric Crete: settlement perspectives on Minoan state formation', in *Back to the Beginning*.

____, P. M. Day, E. Kiritazi, V. Kilikoglou and D. E. Wilson, 1997. 'Ceramic traditions at EM IIB Myrtos–Fournou Korifi', in R. Laffineur and P. P. Betancourt (eds.), *TEXNH. Craftsmen, Craftswomen and Craftsmanship in the Aegean Bronze Age*. Aegaeum 16. Liège and Austin: 265–74.

Wiencke, M. H., 2000. *Lerna* IV. *The Architecture, Stratification and Pottery of Lerna III*. Princeton.

Willerding, U., 1973. 'Bronzezeit Pflanzenreste aus Iria und Synoro', in *Tiryns. Forschungen und Berichte* VI. Mainz: 221–40.

Wilson, D. E., 1984. 'The Early Minoan IIA West Court House at Knossos' (PhD thesis, University of Cincinnati).

____, 1985. 'The pottery and architecture of the EM IIA West Court House at Knossos', *BSA* 80: 281–364.

___, 1987. 'An Early Minoan IIA triple-bodied jug from Knossos', *BSA* 82: 335–8.

___, 1994. 'Knossos before the Palaces: an overview of the Early Bronze Age (EM I–EM III)', in *Knossos Labyrinth*: 23–44.

___, 1999. *Keos* IX. *Periods I–III: the Neolithic and Early Bronze Age Settlements* 1. *The Pottery and Small Finds*. Mainz.

___, 2007. 'Early Prepalatial (EM I–EM II): EM I Well, West Court House, North-East Magazines and South Front Groups', in *KPH*: 49–77.

___, 2010. 'Knossos 1955–1957: early Prepalatial deposits from Platon's tests in the Palace', *BSA* 105: 97–155.

Wilson, D. E., and P. M. Day, 1994. 'Ceramic regionalism in Prepalatial central Crete: the Mesara imports at EM I to EM IIA Knossos', *BSA* 89: 1–87.

Wilson, D. E., and P. M. Day, 1999. 'EM IIB ware groups at Knossos: the 1907–1908 South Front tests', *BSA* 94: 1–62.

Wilson, D. E., and P. M. Day, 2000. 'EM I chronology and social practice: pottery from the early Palace tests at Knossos', *BSA* 95: 21–63.

Wilson, D. E., P. M. Day and N. Dimopoulou-Rethemiotaki, 2004. 'The pottery from Early Minoan I–IIB Knossos and its relations with the harbour site of Poros–Katsambas', in *KPCS*: 67–74.

Wilson, D. E., P. M. Day and N. Dimopoulou-Rethemiotaki, 2008. 'The gateway port of Poros–Katsambas: trade and exchange between north-central Crete and the Cyclades in EB I–II', in N. Brodie, J. Doole, G. Gavalas and C. Renfrew (eds.), *Horizon/Ορίζων. A Colloquium on the Prehistory of the Cyclades*. McDonald Institute Monographs. Cambridge: 261–70.

Xanthoudides, S., 1918a. 'Μέγας πρωτομινωϊκός τάφος Πύργου', *ADelt* 4: 136–70.

___, 1918b. 'Πρωτομινωϊκοί τάφοι Μεσαράς', *ADelt* 4, Par.: 15–23.

___, 1924. *The Vaulted Tombs of Mesará: an Account of some Early Cemeteries of Southern Crete*. Liverpool and London.

Yule, P., 1981. *Early Cretan Seals: a Study in Chronology*. Marburger Studien zur Vor- und Frühgeschichte 4. Mainz.

Zapheiropoulou, P., 1975. 'Όστρακα εκ Κέρου', *AAA* 8: 79–85.

Zerner, C. W., 1978. 'The beginning of the Middle Helladic period at Lerna' (PhD thesis, University of Cincinnati).

___, 1993. 'New perspectives on trade in the Middle and early Late Helladic periods on the Mainland', in C. Zerner, P. Zerner and J. Winder (eds.), *Wace and Blegen: Pottery as Evidence for Trade in the Aegean Bronze Age 1939–1989*. Amsterdam: 39–56.

Zervos, C., 1956. *L'art de la Crète néolithique et minoenne*. Paris.

___, 1957. *L'art des Cyclades du début à la fin de l'age du bronze, 2500–1100 avant notre ère*. Paris.

Zois, A. A., 1965. 'Φαιστιακά', *ArchEph*: 27–109.

___, 1967a. 'Έρευνα περί της μινωϊκής κεραμεικής', *Πανεπιστήμιον Αθηνών, Επετηρίς Επιστημονικών Ερευνών* 1: 703–32.

___, 1967b. 'Υπάρχει ΠΜ III εποχή;', in *Cretological* 2: A, 141–56.

___, 1968a. 'Der Kamares-Stil. Werden und Wesen' (PhD thesis, University of Tübingen).

___, 1968b. 'Two Minoan bridge-spouted jugs of Athens University', in *Χαριστήριον εις Αναστάσιον Κ. Ορλάνδον* 4. Athens: 119–28.

___, 1969. *Προβλήματα χρονολογίας της μινωϊκής κεραμεικής: Γουρνές-Τύλισος-Μάλια*. Βιβλιοθήκη της εν Αθήναις Αρχαιολογικής Εταιρείας 66. Athens.

___, 1976. *Βασιλική* I. *Νέα αρχαιολογική έρευνα εις το Κεφάλι πλήσιον του χωριού Βασιλική Ιεράπετρας*. Βιβλιοθήκη της εν Αθήναις Αρχαιολογικής Εταιρείας 83. Athens.

Index*

administration 234, 294
Aegean 29–30, 59, 285
 E Aegean 142, 293
 NE Aegean 29, 113
Akrotiri peninsula, Crete 28, 67
Akrotiri, Thera 67
Alexiou, S. 52, 92
Amarna 9
Amorgos 69, 103
Amuq F 54
Anatolia 25, 29–30, 124
Andreou, S. 5, 14, 127, 239
animal bones *see* faunal remains
Ano Karnari cave *see* Juktas, Mt
Antalya region 289
Apesokari 6
Aphrodite's Kephali 6, 13–14, 31, 54, 70, 103
Arad II 57
Arapi 69
Archanes 6, 13
 Fourni, Burial Building 18 279
 Burial Building 19 162
 Tholos T. Γ 234
 see also Juktas, Mt
Argive Minyan *see* MH pottery
Argolid 69
Arkalochori 6, 58, 246, 263
Arkoudia cave 28
Asea 29 (n. 61), 59 (n. 288)
Ashmolean Museum, Oxford (AM) 239–40, 245,
 247, 251, 254, 256, 266–71, 273–4, 276, 278, 299
Asine 266
Assiros 66, 292
Athens, Grotto above the Aklipeieon 29 (n. 61)
Ayia Fotia (Ierapetra) 6, 43
Ayia Fotia (Siteia) 6, 31, 34, 36, 54, 70, 116, 236,
 248, 282, 284
Ayia Galini 6
Ayia Kyriaki 6, 28, 33, 48, 97–8, 102, 105, 107,
 109, 118, 120, 247
Ayia Triada 6, 28, 68, 99, 227, 254, 256
 Piazzale dei Sacelli 282
 tholos 5, 11
Ayios Antonios 6, 248
Ayios Charalambos cave 6, 49, 277

Ayios Kosmas 69
Ayios Onouphrios 6, 8, 11, 26, 121; *see also* EM I
 pottery, 'Ayios Onouphrios' ware
Ayioyioryitika 59 (n. 288)

badgers 80, 229, 231, 237
balls, clay 227–8
 stone (? potboiler) 227, 229
Banti, L. 99
barbotine *see* EM III pottery
beehives 30, 59
Betancourt, P. P. 17, 98–9, 116, 119, 175, 202, 213,
 245, 285
Beycesultan 130, 174
bins, unbaked clay 23, 60, 70, 292
Bird, E. 84
Blackman, D. J. 29, 97–9, 247
Blegen, C. W. 17, 29, 58
Blitzer, H. 68
bone tools 60, 228, 236
Boston Museum of Fine Arts 239 (n. 1)
Boyd Hawes, H. 8, 12
Branigan, K. 29, 50, 97–9, 247
British Museum, London (BM) 239–40, 266, 276,
 278, 288, 299
British School at Athens
 1900 excavations at Knossos 1
 1957–61 excavations at Knossos 1–4, 17–18
Broodbank, C. 28
Brussels, Musées Royaux d'Art et d'Histoire (MRAH)
 239–40, 266–7, 274–5, 300
butchery 63–4, 66, 231, 237
Byblos 52

Cadogan, G. 75, 84
Cameron, M. A. S., *et al.* 59, 227, 234
Can Hasan 1 29
Carter, T. 229
cattle 63–6, 229, 231–3, 237
Chalandriani, Syros 68–9
Chalcolithic, Late 29
Chamalevri 6
Chania–Kastelli 6, 29, 36, 99
Chania Museum 277
Charbonneaux, J. 13

* The Index covers the main text of pages 1–300 but not, except
for one or two citations, the catalogue entries or footnotes.

ANCIENT AUTHORS

Plates

PLATE 1

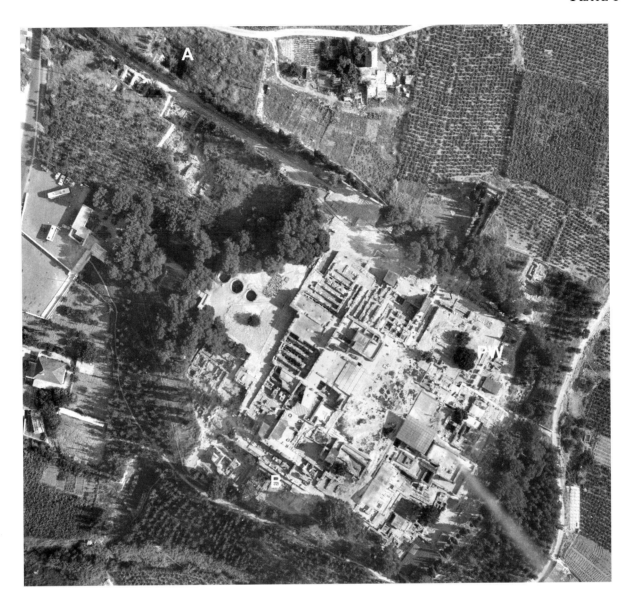

Aerial view of Knossos in 1976, Kephala hill and (later) Palace. PW: Palace Well; A: Royal Road: North; B: Early Houses.

PLATE 2

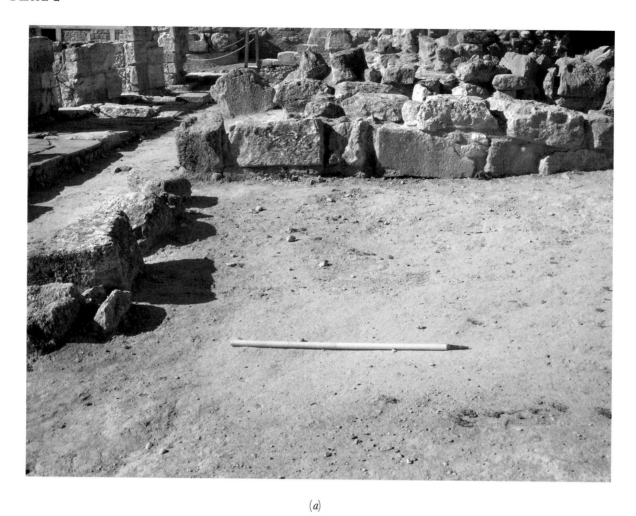

(a)

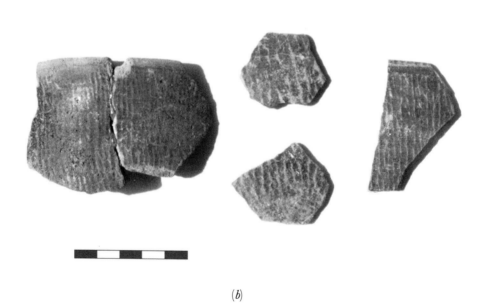

(b)

Palace Well. (a) Location from N; (b) Neolithic (FN IA) rippled ware.

PLATE 3

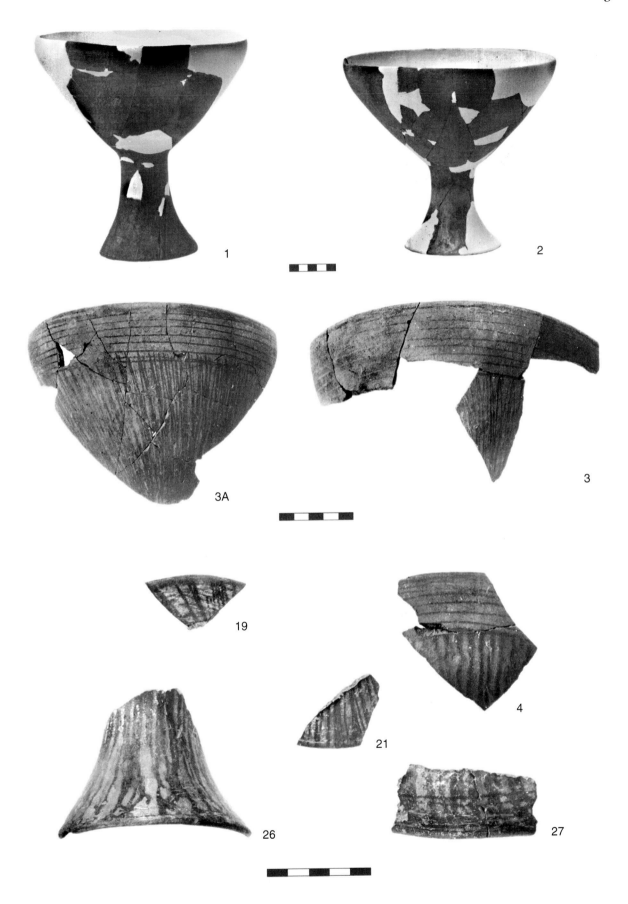

Palace Well (EM I). Type 1 chalices **1–4**, **21**, **26–27**; type 3 pedestal (?) dish **19**.

PLATE 4

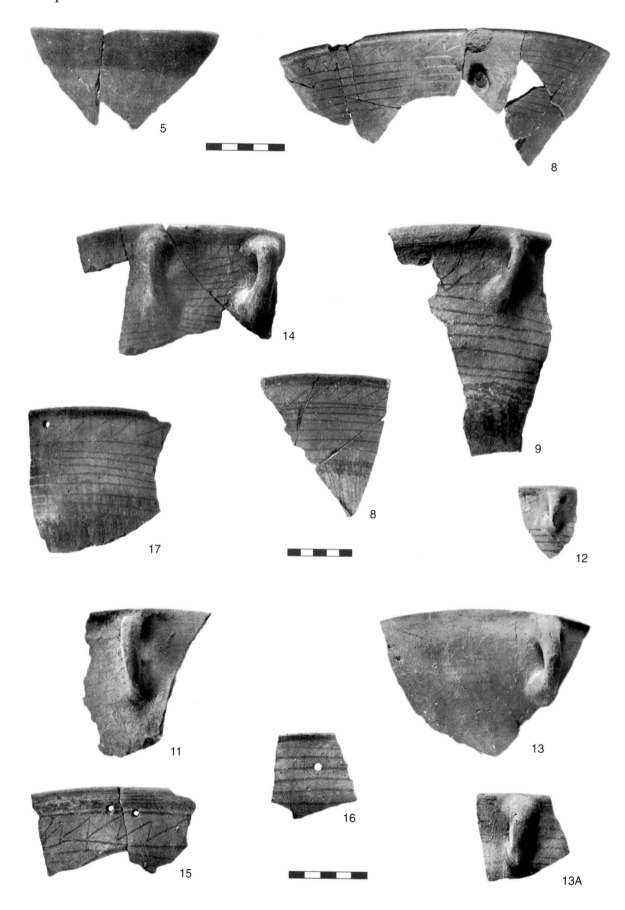

Palace Well (EM I). Type 1 chalice (?) **5**; type 2 bowls **8–9, 11–17**.

PLATE 5

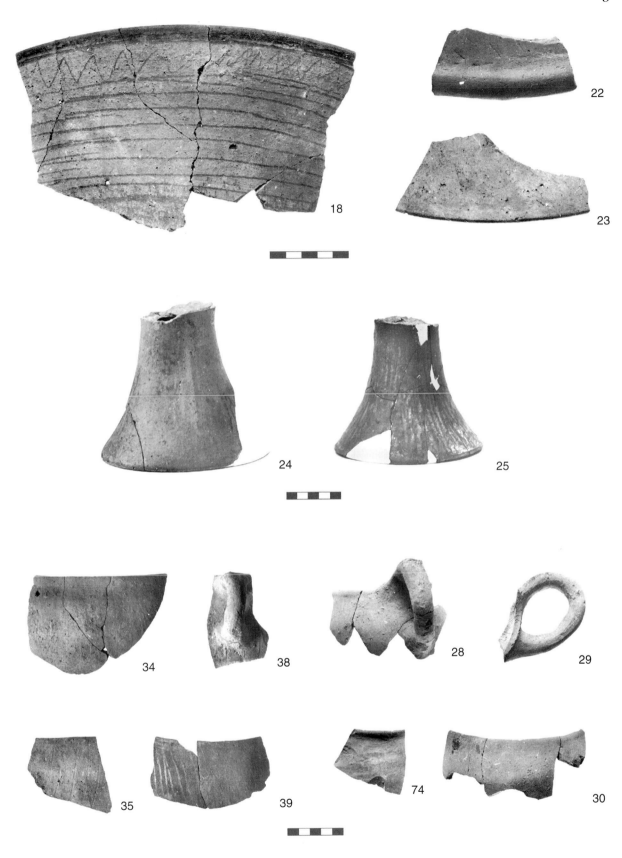

Palace Well (EM I). Type 2 bowls **18**, **22–25**; type 4 cups or bowls **28–30**; type 5 bowls **34–35**, **38–39**; bowl or jar **74**.

PLATE 6

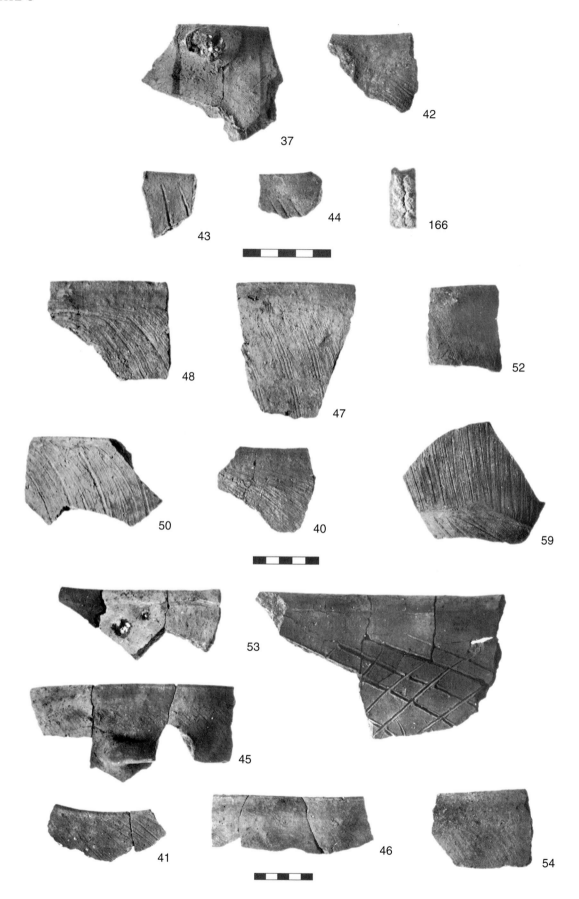

Palace Well (EM I). Type 5 bowl **37**; type 6 bowls **40–44**; type 7 bowls **45–48, 50, 52–54, 59**; clay rod **166**.

PLATE 7

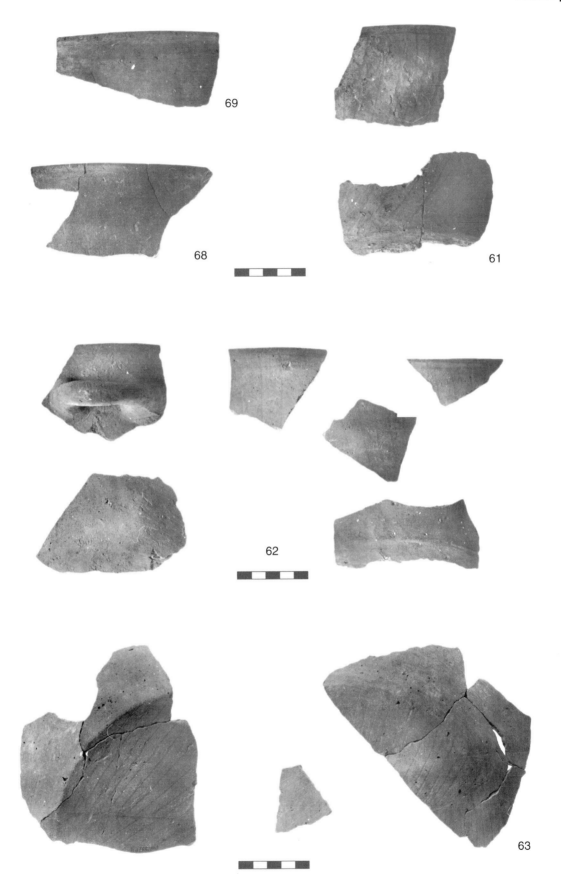

Palace Well (EM I). Type 8 bowls **61–63**; type 9 bowls **68–69**.

PLATE 8

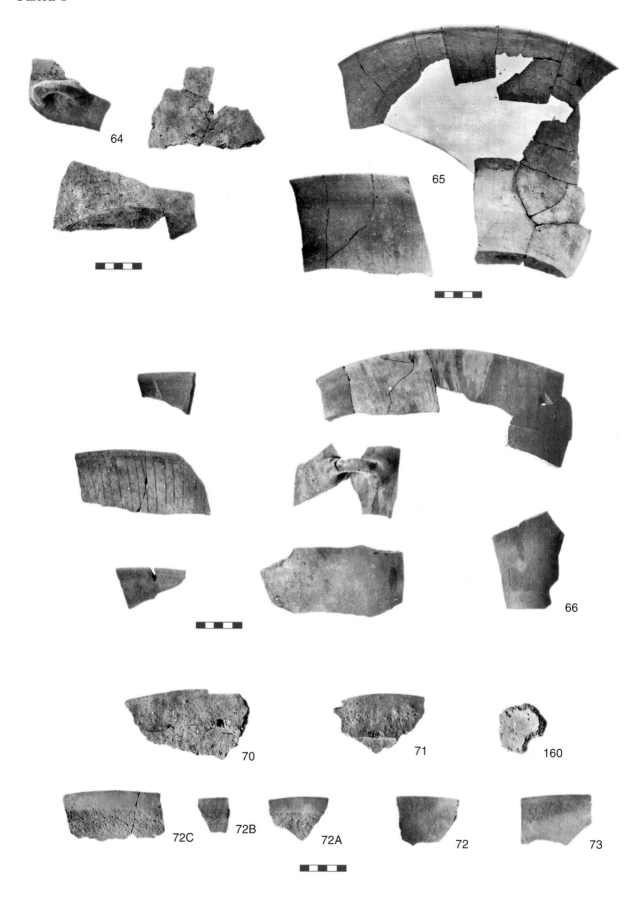

Palace Well (EM I). Type 8 bowl **64**; type 9 bowls **65–66**; type 10 baking plates **70–73**; **160**.

PLATE 9

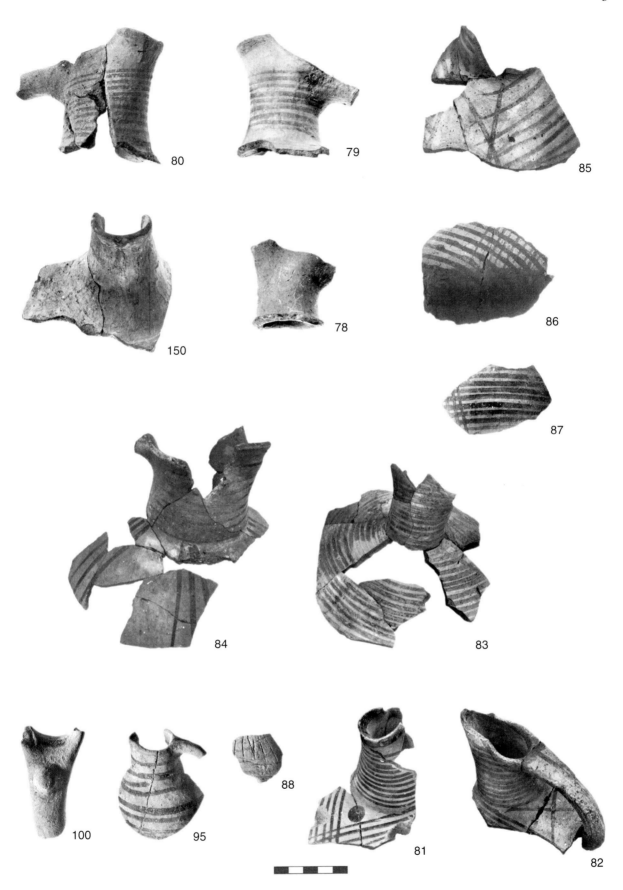

Palace Well (EM I). Type 11 jugs **78–87**; miniature jug **88**; type 12 jugs **95** (miniature), **100**; spout **150**.

PLATE 10

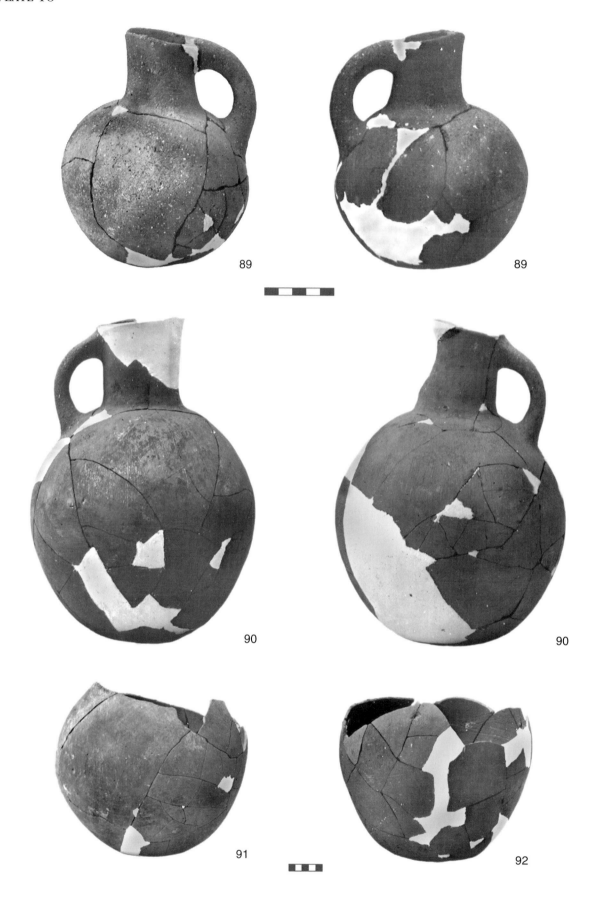

Palace Well (EM I). Type 12 jugs **89–92**.

PLATE 11

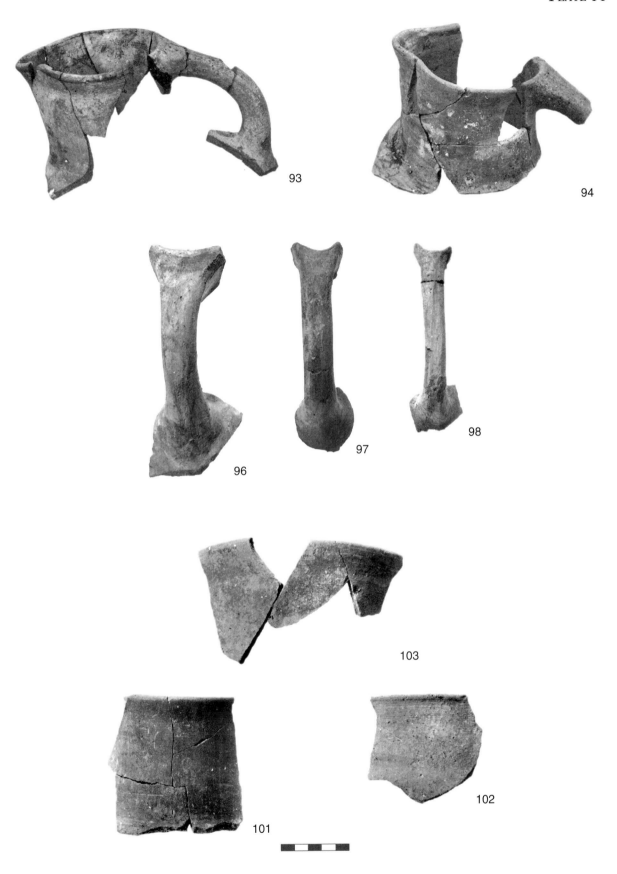

Palace Well (EM I). Type 12 jugs **93-94**, **96-98**; type 13 jars **101-103**.

PLATE 12

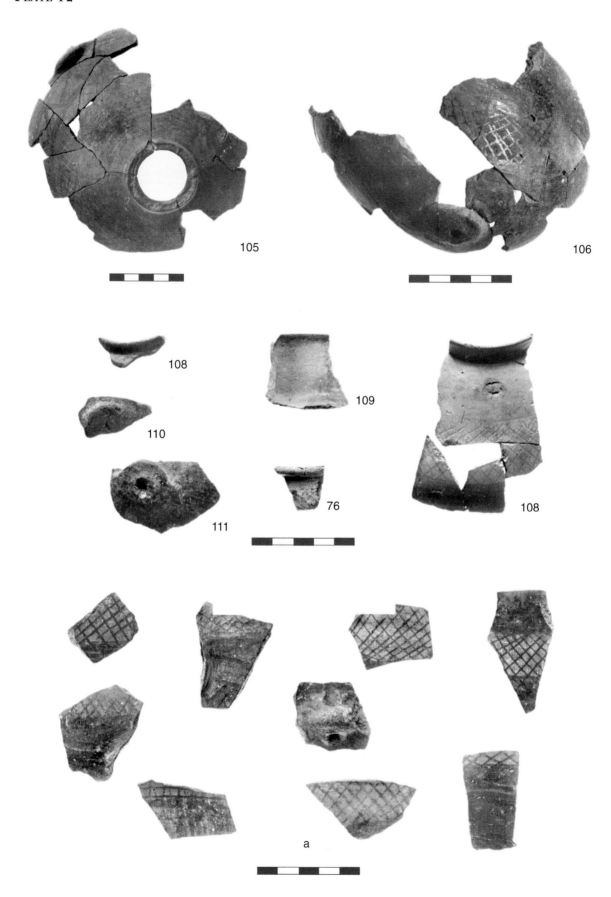

Palace Well (EM I). Bowl or jar **76**; type 14 suspension pots **105–106**, **108–111**, and *a*: probable fragments.

PLATE 13

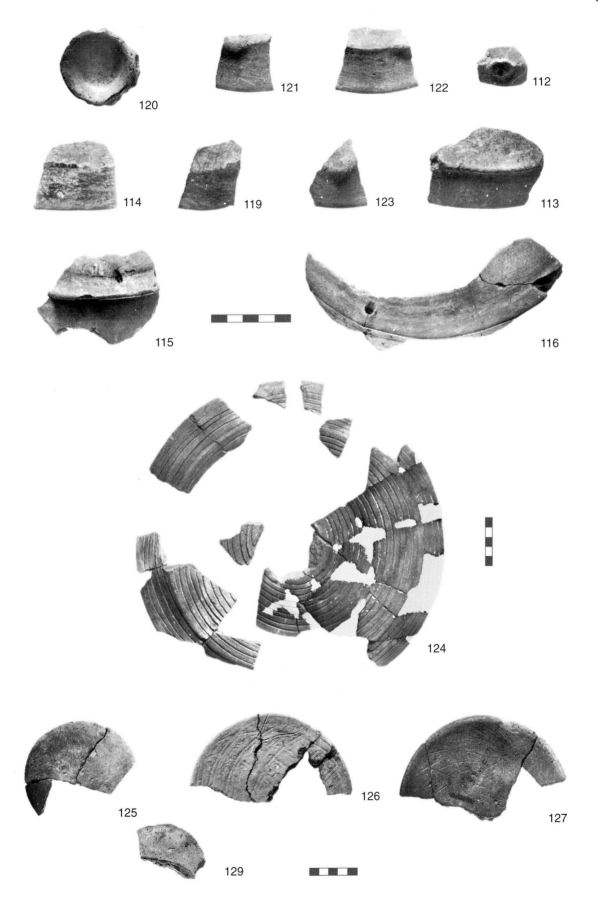

Palace Well (EM I). Type 15 suspension pot lid **112**; type 16 lids **113–116**; type 17 lids **119–123**; type 18 lid **124**; type 19 lids or plates **125–129**.

PLATE 14

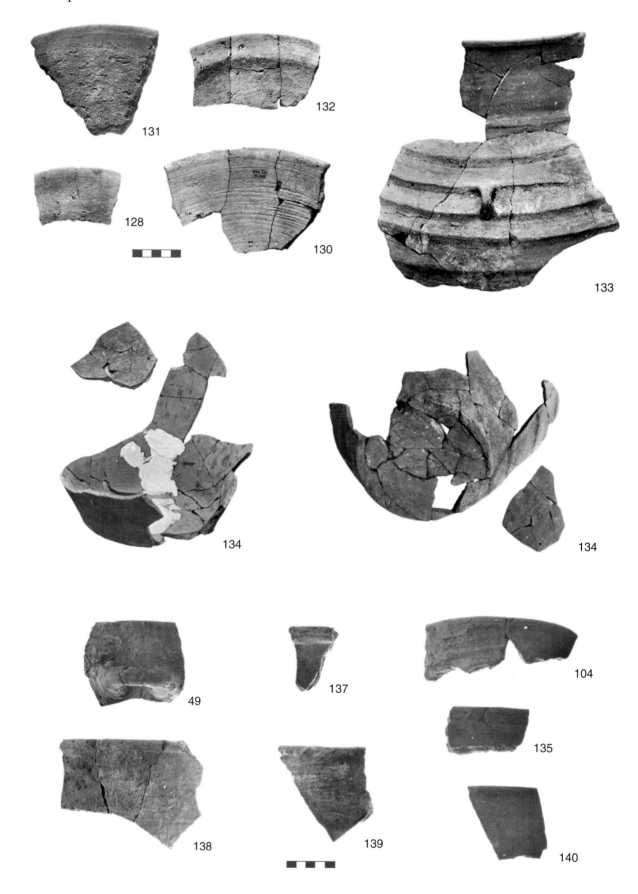

Palace Well (EM I). Type 7 bowl **49**; type 13 jar **104**; type 19 lid or plate **128**; type 20 lids or dishes **130–132**; type 21 storage jars (pithoi) **133–135, 137–140**.

PLATE 15

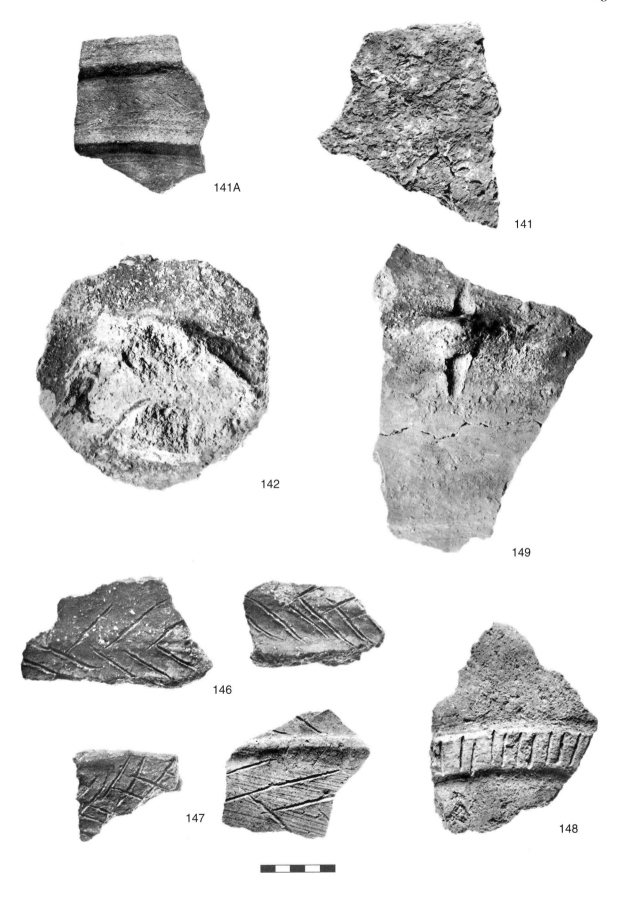

141A

141

142

149

146

147

148

Palace Well (EM I). Type 21 storage jars (pithoi) **141–142, 146–149**.

PLATE 16

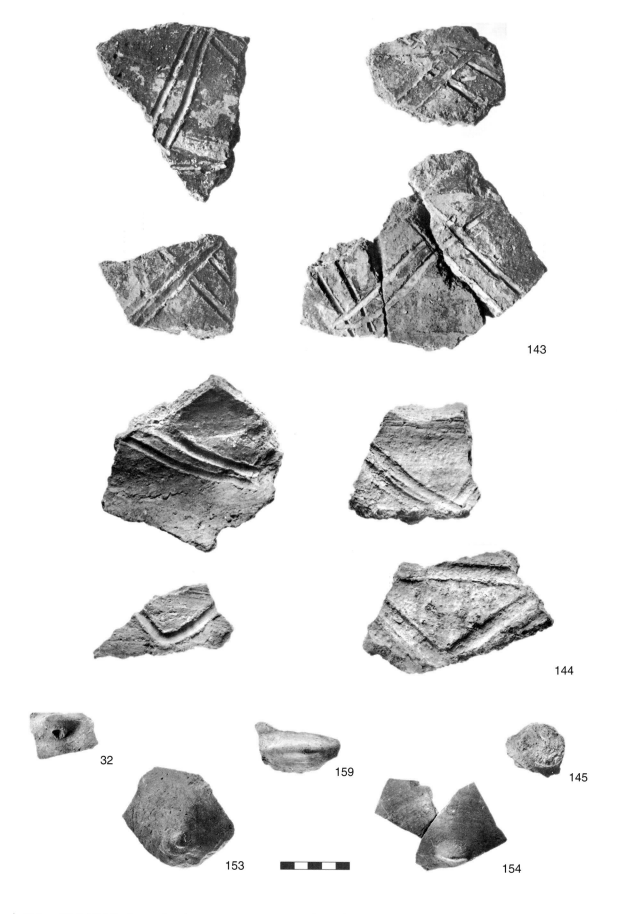

Palace Well (EM I). Type 5 bowl **32**; type 21 storage jars (pithoi) **143–145**; bases: type 3 **153**; type 5 **154**; wart **159**.

PLATE 17

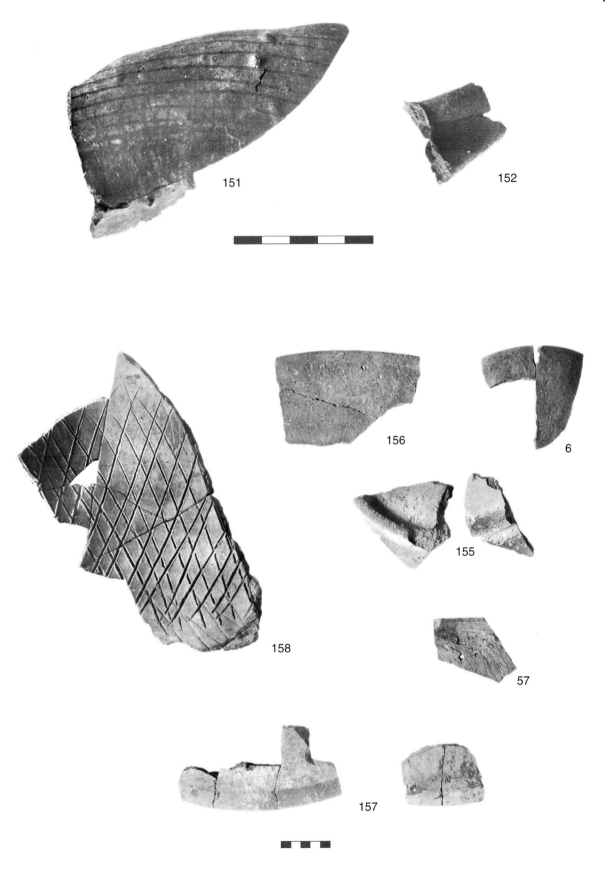

Palace Well (EM I). Bases: type 1 (?) **6**; type 6 **155–156**, and **157** (?); type 7 **57**; spouts **151–152**; scoring **158**.

PLATE 18

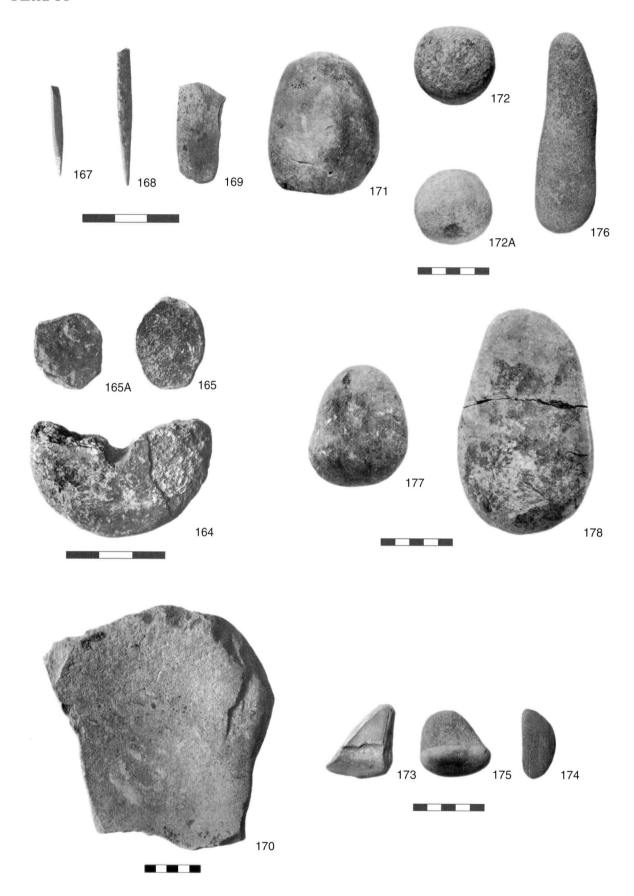

Palace Well (EM I). Clay spindlewhorl **164**; roundels **165–165A**; bone implements **167–169**; quern **170**; pounders **171–172A**; rubbers **173–176**; pot boilers (?) **177–178**.

PLATE 19

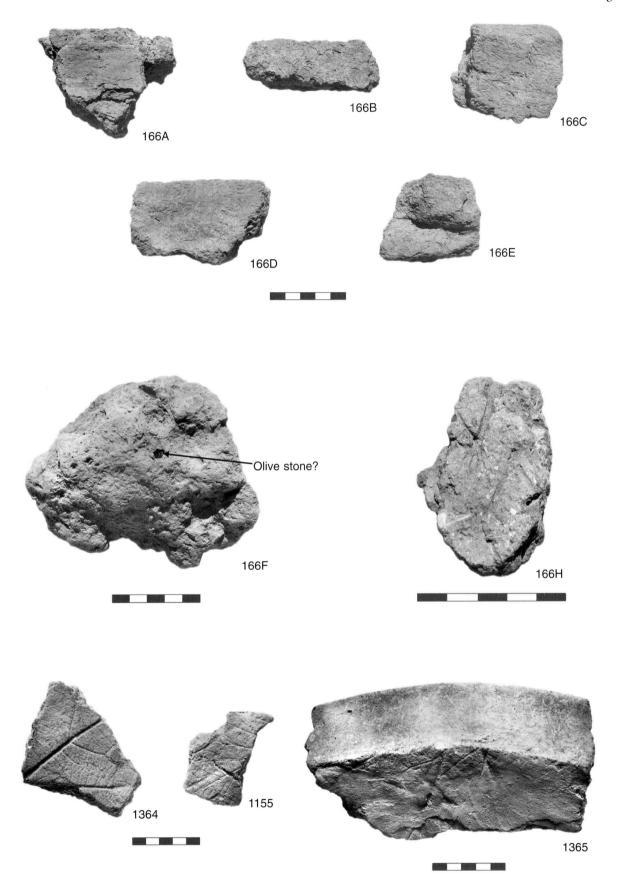

Palace Well (EM I). Clay bins **166A–166E**; mud brick with olive stone (?) **166F**; vine leaf impression **166H**. Deposit A3 (EM IIB); SMK. Vine leaf impressions: **1155** (A3); **1364–1365**.

PLATE 20

Area A — Royal Road: North. (*a*) At close of excavations in 1961, from SW; (*b*) Floors I (LM IB), II (LM IA) and III–IV (EM III: deposits A7–A5); feature αμ (Floor III), from SW; (*c*) Wall απ: to W (left) Floor VI (deposit A2); to E (right) Floor VII, with traces of hearth; deposit Ao (bottom right), from SW; (*d*) Floor VI (deposit A2) to E of wall απ, from N; (*e*) Floor VI (deposit A2) to W of wall απ and pivot stone, from SW.

PLATE 21

Area B. (*a*) Area B in 2009 from sw beside South House; (*b*) Floor 5 of South Front House on discovery in 1957, from E; (*c*) Floor 5 of South Front House after cleaning in 1957, from E; (*d*) Floor 5 and walls α, β, γ, MW 13, MW 14 and MW 15 after cleaning in 1957, from E; (*e*) Early Houses during cleaning in 1957, from NW; (*f*) Early Houses after cleaning in 1957, from W. (Views (*b*)–(*f*) courtesy of L. Platon.)

PLATE 22

Area B. (*a*) Trench A, E section. Floors 1–5; pits A and C; wall β, from W; (*b*) trench A, W section. Floors 3–5; walls β and δ (with pit B); South House in cutting beyond, from E; (*c*) trench B, N section with floors 0, 1 and 2; walls δ, MW 15, β and γ; part of N section of trench A beyond, with floors 4 and 5, and plastered face of wall α at back, from S (*d*) trenches D and F, walls α and β, from NW; (*e*) trenches D and F, walls α and β, from NE; (*f*) trench E, walls β and γ, from S.

PLATE 23

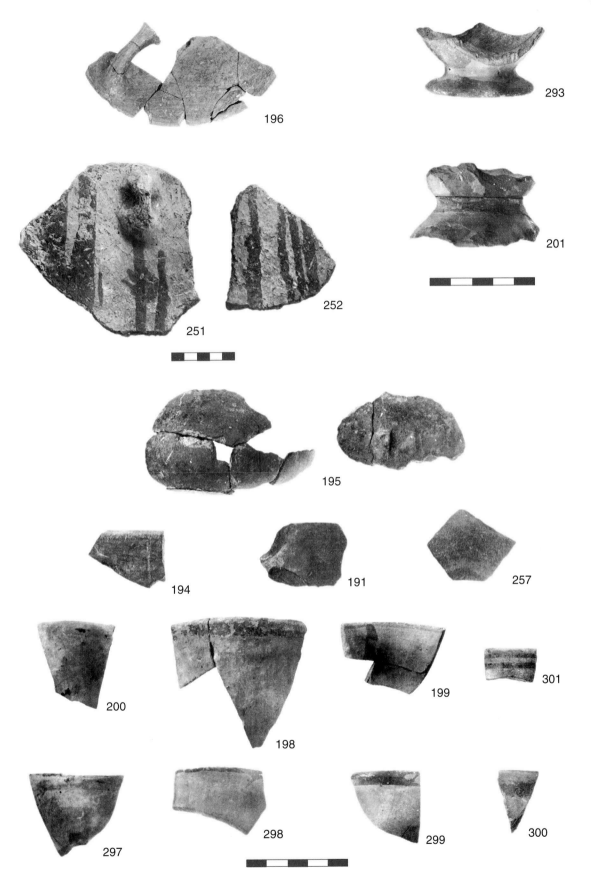

Deposits A1 (EM IIA) and A2 (EM IIB). Red and light brown burnished wares: goblet **191**; bowl **194**; type 20 suspension pot **195**; type 21 lid **196**. Type 2 goblets **201** (A1), **293** (A2); type 2 or 3 goblets **198–200** (A1), **297–301** (A2); pithoi **251–252**; base **257** (A1).

PLATE 24

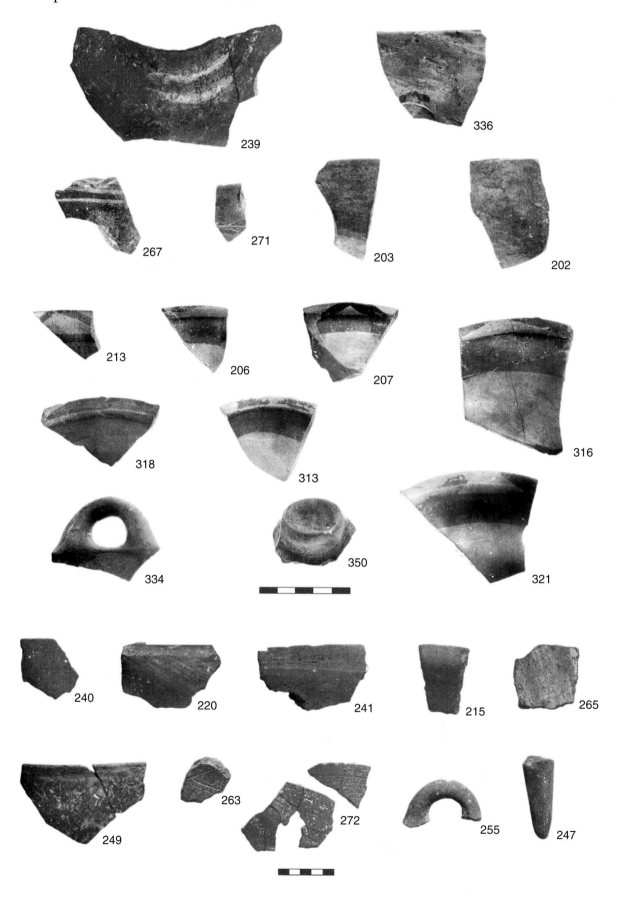

Deposits A1 (EM IIA), A2 (EM IIB). Goblets or small bowls **202–203**; type 4 bowls **206–207** (A1), **313, 316, 318, 321**; type 5 or 6 bowls **334, 336** (A2); type 8 bowl **213**; type 9 bowl **215**; type 11 bowl **220**; type 15 jug **239**; type 17 bowl or jar **240–241**; type 23 tripod cooking pots **247, 249**; handle **255**; base **263**; dark-on-light decoration **265**; light-on-dark decoration **267**; incised decoration **271**; scored ware **272** (A1); miniature **350** (A2).

PLATE 25

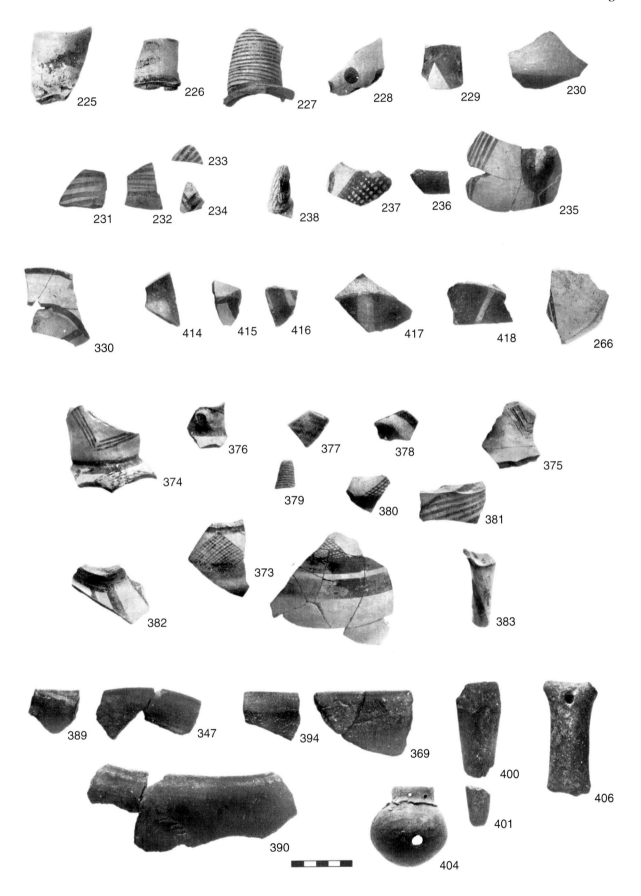

Deposits A1 (EM IIA), A2 (EM IIB). Type 8A bowl **347**; type 11 bowl **369** (A2); type 15 jugs **225–238** (A1), **373–383**; type 17 bowls or jars **389–390**; type 18 bowl or jar **394**; type 23 tripod cooking pot feet **400–401**; type 25 incense burner **404** (A2); bases with crosses **266** (A1), **330, 414–418**; handle **406** (A2).

PLATE 26

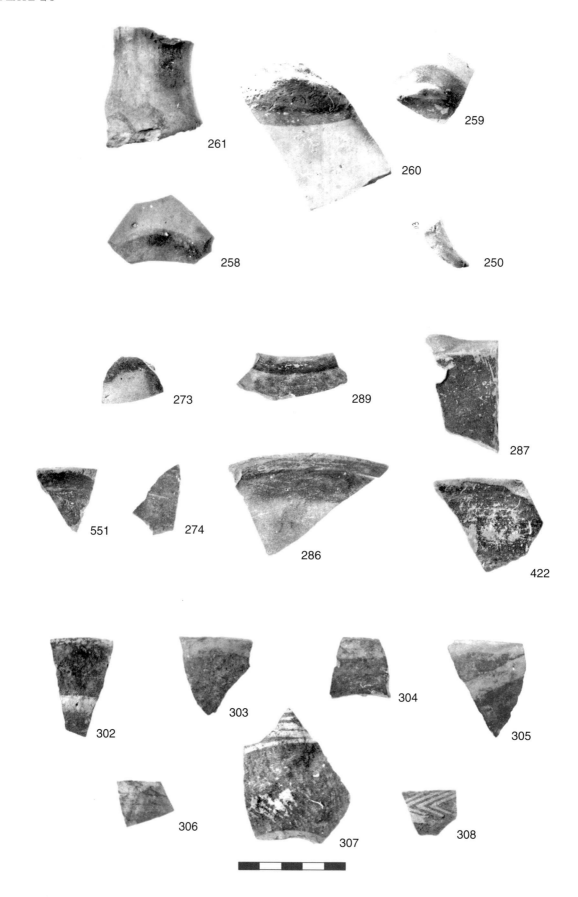

Deposits A1 (EM IIA), A2–A3 (EM IIB), A5 (EM III). Type 26 theriomorphic vessel (?) **250**; bases **258–261**; Vasiliki ware: **273–274** (A1), **286–287, 289** (A2), **422** (A3), **551** (A5); goblets **302–308** (A2).

PLATE 27

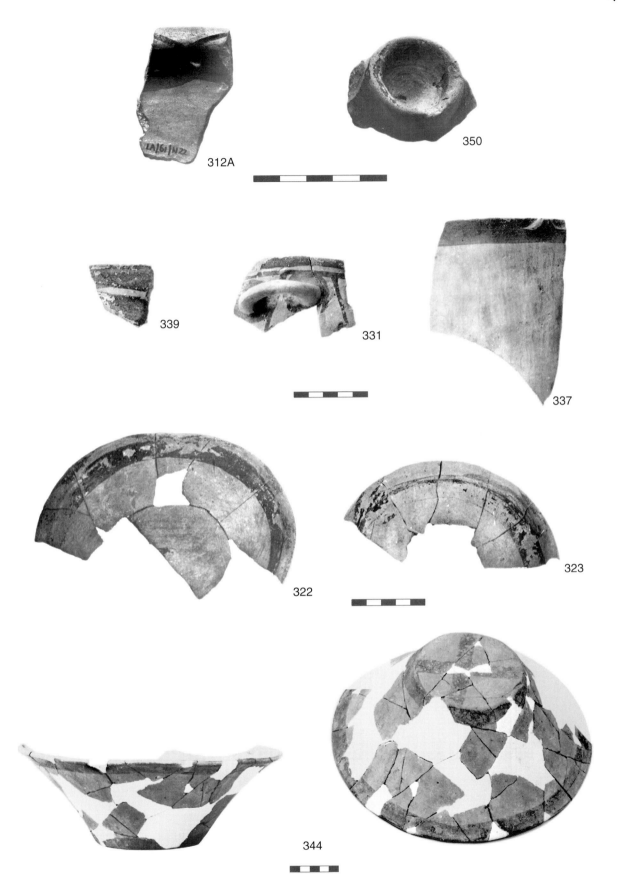

Deposit A2 (EM IIB). Type 4 bowls **312A**, **322–323**; type 5 or 6 bowls **331**, **337**, **339**; type 8B bowl **344**; miniature **350**.

PLATE 28

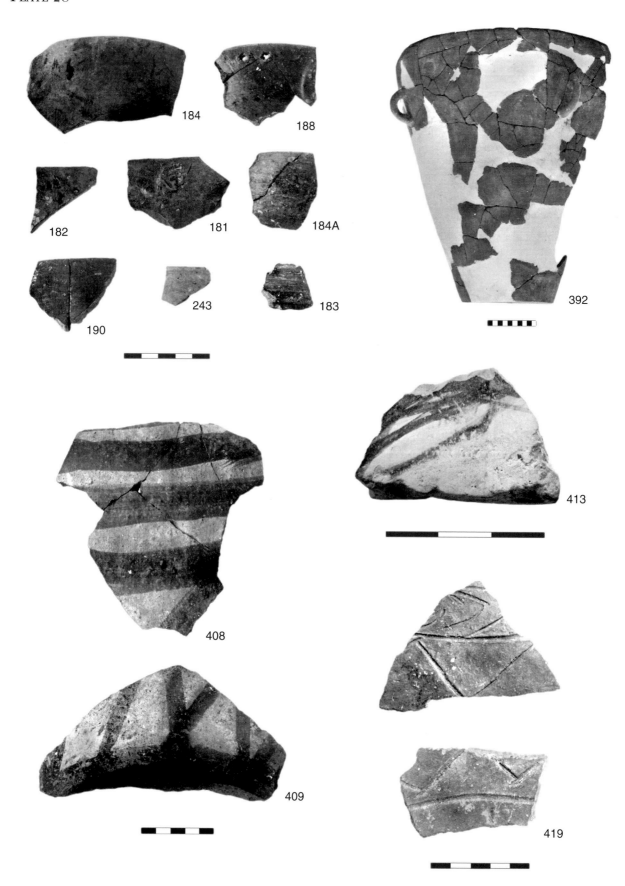

Deposits A1 (EM IIA), A2 (EM IIB). Dark grey burnished ware: bowl **181**; goblets **182–184A**; bowl **190**; light grey ware type 20 suspension pot **243** (A1); Type 18 bowl or jar **392**; dark-on-light decoration **408–409**; bowl base **413**; (Cycladic ?) jar **419** (A2).

PLATE 29

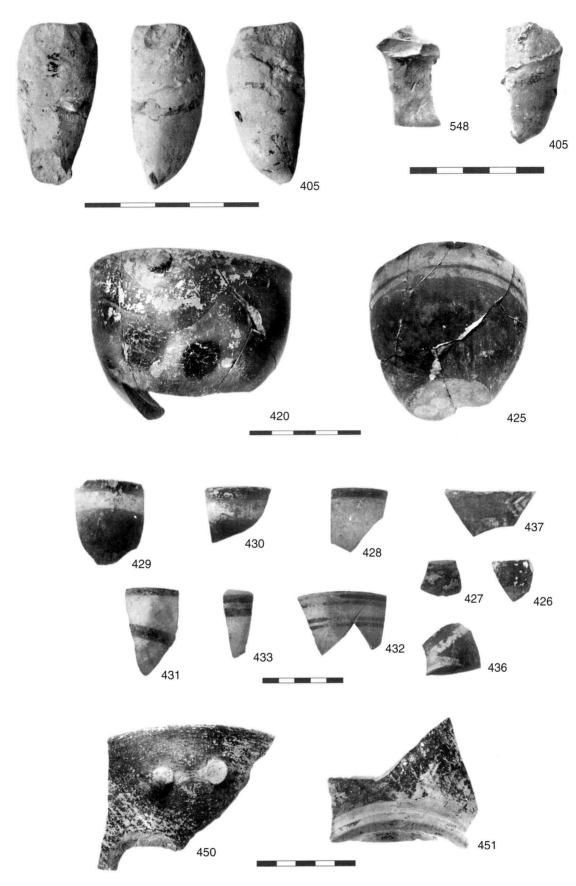

Deposits A2–A4 (EM IIB). Type 26 theriomorphic vessels **405** (A2), **548** (A4); Vasiliki ware goblet or bowl **420**; type 3 goblets **425–433, 436–437**; type 6 bowls **450–451** (A3).

PLATE 30

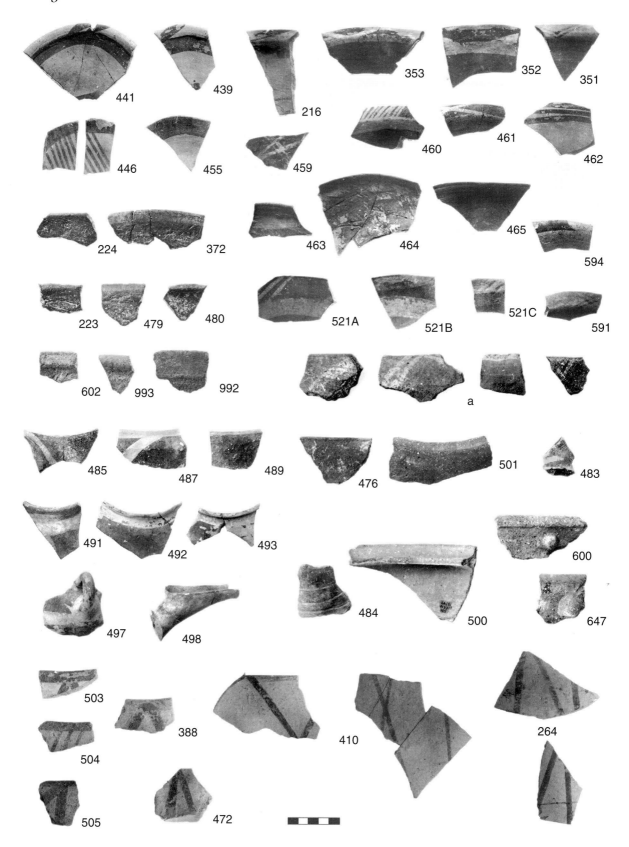

Deposits A1 (EM IIA), A2–A4 (EM IIB), A5–A6 (EM III), B2 (EM IIB). Type 4 bowls **439**, **441**, **446**; type 8A bowl **455** (A3); type 9 bowls **216** (A1), **351–353** (A2), **459–465** (A3), **521A–521C** (A4), **591**, **594** (A5); type 10 bowl **472** (A3); type 12 bowls or jars **600** (A5), **647** (A6); type 14 baking plates **223–224** (A1), **372** (A2), **479–480** (A3), **602** (A5), **992–993** (B2); type 15 jugs **483–484** (A3); type 16 bowl-jars **485**, **487**, **489**, **491–493**, **497–498**; bowl or jar **476**; jars with internal ledges **500–501**; type 17 bowls or jars: **388** (A2), **503–505** and row *a*: four rims (A3); dark-on-light decoration **264** (A1), **410** (A2).

PLATE 31

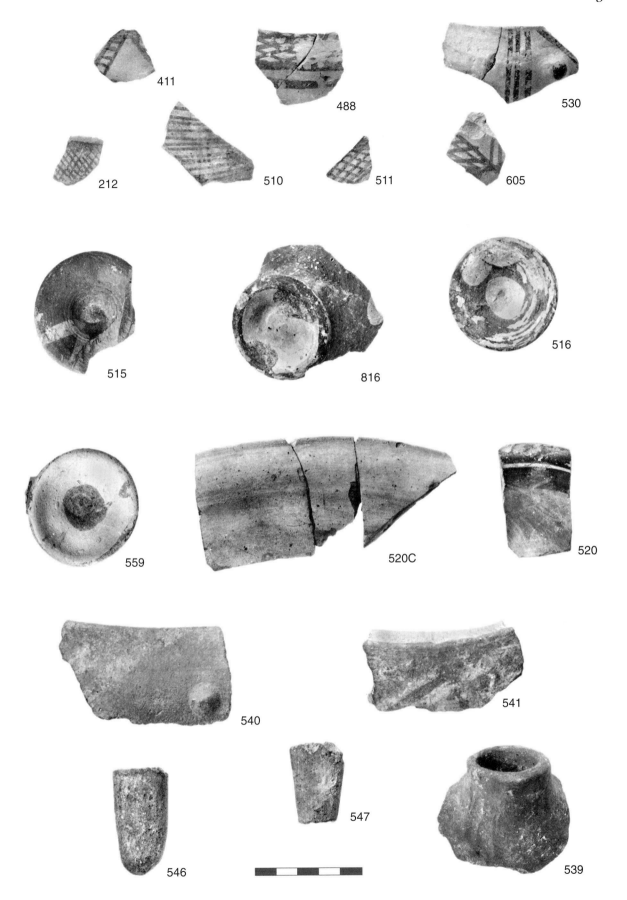

Deposits A1 (EM IIA), A2–A4 (EM IIB), A5 (EM III); A9 (RRS). Type 2 goblet feet with marks **515–516** (A4), **559** (A5), **816** (A9); type 8 bowls **212** (A1), **520**, **520C** (A4); type 15 jugs **510–511** (A3), **605** (A5); jug or jar **411** (A2); type 16 bowl-jars **488** (A3), **530**; type 17 jars **539–541**; type 23 tripod cooking pot feet **546–547** (A4).

PLATE 32

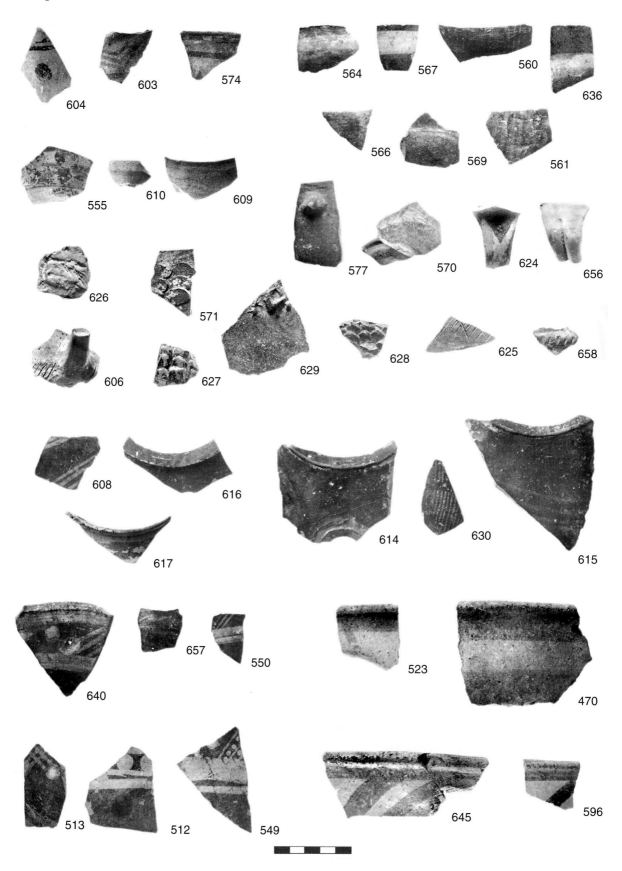

Deposits A3–A4 (EM IIB), A5–A6 (EM III). Type 1B cup **555**; types 2 and 3 goblets **560–561**, **564**, **566–567**, **569** (A5), **636** (A6); type 5 bowl **574**; type 6 bowl **577** (A5); type 7 bowl **640** (A6); type 10 bowls **470** (A3), **523** (A4), **596** (A5), **645** (A6); type 15 jugs **603–604**, **606**; type 16 bowl-jars **608–610**, **614–617** (A5); light-on-dark decoration **512–513** (A3), **549–550** (A4), **657** (A6); barbotine **571**, **627–629**; incised decoration **625–626** (A5), **658**, (A6); rippling decoration **630**; handles **624** (A5), **656** (A6).

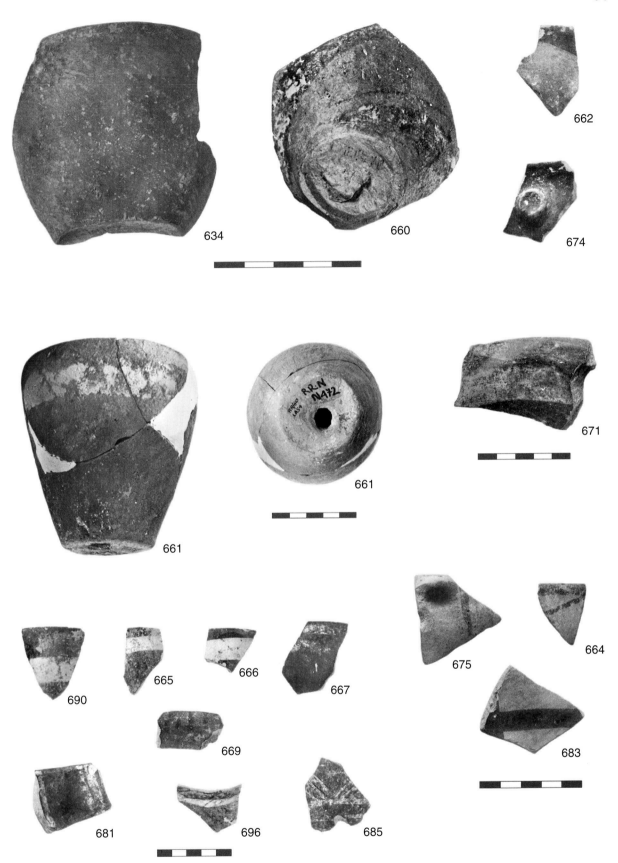

PLATE 33

Deposits A6–A7.2 (EM III). Type 2 goblet **660** (A7.1); type 3 goblets **634** (A6), **661**; type 2 or 3 goblets **662, 665–667** (A7.1), **690** (A7.2); type 8 or 9 bowls **669, 671**; jar **674**; EM II survivors (?) **664, 675, 683**; spout **681**; light-on-dark decoration **685** (A7.1).

PLATE 34

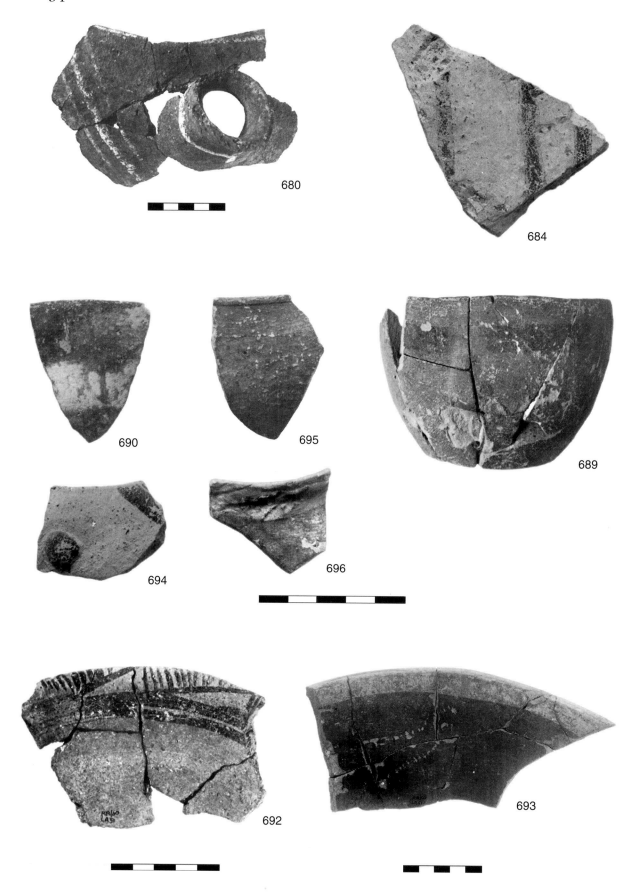

Deposits A7.1–A7.2 (EM III). Type 3 goblet **689**; type 2 or 3 goblet **690**; type 8 or 9 bowls **692–693** (A7.2); spouted jar **680**; jar with trickle ornament **684** (A7.1); jars **694–696** (A7.2).

PLATE 35

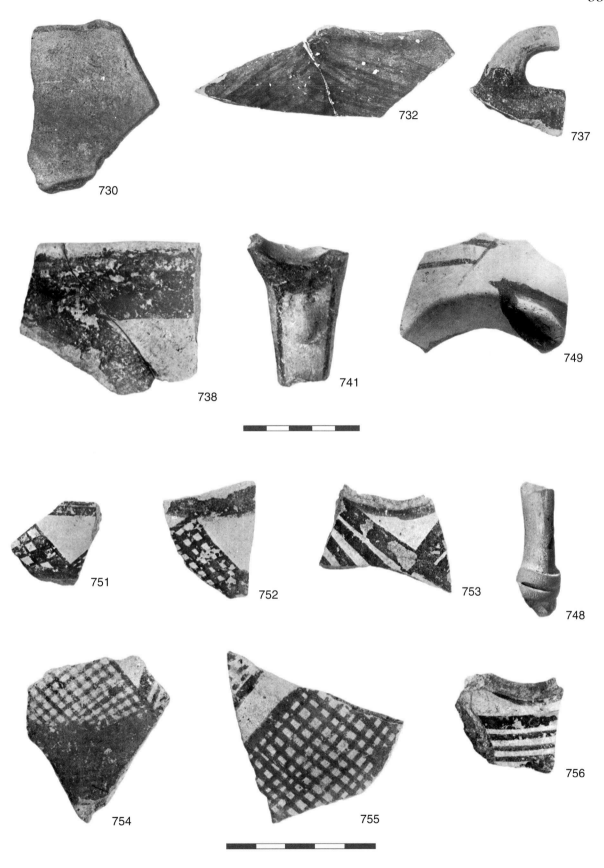

Deposit A8 (EM II). Type 9 bowls **730, 732**; bowls **737–738**; handles **741, 748**; base **749**; dark-on-light decoration **751–756**.

PLATE 36

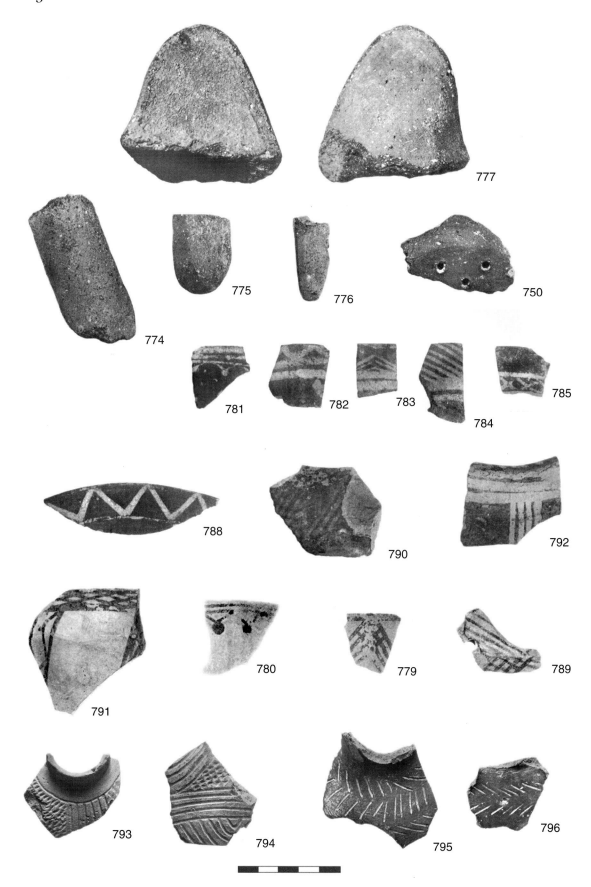

Deposit A8 (EM II), A9 (RRN, RRS). Type 2 or 3 goblets **779–785**; type 14 bowls **788–789**; jars **790–792** (RRN); type 15 jugs **795** (RRS), **796** (RRN); light grey ware type 20 suspension pots **793–794** (RRN); strainer **750**; type 23 tripod cooking pots **774–776**; type 24 horned stand **777**.

PLATE 37

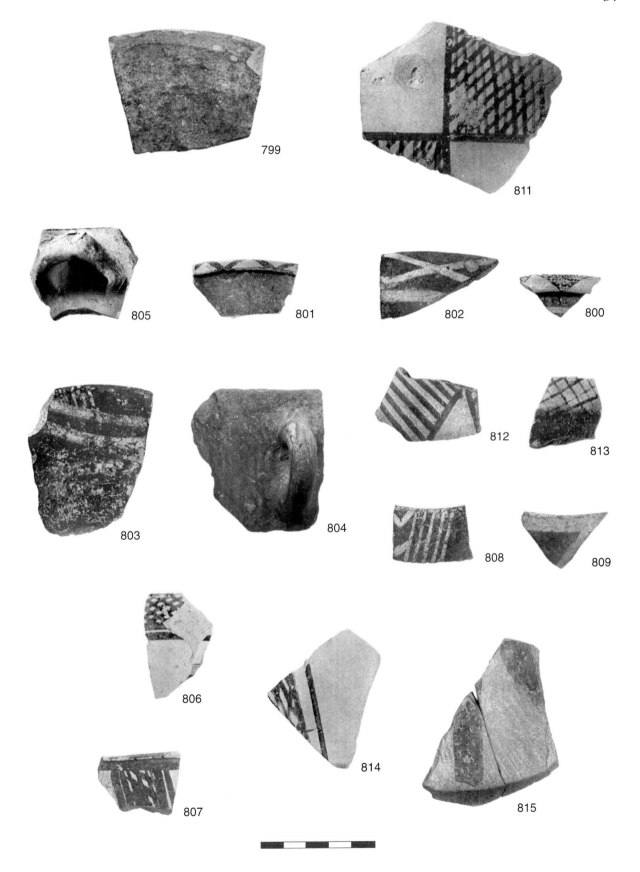

A9 (RRS). Type 2 or 3 goblet **806**; bowls **799, 802, 811, 815**; type 4 bowls **800–801**; type 8 or 9 bowl **803**; bowls or jars **804–805**; jars **807–809, 812–814**.

PLATE 38

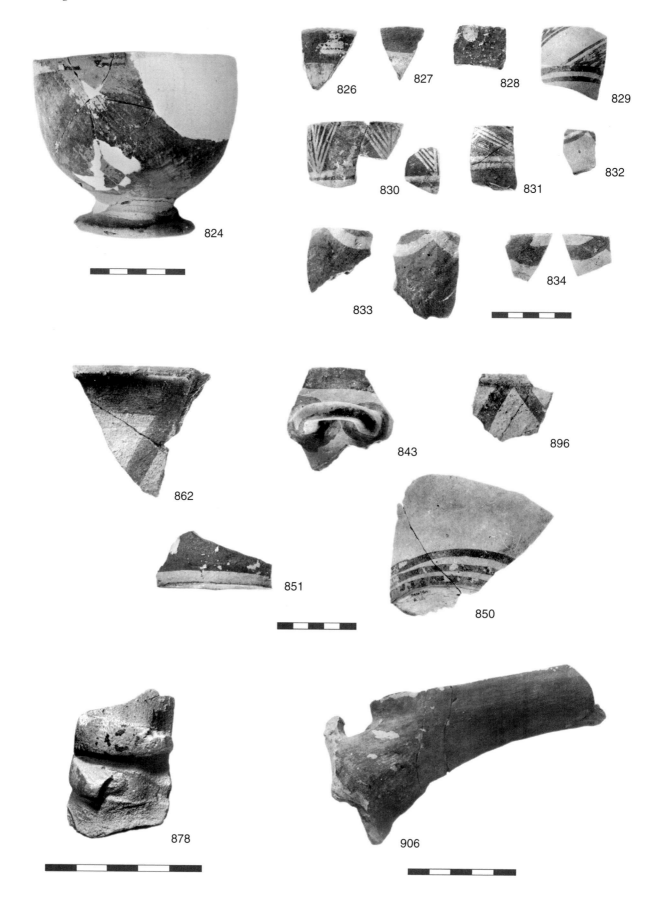

Deposit B1 (EM IIB). Type 2 goblet **824**; type 2 or 3 goblets **826–834**; type 5 or 6 bowl **843**; type 9 bowls **850–851**; type 10 bowl **862**; type 15 jug **878**; type 18 bowl or jar **896**; spout **906**.

PLATE 39

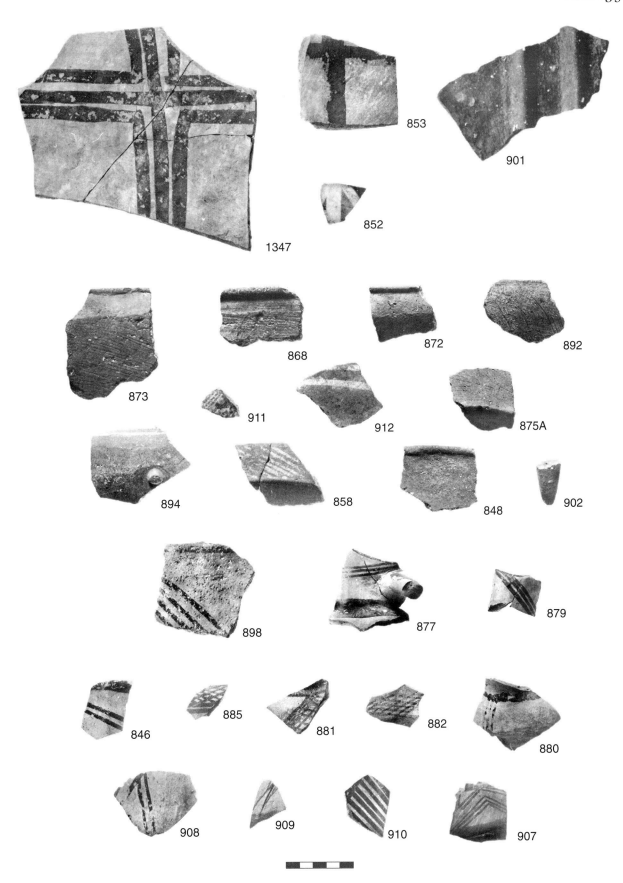

853

901

852

1347

868

872

892

873

911

912

875A

894

858

848

902

898

877

879

846

885

881

882

880

908

909

910

907

Deposit B1 (EM IIB). Type 5 or 6 bowl **846**; type 8 bowl **848**; bowls **852–853**; type 9 bowl **858**; bowl **868**; type 11 bowls **872–873**, **875A**; type 15 jugs **877**, **879–882**; type 16 bowl-jar **885**; type 17 bowls or jars **892**, **894**; type 19 jar **898**; type 20 suspension pot **901**; type 23 tripod cooking pot **902**; dark-on-light decoration **907–910**; light-on-dark decoration **911–912**. SMK. EM IIB bowl **1347**.

PLATE 40

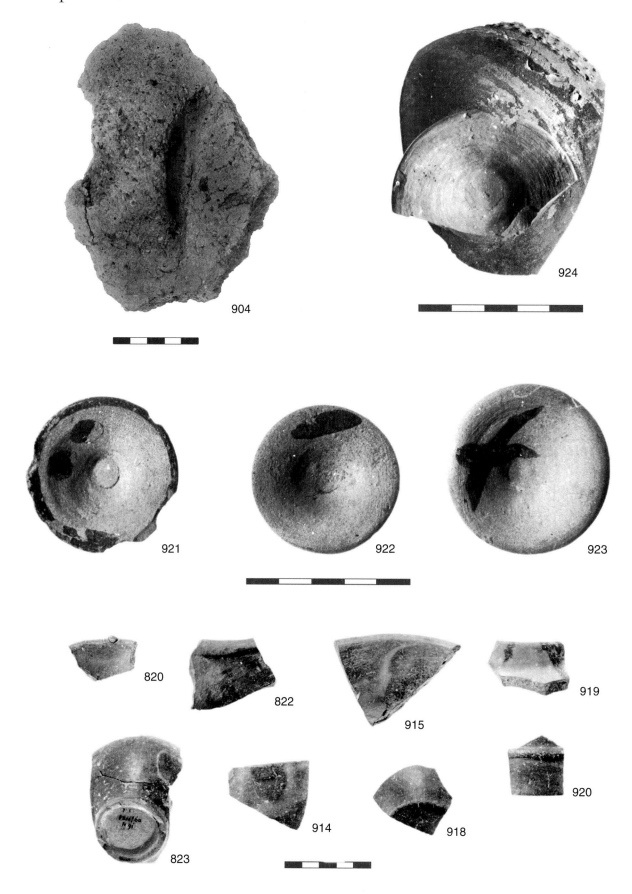

Deposits B1–B2 (EM IIB). Type 2 goblets **921–924**; Vasiliki ware **820**, **822–823**, and **914** (unstratified) and **915**, **918–920** (B2); type 27 pithos **904** (B1).

PLATE 41

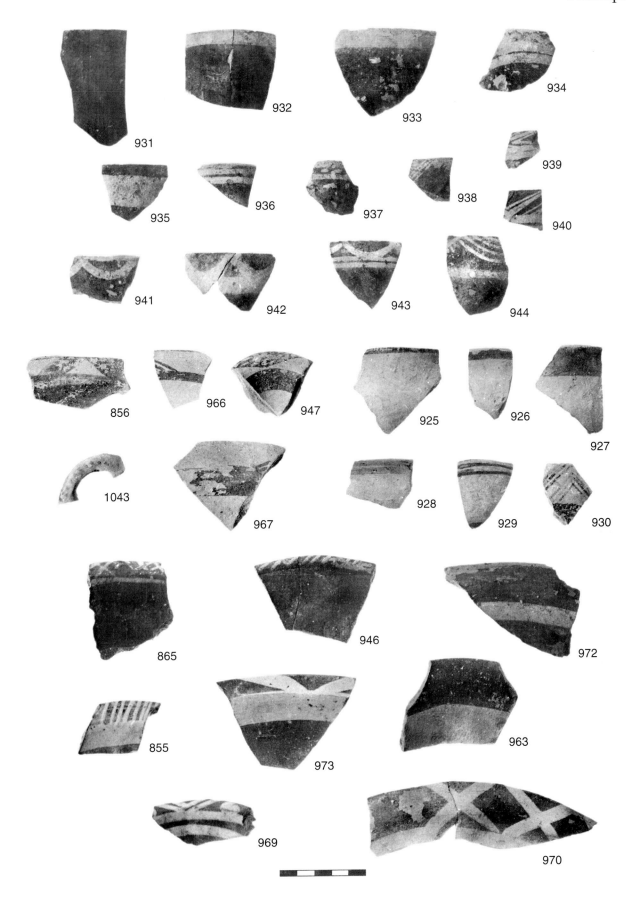

Deposits B1–B2 (EM IIB). Types 2 or 3 goblets **925–944**; type 4 bowls **946–947** (miniature; unstratified); type 8 bowl **963** (B2); type 9 bowls **855–856** (B1), **966–967**, **969–970**, **972–973** (B2); type 10 bowls **865** (B1); handle **1043** (B2).

PLATE 42

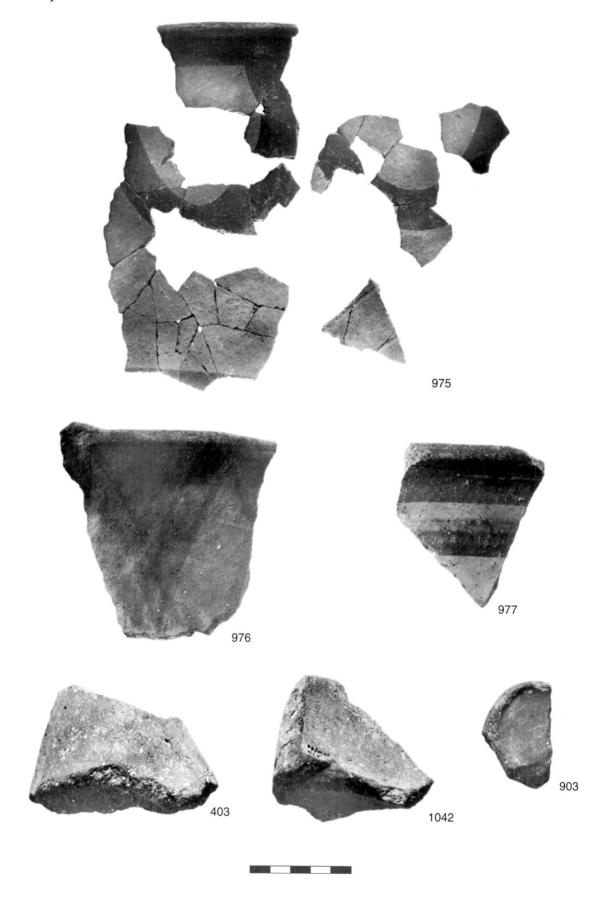

975

976

977

403

1042

903

Deposits A2, B1–B2 (EM IIB). Type 10 bowls **975–977** (B2); type 24 horned stands **403** (A2), **903** (B1), **1042** (B2).

PLATE 43

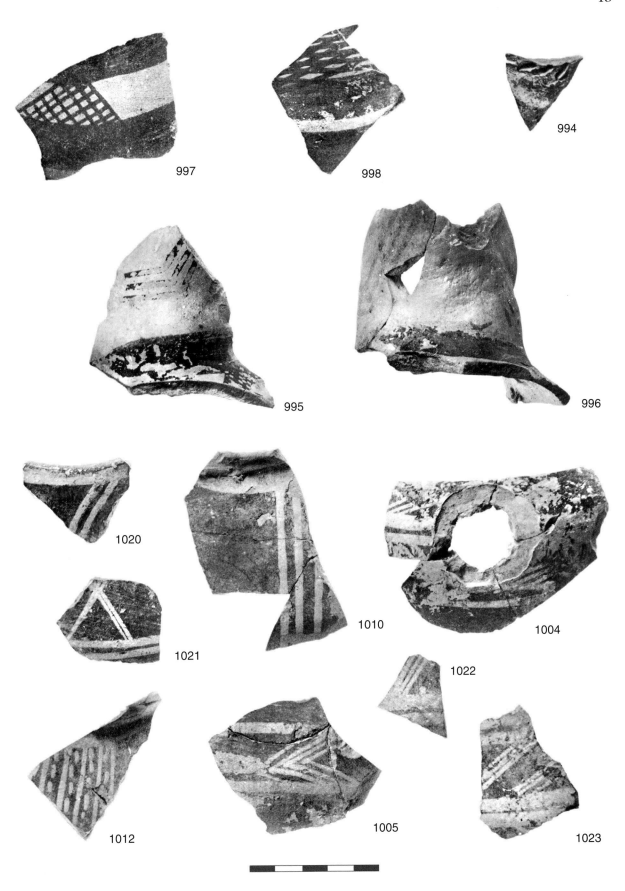

Deposit B2 (EM IIB). Type 15 jugs **994–998**; type 16 bowl-jars **1004–1005, 1010, 1012, 1020–1023**.

PLATE 44

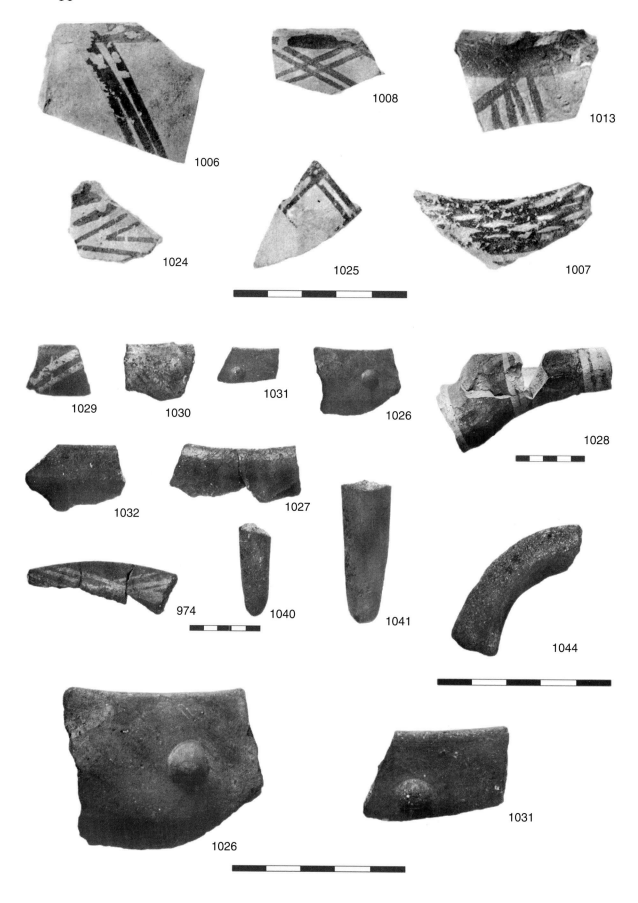

Deposit B2 (EM IIB). Type 9 bowl **974**; type 16 bowl-jars **1006–1008**, **1013**, **1024–1025**; type 17 bowls or jars **1026–1031**; type 18 bowl or jar **1032**; type 23 tripod cooking pots **1040–1041**; handle **1044**.

PLATE 45

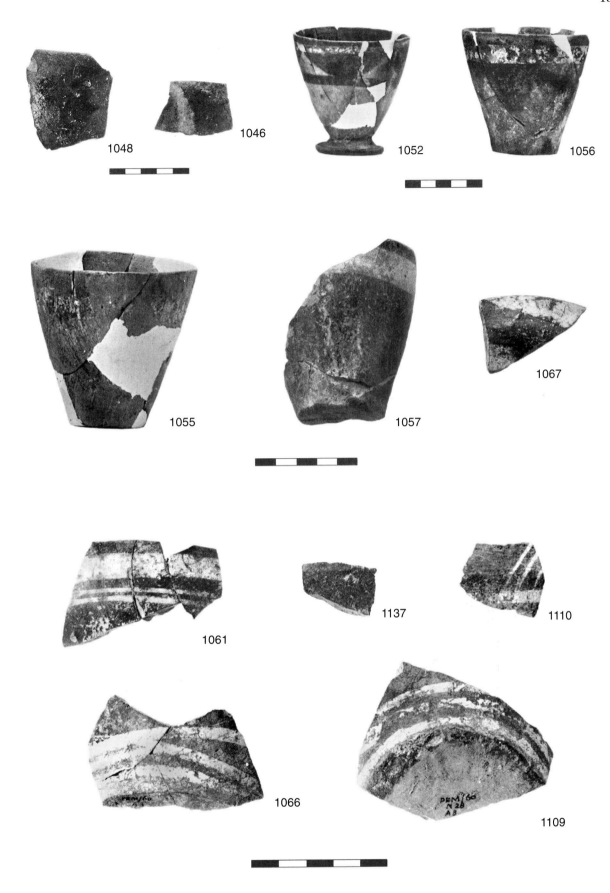

Deposit B3 (EM III). Vasiliki ware **1046**, **1048**; type 2 goblet **1052**; type 3 goblets **1055–1057**; cup or goblet **1061**; type 8 or 9 bowls **1066–1067**; base **1109**; carination **1110**; jar **1137**.

PLATE 46

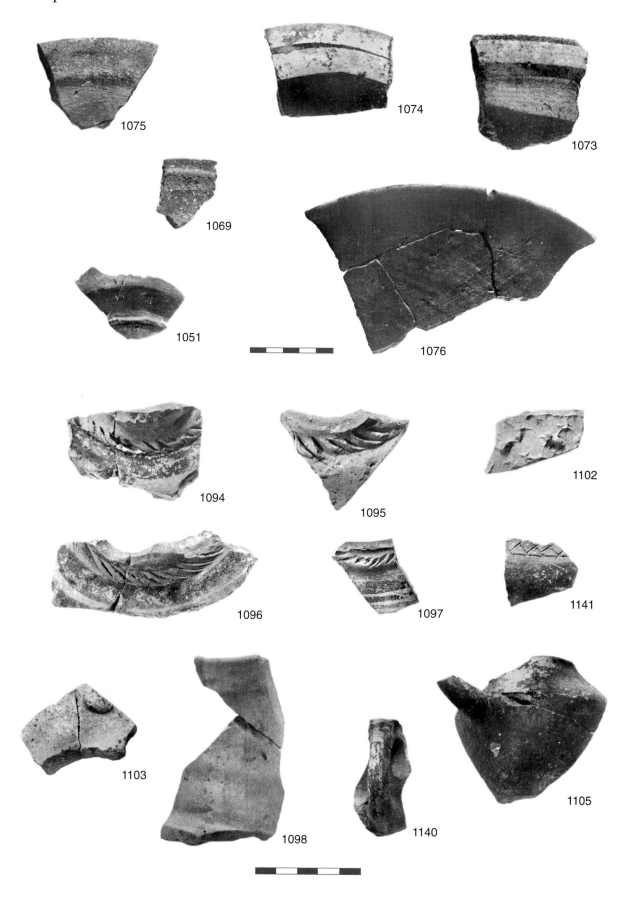

Deposit B3 (EM III). Type 1B cup **1051**; type 8 or 9 bowls **1069, 1073–1076**; type 15 jugs **1094–1097, 1102** (barbotine); dark-on-light decoration **1098**; wart **1103**; type 16 bowl-jars **1105, 1140**; incised lattice **1141**.

PLATE 47

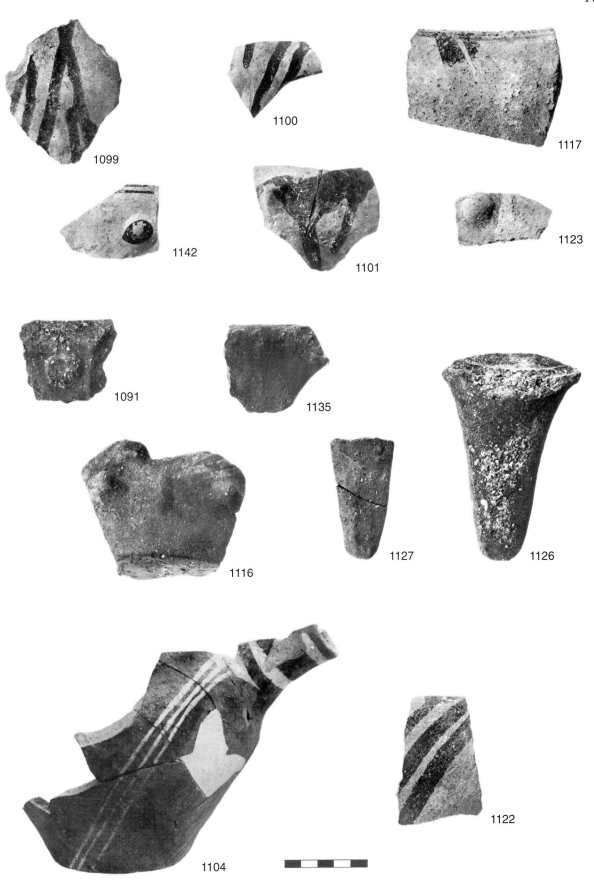

Deposit B3 (EM III). Type 12 bowl or jar **1091**; trickle decoration **1099–1101**; type 16 bowl-jars **1104, 1116**; type 17 bowls or jars **1117, 1122–1123**; type 20 tripod cooking pots **1126–1127**; type 24 horned stand **1135**; wart **1142**.

PLATE 48

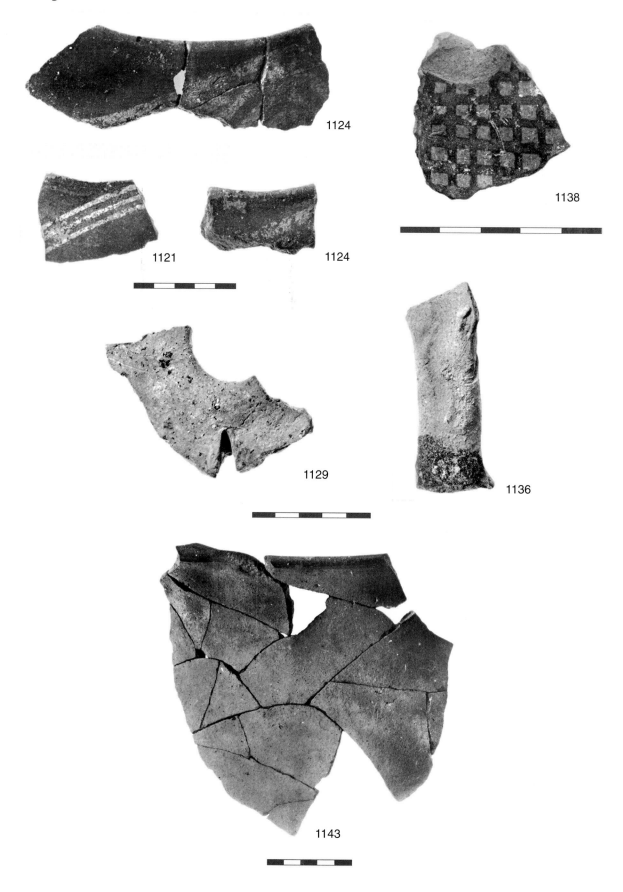

1124

1138

1121

1124

1129

1136

1143

Deposit B3 (EM III). Type 17 bowl or jar **1121**; East Cretan imported jar **1124**; type 21 brazier **1129**; handle **1136**; dark-on-light decoration **1138**; imported jar **1143**.

PLATE 49

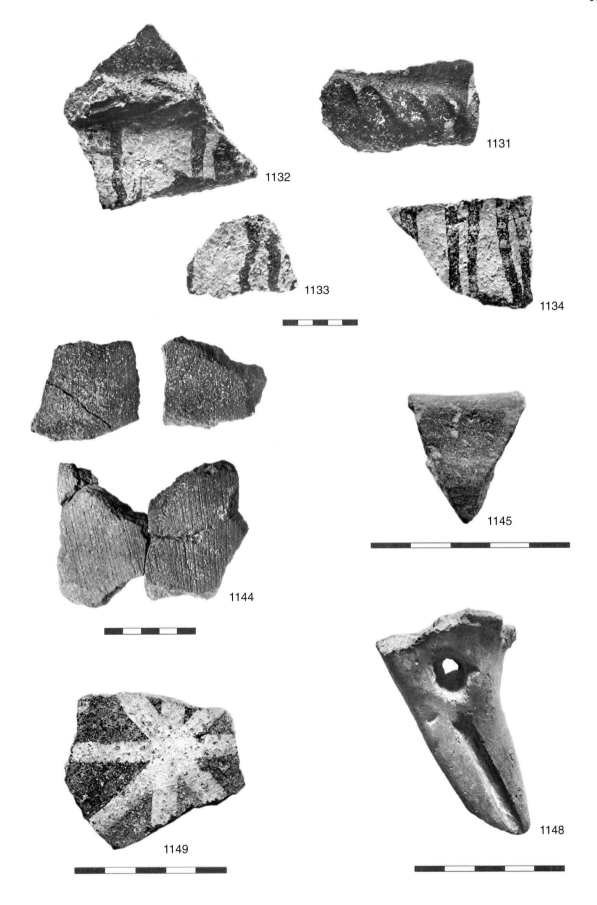

Deposit B3. EM III: type 22 pithoi **1131–1134**; imported jars **1144–1145**. Area B (unstratified). Foot of vessel (?) **1148**; jar or jug **1149**.

PLATE 50

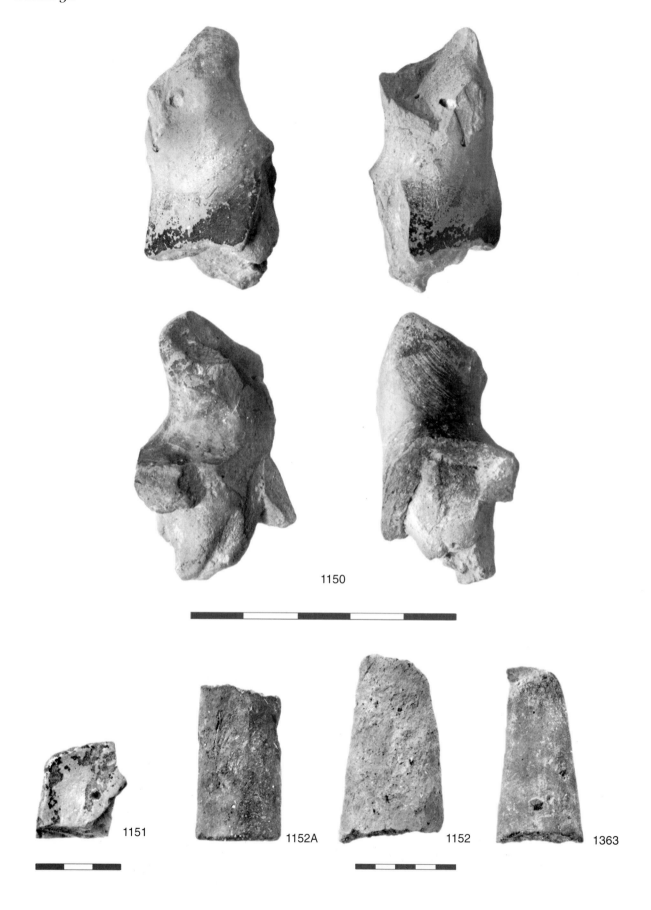

1150

1151 1152A 1152 1363

Area A; SMK. Figurine **1150** (A4); model **1151** (A5); phalli: **1152–1152A** (A3), **1363** (SMK).

PLATE 51

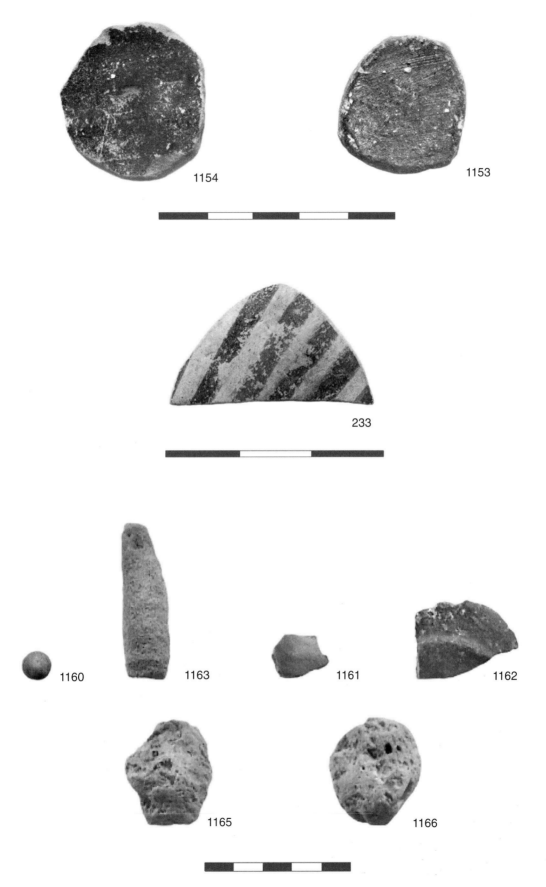

Area A. Sherd rubber **233** (A1); roundels **1153–1154** (A5; A6); stone ball **1160** (A1); tufa bowl **1161** (A5); serpentine bowl **1162** (A7.1); stone rubber or sharpener **1163** (A8); pumice **1165–1166** (A3; A2).

PLATE 52

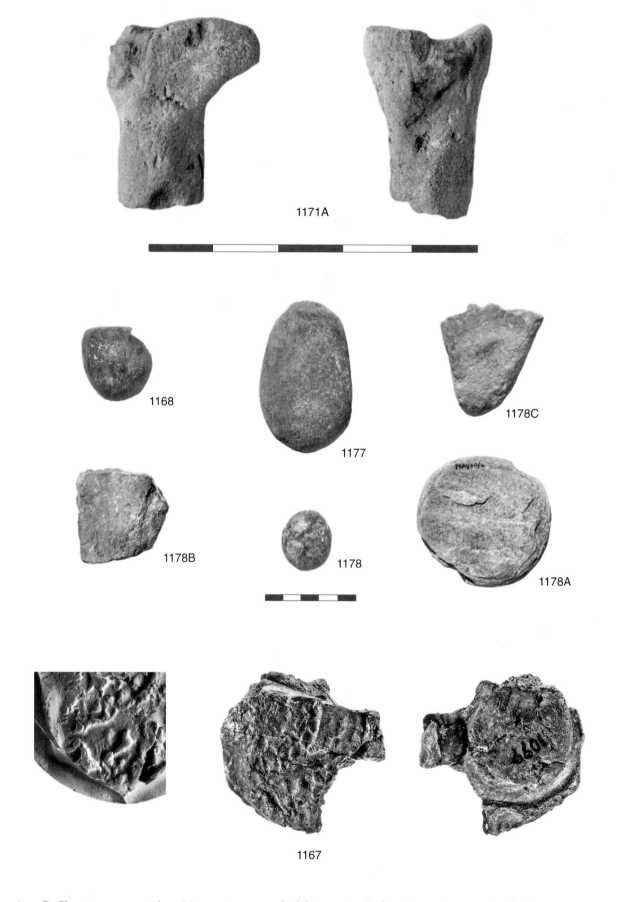

Area B. Clay: jar stopper with seal impressions **1167** (B3) (courtesy I. Pini); spindle whorl **1168** (B1); figurine **1171A**; stone: pounder **1177**, rubber ? **1178** (B1); disc **1178A**; **1178B–1178C**.

PLATE 53

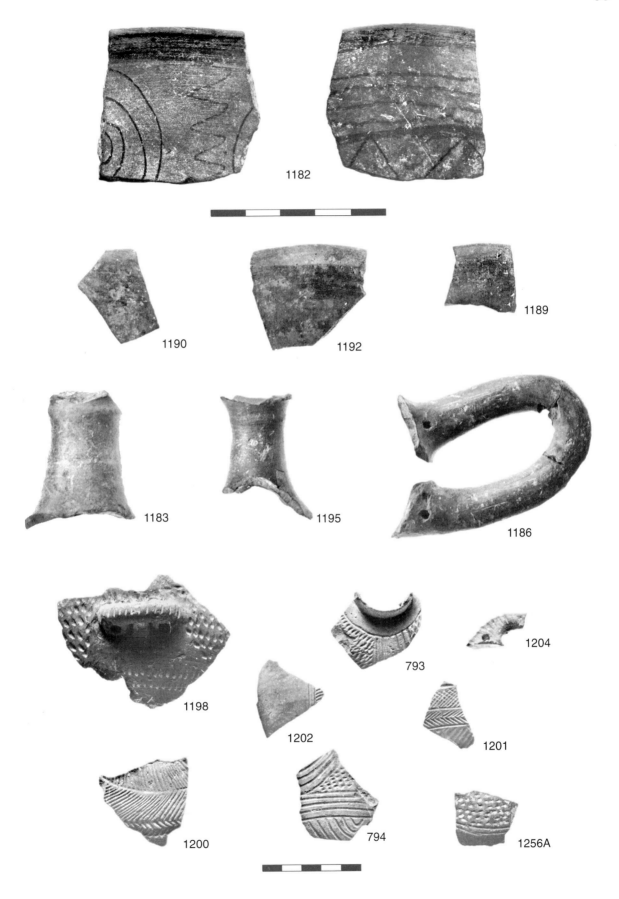

1182

1190 1192 1189

1183 1195 1186

1198 793 1204

1202 1201

1200 794 1256A

SMK; RRN. EM I type 1 chalice **1182**; light grey ware **1183**; EM IIA light grey ware: type 1A cup **1186**; type 2 goblets **1189–1190, 1192, 1195**; type 20 suspension pots **793–794** (RRN), **1198, 1200–1202, 1204, 1256A** (dark grey burnished ware).

PLATE 54

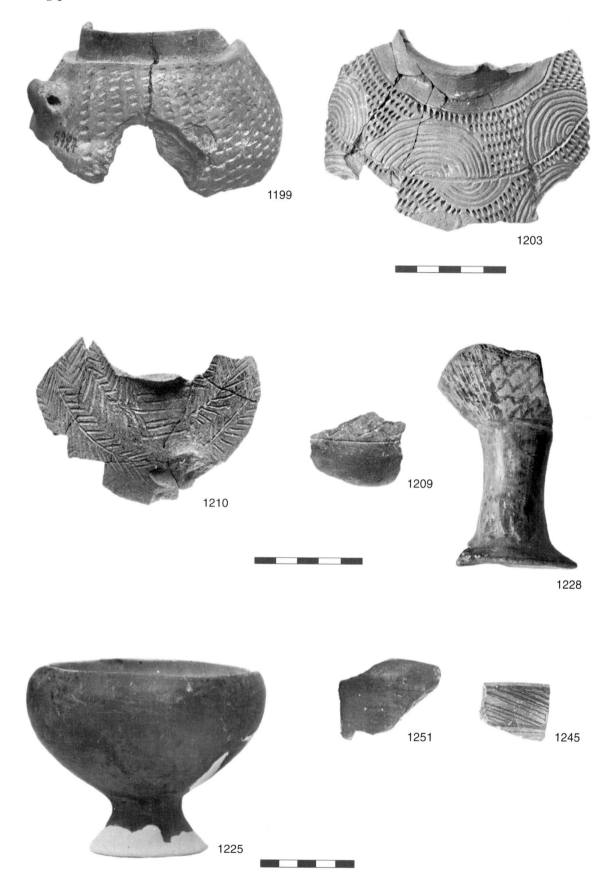

HM; SMK. EM IIA type 20 suspension pots **1199** (HM), **1203**; jar **1209**; jug **1210**; dark grey burnished ware: type 2 goblets **1225**, **1228**; type 6 bowl **1245**; type 9 bowl **1251**.

PLATE 55

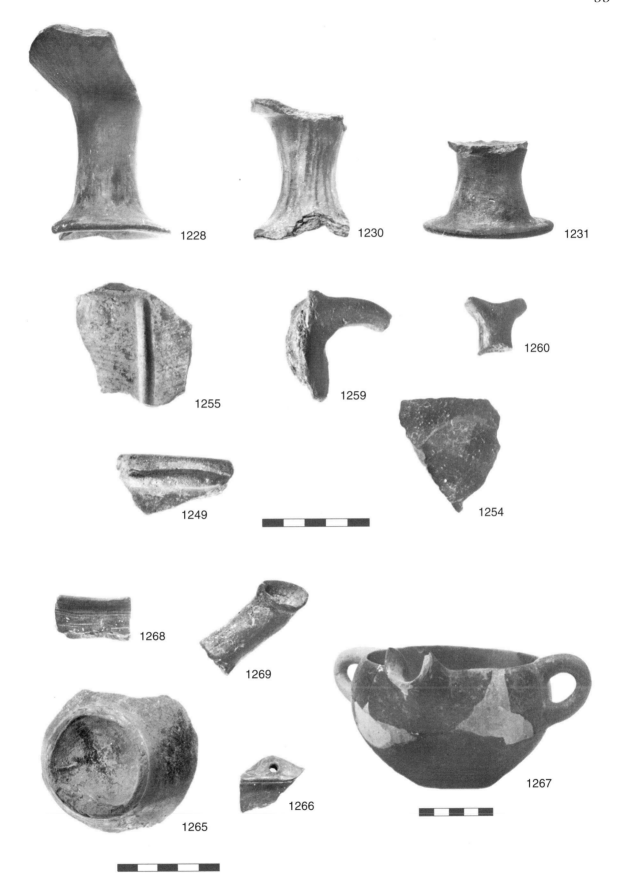

SMK. EM IIA dark grey burnished ware: type 2 goblets **1228**, **1230**, **1231**; type 8 bowl **1249**; bowl **1254**; type 20 suspension pot **1255**; handles **1259–1260**; brown burnished wares: type 2 goblet **1265**; type 4 bowl **1266**; type 16 bowl-jars **1268–1269**.

PLATE 56

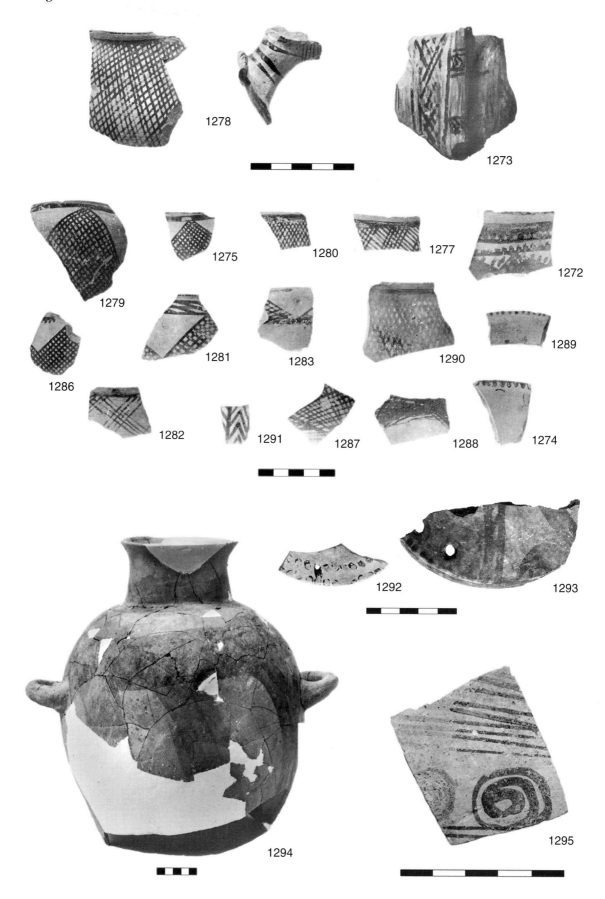

SMK. EM IIA fine painted ware: type 6 bowls **1272–1273** (basket vessel ?); type 8 bowl **1274**; type 16 bowl-jars **1275, 1277–1283, 1286–1288**; type 19 (?) jars **1289–1290**; chevron decoration **1291**; lids **1292–1293**; buff ware: type 19 jar **1294**; spiral decoration **1295**.

PLATE 57

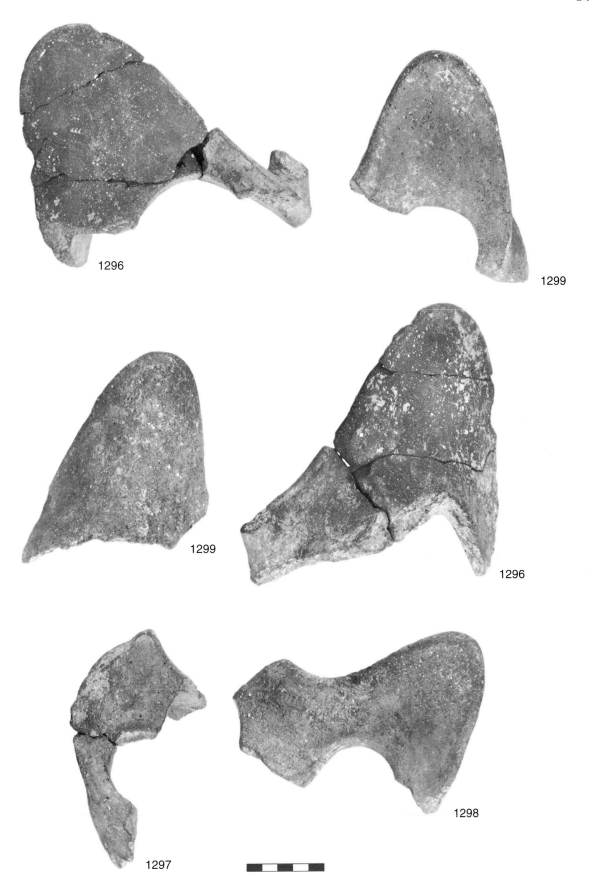

1296

1299

1299

1296

1297

1298

SMK. EM IIA type 24 horned stands **1296–1299**.

PLATE 58

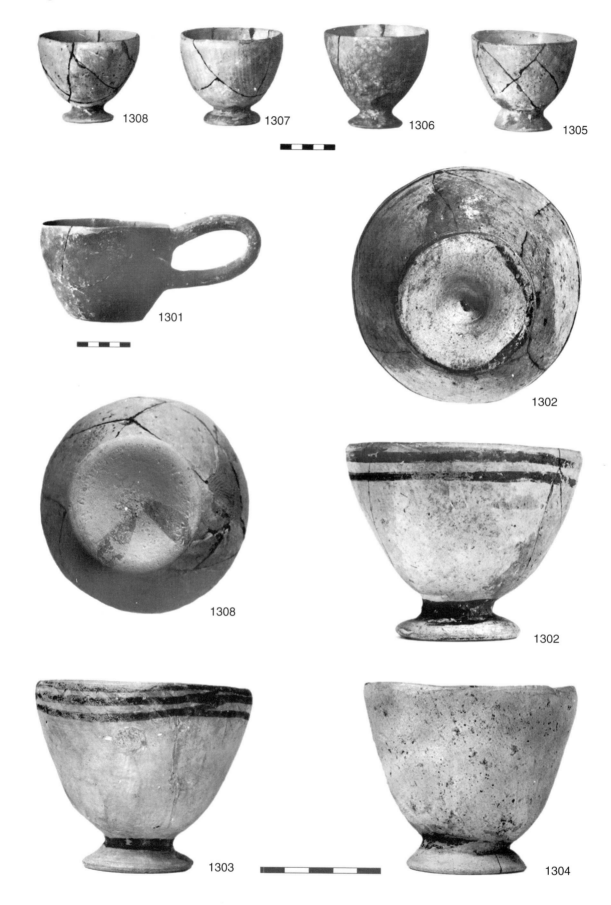

AM; HM. EM II type 1A cup **1301** (HM); type 2 goblets **1302–1304** (courtesy Ashmolean Museum), **1305–1308** (HM).

PLATE 59

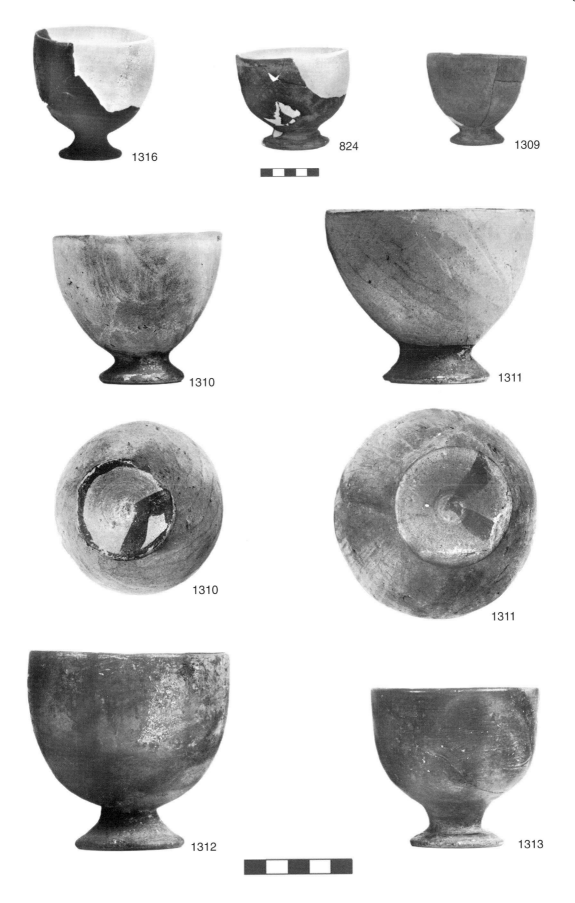

Deposit B1; AM; SMK. EM IIB type 2 goblets **824** (B1); **1309**; **1310–1313** (courtesy Ashmolean Museum); **1316**.

PLATE 60

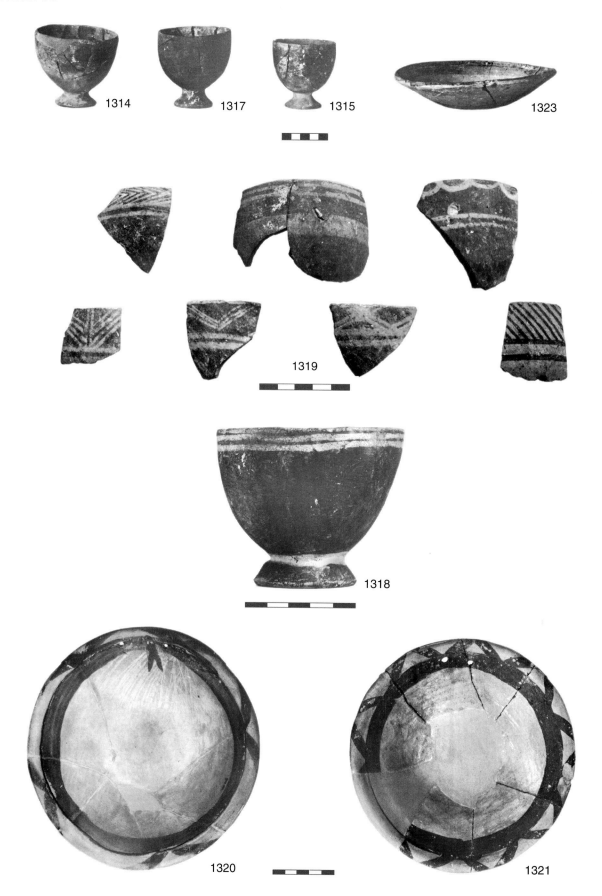

1314 1317 1315 1323

1319

1318

1320 1321

AM; HM. EM IIB: type 2 goblets **1314–1315**, **1317** (HM), **1318** (courtesy Ashmolean Museum), **1319** (HM); type 4 bowls **1320–1321** (courtesy Ashmolean Museum), **1323** (HM).

PLATE 61

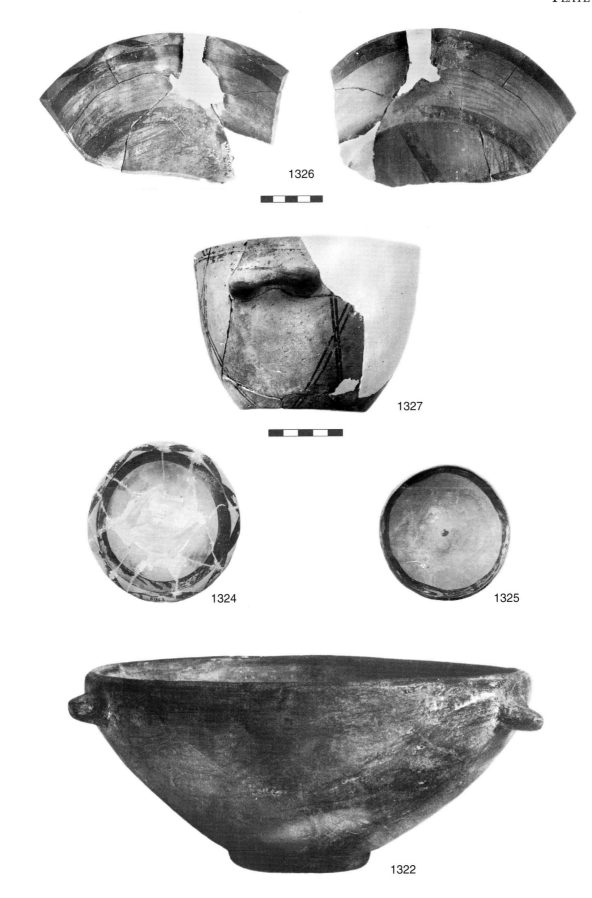

1326

1327

1324

1325

1322

AM; MMA; SMK. EM II type 4 bowl **1322** (courtesy Ashmolean Museum); EM IIB: type 4 bowls **1324–1325** (courtesy Metropolitan Museum of Art); type 5 bowl **1326**; type 6 bowl **1327**.

PLATE 62

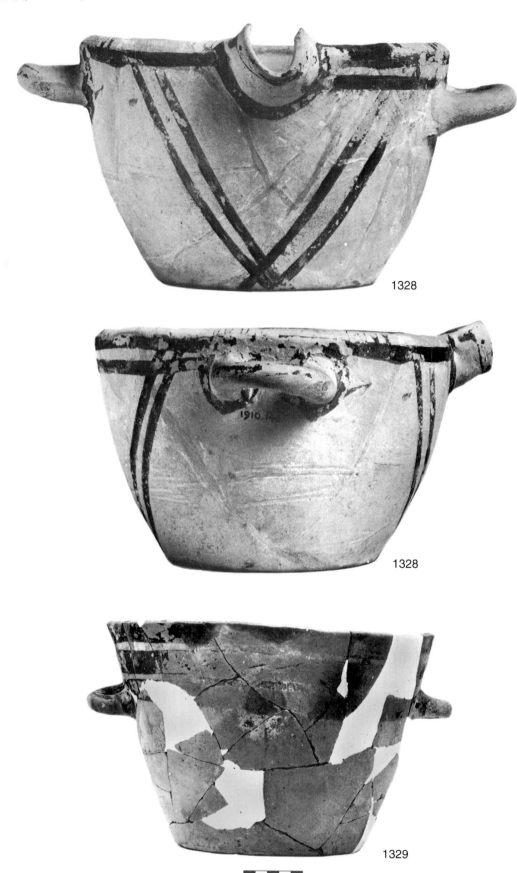

1328

1328

1329

AM; SMK. EM IIB: type 6 bowls **1328** (courtesy Ashmolean Museum), **1329**.

PLATE 63

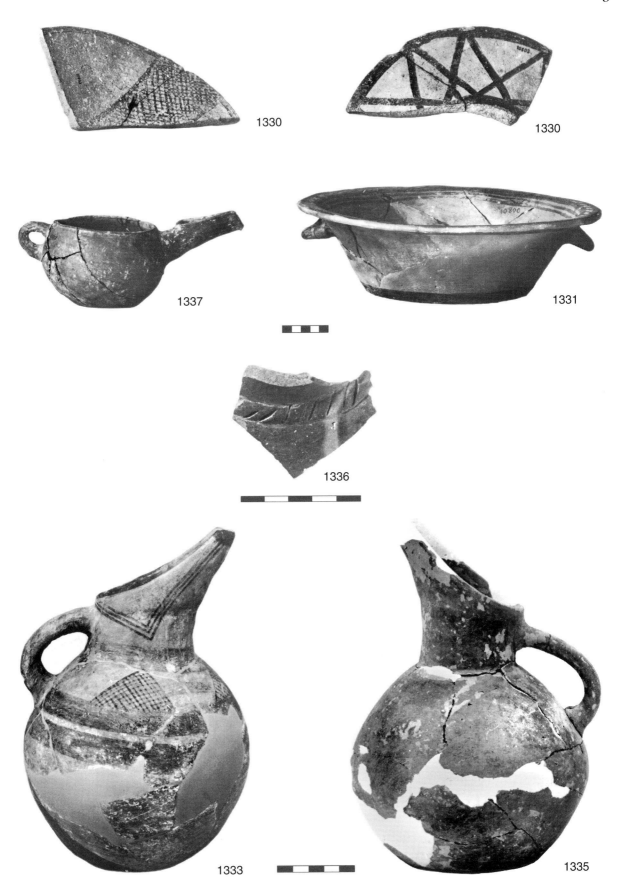

HM; MMA; SMK. EM IIB: type 8 bowl **1330** (inside, outside), type 9 bowl **1331** (HM); type 15 jugs **1333** (courtesy Metropolitan Museum of Art), **1335–1336**; type 16 bowl-jar **1337**.

PLATE 64

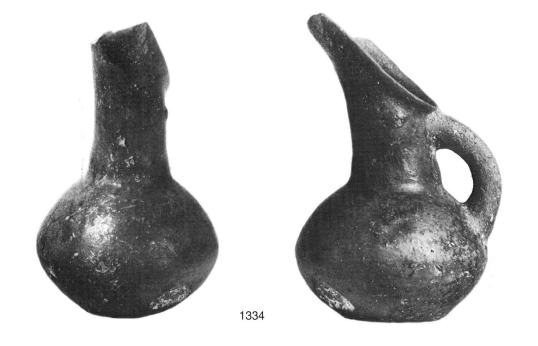

1334

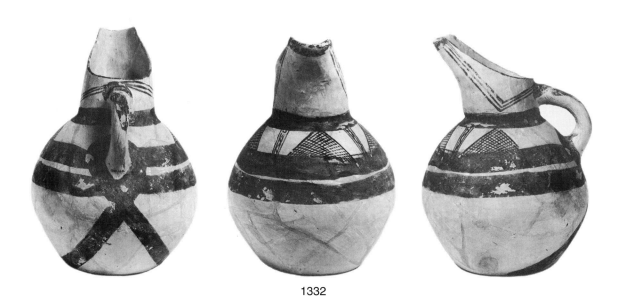

1332

AM. EM II type 15 jugs **1332**, **1334** (courtesy Ashmolean Museum).

PLATE 65

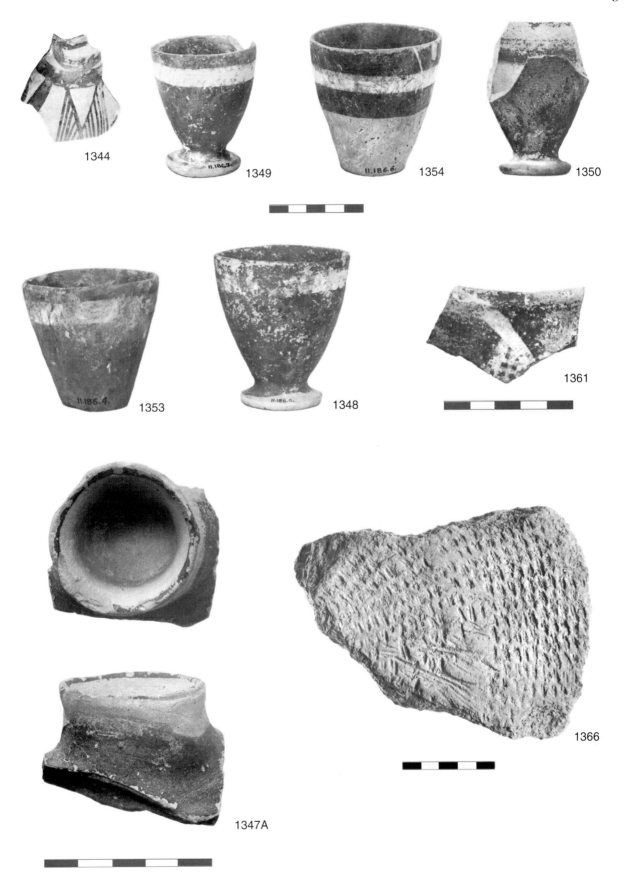

1344

1349

1354

1350

1353

1348

1361

1347A

1366

SMK; MMA. EM IIA: type 15 jug **1344**; mat impression **1366**. EM II/III miniature bowl **1347A**. EM III: type 2 goblets **1348–1350**; type 3 goblets **1353–1354** (courtesy Metropolitan Museum of Art); East Cretan imported jar **1361**.